FROM IRELAND COMING

INDEX OF CHRISTIAN ART

OCCASIONAL PAPERS IV

From Ireland Coming

IRISH ART FROM THE EARLY CHRISTIAN

TO THE LATE GOTHIC PERIOD AND

ITS EUROPEAN CONTEXT

·

EDITED BY

Colum Hourihane

INDEX OF CHRISTIAN ART

DEPARTMENT OF ART AND ARCHAEOLOGY

PRINCETON UNIVERSITY

IN ASSOCIATION WITH

PRINCETON UNIVERSITY PRESS

Library of Congress Cataloging-in-Publication Data

From Ireland coming : Irish art from the early Christian to the late Gothic period
and its European context / edited by Colum Hourihane.
p. cm.—(Index of Christian art occasional papers ; 4)
Majority of papers presented at a conference organized by the Index of Christian
Art at Princeton Univ. on Mar. 5–6, 1999.
Includes bibliographical references and index.
ISBN 0-691-08824-1 (alk. paper)—ISBN 0-691-08825-X (pbk. : alk. paper)
1. Art, Irish—Foreign influences. 2. Art, Medieval—Ireland—Foreign influences.
3. Christian art and symbolism—Medieval, 500–1500—Ireland.
I. Hourihane, Colum, 1955– II. Series.
N6784.F76 2001 709′.415—dc21 00-062375

Books published by the Department of Art and Archaeology, Princeton University,
are printed on acid-free paper and meet the guidelines for permanence
and durability of the Committee on Production Guidelines for Book Longevity
of the Council on Library Resources.

This book has been composed in Baskerville
by Impressions Book and Journal Services, Inc.

Printed in the United States of America by CRW Graphics

Designed and produced by Laury A. Egan

1 3 5 7 9 10 8 6 4 2

Contents

·

Preface

·

TO FULFILL A PROMISE made to the Index of Christian Art Committee in 1997, the first conference devoted to Irish art ever held in Princeton took place over a two-day period in March 1999. Little did we know when organizing this event that the response would be so encouraging, with full attendance for both days. This was not only the first conference with Irish art as its main subject to be held in Princeton but was also, I believe, the only such event in recent memory in the United States. Single lectures have been given in the past, especially in conjunction with the major exhibition of Irish art that circulated throughout the United States in 1977, but the Princeton conference was the first devoted entirely to this subject, which has received considerable attention over the last few years from American scholars. Eminent scholars as well as students from both sides of the Atlantic were enthusiastic in their response to the papers, which attempted to place Irish art in the broader context of its European background.

My thanks must firstly go to all of the speakers who contributed so eagerly and met all of the deadlines, sometimes at short notice. The Department of Art and Archaeology, Program in Medieval Studies, Council of the Humanities, and Fund for Irish Studies, all in Princeton University, gave generously to ensure the success of the event. Thanks must also go to the Samuel H. Kress Foundation, which generously supported the conference. Within the Index of Christian Art, Marie Holzmann and John Blazejewski willingly gave of their time, advice, and assistance in ensuring the smooth running of the conference and the preparation of images for this publication. The moderators at the conference, John Fleming, Catherine McKenna, Elizabeth McLachlan, Michael Curschmann, and Pamela Sheingorn, must be thanked for their good work.

The publication of the proceedings was encouraged and supported financially by the Publications Committee of the Department of Art and Archaeology at Princeton University. I would like to acknowledge the practical advice and encouragement of Susan Lehre, Manager of the Department of Art and Archaeology, in ensuring that this volume appeared on time. Diane Schulte, of the Department of Art and Archaeology, assisted in the preparation of the typescript for publication. I am also indebted to Christopher Moss, Editor of Publications in the Department of Art and Archaeology, who, with energy and enthusiasm, has given generously of his many skills and expertise in the making of this volume.

<div align="right">

COLUM HOURIHANE, DIRECTOR
INDEX OF CHRISTIAN ART

</div>

Notes on the Contributors

·

CORMAC BOURKE is a fellow of the Society of Antiquaries and has been curator of medieval antiquities at the Ulster Museum since 1983. His publications include *Patrick: The Archaeology of a Saint* (Belfast, 1993) and *Studies in the Cult of Saint Columba* (Dublin, 1997). He also edited *From The Isles of the North: Early Medieval Art in Ireland and Britain* (Belfast, 1995).

MILDRED BUDNY received her Ph.D. in 1985 from the University of London for a study supervised by Sir David Wilson, "British Library Manuscript Royal 1 E.vi: The Anatomy of an Anglo-Saxon Bible Fragment." She is the founding member, editor, and director of the Research Group on Manuscript Evidence. Among her numerous publications is *Insular, Anglo-Saxon, and Early Anglo-Norman Manuscript Art at Corpus Christi College, Cambridge: An Illustrated Catalogue* (Kalamazoo, Mich., 1997).

TESSA GARTON received her Ph.D. from the Courtauld Institute of Art, University of London, in 1974, for a dissertation on early Romanesque sculpture in Apulia. She is currently associate professor at the College of Charleston, South Carolina, and has also taught at the University of Aberdeen and Trinity College, Dublin. Her particular interest is Romanesque sculpture, and she has published on Irish, Italian, and Scottish material of that period. She is currently working on a catalogue of Irish Romanesque sculpture for the *Corpus of Romanesque Sculpture in Britain and Ireland*.

PETER HARBISON was archaeologist to the Irish Tourist Board for a number of years prior to becoming honorary academic editor in the Royal Irish Academy. He is also professor of archaeology at the Royal Hibernian Academy of Arts. His numerous publications embrace a wide variety of subjects, and his books include *The Archaeology of Ireland* (London, 1976), *Pre-Christian Ireland* (London, 1988), *The High Crosses of Ireland: An Iconographical and Photographic Survey* (Bonn, 1992), *Ancient Ireland: From Prehistory to the Middle Ages* (London, 1996), and recently *The Golden Age of Irish Art* (London, 1999). His *Guidebook to the National Monuments of Ireland*, now in its third edition, has been a classic for over twenty-five years.

JANE HAWKES received her Ph.D. from Newcastle University in 1989 for a study on the iconography of Anglo-Saxon sculpture. She has held lecturing posts in medieval studies and medieval art history at the Universities of Newcastle and Edinburgh and currently lectures in art history at the University of York. Her many publications, which include *The Golden Age of Northumbria* (Morpeth, England, 1996), have dealt with the art and material culture of Anglo-Saxon Northumbria and the iconography of Insular sculpture. She recently coedited *Northumbria's Golden Age* (London, 1999).

COLUM HOURIHANE studied archaeology at University College, Cork, before receiving his Ph.D. at the Courtauld Institute of Art, University of London. His publications on Early Christian iconography and standards for art-historical classification include a study of subject classification that appeared as a special report of the Visual Resources Association in 1999. He has recently edited *Virtue and Vice: The Personifications in the Index of Christian Art* (Princeton, 2000), and his monograph *The Mason and His Mark: Mason's Marks in the Medieval Irish Archbishoprics of Cashel and Dublin* was published by British Archaeological Reports in 2000. He has been the director of the Index of Christian Art since 1997.

CATHERINE E. KARKOV received her Ph.D. from Cornell University in 1990 and is presently associate professor of art history at Miami University in Oxford, Ohio. In addition to her many publications in the area of Anglo-Saxon and Insular art, she was the coeditor of *Studies in Insular Art and Archaeology* (Oxford, Ohio, 1991), *The Insular Tradition* (New York, 1997), *Theorising Anglo-Saxon Stone Sculpture* (Kalamazoo, Mich., forthcoming), and *Anglo-Saxon Style* (Kalamazoo, Mich., forthcoming).

HEATHER KING is currently completing a Ph.D. dissertation at Trinity College, Dublin, on late medieval Irish crosses. She is attached to Dúchas, The Heritage Service, with responsibility for monuments in the west of Ireland. She has undertaken archaeological excavations at a number of sites but is principally associated with the early monastic site at Clonmacnois, where she has worked for over ten years. Her publications include numerous excavation reports as well as articles on later medieval crosses, and she recently edited *Clonmacnoise Studies*, volume 1, *Seminar Papers* (Dublin, 1994).

SUSANNE MCNAB received her Ph.D. in 1986 from Trinity College, Dublin, for a study on twelfth-century Irish figure sculpture. She has been visiting lecturer at Trinity College, Dublin, as well as the National Gallery of Ireland, and since 1979 has been lecturer in the history of art and coordinator of foundation studies at the National College of Art and Design, Dublin. She is a member of the Association of Irish Art Historians and the International Association of Art Critics and has published extensively in the area of Romanesque and Early Christian Irish art.

RAGHNALL Ó FLOINN is assistant keeper in the Irish antiquities division of the National Museum of Ireland. One of the foremost experts on medieval Insular metalwork, he has lectured widely and has authored numerous publications on this subject, including a recent article on Irish metalwork of the Romanesque period in *The Insular Tradition* (New York, 1997). His other recent publications include *Irish Shrines and Reliquaries of the Middle Ages* (Dublin, 1994) and a coedited volume, *Ireland and Scandinavia in the Early Viking Age* (Dublin, 1998). He is also the editor of the *Journal of Irish Archaeology*.

EMMANUELLE PIROTTE, a native of Belgium, has just completed her Ph.D. at the Université Libre de Bruxelles for a study entitled "La Chair du Verbe: L'Image, le texte et l'écriture dans les évangéliaires insulaires enluminés (VII–IXème siècles)." She has lectured and published on Insular iconography and structural analysis. Her article on word and image in Insular Gospel books appeared in the *Bulletin de l'Institut Historique Belge de Rome* for 1999, and an article on the principles of space organization in Insular Gospel books will be published in the *Proceedings of the Fourth International Conference on Insular Art*.

ROGER STALLEY is a graduate of Oxford University and is currently professor of the history of art at Trinity College, Dublin. He is one of the foremost experts on medieval Irish architecture but has published numerous articles and books on a wide variety of other topics. Among his most recent publications are *The Cistercian Monasteries of Ireland* (New Haven, 1987), and *Early Medieval Architecture* (Oxford, 1999). A volume of his collected essays, *Ireland and Europe in the Middle Ages*, was published by the Pindar Press in 1994. He is a member of the Royal Irish Academy and an honorary member of the Royal Institute of Architects in Ireland.

KEES VEELENTURF studied art history and archaeology at the Universities of Amsterdam and Utrecht and now teaches at the University of Nijmegen. His publications range from studies on the historiography of Celtic studies in the Netherlands to early medieval Christian iconography. He is the author of *Dia Brátha: Eschatological Theophanies and Irish High Crosses* (Amsterdam, 1997) and has recently edited *Geen povere schoonheid* on the *devotio moderna* in the visual arts.

DOROTHY HOOGLAND VERKERK holds a Ph.D. from Rutgers University (1992) and is currently associate professor of art history at the

University of North Carolina, Chapel Hill. She has published on topics ranging from Roman manuscript illumination to Early Christian funerary art. Her book *Early Medieval Bible Illumination and the Ashburnham Pentateuch* will be published by Cambridge University Press in the series Cambridge Studies in Codicology and Palaeography.

NIAMH WHITFIELD received her initial training as an archaeologist in University College, Dublin, before undertaking further studies at the Courtauld Institute of Art, University of London. She received her Ph.D. from University College, London, in 1990 for a study of Celtic filigree from the seventh to the ninth century. She is one of the foremost experts on Irish metalwork, combining a technical and art-historical approach in her many publications on metal objects from the seventh to the twelfth century. She is a fellow of the Society of Antiquaries of London.

MAGGIE MCENCHROE WILLIAMS was a graduate student at Columbia University, where she completed her Ph.D. dissertation in 2000 on the Irish high cross as cultural emblem, under Stephen Murray. In her short career she has lectured widely in both America and Europe and has published on the secular and the sacred in contemporary costume in Irish high cross iconography.

SUSAN YOUNGS is a curator in the Department of Medieval and Later Antiquities at the British Museum with special responsibility for the medieval Celtic collection. After graduating from Cambridge and conducting post-graduate research on the early history of Kent, she joined the Sutton Hoo publication team and subsequently worked in the area of Anglo-Saxon material culture. She has published extensively on Insular metalwork and is presently compiling a catalogue of the medieval Celtic holdings in the British Museum. Elected a fellow of the Society of Antiquaries in 1985, she is now its secretary.

List of Illustrations

·

Abbreviations

·

ActArch	*Acta Archaeologica*
ArtB	*The Art Bulletin*
BAR	British Archaeological Reports
CahArch	*Cahiers archéologiques*
CahCM	*Cahiers de civilisation médiévale, X^e–XII^e siècles*
CCSL	Corpus Christianorum, Series Latina
CDI	*Calendar of the Documents Relating to Ireland, 1171–1307*, ed. H. S. Sweetman, 5 volumes. London, 1875–86.
CJR	*Calendar of the Justiciary Rolls of Ireland, 1295–1314*, ed. J. Mills and M. C. Griffiths, 3 volumes. Dublin, 1905–14.
CMCS	*Cambridge Medieval Celtic Studies*
Col.	Colossians
Cor.	Corinthians
Dan.	Daniel
DOP	*Dumbarton Oaks Papers*
Dublin, T.C.L.	Dublin, Trinity College Library
Eccl.	Ecclesiastes
Eph.	Ephesians
Ex.	Exodus
Gen.	Genesis
JBAA	*Journal of the British Archaeological Association*
JbAC	*Jahrbuch für Antike und Christentum*
JCHAS	*Journal of the Cork Historical and Archaeological Society*
JCKAS	*Journal of the County Kildare Archaeological Society*
JCLAHS	*Journal of the County Louth Archaeological and Historical Society*
JEH	*Journal of Ecclesiastical History*
JGAHS	*Journal of the Galway Archaeological and Historical Society*
JRSAI	*Journal of the Royal Society of Antiquaries of Ireland*
JTS	*Journal of Theological Studies*
JWCI	*Journal of the Warburg and Courtauld Institutes*
Lk.	Luke
London, B.L.	London, British Library
Matt.	Matthew
MGH	Monumenta Germaniae Historica
New York, Morgan Lib.	New York, Pierpont Morgan Library
NGR	National Grid Reference

NMAJ	*North Munster Antiquarian Journal*
Oxford, Bodl.	Oxford, Bodleian Library
Paris, Arsenal	Paris, Bibliothèque de l'Arsenal
Paris, B.N.F.	Paris, Bibliothèque Nationale de France
PL	Patrologiae Cursus Completus, Series Latina. Ed. Jacques-Paul Migne. 221 volumes. Paris, 1844–80.
PRIA	*Proceedings of the Royal Irish Academy*
PSAS	*Proceedings of the Society of Antiquaries of Scotland*
RBPhil	*Revue belge de philologie et d'histoire*
RCelt	*Revue celtique*
Pet.	Peter
Rome, Bibl. Vat.	Rome, Biblioteca Apostolica Vaticana
Stiftsbibl.	Stiftsbibliothek
Turin, Bibl. Naz.	Turin, Biblioteca Nazionale
UJA	*Ulster Journal of Archaeology*
Wis.	Book of Wisdom

FROM IRELAND COMING

Introduction

·

COLUM HOURIHANE

L YING AS IT DOES on the edge of the European continent, Ireland has throughout history viewed itself, and has been viewed by the rest of the world, as a place apart, with few if any connections to the world beyond her shores. This image is not always true, but it is one we have chosen, for a variety of reasons, to perpetuate throughout our history. Ireland's physical surround of water and its historical background have not encouraged close interaction. Now, however, thanks to modern technology distance means very little, and Ireland has come to play a more prominent role not only in European history but in the larger world. Its rich art-historical legacy, which stretches from the Neolithic period to the twenty-first century, has undergone constant re-evaluation, and it is now clear that it has given to other cultures as well as taken from them. Whereas much of Irish art is uniquely Insular in spirit and execution, it is short-sighted to view it only in this context. Antiquarian studies have in the past tended to promote this approach, which has in many ways hindered a full evaluation of what was indigenous and what was influenced from and created outside of Ireland. The whole discipline of art history in Ireland was hindered in the past by a lack of comparative material from other countries, but thankfully this is now being slowly corrected. It is only within the last thirty or so years that there has been any large-scale attempt to contextualize the art-historical heritage of Ireland, not solely in relation to its nearest neighbour, Britain, but also to areas farther afield.

The study of Irish art has always attracted foreign historians to its shores, be it Arthur Kingsley Porter[1] or Eric Sexton,[2] to name just two of the more eminent scholars. Such external appraisals of our artistic background, however, received their greatest impetus from the pioneering studies undertaken by the French art historian Françoise Henry.[3] She was one of the first art historians to look systematically at what were previously considered to be Insular creations and to break down many of the conceptual and real barriers that prevented their full evaluation. Her pioneering studies were followed by a number of other scholars both from Ireland and abroad who were not afraid to propose links and relationships for material that was previously considered unique to its shores.

The majority of the papers in this volume were given at a conference organized by the Index of Christian Art and held at Princeton University on 5 and 6 March 1999. In addition to focusing on current research on Irish art against its broader European context, it also attempted to bring together some of the most eminent experts in their respective fields from both sides of the Atlantic and to evaluate their differing approaches and perspectives. This was the first large-scale conference devoted to Irish art to be held in the United States, and it attracted the attention of some scholars who did not present their research at the symposium but who wished to contribute to the publication. This volume includes three essays that were not given at the conference.

The papers presented at the conference deal with Irish art, not from the prehistoric period, but, as befits the focus of the organizing host, from the Early Christian to the end of the Gothic period. The particular directive to all speakers was to evaluate the role of Irish art of this period from the perspective of external and internal contacts, and this was admirably accomplished by every contributor. Even though the aim was to cover all periods and styles with equal emphasis, it is possible to claim with a certain justification that there is an undue emphasis firstly on Christian art, and secondly on the high cross. No apologies are made for these emphases. Secular art was dealt with only tangentially, but credit has to be given to the scholars who attempted to extend their perspectives to include that background. The high crosses, on the other hand, were quite by accident the focus of a number of contributors, who saw the role of these monuments as being pivotal for succeeding generations. The crosses were also seen as a type of monument whose external parallels had never before been approached from this perspective. Despite this slight bias towards the stone cross, studies of objects in media ranging from manuscripts to architecture to woodwork—reflecting, once again, the scope of the Index of Christian Art—appear in this publication.

Ireland's earliest art, that of the megalithic tombs of the Neolithic period, which date back to circa 3000 B.C., presents evidence of the close ties that existed in prehistory with the rest of Europe. This was an art form which reached its zenith of execution in Ireland at sites such as Newgrange, Knowth, and Dowth (Co. Meath). The broad distribution of Neolithic art, which stretches from Iberia to Brittany to Ireland, shows how receptive our ancestors were to these travellers from across the seas. Successive movements into and out of Ireland in the Bronze and Iron Ages brought with them art styles that show a fusion of the foreign and the native, a tradition that lasted to the coming of Christianity in the fifth century A.D. Throughout history Ireland was invaded by a series of forces ranging from the Vikings to the Anglo-Normans, all of whom brought their own distinctive styles of art, which were either adopted or adapted. The purpose of this volume is not only to examine these large-scale and better-known influences, but also to see what happened in the intervening periods and to fill some of the lacunae in our understanding of the entire artistic heritage of Ireland.

Traditions die slowly in Ireland, and this is admirably demonstrated by Susanne McNab, who convincingly shows the distinctiveness of Irish art in the profiles and poses of human representations in Insular manuscripts, and also demonstrates that this ninth-century style has a history that can be traced back to the Celtic tradition of the Iron Age. Although not the first paper in either this volume or the conference, it deals with the oldest material and covers one of the widest time spans. McNab's paper highlights the need to look more closely at the details of the manuscripts which are the core of her study, not solely in relation to other manuscripts, but from the perspective of all media, and not necessarily from an Insular context alone. Against a background as far-reaching as coins from Armorica and metalwork from central and southern Europe, this insightful study shows the value in looking at the minutiae.

One of a number of papers to deal with the high cross, although not to the exclusion of other media, is that by Dorothy Verkerk, who examines these impressive figurative monuments, which are found throughout Ireland, in the context of the other great series of sculptural monuments in Early Christian Europe: the sarcophagi. She engagingly refers to these as two "book-ends," a term which emphasizes their unique relationship but at the same time implies the

distance that separates them. Robin Flower's interesting study[4] was one of the pioneering examinations of the common set of influences that existed for these monuments, and this linkage has subsequently been investigated by a number of scholars. Verkerk's study is the first to look at the whole picture, not just the iconographical parallels, from an interdisciplinary standpoint. She points in particular to the lack of Irish subject matter on these monuments and the difficulties that such a schema must have posed for the medieval audience. Far from adopting the complete interpretative cycle proposed by Kingsley Porter, who more than any other iconographer based his interpretations on Irish mythology and legend to the near exclusion of any biblical subjects, she convincingly argues that a balance must be maintained. Such an approach, which focuses on the medieval appreciation and value system, is a constant theme throughout these papers.

Kees Veelenturf also examines the high crosses not solely in terms of their subject matter, but also from the perspective of the time in which they were created. Now that the first large-scale photographic corpus of these monuments is available, Veelenturf, like McNab, argues that it is time to look at the minutiae and to sift out the intentions of the artists as distinct from our twentieth-century interpretations. He also emphasizes that the enigmatic imagery of these monuments needs to be evaluated against the entire medieval background and not only Insular models. Jane Hawkes extends the study of the Irish high cross with a paper on a little-known fragment from Mayo Abbey and its relationship with parallels across the Irish Sea. This iconographical study places the Mayo Abbey cross-head against the political and religious background of late eighth- to early ninth-century Ireland and shows how influences closer to home than previously discovered may also have had a bearing on these monuments.

Cormac Bourke makes a similar plea for the reinterpretation of a folio of one of the most treasured and best-known works of Irish art, the Book of Kells, by shifting the emphasis from the concept of time, as dealt with by Kees Veelenturf, to that of composition and our perceptions of spatial and structural values. The Book of Kells must be one of the most studied of all manuscripts, and yet Bourke's investigation shows the value in looking once again at the details and studying them in relation to both later and foreign comparanda. This paper highlights the need to view the reception of these works from a medieval perspective, which we are only now adopting thanks to research such as Bourke's.

No publication on medieval Irish art could fail to include a study on the broader aspects of the manuscript tradition. There has been much dispute about and discussion of the origins and styles of manuscripts such as the Book of Durrow and the Stowe Missal, and they are likely to fill many future volumes. Emmanuelle Pirotte and Mildred Budny have focused on different aspects of this tradition, examining the Insular qualities against their European background of the ninth century. Pirotte looks at the twin characteristics of ornament and script from the perspectives of function, purpose, and efficiency. Her analysis attempts to rationalize the decoration of these texts against the medieval Insular perception and to look at both text and image as a single unit. She proposes that Continental Gospel books were seen as foreign objects, alien in both their language and their very form, by Insular viewers and were infused with the local decorative repertoire to appropriate them to Insular culture. Mildred Budny's study complements this examination by looking solely at interlace, one of the hallmarks of the entire Insular tradition. While not restricting her view to a single medium or period, she principally examines examples in manuscripts, presenting a detailed analysis of the various forms used and offering a system to an-

alyze their construction. While interlace is recognized chiefly as one of the hallmarks of the Irish style of the golden age, Budny's essay places the practice in a broader context and wisely avoids any interpretation of its symbolic meaning.

Throughout their history the Irish have always shown an affinity not only for the written word, but also for the metalwork object. Shrines, reliquaries, chalices, and brooches have been held by dynasties and passed from one generation to the next with a sanctity that is unparalleled. If the golden age of Irish art is not best known for its manuscripts, then it must be for its metalwork, and one of the finest of these works is the Tara brooch. It has been studied extensively from a structuralist as well as an artistic perspective, but to date nothing has been written on its European background. Niamh Whitfield, one of the foremost experts on metalwork of this period, looks in detail at the older tradition of such brooches and convincingly parallels the Irish example with brooches used in Byzantium. Her interdisciplinary approach takes into account factors such as coloration, form, and purpose, and examines the background of this object whose religious or secular context remains problematic. From one of the best-known objects to one of the least known: Susan Youngs presents a study of a gilt-bronze mount of Irish origin which was found on the banks of the river Medway in Kent. Against a background of the purpose and form of such pieces, she looks at comparative material and places the mount in the context of Viking burial practices. In its detailed treatment this paper is a fine example of how single and apparently insignificant objects can be used to enrich our understanding of the practices of trade and the interchange of artistic influences.

Ireland's turbulent history has always influenced its art, whether it is the conflicts of the Viking period or the even more influential series of wars in later medieval times. Previous studies have shown how art was used for political ends by different cultural groups, and have tended to look at art in relation to the group for whom it was created and the group it was designed to control and influence. Breaks from these past approaches and methodologies are made by Maggie Williams, Roger Stalley, and Catherine Karkov. While the high crosses remain one of the most enduring groups of monuments in the Irish landscape, they have never before been evaluated from a nationalistic standpoint. Maggie Williams's study of the Market Cross at Tuam and the role of cultural patriotism in the study of Irish high crosses examines this symbol of national identity from a nineteenth-century perspective. Against a broadly painted background which includes historical museum displays, contemporary representations, and written descriptions, she shows how the antiquarian approach has at times romanticized them and at other times forced them into a reality for which they were never intended. Another equally enduring symbol of Irish national identity, the round tower, is studied by Roger Stalley. He masterfully surveys the various theories relating to the construction of this group of monuments and, like many of the other contributors, then approaches the structures from the standpoint of function and design. Like Williams, he is not afraid to debunk certain long-held theories as to their origins and functions. In looking for influences he relates the round towers to Italian predecessors and for the first time places them in the broader framework of European tower design. Catherine Karkov's study focuses on an equally enigmatic group of object: the exhibitionist figures known as sheela-na-gigs. These carvings have long attracted popular attention but have never been seriously examined in the wider cultural or political milieu. Possibly beginning in the Romanesque period, they lack clear iconographic and architectural contexts as well as firm dates and have to be studied, as Karkov proposes, against the surviving textual sources. Her study, like a number of other

essays in this volume, focuses on the impact these carvings may have had on an audience whose perceptions are long distanced from those of the modern museum visitor. In doing so she seeks to reveal even further the meaning they may originally have had for their medieval audience.

The twelfth century was one of the most formative periods in Irish art, when a particularly distinctive handling of the Romanesque style was created. This was the age when churches such as Cormac's Chapel on the Rock of Cashel (Co. Tipperary) introduced the Romanesque style into Ireland and started one of the most distinctive periods in Irish art history. Comparable to the finest Romanesque churches anywhere in Europe, Cormac's Chapel was to play a pivotal role in the dispersal of the style after its consecration in 1134. It forms the background to a number of essays in this publication, particularly those by Tessa Garton and Peter Harbison. With detailed analysis and from a broad understanding of the motifs employed, Garton discusses two of the motifs most frequently found in the Irish repertoire. The recurring themes of human masks and monster heads in many ways start a trend which was to last right up to the end of the Gothic period, demonstrating once again how long artistic traditions survived in Ireland. Her study complements McNab's article on manuscripts of a slightly earlier period and shows the wide variety of influences that foreigners such as the Vikings, the French, and the Italians had on the art of twelfth-century Ireland. Garton focuses on the concept of re-interpretation and re-use of motifs in the medium of sculpture against the whole range of art forms, including manuscripts and metalwork.

If Garton's paper examines the minutiae of the Romanesque style and identifies them as an Insular characteristic, Peter Harbison's study points up the differences of this style in Ireland when it is compared to the rest of Europe. He detects this "otherness" in material remains as diverse as manuscripts, metalwork, and architecture. His particular focus is, as is to be expected from such an expert, on the high crosses of the twelfth century. This aspect of Harbison's study is a logical extension of the theme of other papers in this volume, which deal with the earlier crosses, into the twelfth century. He also explains the Insular qualities of this art form in Ireland as a result of the innate resistance of the Irish Church to the gathering changes which were underway in the church reform movement and that were eventually to sweep through the country.

The changes that occurred earlier in the twelfth century may have been cataclysmic, but they were minor compared to what happened after the arrival of the Anglo-Normans in 1169. That conquest has been said to mark the end of the native tradition in the arts in Ireland and to herald the integration of what was previously considered an Insular style into the mainstream European tradition. Partly as a result of this preconception, Gothic art in Ireland has been a neglected area, and few studies have been undertaken on the wealth of material that survives. The Princeton conference, in fact, was one of the first to include a session devoted to Irish art of the Gothic period. Much of the metalwork that survives from this period consists of additions to older shrines and has been studied previously only in relation to the earlier period. One of the most neglected category of metal objects, in Irish as well as European material, is the seal. Raghnall Ó Floinn's paper is the first attempt since the turn of the century to study the large corpus of Irish secular and religious seals that survives from this period. He examines these in relation to some of the lesser-known objects, as well as in light of the role of the goldsmith in the later medieval period. This is the first study to look at the entire assemblage of objects produced by the goldsmith in this period from a functional perspective and to show how rich a period it was. His methodical and object-based approach provides an unrivalled analysis of this neglected material.

This volume begins with the cultural linkages between Ireland and Italy that existed from the sixth century onwards and goes on to focus in particular on the importance of the material evidence of the high crosses. The significance of these crosses is highlighted by several scholars who discuss the changes that occurred in them throughout the centuries. It is therefore entirely appropriate that the final paper on the Anglo-Norman period should also deal with the carved stone cross, this time in the later medieval period. Heather King's iconographical assessment of the late fifteenth- to early sixteenth-century crosses provides a perfect conclusion to this particular theme. She shows how carved crosses had now become part of the mainstream European tradition and had lost all of their Insular qualities. Like the other scholars investigating art of this later period, she points out the need for further research on these neglected objects before wide-ranging conclusions can be drawn.

This publication is the first collection of essays to be entirely devoted to an examination of what Ireland's artistic heritage gave to the rest of the world and what it was in turn given. The title of the volume, *From Ireland Coming*, is a quotation from Shakespeare's *Henry V* (act 5) and was intended to suggest the art-historical interchange that existed from the Early Christian period up to the end of the sixteenth century. By extending the limits of that artistic influence to include other styles and regions as distant as Byzantium, Italy, and Anglo-Saxon England, as well the more familiar France and Spain, it is hoped that this volume will add yet another stepping-stone on the path towards a fuller understanding of the rich heritage of Irish art which has yet to be unearthed.

NOTES

1. A. Kinglsey Porter, *The Crosses and Culture of Ireland* (New Haven, 1931).

2. E. H. L. Sexton, *A Descriptive and Bibliographical List of Irish Figure Sculptures of the Early Christian Period, with a Critical Assessment of Their Significance* (Portland, Maine, 1946).

3. An interesting appreciation of Henry's publications and approaches is to be found in Isabel Henderson's "Françoise Henry and Helen Roe: Fifty-Five Years' Work on Irish Art History and Archaeology," *CMCS* 17 (1989), 69–74.

4. R. Flower, "Irish High Crosses," *JWCI* 17 (1954), 87–97.

Pilgrimage *ad Limina Apostolorum* in Rome:
Irish Crosses and Early Christian Sarcophagi

·

DOROTHY HOOGLAND VERKERK

IRELAND'S HIGH CROSSES, particularly those displaying figural and narrative scenes, elicit a host of questions about origins, influences, and functions. In pursuit of answers to these questions, art historians have traditionally concentrated their efforts on seeking the sources of the iconography of the crosses and tracing artistic influences. The iconographic and stylistic affiliations between the Irish crosses and Roman sarcophagi have been remarked upon with some frequency.[1] One purpose of this essay is to synthesize the work of scholars who have proposed a sarcophagus/cross connection and to examine the merits of this proposal. Furthermore, a survey of this material makes it clear that certain unresolved issues are more pressing and require fuller consideration. Two questions that are embedded within the scholarly literature but have not been fully discussed will be emphasized here. First, what was the reason for breaking with indigenous traditions and creating figural crosses with narrative programs? Cross-slabs and ornamental or plain crosses were the Irish tradition,[2] and the introduction of this radically new type of cross demands a compelling reason, or shift in patronage, for breaking with long-established custom and embracing a distinctly fresh approach. The second question concerns the peculiar absence of Irish saints from the crosses. In a country famous for its Sts. Patrick, Colum Cille, and Brigit, why are they strangely absent from the crosses?[3]

In addition to assembling the pertinent material, I also want to provide a plausible historical and methodological account of the affinities between these two groups of sculpture separated by time and geography. I propose that the figural crosses were a distinctively Irish response to the pilgrimage experience, principally the pilgrimage to Rome—*ad limina apostolorum*. Pilgrimage offers both an explanation of the sudden appearance of the Irish monumental crosses and a means of understanding the absence of the all-important Irish saints from their decoration. The role of saints in the Irish pilgrimage experience prompts a reexamination of the iconography of the figural crosses. The typological and allegorical multivalence among biblical heroes, Roman saints, and Irish saints, which is so prominent in Irish literature suggests a new avenue of investigating the connection of Ireland's saints with the crosses. Pilgrimage, especially to the "threshold of the apostles," thus offers an answer to both questions.

Although the relationship between Early Christian sarcophagi and Irish figural crosses is a leitmotif in scholarship on the crosses, the gulf between them is vast in terms of both geography and time. Ireland is 1,182 miles "as the crow flies" from Rome, and the sarcophagi were created five centuries before the figural crosses. The persistent inclination throughout the scholarly lit-

erature to link the two may be due to the fact that they are the two "bookends" of figural and narrative relief sculpture which bracket the rise and development of early medieval manuscript illumination.

Although the figural crosses of Ireland are sometimes viewed as peripheral—an odd manifestation of Eastern influence[4]—or as mere precursors to later Romanesque sculpture,[5] they are the artistic fruits of their own time, place, and patronage. Although scholars have sought sources for the Irish crosses in far-flung Armenia and Coptic Egypt, the historical and visual links are weak. Moreover, the paradigm of one "periphery" influencing another "periphery" is fundamentally flawed, requiring unprecedented jumps of geography, chronological hurdles, and historical leaps of faith. What is needed, then, is a methodological framework that links the sarcophagi and the crosses both historically and ideologically, and avoids the periphery/periphery model which has placed the crosses outside the mainstream of medieval artistic production.

METHODOLOGY

Irish pilgrimage can be better understood in light of Victor and Edith Turner's fundamental study of the historical and anthropological categories of pilgrimage and the image structures that shaped the pilgrimage experience.[6] The application of an anthropological theory of pilgrimage also fosters a greater appreciation of the power the sarcophagi may have played in the artistic experience of the Irish pilgrim in Rome. Using Victor Turner's terminology, the Irish pilgrimage to Rome is "prototypical": it enjoyed international repute, the cult site was founded by great disciples such as Sts. Peter and Paul, and it is characterized by enhancement of the faith's orthodoxy through symbolism.

Two key points in this anthropological interpretation of pilgrimage are relevant to the Irish figural crosses. First, pilgrimage sites provided a crescendo of symbolic structures that brought the pilgrim to the "threshold" of the site:[7] these would include shrines, churches, icons, and religious images on objects such as sarcophagi. The Turners observe that after the trials and perils of the long pilgrimage journey, religious images could strike pilgrims in new and profound ways, even though these same images may have been familiar in their local churches. Being separated from the ties of a tight kinship group, a hallmark of Irish monasticism, the pilgrim is in a marginal state and therefore highly susceptible to visual stimulation and impression. Secondly, Catholic pilgrimage creates *communitas*, especially through participation in the Eucharist: one leaves his or her regional identity to be subsumed within the larger community of the universal church, with the sharing of Christ's body and blood as a symbol of this unity. The words of the creed, "one holy catholic Church," would take on profoundly new meaning within the context of pilgrimage in a strange land.

The Irish delegation that went to Rome in A.D. 631 seeking a solution to the conflict over the correct date of the Easter celebration, for example, can be read with new meaning through the Turners' lens of *communitas*. Disturbed by the bishop of Rome's threat of excommunication, bishops from the south of Ireland sent twelve men to Rome to determine when other churches celebrated the Pasch. Cummian's letter describes how the Irish delegation met many foreign fellow travelers in their lodgings, a hospice built against the walls of St. Peter's:[8]

And they saw all things just as they had heard about them, but they found them more certain inasmuch as *they were seen rather than heard*. And they were in one lodging in the church of St. Peter with a Greek, a Hebrew, a Scythian, and an Egyptian at the same time at Easter, in which we differed by a whole month. And so *they testified to us before the holy relics*, saying "As far as we know, this Easter is celebrated throughout the whole world."[9]

The key words are those that privilege the sensory faculty of sight and the affirmation that the relics gave to the spoken word.[10] Seeing the wonders of Rome and viewing its relics were the persuasive tools for change. Fortified by their communal witnessing of Rome's relics and the testimony of far-flung Catholic Christians, the Irish delegation returned and urged compliance with the universal Church.[11]

Edith and Victor Turner's structural interpretation, however, has come under increasing scrutiny and criticism, and requires modifications when applied to Irish pilgrimage. Two studies in particular are correctives to the Turner's thesis and are pertinent to my arguments. Mary Nolan, in her study of internal Irish pilgrimage, emphasizes that the Irish tended to create indigenous pilgrimages at an early point, prior to the year 1000, and that the foci of pilgrimage within Ireland were male saints rather than the Marian cult.[12] Irish pilgrimages differ from Continental pilgrimages in both their early foundation dates and their emphasis on Irish cult figures, a finding that accords well with Irish monastic foundations' expansion and reform. The early establishment of pilgrimage sites within Ireland and the emphasis on Irish, rather than Continental saints illustrate the vigor of Irish saints' cults in the centuries when the Irish crosses were commissioned. Nolan's findings caution us that the lack of depictions of Irish saints on the crosses, as perceived by the prevailing art-historical scholarship, may be an interpretive error and require further investigation. John Eade and Michael Sallnow support Nolan's argument that the Turner's structured universality creates a paradoxical, reductive account of pilgrimage.[13] They argue for the importance of local peculiarities of the pilgrimage site, a deconstruction of the center, and a greater appreciation of the multivocal and indigenous responses to pilgrimage.

In summary, the Turners' understanding of the power of images and the creation of universal *communitas* can be balanced with Nolan's, Eade's, and Sallnow's arguments emphasizing local manifestations to sketch out a better understanding of the particular Irish response to Roman pilgrimage and the images that shaped their experience.[14] Although Irish pilgrims may have joined in the *communitas* created by worshiping *ad limina apostolorum* in the basilicas of Rome, their artistic response resonated within prevailing and indigenous artistic traditions. Carved crosses, which date roughly from the sixth to the eighth century, had a long and venerable tradition within Ireland, and it was only in the ninth and tenth centuries that the Irish made the dramatic shift from nonfigural to figural crosses. It is precisely at this time that pilgrimage to Rome and pilgrimage to Irish cult sites were fully established.

The Irish would not have been alone in creating an artistic replication of the symbolic structures that shaped their pilgrimage experience. Pilgrimage generated many visual responses in architecture, sculpture, painting, and metalwork. Robert Ousterhout, for example, has demonstrated the widespread architectural response to the Holy Sepulcher in Jerusalem and to Old St. Peter's in Rome.[15] Building on Richard Krautheimer's work,[16] he argues that architectural copies were generated by the architectural experience of the pilgrim. Bishop Meinwerk of Paderborn, for example, built a chapel of the Holy Sepulcher and was buried near it so that he might

reach the Heavenly Jerusalem.[17] The gates of the Heavenly Jerusalem were made accessible to this Frankish bishop by a structure that emulated the Holy Sepulcher in Jerusalem; thus, both temporal and geographical barriers were overcome by imitation and emulation. The Irish figural crosses are not unlike Bishop Meinwerk's re-creation of a holy site in that they too re-created Rome.[18]

Another example of replication in response to Roman pilgrimage is that of French pilgrims who paid homage to the equestrian statue of Marcus Aurelius. Believing that the statue depicted the first Christian emperor, Constantine, they commissioned "copies" of it when they returned home. In western France, equestrian statues of Constantine can still be seen on the west facades of churches in Chateauneuf, Melle, Civray, and Parthenay-le-Vieux.[19] Linda Seidel argues that the Melle equestrian statue was both Constantine and Charlemagne, uniting local heroic saints with more universal heroes.[20] This example is particularly significant, since I believe that the same phenomenon was at work in the iconographies of the Irish crosses, where local saints were pictorialized as universal or biblical heroes such as Moses. This aspect is discussed in greater detail below.

This phenomenon of pilgrimage and the emulation it inspired was so widespread throughout Europe that the question arises: Did the Irish similarly study the images they encountered on pilgrimage? Was their interest in holy sites and images as powerful as it was for their Continental counterparts? Surviving textual evidence indicates that the Irish pilgrims were in fact strongly motivated to record accounts of holy places and images, and to bring them back to Ireland and the British Isles. Written descriptions of Roman painting, for example, circulated among the Irish. Bernard Bischoff showed that the Reference Bible, a late eighth-century compilation of Irish commentaries on the Old and New Testaments, was assembled by an Irishman on the Continent.[21] The title of a list describing the tonsures of the apostles, found between the exegesis of Acts and John I, reads: "De tonsura apostolorum. Romanorum pictura apostolorum imagines sic depinguit" (Concerning the tonsures of the Apostles. The painting of the Romans depicts the appearance of the apostles in this manner). The list describes the apostles' hair color and tonsures in detail, as well as their white robes and tunics of meline, hyacinth, purple, and red. Dáibhí Ó Cróinín argues that lists such as this one, of which seven copies are housed in Dublin and one in London, were compiled by Irish pilgrims in Rome who saw paintings of the apostles in Roman basilicas, copied the written description on several occasions, and brought the descriptions back to Ireland for educational purposes.[22] Thus, Roman pilgrimage produced a written record of the images that shaped the Irishman's visual experiences in the basilicas of Rome.

Cummian's Irish delegation of A.D. 631, mentioned above, brought back relics and books from Rome, though none of those books are specifically identified as illuminated. According to Cummian's letter, the Roman books and the relics performed miracles in Ireland, thereby testifying to their God-given power and the prestige of their Roman provenance: "And we have tested that the power of God is in the relics of the holy martyrs and in the writings which they brought back. We saw with our own eyes a totally blind girl opening her eyes at these relics, and a paralytic walking, and many demons cast out."[23] Although this account does not mention visual material specifically, it articulates two apposite points: first, the significance of obtaining Roman materials for Irish monasteries, and, secondly, the power of those items to perform miracles in an apostolic manner. In Ireland these Roman relics drove out demons, cured the blind, and made the paralyzed walk, just as the apostles did, as related throughout the Acts of the Apostles.

Adomnán, the biographer of Colum Cille, provides another instance of Irish interest in the material setting of holy sites. The plan of the Holy Sepulcher in Jerusalem now in Vienna (Nationalbibliothek, Cod. 458, f. 4v) is a ninth-century copy of Adomnán's sketch, which he etched on a wax tablet.[24] When the Gallic bishop Arculf returned from his pilgrimage to Jerusalem, Constantinople, and Rome, Adomnán interrogated the learned traveler, writing down Arculf's descriptions of what he had seen and making diagrams based on his testimony. Adomnán's narrative is similar to Cummian's letter in its emphasis on seeing the mosaics and the buildings.[25] Adomnán's book on the holy places circulated throughout Northumbria,[26] and although it is difficult to determine whether it also had a wide audience in Ireland, it does establish that the Irish had an avid interest in "eye-witness" descriptions of holy places and in writing down or sketching things seen by pilgrims.

Poems and travel accounts may have been one means of conveying information about the Roman sarcophagi to those who remained in Ireland. Although no Irish drawings of Roman sarcophagi survive, Susanne McNab has suggested that they may have been used as memory aides in the construction of the Irish crosses.[27] As Arthur Champneys suggested,[28] a variety of means of transmission of such images should be considered, since no one method—whether drawings made by artists, literature, portable works of art such as ampullae,[29] or even verbal accounts—can be discounted.

In summary, studies of pilgrimage suggest that the power of images to shape and define the pilgrimage experience must be taken in account when considering the possible connections between the Roman sarcophagi and the Irish crosses. The early medieval phenomenon of emulation was frequent on the Continent, and it should not be surprising to find it in Ireland.[30] Irish interest in Rome, the apostles, and saints' relics seems well established by written accounts and is confirmed in the well-documented Irish pilgrimages to Rome.

Ad Limina Apostolorum

Kathleen Hughes has traced the changing purpose of Irish pilgrimage from that of leaving Ireland, with the goal of permanent exile from ties of kinship and home, to that of destination, whose purpose was to see the relics of the apostles and then to return to Ireland.[31] Irish pilgrimage to Rome throughout the period from the seventh to the twelfth century is thoroughly documented in saints' Lives, charters, and legislation. What would the Irish pilgrims have encountered in Rome, and what would they have done while in Rome?

The primary objective of the Irish pilgrim, indeed, of almost all pilgrims, was to venerate the relics of the apostles and martyrs in Rome. Sarcophagi played a prominent role in the display of those relics; often it was not the bodies of the saints themselves that were viewed, but the sarcophagi that contained the bodies. One of the pilgrim's primary experiences of the churches in Rome was seeing the sarcophagi that lined the walls of the basilicas and mausolea. Early Christian sarcophagi were often reused, eventually containing several much later burials, especially those of important figures. For example, Gregory the Great, so highly regarded in Ireland, was entombed in one such reused Early Christian sarcophagus. The earliest drawing of Old St. Peter's, preserved in the eleventh-century manuscript of John the Deacon's *Vitae S. Gregorii* from Farfa (Eton College Library, Ms. Bl.3.10, f. 122r), shows the body of Gregory entombed within a strigil-

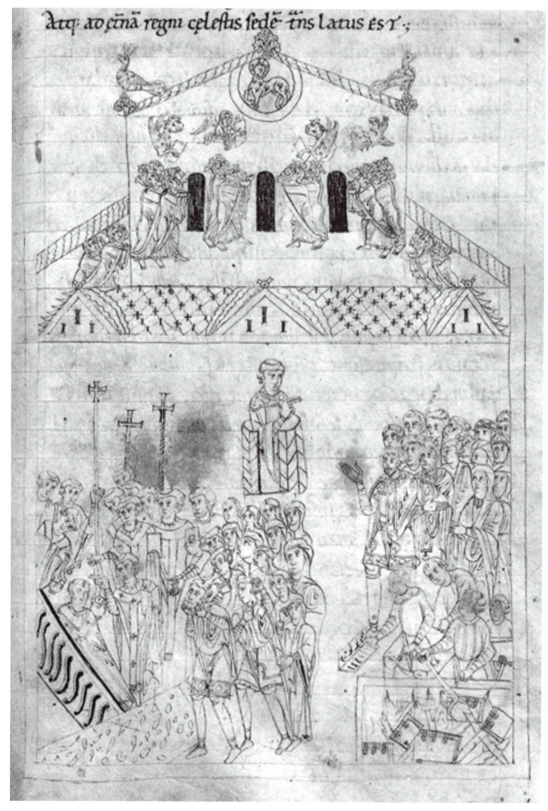

1. Eton College, Ms. Bl.3.10, f. 122r, funeral of Gregory the Great

lated sarcophagus placed in the atrium (Fig. 1). Although the architecture is contracted and abbreviated, the mosaics on the facade are accurately rendered,[32] suggesting that the artist carefully recorded the physical setting.

Another well-known and much venerated sarcophagus in Rome in that period was that of a Roman lady, Aurea Petronilla. This "relic" was brought into the city at the time of Stephen II (752–57) and Paul I (757–67), when, as a result of neglect and Lombard searching of the outlying catacombs for relics, the bones of saints were hauled in from the catacombs by the cartload.[33] In the eighth century, for example, Aurea Petronilla's inscribed sarcophagus was placed in the fourth-century mausoleum attached to Old St. Peter's, where she was venerated as the daughter of St. Peter.[34] Throughout the Middle Ages and into the Renaissance, the great, both ecclesiastical and secular, continued to be buried in ancient sarcophagi.[35] In A.D. 985, for example, Otto II's remains were placed in an Early Christian sarcophagus in the atrium of Old St. Peter's. Dozens of other ancient sarcophagi survived in Roman basilicas as burial places, as reliquary shrines, or as fonts.[36] The sarcophagi containing the bones of martyrs, saints, and bishops of Rome which lined the basilicas of Sts. Peter, Paul, and Sebastian thus provided powerful visual stimuli. With the relics themselves hidden from view, the defining visual imprints of these Roman relics would have been the sarcophagi that housed them.

Under Hadrian I (772–95) the suburban churches were restored and accesses to catacombs were repaired. Throughout much of the eighth century and into the ninth, with the continued upkeep of suburban sites by Leo III (795–816), Benedict III (855–58), and Nicolas I (858–67), the vast majority of catacombs was still accessible, and they remained an object of Christian pilgrimage into the tenth century.[37] Although the most often discussed iconographic links are between the crosses and the sarcophagi, the catacombs may also provide additional material, since they share many of the iconographic traditions found on the sarcophagi. The iconographic quotations taken from the funerary art of Early Christian Rome are far more widespread than is generally acknowledged.

The Iconographic and Formal Connections

Thomas Wright, traveling through County Louth in the early eighteenth century, reported a local tradition which maintained that the South Cross at Monasterboice, Muiredach's Cross, was sent by the pope in Rome to the people of Ireland.[38] Although in this case Wright documented a local folktale, the association between the crosses and Rome is also found throughout scholarly literature. Arthur Champneys first gave scholarly credence to this notion in 1910, when he observed that the crosses often resembled the sarcophagi.[39] He pointed out, for example, that the arrest of Christ on Muiredach's Cross (Fig. 2) bears iconographical similarities to the arrest of Peter on the sarcophagi (Fig. 3). Champneys, however, in a manner typical of early twentieth-century art-historical scholarship, paints these connections in broad strokes and gives a survey of possible sources from a large geographic area, in a variety of media, and from a long chronological span.

Françoise Henry, writing in the mid-twentieth century, was far more specific in her discussion of links between the sarcophagi and the crosses. She suggested, for example, that the animal under the feet of the enthroned Christ on Muiredach's Cross (Fig. 4) must be a misunderstanding of Coelus under Christ's feet on the sarcophagus of Junius Bassus.[40] In addition to the Junius

2. Monasterboice, County Louth, Muiredach's Cross, Arrest of Christ

4. Monasterboice, County Louth, Muiredach's Cross, *traditio clavium*

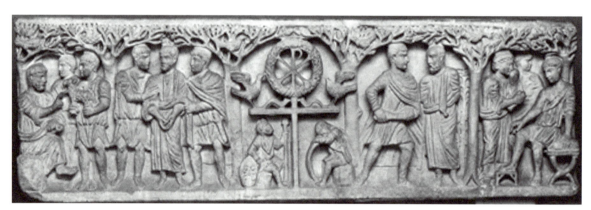

3. Passion sarcophagus. Vatican, Museo Pio Cristiano

Bassus example, a sarcophagus from the Vatican, made in the third quarter of the fourth century,[41] also has this motif, indicating that the Coelus figure under Christ's feet was not limited to one sarcophagus. Six of ten scenes appear on both Muiredach's Cross and the Junius Bassus sarcophagus, as Roger Stalley has pointed out, suggesting that Irish artists may have had access to an older, Early Christian version of the scene.[42] Stalley also proposes that the Irish *traditio clavium* scene is based on the Early Christian *traditio legis* so common on Early Christian sarcophagi, in painting, and in apse mosaics. The sarcophagi and the crosses, as many scholars have previously noted, share a preponderance of scenes that depict the Fall and God's Deliverance, and Christ's Life and Passion. Robin Flower, noting the commonality of themes, linked the figural crosses to penitential litanies asking for God's deliverance.[43] These prayers are the same as the ones that

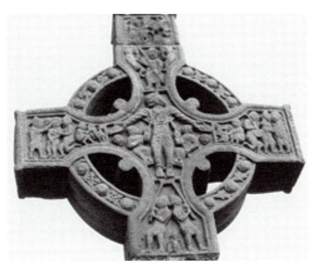

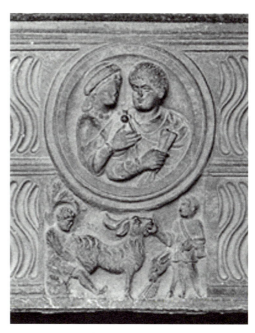

5. Monasterboice, County Louth, West Cross, milking and shearing of sheep

6. Strigil sarcophagus. Vatican, Museo Pio Cristiano

have been used to interpret the sarcophagi,[44] but they survive only in manuscripts that postdate the Early Christian tombs.

Helen Roe consistently maintained that iconographical peculiarities on the crosses could be traced only to Early Christian sarcophagi. They share genre scenes, such as husbandry and hunting, and Roe established that the milking and shearing of sheep flanking the Crucifixion on the West Cross at Monasterboice were related to images of Christ as the Good Shepherd (Fig. 5).[45] The correspondence is striking and the connection compelling: this is clearly a quotation of the scene that appeared on sarcophagi. A shepherd milking sheep is a common motif on surviving sarcophagi, for example, on a strigillated sarcophagus from the Catacomb of Praetextatus (Fig. 6), and it also appears in paintings, e.g., in the third-century Coemeterium Maius.[46] On an Early Christian tomb this motif refers to Paradise and is borrowed from the bucolic afterlife of the classical tradition. What aspect of this genre scene would have appealed to the Irish who placed it in such a prominent position on a cross? Roe believes that it refers to Christ feeding the mystical milk of Paradise to his flock. However, the shepherd milking a sheep is not commonly associated with Christ, who is typically shown as a shepherd with a sheep draped around his neck. I believe that the shepherd genre scene on the West Cross at Monasterboice, whose classical bucolic origins would have been lost, could refer to an Irish saint such as Patrick, who wrote in his *Confession* that when he arrived as a slave in Ireland he tended sheep every day.[47] His boyhood miracles, in fact, took place while he was tending sheep and milking cows. The scenes on the cross flank the Crucifixion, perhaps implying that as Christ sacrifices himself for his flock, so Patrick, as a shepherd, tends his sheep. The milking shepherd motif demonstrates that it is not enough to identify

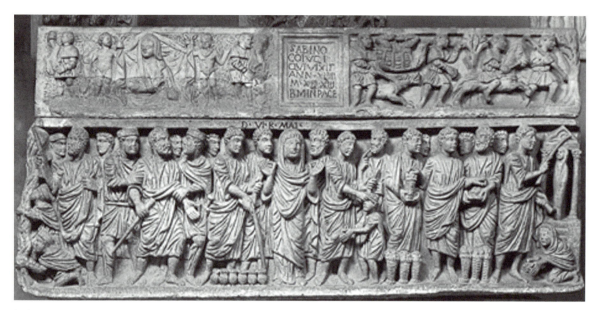

7. Sarcophagus with hunting and miracle scenes. Vatican, Museo Pio Cristiano

the correspondences between the Roman sarcophagi and the crosses, but that we must also ask why certain motifs were chosen and for what possible context in an Irish milieu.

Most recently, Catherine Herbert has joined the scholars who have found similarities between the sarcophagi and the crosses. She argues that the hunting and herding scenes on the Irish crosses,[48] for example, on the base of the Cross of the Scriptures at Clonmacnois (Co. Offaly), are another example of a borrowed motif, since they are quite common on the sarcophagi (Fig. 7).[49] Herbert, however, asks important questions that contextualize these quotations and finds that the crosses invert their original meaning.[50] Rather than a celebration of husbandry in the afterlife, these scenes are now a call for God's deliverance, a type of supplication found in the Psalms. This is an important step in that it moves beyond identification of an iconographical quote to examine the meaning of the quotation in its new language.

In addition to iconographic borrowings, similar formal qualities have also been found on the sarcophagi and the crosses. Roger Stalley observed that the crosses and the sarcophagi share rectangular frames, angle moldings, engaged shafts, and arches, and points out that the compositions were adjusted to suit the "architectural" demands of the particular cross.[51] Although the Irish ringed cross is frequently compared with a Coptic textile in the Minneapolis Institute of Art (Fig. 8),[52] Stalley has also noted that the wreath and cross are common on Passion sarcophagi in Rome (Fig. 3).[53]

The stylistic borrowings, like the iconographic ones, underscore that not only were the Irish looking at Early Christian sarcophagi, but also that the borrowings were quickly incorporated into the Irish artistic vocabulary. The depiction of Adam and Eve on Muiredach's Cross (Fig. 9), for example, is a composition notable only in Early Christian art in Ireland. The Irish depiction is easily identifiable by the tree that stands between the figures because its branches arch out to create a canopy over Adam and Eve. In other Irish examples of the scene, the "leaves" frequently become a pattern of round knobs that frame the figures. Trees were similarly used as framing mo-

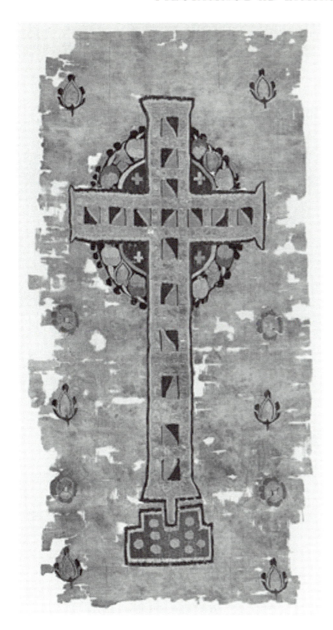

8. Coptic textile with jeweled cross. Minneapolis, Institute of Arts, acc. no. 83.126

tifs on Early Christian sarcophagi.[54] Although they do not separate figures within a single scene, they do act as dividers between scenes. A fourth-century sarcophagus provides a compelling comparandum of the tree-as-frame motif (Fig. 3), which quickly became a standard compositional device for the Irish Adam and Eve depictions.

The Three Hebrews in the Fiery Furnace on the cross of Moone (Co. Kildare) (Fig. 10) may also be a compositional adaptation of a scene rendered on many early sarcophagi.[55] On the sarcophagi, Shadrach, Meshach, and Abednego stand above three semicircular arches which indicate the fiery furnace. On the cross, the three figures are crowded together under one arch, no doubt to accommodate the horizontal composition to the more vertical format of the base.

It is important to keep in mind that emulation is not mere copying in the sense of replicating, but involves borrowing concepts and motifs and then adapting them to local vernacular artistic traditions.

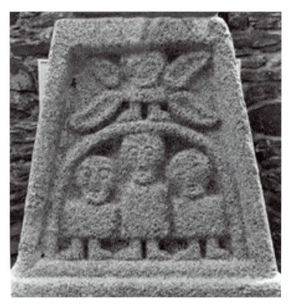

9. Monasterboice, County Louth, Muiredach's Cross, Adam and Eve

10. County Kildare, cross of Moone, the Three Hebrews in the Fiery Furnace

In summary, the sarcophagi and the crosses share thematic programs, iconographic details, and formal devices, suggesting that the links are more than mere coincidence or the random echoes of a distant pictorial tradition. Stalley has also argued that the iconography of the figural crosses reflects a broader intellectual milieu, since Ireland "had its own traditions of biblical exegesis . . . its [the Irish Church's] scholars acquired an impressive knowledge of the Early Christian Fathers."[56] He questioned Harbison's contention that the figural crosses were the product of, or were directly influenced by, Carolingian crosses in stucco that were introduced to Ireland during the reign of Louis the Pious (814–40). Documentary, artistic, and literary evidence argue in favor of the Irish traveling widely and emulating and adapting what they saw and read to their own traditions. In this case it seems more reasonable that Mohammed traveled to the mountain, rather than the mountain coming to Mohammed, so to speak.

The long-standing recognition of the debt to Early Christian sarcophagi, or rather that the sarcophagi were the source of inspiration for the Irish, has previously lacked a methodological and historical context for such borrowings. In the course of the twentieth century, scholarship has refined our understanding of the identification of the quotations, both iconographic and formal, and, with the recent work of Herbert, has begun to seek the rationale for these choices. Irish pilgrimage, both to Rome and within Ireland, provides an important context for understanding a possible impetus for the conversion to figural crosses and for seeking the interplay between the Irish saints and the crosses.

IRISH SAINTS

Irish hagiographical sources contain valuable information about the relationship among Irish saints, pilgrimage to Rome, and the crosses, and have not previously been utilized to the fullest extent. Often dismissed as being merely folktales containing no historical facts, the Irish saints' Lives convey what their writers knew to be meaningful, and thus demand a closer reading.[57] The dates of the Irish Lives are now becoming clearer, and references to Rome and the crosses are found in what are now known to be the earliest (eighth-century) Lives, as well as those written in the eleventh or twelfth century.[58]

A pilgrimage to Rome was a necessary part of an Irish saint's repertoire of heroic deeds.[59] Germanus, for example, sends Patrick to Rome to be ordained a bishop.[60] On his way to Rome Patrick meets Senàn, Abbán, Ibar, and Cairán, who, having been consecrated as bishops in Rome, are returning to Ireland.[61] Colum Cille and Coemgen venerate the relics of the apostles in Rome.[62] When Maedóc of Ferns, with his devout and holy band of saints, arrives at the threshold of the apostles, the bells of Rome miraculously ring out to greet the Irish pilgrims.[63]

A countercurrent against pilgrimage to Rome can also be found in the Lives, suggesting that, despite its perils, the pilgrimage *ad limina apostolorum* was becoming too popular.[64] St. Samthan, for example, taught her followers that God is as near in Ireland as in Rome, so pilgrimage overseas was unnecessary.[65] Weary of study in England, Finnian had a great desire to see Rome, but an angel persuaded him that the same rewards are to be found in Ireland and in Rome.[66] Moreover, seven pilgrimages to the fair of Coemgen were equal in sanctity to one pilgrimage to Rome.[67] Conlaed, bishop of Kildare and its chief artist, desires to see Rome.[68] Unfortunately for Conlaed, he ignores St. Brigit's dire warnings against the pilgrimage, and wolves devour him before he sets sail, thus justifying Brigit's fears. A pithy ninth-century poem sums up the situation: "To go to Rome, much labor, little profit."[69] These appeals to remain in Ireland indicate the strength of the desire to venerate the apostles' relics in Rome.

One of the more fascinating stories in this vein is from the Life of Berach.[70] Colmán, Berach's disciple, will not rest until he sees Rome with his own eyes. Trying to dissuade him, Berach walks with Colmán until they meet Ciarán Máel. Berach makes the sign of the cross over Colmán's eyes and the three of them see a vision of Rome. Praising God, they erect a church and two crosses, one of which is dedicated to Sts. Peter and Paul. The story admonishes the reader that visiting these crosses is the same as going an equal distance on the road to Rome. The cross brings them the vision of Rome, and two crosses commemorate this visual pilgrimage to Rome and act as surrogates for Rome. The Lives also indicate that dirt brought from Rome was sprinkled on Irish cemeteries, which were then known as *ruams*, or "Romes." Glendalough was particularly famous for its "Romes," or cemeteries.[71] This is not unlike the books and relics that Cummian brought from Rome which then performed miracles in the manner of the apostles. Clearly there is a strong desire in this period to re-create the wonders of Rome in Ireland, though in a context that is adapted to the needs of the Irish.

There is also an intimate relationship between the saints and the crosses. This relationship has sometimes been dismissed because the sources do not specify carved, figural crosses. I believe, however, that it is necessary to explore this territory in order to create a context for the figural crosses within the larger culture of the Irish veneration of the cross. An exploration of the sources for the relationship of the crosses to the saints also makes it clear that the absence of

saints from the figural crosses is truly remarkable. On the site where Finnian was born, for example, a cross was erected and called Finnian's Cross.[72] Abandoned by his mother, Cummian was left on top of a cross in a small basket.[73] Crosses also marked places of saints' miracles, the building of a saint's *civitas*, or the places of prayer associated with saints.[74] One of the heroic sufferings that distinguished Irish saints was their ability to endure the cross vigil, a form of asceticism exclusive to Irish monasticism. One inspiration for the cross vigil, in addition to the obvious example of Christ on the cross, may have been Moses' vigil on the mountaintop during the battle with the Amalekites (Ex. 17:8–16).[75] Coemgal, for example, fasts for three days with his arms outstretched in emulation of Christ's cross.[76] The indigenous Irish reverence for the cross may explain, in part, the appearance of the Crucifixion on the figural crosses, a scene notably absent from Early Christian art, but certainly prominent by the ninth and tenth centuries in Rome. Moreover, crosses were frequently named for saints, including the five erected in Armagh: Coemgal, Colum Cille, Brigit, Sechnall, and Eogan.[77] There is, of course, the inscription on the cross at Kells, which names Sts. Patrick and Colum Cille.[78] In summary, the *vitae sanctorum* bear witness to a close relationship between the saints and the crosses, and the annals show that crosses were even named after saints. One would expect, then, to see the saints figured prominently on the crosses.

Saints derive much of their power by emulating the mighty acts of biblical heroes and the miracles of Christ. The illustrated saints' Lives often include scenes based on Christ's miracles and Passion or drawn from the lives of Old Testament heroes. In Early Christian art, especially on sarcophagi, Moses striking the rock is transformed into St. Peter baptizing his captors. The only change in the representation of the scene is in the caps of the men kneeling by the water, which are identical to those of St. Peter's captors in the scene of his arrest, and these two scenes are in fact often paired on sarcophagi (Fig. 7).[79] Peter's miracle is enhanced by its visual reliance on Moses' miracle. The visual quotation is not merely a model/copy paradigm, but a typological layering in which Peter becomes Moses. This gives an additional clue to the possible presence of Irish saints on the figural crosses: if Moses can be reincarnated as Peter, can he also be reincarnated as Patrick? Or, for that matter, does Moses/Peter/Patrick exist on the crosses?

The *vitae* and annals are literary witnesses that Irish saints were also viewed as local typological manifestations of biblical and apostolic heroes. Brendan's Life introduces the saint in the following manner:

> This Brendan was the head of the belief and devotion of the great part of the world like faithful Abraham, a pre-eminently prophetic psalmist like David the son of Jesse, a distinguished sage like Solomon the son of David, a lawgiver to hundreds like Moses the son of Amram, a prolific translator like Jerome, a wondrous thinker like Augustine, a virgin like John, an evangelist like Matthew, a teacher like Paul, a chief apostle, gentle and forgiving, like Peter, an eremite like John the Baptist, a commentator like Gregory of Rome, a prudent and wondrous emissary by sea and land like Noah in the ark. . . .[80]

Thus, Brendan is the Irish Hebrew patriarch, the Irish apostle, and the Irish Church Father. Other saints are introduced in their *vitae* as having the qualities of biblical heroes. Mochuda, for example, has the characteristics of Daniel, David, and Moses, while Berach possesses those of Abraham, Moses, David, Solomon, and John the Beloved.[81] These literary models suggest that similar typological layers may have existed in the iconography of the crosses. The understanding

of how this process works on the sarcophagi opens up a new field of inquiry for understanding the Irish crosses. The identification of a figure as Moses or Christ may be too limiting and may restrict the potential of typology and allegory to incorporate Irish saints into the crosses.

In conclusion, the thematic, iconographical, and formal intercourse between the crosses and the sarcophagi seem to demand a historical context. How can we explain the direct visual "quotes" on the crosses that can be traced only to the sarcophagi? The medieval Irish are quite clear that their own center was the "threshold of the apostles." Roman pilgrimage and its powerful visual stimuli may have provided the inspiration for the figural and narrative crosses. The desire to create local Irish pilgrimages may also have been at work in the creation of these figural crosses. As the saints' *vitae* indicate, there was an indigenous desire to create a Rome in Ireland, bridging temporal and geographical barriers. Just as sculptural images defined the Irish experience of Rome's relics, the re-creation of these symbolic structures was eminently suited to the local traditions of carving and the special Irish veneration of the cross.

NOTES

1. My deep appreciation goes to Douglas MacLean for his generous bibliographic contributions, advice, and insight. P. Harbison, *The High Crosses of Ireland: An Iconographical and Photographic Survey* (Bonn, 1992), vol. 1, 4–8, gives a cogent summary and a comprehensive bibliography.

2. F. Henry, *Irish Art in the Early Christian Period (to 800 A.D.)* (Ithaca, 1965), 117–58; H. M. Roe, *The High Crosses of Western Ossory* (Kilkenny, 1969); eadem, "The Heart of the Matter: Models for the Irish High Crosses," *JRSAI* 121 (1991), 105–45; D. Kelly, "Irish High Crosses: Some Evidence from the Plainer Examples," *JRSAI* 116 (1986), 51–67; eadem, "Some Remains of High Crosses in the West of Ireland," *JRSAI* 123 (1993), 152–63.

3. Harbison, *High Crosses* (as in note 1), vol. 1, 309, tentatively identifies one scene as Patrick and Colum Cille. A. Kingsley Porter's *The Crosses and Culture of Ireland* (New Haven, 1931; repr. New York, 1971), a dubious and highly romanticized discussion of Irish crosses, saints, and folklore, seems to have effectively stopped further inquiry into possible links between the crosses and the Irish saints.

4. J. Raftery, "Ex Oriente . . . ," *JRSAI* 95 (1965), 193–204, provides the most comprehensive criticism of this approach. See also L. Nees, "A Fifth-Century Book Cover and the Origin of the Four Evangelist Symbols Page in the Book of Durrow," *Gesta* 17 (1978), 3–8.

5. F. Henry, *Irish High Crosses* (Dublin, 1964), 13, did not view the crosses as one of a pair of "bookends" but rather as "bridging the gap which separates the late Roman carvings of Christian sarcophagi from the Romanesque capitals and tympana." The tendency to claim the crosses as precursors to Romanesque architectural sculpture has the potential to obscure the cultural context of

the crosses, which, like the sarcophagi, are freestanding, monumental works of relief sculpture.

6. V. Turner and E. Turner, *Image and Pilgrimage in Christian Culture: Anthropological Perspectives* (New York, 1978), esp. 1–39; see also J. Z. Smith, *To Take Place: Toward Theory in Ritual* (Chicago, 1987).

7. The Turners are building on the fundamental work by A. van Gennep, *Les Rites de passage* (Paris, 1909; revised edition, trans. M. Vizedom and G. Chaffee, Chicago, 1960).

8. R. Krautheimer, *Rome: Profile of a City, 312–1308* (Princeton, 1980), 261, states that there were five hospices around Old St. Peter's, with one especially reserved for the "footsore," as well as individual cells for hermits.

9. *Cummian's Letter "De Controversia Paschali" Together with a Related Irish Computistical Tract, "De Ratione Computandi,"* ed. M. Walsh and D. Ó Cróinín (Studies and Texts 86) (Toronto, 1988), 93–95. The emphases are mine.

10. C. Hahn, "Seeing and Believing: The Construction of Sanctity in Early-Medieval Saints' Shrines," *Speculum* 72 (1997), 1079–1106, discusses in detail the primacy of sight at saints' shrines.

11. The discord between the Ionian Irish reckoning of Easter and the Roman church has dominated art-historical literature, placing undue emphasis on ties to the East, rather than to Rome. As a corrective, see J. Murphy, "Professor Stokes on the Early Irish Church," *The Irish Ecclesiastical Record* 12 (1891), 318–33; J. Ryan, "The Early Irish Church and the See of Peter," in *Medieval Studies Presented to Aubrey Gwynn*, ed. J. A. Watt, J. B. Morrall, and F. X. Martin (Dublin, 1961), 3–18; Raftery, "Ex Oriente" (as in note 4).

12. M. L. Nolan, "Irish Pilgrimage: The Different Tra-

dition," *Annals of the Association of American Geographers* 73 (1983), 421–38; see also P. Harbison, *Pilgrimage in Ireland: The Monuments and the People* (Syracuse, 1992).

13. J. Eade and M. J. Sallnow, "Introduction," in *Contesting the Sacred: The Anthropology of Christian Pilgrimage*, ed. J. Eade and M. J. Sallnow (New York and London, 1991), 1–29.

14. Hahn, "Seeing" (as in note 10), 1081, also emphasizes that a shrine must promote a local need or act as a "patron" or "friend" of the community it serves.

15. R. Ousterhout, "The Architectural Response to Pilgrimage," in *The Blessings of Pilgrimage*, ed. R. Ousterhout (Urbana and Chicago, 1990), 108–24.

16. R. Krautheimer, "Introduction to an 'Iconography of Medieval Architecture,'" *JWCI* 5 (1942), 1–33.

17. Ousterhout, "Architectural Response" (as in note 15), 115.

18. B. Aitchison, *Armagh and the Royal Centres in Early Medieval Ireland: Monuments, Cosmology, and the Past* (Woodbridge, Suffolk, and Rochester, N.Y., 1994), 207–10, 274–77, argues that through its hagiographical tradition, its relics, and boundary markers such as high crosses, Armagh claimed a position second only to Rome. Indeed, the Annals of Ulster (s.a. 444) state that Armagh was founded 1,194 years after the building of Rome, implying that Armagh was modeled on Rome. On Armagh as a center for high cross production, see A. Hamlin, "The Blackwater Group of Crosses," in *From the Isles of the North: Early Medieval Art in Ireland and Britain: Proceedings of the Third International Conference on Insular Art Held in the Ulster Museum, Belfast, 7th–11th April, 1994*, ed. C. Bourke (Belfast, 1995), 187–96.

19. J. Sumption, *Pilgrimage: An Image of Mediaeval Religion* (London, 1975), 224; P. Gabet, "L'Image équestre dans le nord de la France au moyen âge," *CahCM* 31 (1988), 347–60.

20. L. Seidel, "Constantine 'and' Charlemagne," *Gesta* 15 (1976), 237–39.

21. B. Bischoff, *Mittelalterliche Studien: Ausgewählte Aufsätze zur Schriftkunde und Literaturgeschichte*, vol. 1 (Stuttgart, 1966), 205–73; the work survives in its entirety in two manuscripts and in numerous fragments and excerpts. See M. McNamara, "Plan and Analysis of *Das Bibelwerk*, Old Testament," and J. F. T. Kelly, "*Das Bibelwerk*: Organization and *Quellenanalyse* of the New Testament Section," in *Irland und die Christenheit: Bibelstudien und Mission/Ireland and Christendom: The Bible and the Missions*, ed. P. Chatháin and M. Richter (Stuttgart, 1987), 84–112 and 113–23.

22. D. Ó Cróinín, "Cummianus Longus and the Iconography of Christ and the Apostles in Early Irish Literature," in *Sages, Saints, and Storytellers: Celtic Studies in Honour of Professor James Carney* (Maynooth Monographs 2), ed. D. Ó Corráin, L. Breatnach, and K. McCone (Maynooth, 1989), 268–79. Ó Cróinín notes that the title can be translated "of the Romani," a group of Irish clerics who supported the Roman date of Easter. Since the exegesis does not discuss Easter, and the archeological data support Rome, the meaning "Roman painting" seems reasonable.

23. *Cummian's Letter* (as in note 9), 93–95.

24. This folio is illustrated and discussed by Cormac Bourke elsewhere in this volume. See also *Adamnan's De Locis Sanctis* (Scriptores Latini Hiberniae 3), ed. D. Meehan (Dublin, 1958; repr. Dublin, 1983), 50–51. Other sketches in this manuscript include the basilica on Mount Sion (f. 9v), the Church of the Ascension (f. 11v), and Jacob's well at Sichem (f. 17v).

25. T. O'Loughlin, "The View From Iona: Adomnán's Mental Maps," *Peritia* 10 (1996), 98–122. N. Delierneux, "Arculfe, sanctus episcopus gente Gallus: Une existence historique discutable," *RBPhil* 75 (1997), 911–41, argues that Arculf is a historical fiction created to bolster Adomnán's narrative.

26. See *Adomnán of Iona, Life of St. Columba*, trans. R. Sharpe (London and New York, 1995), 53–54.

27. S. McNab, "Early Irish Sculpture," *Irish Arts Review Yearbook* (1990–91), 164–71.

28. A. Champneys, *Irish Ecclesiastical Architecture, with Some Notice of Similar and Related Work in England, Scotland, and Elsewhere* (London, 1910; repr. New York, 1970), 88–91.

29. Ampullae brought back from the Holy Land also circulated among the Continental Irish; see A. Grabar, *Ampoules de Terre Sainte (Monza, Bobbio)* (Paris, 1958).

30. É. Ó Carragáin, *The City of Rome and the World of Bede* (Jarrow, 1994), provides an excellent discussion of Anglo-Saxon liturgical emulation.

31. K. Hughes, "The Changing Theory and Practice of Irish Pilgrimage," *JEH* 10 (1959–60), 143–51.

32. R. Krautheimer, S. Corbett, and W. Frankl, *Corpus Basilicarum Christianorum Romae: The Early Christian Basilicas of Rome*, vol. 5 (Vatican City, 1977), fig. 119.

33. J. Osborne, "The Roman Catacombs in the Middle Ages," *Papers of the British School at Rome* 53 (1985), 278–328.

34. D. H. Farmer, *Oxford Dictionary of Saints*, 3rd ed. (Oxford and New York, 1992), 396.

35. I. Herklotz, *"Sepulcra" e "monumenta" del medioevo: Studi sull'arte sepolcrale in Italia* (Rome, 1985), N. Gramaccini, *Mirabilia: Das Nachleben antiker Statuen vor der Renaissance* (Mainz, 1996), and J. Gardner, *The Tomb and the Tiara: Curial Tomb Sculpture in Rome and Avignon in the Later Middle Ages* (Oxford, 1992), 27–31, 55–59, discuss the reuse of both classical and Early Christian sarcophagi by the papacy.

36. Krautheimer, *Rome: Profile* (as in note 8), 212–13.

37. Osborne, "Roman Catacombs" (as in note 33), 292–94.

38. H. M. Roe, *Monasterboice and Its Monuments* (Dundalk, 1981), 7.

39. Champneys, *Irish Ecclesiastical Architecture* (as in note 28), 88–91.

40. F. Henry, *Irish Art during the Viking Invasions (800–1020 A.D.)* (London, 1967), 185; on the sarcophagus, see E. S. Malbon, *The Iconography of the Sarcophagus of Junius Bassus: Neofitus Iit ad Deum* (Princeton, 1990), fig. 44; M. C. Murray, review of E. S. Malbon, *The Iconography of the Sarcophagus of Junius Bassus*, in *Journal of Theological Studies* 43 (1992), 685–90.

41. F. W. Deichmann, G. Bovini, and H. Brandenburg, *Repertorium der christlich-antiken Sarkophage*, vol. 1, *Rom und Ostia* (Wiesbaden, 1967), no. 677, pl. 106 (677,1).

42. R. Stalley, "European Art and the Irish High Crosses," *PRIA* 90 (1990), 135–58. Stalley, however, does not concur with Henry and Harbison that Carolingian ivories or stuccoes were the models for the Irish figural crosses: see R. Stalley, review of P. Harbison, *The High Crosses of Ireland: An Iconographical and Photographic Survey*, in *Irish Arts Review Yearbook* 10 (1994), 258–60. The Christ/Coelus scene is not limited to the Junius Bassus sarcophagus; see J. Wilpert, *I sarcofagi cristiani antichi*, vol. 3 (Rome, 1936), pls. CCLXXXIV:5, CCLXXXVI:10.

43. R. Flower, "Irish High Crosses," *JWCI* 17 (1954), 87–97.

44. E. Le Blant, "Les Bas reliefs des sarcophages chrétiens et les liturgies funéraires," *Revue archéologique* 20, no. 38 (1879), 233–41; A. Grabar, *Christian Iconography: A Study of Its Origins* (Princeton, 1968), 10–11.

45. Roe, *Monasterboice* (as in note 38), 46.

46. Deichmann, Bovini, and Brandenburg, *Repertorium* (as in note 41), nos. 2, 6, 85, 239, 811, 939, pls. 1, 2(6,1), 25(85,2), 53, 130, 150; A. Grabar, *The Beginnings of Christian Art, 200–395*, trans. S. Gilbert and J. Emmons (London, 1967), 107, fig. 104. See also J. Weitzmann-Fiedler, "Some Observations on the Theme of the Milking Shepherd," in *Byzantine East, Latin West: Art-Historical Studies in Honor of Kurt Weitzmann*, ed. D. Mouriki et al. (Princeton, 1995), 103–11.

47. *St. Patrick: His Writings and Muirchu's Life* (Arthurian Period Sources 9), ed. and trans. A. B. E. Hood (London, 1978).

48. Harbison, *High Crosses* (as in note 1), vol. 3, figs. 970, 977.

49. Deichmann, Bovini, and Brandenburg, *Repertorium* (as in note 41), nos. 34, 239, 778, 811, 939, 950, 988, pls. 11, 53, 124, 130, 150, 153, 158. In general, see B. Andreae, *Die römischen Jagdsarkophage* (Die Sarkophage mit Darstellungen aus dem Menschenleben 2) (Berlin, 1980).

50. C. Herbert, "Psalms in Stone: Royalty and Spirituality on Irish High Crosses" (Ph.D. dissertation, University of Delaware, 1997), 74–141.

51. Evidence for polychromy on the sarcophagi has been gathered by P. Hilippot, "Sur la polychromie de sarcophages romains du IIIᵉ siècle," in *Von Farbe und Farben: Albert Knoepfli zum 70. Geburtstag*, ed. M. Hering-Mitgau, B. Sigel, J. Ganz, and A. Morel (Zürich, 1980), 279–82. Polychromy on the crosses has been briefly discussed by Harbison, *High Crosses* (as in note 1), 271, 275, 279, 329, 351; and R. Stalley, *Irish High Crosses* (Dublin, 1996), 13.

52. M. Werner, "On the Origin of the Form of the Irish High Cross," *Gesta* 29 (1990), 98–110; Stalley, *Irish High Crosses* (as in note 51), 5–10.

53. Stalley, review (as in note 42), 260. Cf. Wilpert, *Sarcofagi* (as in note 42), vol. 2, pls. CCXXXVIII:1, 7; CCXXXIX:2; CCXXXXI:1, 2, 3.

54. Wilpert, *Sarcofagi* (as in note 42), vol. 2, pls. CCXX:2; CCXXVII:2; CCXXVIII:2, 3, 7; CCXXXVI:6; vol. 3, pls. CCLXXXV:1, 2; CCXXXVI:5, 9, 10; CCLXXXII:1.

55. Cf. Wilpert, *Sarcofagi* (as in note 42), vol. 2, pls. CCXVIII:1, 2; CCXXVI:3.

56. Stalley, review (as in note 42), 259.

57. N. Frye, *The Great Code: The Bible and Literature* (New York and London, 1982), discusses the importance of folktales and myths to a society's belief systems.

58. On the dates of the Irish Lives, see R. Sharpe, *Medieval Irish Saints' Lives: An Introduction to the "Vitae Sanctorum Hiberniae"* (Oxford, 1991); K. Hughes, *Early Christian Ireland: Introduction to the Sources* (London, 1972); J. F. Kenney, *The Sources for the Early History of Ireland: An Introduction and Guide* (New York, 1929).

59. D. A. Bray, *A List of Motifs in the Lives of the Early Irish Saints* (Helsinki, 1992). For Irish pilgrimage, see L. Gougaud, *Gaelic Pioneers of Christianity: The Work and Influence of Irish Monks and Saints in Continental Europe (Sixth–Twelfth Century)*, trans. V. Collins (Dublin and New York, 1923); A. M. Tommasini, *Irish Saints in Italy* (London and Glasgow, 1937); Hughes, "Changing Theory" (as in note 31). For English pilgrimage to Rome, see W. J. Moore, *The Saxon Pilgrims to Rome and the Schola Saxonum* (Fribourg, 1937); B. Colgrave, "Pilgrimages to Rome in the Seventh and Eighth Centuries," in *Studies in Language, Literature, and Culture of the Middle Ages and Later*, ed. E. B. Atwood and A. A. Hill (Austin, 1969), 156–72; Sumption, *Pilgrimage* (as in note 19); Ó Carragáin, *City of Rome* (as in note 30); D. J. Birch, *Pilgrimage to Rome in the Middle Ages: Continuity and Change* (Woodbridge, Suffolk, 1998).

60. *Lives of Saints from the Book of Lismore*, trans. W. Stokes (Oxford, 1890), 155.

61. R. Sharpe, "*Quattuor Sanctissimi Episcopi*: Irish Saints Before St. Patrick," in *Sages, Saints, and Storytellers* (as in note 22), 376–99, provides the most comprehen-

sive and coherent discussion of the thorny issue of Christian bishops in Ireland before St. Patrick.

62. Cairán sends his fosterling son Cartach to Rome to fulfill a penance; Macre, son of Senàn, suffers martyrdom in Rome: *The Martyrology of Oengus the Culdee*, trans. W. Stokes (London, 1905), 80, 87.

63. *Bethada náem nÉenn: Lives of Irish Saints*, trans. C. Plummer (Oxford, 1922; repr. Oxford, 1968 and 1997), vol. 2, 194–95.

64. Hughes, "Changing Theory" (as in note 31).

65. *Vitae Sanctorum Hiberniae*, ed. C. Plummer (Oxford, 1910; repr. Oxford, 1968), vol. 2, 260.

66. *Book of Lismore*, trans. Stokes (as in note 60), 224.

67. *Lives*, trans. Plummer (as in note 63), 139. The first Life (p. 121) states that one pilgrimage to the relics of Coemgen is equal to one pilgrimage to Rome, though this passage may refer to the relics of Sts. Peter and Paul, as well as the soil from Rome that Coemgen was famous for bringing to Glendalough.

68. *Martyrology of Oengus* (as in note 62), 122, 129, gloss for May 3rd. The story also reminds us that monks who were also artists would have traveled to Rome.

69. *Thesaurus Palaeohibernicus*, ed. W. Stokes and J. Strachan (Cambridge, 1901–1903; repr. Dublin, 1975), vol. 2, 294.

70. *Lives*, trans. Plummer (as in note 63), 141–42.

71. *Lives*, trans. Plummer (as in note 63), 124.

72. *Vitae Sanctorum Hiberniae: Ex Codice olim Salmanticensi nunc Bruxellensi*, ed. W. W. Heist (Subsidia Hagiographica 28) (Brussels, 1965), 96.

73. *Martyrology of Oengus* (as in note 62), 234, 243, gloss for Nov. 12th.

74. Plummer (*Vitae Sanctorum*, ed. Plummer [as in note 65], vol. 1, cxxxvi and note 1) notes the marked influence of pagan solar beliefs in the Lives of the saints and the solar symbolism of the Celtic wheeled cross.

75. *The Celtic Monk: Rules and Writings of Early Irish Monks*, trans. U. Ó Maidín (Cistercian Studies Series 162) (Kalamazoo, Mich., 1996), 40, n. 9.

76. "Vita S. Comgalli," in *Vitae Sanctorum* (as in note 72), 14.

77. Harbison, *High Crosses* (as in note 1), 4.

78. Harbison, *High Crosses* (as in note 1), cat. 127.

79. See Wilpert, *Sarcofagi* (as in note 42), pls. CLXVI:4; CCLII:1; CCXVIII:1, 2; CCXXIX:1.

80. *Lives*, trans. Plummer (as in note 63), 44.

81. Ibid., 42, 283.

Sex, Symbol, and Myth: Some Observations
on the Irish Round Towers

·

ROGER STALLEY

THE ROUND TOWERS of Ireland have been the focus of more speculation and eccentric theorizing than any other class of medieval monument. The arguments reached an intense pitch in the early years of the nineteenth century, when there was no shortage of fabulous ideas about the function and origin of these remarkable structures.[1] According to one popular view, they were fire temples, the idea being that they were designed for sun worship, with a fire kept perpetually burning at the summit. Then there was the notion that they were intended for celestial observations by the Druids, functioning, it was supposed, as primitive astronomical observatories. Given their distinctive form, it was perhaps inevitable that some would see them as monuments to Priapus. A certain Henry O'Brien, who was active in the middle years of the nineteenth century, had no doubt that they were relics of phallus worship, a cult supposedly brought to Ireland by Buddhist emigrés from India, who, he claimed, colonized the country in the pre-Christian era. In 1832 this gentleman was awarded a prize of £20 for his work by no lesser body than the Royal Irish Academy, paid not to reward his endeavours but as an attempt to keep him quiet.[2] Already in the eighteenth century, many antiquaries had come to appreciate that the round towers were Christian buildings, though there was much dispute about their precise purpose. For some it was self evident that they were built by Irish followers of Symeon Stylites and were the dwellings of devout anchorites imprisoned a hundred feet above the ground.[3] A variant of this interpretation was the penitential tower, the theory being that miscreants were sent to the top storey and allowed to descend floor by floor as they gradually fulfilled their penance. Others saw them as gnomons, with the towers as the centres of giant sun-dials.[4] With the publication of George Petrie's book in 1845, most of these bizarre and splendid theories were, it is sad to relate, banished to the footnotes.[5]

By establishing the historical context of the towers, and by confirming their religious and moral respectability, Petrie helped to give them a new lease of life as a symbol of Irish nationalism (discussed elsewhere in this volume by Maggie Williams). During the second half of the nineteenth century, the round tower joined the wolfhound, the shamrock, the high cross, and the Irish harp as a national emblem, a context in which it appeared in some very strange locations. It found favour with a number of publicans, and there was a famous pub in Dublin, now destroyed, in which a line of six round towers was silhouetted on the skyline, advertising alcohol and Ireland, rather than the Christian faith. At Listowel in County Kerry a round tower, painted appropriately in green, takes its place alongside a buxom Érin over the doorway to the Central Hotel.[6] With only a slight shift in meaning, the round tower came to be exploited as a memorial for he-

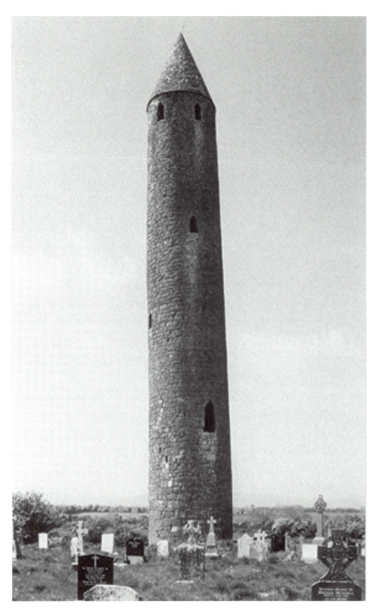

1. Kilmacduagh, County Galway, the tallest of the Irish towers, where
the doorway is almost thirty feet above the ground

roes. Thus a massive tower in Glasnevin cemetery in Dublin was one of the buildings constructed
to celebrate the achievements of Daniel O'Connell. This was a truly heroic version of the ancient
form, over fifty feet higher than any of its medieval predecessors. Another tower was erected at
Ferrycarrig (Co. Wexford) as a memorial to those who died in the Crimean War. Even today the
round tower retains an association with fallen heroes. Within the last few years a new round tower
has been constructed at Messines in Belgium to commemorate Irish soldiers who died during the
First World War.[7] In the nineteenth century many antiquaries were convinced that round towers
had once functioned as giant mausolea, an interpretation which has now, belatedly, been fulfilled
by Irish builders in Belgium.[8]

Despite the symbolism, myth, and speculation that have encompassed the study of round towers, there is a mistaken belief that scholars have established a clear view of their function and meaning. While most of the more bizarre theories have been cast aside, the twentieth century has managed to create a few myths of its own. In recent years it has been suggested that the towers provided high-level chapels, on the lines of those depicted in the St. Gall plan. This was a red herring started by Walter Horn, who somewhat mischievously reconstructed the St. Gall towers on the basis of the Irish round towers.[9] As the plan gives no indication of the height or design of the towers at St. Gall, this is a circular argument in every sense of the phrase. The Carolingian drawing has an inscription with the word "clocleam," indicating that spiral staircases were projected for the interior of the towers, not wooden ladders as was the case in Ireland.[10] Struggling up a network of ladders might have been a useful penitential exercise, but it was scarcely a convenient means of access for regular worship.[11] This suggestion at least has more historical credibility than a theory which emanated from Kansas in 1982. Thanks to the research of a professor of entomology, we have been informed that the position, and alignment, of the sixty-odd remaining towers are related to the position of the stars in the map of the northern sky at the time of the December solstice: the towers, we are told, are in fact "magnetic antennae used for concentrating paramagnetic energy" for eco-agricultural purposes.[12] It is good to know that the speculative endeavours of the eighteenth-century antiquaries are still alive.

Anyone who has listened to the local guides in Ireland will be well aware of the popular view of round towers: that in times of danger everyone in the monastery dashed for the tower and climbed up a ladder. When all were safely inside, the ladder was pulled up behind them and the door firmly locked. It does not seem to have occurred to most people that, in many cases, pulling up a ladder would have been a physical impossibility. At Kilmacduagh (Co. Galway) the door is so high that an external ladder would have been over thirty feet long; only if it had been made of rubber or some other flexible material could it have been manipulated into the tower (Fig. 1). Lennox Barrow in his 1979 book on round towers was well aware of this, and, not to be defeated, came up with an imaginative solution, namely, rope ladders. This conjures up a rather extraordinary picture of life in the early Irish monastery, with elderly monks scrambling up rope ladders at the first sign of danger, books and reliquaries under their arms. And the *aistreoir*, or bell-ringer, who sounded the regular offices would presumably have been selected for his physical prowess on the ropes. It does not seem a very plausible scenario. The external ladder or steps must have been semi-permanent structures, probably with a platform outside the door.[13] There is some confirmation of this at Inishcealtra (Co. Clare), where excavations have uncovered post-holes outside the base of the tower.[14] In fact, the occasional burning of towers suggests that an aggressor with enough determination could reach the first floor without too much difficulty. If defenders managed to raise a ladder to protect themselves, it was more likely to be an internal one between the first and second floor.

There are six references in the annals to people being killed in the towers at times when they were being used as places of protection and escape.[15] Together with the raised doorways, this has encouraged the almost unstoppable belief that the towers were designed, at least in part, as places of refuge. While George Petrie saw this as very much a secondary function,[16] Margaret Stokes gave it far more emphasis, valiantly trying to link the towers with areas of known Viking activity.[17] It is very unlikely that the design of the towers had anything to do with defence. If monastic communities seriously regarded them as some sort of proto-keep, it would have been logi-

cal to install stone vaults to guard against fire; there are only three cases where this happened.[18] It is an interesting coincidence, too, that the monastery at Kilmacduagh, whose tower has the highest doorway, was, as far as we know, never attacked. This makes an interesting contrast to that on Scattery Island (Co. Clare), where the door is at ground level.[19] Scattery was a sitting target, exposed to every band of marauders sailing up the Shannon estuary, and it is no surprise to learn that it was ransacked at least five times in the two hundred years between 972 and 1176.[20] Here is one case where a raised doorway would have made good sense. While round towers were certainly regarded as a suitable place to hide, it is unlikely that defence was uppermost in the minds of the first builders.[21] The raised doorway certainly made access more difficult, which meant that the chambers within the tower could function as secure places for storing valuables, but this was very much a secondary purpose, as Petrie argued.[22]

In the erection of circular towers, there may have been structural advantages in lifting the doorway well above the level of the foundations. A large opening in the main wall at ground level was a potential weakness, and this is the belief of experts on castle design, who have argued that the elevated entrance served a structural as well as a defensive purpose. It is particularly relevant in the context of the tall cylindrical towers which became fashionable in France during the second half of the twelfth century. In some instances, as at Piégut-Pluviers (Dordogne), the visual parallels with the Irish towers are surprisingly close.[23]

For much of this century there has been a broad consensus about the date and purpose of the round towers. It is generally accepted that they were designed primarily as belfries, and that they were constructed from some time shortly before 950 until 1238, the latter being the last recorded date we have for the building of a (medieval) round tower, that at Annaghdown.[24] There is also general agreement that the prototypes must be associated in some way with the campaniles of Italy, where the detached circular belfry found its ultimate expression in the twelfth-century tower at Pisa.[25] It is also generally agreed that a high proportion of the surviving towers belong to the twelfth century.[26] The discovery of the foundations of an earlier tower at Devenish (Co. Fermanagh) twenty years ago underlined the fact that in many cases we are looking at a second generation of towers (Fig. 2).

There are, however, at least four other questions which are not so easy to answer:

1. Why are the towers so remarkably consistent in design, and why was there so little change over a period of almost three hundred years? There are of course variations, like those in the quality of masonry noted by Margaret Stokes or the addition of Romanesque ornament. But the general form shows remarkably little alteration, especially when seen in the context of the changes that occurred in European architecture between 900 and 1200.

2. Where was the first round tower erected in Ireland, and in what circumstances? Why were they deemed to be such an essential feature of the monastic environment?

3. What determined their dimensions, in particular their height? It has often been observed that they are out of all proportion to the neighbouring churches. Was it really necessary to build them so high? Kilmacduagh, the tallest, rises over 34 metres (111 feet) above the surrounding graveyard.[27]

4. What sort of bells were used in the towers, and how were they rung?

When considering these questions, it is very easy to take the form of the towers for granted, not least the gradual taper, the raised doorways, and the conical roofs of stone. The corbelled

2. Devenish, County Fermanagh. The twelfth-century tower replaced an earlier
tower, the foundations of which have been recovered in excavation

roofs are particularly curious.[28] Constructed one hundred feet above the ground, these roofs
were no mean feats of engineering (Figs. 3 and 4). Masonry caps were virtually unknown in Eu-
rope before the development of the stone spire in the twelfth century. Early Romanesque towers
usually had roofs of lead, tiles, or stone slates, built over a wooden frame.[29] So what was the ad-
vantage of the stone roof? Presumably it had something to do with the fact that it was less vulner-
able to lightning, a regular cause of fire in medieval churches. The annals contain six references
to towers being damaged by lightning or thunderbolts, a danger to which, in an age before lightning

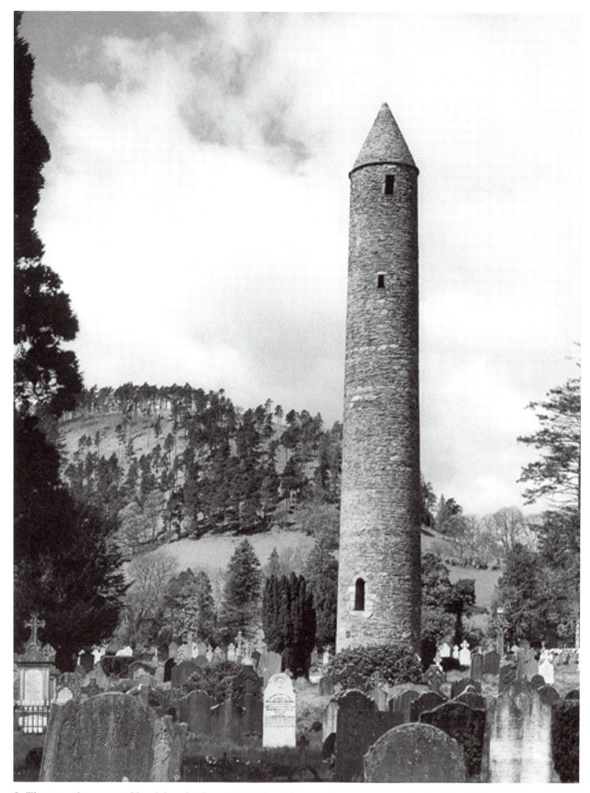

3. The round tower at Glendalough, County Wicklow; the capstone was reconstructed in 1876

4. Kilmacduagh, County Galway, the interior of the cap, showing the corbelled system of construction

conductors, the towers were exceedingly vulnerable. Examples include Tullaherin (Co. Kilkenny) and Clonmacnois (Co. Offaly), both of which survive today (Fig. 5).[30] Tullaherin was struck in 1121, resulting in the death of a student who was killed by falling masonry. In 1134 the annals report that "lightning knocked off the head of the steeple of Cluain-muc-Nois," the head presumably referring to the capstone of the fine tower which had been completed only eleven years before. More interesting, however, are two earlier references in the annals, in 995 and 1015, which relate to Armagh and Down. Here the entries record towers which were *burned* by lightning, whereas all subsequent references are to caps being split or knocked off.[31] In other words, fire seems to have been a factor only in the early cases. From this one must deduce that the first towers had wooden roofs, and that the introduction of the stone roof was an attempt to reduce this danger. It is possible that the stone roof also offered some acoustic advantages, providing added resonance to the sound of the bell.[32]

Another intriguing feature of the towers is the tapering profile, which varies quite considerably from tower to tower. At Rattoo (Co. Kerry), for example, the batter follows an almost straight line, and the diameter of the tower is reduced by almost a quarter, from 4.60 metres at

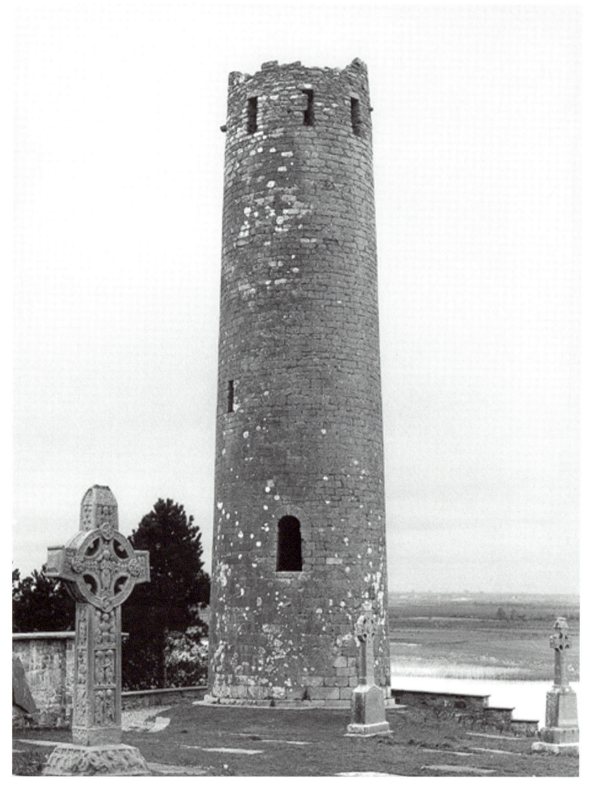

5. Clonmacnois, County Offaly. The round tower was started in 1124, a date confirmed by the fine ashlar masonry

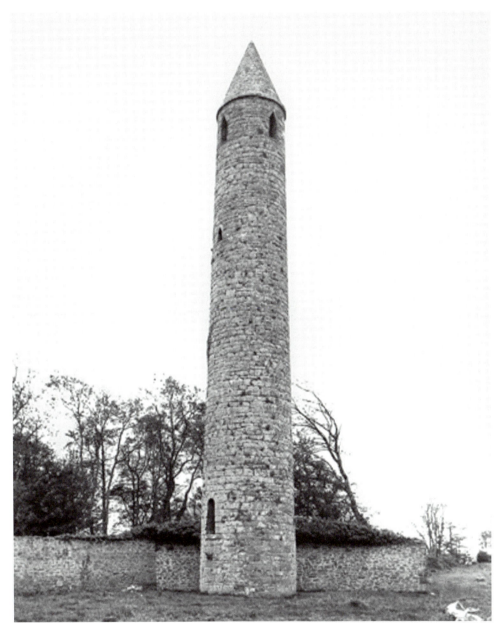

6. Rattoo, County Kerry. The diameter of the tower is reduced by almost a quarter, from 4.60
metres at the base to 3.50 metres at the cap

the base to 3.50 metres at the cap, a reduction of 1.10 metres (Fig. 6). At Glendalough (Co. Wick-
low) the reduction is far more gentle—a mere 34 cm—though it is still sufficient to give the
tower a certain life and elasticity (Fig. 3).[33] In both these cases the reduction follows a straight line
from base to summit, but this is not always the case. At Clonmacnois, for example, the batter on
the west side of the tower is quite acute up to the level of the doorway, at which point there ap-
pears to have been some change in design or construction.[34] Although the batter usually im-
proves the look of the buildings, it is quite rare to find diminution of this sort elsewhere in early

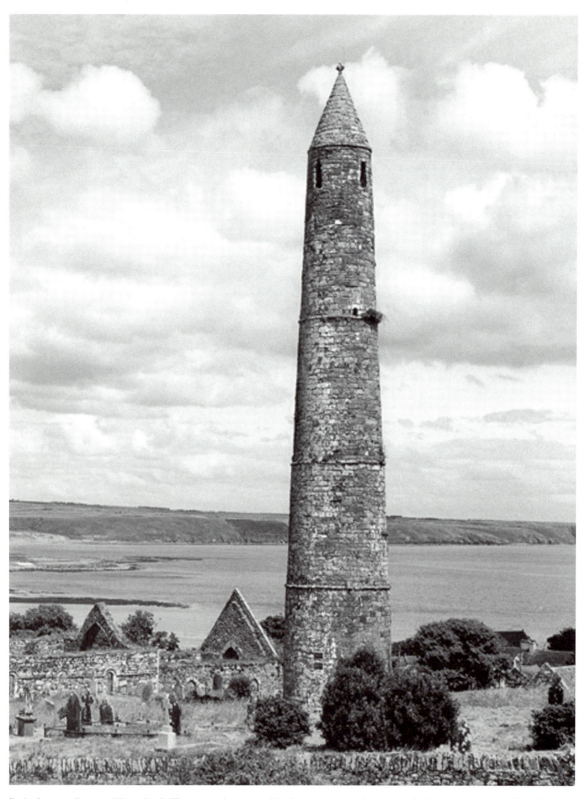

7. Ardmore, County Waterford. The tower is unusual in its exaggerated taper and the employment of horizontal string courses

medieval Europe. Most circular towers on the continent are constructed as cylinders, and, if they were narrowed, this was achieved in a regular manner by the introduction of offsets. This is particularly obvious in the brick towers at Ravenna, as in the example beside the cathedral or that at Sant'Apollinare in Classe.[35] In Romanesque architecture such offsets were often marked by decorated string courses, which were introduced in some of the Irish twelfth-century towers. Diminution and offsets were really distinct alternatives, but at Ardmore (Co. Waterford) the builders tried to get the best of both worlds, with string courses and an element of batter (Fig. 7). In this case the narrowing is pronounced and irregular: indeed, the tower is almost two metres narrower at the top than at the bottom, with the diameter diminishing from 5.0 metres to 3.05 metres.[36] The gradual reduction in diameter must have been quite difficult to control, and it meant that the Irish builders would not have found it easy to use plumb-lines to test the verticality of the towers. Clearly, diminution mattered, but what was its purpose? While it has been regarded as an architectural refinement, akin to the entasis on Greek columns, it is more likely that it was felt to have some structural value, an equivalent to the inclined jambs found on so many lintelled doorways. As such, it may have been founded on constructional beliefs stretching far back into Irish prehistory. The gradual taper may have been regarded as a means of improving stability, a view which could have been reinforced when the corbelled roof was introduced at the top. In other words, diminution was a sign of strength.

The presence of putlog holes in several towers shows that they were erected with external scaffolding, perhaps not dissimilar to that used by the Board of Works when repairing the tower on Scattery Island in the years around 1916 (Fig. 8).[37] But this raises another interesting point about construction. The lifting of stone to heights in excess of one hundred feet was without precedent in Ireland and must have demanded considerable mechanical expertise in the use of pulleys and hoists. The introduction of the round tower may thus represent a technological, as well as an architectural, milestone in Irish society.

The question of the height of the towers is a further issue that has never been seriously addressed. Why was it thought necessary to build to such a height? It cannot simply be a question of ensuring that the bells were heard by the entire community. Belfries attached to churches, as at St. Kevin's church at Glendalough or Temple Finghin at Clonmacnois, were far smaller in scale, and presumably their bells were intended to be heard over a wide area. There are several alternative ways of approaching the issue:

1. Were the dimensions an arbitrary matter, something that was left to local masons and local clergy? Once the stone or the money ran out, was work brought to a halt?

2. Were the dimensions related to the size of the adjoining church? This is suggested by the famous commentary on the Laws which attempts to fix the cost of churches and round towers; in this the height of a round tower was related to the length and breadth of a "domliacc."[38]

3. Were the dimensions fixed either by a famous exemplar or by a number with symbolic connotations? In other words, was there a "correct" height for a round tower?

4. Was there a proportional relationship between the height and the plan? It has long been established that builders in the later Middle Ages made use of proportional formulae, sometimes in the belief that they helped to ensure the stability of their work.

There are over twenty towers whose original height is more or less known. If one excludes three abnormally low towers—Dromiskin (Co. Louth), Castledermot (Co. Kildare), and Tur-

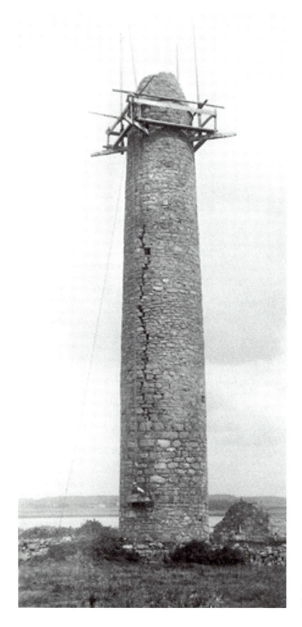

8. Scattery Island, County Clare, the tower under repair in 1916, showing an economical system of scaffolding

lough (Co. Mayo)—the average height is 29.53 metres.[39] This of course is only an average, and many towers differ quite considerably from this dimension. The tower at Devenish, for example, is only 25 metres (82 feet) high, whereas that at Fertagh (Co. Kilkenny) must have reached a height of 35 metres (115 feet), the tallest example known.[40] But it is interesting to note that the average of 29.53 metres corresponds to 97 English feet. This brings us to the topic of medieval systems of measurement, a subject which is extremely complex in view of medieval variations in the value of the foot.[41] Although the Irish used feet and inches,[42] the exact length of the Irish foot is unknown; nor is it clear whether the same foot was used consistently throughout the country. If the Irish foot approximated to the English foot, the average height of 29.53 metres

for the round towers tends to suggest that on a fair number of occasions the builders were aiming at 100 feet.

The circumference of the towers, measured at the base, is also interesting. The dimensions vary from 13.10 to 17.86 metres, but a high proportion cluster around the average of 15.63 metres, which is 51 feet 3 inches, close to half the average height. Could it be that Irish builders were following a formula which ordained that the height of a round tower should be approximately twice its circumference? While hard to prove, it is at least worth thinking about.[43] Glendalough, incidently, is the most perfect exemplar of the 1:2 ratio, being 100 feet high (30.48 metres), and 50 feet 2 inches in circumference (15.30 metres) at the base (Fig. 3).[44] It is hard to believe this is a coincidence.

What would have been the merit of such a scheme? A relationship between height and circumference may have been regarded as a way of achieving stability or correct proportions, much as Gothic architects built their cathedrals to the square or the triangle. But the 100-foot tower also invites symbolical readings.[45] As a perfect number, 100 is frequently cited in both the Old and New Testaments, and the same figure is frequently alluded to in Early Christian commentaries. It was used as a sign of the heavenly life, and it could also represent the words of the Gospels. Bede, in his commentary *De Tabernaculo*, for example, dwells on the heavenly significance of the number 100.[46] Without delving too far into the world of allegory and symbolism, it is not difficult to see why 100 feet would have had its attractions for a Christian community well versed in the Scriptures.[47] The fact that the number 100 was associated with the Gospels would have had a particular relevance for towers, from which bells sounded the regular hours of Christian worship. The figure is also frequently encountered in early medieval architecture: the cloister at St. Gall was intended to have a width of 100 feet, and the internal width of Charlemagne's palace chapel at Aachen measures 100 Roman feet.[48]

This brings us to an important historical issue, namely, which monastery was responsible for introducing the round tower to the Irish landscape. The evidence is meagre, but there are a few pointers. The general consistency of their architectural form suggests that there was a prestigious exemplar which provided a model for the early builders. If such a model existed, it was presumably to be found at one of the more influential monastic establishments: Kildare, Clonmacnois, Kells, or Armagh perhaps. In this context the annals provide a few hints. A majority of the references to round towers in the tenth and eleventh centuries relate to places in the north and east of the country; in fact, four of the first five entries are linked to establishments associated with St. Patrick or Armagh (Slane, Louth, Armagh twice, and Down).[49] If one were forced to choose, Armagh surely has one of the best claims to be the monastery which introduced the round tower. Armagh was an important centre of ecclesiastical art in the decades around 900, with a climate of patronage that seems to have encouraged both cross carving and the production of illuminated manuscripts, a context in which architectural experiments would not have been out of place.[50] The construction of the first circular belfry, 100 feet high, must have been a momentous occasion, a dramatic innovation which would have accorded well with Armagh's claims to jurisdiction over all the churches of Ireland.[51]

But why did tall belfries acquire so much importance in the years between 900 and 950? It is too simple to assume that they were merely copied from the detached campaniles of the Mediterranean world, as if they spread to Ireland like some sort of virus.[52] They must have had some

more specific function or meaning for the Irish clergy, or some important association. In what way did they improve or enhance Irish monastic life? The most obvious advantage is that a bell rung from a high tower could be heard over a much wider distance than a bell rung at ground level. For any well-disciplined monastery, the bell had to be audible, and we know from the penitentials that those who arrived late at the daily offices were punished. The rule of St. Columbanus makes it clear that failure to hear the bell was not accepted as an excuse.[53] Hearing the bell must have become more of a problem as monastic settlements grew larger and the general noise and hubbub increased. A tall campanile was one way of improving discipline.[54] The sound of the monastic bell was, however, more than just a call to prayer. For everyone living in the neighbourhood, it divided up the day, much as country people fifty years ago could tell the time from the passing of the trains. Bells and belfries were in fact the clocks of the medieval world, a point neatly made in the words of the Tudor poet Stephen Hawes:

> For though the day be never so longe
> At last the belles ryngeth to evensonge.[55]

When public clocks came to be mass produced, it was natural that they were fixed to church belfries. Indeed, the importance of church bells in medieval time-keeping suggests a greater social significance for the round towers than is sometimes realized. Almost certainly they are one more reflection of the so-called urbanisation of the Irish monasteries, which was well under way by the tenth century.[56]

It is usually assumed that at appropriate times the bell-ringer climbed up the tower and rang a handbell out of each of the four windows. While this might be true, it is odd that Irish monasteries put their bell-ringer to so much trouble; if a bell was rung from the tower at the start of each of the seven offices, the *aistreoir* would have had to climb almost 700 feet each day, almost 5000 feet each week. Elsewhere in Europe such physical labour was avoided by the use of bell ropes. Notker, for example, tells a story about a craftsman named Tancho from St. Gall who cast a bell for the emperor Charlemagne. He tried to cheat the emperor by substituting tin for silver in the alloy, and when the bell was eventually hung in the bell tower, nobody could make it ring. Tancho "seized hold of the rope and tugged at the bell," whereupon it broke free from its frame and crashed to the ground, hitting the unfortunate Tancho en route and "taking his bowels and testicles with it."[57] Notker wrote his Life about 883–87, and he writes as if what he says about bells was a perfectly normal arrangement. Bell ropes were known from at least the sixth century,[58] and there is a famous painting in a Spanish Apocalypse which shows a multi-storey belfry, with a bell-ringer using ropes to sound the two bells suspended in turrets at the top (Fig. 9).[59] This dates from circa 970. Why, therefore, did the Irish not adopt the same solution? Is it possible that larger bells were hung permanently at the top of the towers and operated by ropes?

At first sight there seems to be little evidence to support this. Over seventy Irish bells survive, but all are handbells, and there is not a single example of a larger bell such as might be hung in a permanent frame.[60] Early Irish bells have been catalogued and studied by Cormac Bourke, who divided them into two classes: those made from sheet iron and those cast in bronze. The largest examples are 31 cm in height.[61] Given the size of this collection, it is odd that no large bells survive, if indeed they were manufactured for the early Irish Church. Bourke's study may provide the answer. The vast majority of the handbells belong to the period 700–900, a period in which they are occasionally depicted in sculpture, as on one of the famous stelae on White Island (Ferman-

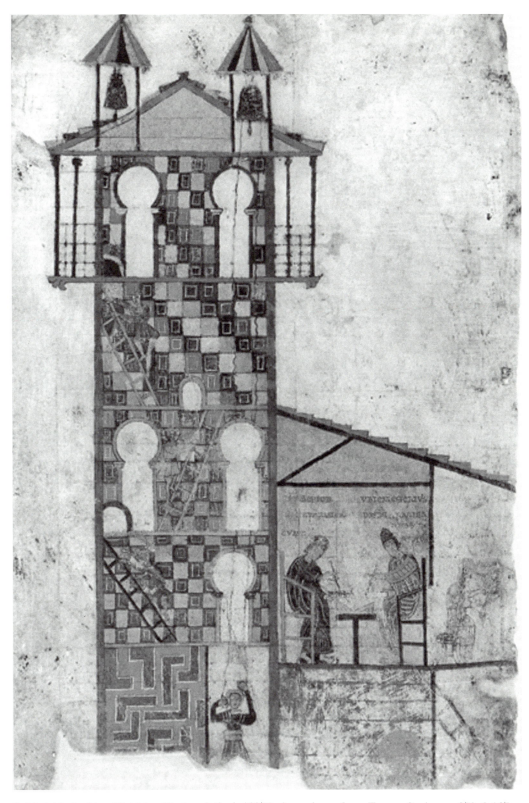

9. Madrid, Archivo Histórico Nacional, Cod. 1097B, Apocalypse from Tavara, Spain, ca. 970, f. 167v, showing a multi-storey belfry, with a bell-ringer using ropes to sound the two bells suspended in turrets at the top

agh). There are few bells that can be assigned to the twelfth century with any confidence.[62] For some reason handbells seem to have gone out of fashion after 900, at the very period when the round towers began to appear on the landscape. Having gone to the trouble and expense of building huge campaniles, it seems extraordinary that new bells were not commissioned at the same time. In fact, I suspect that new and larger bells were produced.[63] The old handbells were retained in the monastery, but as they became obsolete they were valued more as relics than practical items.[64] Yet if this was the case, why do none of the larger bells survive? The dearth of evidence is not altogether surprising. Many of the round towers remained in use as belfries during the later Middle Ages, so their bells never became redundant like the early handbells. When a bell was cracked or damaged, it was simply recast, especially if it was made of bronze. Hundreds of large bells occupied the medieval belfries of Ireland, but, with one or two exceptions, they have vanished without trace.[65] Bell metal was just too valuable to survive. In 1552, for example, the English garrison of Athlone seized the "large bells" from the *cloigtheach* of Clonmacnois, no doubt with an eye on their potential use as gun metal.[66]

There is no doubt that bell ropes were employed in Ireland in the twelfth century, if not before. A rope must have been used at St. Kevin's church at Glendalough, for nobody could have been expected to scramble into the turret every time the bell had to be rung. From the outset, the "pepper-pot" tower was designed to hold some form of hanging bell. Moreover, there is documentary evidence for the use of bell ropes in Connacht in the twelfth century. One of the endowments granted by Ruaidri Ua Conchobhair, king of Connacht (ruled 1156–98), to the abbey of Cong included the right to receive a bell rope from every ship coming to the port of Cill Mór from time to time for fishing and trading.[67] Bell ropes were thus familiar items in twelfth-century Ireland; it would be extremely odd if they were not used in the round towers, where their advantages would be most appreciated.

Finally, it is important to remember that the early sources suggest that there were different types of bell. As the Laws explain when describing the duties of the *aistreoir*, or bell-ringer: "Noble his work when the bell is that of a *cloictheach*, humble his work when it is a handbell."[68] The bells of the *cloigtheach* were clearly different and evidently harder to ring.

To confirm the point, an obvious step would be to search for archaeological evidence of bell frames within the actual towers. This is not as easy as its sounds. There are only a handful of towers with access to the top, and in virtually every case the fabric has been subject to extensive repair and reconstruction. Even if joist holes were found in the right area, there would be no guarantee that they belonged to the early Middle Ages, unless of course a piece of timber had actually been left behind. Several of the surviving towers remained in use as belfries until relatively recent times; at Cloyne (Co. Cork) a round tower is still in use today. Here the chapter books of the cathedral record the replacement of bells on several occasions. In 1663, for example, there were payments for taking down two old bells, which were then sent to Cork, presumably to be melted down. They were replaced by a new bell, which cost £10 12s. to cast. At the same time a new bell cage was constructed at a cost of £9.[69] In such contexts, the search for archaeological evidence for ancient bell frames is likely to prove fruitless.

Debates about the nature of the bells or the reasons for the height of the towers may seem rather modest issues compared with the excitement generated long ago by fire temples, anchorite prisons, and phallic worship. Although the writings of George Petrie lifted the discussion to a more sober level, he failed to confront a number of fundamental issues. The purpose of this

paper is to encourage archaeologists and historians of architecture to question the myths and assumptions of our own era, many of which can be traced back to the days of George Petrie. At the very least I hope I have managed to rescue one of Ireland's most impressive groups of monuments from the speculative fringes of academe, without succumbing to the spell of eccentricity which seems to have contaminated so many of those who have studied them in the past.

ACKNOWLEDGMENTS

I should like to place on record the help and encouragement I have received from Professor John Scattergood, Professor Liam Breathnach, Professor James Lydon, Professor Etienne Rynne, Dr. Ann Hamlin, Dr. Peter Harbison, Dr. Cormac Bourke, Dr. Colum Hourihane, Conleth Manning, Rachel Moss, George Cunningham, and the late Liam de Paor. I should stress, however, that I must take responsibility for the suggestions and conclusions.

NOTES

1. The literature on round towers is extensive. The most recent general survey is that by B. Lalor, *The Irish Round Tower* (Cork, 1999). More detail is contained in G. L. Barrow, *The Round Towers of Ireland: A Study and Gazetteer* (Dublin, 1979), a book which has useful descriptions of the towers but is seriously at fault in its interpretations of the historical evidence. It contains a lengthy bibliography. For a recent summary of antiquarian opinions, see S. O'Reilly, "Birth of a Nation's Symbol: The Revival of Ireland's Round Towers," *Irish Arts Review Yearbook* 15 (1999), 27–33. Amongst antiquarian writers, see especially M. Keane, *The Towers and Temples of Ancient Ireland: Their Origin and History Discussed from a New Point of View* (Dublin, 1867); R. Gough, *Observations on the Round Towers in Ireland and Scotland* (London, 1779); H. de Montmorency-Morres, *A Historical and Critical Enquiry into the Origin and Primitive Use of the Irish Pillar Tower* (London, 1821); H. O'Brien, *The Round Towers of Ireland or the Mysteries of Freemasonry, of Sabaism, and of Buddhism for the First Time Unveiled* (London, 1834; new edition 1898), republished as *Atlantis in Ireland* (Blaufelt, New York, 1976); R. Smiddy, *The Round Towers of Ireland: Their Origin, Use, and Symbolism* (Dublin, 1876); J. H. Rice, *The Round Towers: Their Use and Origin* (Dublin, ca. 1920); and C. B. Phipps, "The Monastic Round Towers of Ireland" (unpublished typescript in the Royal Dublin Society Library, Dublin).

2. O'Brien, *Round Towers* (as in note 1), 91, 101, 176. O'Brien complained bitterly about the failure of the academy to award him first prize for the best essay on the subject (it went to George Petrie). There was a vitriolic correspondence, with O'Brien complaining that the academy had even failed to return his essay. Despite the obvious eccentricity of O'Brien's ideas, an American publisher was sufficiently impressed by them to produce a complete reprint of his book twenty-four years ago (see note 1).

3. One advocate of this view was the Reverend J. Milner, *An Inquiry into Certain Vulgar Opinions Concerning the Catholic Inhabitants and the Antiquities of Ireland* (London, 1808). Milner's opinions are discussed by O'Reilly, "Birth of a Nation's Symbol" (as in note 1), 27–28.

4. L. C. Beaufort, "An Essay upon the State of Architecture and Antiquities, Previous to the Landing of the Anglo-Normans in Ireland," *Transactions of the Royal Irish Academy* 15 (1828), 210–11.

5. G. Petrie, *The Ecclesiastical Architecture of Ireland: An Essay on the Origin and Uses of the Round Towers of Ireland*, 2nd ed. (Dublin, 1845; repr. Shannon, 1970).

6. J. Sheehy, *The Rediscovery of Ireland's Past: The Celtic Revival, 1830–1930* (London, 1980), 70, 76, 91. The work at Listowel was executed by Pat McAuliffe (1846–1921). The Irish pub was O'Meara's Irish House on Wood Quay in Dublin, designed by Burnet and Comerford, 1870.

7. It is interesting to observe the coincidence of dates: the first documented reference to an Irish round tower comes in the year 950; the last round tower was built in 1998, an interval of almost 1050 years. The tower at Messines is reported to be 120 feet high, nine feet higher than the tallest of the medieval towers, that at Kilmacduagh.

8. In 1841, for example, "some gentlemen composing a society of antiquaries" sought permission to excavate within the round tower at Cloyne (Co. Cork), and much to their delight discovered human bones. They were unaware that debris from the churchyard had been shovelled into the lowest storey of the tower; R. Caulfield, *Annals of the Cathedral of Cloyne* (Cork, 1882), 39.

9. W. Horn and E. Born, *The Plan of St. Gall* (Berkeley, 1979), vol. 1, 129, 166.

10. Ibid., vol. 3, 35: "ascensus per clocleam ad universa super inspicienda."

11. In 1992 a different role for the monuments was

suggested by Peter Harbison; he argued that they might have served as focal points of pilgrimage, with relics being displayed from the doorways to crowds assembled below. Given that shrines are known to have been stored in the towers, at least in times of crisis, it is an interesting idea, though it lacks documentary support; P. Harbison, *Pilgrimage in Ireland: The Monuments and the People* (London and Syracuse, 1992), 169–74.

12. D. Ó Cróinín, *Early Medieval Ireland, 400–1200* (London, 1995), 8, citing P. S. Callahan, *Ancient Mysteries, Modern Visions: The Magnetic Life of Agriculture* (Kansas City, Missouri, 1984).

13. In conversation (7th July 1997) the late Liam de Paor explained that he had come to a similar conclusion, favouring the idea of a wooden platform in front of the doorways. In such circumstances the stairs may have descended beside the tower, rather than directly in front.

14. My information comes from Liam de Paor. The excavation report has still to be published.

15. The references in the annals are conveniently listed by Ann Hamlin in M. Hare and A. Hamlin, "The Study of Early Church Architecture in Ireland: An Anglo-Saxon Viewpoint, with an Appendix on the Documentary Evidence for Round Towers," in *The Anglo-Saxon Church: Papers on History, Architecture, and Archaeology in Honour of Dr. H. M. Taylor*, ed. L. A. S. Butler and R. K. Morris (London, 1986), 140–42.

16. Petrie, *Ecclesiastical Architecture* (as in note 5), 2, felt the towers had a twofold use, "to serve as belfries, and as keeps, or places of strength."

17. M. Stokes, *Early Christian Architecture in Ireland* (London, 1878), 77–78, 103–9.

18. At Meelick, Castledermot, and Tory Island; Barrow, *Round Towers* (as in note 1), 24.

19. As Peter Harbison pointed out to me, the lost round tower at Downpatrick also appears to have had a doorway at or near ground level; Barrow, *Round Towers* (as in note 1), 80.

20. A. T. Lucas, "The Plundering and Burning of Churches in Ireland, Seventh to Sixteenth Century," in *North Munster Studies: Essays in Commemoration of Monsignor Michael Moloney*, ed. E. Rynne (Limerick, 1967), 173, 209. The years are 972, 977, 1057, 1101, and 1176.

21. It has been suggested that it was structurally more efficient to raise the doorway well above ground, thus avoiding a large opening close to the foundations.

22. It is worth noting that towers with raised doorways are not unique to Ireland. A number of Anglo-Saxon towers have doorways at a high level, as in the distinctive tower at Earls Barton; H. M. and J. Taylor, *Anglo-Saxon Architecture* (Cambridge, 1965–80), vol. 1, 222–26.

23. J. Mesqui, *Châteaux et enceintes de la France médiévale* (Paris, 1991), vol. 1, 103.

24. Hare and Hamlin, "Early Church Architecture" (as in note 15), 140–42.

25. The case for an Italian origin for the round tower has been reviewed by Hector McDonnell, "Margaret Stokes and the Irish Round Tower: A Reappraisal," *UJA* 57 (1994), 70–80. Peter Harbison has suggested a specific origin in Rome, on the basis of the circular towers depicted in the Grimaldi drawings of the frescoes inside Old St. Peter's: Harbison, *Pilgrimage in Ireland* (as in note 11), 170. The problem with Rome as a source is that there is no documentary or archaeological record of circular towers having been built within the city, as demonstrated by Ann Edith Priester, "The Bell Towers of Medieval Rome and the Architecture of Renovatio" (Ph.D. diss., Princeton University, 1990), especially chapter 4. The circular towers depicted by Grimaldi recall those found in a number of illuminated manuscripts, especially psalters, for example, in the ninth-century Khludov Psalter (Moscow, State Historical Museum, gr. 129), which contains (f. 61v) an image of Sion depicted as a basilica with a detached circular belfry alongside. Although this manuscript was produced in Constantinople, there are no surviving campaniles of this type in the Byzantine world. As with the frescoes in Old St. Peter's, the motif of a detached tower does not appear to have a relationship with contemporary building. The suggested Italian origin for the round towers is thus fraught with difficulties. Detached circular towers appear in a number of contexts in paintings and ivories between the sixth and ninth century; these include an ivory in the Domschatz at Trier depicting the arrival of relics (W. F. Volbach, *Elfenbeinarbeiten der Spätantike und des frühen Mittelalters*, 3rd ed. [Mainz, 1976], 95–96, pl. 76); the Utrecht Psalter, ca. 820, Psalm 26, folio 15r (*The Utrecht Psalter in Medieval Art*, ed. K. Van der Horst, W. Noel, and W. C. M. Wüstefeld [Utrecht, 1996], 144); and the ivory cover of the Prayer Book of Charles the Bald, ca. 860, in Zürich, Schweizerisches Landesmuseum (ibid., 205–6). Although Ravenna is frequently cited as a source for the Irish examples, the various examples clustered in and around Ravenna (Sant'Apollinare Nuovo, Sant'Apollinare in Classe, the cathedral, Santa Maria Fabriago, and the Pieve Quinta near Forlì) are exceptional in an Italian context. Sometimes attributed to the eighth century, they are now thought to date from the eleventh century at the earliest, post-dating the earliest documented dates for towers in Ireland; Priester, "Bell Towers of Rome," 132; M. Mazzotti, "I campanili di Ravenna e del suo territorio," *Corso di cultura sull'arte ravennate e bizantina* 4 (1958), 85–93; and F. W. Deichmann, *Ravenna, Hauptstadt des spätantiken Abendlandes* (Wiesbaden, 1974), passim.

26. A point made by E. Rynne, "The Round Towers of Ireland: A Review Article," *NMAJ* 22 (1980), 28.

27. Measurements are all taken from Barrow, *Round Towers* (as in note 1).

28. It should be noted that most of the existing caps were rebuilt in the nineteenth century. Those at Swords and Dromiskin appear to represent medieval repairs.

The cap at Temple Finghin at Clonmacnois was constructed with carefully shaped trapezoid blocks, before being reconstructed in the later years of the nineteenth century. For the original form, see the Dunraven photograph reproduced in J. Scarry, "Early Photographs of Clonmacnoise," in *Clonmacnoise Studies*, vol. 1, *Seminar Papers, 1994*, ed. H. A. King (Dublin, 1998), 26.

29. This was presumably the form of the roof of the bell tower at York, for which Alcuin gave one hundred pounds of tin in 801; "Alcuini Epistola 226," in *Epistolae Karolini Aevi*, vol. 2 (MGH, Epistolae 4), ed. E. Dümmler (Berlin, 1895). It is also the type of roof found in the many belfries of Rome between 1100 and 1250; Priester, "Bell Towers of Medieval Rome" (as in note 25), passim.

30. C. Manning, "The Date of the Round Tower at Clonmacnoise," *Archaeology Ireland* 11, no. 2 (summer, 1997), 12–13; C. Manning, "Some Notes on the Early History and Archaeology of Tullaherin," *In the Shadow of the Steeple* 6 (1998), 19–31. In the latter instance the author demonstrates that references in the annals to Telach nImmaine in fact relate to the surviving tower at Tullaherin (Kilkenny).

31. Hare and Hamlin, "Early Church Architecture" (as in note 15), 140.

32. This was a point made to me by a number of delegates at the Princeton conference.

33. The figures come from Barrow, *Round Towers* (as in note 1), 110, 197.

34. There appears to be a constructional break at the level of the doorway, marked by the change in angle of the batter, a slight change in the colour of the stone, and a change in the size of the masonry blocks.

35. There is, however, quite marked diminution in the campanile of the cathedral at Ravenna.

36. Barrow, *Round Towers* (as in note 1), 193.

37. Putlogs are most obvious in the tower at Roscam (Co. Galway). It is puzzling that there is no trace of them in many of the towers. Either they have been carefully filled by the Office of Public Works or a different method was employed to support the scaffolds.

38. The ambiguous passages in the Laws have been discussed on many occasions. Petrie drew attention to their significance: Petrie, *Ecclesiastical Architecture* (as in note 5), 364–66. For a recent consideration of their meaning, see W. H. Long, "Medieval Glendalough, An Interdisciplinary Study" (Ph.D. thesis, Trinity College, Dublin, 1997), chapter 5.

39. Despite Barrow's view to the contrary (Barrow, *Round Towers* [as in note 1], 148–49), I believe the tower at Dromiskin was reduced in height in the later Middle Ages. On the west side the crude belfry opening almost overlaps a window of much earlier form; it is difficult to believe that the tower was designed in this way.

40. Barrow, *Round Towers* (as in note 1), 92, 128.

41. For the potential pitfalls in this sort of exercise, see E. Fernie, "A Beginner's Guide to the Study of Architectural Proportions and Systems of Length," in *Medieval Architecture and Its Intellectual Context: Studies in Honour of Peter Kidson*, ed. E. Fernie and P. Crossley (London, 1990), 229–37.

42. Long, "Medieval Glendalough" (as in note 38), 141.

43. It is interesting to observe that the diameter of a circle with the circumference of 15.63 metres is 4.97 metres or 16 feet 4 inches, which is within two inches of the medieval perch (16 feet 6 inches).

44. The measurements are taken from Barrow, *Round Towers* (as in note 1), 197. The circumference was measured at the top of the two offsets which form the foundation. The height was measured from existing ground level. From the base of the foundations, the tower is 31.40 metres.

45. I am grateful to Gosia D'Aughton for helping me with symbolical references to the number 100.

46. *Bede: On the Tabernacle*, translated and introduced by A. Holder (Liverpool, 1994), 96–97, 103. Abraham, for example, was a hundred years old when Isaac was born (Genesis 21:5), and Isaac sowed in Gerar and in the same year acquired a hundredfold (Genesis 26:12). When the word of the Gospels fell on good soil, it gave fruit a hundredfold (Luke 8:8). Bede explains that those who live for Christ will receive a hundredfold reward in this life and everlasting life in the future. In speaking of the "harvest of the Lord," the so-called second synod of St. Patrick explains that "the hundredfold are the bishops and teachers, for they are all things to all men. . . . Monks and virgins we may count with the hundredfold"; L. Bieler, *The Irish Penitentials* (Dublin, 1975), 191–93. An old Irish metrical rule stipulated that monks were to perform "one hundred prostrations at the Beati every morning and evening"; J. F. O'Sullivan, "Old Ireland and Her Monasticism," in *Old Ireland*, ed. R. McNally (Dublin, 1965), 113.

47. O. K. Werckmeister pointed out that there are a hundred dots in the tonsure of the "imago hominis" in the Echternach Gospels, which he interprets as a sign of perfection in relation to man and monks; *Irische-northumbrische Buchmalerei des 8. Jahrhunderts und monastische Spiritualität* (Berlin, 1967), 35–38.

48. E. Fernie, "Historical Metrology and Architectural History," *Art History* 1 (1978), 389–91.

49. Hare and Hamlin, "Early Church Architecture" (as in note 15), 140: Slane (950), Louth (981), Armagh (995–96), Down (1015–16), Armagh (1020). The odd tower is Tuamgraney in County Clare (964). The distribution may of course be explained by the origin of the annals.

50. A. Hamlin, "The Blackwater Group of Crosses," in *From the Isles of the North: Early Medieval Art in Ireland and Britain*, ed. C. Bourke (Belfast, 1995), 187–96.

51. I have not been able to identify any particular event or circumstance which might have led to the build-

ing of a round tower at Armagh between 900 and 950. A desire to improve monastic discipline, however, might have coincided with the arrival sometime before 921 of the *Céli Dé;* A. Gwyn and R. N. Hadcock, *Medieval Religious Houses: Ireland* (London, 1970), 29. For the general development of Armagh, see N. B. Aitchison, *Armagh and the Royal Centres in Early Medieval Ireland* (Woodbridge, Suffolk, 1994).

52. The European background of the towers has been discussed by Stokes, *Early Christian Architecture* (as in note 17); A. Champneys, *Irish Ecclesiastical Architecture* (London, 1910), 48–62; F. Henry, *Irish Art during the Viking Invasions (800–1020 A.D.)* (London, 1967), 54–57; Harbison, *Pilgrimage in Ireland* (as in note 11), 169–74. The presence of a "domus clocarum" at York in 801 indicates that detached campaniles were not unknown in Britain. The fact that the Irish word *cloigtheach* appears to be a direct translation from the Latin underlines the point that this type of building was introduced to Ireland from abroad. The first use of the term *cloigtheach* is found in connection with Slane in the year 950 (Annals of Ulster): Hare and Hamlin, "Early Church Architecture" (as in note 15), 139–40.

53. "Regula Coenobialis S. Columbani Abbatis," ed. O. Seebass, *Zeitschrift für Kirchengeschichte* 17 (1897), pt. 12, p. 230: "Et qui audierit sonitus orationum, XII psalmos." For references in the penitentials along the same lines, see Bieler, *Irish Penitentials* (as in note 46), 55, 63, 107, 127.

54. The argument that bell towers were associated with discipline and reform was also invoked by Priester to explain the remarkable flowering of belfry towers in Rome after 1100: "By providing a monumental framework for bells, belltowers served as architectural symbols for liturgical regularity and reform, a symbol that was all the more apt in the context of the Gregorian reform movement, given Gregory's advocacy of a regular life for secular as well as monastic clergy"; Priester, "Belltowers of Medieval Rome" (as in note 25), 196.

55. *The Oxford Book of Late Medieval Verse and Prose,* ed. D. Gray (Oxford, 1985), 361; S. Hawes, *The Pastime of Pleasure* (1509), ed. W. E. Mead (Early English Text Society 173) (London, 1928). For a discussion of time-keeping in the early Irish Church, see A. Hamlin, "Some Northern Sun-dials and Time-keeping in the Early Irish Church," in *Figures from the Past: Studies on Figurative Art in Christian Ireland in Honour of Helen M. Roe,* ed. E. Rynne (Dun Laoghaire, 1987), 29–42; also Harbison, *Pilgrimage in Ireland* (as in note 11), 211–15.

56. C. Doherty, "The Monastic Town in Early Ireland," in *The Comparative History of Urban Origins in Non-Roman Europe: Ireland, Wales, Denmark, Germany, Poland, and Russia from the Ninth to the Thirteenth Century* (BAR International Series 255), ed. H. B. Clarke and A. Simms (London, 1985), 45–75. The utilitarian function of bells and belfries should not obscure the possibility that in the eyes of the monks they had some mystical resonance. The sound of the bell was not just a summons to the church; in some contexts it was likened to the holy spirit spreading its protective powers around the monastic precinct. There is a tenth-century French prayer which makes these associations in a very explicit way: "Christ, absolute and all-powerful master who calmed the tempest on the sea . . . , now help your people in their time of need, spread the ringing of this bell like a dew of the Holy Spirit; at its sound the enemy will always flee; that the Christian people should be called to the faith . . . , that today, every time the sound of this bell traverses the sky, the angels themselves attend with their hands the united assembly of the church, and that eternal protection assures the safety of all the goods of the faithful, of their souls and of their bodies"; C. Voguel and B. Elzé, *Le Pontifical romano-germanique du X^e siècle,* vol. 1, *Le Texte* (Studi e testi 226) (Vatican City, 1963), cited by E. Vergnolle, *L'Art roman en France* (Paris, 1994), 71, 354 n. 71.

57. L. Thorpe, *Einhard and Notker the Stammerer: Two Lives of Charlemagne* (Harmondsworth, 1969), 126–27.

58. Horn and Born, *St. Gall* (as in note 9), vol. 1, 129–31, citing Gregory of Tours, *History of the Franks.*

59. Madrid, Archivo Histórico Nacional, Cod. 1097B, folio 167v; *Los Beatos,* ed. L. Revenga, exhib. cat., Madrid, Biblioteca Nacional (Madrid, 1986), 111, 137. The illumination also shows the way in which the different floors within the tower were reached by separate ladders, as must have been the case in the Irish round towers.

60. Ledwich, citing Smith in his *History of Waterford,* records that "there was no doubt but the round tower at Ardmore was used for a belfry, there being towards the top not only four opposite windows to let out the sound, but also three pieces of oak still remaining in which the bell was hung; there were also two channels cut in the cill of the door where the rope came out, the ringer standing below the door on the outside"; E. Ledwich, *The Antiquities of Ireland* (Dublin, 1790), 295.

61. C. Bourke, "Early Irish Hand-Bells," *JRSAI* 110 (1980), 52–66.

62. Ibid., 59, 61.

63. The size of such bells would have been limited by the width of the doorway, assuming that they were lifted up internally.

64. One such bell was sent by the doge of Venice ca. 867–86 to the emperor Basil I, the first time a bell suitable for ringing from a belfry had been encountered in the capital of the Byzantine world; McDonnell, "Margaret Stokes and the Irish Round Tower" (as in note 25), 73, citing G. T. Rivoira, *Lombardic Architecture: Its Origin and Development* (Oxford, 1934), 52–53.

65. There appears to be no comprehensive list of medieval bells; one of the earliest is that dated to 1423 in St. Audeon's Church, Dublin: D. Murphy and L. Taylor, *The Bells of Christ Church Dublin* (Dublin, 1994), 1.

66. *Annals of the Four Masters,* ed. J. O'Donovan (Dub-

lin, 1848–51), 1552: "Clonmacnoise was plundered and devastated by the English of Athlone and the large bells were taken from the Cloigtheach. There was not left, moreover, a bell, small or large, an image, or an altar, or a book, or a gem, or even glass in a window, from the wall of the church out, which was not carried off. Lamentable was this deed, the plundering of the city of Kieran, the holy patron." Bells were among the items of value stripped from Irish monastic houses at the time of the Reformation: C. McNeill, "Accounts of Sums Realised by Sales of Chattels of Some Suppressed Irish Monasteries," *JRSAI* 52 (1922), 11–37, esp. 20-21, 26-28. A few bells were retained for the use of the local parish, but most were sold for the profit of the royal exchequer. There are further references to bells at the time of the Reformation in *Extents of Irish Monastic Possessions, 1540–1541*, ed. N. B. White (Dublin, 1943), passim.

67. M. Ó. Duigeannáin, "On the Temporalities of the Augustinian Abbey of St. Mary the Virgin at Cong, Co. Mayo," *JGHAS* 18 (1938), 145, 148.

68. Petrie, *Ecclesiastical Architecture* (as in note 5), 382–83. The word "aistreoir" is derived from the Latin "ostiarius," listed seventh in the order of ecclesiastical officials in the Irish canons; H. Wasserschleben, *Die irische Kanonsammlung* (Leipzig, 1885), 25. Cormac Bourke has pointed out to me that the reference in the Laws is found in a commentary which may be of twelfth-century date. This of course was an era of intensive round tower construction.

69. Caulfield, *Annals of Cloyne* (as in note 8), 17. A new bell had to be made in 1749 after the tower was struck by lightning, the bell dropping through three of the wooden floors. The present bell at Cloyne dates from 1857; P. Galloway, *The Cathedrals of Ireland* (Belfast, 1992), 54. I am grateful to Rachel Moss for the references to the annals of Cloyne.

The Book of Kells: New Light
on the Temptation Scene

·

CORMAC BOURKE

A MINIATURE illustrating Luke's account of the temptation of Christ on the Temple roof[1] occupies folio 202v of the Book of Kells (Fig. 1).[2] The lower part of the picture includes a central figure framed by the Temple doorway and two groups of smaller figures flanking a central panel. Duignan was perhaps the first to comment in detail on this part of the illustration, which he saw as a subsidiary Last Judgment scene:

> A nimbused, beardless, *full-length* figure stands *before* the door of the temple. What looks like the threshold of the doorway cuts this figure in two at the waist, so producing the illusion, at first glance, of a bust framed in the doorway. This illusion, which may be exaggerated in monochrome reproductions, is heightened by the abrupt colour-change of the garments at the waist: a ruby outer garment above, a 'white' robe below. But a ruby tint glimmers all through the white, as if the white pigment had been applied on top of ruby, and the ruby proper reappears at the lower hem, just as the white reappears at the throat. The folds of the robe are delineated by dark and red-to-orange verticals and by red-orange oblique hatching. There can be no doubt that this is a full-length standing figure.[3]

More recently, both O'Reilly and Farr have studied the Temptation miniature in its entirety and explored its multiple symbolism.[4] Thus they see Christ as the apex of the Temple and the building as a metaphor of the Church, his body. But the building is also the Tabernacle of the wandering Israelites and the Ark of the Covenant in which the presence of God was manifested, while the angels hovering above are the paired cherubim referred to in Exodus[5] and I Kings.[6] In O'Reilly's view the central figure framed by the doorway refers both to Christ and to Aaron, the archetypal Old Testament priest.[7] A shield held by one of the onlookers at top left is a reference, Farr suggests, to the shield of Christ's truth mentioned in Psalm 90:5, the psalm which the Devil sarcastically quotes in the Gospel account.[8] The figures at the bottom of the picture are seen by O'Reilly as being beneath the building and are taken to represent the "living stones" of the Church referred to in exegesis, as well as the foundation of apostles and prophets mentioned in I Peter and Ephesians.[9] Farr suggests that the Temptation picture is placed in the Book of Kells in the context of readings for Quadragesima Sunday, the first Sunday of Lent; the relevant text (Lk. 4:1–13) details Christ's forty-day fast in the desert and the three temptations to which he was subjected.[10] O'Reilly, by contrast, stresses the relationship between the illustration and the preceding accounts of the baptism and genealogy of Christ.[11]

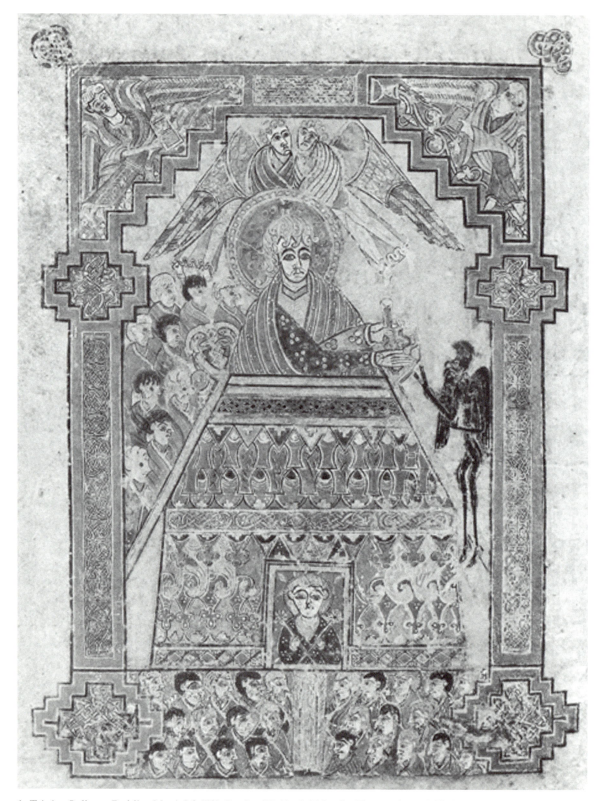

1. Trinity College, Dublin, Ms. A.I.6 (58), Book of Kells, f. 202v, the Temptation of Christ on the Temple roof

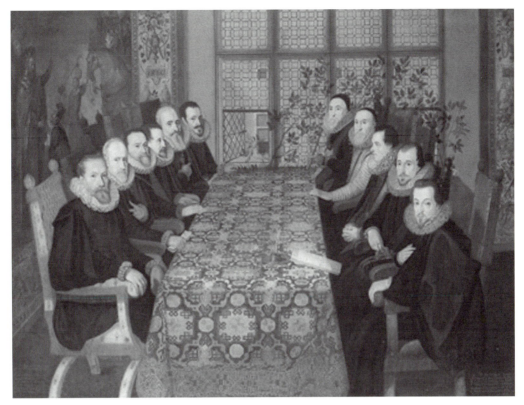

2. Juan Pantoja de la Cruz, *The Somerset House Conference, August 1604*. Greenwich, National Maritime Museum BHC2787

Farr, following Duignan, makes the further suggestion that the central figure is metaphorically a pillar of the Temple whose body, the central panel, is deliberately shown in a stylized, columnar form. She refers to Bede's interpretation of the boards of the Tabernacle as the apostles and their successors,[12] and suggests that the Kells image "may present, in visual form, the same idea of a saint or an elect as a column of the Temple/Tabernacle."[13] O'Reilly says of the central figure that his "lower body reaches to the bottom edge of the picture through the middle of the 'living stones,'"[14] while "the group of figures around his feet [sic] . . . appear as the earthbound church waiting [sic] its own completion outside the heavenly sanctuary as the high priest reappears at the end of time."[15]

My purpose here is to suggest an alternative interpretation of the central panel in the lower part of the Temptation scene which is at once simple and significant in the context.[16] The building, which stands on a horizontal base line, is self contained and coherently proportioned. The figures at the bottom of the picture, consisting of two groups of thirteen, are distinct, and their verticality is an illusion determined by medieval perspective. They are shown, as it were, obliquely from above, and the same perspective might govern the central panel. The latter is a rectangle, featureless but for fine decoration in red like that on the wooden door-frame and barge-boards of the building itself. When perceived as a horizontal rather than as a vertical, the panel declares itself to be a *table*, and the two groups of thirteen sit (or stand) to either side. An analogous perspective applies in a painting of a conference held in London in 1604 (Fig. 2).[17] Thus the central

figure in the Kells picture is shown in bust, as are all the other incarnate figures; only angels (including the devil) are shown full length.[18]

The presence of a table can be explained in terms of Farr's own reading of the upper part of the picture. If the image functioned in the context of Lenten readings, it may be that the act of *fasting* is represented, and that this is an image of stolid self-denial in which the monastic family (or the whole community of the Church)[19] flank an empty board. The monastic dimension and the Columban connection are alike reinforced by Adomnán's allusion, in his Life of Columba (iii.8), to the use and context of fasting. Following a visitation of devils to a monastery on Tiree, Columba is said to remark: "With God's help, Baithéne has managed everything well, so that the community in that church over which he presides [*praeest*] in Mag Luinge has been saved by prayer and fasting [*ieiuniis et orationibus*] from the attack of the demons."[20]

Thus the community depicted in the Book of Kells are engaged in a perpetual fast in response to a perpetual threat represented by a single devil who assaults the body of the Church. Moreover, there is evidence here for a subdivision of function: if the lower figures are fasting at an empty board, the upper group presumably sing psalms, if the shield of Christ's truth be read emblematically. The shield's counterpart is an extension, or mutation, of the devil's right hand, a feature convincingly compared by O'Reilly with the lassos with which devils pull monks from the *scala paradisi* in at least one late depiction.[21] On folio 202v this feature surely alludes expressly to the "fowler's snare," the *laqueus venantium*, mentioned in Psalm 90:3 and here visually opposed to the shield of Christ's truth on the opposite side.[22]

The depiction of the Tabernacle in the Codex Amiatinus, a late seventh- or early eighth-century Bible from Northumbria, is relevant to this discussion (Fig. 3). Here the tabernacle has a lintelled doorway, as in the Kells image, and it encloses, besides the Ark of the Covenant, the table for the shewbread (or "loaves of proposition") which is provided for in Exodus as part of the liturgical furniture.[23] Labelled *mensa*, the table is bare and shares the proportions and orientation of the table in the Temptation scene in Kells.[24] The decoration of the Kells table, if not intended to match the door-frame and barge-boards of the building, might suggest the golden "border" and "crown" of the table in Exodus. The Amiatinus image relates, moreover, to the plan of Jerusalem in the Book of Armagh, a manuscript contemporary with the Book of Kells. Assuming the identity of the tables in the two manuscripts, the two groups of thirteen figures in the Kells miniature might be the monastic community cast in the image of priests of the Tabernacle and Temple. The latter group, with the high priest at their head, were alone permitted to eat the shewbread for which the original table was made, although they are shown here in an act of abstinence. This is consistent with the thesis advanced by Ó Corráin that the early Irish monastic élite identified with the Levites, the Old Testament priestly caste.[25] In the illustration on folio 202v of the Book of Kells we see them as they wished to see themselves.

It follows from the argument I have advanced that the table in the Book of Kells is neither below nor outside the Temple/Tabernacle but is housed within its enclosure. Two interpretations present themselves. If the central figure presides at the head of the table, his position in the doorway might be an illusion, a trick of perspective, created by an attempt to lift the building and to show the action within. A parallel is provided by the scene of the multiplication of loaves and fishes on the cross at Arboe (Co. Tyrone), in which Christ presides over a basket which is flanked by lesser figures.[26] But this is not to argue, with Duignan[27] and perhaps Henry,[28] that the presiding figure in the Temptation scene is Christ, unless we accept that he is depicted twice on the

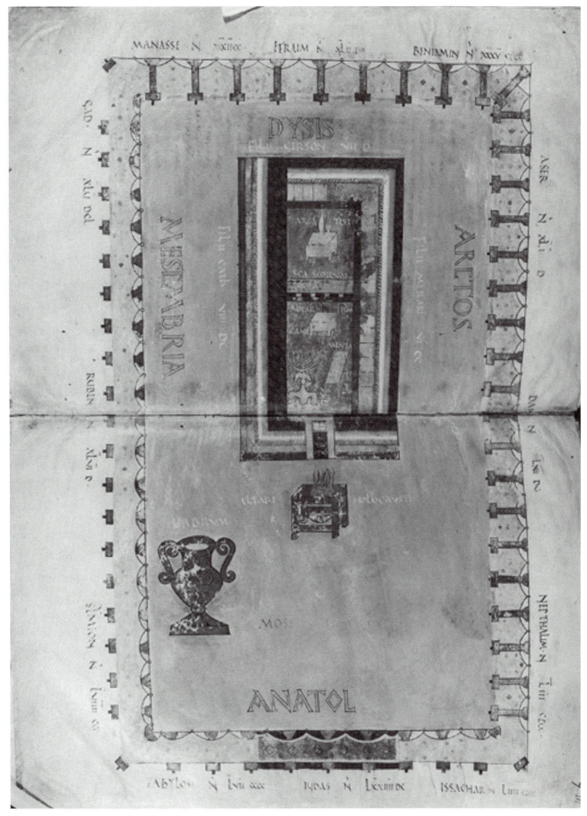

3. Florence, Biblioteca Medicea-Laurenziana, Ms. Laur. Amiatino 1, Codex Amiatinus, Bible, ff. 2v–3r, the Tabernacle

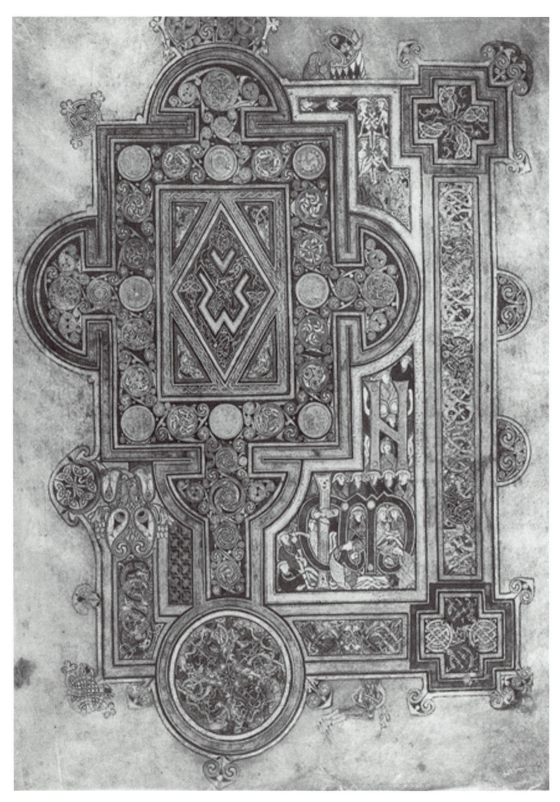

4. Trinity College, Dublin, Ms. A.I.6 (58), Book of Kells, f. 188r, *Quoniam* page beginning the Gospel of Luke

same page. Baithéne, when abbot on Tiree,[29] led his community in prayer and fasting. Might not the figure in the Book of Kells be Columba himself, the Aaronic, archetypal priest, leading his community in their stoical fast? Alternatively, we might see the uprights framing the illumination as the twin pillars at the entrance to Solomon's Temple, framing a view of the Court of the Priests, with its table and personnel, and of the Holy of Holies beyond, a miniature temple with the high priest in its doorway.[30] Both interpretations are valid.

The two groups of thirteen flanking the table in the Book of Kells illustration are symmetrical and arranged in orderly lines, perhaps in deliberate contrast to the seemingly chaotic, even drunken scene of the *Quoniam* page (f. 188r, Fig. 4) which begins St. Luke's gospel.[31] They represent good order and might be seated according to rank, perhaps even reflecting arrangements in a real Columban house. There is a well-known analogy between the *Dindshenchas* account of the banqueting hall at Tara and that of the Temple of Solomon in I Kings;[32] relevant Irish texts are preoccupied with the hierarchy of seating, and the earliest graphic depiction, in the twelfth-century Book of Leinster, names and locates the functionaries of the king's household and recalls earlier plans, such as that of Jerusalem in the Book of Armagh.[33] The latter, like the Amiatinus drawing, assigns its place to each of the tribes of Israel by name. Might we see on folio 202v of the Book of Kells a mirror image, even a corrective image, of the idealized court of a king? The laws confirm the abbot's status as the king's equivalent.[34]

But what of the archaeology of the Kells illustration? The image of the Tabernacle in Amiatinus is based on a specific exemplar, namely that in the Codex Grandior of Cassiodorus, which was brought back to Wearmouth from Rome by Ceolfrith in 679–80. Bede knew this manuscript and discusses the Tabernacle and its furniture in *De Tabernaculo*, interpreting the table as symbolic of Scripture which "supplies us with the food of salvation and life" and "remains for all time without ever being abolished."[35] There was regular contact between Iona and Northumbria: Adomnán is known to have visited the kingdom twice, and Bede reports that he spent time at Wearmouth-Jarrow and spoke to Ceolfrith there.[36] This was in the 680s,[37] not long after the Codex Grandior had been acquired, and Adomnán in all likelihood saw the manuscript. He was himself a student of the holy places; his *De locis sanctis* included a ground-plan of Jerusalem's Church of the Holy Sepulchre and its environs which, as transmitted in one ninth-century source (Fig. 5), is furnished with lamps and with the chalice of the Last Supper depicted frontally, thus combining two perspectives as in the image of the Tabernacle in Amiatinus. The illustration includes a table "on which alms are offered by the people for the poor";[38] located in an open court, the table is represented by an outline rectangle and labelled, in a manner reminiscent of Amiatinus, *mensa lignea in loco isto*. Even disallowing this thematic connection between Amiatinus and Adomnán's work, it remains possible that the codex was seen during the eighth century by members of the Columban *familia* who adapted its iconography in the Book of Kells itself and/or in earlier reworking. Both the Codex Amiatinus and the Book of Kells have *conflate* images of the Tabernacle and Temple, combined in the latter manuscript with allusion to the Ark of the Covenant,[39] and the identity of the tables in the two images can scarcely be doubted in the context of this relationship.[40] In the Book of Kells an irregular area of colour at the lower (or outer) end of the table matches the shade worn by the central figure, as Duignan observed, but cannot be said to represent feet: the feature is asymmetrical and bears no resemblance to feet, whether bare or shod, depicted in this illustration or elsewhere in the manuscript.[41] That it forms no part of the

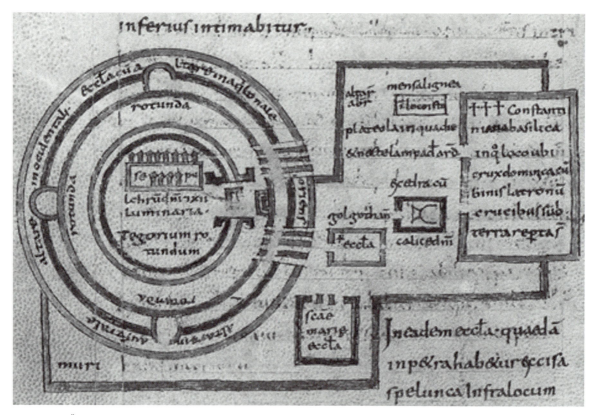

5. Vienna, Österreichische Nationalbibliothek, Cod. lat. 458, Adomnán, *De locis sanctis*, f. 4v, sketch of the Church of the Holy Sepulchre

surface of the table is suggested by the fact that two groups of three yellow dots immediately above are repeated in the upper angles; presumably they mark the four corners.[42]

As George Henderson noted,[43] another Northumbrian product, the Franks Casket (a composite box made of whalebone plaques), also bears comparison with the Book of Kells. Farr has referred to the casket's scene of the sacking of Jerusalem in A.D. 70 by the Roman general, later emperor, Titus, in which the Temple is centrally depicted (Fig. 6), and mentions a general resemblance to the image in the Book of Kells. But it is worth dwelling on the scene on the Temple roof, for two figures are pulled upwards by the hands of those above in an action recalling the strange pose of figures with interlocking hands in the N on the *Quoniam* page of the manuscript (Fig. 4).[44] Two men in the M on the same page grip their own projecting forelocks, a gesture reminiscent of the scene at lower left on the same panel of the casket, in which one figure grips or pulls the forelock of another. If the figures on the *Quoniam* page are depicted in an unsympathetic light, as already suggested, there are grounds for further comparison with the casket's sacking scene. The group on the Temple roof must be associated with the Jews who flee in a body on the right-hand side and whose negative connotation is implicit in their perceived failure to recognize the Messiah. The action on the roof—the Jews seemingly saving themselves—might even be seen as antithetical to the earlier temptation of Christ on the same spot, the empty ark signifying his absence from within.[45]

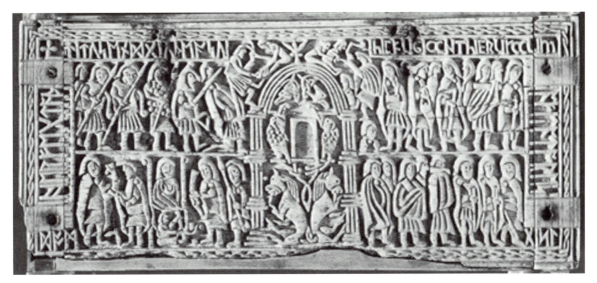

6. London, British Museum, Franks Casket, back panel, sacking of Jerusalem

Two other panels of the Franks Casket display a horse in profile walking between lines of text, a group of three figures made up of a frontal figure flanked by two in profile, and the Virgin and Child (in an Adoration scene). Details of the Book of Kells recalled by these images are, respectively, its interlinear animals (e.g., the wolf on folio 76v), the "Arrest" on folio 114r, and the Virgin and Child on folio 7v. The latter image has often been compared with the Virgin and Child group on St. Cuthbert's coffin, a late seventh-century product of Lindisfarne.[46]

These reminiscences suggest that the artists of the Book of Kells were conscious of Northumbrian models. The Franks Casket dates to the eighth century and has been compared with the Codex Amiatinus in that it reproduces, albeit by adaptation, a Mediterranean exemplar.[47] The casket, or similar works, might have been seen alongside Amiatinus by visitors from the Columban *familia* before the Book of Kells was made. It is the argument of this paper that the table newly identified in the Temptation miniature, whether or not it was adapted from Amiatinus and its ilk, is creatively employed in the Book of Kells as a foil in depicting the passive act of fasting and as a symbol of priestly functions.

ACKNOWLEDGMENTS

I am grateful to Bernard Meehan and Felicity O'Mahony for their comments and to Thomas O'Loughlin for specific advice.

NOTES

1. Luke 4:9–12.

2. Dublin, T.C.L., Ms. A.I.6 (58); *The Book of Kells: Ms. 58, Trinity College Library, Dublin*, ed. P. Fox (Lucerne, 1990).

3. M. V. Duignan, "Three Pages from Irish Gospel-Books," *JCHAS* 57 (1952), 11–17, at 13–14.

4. C. Farr, "Liturgical Influences on the Decoration of the Book of Kells," in *Studies in Insular Art and Archae-*

ology (American Early Medieval Studies 1), ed. C. Karkov and R. T. Farrell (Oxford, Ohio, 1991), 127–41, at 131–35; eadem, "History and Mnemonic in Insular Gospel Book Decoration," in *From the Isles of the North: Early Medieval Art in Ireland and Britain*, ed. C. Bourke (Belfast, 1995), 137–45; eadem, *The Book of Kells: Its Function and Audience* (London, 1997); J. O'Reilly, "Exegesis and the Book of Kells: The Lucan Genealogy," in *The Book of Kells: Proceedings of a Conference at Trinity College Dublin, 6–9 September 1992*, ed. F. O'Mahony (Aldershot, 1994), 344–97. See also G. Henderson, *From Durrow to Kells: The Insular Gospel-Books, 650–800* (London, 1987), 168–74.

5. Ex. 25:18–22.

6. I Kings 6:23–28.

7. O'Reilly, "Exegesis" (as in note 4), 382–89. An identification as Solomon was proposed by P. Harbison, "Three Miniatures in the Book of Kells," PRIA 85C (1985), 181–94, at 189.

8. Ps. 90:11–12; Luke 4:10–11; Farr, "Liturgical Influences" (as in note 4), 132; Farr, "History and Mnemonic" (as in note 4), 141; Farr, *Book of Kells* (as in note 4), 64–65.

9. O'Reilly, "Exegesis" (as in note 4), 360–61; I Pet. 2:5; Eph. 2:20.

10. Farr, "Liturgical Influences" (as in note 4), 131–35; Farr, *Book of Kells* (as in note 4), 76–94.

11. O'Reilly, "Exegesis" (as in note 4), passim.

12. *De Tabernaculo*, in *Bedae Venerabilis Opera* (CCSL 119A), ed. D. Hurst (Turnhout, 1969), 1–139, at 59–60; *Bede: On the Tabernacle*, trans. A. G. Holder (Translated Texts for Historians vol. 14) (Liverpool, 1994), 66.

13. Farr, *Book of Kells* (as in note 4), 60.

14. O'Reilly, "Exegesis" (as in note 4), 382.

15. O'Reilly, "Exegesis" (as in note 4), 388.

16. I note, in passing, the suggestion made by Masai that the panel is skeuomorphic of a clasp on a bookcover: F. Masai, *Essai sur les origines de la miniature dite irlandaise* (Brussels, 1947), 57.

17. The painter was Juan Pantoja de la Cruz, and the conference was the occasion of peace negotiations between England and Spain. See the catalogue entry by E. Davies in *Armada: 1588–1988*, ed. M. J. Rodríguez-Salgado et al. (London, 1988), 284, no. 16.35.

18. It is a corollary of my reading of the illumination that the "three horizontal divisions of the building" recognized by Farr, *Book of Kells* (as in note 4), 52, must be reduced to two, ruling out an equation with the three divisions of the Temple of I Kings 6:6.

19. "The Old Covenant priests who . . . could alone enter the Temple court do not just represent ordained Christian priests or religious but prefigure all those who, through baptism, share in Christ's priesthood": J. O'Reilly "Introduction," in *Bede: On the Temple*, trans. S. Connolly (Translated Texts for Historians vol. 21) (Liverpool, 1995), xvii–lv, at xxxiii.

20. *Adomnán of Iona, Life of St Columba*, trans. R. Sharpe (Harmondsworth, 1994), 212; *Adamnán's Life of Columba*, ed. and trans. A. O. Anderson and M. O. Anderson (London, 1961; rev. ed. Oxford, 1991), 482. As O'Reilly points out ("Exegesis" [as in note 4], 392), St. Cuthbert is also said to have resisted the devil by prayer and fasting: *Two Lives of St. Cuthbert*, ed. and trans. B. Colgrave (Cambridge, 1940), 214–15. Cf. Matt. 17:21 with reference to devils: "Howbeit, this kind goeth not out, but by prayer and fasting (Hoc autem genus non ejicitur, nisi per orationem et jejunium)."

21. O'Reilly, "Exegesis" (as in note 4), 391.

22. Farr, by contrast, "History and Mnemonic" (as in note 4), 141, notes in this context the words of Psalm 90:10, "et flagellum non appropinquabit tabernaculo tuo," translating "and the scourge will not come near your tabernacle."

23. Ex. 25.23–8; *Bede: On the Temple* (as in note 19), 105, n. 1.

24. "At the destruction of the Temple under Titus in A.D. 70, the Table was rescued and its transport to Rome by captured Jews is prominently depicted on the Arch of Titus. It eventually reached Constantinople, whence it was sent back to Jerusalem under Justinian. . . . It probably perished in the sack of Jerusalem by Chosroes in 614": *Oxford Dictionary of the Christian Church*, ed. F. L. Cross and E. A. Livingstone, rev. ed. (Oxford, 1974), 1271. There is no reason why the table as depicted on the arch should not have been seen by Insular pilgrims in Rome.

25. D. Ó Corráin, L. Breatnach, and A. Breen, "The Laws of the Irish," *Peritia* 3 (1984), 382–438, at 394–96.

26. P. Harbison, *The High Crosses of Ireland: An Iconographical and Photographic Survey* (Bonn, 1992), vol. 2, figs. 36, 37.

27. Duignan, "Three Pages" (as in note 3), 14.

28. F. Henry, *The Book of Kells: Reproductions from the Manuscript in Trinity College, Dublin* (London, 1974), 189.

29. He was to succeed Columba as second abbot of Iona.

30. Cf. O'Reilly, "Exegesis" (as in note 4), 388–89; Farr, *Book of Kells* (as in note 4), 52.

31. B. Meehan, *The Book of Kells: An Illustrated Introduction to the Manuscript in Trinity College Dublin* (London, 1994), 71–72; but cf. Farr, "History and Mnemonic" (as in note 4), 143–44; Henderson, *From Durrow to Kells* (as in note 4), 165–68. It is a further point of contrast that the figures in the lower part of folio 202v, though not tonsured, have relatively short hair, while those on folio 188r wear their hair long. On the other hand, Christ himself is long-haired on 202v. Luke 21:34, after an admonition against drunkenness, refers to the Day of Judgment closing suddenly, *tamquam laqueus*, "as a snare," in terms reminiscent of Psalm 90:3, an image perhaps graphically represented on folio 188r by two men

with their heads in lions' jaws.

32. *The Metrical Dindshenchas*, pt. 1, *Text, Translation, and Commentary*, ed. E. Gwynn (Royal Irish Academy, Todd Lecture Series vol. 8) (Dublin, 1903; repr. Dublin 1991), 70–74.

33. E. Bhreathnach, "The *Tech Midchúarta*, 'the House of the Mead-Circuit': Feasting, Royal Circuits and the King's Court in Early Ireland," *Archaeology Ireland*, 12 no. 4 (winter 1998), 20–22.

34. F. Kelly, *A Guide to Early Irish Law* (Dublin, 1988), 41.

35. *De Tabernaculo* (as in note 12), 21, 28; *Bede: On the Tabernacle* (as in note 12), 21, 30.

36. *Historia Ecclesiastica* 5.21; *Bede's Ecclesiastical History of the English People*, ed. and trans. B. Colgrave and R. A. B. Mynors (Oxford, 1969), 550–51.

37. *Life of St Columba*, trans. Sharpe (as in note 20), 47–48.

38. *Adamnán's De Locis Sanctis*, ed. and trans. D. Meehan (Dublin 1958; repr. 1983), 50–51.

39. Farr, "History and Mnemonic" (as in note 4), 137; Farr, *Book of Kells* (as in note 4), 53–56; O'Reilly, "Introduction" (as in note 19), lii–liv.

40. Schapiro suggested that a diagram on folio 7r of the Codex Amiatinus "might well be an example of the forms that underlie as models the . . . frames on certain pictorial pages of the Book of Kells": M. Schapiro, "The Decoration of the Leningrad Manuscript of Bede," *Scriptorium* 12 (1958), 191–207, at 207. Note that C. Thomas, *Christian Celts: Messages and Images* (Stroud, 1998), 110–14, has recently argued that a ground-plan of the Temple is encoded in a fifth-century inscription from Whithorn, Wigtownshire.

41. The definition of the "feet" has been enhanced by retouching, e.g., in *Evangeliorum Quattuor Codex Cenannensis*, ed. E. H. Alton and P. Meyer (Berne, 1950–51), vol. 2.

42. The twelve "loaves of proposition" are represented by four groups of three dots of appropriate scale in the angles of the table in a sixth-century Byzantine miniature, a type of image shown by Meyvaert to be immediately ancestral to that in the Codex Grandior as reproduced in Amiatinus: P. Meyvaert, "Bede, Cassiodorus, and the Codex Amiatinus," *Speculum* 71 (1996), 827–83, at 849–53 and fig. 3. Although the dots on folio 202v are too small to have this representative function in the Book of Kells, their origin might lie in such a scheme. On the other hand, it must be admitted that triplets of coloured dots are a commonplace in the manuscript.

43. Henderson, *From Durrow to Kells* (as in note 4), 165–68.

44. This comparison has been anticipated by Isabel Henderson, who also refers to a related scene on a slab at Meigle, Perthshire: I. Henderson, "Pictish Art and the Book of Kells," in *Ireland in Early Mediaeval Europe: Studies in Memory of Kathleen Hughes*, ed. D. Whitelock, R. McKitterick, and D. Dumville (Cambridge, 1982), 79–105, at 96.

45. Parallelism and antithesis are characteristic of the Franks Casket, and the contrast between the Temptation and *Quoniam* pages of the Book of Kells (p. 55 above) seems to suggest similar thinking.

46. E. Kitzinger, "The Coffin-Reliquary," in *The Relics of Saint Cuthbert*, ed. C. F. Battiscombe (Oxford, 1956), 203–304; M. Werner, "The Madonna and Child Miniature in the Book of Kells," *ArtB* 54 (1972), 1–23, 129–39.

47. L. Webster, "Stylistic Aspects of the Franks Casket," in *The Vikings*, ed. R. T. Farrell (London, 1982), 20–31; eadem, "The Franks Casket," in *The Making of England: Anglo-Saxon Art and Culture, A.D. 600–900*, ed. L. Webster and J. Backhouse (London, 1991), 101–3. See also C. Neumann de Vegvar, *The Northumbrian Renaissance: A Study in the Transmission of Style* (Selinsgrove, 1987), 259–73.

De Camino Ignis: The Iconography of
the Three Children in the Fiery Furnace
in Ninth-Century Ireland

·

COLUM HOURIHANE

THE IRISH HIGH CROSSES have been described as "one of the two bookends" of Early Christian sculpture, along with the Roman sarcophagi.[1] Similarities in the iconographical programmes of these two groups of monuments have been noted in the past.[2] Close cultural connections existed between Ireland and Italy through pilgrimage from the sixth century onwards, and this has been proposed as one possible transmission route for the shared imagery. With the recent publication of the first large-scale photographic and iconographic survey of the Irish crosses, it is now possible to see how their subject matter relates to European art of this period.[3] This survey, relying in part on the work of previous scholars, identifies some one hundred scenes which are based on the Bible, including thirty-seven from the Old Testament and forty-nine from the New Testament; a further nine are hagiographical scenes.[4] The high crosses thus emerge as the largest single Insular source of biblical representations. The earliest crosses have been recognized as owing significantly to the Old Testament, in particular the Books of Genesis, Exodus, Samuel, and Daniel, but isolated scenes also depict Solomon, Manasseh, and Elijah.

Despite studies like that of Kees Veelenturf, which was the first large-scale eschatological evaluation of these monuments, there are still problems in our understanding of not only their purpose, but also their iconographical programmes.[5] One such problem is the tendency to view all of the monuments in terms of a single meaning or iconographical programme, or to conclude that all of the depictions on a number of monuments have the same meaning. As research progresses, it is becoming clear that each cross deserves to be studied on its own, and that no two are alike. Significant study must still be undertaken before art historians can appreciate the various influences and motives, not all unified, that may lie behind these monuments.

This paper will attempt to evaluate one biblical composition that appears on the high crosses, the Three Hebrews in the Fiery Furnace, and to see how this subject is dealt with firstly in a European context and secondly in an Insular context. It will show that there was difficulty in reconciling the contradictory elements in the biblical text when it came to depicting the fourth figure in the furnace, who is described as either an angel or the Son of God. This difficulty first appeared in fourth-century Italy but was resolved in ninth-century Ireland with the development of a unique iconography which provided a visual model for subsequent generations.

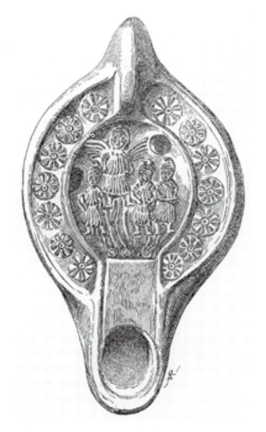

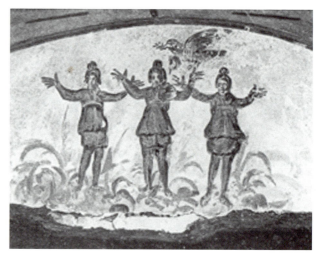

2. Rome, Catacomb of Priscilla, cubiculum 7, right wall

1. Terra-cotta lamp with the Three Hebrews in
the Fiery Furnace. Constantine, Musée de
Cirta

THE EARLY CHRISTIAN ICONOGRAPHY OF
THE THREE HEBREWS IN THE FIERY FURNACE

The group of three figures in a flaming furnace has been referred to using terms such as Three
Children in the Fiery Furnace; Three Hebrews in the Fiery Furnace; Shadrach, Meshach, and
Abednego in the Fiery Furnace; and the Chaldeans in the Fiery Furnace. All of these describe a
scene from the Old Testament Book of Daniel (3:21–25), the episode in which Nebuchadnezzar
ordered the mightiest men in his army to bind the three children and cast them into a fiery fur-
nace because of their refusal to worship an idol. They survived because of their faith, much to Ne-
buchadnezzar's astonishment. When Nebuchadnezzar looked into the fires of the furnace he
claimed to see four men inside, all of whom were unhurt. The fourth figure he believed was like
the Son of God. When he addressed them and asked them to come forth, they appeared with the
help of an angel. Much of the Book of Daniel was not written in Hebrew, but in Aramaic, possibly
in the second century. There were also Greek translations that included certain additions, in-
cluding the Prayer of Azariah and the Song of the Three Young Men (inserted after Dan. 3:23).
The book can be divided into two sections: one part consists of the first six and the last two chap-
ters, which were haggadic in purpose, while the remainder were apocalyptic in intent.

The theme of the three Hebrews in the fiery furnace has been previously studied by scholars such as Carletti, who described some 177 depictions in various media, and Rassart-Debergh, whose 1978 study extended Carletti's work. It was also dealt with by Seeliger in an encyclopedic article in 1983 and received further attention in relation to the Adoration of the Magi in the recent examination by Irwin.[6] None of these studies, however, has attempted to evaluate the frequency of this scene in the period after the seventh century. This paper will add yet another block to the attempt to reconstruct the evolution of the scene in an Insular context of the ninth century, and it is hoped that further studies will add to its history in the late medieval period.

The theme is amongst the earliest to be found in Christian iconography, and examples in sculpture, painting, and gold-glass first occur in the third century. An interesting and cohesive group of objects with this scene are terra-cotta lamps from North Africa, such as that in the Musée de Cirta in Constantine (Fig. 1), which in many ways establish a pattern that changes little throughout the entire medieval period.[7] The full-length figures stand in the flames, while above them at the left is the larger protecting figure of the angel. The three figures have their hands by their waists in various poses of excitement and have not adopted the more familiar pose of the orant. Their Persian or foreign identity is shown by their exotic head-dresses. The subtle iconographical linking of these three figures, who were responsible for showing Nebuchadnezzar the light of redemption through an ordeal by fire, to objects that stored and shed actual light was not coincidental. For the Christian viewer these lamps represented the fiery furnace in miniature.

This same moment of truth, where the peril facing the three figures is represented with little attempt at narrative, is depicted in catacomb paintings, for example, in the Via Latina Catacomb[8] and the Catacomb of Priscilla.[9] The scene in cubiculum V of the Catacomb of Priscilla (Fig. 2) shows the dove of Noah's Ark returning with a branch in its mouth, announcing to the three Hebrews the message of salvation and delivery which had also been given to Noah.

By the end of the third century the pose of the three Hebrews had changed to that of the formal orant, as found in the Coemeterium Maius[10] and Catacomb of the Jordani.[11] In the fourth century, when the motif is found with increasing frequency,[12] the iconography is also extended: the three Hebrews are merged with and linked to other scenes. These other scenes are relatively few in number and include Noah in the Ark, Jonah Cast Overboard, the Raising of Lazarus, and Daniel in the Lions' Den. Like the scene of the three Hebrews, they focus on salvation through faith. It is also at this stage that the motif is linked to scenes, such as Adam and Eve, depicting what could be termed oppositional iconography. If the three Hebrews could be seen as a symbol of salvation, then the need for deliverance must be embodied in the two figures of Adam and Eve, who were responsible for the Fall of Man.[13] Christ as shepherd or with the apostles is also juxtaposed with the three Hebrews, showing the reason for their worship and the source of their salvation. During this period the Adoration of the Magi becomes inextricably linked to the Three Hebrews in the Fiery Furnace. Both Schiller[14] and, more recently, Irwin[15] have shown how this scene contrasts with that of the three Hebrews: the Magis' willingness to worship the true God is contrasted with the Hebrews' refusal to worship a false god. The three Hebrews and the three Magi, all of whom are foreign and usually dressed in exotic clothing, are seen as paralleling each other. The universal possibility of salvation through faith which the three Hebrews exemplified to believers is also transferred into the more personal salvational programmes on sarcophagi, where the three Hebrews may accompany a portrait of the deceased.[16]

In the fourth century, narrative comes to the fore in the iconography of this motif. Even

when the three Hebrews adopt the orant pose, they frequently have their heads and bodies turned in movement. In the earliest depictions of this scene the furnace was often not represented; a series of flames at the feet of the figures was enough to convey their ordeal. By the fourth century, however, when the furnace is shown it is an elaborate structure, usually constructed of bricks and nearly always with flames. Similarly, additional figures are included in the scene at this time; these can be the soldiers stoking the fire, the Chaldeans, Nebuchadnezzar, or the fourth figure which Nebuchadnezzar saw in the furnace.[17]

The angel, which is first found in the late third century, is the most difficult figure in the composition and does not appear as an integral or consistent part of the scene in the early period. Irwin has recorded twenty-three examples, dating from the third to the start of the fifth century, with a fourth figure in the furnace, and in the past this figure has been interpreted as representing the angel.[18] At the start of the fifth century, the fourth figure is clearly intended to represent the angel and in the majority of the examples has all of the usual angelic attributes. When the furnace is represented, he is usually shown within it, at the side of the three nimbed figures, and he carries a staff which he uses to protect them from the ordeal of the flames.[19] Prior to this standardization of the fourth figure, it is clear that there was uncertainty as to whether he should be included, and, if so, how he should be represented.[20] There appear to have been two traditions, the earlier of which shows a recognizable winged angel standing with the Hebrews, as on the terra-cotta lamps (Fig. 1). In the second tradition, which is first found in the early fourth century, the fourth figure does not have the standard angelic attributes of the first group; this type of figure is sometimes included in the scene when it appears on sarcophagi. This figure without the usual angelic features has traditionally been interpreted as the angel whom Nebuchadnezzar saw in the flames, as recounted in the deuterocanonical preface to the Canticle of the Three Hebrews in the Fiery Furnace (3:49): "But the angel of the Lord went down with Azarias and his companions into the furnace: and he drove the flame of the fire out of the furnace."

This fourth figure usually wears a toga, may be bearded, and is shown as an equal standing alongside the three Hebrews in the furnace.[21] The passive stance of this figure and the similarity of his dress and pose to the representations of Nebuchadnezzar in this scene are unusual. The evidence for interpreting this figure as the angel is limited and not convincing; on the contrary, the attributes of a beard and toga are rarely associated with angels but could be used in depictions of the Son of God.[22] One toga-clad but beardless representation of the Son of God in his role of saviour to the three Hebrews from this period, on a gold-glass bowl presently in the Metropolitan Museum of Art in New York, shows Jesus standing outside of the flames and holding a wand in his raised hand.[23] It is clear that there is a certain confusion not only about whether this fourth figure should be included, but about its true nature. This confusion is also seen in the writings of the biblical commentators[24] and appears to have been resolved in the ninth-century Irish carvings.

From the mid-sixth to the ninth century the scene of the three Hebrews appears infrequently and differs little from the established formula of the fourth and fifth centuries. By the time the motif was introduced into Ireland in the ninth century, this was a firmly established iconography which was immediately recognizable through a number of standard elements. These consist of three half-length or full-length figures, always in the orant pose, usually wearing exotic headdresses and clothing, and standing in or on a furnace which is usually surrounded by flames. An

angel accompanies these figures and is usually represented as the traditional winged male who appears to help the three Hebrews.[25] If additional figures are included they are most likely to be either Nebuchadnezzar or the soldiers attending the fire, but such figures are rare after the fifth century.

The interpretations of and commentary on the symbolism of this narrative are varied and have been summarized by Irwin.[26] These range from biblical commentaries by Clement of Rome to Basil, John Chrysostom, Jerome, and Cyprian, to the modern art-historical interpretations. The three Hebrews are interpreted as representing the persecuted (Clement), the righteous (John Chrysostom), or the power of faith (Jerome, Cyprian). Cyprian, more than any other commentator, together with the frequent association of the scene with other representations of deliverance, has been responsible for the belief that the three Hebrews symbolize salvation. It is clear that the composition worked on many levels and that it would be a pointless exercise to view all of the depictions from the standpoint of one belief.

This paper will now look at the largest corpus of ninth-century representations of the three Hebrews, which are the panels on the Irish high crosses, and examine how the eschatological meanings of the scene were developed in an Insular context. The composition subtly changed in these Insular examples to reflect the biblical text, and the fourth figure of the composition—which, as we have seen, was problematic in the fourth century—came to play a pivotal role.

THE IRISH DEPICTIONS

The purpose and function of the Irish crosses have been extensively studied, and yet they are still one of the enigmas of Irish art history.[27] They have been associated with the church reform movement that was underway at this time, the *Céli Dé*, which literally means "the followers of Christ."[28] This movement must have sought to win support for their beliefs through public manifestations such as the high crosses. The beliefs of this movement have been described elsewhere,[29] but their association with the crosses has not been conclusively proved.

The scene of the three Hebrews is one of two taken from the Book of Daniel to be found on the Irish high crosses, where it is frequently accompanied by representations of Daniel in the Lions' Den. The Three Hebrews in the Fiery Furnace appears on the following Irish high crosses: Arboe (Co. Tyrone); Armagh, North Market Cross; Galloon (Co. Fermanagh), West Cross; Kells (Co. Meath), Cross of Sts. Patrick and Columba; Monasterboice (Co. Louth), Tall or West Cross; Moone (Co. Kildare); and Seirkieran (Co. Offaly). The placement of these scenes on these crosses and their features are given in Table 1. Although the orientation of the crosses may have changed, the original has been given insofar as that can be determined. The positions of the individual panels are determined in relation to the base of the cross, e.g., "6th" describes the sixth panel from the bottom.

Excluded from this list are a representation at Camus (Co. Derry),[30] which was identified as a representation of this scene in the Index of Christian Art, and a fragment of a cross believed to have originally been at Drumcliffe (Co. Sligo), and now in the National Museum, Dublin,[31] which is not included because of its fragmentary nature. A panel on the South Cross (west face, head) at Castledermot (Co. Kildare) showing three figures, which was previously identified by Herity,[32]

Hawkes,[33] and Streit[34] as representing the deliverance of the three Israelites from the fiery furnace, is not included because it is badly damaged and does not relate iconographically to the group discussed here.

Table 1: Irish high crosses with the Three Hebrews in the Fiery Furnace

LOCATION	PLACEMENT	HEBREWS	ANGEL	WINGS	KILN	FLAMES	SOLDIERS
Arboe	Shaft, east face	Kneeling, non-orant	X	X	No (W)	X	
Armagh	Shaft, north side	Standing, non-orant	X	X	No (W)	X	
Galloon	Shaft, west face	Kneeling, non-orant	X	X	No (W)		
Kells	Shaft, east face, 6th	Standing, non-orant	X	X	No (W)		2
Monasterboice	Shaft, east face, head	Standing, non-orant	X	X	No (W)		2
Moone	Shaft, south side, 3rd	Standing, non-orant	X	X	Yes		
Seirkieran	Base, east face	Standing, non-orant	X	X	No (W)		3?

(W) = a kiln-like structure formed by the angel's wings

Iconography

The seven Irish examples of the scene fall roughly into two divisions depending on the pose of the children, the number of figures shown in the composition, and the point of the narrative that is depicted (Fig. 3). In the first group the three figures are depicted in a standing pose and viewed frontally. This composition does not include any additional figures apart from the angel. The second group consists of two children in profile and kneeling on either side of the third, who stands facing the viewer. This composition also includes the angel as well as two soldiers who attend the fire. The carving at Armagh (Fig. 3b) is weathered, and it is not clear to which of these groups it belongs, though is closer in style to the first group.

The pose of the first group is best exemplified by the cross of Moone panel (Fig. 4), which partly adheres to the biblical description of the three Hebrews undergoing an ordeal by fire without suffering or showing fear. Unlike the Continental comparanda, however, they do not pray but stand motionless under the protection of the angel. Despite the fact that the Bible states that they walked in the midst of the fire, no motion is shown in any of the Irish representations. This is in contrast with the scene immediately beneath the three Hebrews on the cross of Moone, showing either the Flight into or out of Egypt, where the motion of the ass on which the Virgin sits is conveyed with vigour.

The second group of scenes shows the Hebrews in terror and attempts to convey the action and narrative of the story. The composition, with two of the figures in profile and the central one seen frontally, is a uniquely Insular creation, and no parallels exist for it in Early Christian representations. The kneeling pose of the figures in this group can be interpreted as indicating prayer, adoration, or supplication before death. As the three children certainly did not suffer

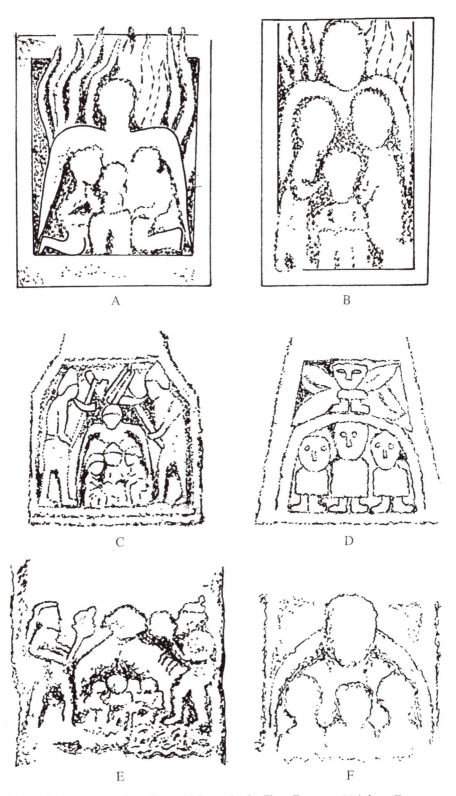

3. Six Irish examples of the Three Hebrews in the Fiery Furnace: *(a)* Arboe, County Tyrone; *(b)* Armagh, North Market Cross; *(c)* Monasterboice, County Louth, Tall or West Cross; *(d)* cross of Moone, County Kildare; *(e)* Kells, County Meath, Cross of Sts. Patrick and Columba; *(f)* Galloon, County Fermanagh, West Cross

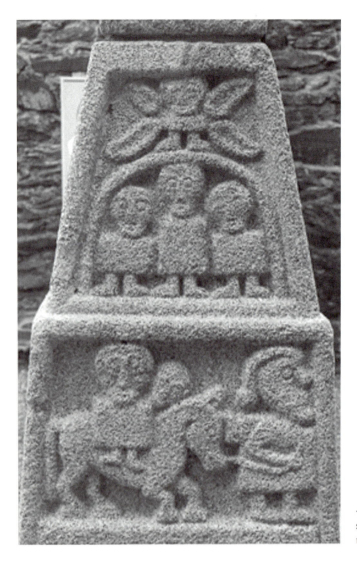

4. Cross of Moone, County Kildare, south side of shaft showing the Three Hebrews in the Fiery Furnace

death, and the whole point of the episode is that they escaped intact and untouched by the flames, it cannot be supplication before death that is being represented. In fact, the standard pose for the three Hebrews since the fourth century is one of prayer or piety, and the orant pose is particularly characteristic of these three figures. This stance is found in other scenes on the high crosses, but not with great frequency, so it is clear that the sculptors knew of the orant pose but consciously chose to ignore it in scenes of the three Hebrews.[35] In depictions of the three Hebrews, the orant pose refers to the prayer which Azarias recited in the furnace (Dan. 3:25). A considerable number of the ninth-century examples outside of Ireland retain this pose in depicting the three figures, for example, the Khludov Psalter (Fig. 6).[36] The orant pose, however, is by no means standard at this stage outside of Ireland, and variations are also found.[37]

The kneeling pose, on the other hand, is not found outside of Ireland, and it also occurs with great frequency in other scenes on the high crosses, where it is used in depictions such as the Sacrifice of Isaac or the Last Judgment to convey any of the three emotions mentioned above. One of the most frequent occurrences of the kneeling pose in a group of three figures is

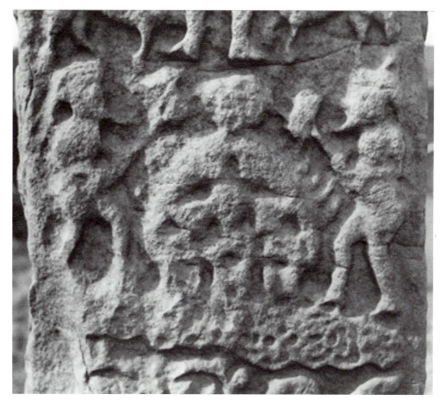

5. Kells, County Meath, Cross of Sts. Patrick and Columba, showing the Three
Hebrews in the Fiery Furnace

in scenes of the Adoration of the Magi, which is a typological prototype of the Three Hebrews in
the Fiery Furnace. On the high crosses, however, the Adoration of the Magi always shows a stand-
ing file of three figures approaching the infant. Depictions of the three Hebrews on the crosses,
such as that at Kells (Fig. 5), are reminiscent of the Nativity, with the two figures on either side ap-
parently looking at the smallest of the figures, who takes on the role of the infant Jesus. The
smaller size of the central figure in these scenes is also something that is not found outside of Ire-
land. Conflation of ideas, however, has to be dismissed in this scene, since the Adoration of the
Magi is also found on approximately half of the crosses which depict the Three Hebrews in the
Fiery Furnace.

In a number of instances it is possible to identify this scene only because three figures are
present. But the surviving evidence is enough to indicate that the Irish composition is radically
different from that seen in mainland Europe and that it focuses on certain aspects of the biblical
narrative that had never before been included. The first characteristic is the size of the figures:
whereas the three Hebrews are described as youths in earlier parts of the Book of Daniel (1:4,
1:10, 1:17), their age is not mentioned in chapter three. Nevertheless, in the Irish examples the
three figures are rarely the same size, and their youthful or childlike status is indicated by the fact
that they are smaller than the other figures that are shown, as in the examples at Kells (Fig. 5) and
Monasterboice (Fig. 7). Unlike the Continental examples, the figures in the Irish depictions have
no indication of any exotic or unusual clothing, and in this respect they are not distinguished

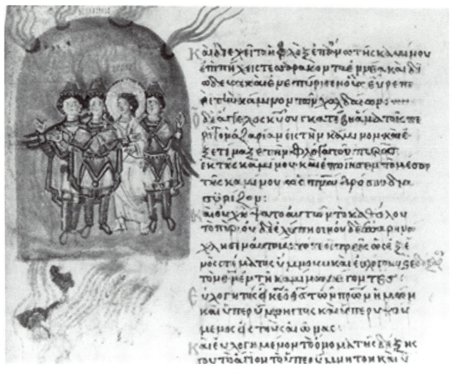

6. Moscow, Historical Museum, Ms. gr. 129, Khludov Psalter, f. 160v

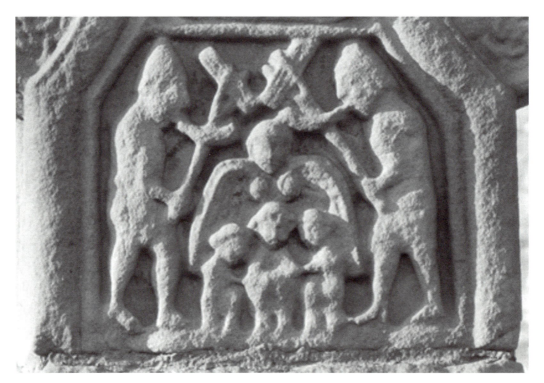

7. Monasterboice, County Louth, Tall or West Cross, east face showing the Three Hebrews in the Fiery Furnace

from other figures on the high crosses. When the need arose to show details such as clothing (for example, the soldiers' helmets on Muiredach's Cross), this was accomplished in fine detail. Despite the fact that the biblical text says that the three Hebrews "were cast into the furnace of burning fire with their coats, and their caps, and their shoes, and their garments" (Dan. 3:22), these features are absent from the crosses.

The furnaces on earlier Continental comparanda are nearly always rectangular, box-like, brick structures with three openings, usually with one placed under each of the figures. These must represent some form of industrial structure from fourth-century Italy. Five different Hebrew nouns have been translated as "furnace" in the King James Bible, and these refer to ovens, kilns, and domestic fires.[38] Of the thirty references to furnaces in the Bible, the majority imply an industrial type structure for smelting or some other such process. The biblical text refers to the three children who "fell down bound in the midst of the burning fire" (Dan. 3:23), indicating a high structure, and at a later stage Nebuchadnezzar "came to the door of the burning fiery furnace" (Dan. 3:93) and could see the Hebrews within, suggesting that it was a large structure. Later representations of this type of furnace, which are slightly higher than the earlier examples but with the same openings and bricks, are found in a number of ninth-century manuscript illuminations of the three Hebrews.[39] In the only Irish depiction that shows a kiln, that on the cross of Moone (Fig. 4), it is dome shaped and the children within it are visible from the outside, as the biblical text describes. Kilns were used in Ireland for firing pottery, burning lime, and drying cereals,[40] but unfortunately no pre-medieval examples have been excavated, so it is impossible to relate the furnace on the cross of Moone to any physical evidence. This type of furnace is not unique to the cross of Moone and is more graphically depicted in the Khludov Psalter (Fig. 6) and a psalter in the Pantokrator Monastery on Mount Athos (Ms. 61, f. 222r), where the round-topped furnace is pierced by four holes through which flames rise.[41]

In the two scenes where the soldiers attending the fire are shown (Kells and Monasterboice, Figs. 5 and 7), no structure separates the children and angel from these figures, and the furnace is only implied by the dome-like wings of the angel, which mirror the shape of the furnace at Moone. It is possible that the furnace was painted, although there is no evidence to support such a theory, and it seems unlikely that only this single element would have been distinguished in this way. The flames of the furnace are still visible in two of the carvings, where they rage behind the angel. In the example at Arboe (Fig. 3a) they pass beyond the frame of the panel and may depict the stage when the flame rose above the furnace or when the angel went into the furnace. The Continental examples often show the flames alone without any depiction of the actual furnace.

Another element in these Insular representations that is unique at this period are the standing and helmeted figures of the soldiers which tend the fire and throw faggots onto the blaze. These figures are not found in other ninth-century examples, although they do appear in a tenth-century Spanish manuscript (Valladolid, Biblioteca Santa Cruz, Jerome, *In Danielem*, f. 199v). In the examples at Monasterboice (Fig. 7) and Kells (Fig. 5) both soldiers have horns in their mouths, and these may have been included for three reasons. The horns may have been used to identify the soldiers as those who worshipped the false idol, and who we are told made music to celebrate the statue: "That in the hour you shall hear the sound of the trumpet, and of the flute, and of the harp, and of the sackbut, and of the psaltry, and of the symphony, and of all kind of music" (Dan. 3:5). Helen Roe, on the other hand, believed the horns on the Kells cross to be a

kind of mouth bellows, which is at variance to their use elsewhere in high cross iconography.[42] A third reason for including these horns may have been to emphasize the heat in the furnace. The horn is frequently found on the high crosses, nearly always in scenes of Samuel Anointing Saul or David, or the Chief Butler Giving the Cup to the Pharaoh, with examples at Monasterboice (Cross of the Scriptures, West Cross), Galloon (East Cross), Iniscealtra (Ringed Cross), and Kells (Market Cross). In such scenes the horns appear to serve as containers for liquid. The fact that the soldiers in the scenes of the three Hebrews drink from their containers while adding faggots to the flames may have been understood by the viewer as a means of conveying the thirst of the fire tenders and the heat within the furnace.

Although soldiers were sometimes included in this scene on the sarcophagi, they are by no means standard, and rarely do they have such an integral role in the composition. Their symmetrical positioning in the high cross panels is an Insular creation. The scene on the crosses at Monasterboice and Kells does not depict the point of the narrative at which the children prayed or walked in the fire; it must be an earlier stage when they had been placed in the fire and the flames were being tended. The soldiers in these two panels reflect an element of conflation which is common to other panels on these crosses. Long narratives are condensed into single panels, with elements drawn from the entire text and not just from what is purportedly the main theme. It is interesting that these soldiers, like the angel, are part of a revisionist programme which goes back to the Late Antique prototype and not to a Carolingian model, where they are never found.

The most distinctive element in all these scenes is without doubt the angel, who may have taken on a new role in these representations. The emphasis on the angel as protector is stressed in all of the Irish examples. He always assumes the same unique protective stance, positioned centrally over the three figures and using his wings as a shield, under which the three figures huddle, stand, or kneel. The wings form a protective covering and cloak the three Hebrews from the flames. They are always widely splayed to form a perfect arch over the figures and are reminiscent of later depictions of the Virgin's protective mantle.[43] The angel in these panels differs considerably from the numerous other angels on the crosses,[44] who assume a more secondary role. The only other cross with a similar angel composition is the Cross of the Scriptures at Clonmacnois (Fig. 8). Here, the single angel with enveloping wings spread over an unidentified standing ecclesiastic could be interpreted as the Lord protecting the personified Church.

That the wings were meant to protect and resemble a cloak may be linked to the modern use of the word *coimed* in the Irish language. A text in the Bodleian Library (Ms. Rawlinson 512), which is a collection of early ninth-century litanies used in the Irish Church, was written in a combination of Old and Middle Irish. In one such litany, that of the Trinity (f. 42), a petition is made to the Lord as *A Coimed na Cristaide*, which is translated as "O Guardian of the Christians."[45] Derived from the Old Irish verbal noun of the root verbs *con-eim* and *con-oi*, the word *coimed* is explained as an act of preserving or guarding; *coimetaid* is derived from this verbal noun (*t* and *d* were often interchanged in this period). Although there is no etymological basis for the thesis that the word can also be translated as "cloak, covering, protection or relief, lap, waist, bosom or middle,"[46] it is tempting to see these carvings as literally representing the cloak of protection.

Although the angel is present in ninth-century representations outside of Ireland, he never assumes the same dominant role. He is found behind and above the three figures in two of the

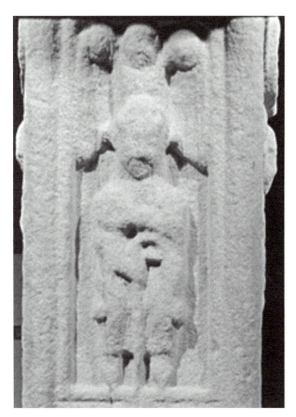

8. Clonmacnois, County Offaly, Cross of the Scriptures, south side, fourth panel ex base, showing an ecclesiastic standing beneath an angel

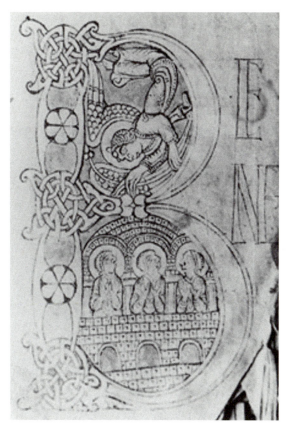

9. Amiens, Bibliothèque Municipale, Ms. 18, Corbie Psalter, f. 134v

examples mentioned above—Paris, B.N.F., Ms. gr. 510, f. 435v, and Mount Athos, Pantokrator Monastery, Ms. 61, Psalter, f. 222r—but his wings do not have the same protective and enclosing pose. In the Corbie Psalter (Fig. 9) the angel flies over the three Hebrews, who stand below praying in a brick kiln. The only Irish exception to this kiln-like wing structure of the angel is on the cross of Moone, where he stands on top of the furnace, a pose which is also not shown on any of the other examples. At Moone the angel is more removed from the three figures beneath, who stand stoically and face the viewer.

The importance of the three Hebrews panels on these seven crosses can also be seen in their position on the monuments. Even though some of the crosses may have changed orientation over time, the scene is presently found on the east face in four examples (the original orientation of the crosses at Armagh and Moone is unknown). In three of these programmes it starts the sequence of viewing, if it is accepted that this commences at the base and moves towards the top. The eastern face of these crosses, like other monuments of Christian art and architecture, has always been viewed as being the most significant. If the help of God is a major theme in these programmes, it would have been important that the first image would have incorporated not only a representation of the power of faith, but also the actual deed of salvation with Jesus present, pro-

vided it is accepted that at this stage the angel is one and the same with Jesus. Hence it is a representation of Jesus in the first panel that begins the programme on these crosses.

The relationship of this scene to other panels on the crosses is more complex and appears to vary from monument to monument. On the Galloon cross, for example, all of the scenes present a cohesive programme devoted to salvation and include the Baptism of Christ, Daniel in the Lions' Den, Adam and Eve, the Three Children in the Fiery Furnace, the Sacrifice of Isaac, and Noah's Ark. A similar unity is found at Arboe, which also has scenes of the Sacrifice of Isaac, Daniel in the Lions' Den, and the Three Hebrews in the Fiery Furnace. The meaning of the three Hebrews panel on the cross of Moone, where it occurs in the significant position next to the Multiplication of the Loaves and Fishes and the Flight into or out of Egypt, has been explained in relation to the eucharistic nature of the programme. The complex nature of these programmes will only be understood when the iconographic significance of the individual panels and how they were used in an Irish context have been studied.

Art historians have in the past proposed single solutions to elucidate the very diverse corpus of Irish crosses, for example, by viewing them as visual representations of literary texts with a strong focus on salvation.[47] Individual panels and parts of programmes have been examined in relation to eucharistic themes,[48] and entire monuments have been seen as eschatological manifestations.[49] Instead of looking at the entire corpus, or even at individual crosses, the approach used here is that suggested by Ó Carragáin[50] of viewing each panel as a unit or a word. What has been seen in the past as one theme in fact consists of various sections of the biblical narrative condensed into one scene. Despite the relative unity in the seven examples of the three Hebrews scene, there is also a wide divergence in the part of the episode that is represented, ranging from the moment when the Hebrews are thrown into the fire, which is conveyed through their frightened and huddled pose (Arboe [Fig. 3a], Kells [Fig. 5], Monasterboice [Fig. 7]), to the verse where they stand and sing passively in the midst of the fire (Armagh [Fig. 3b], Galloon [Fig. 3f], Moone [Fig. 4], Seirkieran), to their persecution by the soldiers, at which stage the angel should not be present. Such minor differences were not accidental but need to be viewed in relation to the perceptions of the ninth-century viewer, whose spiritual and artistic understanding would have enabled him to realize their significance.

Unlike the considerable number of other depictions on the high crosses whose origins can be traced back to a Carolingian source, the scene of the three Hebrews does not appear in the larger and most influential fresco cycles, ivories, or mosaics that share a common iconography with the crosses and which are believed to have given impetus to the crosses' programmes.[51] While it does not appear in these larger cycles, this scene is found in Carolingian art, mainly in manuscripts and painting. Fourth- and early fifth-century sarcophagi with scenes such as Noah in the Ark, Daniel in the Lions' Den, and Adam and Eve combined with the Three Hebrews in the Fiery Furnace also provide programmes which are closely paralleled on the Irish monuments.[52] While the ultimate origins of this scene may lie in fourth- or fifth-century Italy, it developed over time and changed significantly in the later period, and nowhere more clearly than in Ireland. The infrequent occurrence of this theme from the end of the fifth to the end of the eighth century and its reappearance in ninth-century Ireland are unusual. There are fewer than eight recorded representations dating to the seventh and eighth centuries in all of mainland Europe compared to the seven from the ninth century in Ireland alone.[53] It was a motif that was adopted by the Irish on a scale that was unparalleled for the previous two centuries.

It is clear that the Irish representations carry on the tradition from the fourth and fifth centuries but also significantly change it, possibly to resolve whatever ambiguity or difficulties there may have been in the earlier period in the meaning of the fourth figure. The dominant presence and pose of the angel in every ninth-century example and its important role in the scene indicate that it had now assumed considerable significance, in many ways shifting the focus from the three small figures to the protection of the angel's wings. What was this new role, and how was the angel viewed in ninth-century Ireland? Even though the angel is always included in sixth- and seventh-century examples of this scene from outside of Ireland, it is clear that its significance was not fully exploited on a visual level until it appeared in an Insular context.[54] The Three Hebrews in the Fiery Furnace is not found in Insular art outside of Ireland, but one example of the angel's wings in a similar pose is found in Scotland.[55]

The Christ-Angel Theme

As has been shown above, there seems to have been a certain confusion or difficulty in establishing the role or identity of the fourth figure which first appears in this scene in fourth-century Italy. Whereas the preface to the Canticle of the Three Hebrews in the Fiery Furnace records that it was "the angel of the Lord" (Dan. 3:49) that came down into the furnace to help the Hebrews, Nebuchadnezzar says "Behold I see four men loose, and walking in the midst of the fire, and there is no hurt in them, and the form of the fourth is like the Son of God" (Dan. 3:92). With these contradictory statements, it is not surprising that artistic difficulties arose as to how the figure should be represented.

More often than not, the fourth figure was simply excluded from the scene in the fourth and fifth centuries, and where he does appear he is most commonly represented as a wingless, toga-clad male who stands in the midst of the furnace with the three figures. The group of third- to fourth-century lamps, on the other hand, shows him with wings and sometimes nimbed. If this fourth figure was intended to depict the Son of God it would not be unusual for the artist to depict him in the role and robes of the Roman emperor, but the presence of a parallel tradition of showing the angel with wings indicates that there was confusion as to who should be represented. Angels without wings are not common in this early period.

The nature of this fourth character is also a problematic point in the writing of the biblical commentators. Cyprian believes that it was Christ who was with the Hebrews, but Jerome relates that it was an angel, and then adds as a postscript that this angel foreshadowed Christ.[56] The critical period which could not satisfactorily identify the true nature of this fourth figure was the fourth to early fifth centuries. By the start of the fifth century it is clearly an angel, with wings and nimbus, which is included in the scene. He usually stands by the side of the figures and points with his rod towards the fire in an attempt to drive it from the furnace. By the ninth century, however, the whole issue of the nature of the angel and his relationship with the Son of God has once again come to the fore and receives a new treatment at the hands of the Insular artist, possibly in an attempt to merge the two perspectives of the angel.

In the ninth-century Irish examples, the eye is drawn immediately to the protective power of the angel and his enveloping, cloak-like wings. Such a role was never given to the angel in Daniel (Canticle of the Three Hebrews in the Fiery Furnace 3:49), where his function was to drive the flames from the furnace, as he does with his rod in sixth- and seventh-century depictions. The

later protective stance does not illustrate such an active role. Instead of driving the flames away, the angel has now assumed the role of *Salvator Mundi*—the angel has become the Son of God. The belief that the Saviour assumed the role of a servant or angel, especially to aid or assist the needy, is found in a number of Irish liturgical sources of this period. Irish litanies, for example, state "By thy coming humbly from heavenly places in the form of a *servant* to help it and rescue it from the dominance of the devil."[57] That it is Jesus who is now represented is also reinforced by the visual play on his wings as those of the *Coimed na Cristaide*, a litany which is directed to the Saviour. In shifting the emphasis away from the faith of the figures and the power of the righteous over the false adoration, there has been a redirection of the role of Jesus, as represented by the angel.

In a recent study, Ó Carragáin[58] has shown how liturgical texts support the belief that Christ was identified as the "angel" or "messenger" of God the Father, and that this was reinforced at every mass. One such prayer, the "Supplices te rogamus omnipotens Deus,"[59] which was a consecratory epiclesis of the Roman Canon, would have informed the church membership of the dual nature of the angel. The three Hebrews panels would have been understood not only as a representation of the power of faith in salvation, but also as a depiction of Jesus in his role of saving and protecting those who believed. In this role he was believed to have come to rescue those who were in need. Angels were not viewed simply as messengers of God, but also as embodiments of his being or of certain aspects of his character related to the tasks they undertook.[60]

There has been extensive research on the biblical, liturgical, and literary aspects of the Christ-Angel theme recently, but as yet no interdisciplinary approach has encompassed the visual evidence.[61] The Devil is found in medieval art as an angel, a disguise which he assumes in the scene with Nicholas of Myra. In much the same way Christ also assumes the guise of an angel in the scene of the Three Children in the Fiery Furnace. It is, however, the coming of the Lord in his role as saviour that is shown on these crosses, which is a fitting start to a Christian iconographic programme. The angel in these scenes has now become, to use a term originally created by Emile Mâle, a type of Christ. In much the same way that Isaac, in his role of the sacrificed, came to parallel the sacrifice of Christ on the cross, the angel has also come to represent another type of Christ.[62]

These Irish representations are not unique in their use of this multiple meaning. The equation of Christ with an angel is also found in the Eastern church from the ninth century onwards.[63] There is little difficulty in recognizing the usually seated figure of Christ in these Eastern depictions as an angel: he is nearly always enclosed within a mandorla and has fully developed wings. The figure of the angel in Ireland often assumes multiple meanings, and this has been noted as one of the hallmarks of the early Irish scholarly and artistic tradition.[64] The impetus behind the visual reinterpretation of this scene must surely lie in the biblical and liturgical studies which were characteristic of the Church in ninth-century Ireland.[65]

Literary Evidence

Scholars have stressed the unique nature of the surviving Irish texts, and it is therefore not surprising to find a unique rendition of this scene which redefines the contradictory nature of the angel and the Son of God. Irish scholars of this period were particularly conscious of the symbolism of numbers and in particular the significance of the number three, which has its roots in the

three persons of the Holy Trinity. With its focus on the triad, which is also found in themes such as the three Magi, the subject was one which lent itself ideally to the native Irish approach to biblical study.[66] In the late eighth century, Irish biblical commentators were dealing with texts that had long since been discarded by the rest of Europe.[67] It is no accident that the visual redefinition of the three Hebrews scene also took place at the same time.

A number of other liturgical texts attest the popularity of this episode in ninth-century Ireland, and all of them focus on salvation as the primary meaning of the biblical narrative. The three Hebrews in the Fiery Furnace can be seen as representing a text dealing with salvation since they are included in two prayers written in Ireland in the late eighth and early ninth centuries which are very close to the *Commendatio Animae* of the Roman Breviary.[68] These include an appeal to God in verse form which asks for salvation and includes the parallel of the three Hebrews: "Save me as Thou didst save the Three Children *de camino ignis*." Reference to the three Hebrews is also found in the *Liber Hymnorum* (Dublin, T.C.L., Ms. E.4.2), a collection of hymns and prayers used for worship in the Early Christian Irish church. Interestingly, in this collection the *Benedicite*, or Song of the Three Hebrews, follows the Hymn of The Three Kings (no. 42).[69] The full text of the Canticle follows the preface, and it records the prayer for the three Hebrews: "Benedicite Annanais et Azarias Misael domini dominum ymnum dicamus et superexaltemus eum in secula" (*Benedicite* 33).

Another Irish petition for the Help of God which survives in manuscript form invokes the three Hebrews in the *Sean De* hymn, which is also included in the *Liber Hymnorum*.[70] This hymn, written in a combination of Latin and Irish, shares part of its structure with the *Commendatio Animae* in that it includes the petitions for help which are also extended to Irish saints such as Patrick and Colum Cille. The fame of the three Hebrews is also recorded in the *Commendatio Animae* itself, which is found at the end of the *Felire* of Oengus.[71] The emphasis here is on the actual victory of the three figures: their delivery from the furnace. The protective and active stance of the angel in the high cross panels emphasizes this aspect, in contrast with the passive pose of the angels in the Late Antique representations.

CONCLUSIONS

In ninth-century Ireland the composition of the Three Hebrews in the Fiery Furnace changed drastically. Numerous aspects such as the repositioning of the figures, the conscious reduction in the size of the Hebrews, the abandonment of the orans pose, the inclusion of ancillary figures such as the soldiers (who had been abandoned on mainland Europe since the late fourth century), the conflation of the whole narrative into one panel, and above all the focus on the angel as protector and the visual merging of that character with the Son of God, indicate that this change was not accidental. The intrinsic suitability of this scene, with its multiple levels of meaning, as a symbol of salvation was clearly close to the heart of the Church in ninth-century Ireland, where its theological significance received its first visual rendering. These seven examples may have provided a model for later depictions of the scene outside of Ireland which follow the pattern of these Insular originals.[72] Whatever the origins of this scene, it was at the hands of Insular artists that the difficulties and theological problems which first manifested themselves in fourth-century Italy were finally resolved.

ACKNOWLEDGMENTS

Thanks must go to Peter Harbison, Royal Irish Academy; Dorothy Verkerk, University of North Carolina at Chapel Hill; Kees Veelenturf, University of Nijmegen; Jane Hawkes, University College, Cork; and Éamon Ó Carragáin, University College, Cork, for generously giving of their time and knowledge in helping with this article.

NOTES

1. Dorothy Verkerk in this volumne, p. 10.

2. R. Flower, "Irish High Crosses," *JWCI* 17 (1954), 87–97; F. Henry, *Irish Art During the Viking Invasions, 800–1170 A.D.* (London, 1967); R. Stalley, "European Art and the Irish High Cross," *PRIA* 90 (1990), 135–58; P. Harbison, *The High Crosses of Ireland: An Iconographical and Photographic Survey* (Bonn, 1992), vol. 1, 310–30.

3. Harbison, *High Crosses* (as in note 2).

4. Harbison, *High Crosses* (as in note 2), vol. 1, 186–310.

5. K. Veelenturf, *Dia Brátha: Eschatological Theophanies and Irish High Crosses* (Amsterdam, 1997).

6. Publications which have dealt with the subject include H. Swarzenski, "The Song of the Three Worthies," *Bulletin of the Museum of Fine Arts, Boston* 58 (1958), 30–49; M. Velimirović, "Liturgical Drama in Byzantium and Russia," *DOP* 16 (1962), 349–85; C. Carletti, "Sull'iconografia dei tre giovani ebrei di Babilonia di fronte a Nabuchodonosor," in *Atti del III Congresso Nazionale di Archeologia Cristiana* (Trieste, 1974), 17–30; A. Wrześniowski, "The Image of Nebuchadnezzar in Early Christian Iconography," *Archeologia Polona* 14 (1973), 391–94; C. Carletti, *I tre giovani ebrei di Babilonia nell'arte cristiana antica* (Brescia, 1975); M. Panayotidi, "Un reliquaire paléochrétien récemment découvert près de Thessalonique," *CahArch* 24 (1975), 33–48; M. Rassart-Debergh, "Les trois Hébreux dans la fournaise dans l'art paléochrétien: Iconographie," *Byzantion: Revue Internationale des Etudes Byzantines* 48 (1978), 430–55; C. Carletti, "Un nuovo frammento di sarcofago dal cimitero di Bassilla ad Sanctum Hermetem," *Vetera Christianorum* 16 (1979), 195–202; P. van Moorsel, "Le sarcophage de Marcia Romania Celsa: Un nouveau sujet de divergence d'interprétation?" in *Pietas: Festschrift für Bernhard Kötting* (Münster, 1980), 499–508; V. Alborino, *Die Silberkästchen von San Nazaro in Mailand* (Bonn, 1981); G. Binazzi, "Frammento scultoreo cristiano della Pinacoteca Communale di Assisi," *Rivista di archeologia cristiana* 58 (1982), 131–35; H. R. Seeliger, "Πάλαι Μάρτυρες: Die drei Jünglinge im Feuerofen als Typos in der spätantiken Kunst, Liturgie und patristischen Literatur, mit Einigen Hinweisen zur Hermeneutik der christlichen Archäologie," in *Liturgie und Dichtung: Ein Interdisziplinäres Kompendium*, vol. 2, *Interdisziplinäre Reflexion* (Pietas Liturgica 2), ed. H. Becker and R. Kaczynski (Sankt Ottilien, 1983), 257–334; K. M. Irwin, "The Liturgical and Theological Correlations in the Associations of Representations of the Three Hebrews and the Magi in the Christian Art of Late Antiquity" (Ph.D. diss., Graduate Theological Union, 1985); and A. Walton, "The Three Hebrew Children in the Fiery Furnace: A Study in Christian Iconography," in *The Medieval Mediterranean: Cross-Cultural Contacts*, ed. M. J. Chiat and K. L. Reyerson (St. Cloud, Minn., 1988), 57–66.

7. Illustrated in F. Cabrol, *Dictionnaire d'archéologie chrétienne et de liturgie*, vol. 3, pt. 2 (Paris, 1914), col. 2731, fig. 3259; C. R. Morey, *Early Christian Art: An Outline of the Evolution of Style and Iconography in Sculpture and Painting from Antiquity to the Eighth Century* (Princeton, 1942), 98, 129, 263, fig. 96; R. Garrucci, *Storia della arte cristiana nei primi otto secoli della chiesa*, vol. 6, *Sculture non cimiteriali* (Prato, 1880), 475. Similar lamps, dating from about the mid-fifth to the mid-sixth century, are in the British Museum, London (D. M. Bailey, *A Catalogue of Lamps in the British Museum*, vol. 3, *Roman Provincial Lamps* [London, 1988], 34–35, 197–98, pl. 23, nos. Q 1795–Q 1797), the Musée Archéologique, Carthage, and the Bardo Museum, Tunis (A. Ennabli, *Lampes chrétiennes de Tunisie* [Paris, 1976], 43–44, nos. 17–26, pl. 1).

8. Cubiculum A, right wall, arcosolium, and cubiculum O, back wall, arcosolium: A. Ferrua, *Pitture della nuova catacomba* (Vatican City, 1960), 41, pls. VI.2, VIII, XIII.1, 2, XIV, LXXXIX.1; A. Ferrua, *The Unknown Catacomb: A Unique Discovery of Early Christian Art* (New Lanark, 1991), 71–72, 151–52, figs. 41, 44.

9. Cubiculum 7, right wall: J. Wilpert, *Roma sotteranea: Le pitture delle catacombe romane* (Rome, 1903), pl. 78:1.

10. Cubiculum III, back wall, arcosolium: R. Garrucci, *Storia della arte nei primi otto secoli della chiesa*, vol. 2, *Pitture cimiteriali* (Prato, 1873), pl. 64:2 (Ostrianum); Wilpert, *Roma sotteranea* (as in note 9), pl. 300.

11. Garrucci, *Storia della arte*, vol. 2 (as in note 10), pl. 68:1; Wilpert, *Roma sotteranea* (as in note 9), pls. 62:1, 332:16 (Vigna Massimi).

12. A comprehensive catalogue of all known representations is included in previous publications on this motif cited in note 6 above.

13. Examples in which the two motifs are found include the Catacomb of Domitilla, cubiculum with the Magi, right wall (Wilpert, *Roma sotteranea* [as in note 9], pl. 231:1); the sarcophagus of Agricus in the Rheinisches

Landesmuseum, Trier (F. Gerke, *Der Trierer Agricus-Sarkophag* [Trier, 1949], pl. 1); a sarcophagus in the Museo Laterano, Rome, inv. 152 (J. Wilpert, *I sarcofagi cristiani antichi*, vol. 2 [Rome, 1932], pl. CXC:1, 2; F. Deichmann, *Repertorium der christlich-antiken Sarkophage*, vol. 1, *Rom und Ostia* [Wiesbaden, 1967], no. 52, pl. 17); and a sarcophagus in the Museo Laterano, Rome, inv. 161 (Wilpert, *Sarcofagi*, pl. CCVI:4; Deichmann, *Repertorium*, no. 6, pl. 2:6,2, 6,3).

14. G. Schiller, *The Iconography of Christian Art* (London, 1972), 97.

15. Irwin, "Liturgical and Theological Correlations" (as in note 6).

16. A particularly fine example is the sarcophagus of Plotius Tertius in the Museo Laterano, Rome, inv. 99 (Wilpert, *Sarcofagi* [as in note 13], pl. CLXX:4; Deichmann, *Repertorium* [as in note 13], no. 130, pl. 31), where the three Hebrews are found to the right of the portrait bust of the deceased, who points at and looks towards them.

17. Examples in which the soldiers are shown include the sarcophagus of Plotius Tertius, Museo Laterano, Rome (as in note 16); sarcophagus, Museo Laterano, Rome, inv. 182 (Wilpert, *Sarcofagi* [as in note 13], pl. CLXXIV:10; Deichmann, *Repertorium* [as in note 13], no. 143, pl. 33); a sarcophagus cover in the Museo Nazionale delle Terme, Rome, inv. 6708 (Wilpert, *Sarcofagi*, pl. CLXX:2; Deichmann, *Repertorium*, no. 801, pl. 128); a sarcophagus cover in the Musée du Louvre, Paris (Wilpert, *Sarcofagi*, pl. CCII:4; F. Baratte and C. Metzger, *Catalogue des sarcophages en pierre d'époque romaine et paléochrétienne* [Paris, 1985], no. 213); and a sarcophagus in the Museo Laterano, Rome, inv. 134 (Wilpert, *Sarcofagi*, pl. CLXXV:6; Deichmann, *Repertorium*, no. 121, pl. 30). Examples in which Nebuchadnezzar is shown include a sarcophagus in the Cemetery of Marcus and Marcellianus, Rome (Wilpert, *Sarcofagi*, pl. CXXIX:2; Deichmann, *Repertorium*, no. 625, pl. 94); a sarcophagus in the Museo Laterano, Rome, inv. 152 (Wilpert, *Sarcofagi* pl. CLXXX:2; Deichmann, *Repertorium*, no. 52, pl. 17); the sarcophagus of Atronius Fidelicus, Catacomb of Novatianus (Wilpert, *Sarcofagi*, pl. CLXXVIII:2; Deichmann, *Repertorium*, no. 664, pl. 101); and a sarcophagus cover in the Museo Capitolino, Rome (Wilpert, *Sarcofagi*, pl. CLXXXI:3; Deichmann, *Repertorium*, no. 834, pl. 134).

18. Irwin, "Liturgical and Theological Correlations" (as in note 6), 79.

19. Examples include the paintings in the hypogeum at Santa Maria in Stelle, north chamber, west wall, dated to the fifth–sixth centuries (W. Dorigo, "Ipogeo di Santa Maria in Stelle," *Saggi e memorie di storia dell'arte* 6 [1968], 17, fig. 10; D. Dalla Barba Brusin, "Un probabile 'aedes catechizandorum' nell'ipogeo di Santa Maria in Stelle in Val Pantena," *Aquileia Nostra* 48 [1977], 258–72) and at the Monastery of Jeremias at Saqqara, Cell F, east wall, niche (J. Quibell, *Excavations at Saqqara*,

vol. 2 [Cairo, 1906–7], pl. LVII:1); an ivory plaque in a book cover in the Museo Nazionale, Ravenna, inv. 1002 (Morey, *Early Christian Art* [as in note 7], fig. 93; *Avori bizantini e medievali nel Museo Nazionale di Ravenna* [Ravenna, 1990], 62–65, cat. no. 5, pl. 2); and an icon at the Monastery of Saint Catherine at Mount Sinai (K. Weitzmann, *The Monastery of Saint Catherine at Mount Sinai: The Icons*, vol. 1, *From the Sixth to the Tenth Century* [Princeton, 1976], cat. B.31, p. 6, pl. XXII; G. Galavaris, "Early Icons from the Sixth to the Eleventh Century," in *Treasures of the Monastery of Saint Catherine, Sinai* [Athens, 1990], 95, fig. 8).

20. As a general rule each of the Hebrews stands over an opening in the furnace; however, in a number of instances where a fourth figure is included the sculptor had started to carve a fourth opening and decided to remove or rework this feature. An example is a sarcophagus cover in the Museo Capitolino, Rome, inv. 67 (Wilpert, *Sarcofagi* [as in note 13], pl. CLXXXI:3; Deichmann, *Repertorium* [as in note 13], no. 834, pl. 134). For the view that the inclusion or omission of the angel was a narrative device, see Walton, "Three Hebrew Children" (as in note 6).

21. Examples of this fourth figure in the actual furnace include a sarcophagus cover in the Museo Capitolino, Rome (Wilpert, *Sarcofagi* [as in note 13], pl. CLXXXI:3; Deichmann, *Repertorium* [as in note 13] no. 834, pl. 134), and the sarcophagus of Atronius Fidelicus, Catacomb of Novatianus (Wilpert, *Sarcofagi*, pl. CLXXVIII:2; Deichmann, *Repertorium*, no. 664, pl. 101). More often than not, the same toga-clad figure is shown standing to the side and clearly not in the furnace, as on a sarcophagus (inv. 152), in the Museo Laterano, Rome (Wilpert, *Sarcofagi*, pl. CLXXX:2; Deichmann, *Repertorium*, no. 52, pl. 17), the cover of the sarcophagus of Plotius Tertius in the Museo Laterano, Rome, inv. 99 (Wilpert, *Sarcofagi*, pl. CLXX:4; Deichmann, *Repertorium*, no. 130, pl. 31), and the sarcophagus in the Museo Laterano, Rome, inv. 182 (Wilpert, *Sarcofagi*, pl. CLXXIV:10; Deichmann, *Repertorium*, no. 143, pl. 33).

22. Wings have traditionally been used to distinguish the angel from the man, but from the Early Christian period onwards the wingless angel is also found, for example, in the Via Latina catacomb painting of Abraham entertaining the three angels under the oak of Mamre (A. Grabar, *Early Christian Art* [New York, 1968], 231, pl. 254). From the fourth to the tenth century, however, this subject is rarely represented, with fewer than two dozen examples recorded in the Index of Christian Art, and these date predominantly to the fourth and ninth centuries. The angel in art has been studied by C. Clement, *Angels in Art* (Boston, 1898); T. Ward, *Men and Angels* (New York, 1969), 80–140; H.-G. Held, *Engel: Geschichte eines Bildmotivs* (Cologne, 1995); and Y. Cattin, *Les anges et leur image au moyen age* (Saint-Léger-Vauban, 1999).

23. Illustrated in T. Mathews, *The Clash of the Gods: A*

Reinterpretation of Early Christian Art, rev. ed. (Princeton, 1999), fig. 37.

24. Some of the disagreement about whether the fourth figure in the furnace is the angel or the Son of God is discussed in the recent study by D. Keck, *Angels and Angelology in the Middle Ages* (New York, 1998), 35–36, which also provides an extensive bibliography of both original and secondary sources. Keck (pers. comm.) has also noted that in the fourth century, precisely the time when these monuments were created, the Arians held the strong belief that Jesus was a messenger, and as such could be represented as an angel.

25. Examples include a pyxis in the Hermitage Museum, St. Petersburg, which dates to the sixth century (H. Woodruff, "Iconography and Date of the Mosaics of La Daurade," *ArtB* 13 [1931], 80–104; J. Engemann, "Eine spätantike Messingkanne," in *Vivarium: Festschrift Theodor Klauser zum 90. Geburtstag* [Münster, 1984], 115–31), and the panel at Mount Sinai (cited in note 19 above), which dates to the seventh century.

26. Irwin, "Liturgical and Theological Correlations" (as in note 6), 87–98.

27. A. Hamlin, "Crosses in Early Ireland: The Evidence from Written Sources," in *Ireland and Insular Art, A.D. 500–1200*, ed. M. Ryan (Dublin, 1987), 138–40; Stalley, "European Art" (as in note 2); Harbison, *High Crosses* (as in note 2); E. Rynne, "Ireland's Earliest 'Celtic' High Crosses: The Ossory and Related Crosses," in *Early Medieval Munster: Archaeology, History, and Society*, ed. M. A. Monk and J. Sheehan (Cork, 1998), 125–37.

28. P. O'Dwyer, *Céli Dé* (Dublin, 1977).

29. See O'Dwyer, *Céli Dé* (as in note 28), and M. Richter, *Medieval Ireland: The Enduring Tradition* (New York, 1983), 100–4.

30. Harbison, *High Crosses* (as in note 2), vol. 1, cat. no. 29, E3.

31. Harbison, *High Crosses* (as in note 2), vol. 1, cat. no. 81, W2.

32. M. Herity, "The Context and Date of the High Cross at Disert Diarmada (Castledermot), Co. Kildare," in *Figures from the Past: Studies on Figurative Art in Christian Ireland in Honour of Helen M. Roe*, ed. E. Rynne (Dun Laoghaire, 1987), 111–30.

33. W. Hawkes, "The High Crosses of Castledermot," *Repertorium Novum: Dublin Diocesan Historical Record*, vol. 1, no. 2 (1956), 237–62.

34. J. Streit, *Sun and Cross: The Development from Megalithic Culture to Early Christianity in Ireland* (Edinburgh, 1984), 146.

35. H. Roe, "The Orans in Irish Christian Art," *JRSAI* 100 (1970), 212–21; Harbison, *High Crosses* (as in note 2), vol. 1, 41, 44, 132, 219.

36. For example, Paris, B.N.F., Ms. gr. 510, f. 435v (L. Brubaker, *Vision and Meaning in Ninth-Century Byzantium: Image as Exegesis in the Homilies of Gregory of Nazianzus* [Cambridge, 1999], 369–70, fig. 43; for a general

study of this manuscript, see L. Brubaker, "Miniatures and Liturgy: Evidence from the Ninth-Century Codex Paris, Gr. 510," *Byzantion* 66 [1996], 9–34); Moscow, Historical Museum, Ms. gr. 129, Khludov Psalter, f. 160v (M. Shchepkina, *Miniatiury Khludovskoi Psaltyri: Grecheskii Illustrirovannyi Kodeks IX Veka* [Moscow, 1977]).

37. Minor variations are found in the Corbie Psalter, Amiens, Bibliothèque Municipale, Ms. 18, f. 134v (Fig. 9), where their hands are joined in prayer in front of their chests; on the scriptorium at Corbie, see D. Ganz, *Corbie in the Carolingian Renaissance* (Sigmaringen, 1990). Another variation, in which their hands are not shown at all, is found in the Utrecht Psalter, Bibliothek der Universiteit, Ms. 484, f. 87v (E. T. Dewald, *The Illustrations of the Utrecht Psalter* [Princeton, 1932], 69, pl. 137); on the Utrecht Psalter in general, see K. Van der Horst, W. Noel, and W. Wüstefeld, *The Utrecht Psalter in Medieval Art: Picturing the Psalms of David* (Utrecht, 1996).

38. W. R. F. Browning, *A Dictionary of the Bible* (Oxford, 1996), 142, s.v. "furnace."

39. Amiens, Bibliothèque Municipale, Ms. 18, f. 134v; Utrecht, Bibliothek der Universiteit, Ms. 484, Utrecht Psalter, f. 87v. See note 37 above.

40. L. Flanagan, *A Dictionary of Irish Archaeology* (Dublin, 1992), 132–33, s.v. "kiln."

41. Brubaker, *Vision and Meaning* (as in note 36), fig. 158.

42. H. Roe, *The High Crosses of Kells* (Meath, 1966), 2nd ed., 13.

43. On the protecting Virgin, see C. Belting-Ihm, *"Sub Matris Tutela": Untersuchungen zur Vorgeschichte der Schutzmantelmadonna* (Heidelberg, 1976).

44. Harbison, *High Crosses* (as in note 2), vol. 1, 15–18, 20–22, 29, 31–34, 37, 39–40, 46, 49–52, 55, 62–67, 69, 71, 73–74, 77–79, 91–93, 96–97, 102, 105–6, 109, 111–12, 114, 122, 124, 141–49, 153, 155, 157, 159, 165–66, 170–72, 182–83, 189, 199–200, 206, 214, 221, 226, 229, 231, 236, 239, 241, 243–44, 251, 274–75, 278, 286–91, 293, 296–302, 330, 337–38, 340, 352, 369, 373.

45. *Irish Litanies: Text and Translation* (Henry Bradshaw Society, vol. 62), ed. C. Plummer (London, 1925), 83.

46. P. Dinneen, *Foclóir Gaedilge agus Béarla: An Irish-English Dictionary, Being a Thesaurus of the Words, Phrases, and Idioms of the Modern Irish Language* (Dublin, 1927), 221.

47. Flower, "Irish High Crosses" (as in note 2), 87–97.

48. É. Ó Carragáin, "The Meeting of Saint Paul and Saint Anthony: Visual and Literary Uses of a Eucharistic Motif," in *Keimelia: Studies in Medieval Archaeology and History in Memory of Tom Delaney*, ed. G. Mac Niocaill and P. Wallace (Galway, 1988), 1–59.

49. Veelenturf, *Dia Brátha* (as in note 5).

50. Ó Carragáin, "Meeting of Saint Paul and Saint Anthony" (as in note 48), 2.

51. Harbison, *High Crosses* (as in note 2), vol. 1, 388–89.

52. For example, the sarcophagus cover in the Museo Capitolino, Rome (Wilpert, *Sarcofagi* [as in note 13], pl. CLXXXI:3; Deichmann, *Repertorium* [as in note 13], no. 834, pl. 134).

53. As documented in the files of the Index of Christian Art.

54. In addition to the examples previously referred to in this article, there are a number of other representations dating from the sixth and seventh centuries which include the angel, who is always seen to the side of the three Hebrews. These include a painting from Wadi Sarga, Egypt, now in the British Museum (A. Rubens, *A History of British Costume* [London, 1967], 22); an icon panel painting at St. Catherine's Monastery, Mount Sinai (H. Gerhard, *The World of Icons* [New York, 1971], 15); and an ivory in the Museo Nazionale, Ravenna (Morey, *Early Christian Art* [as in note 7], fig. 93; *Avori bizantini* [as in note 19]).

55. The complete absence of the scene from related crosses and cross-slabs in England, Scotland, and Wales is unusual. Although two examples of the Three Hebrews in the Fiery Furnace had been recorded at Aycliffe Church, Co. Durham (A. Gardner, *A Handbook of English Medieval Sculpture* [Cambridge, 1935], 35), and Iona (Iona, no. 1, St. Martin's Cross: J. R. Allen and J. Anderson, *The Early Christian Monuments of Scotland*, vol. 2, pt. 3 [Edinburgh, 1903], 382), these have now been reinterpreted. Even though there are no Anglo-Saxon examples, one related carving is found in the Abbey Museum, Iona (*Royal Commission on the Ancient and Historical Monuments and Constructions of Scotland; Argyll, An Inventory of Ancient Monuments*, vol. 4 [Edinburgh, 1982], 211). This carving was found at Reilig Odhrain in 1972 and is part of the shaft of a free-standing cross. Although now worn, it shows two figures depicted frontally under what may be the outstretched wings of an angel. Although no precedents exist for there being two Hebrews instead of three, the pose of the angel is significant.

56. *Saint Cyprian: Treatises* (Fathers of the Church 36) (New York, 1958), 108; G. Archer, *Jerome's Commentary on Daniel* (Grand Rapids, Mich., 1958), 40–44.

57. *Irish Litanies*, ed. Plummer (as in note 45), 21.

58. É. Ó Carragáin, "Rome, Ruthwell, Vercelli: 'The Dream of the Rood' and the Italian Connection," in *Vercelli tra Oriente ed Occidente tra tarda antichità e medioevo: Atti delle giornate di studio*, ed. V. Dolcetti Corazza (Alessandria, 1998), 85–86.

59. "Supplices te rogamus omnipotens Deus, iube haec perferri per manus angeli tui in sublime altare tuum, in conspectu divinae maiestatis tuae, ut quot-quot ex hac altaris participatione sarcosanctum filii tui corpus et sanguinem sumpserimus omni benedictione caelesti et gratia repleamur. Per christum dominum nostrum." (We humbly beseech you, almighty God, command these [offerings] to be brought by the hands of your angel into your altar on high, into the sight of your divine majesty, so that each time we receive the most sacred body and blood of your son through participation in this altar we may be filled with every heavenly blessing and grace. Through Christ our Lord): J. Deshusses, *Le Sacramentaire grégorien: Ses principales formes d'après les plus anciens manuscrits*, vol. 1, *Le Sacramentaire, le supplément d'Aniane* (Fribourg, 1971), 1:90. A. Jungmann, *The Mass of the Roman Rite: Its Origins and Development (Missarum Solemnia)*, vol. 2 (New York, 1955), 233–34, believes that this prayer should be interpreted, not as Christ represented as the angel (*magnii consilii angelus*), but as Christ being brought as an offering to the Holy of Holies in heaven accompanied by one or more angels. His belief that the Christ-Angel equation happens much later in the Middle Ages is not supported by the visual evidence. O. Burmester, "The Epiclesis in the Eastern Church and the Heavenly Altar of the Roman Canon," in *Tome commémoratif du millénaire de la bibliothèque patriarcale d'Alexandrie* (Alexandria, 1953), 277–96, believes that this prayer was originally a consecratory epiclesis of the Holy Spirit used from the end of the fifth century to the seventh century, when it was modified due to the teachings of St. Augustine.

60. W. Helder, "The Engel Drytnes in The Dream of the Rood," *Modern Philology* 73 (1975), 148–50.

61. See note 63 below.

62. E. Mâle, *The Gothic Image: Religious Art in France of the Thirteenth Century* (New York, 1972), 153–58.

63. J. Meyendorff, L'Iconographie de la Sagesse Divine," *CahArch* 10 (1959), 259–77; S. der Nersessian, "Note sur quelque images se rattachant au théme du Christ-Ange," *CahArch* 13 (1962), 209–16. The Christ-Angel theme is also examined from a theoretical perspective by J. Barbel, *Christos Angelos: Die Anschauung von Christus als Bote und Engel in der gelehrten und volkstümlichen Literatur des christlichen Altertums* (Bonn, 1941). A number of recent studies have highlighted the background of this subject in Middle English literature: R. Burlin, *The Old English Advent: A Typological Commentary* (Yale Studies in English 168) (New Haven, 1968); Helder, "Engel Drytnes" (as in note 60); É. Ó Carragáin, "Crucifixion as Annunciation: The Relation of the Dream of the Rood to the Liturgy Reconsidered," *English Studies: A Journal of English Language and Literature* 63 (1982), 487–505.

64. A. Hamlin, "*Dignatio Dei Dominici:* An Element in the Iconography of Irish Crosses?" in *Ireland in Early Mediaeval Europe: Studies in Memory of Kathleen Hughes*, ed. D. Whitelock, R. McKitterick, and D. Dumville (Cambridge, 1982), 74.

65. D. Ó Cróinín, *Early Medieval Ireland, 400–1200* (London, 1995), 205–7.

66. P. Sims-Williams, "Thought, Word and Deed: An Irish Triad," *Ériu* 29 (1978), 78–111.

67. Ó Cróinín, *Early Medieval Ireland* (as in note 65), 206.

68. Flower, "Irish High Crosses" (as in note 2), 91.

69. *The Irish Liber Hymnorum* (Henry Bradshaw Society, vol. 13), ed. J. Bernard and R. Atkinson (London, 1898), 195.

70. *Liber Hymnorum* (as in note 69), 115.

71. *Felire Oenguso Ceil De: The Martyrology of Oengus, the Culdee* (Henry Bradshaw Society, vol. 29), ed. W. Stokes (London, 1905), cciii.

72. Representations in which the angel is centrally positioned above the three Hebrews with his wings spread over their heads and which date to the period after the Insular examples include the illuminations in the following manuscripts: Valladolid, Biblioteca Santa Cruz, Jerome, *In Danielem*, f. 199v, ca. 970; Vatican, Cod. gr. 1613, Menologion of Basil II, p. 251, dated 976–1025, in *Il menologio di Basilio II (Cod. Vaticano Greco 1613)* (Turin, 1907), vol. 2, 251; New York, Morgan Library, Ms. 644, the Morgan Beatus, f. 248v, dated to ca. 940–945 by J. Williams, *The Illustrated Beatus: A Corpus of the Illustrations of the Commentary on the Apocalypse,* vol. 2 (London, 1994), no. 2, 21–33, fig. 107; and a Bible dated to 1162, Léon, church of S. Isidoro, Ms. 3, ff. 151r and 151v.

Irish High Crosses and Continental Art:
Shades of Iconographical Ambiguity

·

KEES VEELENTURF

THE ENGLISH POET and scholar William Empson distinguished seven types of ambiguity in poetry, which he discussed in an influential book on that subject.[1] The following essay is not a comparably systematic survey of ambiguity in iconography, but is merely a brief report on some varieties or shades of this phenomenon that I have encountered in my studies of early Irish art.[2] One of the particular aspects that will be dealt with is the relationship between text and image.

For iconographers studying Christian representations it is often difficult to detach the image from the word. This is understandable, of course, since Christianity is a religion which takes its knowledge and wisdom from a composite written work designated by the plural of the Greek word for "book." These *biblia* have stimulated the transposition of their contents into images, not only as illustrations of texts, but also as derivatives in a wide variety of contexts. But the self-evidence assumed here is not as obvious as it may seem. Firstly, the importance—perhaps even the priority—of the visual may be inferred from the fact that, according to the Book of Genesis, God created man in his own image and likeness.[3] This, of course, is an act full of meaning, which, paradoxically, we know from *Scripture* in the first place. Secondly, iconographers are usually art historians, and art is predominantly concerned with the "languages" of form: line, colour, space, volume, and texture.

The work of art reproduced in Figure 1 was made by the Icelandic-Dutch artist Sigurður Guðmundsson, and the words in its title are part of the work itself. Photograph and words are: *Pavement, Street*. In a poetic and humourous way this photo and text are a statement about the relationship of "language" and visual art.[4] I believe that this work also conveys a message to the student of early medieval iconography, and so it provides a suitable starting point for this paper and neatly summarizes some of the ensuing arguments.

I

Certain depictions of theophanies are among the most notoriously ambiguous themes in Early Christian art and have generated considerable discussion. The Eastern way of depicting the Ascension of Christ, as seen, for example, in the Rabbula Gospels miniature (Fig. 2) and the apse mural of Chapel XVII in the monastery of Apollo(nius) in Bawît, has been analysed more than once.[5] Not every scholar believed that this image shows the "historical" Ascension as narrated in

1. Sigurður Guðmundsson, *Pavement, Street,* 1973, colour photograph, text

Scripture. It has been interpreted as an eschatological theophany of Christ before his church, represented by the Virgin Mary and the apostles, and as the exalted Christ in a supratemporal theophany. The Ascension in the Acts of the Apostles also implies the Second Coming of Christ because of the prophecy made to the apostles by the two men clad in white who were present:

> Ye men of Galilee, why stand you looking up to heaven? This Jesus who is taken up from you into heaven, shall so come as you have seen him going into heaven.[6]

There can be no doubt that Joseph Engemann was correct when he declared that these images represent synchronously the biblical "historical" event of the Ascension, the exalted condition of Christ over his church, as well as the future occasion of the *Secundus Adventus*.[7] Irrespective of whether the multiple meanings of this image were a conscious or subconscious matter from its creation, what we encounter in the Eastern Ascension image should be called *deliberate* or *intentional* ambiguity. This is probably the most common ambiguity found in Early Christian iconography.

In Irish high cross sculpture the same intentional polyvalence is inherent in the morphology of the monuments. The cross itself is most naturally perceived as the cross of the Passion. Iconographically speaking, Christ is crucified *upon* the high crosses themselves, as there is no indication of a Passion cross on the cross-heads on which the Crucifixion is carved.[8] However, as is often stated, implied, or alluded to in both Scripture and theology, the eschatological connotations of the cross shape are expressed simultaneously. At the end of time the sign of the Son of man will appear as the harbinger of the Last Judge. Both aspects of the form of the cross, pertaining to Passion and to Parousia, can be related to the Irish high cross. This is corroborated by the interrelationship of Crucifixion and eschatological theophany on both cross-head faces of a considerable number of high crosses.[9]

A cognate and very real ambiguity in the iconography of the high crosses is the figure of

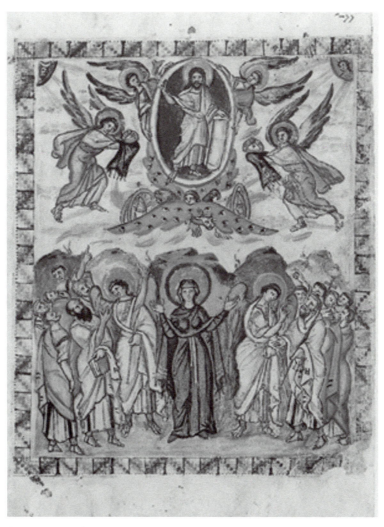

2. Florence, Biblioteca Medicea-Laurenziana, Ms. Plut. I.56, the Rabbula
Gospels from Zagba, Mesopotamia, A.D. 586, f. 13v

Christ in what seems to be an "abridged" Crucifixion scene. This type of representation is some-
times matched on the other face of the cross-head by a figure who must also be the crucified
Christ.[10] Since the double occurrence of the Crucifixion on one monument would be an
anomaly, one of the alleged Crucifixion scenes must have a different meaning. Indeed this figure
should not be regarded as representing the Crucified, but as depicting Christ as he will appear at
the end of time. This cruciate eschatological Christ figure carries a range of connotations, prom-
inent among which are references to the Crucified and the sign of the Son of man. In the early
Middle Ages it was believed that Christ would be seen by the damned in this cruciate pose at the
end of time.[11]

This particular interplay of meanings, which in the examples just mentioned are eschatolog-
ical in nature, can lead to a much more deceptive ambiguity, that of composition. The west face
of the shaft of the Cross of Sts. Patrick and Columba in Kells is not neatly organized into panels
like many other high crosses. Beneath the scene of Christ in an Osiris pose in the centre of the

cross-head is a Crucifixion.[12] Between these two scenes is an eagle, and its position has been questioned by several authors.[13] Does this bird belong to the Crucifixion scene, or is it part of the eschatological representation, which some scholars call a *Maiestas Domini*?[14] The eagle must have been generally understood in the Christian world as a symbol of the Resurrection, and there can hardly be any doubt as to the deliberate reason behind its ambiguous position on this high cross. The eagle functions here as the connective—the hyphen, as it were—between the elements relating to the Passion, on the one hand, and Parousia, on the other.[15]

The Crucifixion, an image that at first sight may seem rather straightforward, is in fact connected with the Christian cross in several ways. On the Irish high crosses the scene has a seemingly narrative aspect because of the figures of Stephaton and Longinus wielding the sponge upon a pole and a lance, respectively. Since the Crucifixion is central to the Christian faith, every present-day onlooker will sense at a glance that this image is not only the representation of an historical event, but that it is also symbolic in that it depicts the sacrifice of Jesus, thus establishing a new phase in God's relationship with mankind. Members of Christian churches that emphasize the ritual renewal of the Last Supper will readily connect the image of the Crucifixion with the Eucharist, and perhaps with the Judgment Day at the same time. Of course central or core elements of the historical scene are needed to recognize its depiction in a more or less compressed guise. For that reason the figure of the crucified Christ is needed, and if he is lacking the viewer needs to see a cross. The figures of Stephaton and Longinus are not indispensable. Why are they there? Are they narrative elements in a symbolic scene or do they have symbolic significance themselves?

Interesting light can be shed on this matter, and also on its methodological implications. Although the acts of Stephaton and Longinus have been rendered as simultaneous events in images, they took place before and after the death of Christ, respectively. René-Jean Hesbert has drawn attention to a gospel manuscript tradition in which the Passion account in the Gospel of Matthew has John 19:34 inserted between Matthew 27:49 and 27:50. Generations of believers must have read or heard a Passion passage in Matthew's account that related:

> And immediately one of them running, took a sponge, and filled it with vinegar; and put it on a reed, and gave him to drink (Matt. 27:48). And the others said: Let be, let us see whether Elias will come to deliver him (Matt. 27:49). But one of the soldiers with a spear opened his side, and immediately there came out blood and water (John 19:34). And Jesus again crying with a loud voice, yielded up the ghost (Matt. 27:50).[16]

The tradition of this interpolated gospel text spans the period from the fourth to the twelfth century, and the Western tradition was especially strong in Ireland.[17] The well-known Crucifixion miniature in the Irish Gospel book at St. Gall (Fig. 3),[18] among others, has been explained using this interpolation.[19] In this miniature, as in many other Irish Crucifixion scenes, we see Christ with open eyes upon the cross, accompanied by Stephaton and Longinus, who perform their deeds. The explanation of Hesbert, who has studied the gospel interpolation and its contexts in detail, seems at first to be well founded and satisfactory.

However, as Aloys Grillmeier has convincingly argued, Hesbert's sensible interpretation does not explain what we really see in this early Crucifixion image. This configuration cannot be "read" like a text, interpolated or not, and it certainly is not a mere illustration of such a text. The ambivalence expressed in the synchronicity of the deeds of Longinus and Stephaton appears to

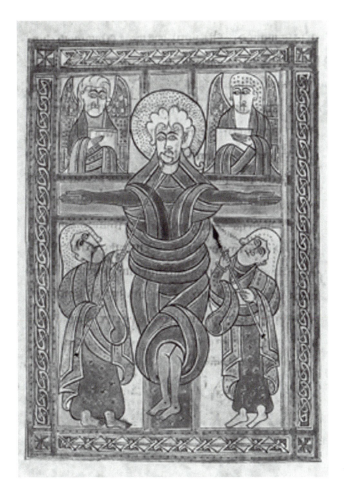

3. St. Gall, Stiftsbibliothek, Ms. 51, Irish Gospel book, A.D. 750–800, p. 266, Crucifixion

have a number of causes. First, we should realize that what we consider to be a mixture of historical representation and symbolism must have been for early medieval Christians a true rendition of reality. The early medieval perception of time, eschatologically and liturgically coloured as it is, must be regarded as being partly responsible for the merging of multiple and disparate events in one image and their projection onto one surface. The theological paradox of the hypostatic union in Christ, the antithetical combination of suffering and victory, the allusion to or representation of a supratemporal condition within a temporal setting—all of these aspects can be distinguished in the early Crucifixion image and contribute to its ambiguous nature.[20] The eternal life of the divine Christ and his humiliation at death as a human are both expressed in the Crucifixion scene through the simultaneous actions of Stephaton and Longinus. What we learn from this example is that we must attempt to discard all modern (pre)conceptions, ideas, and constrictions in order to approach an unprejudiced view of the character of early medieval images. There is no doubt that such a "state of mind" can only be partially attained, but the effort to do so is still necessary before we attempt to connect literary or historical data (like text interpolations in Scripture) with images. This example also shows that images cannot be viewed simply as texts, as meaningful words in a syntactical order, since they have their own ways of conveying meaning.

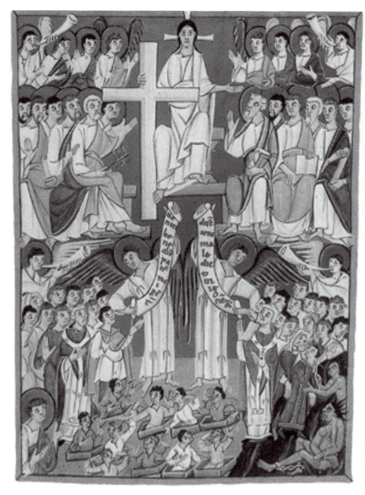

4. Bamberg, Staatsbibliothek, Ms. msc. bibl. 140, Bamberg Apocalypse, A.D. 1001–1002, f. 53r, Last Judgment

The somewhat loose connection between text and image in the early Middle Ages can be demonstrated in a slightly different way by looking at the miniature on folio 53r in the Bamberg Apocalypse (Fig. 4).[21] There can be no doubt that this depicts the Last Judgment, and that John's Revelation offers sufficient material for the imagery of this theme. The text on the banderoles carried by the two angels in the centre of the image is, however, not taken from John's text, but from the Gospel of Matthew.[22] This is not surprising, as cross-references and reciprocal borrowings are very much a part of the Scriptures. At the same time, however, this conflation demonstrates that we should not believe too readily that texts and images always have tightly connected, direct relationships. Even in inscriptions, as in the example in the Bamberg Apocalypse, we may have to make a small detour before the circle can be closed.

If texts *within* images can be problematic, what about texts and images that are not brought together within the same work of art? This can raise problems that are much more tantalizing, as in the medieval iconography of the Antichrist. Descriptions of the appearance of the Antichrist can be found in early apocalyptic literature and have constituted a tradition in *Eastern* Christianity, but visual representations either singly or in narrative cycles appear to have been re-

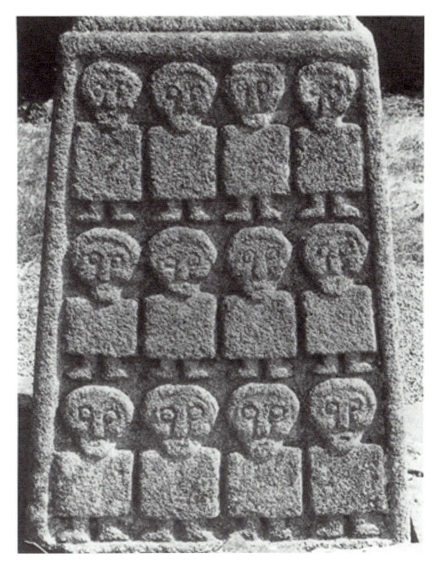

5. The Twelve Apostles, relief on the west face of the base of the high cross of
Moone, County Kildare

stricted to the *Latin* Christian tradition. In his study of this subject, Bernard McGinn concluded
that:

> Not the least of the puzzles . . . is the almost complete independence of the two tradi-
> tions. No physiognomy was ever illustrated as far as I know, and I can detect no real in-
> fluence from the physiognomical descriptions upon Western pictures of the human fig-
> ure of Antichrist. The two traditions are like the proverbial ships passing in the night.[23]

An example from Early Christian Irish art may lead *ad absurdum*, but when the apostle figures on
the base of the high cross at Moone (Fig. 5) are compared to the early medieval Irish texts that
describe the appearance of Christ's disciples, it becomes quite evident how frustratingly divergent

and rudimentary the iconographer's materials sometimes are. To mention just five of Christ's apostles described in such conflicting ways in these early Irish lists, how could we recognize:

> John, with dark (wavy) hair but without any beard. Philip, all red, with a [long] beard. Bartholomew, dark, curly hair with a (short) [long] beard. Thomas (moreover) has dark hair and a (long) [short] beard. Matthew [the evangelist] (with dark, curly hair and a long beard).[24]

II

We can now turn to the relationship between representations—between visual forms—for which no direct connection with texts is at first apparent. It is a commonplace among medievalists that in early medieval art originality was not a criterion for estimating the artistic value or status of a work. The copying of models or exemplars was normal practice.[25] This process of copying was not just a straightforward linear procedure, as we know, for instance, from architecture which did not reproduce its model faithfully, but often copied only its distinguishing elements or most significant symbolic features.[26] Partial or fragmentary copying is not the only problematic issue; the shifting of iconographic meaning is another.

This last phenomenon can be demonstrated by the late medieval image type of "Christ in distress" or "Christ on (the) cold stone," as the Dutch name of this nonbiblical imagery translates.[27] "Christ in distress" shows the seated Christ seemingly waiting while his cross is being prepared. This representation, which is a "summary" image of the last phases of the Passion, was a popular and widespread *Andachtsbild* from the fourteenth to the sixteenth century in north-western Europe. It was very often executed as sculpture in the round. Many years ago Von der Osten showed very plausibly that the scene of Job on the dunghill,[28] who is one of the Old Testament prefigurations of Christ, was subsumed into the devotional image of "Christ in distress." The prototype of the pitiful but patient sufferer has been replaced by its antitype in a development which must have taken place during the fourteenth century, going through iconographic assimilation to reach its final transformation.[29] In some cases only very close observation allows one to distinguish Job from Christ.[30] The ambiguity of this image is created by an iconographical development which was stimulated by a typological connection.

The role of scriptural or theological typology cannot be underestimated, but does present certain problems. Seeliger, for example, in his study of the iconography of the three Hebrews in the fiery furnace in Early Christian art, concluded that (1) iconography, (2) the "imaginal" language of liturgy and devotion, and (3) patristic theology cannot be linked directly. These fields all developed in their own way, introducing digressions and divergences from their common root: the wealth of typologies in Early Christian theology. Connections between iconography and liturgy, for example, did indeed exist because of their shared origin, but they had also become more or less distant relatives thanks to changes introduced by diachronic processes within the various fields themselves.[31]

We come now to another type of ambiguity which is related to the typologically determined shift of meaning, as in the examples of Job on the dunghill and "Christ in distress" discussed above, but is nevertheless different. This ambiguity appears in some highly idiosyncratic images

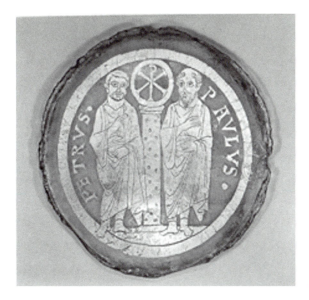

6. Sts. Peter and Paul flanking a column surmounted
with a christogram, bottom of a gold-glass bowl from
Rome, late fourth century. New York, The Metro-
politan Museum of Art, Rogers Fund, 1916 (16.174.3)

on the Irish high crosses that defy identification by the use of formal comparisons.[32] But of course
we cannot abandon the practice of making such comparisons altogether. I suspect that formal
comparanda can even provide us with models that have a completely different iconographic
charge. Just such a model may have been responsible for the transmission of the iconography of
Sts. Paul and Anthony on the Irish high crosses.

The iconography of the two desert fathers is enigmatic in several respects. Firstly, the images,
like so many others on the high crosses, seem to come out of the blue. Secondly, despite the fact
that there are some generally accepted explanations for the inclusion of these Egyptian saints on
the crosses, the use of non-Irish evidence in these arguments remains a problem.[33] There may be
a clue for at least one element in this imagery: the actual disposition of the figures. My discussion
will be limited to the scene in which Paul and Anthony receive bread from a raven. As far as I am
aware, no formal origin has been proposed for this scene.

In looking at the possible origins of this scene it is necessary to follow in the footsteps of
some distinguished historians of Irish art and turn to Rome. It was there, in the late fourth cen-
tury, that a gold-glass bowl now in New York was made (Fig. 6).[34] The standing figures of Peter
and Paul are shown flanking a column on which is placed a christogram within a circle. If we
compare this to the carving on the west face of the cross-shaft of Kilnaruane, near Bantry,[35] a
compositional similarity cannot be denied. If these representations are indeed related, an icon-
ographic shift has taken place: the christogram of the Roman bowl has been transformed into a
raven depositing a loaf of bread. Such a change could have been made either deliberately or
through a misunderstanding of the original model. We do not know, of course, whether the Irish
sculptors had pristine models, or how corrupted the iconographic intermediaries may have been.

There are some minor variants in the Irish iconography of Sts. Paul and Anthony receiving
and sharing bread in the desert. For example, a table or pillar is lacking in the scene on the west
face of the South Cross in Castledermot (Fig. 7), and it is hard to make out whether the saints are
seated or standing.[36] The raven is once again shown depositing a loaf of bread between the two
hermits. This carving also has a parallel in the Roman iconography of Sts. Peter and Paul;

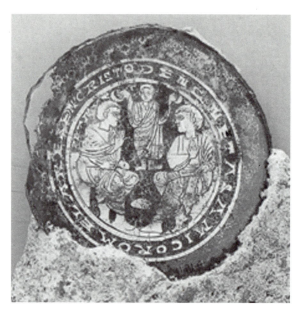

7. Sts. Paul and Anthony on the west face of the shaft of the South Cross at Castledermot, County Kildare

8. Sts. Peter and Paul crowned by Christ, bottom of a Roman gold-glass bowl, fourth century. New York, The Metropolitan Museum of Art, Rogers Fund, 1911 (11.91.4)

another fourth-century gold-glass bowl bottom from Rome has a medallion showing Peter and Paul sitting on benches flanking a relatively small figure of Christ who holds wreaths above the saints' heads (Fig. 8). This composition is frequently found in the iconography of the two saints and has its roots in imperial coin imagery.[37] The formal similarities are obvious; even the contours of the raven and bread correspond roughly to the Christ figure in the centre of the Roman piece, as in the previous example with the shape of the chrismon within a wreath.

A final example is the decoration of the base of a terra-cotta bowl dating to the mid-fourth century and found on the Via Appia (Fig. 9).[38] It consists of a stamped medallion of Sts. Peter and Paul who confront each other in profile and are seated on stools. Between their heads is the chrismon, the monogram of Christ, within a wreath. On the north side of the high cross base at Moone, a rather cumbersome raven hovers above the two Egyptian saints.[39] The similarity of position on the two objects is not matched by similarity of shape here, but there is again some resemblance.

A number of other parallels can be found amongst these Early Christian gold-glass images.[40] It should be noted, however, that not all of them depict Sts. Peter and Paul, and some display other saints (who can be identified by inscriptions) and even married couples.[41] Nevertheless, the frequency of Peter and Paul images on gold-glass is high.

A plausible reason for adopting compositional elements from this apostolic iconography may have been that these images express *concordia*,[42] in particular the *concordia apostolorum*.[43] This unison finds a suitable parallel in that of the desert fathers[44] sharing the bread brought by a raven.[45] The fact that some of the formal variants of this iconography have parallels in the iconography of Sts. Paul and Anthony in Ireland must be regarded as significant. It should not be sug-

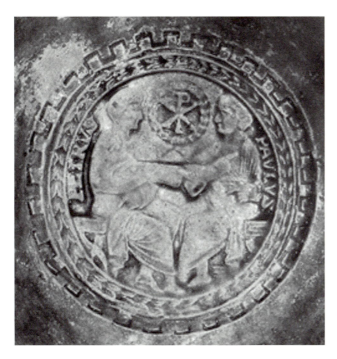

9. Relief of Sts. Peter and Paul on the bottom of a terra-cotta bowl from Rome, fourth century. The Metropolitan Museum of Art, Fletcher Fund, 1952 (52.25.1)

gested that these comparanda from Rome were *the* models for the Irish Paul and Anthony scenes, but it does seem likely that a formal origin for the Irish Paul and Anthony reliefs[46] can be found in early images of Sts. Peter and Paul from the centre of the Christian world.

Iconographic influences from Early Christian Rome also appear in the Irish rendition of the Resurrection of Christ.[47] The Irish sculptors selectively adapted an element of the iconography and not the entire composition. The mummy-like figure of the dead Christ beneath a flat tomb-stone or sarcophagus lid on the bottom panel of the shaft of the Cross of the Scriptures in Clonmacnois is resuscitated by a bird (Fig. 10).[48] The same scene was carved in exactly the same position on the Cross of Durrow,[49] the West Cross in Monasterboice,[50] and the Market Cross in Kells (Fig. 11).[51] The origin of this motif is quite unclear and is not really biblical,[52] but the other figures in the scene, the dozing guards, can be found on a number of Roman sarcophagi. A well-known example is the marble Passion sarcophagus in the Museo Pio Cristiano in the Vatican, which dates to the fourth century.[53] The central relief on one side (Fig. 12) is the symbolic image of the Resurrection of Christ, consisting of a cross topped by a chrismon in a wreath, with a bird on each cross-arm and two resting soldiers at the bottom. It was in this way, rather than in a completely realistic and narrative fashion, that Christians in Late Antique Rome preferred to depict the Resurrection of their saviour.

A number of similar designs can be found on other sarcophagi,[54] for example, on the so-called sarcophagus of Constantine II, also from fourth-century Rome but preserved in Arles.[55] This example now lacks the chrismon. The Market Cross in Kells provides an Irish parallel, with a cross inscribed in a circle, presumably a wreath, on top of a long stem between the two soldiers (Fig. 11).[56] Despite some minor differences, the four Irish scenes are clearly derived from images such as those on the Roman sarcophagi. The combination of symbolic and anecdotal elements

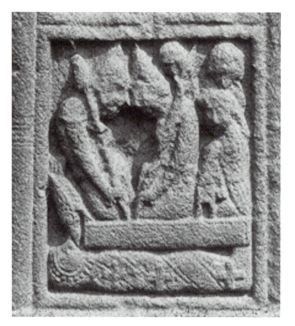

10. The Resurrection, the lowest panel on the west shaft face of the Cross of the Scriptures at Clonmacnois, County Offaly

11. The Resurrection, the lowest panel on the south shaft face of the Market Cross in Kells, County Meath

on the sarcophagi to express the pivotal miracle in Christian history differs from the ambiguity in the Crucifixion scene with Stephaton and Longinus. Here, the symbol needs to be complemented by "narrative" or "anecdotal" elements so that the miraculous event is identifiable. In this respect the Irish sculptor apparently perceived his model from a different perspective, for in the high cross version the symbolism has been replaced by fanciful "realism."

The power of the ambiguous image may be the iconographer's defeat, as can be demonstrated with one frustrating example. On the base of the high cross of Moone is a carving which shows a scene that has generally been interpreted as the Holy Family on the Flight into Egypt (Fig. 13).[57] It is apparently a unique scene in Irish high cross iconography. Equally idiosyncratic is the representation of the Flight on the Ruthwell cross in Dumfriesshire, Scotland (Fig. 14).[58] On this cross, the Holy Family moves from right to left, in contrast with the Moone depiction, and this reversal of direction has led art historians to question whether it is the *Return from Egypt* that is depicted at Ruthwell. The factor that has been seen as crucial is the direction of movement, which is the opposite of that in other scenes on the cross, where "the normal western narrative impulse is maintained—as in reading a text, so in reading an image, the narrative, the action, moves from left to right."[59] Moreover, elsewhere Flight and Return have been visualized within the same framework as a kind of "mirror image."[60] It is possible, however, to argue against these assumptions. Depictions of the Flight into Egypt usually display left-to-right movement, but this is certainly not a hard-and-fast rule.[61] It is precisely this irregularity that again corroborates the principle that we should not read images as if they were texts.

In this connection it has already been noted that there was a liturgical feast in Ireland and Northumbria which celebrated the Return from Egypt, but not the flight to avoid Herod's mas-

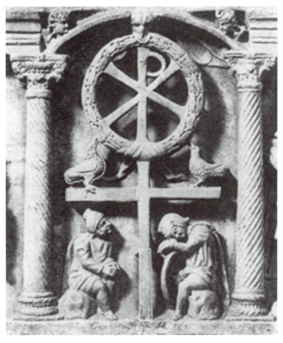

12. The symbolic rendition of the Resurrection in
the centre of the front side of a fourth-century
Passion sarcophagus. Vatican, Museo Pio Cristiano

13. The Return from Egypt (or the Flight into
Egypt?), middle panel on the south side of the base
of the Moone high cross, County Kildare

14. The Return from Egypt (or the Flight into
Egypt?), relief on the lower part of the north side of
the Ruthwell cross, Dumfriesshire

sacre.[62] From a liturgical point of view, then, the Return was more important in early medieval Ireland than the Flight. The scene on the cross of Moone is certainly not there to function as part of a narrative sequence, but most likely for a theological or a devotional purpose.[63] Direction of movement in general thus does not appear to be a firm criterion for identifying images of either an outward journey or its counterpart. It may be modern preconceptions that lead us to identify the scene on the cross at Moone as the more frequently depicted Flight instead of the Return. On balance, it is very likely that the scene does indeed represent the Return from Egypt.[64] However, we must admit that in a case like this we are at the limits of our methods, and that contradictory evidence—here with respect to the "reading" of direction—does not allow us to call our data definitive.

This is not the place for a discussion of another field full of fascinating ambiguities: the so-called abstract ornament on the high crosses and in almost all other media in early Insular art. Mere reference to the work of Victor Elbern and Robert Stevenson, the foremost "early" scholars who explored optical ambiguities in Insular ornament, will have to suffice.[65] The kinetic qualities of ornament and its implications have become the object of new research in which methods of interpretation not usually employed in art history are explored.[66] Thanks to these studies we know that the term "abstract" is not a fitting description of all Insular ornament, since even non-figural designs may have a symbolic or to some degree even a representational significance.[67]

III

What, then, is the basis of iconographical ambiguity in early medieval Christian art? At least four different components played a role. There is first of all its tendency to use cross-references, as in Scripture, which often generated visual reciprocity between antetype and fulfilling type. Secondly, we should not underestimate the role of the early medieval perception of time, which did not recognize sharp divisions between the linear dynamic time of nature, the cyclic element of liturgy, and the timelessness of the exalted church. In compliance with this attitude toward time is the fact that it was not historicity in the modern sense of the word that was pursued in medieval art, but the rendition of what was felt to be experience, in which earthly reality and religious wonder are both present and equally valid. The final element involved in ambiguity is the fact that Christian art is usually doxological, that it was meant to express the glory of God, as well as to contribute to it. These concepts explain, for instance, why early medieval images may display conflated moments or ideas. It must be added, however, that the "untextual" character of the image is a fact that should always be taken into consideration.

In this brief survey two classes of iconographical ambiguity have been distinguished: intentional ambiguities that by nature belong to Christian images, and ambiguities which are raised by the methods of studying that iconography. The first type originated in the doxological and unhistorical character of early medieval Christian art. The second class emanates from our own methodological limitations. We can thus conclude in a well-tried early Irish way by stating that three things are needed in an iconographer: respect, alertness, and modesty.

NOTES

1. W. Empson, *Seven Types of Ambiguity*, 3rd ed. (London, 1953); the first edition was published in 1930. For bringing this book to my notice I wish to thank Professor E. de Jongh, who also remarked that "iconographical ambiguity" is almost a tautology. I hope that this paper will demonstrate that his observation would make an appropriate motto for any study of early Irish images.

2. I am very much aware that the word "ambiguity" itself is subject to a number of semantic varieties, which are listed in dictionaries, but I trust that here the intended meanings will be articulated by their contexts. Cf. Empson, *Seven Types* (as in note 1), 1: "An ambiguity, in ordinary speech, means something very pronounced, and as a rule witty or deceitful. I propose to use the word in an extended sense, and shall think relevant to my subject any verbal nuance, however slight, which gives room for alternative reactions to the same piece of language. Sometimes . . . the word may be stretched absurdly far, but it is descriptive because it suggests the analytical mode of approach, and with that I am concerned."

3. Gen. 1:26–27 (cf. Gen. 5:1, 9:6), Wis. 2:23, Eccl. 17:1, 1 Cor. 11:7, Col. 3:10.

4. *Sigurdur Gudmundsson*, ed. Z.-Z. Eyck (Venlo, 1991), 62, 283. In the following quotation from a study on the oeuvre of the artist this issue is also pursued, although it is not this particular work that the author had in mind (P. Hefting, "Het Grote Gedicht," in *Gudmundsson*, 110–25, at 118): "Gudmundsson insists that his shapes do not generate language. Visual forms create their own language of shape, which has associations, has recognisable or unrecognisable signs, and inevitably generates a language of words. But language does not form the basis of these shapes—what does so is thinking in images. The titles [of his works] are more descriptive than narrative, do not refer to what everyone knows, are not thought up after the sculpture was completed." This passage is a not very accurate translation of the Dutch text on the facing page 119, but is nevertheless pertinent.

5. Florence, Biblioteca Medicea-Laurenziana, Ms. Plut. I. 56, Rabbula Gospels, from Zagba, Mesopotamia, A.D. 586, f. 13b; apse mural at Bawît, Al-Minyā, Egypt, fifth–seventh century (Chr. Ihm, *Die Programme der christlichen Apsismalerei vom vierten Jahrhundert bis zur Mitte des achten Jahrhunderts* [Forschungen zur Kunstgeschichte und christlichen Archäologie 4] [Wiesbaden, 1960], pl. XXIII:1). For more detailed discussions of these images, see J. Engemann, "Zu den Apsis-Tituli des Paulinus von Nola," *JbAC* 17 (1974), 21–46, pls. 1–7, at 39–41; K. Veelenturf, *Dia Brátha: Eschatological Theophanies and Irish High Crosses* (Amsterdamse historische reeks, kleine serie 33) (Amsterdam, 1997), 71–73.

6. Acts 1:9–11.

7. Engemann "Apsis-Tituli" (as in note 5), 72; Veelenturf, *Dia Brátha* (as in note 5), 73 n. 301.

8. There are three exceptions to this rule: the Crucifixion scenes on the South Cross *shaft* in Clonmacnois (P. Harbison, *The High Crosses of Ireland: An Iconographical and Photographic Survey* [Bonn, 1992], 55–56 [W3], figs. 156, 899), on the east face of the cross-head of the *unfinished* cross in Kells (Harbison, *High Crosses*, 112 [head, centre], figs. 360, 887), and on the west face of the *base* of the Moone high cross (Harbison, *High Crosses*, 155 [W2], figs. 514, 515).

9. These matters are discussed at more length in Veelenturf, *Dia Brátha* (as in note 5), chap. 5, "The Crucified and the Eschatological Christ," in particular pp. 135–36, 142–43.

10. This is the case with the South Cross in Graiguenamanagh and the cross of Kilgobbin (Harbison, *High Crosses* [as in note 8], 97, figs. 315, 316, and 117, figs. 383–385, respectively); cf. Veelenturf, *Dia Brátha* (as in note 5), 182 (table 4).

11. See Veelenturf, *Dia Brátha* (as in note 5), chap. 5, "The Crucified and the Eschatological Christ," especially pp. 137–39. In the tables on pp. 179–83, the identifications of cruciate eschatological Christ figures on Irish high crosses are listed.

12. Harbison, *High Crosses* (as in note 8), 110 (W2, head, centre), figs. 353–355, 898, 943.

13. H. M. Roe, *The High Crosses of Kells*, 2nd ed. (Meath, 1959), 22; Harbison, *High Crosses* (as in note 8), 110–11; R. Stalley, "Scribe and Mason: The Book of Kells and the Irish High Crosses," in *The Book of Kells: Proceedings of a Conference at Trinity College, Dublin, 6–9 September 1992*, ed. F. O'Mahony (Aldershot, 1994), 257–65, 560–63 (pls. 81–84), 566 (pl. 87), 568 (pl. 90), at 259–60; Veelenturf, *Dia Brátha* (as in note 5), 64–66.

14. On the identifying tags used in connection with this image, see Veelenturf, *Dia Brátha* (as in note 5), 64–68; K. Veelenturf, "Apocalyptic Elements in Irish High Cross Decoration?" in *Proceedings of the Fourth International Conference on Insular Art, Cardiff, 3–6 September 1998*, ed. N. Edwards, J. Knight, A. Lane, M. Redknap, and S. Youngs (Oxford, forthcoming).

15. The eagle is also depicted above the Crucified on the high cross of Durrow (Harbison, *High Crosses* [as in note 8], figs. 256, 870); between the feet of Christ on Muiredach's Cross in Monasterboice, where on the reverse the eagle is seen above the head of Christ the Judge (Harbison, *High Crosses*, figs. 481, 473); and on the Cross of the Scriptures in Clonmacnois, where it appears in a roundel beneath the feet of the crucified Christ and

above the head of the Judge (Harbison, *High Crosses*, figs. 141, 134). For the eagle as a symbol of the Resurrection, see L. Wehrhahn-Stauch, "Aquila-Resurrectio," *Zeitschrift des Deutschen Vereins für Kunstwissenschaft* 21 (1967), 105–27.

16. I have quoted Vulgate passages from the Douay-Rheims translation. For the interpolated phrasings in the manuscripts, see R.-J. Hesbert, *Le problème de la transfixion du Christ dans les traditions biblique, patristique, iconographique, liturgique et musicale* (Paris, Tournai, and Rome, 1940), 51–64 (Latin gospel manuscripts, pp. 52–59).

17. Hesbert, *Problème* (as in note 16), 52–59.

18. St. Gall, Stiftsbibl., Ms. 51, Irish Gospel book, A.D. 750–800, p. 266.

19. Hesbert, *Problème* (as in note 16), 83–146 (St. Gall, Ms. 51, p. 266: 96–98, pl. V).

20. Cf. A. Grillmeier, *Der Logos am Kreuz: Zur christologischen Symbolik der älteren Kreuzigungsdarstellung* (Munich, 1956), 6–10, 118; Veelenturf, *Dia Brátha* (as in note 5), 139–42, cf. 15ff.

21. Bamberg, Staatsbibliothek, Ms. msc. bibl. 140, from the scriptorium of Reichenau, A.D. 1001–1002.

22. K. Veelenturf, "Wie is er bang voor een nieuw millennium? Het 'profetische' in de kunst rond het jaar 1000," in *Dit is het einde niet (Profetie met het oog op het jaar 2000)*, Onderbreking 2, ed. M. Barnard and A. van der Werff (Kampen, 1998), 65–89, at 83–84 with fig. 6 [p. 76]; cf. p. 70. The quotations on the banderoles were taken from Matthew 25:34 and 25:41.

23. B. McGinn, "Portraying Antichrist in the Middle Ages," in *The Use and Abuse of Eschatology in the Middle Ages* (Mediaevalia Lovaniensia, series 1, studia 15), ed. W. Verbeke, D. Verhelst, and A. Welkenhuysen (Leuven, 1988), 1–48, at 1–2, 28 (quotation).

24. D. Ó Cróinín, "Cummianus Longus and the Iconography of Christ and the Apostles in Early Irish Literature," in *Sages, Saints, and Storytellers: Celtic Studies in Honour of Professor James Carney* (Maynooth Monographs 2), ed. D. Ó Corráin, L. Breatnach, and K. McCone (Maynooth, 1989), 268–79, esp. 278, with the quoted English translation of Irish texts 4–5 on pp. 272–73.

25. This is most clearly evident in so-called model-books, for which see R. W. Scheller, *Exemplum: Model-book Drawings and the Practice of Artistic Transmission in the Middle Ages (ca. 900–ca. 1470)*, 2nd ed. (Amsterdam, 1998).

26. See K. Veelenturf, "De kerk in Germigny-des-Prés als zogenaamde architectuurkopie van de paltskapel te Aken," *Millennium: Tijdschrift voor middeleeuwse studies* 3 (1989), 115–27, at 117 (with references to classic studies on the subject by R. Krautheimer, G. Bandmann, A. Verbeek, and W. E. Kleinbauer).

27. "Christus op (de) koude steen."

28. See Job 2:8.

29. G. von der Osten, "Job and Christ: The Development of a Devotional Image," *JWCI* 16 (1953), 153–58, pls. 20, [21], at 155–58.

30. Cf. Von der Osten, "Job and Christ" (as in note 29), 155–56, pl. [21]. At the conference in Princeton I demonstrated the similarity by showing a reproduction of a stone sculpture of Job, dating to ca. 1415, in the Sint-Martenskerk of Wezemaal, Flanders, and a sculpture of "Christ in distress" in the church of Saint Nizier, Troyes (Aube), France, dating to ca. 1500, for which see H. Sibbelee and F. van der Meer, *Imago Christi: Christusbeeltenissen in de sculptuur benoorden Alpen en Pyreneeën* (Antwerp, 1980), 93, 146–47.

31. H. R. Seeliger, "Πάλαι Μάρτυρες: Die drei Jünglinge im Feuerofen als Typos in der spätantiken Kunst, Liturgie und patristischen Literatur, mit einigen Hinweisen zur Hermeneutik der christlichen Archäologie," in *Liturgie und Dichtung: Ein interdisziplinäres Kompendium*, vol. 2, *Interdisziplinäre Reflexion* (Pietas Liturgica 2), ed. H. Becker and R. Kaczynski (Sankt Ottilien, 1983), 257–334, at 317–18:

> Was . . . sicher einleuchtet, ist, daß man die Ikonographie der Monumente, den Typenschatz und die Bildersprache von Liturgie und Frömmigkeit sowie der patristischen Theologie *nicht unmittelbar* auseinander ableiten kann und darf, wie das die ältere Forschung wollte, wenn sie in bestimmten Gebeten oder Lektionsordnungen die Vorbilder der sepulchralen Bilderwelt erkennen zu können glaubte. . . . Längst hat man nämlich erkannt, daß es sich allenfalls um eine *gemeinsame Wurzel* handeln kann, aus der als verschiedene Zweige ein Großteil der altchristlichen Ikonographie, das Arsenal patristischer typologischer Argumentation und auch beträchtliche Teile der liturgischen Bilderwelt hervorgingen. Diese gemeinsame Wurzel ist der Typologienschatz frühchristlicher Theologie. . . . Freilich wird jede typologische Reihe dabei stets zu einem eigenem, ganz speziellen Zweck innerhalb eines speziellen Argumentationszusammenhanges gebildet.

> Und dementsprechend ist für die Interpretation eines jeden Gebetes, einer jeden Leseordnung und jedes Monumentes der christlichen Archäologie zu fordern, daß sie selbständig und aus sich heraus interpretiert werden müssen. Diese sozusagen synchrone Ebene . . . ist aber aufs engste verschränkt mit der diachronen Dimension, die jedes typologische bzw. ikonographische Element für sich aufweist. Dabei ist zu beobachten, daß die verschiedenen Gattungen der Kunst und des Kunsthandwerks . . . aber auch der Liturgie und Frömmigkeit sowie der Literatur nochmals ihre jeweilige Eigengeschichte haben . . . , die Rückwirkungen auf die typolo-

gischen Einzelelemente von langer Dauer haben kann. So ist zu fragen, ob diese Einzelelemente jeweils ihre eigene einheitliche Grundbedeutung haben oder ob diese wechselt und ob diese den Test der sinnvollen Interpretation auf verschiedenen synchronen Ebenen besteht.

32. This is in fact a typological method borrowed from the discipline of archaeology, which, even if the uniqueness of many Irish representations is not taken into consideration, is not suited to the study of Christian iconography; cf. Veelenturf, *Dia Brátha* (as in note 5), 12.

33. The intrusion of hagiographic figures into iconographic programs which apparently consist almost exclusively of motifs derived from Scripture has been explained by the reputation of the desert fathers as founders of the monastic life. The Irish Church, having been a "monastic" church, is supposed to have revered Sts. Paul and Anthony for that very reason. The sharing of the bread by the two saints has been taken by some scholars to have a eucharistic connotation, which would have made this particular scene especially suitable for inclusion in high cross reliefs. In order to arrive at a full understanding of the desert father scenes, the tiny scraps of liturgical data from early Ireland had to be supplemented by information about Roman liturgical practice, and this must be regarded as a serious methodological problem. Our insight into the acquaintance of Sts. Paul and Anthony in early Ireland certainly needs more study, as does the question of distinguishing between their "cults" in Britain and Ireland. For the most recent detailed discussions of the Irish iconography of Sts. Paul and Anthony, with references to older literature, see É. Ó Carragáin, "The Meeting of Saint Paul and Saint Anthony: Visual and Literary Uses of a Eucharistic Motif," in *Keimelia: Studies in Medieval Archaeology and History in Memory of Tom Delaney*, ed. G. Mac Niocaill and P. F. Wallace (Galway, 1988), 1–58, pls. I–XII; Harbison, *High Crosses* (as in note 8), 304–8; P. Meyvaert, "A New Perspective on the Ruthwell Cross: Ecclesia and Vita Monastica," in *The Ruthwell Cross: Papers from the Colloquium Sponsored by The Index of Christian Art, Princeton University* (Index of Christian Art Occasional Papers 1), ed. B. Cassidy (Princeton, 1992), 95–166, at 131–35.

34. New York, The Metropolitan Museum of Art, inv. 16.174.3. See C. R. Morey, *The Gold-Glass Collection of the Vatican Library, with Additional Catalogues of Other Gold-Glass Collections* (Catalogo del Museo Sacro della Biblioteca Apostolica Vaticana 4), ed. G. Ferrari (Vatican City, 1959), 74, no. 455, pl. XXXVI:455; P. Testini, "L'iconografia degli apostoli Pietro e Paolo nelle cosiddette 'arti minori,'" in *Saecularia Petri et Pauli: Conferenze per il centenario del martirio degli apostoli Pietro e Paolo tenute nel Pontificio Istituto di Archeologia Cristiana* (Studi di antichità cristiana 28) (Vatican City, 1969), 241–323, at 313,

no. 147, 274, fig. 23; N. P. Ševčenko, "Bottom of a Bowl with SS. Peter and Paul Flanking a Column," in *Age of Spirituality: Late Antique and Early Christian Art, Third to Seventh Century. Catalogue of the Exhibition at the Metropolitan Museum of Art, November 19, 1977, through February 12, 1978*, ed. K. Weitzmann (New York, 1979), 570–71, cat. 508.

35. C. P. Hourihane and J. J. Hourihane, "The Kilnaruane Pillar Stone, Bantry, Co. Cork," *JCHAS* 84 (1979), 65–73, at 67–68, pl. II; Ó Carragáin, "Meeting" (as in note 33), 46–47 (iii); Harbison, *High Crosses* (as in note 8), 132 (W1), fig. 441.

36. Harbison, *High Crosses* (as in note 8), 40 (W4), figs. 109, 110.

37. New York, The Metropolitan Museum of Art, inv. 11.91.4. See Morey, *Gold-Glass Collection* (as in note 34), 73, no. 450, pl. XXXVI:450; Testini, "Iconografia" (as in note 34), 313, no. 146; N. P. Ševčenko, "Bottom of a Bowl with SS. Peter and Paul Crowned by Christ," in *Age of Spirituality* (as in note 34), 569–70, cat. 507.

38. New York, The Metropolitan Museum of Art, inv. 52.25.1. See *Early Christian and Byzantine Art: An Exhibition Held at the Baltimore Museum of Art, April 25–June 22, Organized by the Walters Art Gallery* (Baltimore, 1947), 127, no. 642; J. W. Salomonson, "Kunstgeschichtliche und ikonographische Untersuchungen zu einem Tonfragment der Sammlung Benaki in Athen," *Bulletin antieke beschaving: Orgaan van de Vereeniging Antieke Beschaving* 48 (1973), 3–82, at 19–20, fig. 13; N. P. Ševčenko, "Bowl with SS. Peter and Paul," in *Age of Spirituality* (as in note 34), 569, cat. 506.

39. Harbison, *High Crosses* (as in note 8), 155 (N3), figs. 517, 518.

40. A survey including the examples already mentioned:

Compare the high cross carvings of: Arboe (Ó Carragáin, "Meeting" [as in note 33], 45 [i], pl. X; Harbison, *High Crosses* [as in note 8], 16 [S4], figs. 33, 35); Armagh (Ó Carragáin, "Meeting," 45–46 [ii], pl. XI; Harbison, *High Crosses*, 22 [N3], fig. 48); North Cross, Castledermot (Ó Carragáin, "Meeting," 47 [iv]; Harbison, *High Crosses*, 37 [E2], fig. 101); East Cross, Galloon (Ó Carragáin, "Meeting," 48 [vi], pl. XII; Harbison, *High Crosses*, 91 [W3], fig. 292); Cross of Patrick and Columba, Kells (Ó Carragáin, "Meeting," 49–50 [vii], pls. IV, IX; Harbison, *High Crosses*, 109 [head, north arm], figs. 345, 346, 951); Market Cross, Kells (Ó Carragáin, "Meeting," 49–50 [viii]; Harbison, *High Crosses*, 104 [head, end of arm], fig. 330); Muiredach's Cross, Monasterboice (Ó Carragáin, "Meeting," 50–51 [ix], pl. VI; Harbison, *High Crosses*, 146 [head, top], figs. 485, 952), to the gold-glass in Morey, *Gold-Glass Collection* (as in note 34), 10, no. 36, color pl. (no. 36), pl. VI:36; 14, no. 55, pl. IX:55; 16, no. 65, pl. X:65; 18, no. 72, color pl. (no. 72), pl. XII:72; 25, no. 106, pl. XVIII:106; 26–27, no. 112, pl. XIX:112; 44,

no. 242, pl. xxvi:242 (=Testini, "Iconografia" [as in note 34], 310, no. 126); 54, no. 315, pl. xxix:315; 57, no. 341, pl. xxx:341 (=Testini, "Iconografia," 312, no. 140); 65, no. 396, pl. xxxii:396 (=Testini, "Iconografia," 322, no. 214).

Compare the scene on the South Cross of Castledermot (Ó Carragáin, "Meeting," 47–48 [v], pl. iii; Harbison, *High Crosses*, 40 [W4], figs. 109, 110) to Morey, *Gold-Glass Collection*, 8, no. 29, pl. v:29; 10, no. 37, pl. vi:37; 13, no. 50, pl. viii:50 (=Testini, "Iconografia," 317, no. 177); 13, no. 51, pl. viii:51 (=Testini, "Iconografia," 317, no. 178); 16, no. 66, pl. xi:66; 18, no. 74, pl. xii:74; 26, no. 109, pl. xviii:109; 43–44, no. 241, pl. xxvi:241; 54, no. 314, pl. xxix:314 (=Testini, "Iconografia," 312, no. 136, 275, fig. 21); 65, no. 397, pl. xxxiii:397; 73, no. 450, pl. xxxvi:450 (=Testini, "Iconografia," 313, no. 146).

Compare the scene on the high cross of Moone (Ó Carragáin, "Meeting," 51 [x], pl. v[a]; Harbison, *High Crosses*, 155 [N3], figs. 517, 518, 953) to Morey, *Gold-Glass Collection*, 44, no. 243, pl. xxvi:243 (=Testini, "Iconografia," 311, no. 127, 275 [fig. 22]).

Compare the scene on the cross shaft of Kilnaruane (Hourihane and Hourihane, "Kilnaruane Pillar Stone" [as in note 35], 67–68, pl. ii; Ó Carragáin, "Meeting," 46–47 [iii]; Harbison, *High Crosses*, 132 [W1], fig. 441) to Morey, *Gold-Glass Collection*, 18–19, no. 76, pl. xii:76; 74, no. 455, pl. xxxvi:455 (=Testini, "Iconografia," 313, no. 147, 274, fig. 23).

Cf. Salomonson, "Kunstgeschichtliche und ikonographische Untersuchungen" (as in note 38), 20 n. 56.

41. E.g., Morey, *Gold-Glass Collection* (as in note 34), 8, no. 29, pl. v:29; 10, no. 36, color pl. (no. 36), pl. vi:36; 26, no. 109, pl. xviii:109; 54, no. 315, pl. xxix:315; 65, no. 397, pl. xxxiii:397. Cf. Testini, "Iconografia" (as in note 34), 274, 276.

42. On the meaning and use of this and cognate terms in the works of Early Christian writers, see J. K. Coyle, "*Concordia*: The Holy Spirit as Bond of the Two Testaments in Augustine," *Augustinianum: Periodicum Quadrimestre Instituti Patristici "Augustinianum"* 22 (1982), 427–56, at 428–35.

43. On Sts. Peter and Paul, and *concordia* [*apostolorum*], see Ch. Pietri, "Concordia apostolorum et renovatio urbis (culte des martyrs et propagande pontificale)," *Mélanges d'archéologie et d'histoire* 73 (1961), 275–322, pl. i; Ch. Pietri, *Roma christiana: Recherches sur l'Église de Rome, son organisation, sa politique, son idéologie de Miltiade à Sixte III (311–440)* (Bibliothèque des Écoles Françaises d'Athènes et de Rome 224) (Rome, 1976), 1590–96; H. von Heintze, "Concordia Apostolorum: Eine Bleitessera mit Paulus und Petrus," in *Theologia Crucis, Signum Crucis: Festschrift für Erich Dinkler zum 70. Geburtstag*, ed. C. Andresen and G. Klein (Tübingen, 1979), 200–36, pls. 8–13 (figs. 1–15), at 218–19, 233–34.

44. I am grateful to Professor Peter Brown, who pointed out this connection at the conference in Princeton.

45. An elaborate discussion, but inevitably out of date, of the iconography of this event, as narrated by St. Jerome in §10–11 of his *Vita Pauli*, is provided by P. Noordeloos, "De ikonographie van het bezoek van Antonius den Groote aan Paulus van Thebe," in *Het gildeboek: Orgaan van het Sint Bernulphusgilde* 24 (1941), 33–73, at 59–69. A division between the bringing of the loaf and the sharing of it is not always very distinct on the Irish crosses. A precursor for this scene can be found in 3 Kings 17:6, where the prophet Elias is also fed by ravens in the desert.

46. The iconography of Sts. Paul and Anthony from Britain falls beyond our scope.

47. This topic has been mentioned by F. Henry, *Irish Art during the Viking Invasions (800–1020 A.D.)* (London, 1967), 182–84, albeit with no more specific reference than to "some fifth century sarcophagi," and has been discussed in a more balanced way by R. Stalley, "European Art and the Irish High Crosses," *PRIA* 90C (1990), 135–58, at 149–53, referring to a "group of fourth-century sarcophagi in Italy." More recently, the subject has been examined from a completely different angle, for which see Harbison, *High Crosses* (as in note 8), 286–90.

48. Harbison, *High Crosses* (as in note 8), 51 (W1), figs. 139, 140, 909.

49. Harbison, *High Crosses* (as in note 8), 81 (W1), figs. 254, 255.

50. Harbison, *High Crosses* (as in note 8), 149 (W1), figs. 494, 495.

51. Harbison, *High Crosses* (as in note 8), 105 (S1), figs. 335, 336.

52. Cf. Henry, *Irish Art* (as in note 47), 183–84; Harbison, *High Crosses* (as in note 8), 51 (W1), 81 (W1), 105 (S1), 149 (W1), 286–87, in which these images are consistently taken to represent "Christ in the tomb" and not the Resurrection.

53. F. W. Deichmann, *Repertorium der christlich-antiken Sarkophage*, vol. 1, *Rom und Ostia* (Deutsches Archäologisches Institut, Repertorium der christlich-antiken Sarkophage 1), ed. G. Bovini and H. Brandenburg (Wiesbaden, 1967), 48–49, no. 49, pl. 16:49.

54. Deichmann, *Repertorium* (as in note 53), 57, no. 59; cf. 127, no. 208; 57–58, no. 61; 111, no. 175; 133–34, no. 224; 262, no. 653; 268, no. 667; pls. 19:59, 19:61, 43:175, 51:224, 99:653, 101:667.

55. F. Benoit, *Sarcophages paléochrétiens d'Arles et de Marseille: Fouilles et monuments archéologiques en France métropolitaine* (*Gallia* supplement 5) (Paris, 1954), 53, no. 58, pl. xxiii.

56. Roe, *Kells* (as in note 13), 28, described this cross as "adored by angels" and connected it with the Resurrection account in the apocryphal *Gospel of Peter*.

57. Harbison, *High Crosses* (as in note 8), 155 (S2), figs. 513, 813.

58. Cassidy, *Ruthwell Cross* (as in note 33), pl. 25 (panel N2).

59. G. Henderson, "The John the Baptist Panel on the Ruthwell Cross," *Gesta* 24, no. 1 (1985), 3–12, at 6–7.

60. K. Vogler, *Die Ikonographie der "Flucht nach Aegypten"* (Arnstadt, 1930), 13; Henderson, "John the Baptist Panel"(as in note 59), 7.

61. This has been noted before by Meyvaert, "New Perspective" (as in note 33), 129. D. Howlett, "Inscriptions and Design of the Ruthwell Cross," in *Ruthwell Cross* (as in note 33), 71–93, at 74–75 n. 20, has reversed the direction in which the Ruthwell cross donkey of the Holy Family is travelling, but would apparently have a predilection for interpreting it as the Return. Several checks produced evidence that a left-to-right movement is usual in medieval Flight scenes, but that it is not a fixed rule (Vogler, *Ikonographie* [as in note 60], 13 [with notes 47–51 on pp. 79–80]). Sometimes Flight and Return within one context both display left-to-right movement, and in independent images of the Return the same direction can be observed (Vogler, *Ikonographie*, 14 [with notes 53–54 on pp. 81–82]). Cf. H. Hommel, "Profectio Mariae: Zur Ikonographie der 'Flucht nach Ägypten,'" *Theologia Viatorum: Jahrbuch der Kirchlichen Hochschule Berlin* 9 (1963 [1964]), 95–112, pls. 1-12, in which the Flight in Early Christian iconography is related to the imperial *profectio* (and *adventus*), even with respect to internal direction (p. 96 n. 6, 103; there seems to be a discrepancy regarding the direction of movement and the mixture of elements of *adventus* and *profectio*). On medieval seals the direction of the Flight is predominantly, but not always, left-to-right, nor is there always right-to-left movement in seals with the Return (E. Crusius, "Flucht und Heimkehr: Studie zur Ikonographie der mittelalterlichen Siegel," *Archivalische Zeitschrift* 49 [1954] 65–71, pls. I–III). The same conclusion is documented by the files of the Index of Christian Art (s.v. Flight into Egypt, Return from Egypt). For later periods, cf. A. Heimendahl, *Die Flucht nach Ägypten* (Maria in Werken der Kunst: Eine Bücherreihe über das Marien-

bild 3) (Aschaffenburg, 1951), 42 with note, figs. 14, 22. Not taken into account here is the image type of the Return from Egypt which does not depict a journey on a donkey. Cf. Harbison, *High Crosses* (as in note 8), 248–49, where a Return interpretation is proposed for a scene on the Drumcliff cross (p. 72 [W5], figs. 221, 817).

62. Meyvaert, "New Perspective" (as in note 33), 129–30. For the entries on this feast in calendars, etc., see L. Gougaud, "Sur trois anciennes fêtes de Notre-Seigneur," *Bulletin d'ancienne littérature et d'archéologie chrétiennes* 4 (1914), 208–10; M. Schneiders, "The Irish Calendar in the Karlsruhe Bede," *Archiv für Liturgiewissenschaft* 31 (1989), 33–78, at 42, 73.

63. When identified as the Return from Egypt, it can also be associated quite naturally with the other scenes on the Moone high cross that display divine intervention: Daniel in the Lions' Den, the Sacrifice of Isaac, the Multiplication of the Loaves and Fishes, and the Three Hebrews in the Fiery Furnace.

64. This identification was proposed earlier by J. J. Meagher, *St. Lorcán Ó Tuathail, 1128–1180: An Essay in Twelfth-Century History* (Dublin, 1980), 21, who also adduces the liturgical feast of "Eductio Christi de Aegypto." Cf. note 62 above.

65. For instance, the remarkable studies of V. H. Elbern, "Die Dreifaltigkeitsminiatur im Book of Durrow," *Wallraf-Richartz-Jahrbuch: Westdeutsches Jahrbuch für Kunstgeschichte* 17 (1955), 7–42, and R. B. K. Stevenson, "Aspects of Ambiguity in Crosses and Interlace," *UJA* 44–45 (1981–82), 1–27.

66. See E. Pirotte, "Hidden Order, Order Revealed: Some Principles of Space Organization in Insular Art. The Case of Illuminated Gospel Books," in *Fourth International Conference on Insular Art* (as in note 14), and the contribution of the same author to this volume.

67. In connection with an apocalyptic tradition peculiar to early Ireland, I have endeavoured to make an attempt towards an emblematic interpretation of "nonrepresentational" devices in Irish high cross ornament; see Veelenturf, "Apocalyptic Elements"(as in note 14).

The Otherness of Irish Art
in the Twelfth Century

·

PETER HARBISON

THE LABEL "Romanesque" is perhaps too glibly and freely applied to the art and architecture of twelfth-century Ireland. As a stylistic term adapted from the ancient Roman use of the rounded arch, it was quite correctly employed by Liam de Paor[1] when he described the chapel built by Cormac Mac Carthaigh on St. Patrick's Rock at Cashel (Co. Tipperary), between 1127 and 1134, as "a piece of Romanesque *architecture*, as hardly any other church is." He placed this building at the beginning of a series of surviving Irish churches of the genre, but, as this quotation hints, its successors[2] were often little more than small box-shaped, nave-and-chancel structures deserving the title "Romanesque" only on the basis of the rounded shapes and style of decoration used in the doorway, chancel arch, and occasionally the windows. As exemplified by the Nuns' Church at Clonmacnois (Co. Offaly) (Fig. 1) which dates from the last third of the century, they showed little change in scale from the earlier, undecorated, churches found in many parts of Ireland and could be described as having combined an old-fashioned size with the latest decoration of a kind found on Continental churches scattered along the pilgrimage roads to Santiago de Compostela.

Bernard of Clairvaux's[3] implied portrayal of native Irish churches before 1140 as small and conservative in character largely holds good up to the end of the century, and the somewhat stunted successors of the exotic Cormac's Chapel demonstrate that the Irish, when left to themselves, were not going to develop or even consolidate that achievement. The chapel was left to stand in splendid isolation as an innovation copied more in its individual details than in its overall concept. Twelfth-century abbots of old Irish monasteries kept to the traditional and intimate scale of earlier wooden churches, even retaining some of their characteristic features such as antae and inclining door jambs. They clearly did not aspire to the grandiose designs of the great aisled and apsed churches and cathedrals which they could have seen being erected in England and on the European continent from the latter part of the previous century onwards. The presence of an apse in the recently excavated St. Peter's Church in Waterford city[4] suggests that the maritime towns which were rapidly expanding at the time may well have been more progressive and receptive to new ideas from outside. It took St. Malachy's introduction of Arrouaisian canons and Cistercian monks from the 1140s onwards, however, to establish large-scale Continental church design in Ireland at Bangor,[5] Mellifont, and elsewhere.[6]

Even if it succeeded only in part, Cormac's Chapel can be seen in its very novelty as a bold effort to overcome the centuries-old atrophy of Irish church architecture. It reflects influences from the areas overseas whence wafted the winds of change which helped to bring about its crea-

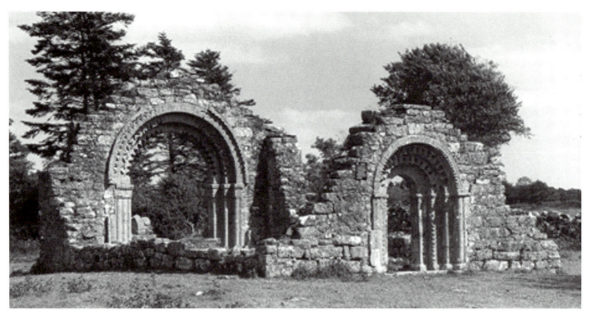

1. The nave-and-chancel Nuns' Church at Clonmacnois, County Offaly, second half of the twelfth century

tion, leading Aubrey Gwynn[7] to see it as a symbol of the incipient reforming movement in Munster, where it stands. The centaur with the Norman-style helmet[8] on the tympanum of the north doorway is only one of a number of features pointing towards the west of England as a source of inspiration, as Liam de Paor[9] and Roger Stalley[10] have both amply demonstrated. But the fan-like arrangement of human heads on the upper part of the chancel arch of Cormac's Chapel indicates further influence from the Romanesque churches of France, which contributed the stimulus not only for the rayed arch of heads,[11] but possibly for sculpture elsewhere as well. One example is the curious figure built at a later stage into the church at Ráth Blathmach in County Clare,[12] which is unthinkable in an Irish context without some foreign, probably French, model.

In contrast to architecture, however, the term "Romanesque" is better avoided in describing the style and nature of most other expressions of twelfth-century art and craftsmanship in Ireland. We find there a predominance of more anti-classical, north European abstract designs of animals and interlace, for which the term "Romanesque" as a label of style rather than period seems singularly inappropriate. This can be clearly seen in the Irish twelfth-century manuscripts which Françoise Henry[13] and Geneviève Marsh-Micheli have restored to their rightful position in the history of Irish art.[14] The decoration of their pages is a far cry from the tall and graceful figures, clothed in long garments with wondrously lined drapes and foldings, that are found in twelfth-century English, French, and German Gospel books, Lectionaries, and frescoes, which are rightly designated "Romanesque."[15] Though occasionally sharing their striking sense of colour, particularly in the blues and reds, the Irish manuscripts of the period have instead a menagerie of birds and fearsome, often acrobatic, beasts whose writhing interlace might at first remind one of the Book of Kells but which, on closer examination, incorporates a strong element of an Irish version of the Scandinavian-inspired Ringerike and Urnes styles.[16] This is coupled with a revival of earlier manuscript designs, as seen in the Chi-Rho on folio 10v of the Gospel manuscript 122

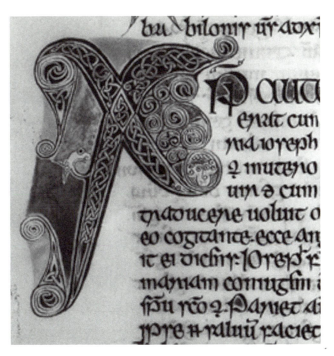

2. Corpus Christi College, Oxford, Ms. 122,
Gospels, Chi-Rho on folio 10v

of Corpus Christi College, Oxford (Fig. 2), which vividly recalls that on folio 34v of the Book of Kells[17] and other manuscripts of the "golden age."[18] It does seem strange, however, that a manuscript such as these Corpus Christi Gospels, which Françoise Henry[19] claimed as a product of the monastery of Bangor under the influence of the arch-reformer Malachy of Armagh, should hark back to Irish designs of three hundred years earlier rather than reflecting new ideas which one might expect to have been introduced from France by the Arrouaisian canons when St. Malachy settled them in County Down around 1140.

The same Irish variant of late Viking animal ornament, and the harking back to designs and techniques of an earlier age, are also found on Irish metalwork of the period, which consists largely of reliquaries. The surviving examples are on a much smaller scale than those found on the European continent, largely because Ireland was not affluent enough to sustain the large bronze-casting workshops that produced magnificent doors, baptismal fonts, and shrines under the masterly guidance of men like Rainer of Huy and Nicholas of Verdun. Irish craftsmen, nevertheless, were so highly regarded in the society of their day that they, too, were allowed to inscribe their names for posterity on the shrines which they produced. We may, however, be under-estimating the scale of other Irish metalwork existing at the time but long since perished at the hands of Reformation zealots or Elizabethan suppressors, as is hinted at by the six-foot-long, solid stone sarcophagus at Clones in County Monaghan, which dates from the twelfth century.[20] With its presumed bishop or abbot figure on one gable end (Fig. 3) and the apparent copying of metal clasps and hinges on the sides, this unique block would seem to be a stone skeuomorph of a bronze (or even gold?) sarcophagus. This may have been similar to the Continental shrines with serried ranks of saints and "weepers" like that of St. Heribert in Cologne-Deutz (which also portrays the saint on a gable end),[21] but with the difference that it probably had a hinged lid to enable the occasional removal of the relic it contained. This Clones sarcophagus, the figures now in

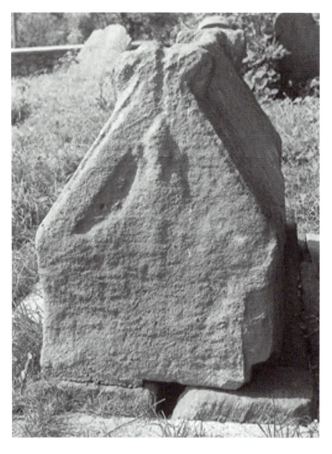

3. Twelfth-century stone sarcophagus at Clones, County Monaghan, probably copied from a now lost wood and metal original

a secondary position on the Breac Maedhóg shrine in the National Museum, Dublin (Fig. 4), the bronze men currently attached to St. Manchan's shrine (Fig. 5),[22] and the (truly "Romanesque") twelfth-century crucifixes studied by Raghnall Ó Floinn[23] are among the clearest indications that Irish craftsmen in metal were very much aware of what their Continental counterparts were producing in their workshops.

But while Ireland joined much of Europe in enshrining relics during the twelfth century, it differed from the rest of Christendom in the nature and decoration of its religious metalwork. The most striking example of this is the awesome collection of croziers and crozier-shrines displayed in the Treasury Room of the National Museum of Ireland which find no parallel outside the country. Nor does the style of their decoration, which almost entirely avoids the typically Romanesque stylized glorification of the human figure in favour of panels bearing long-established native interlace or that peculiar Irish version of the Scandinavian animal ornament encountered in manuscripts. But side-by-side with them we find a reincarnation of techniques practised centuries earlier on Irish metalwork—millefiori, for example, as found on the Lismore crozier,[24] or the juxtaposition of red and yellow enamel, as seen on St. Manchan's shrine (Fig. 5) or the Cross of Cong, though with the relative importance of the colours interchanged, as Françoise Henry pointed out.[25] These croziers, some designed to enclose a relic in the form of a pastoral staff, had the "drop-headed" shape already characteristic of Irish croziers for at least three centuries[26] and

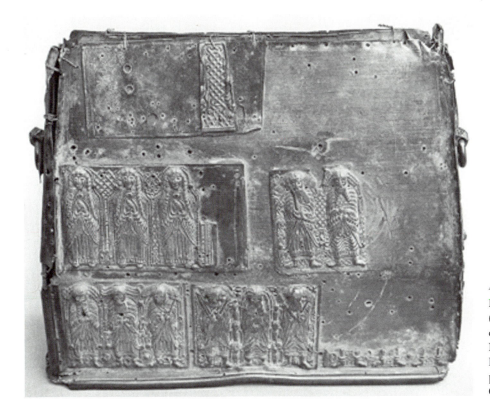

4. The Breac Maedhóg shrine (mid-twelfth century?) in the National Museum, Dublin, with figures possibly inspired by Continental shrines

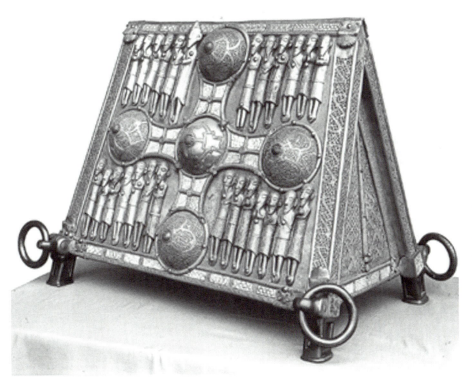

5. Copy of St. Manchan's shrine in the National Museum of Ireland showing the equal-armed cross with domed bosses flanked by bronze figures on the face, and the animal interlace and enamel decoration on the edges and sides

were the symbol of pastoral care, traditional authority, and respect usually associated with the old Irish monasteries.

Croziers are also copied in stone on twelfth-century high crosses[27]—a new, and very different, version of a monument type that had produced great masterpieces in the past, but which was now revived to provide Ireland with something that is entirely unique. These are unmatched by anything similar in Britain, where high crosses had also been carved in earlier centuries. Three different crozier types can be seen together on a single example, the so-called Doorty Cross at Kilfenora, which was the ecclesiastical centre of the petty kingdom of Corco Modruad[28] in north Clare and, through the Synod of Kells/Mellifont in 1152, the country's smallest (and perhaps also its poorest) bishopric. Of the three crozier-bearing figures seen on its east face (Fig. 6), the uppermost has an angel hovering at each shoulder and wears on his head what Françoise Henry[29] identified as a tiara, worn only by the pope. However, an interpretation of the figure as the Roman pontiff is rendered less likely because, as Morrisroe's entry "Crozier" in the 1913 edition of *The Catholic Encyclopedia* intimates, the popes may have stopped carrying croziers as early as the eleventh century, and certainly by the time of Pope Innocent III around 1200. In addition, the figure on the Clones sarcophagus (Fig. 3), who is most likely to represent Tigernach, the local patron saint, also wears a similar tiara-style mitre. The crozier which the Kilfenora figure carries in his left hand is an out-turned volute crozier of Continental type which must have been increasing in popularity during the twelfth century before becoming the standard form by the thirteenth. His right hand, with two small fingers flexed, points not upwards in blessing, as might be expected, but downwards towards two figures with interlocking arms. That on the left bears a typical Irish "drop-headed" crozier, that on the right a T-shaped crozier similar to the attribute of St. Anthony the Hermit in later medieval art but also paralleled in a twelfth-century Irish example of unknown provenance now in the National Museum of Ireland in Dublin.[30] Both figures appear to jab the point of their respective croziers into a winged monster(?) whose claw and web-like tail grip the heads of two further humans beneath, one of whom holds up something horizontally under the "monster's" belly. Elucidation of the tableau in its entirety still eludes us,[31] but the uppermost ecclesiastic is perhaps best interpreted not as the specific local saint or bishop, whose crozier was of the drop-headed variety, as we know from a thirteenth-century incised slab in the chancel of Kilfenora Cathedral (illustrated here as Figure 7), but as the embodiment of a newly instituted episcopacy. The latest Continental style of the figure's crozier and the gesture of pointing down towards two ecclesiastics with more traditional croziers may symbolize Kilfenora's elevation to diocesan status and its confirmation of the authority of the Church of Rome over the old Irish monastery, which we can presume to have existed on the site before the creation of the bishopric.[32]

A figure on the east face of the high cross at Dysert O'Dea in County Clare (Fig. 8), some ten miles to the south-east, also holds a volute crozier in his left hand, but this one turns inwards. Where we would expect his right hand to be raised in blessing, there is nothing but a gaping hole. Surely the best explanation for this curious void is that the hole was once filled with an arm-shaped reliquary, probably of bronze, that could have been removed temporarily for curing, oath-swearing, or other purposes, but which was not returned the last time it was borrowed or taken. The existence of the Shrine of St. Lachtin's Arm, created between 1118 and 1121[33] and now in the National Museum in Dublin, is proof that such relics existed in Ireland. But the reliquary proposed here for the Dysert cross may have had a section containing water (or even oil?) which, as

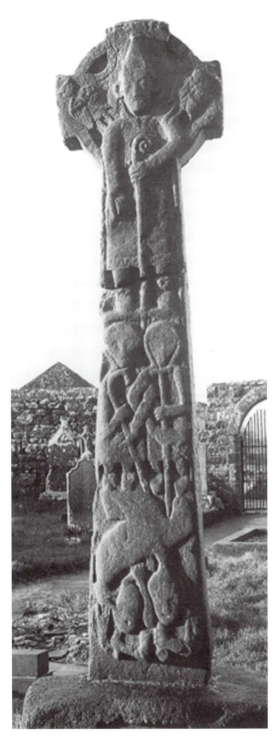

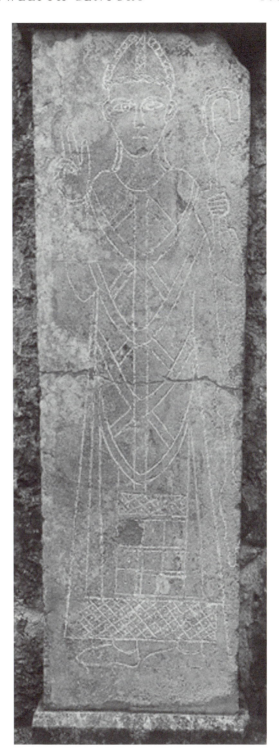

6. The east face of the Doorty Cross at Kilfenora, County Clare, bearing the figure of an ecclesiastic with volute crozier, his right hand pointing down in blessing at two figures with drop-headed and T-shaped croziers, probably representatives of the old monastery which existed there prior to the creation of the bishopric in 1152

7. Kilfenora cathedral, County Clare, incised effigy of a thirteenth-century bishop holding a drop-headed crozier with four knops

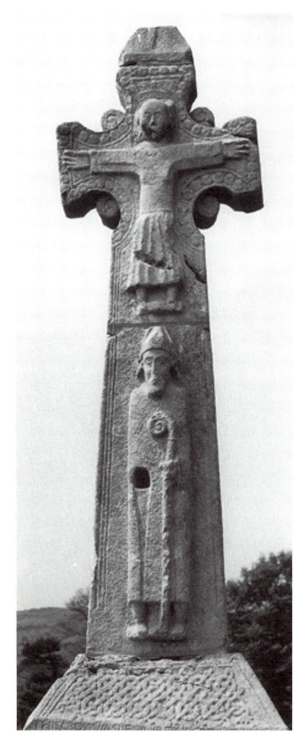

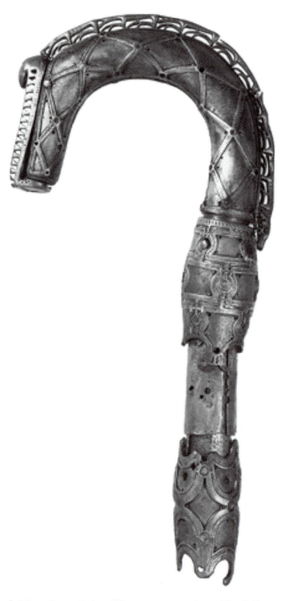

8. The east face of the high cross at Dysert O'Dea,
County Clare, with a figure wearing a mitre and
holding an in-turned crozier. The head-section above
the figure, with Christ standing out in high relief, may
not have been designed originally for this cross.

9. The eleventh/twelfth-century crozier of St. Tóla
(an eighth-century hermit) from Dysert O'Dea,
County Clare, now in the National Museum,
Dublin. It is the typical Irish drop-headed variety,
very different from the volute crozier borne by the
ecclesiastic on the high cross at Dysert O'Dea.

Raghnall Ó Floinn has suggested to me, could have been allowed to flow down the narrowing groove beneath the hole into a vessel which a pilgrim could have carried back home, just as his or her modern counterpart would do at Lourdes. The top of the head-gear worn by this Dysert figure is missing,[34] but the lower part strongly suggests that it is a mitre rather than a tiara. Because of the presumed reliquary in the shape of a right forearm, one might expect this figure to have represented the local saint, Tóla, who lived here as a hermit in the eighth century.[35] But because St. Tóla's crozier, preserved in the National Museum of Ireland (Fig. 9), is of the same old Irish drop-headed variety as that seen on the Kilfenora slab (Fig. 7) and therefore different to the volute crozier represented on the stone cross, we should possibly see the Dysert figure as fulfilling the same role as that on the Doorty cross, but with the added bonus of a built-in reliquary.

These two figures ought to be seen in the context of the church reform movement that was introduced into Ireland in the very first year of the twelfth century by the O'Brien kings of Munster, in whose territory Dysert O'Dea (but not Kilfenora) stood. What was considered to have been most in need of reform was the ecclesiastical system. In the absence of the diocesan organization widely established elsewhere throughout Europe, the virtually autonomous monasteries had been the focus of religious (but also literary and artistic) activity in the country for many hundreds of years. They had become lax in their discipline and observance not once, but many times, since their foundation back in the sixth or seventh century, and perhaps at no time more crassly than in the eleventh century, when their practice of simony and lay control had become an embarrassing thorn in the side of those churchmen who supported the reforming zeal of Pope Gregory VII (Hildebrand) in making Rome the centre of an institutionalized church, to which layman and cleric alike paid homage.

Successive archbishops of Canterbury had been looking askance at the anomalies of the Irish Church, and when the recently Christianized citizens of Dublin gave Canterbury a foot in the door by asking it to ordain their newly elected bishop, the archbishop of Canterbury grasped the opportunity of urging the O'Brien king of Munster (who he thought ruled over the whole country) to gather Ireland into the fold of reform so that it would conform to the rest of Christendom. The upshot was that Muirchertach O'Brien assembled a great collection of bishops and clergy—for there were bishops, though few bishoprics, in Ireland at the time—and held a synod at Cashel. He used this occasion to hand over to the Church the Rock of Cashel on which the synod was held, and where, more than a quarter century later, the foundations of Cormac's Chapel were to be laid. The synod was the first step in introducing reforms, though simony and lay abbacy were still too controversial to be tackled immediately, as they struck at the very heart of the existing monastic framework in Ireland. But the reform which Cashel set in motion was too powerful to stop, and it was at the next synod in the series, which took place exactly a decade later and not far away at Rathbreasail, that a first effort was finally made to carve up the country into new bishoprics which roughly mirrored the political boundaries in force at the time. The presiding genius at Rathbreasail was Gilbert, bishop of the Norse town of Limerick and, being papal nuncio as well, a man of considerable influence and power. His writings formulated the idea that monasteries should be subject to bishoprics—a notion that must have sent a chill down the spines of the ancient and autonomous monasteries who potentially saw the writing on the wall and must have feared the consequences of those winds of reform that had been blowing since the century had opened with the Synod of Cashel a decade earlier.

By the time the next synod sat at Kells/Mellifont in 1152, Kilfenora had been made a bish-

opric in the new scheme, and the Doorty Cross should perhaps be dated shortly after this time if it does in fact illustrate how the new diocesan structure had come to triumph over the monastery and the old "decadent" system it represented. The presence of another high cross of roughly the same period on the Rock of Cashel[36] would support the notion that these twelfth-century crosses were erected by the reforming party, as Liam de Paor suggested almost fifty years ago.[37] The same could also be claimed for the so-called Market Cross at Glendalough[38] if it were erected during the abbacy of St. Laurence O'Toole, who was translated from there to the archbishopric of Dublin in 1162. This cross shows the same configuration as the cross at Dysert O'Dea, namely, Christ above an ecclesiastic (even if the two sections at Dysert do not fit perfectly together). The head of the Market Cross at Tuam (to which its present shaft does not belong) shows Christ on one face, with a large central ecclesiastic flanked on each side by two smaller figures on the other face.[39] If this is not a visual representation of the pope flanked by the four newly appointed Irish archbishops, it may also bear the same interpretation as the figures on the two Clare crosses just discussed, and probably also that on the cross of Roscrea (Co. Tipperary).[40] The Roscrea cross, like the cross-head at Tuam and the Doorty Cross at Kilfenora already mentioned, have figures of Christ back-to-back with the ecclesiastics on the other face and all three places were bishoprics by the time of the Synod of Kells/Mellifont in 1152.

It is not clear what aspect of Christ (merciful judge?) is represented on some of these crosses, and it is only on cross fragments from Killeany[41] and Temple Brecan[42] on the Aran Islands that we can be certain that it is the crucified Christ that is shown, as he is accompanied by Stephaton and Longinus. None of these three fragments shows any signs of an ecclesiastic, whose only presence on the islands is on another cross from Killeany,[43] which, significantly, is more likely to have borne a Christ figure rather than a Crucifixion, as he is apparently unaccompanied. The Aran Islands were, as far as we know, not in line to get a bishopric of their own in the twelfth century, as was the case, too, with Monaincha (Co. Tipperary),[44] whose cross-head also shows a figure of Christ without any ecclesiastic figure back-to-back with it. It would seem, therefore, that a case could be made that it, the Temple Brecan cross fragments,[45] and the cross without ecclesiastic at Killeany were all erected not by reformers, but by what we might call anti-reformers. These were the men of those monasteries whose very existence was threatened by the strictures of Gilbert, the papal nuncio, being put into practice. Because the reformers started out with little or no money to finance the organization and administration of the new dioceses, they seem to have set about robbing the monasteries of their resources and their status. In the words of Donnchadh Ó Corráin,[46] the synodal reformers "destroyed the social, economic and cultural base of Irish learning," but, as inheritors and keepers of Ireland's cultural legacy, the monasteries must have believed that it was their duty to save as much of it as possible by staying in existence for as long as they could. In order to keep themselves in business, they would appear to have encouraged more people to go on pilgrimage, a pious practice common in Ireland for more than six centuries and one of Europe's most popular activities in the twelfth century. They must have increased their income by dusting down old relics and encasing them in shining new reliquaries which would attract people to come on pilgrimage and give offerings that would help the monasteries to survive. The monasteries must have felt that the country's cultural heritage, which they had nurtured down the centuries, would be endangered if they faced elimination at the hands of the reformers, who give the impression of having been more interested in power and change than in culture. It may have been a sense of impending doom which urged the monasteries to gather ear-

lier texts into great codices such as the Book of the Dun Cow or the Book of Leinster, but it was the challenge to survive that encouraged them to house or rehouse the relics of their patron saint in reliquaries which pilgrims could come and venerate, rather than enshrining books as had been popular in the previous century. It was perhaps to emphasize their position as bearers of the nation's long-lived heritage that the monasteries purposely revived the traditional arts and crafts in manuscripts and on metalwork of the twelfth century. This would explain why we find, after a lapse of centuries, the ubiquitous love of animal ornament (albeit in a somewhat altered, Scandinavian-inspired form), the use of millefiori on the Lismore crozier, and the revival of red and yellow enamel on the Cross of Cong. To this may also be added the Adam and Eve figures on the pro-reform crosses of Roscrea and Dysert O'Dea,[47] which could be seen as "throw-backs" to the frequent representation of our First Parents on the older series of high crosses three hundred years earlier.

It might be tempting to see the Scandinavian-style animal interlacing found on a number of the shrines and on high crosses, such as those at Tuam, Roscrea, Kilfenora, and Dysert O'Dea, as an expression, almost the logo, of the reform movement set in motion by the activities of the newly converted and presumably reform-minded citizens of Dublin, whence some of the animal styles may have seeped into Irish art. But it would be difficult to follow through this argument rigorously because it was the monasteries more than the dioceses which commissioned the metal reliquaries and which bequeathed the shrines to hereditary keepers who helped preserve them before they passed into museum collections in the last century. But if the monasteries were responsible at least in part for commissioning these shrines, how then do we explain the fact that apparently pro-reform high crosses in Clare make frequent allusions to the former presence of reliquaries other than the arm-reliquary postulated above for the Dysert cross? These may be briefly summarized as follows:

1. The T-shaped object held up by two figures on the north side of the base of the Dysert O'Dea cross (Fig. 10), on whose stem is a knop (which can be felt more easily than seen) of the kind found on old Irish croziers. As Etienne Rynne[48] pointed out, this object may be identical with that carved into a recumbent slab near the south-western corner of the churchyard at Killinaboy some miles away, and may also be somehow related to the famous Tau Cross formerly at Killinaboy (now in the Heritage Centre at Corofin), and even to the T-shaped crozier held by one of the figures on the east face of the Doorty Cross at Kilfenora (Fig. 6).

2. The equal-armed cross consisting of five raised diamond shapes decorated with floral motifs on the head of the west face of the Dysert cross (Fig. 11). This could, by analogy with the equal-armed cross on the Shrine of St. Manchan (Fig. 5), mirror the decoration of a reliquary bearing an equal-armed cross made up of flat, diamond-shaped bosses. Shrines of similar shape and decoration may be copied by the two "boxes" decorated with saltires in the shape of an equal-armed cross (possibly with flattened bosses at the ends of each arm) at either side at the bottom of the shaft of a cross at Inishcealtra (Co. Clare), dating probably to the twelfth century (Fig. 12). It is also interesting to note that there is a roughly equal-armed cross on both faces of a high cross of uncertain date at Clonmore (Co. Carlow), where there is known to have been a great collection of relics.[49]

3. At the bottom of the west face of the Doorty Cross in Kilfenora, back-to-back with the face showing the three croziers, is a rider who places his leg on a shingled roof (Fig. 13) which may be

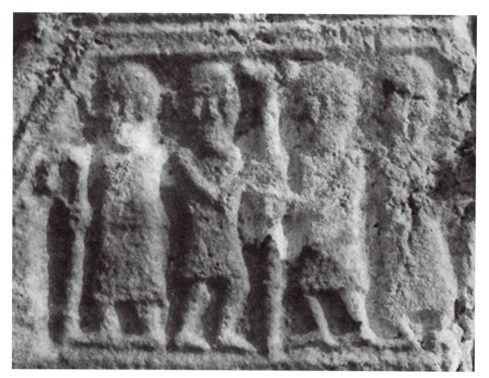

10. The central figures on the north face of the base of the twelfth-century high cross
at Dysert O'Dea, County Clare, holding what may be a T-shaped relic or reliquary between
them, and flanked by two figures with longer robes, one of them holding what may be a
pilgrim staff. The whole scene may represent a reliquary procession.

copying an old-fashioned house-shaped shrine once present on the site.[50] A similar but hooded
horseman on one of the Killeany crosses on Aran[51] has his horse's front legs on a step-like object
which could also represent a reliquary. If we interpret the rider in each case as a pilgrim coming
on horseback to venerate the relic of a local saint, then we might well ask if such an interpreta-
tion could also apply to the procession of horsemen and chariots on some of the earlier high
crosses in the centre and east of the country.

 4. In a field to the west of the cathedral of Kilfenora is a cross which has on its east face (Figs.
14, 15) a figure of Christ standing on a little ledge supported by a double rope-moulding. This
moulding descends along the centre of the shaft before forking at an angle into a gable shape
which is left rough and undecorated. Fergus O'Farrell[52] has made the ingenious suggestion that
one end of a sarcophagus shrine may have been placed up against this gable, like that already
seen translated into stone at Clones, where, significantly, one gable is left undecorated (Fig. 3). In
the County Monaghan town, however, there is no surviving cross of twelfth-century date at the
foot of which it could have been placed.[53]

 5. The same figure of Christ on the east face of the "Cross in the Field" at Kilfenora bears a
small satchel suspended from his neck by crossed straps. This satchel may be understood as a sym-
bolic container for relics, as may also have been the case with those seen on the Christ figure on
the Cashel cross[54] and a small figure on the Lismore crozier.[55] A figure on one of the crosses at

11. The west face of the high cross at Dysert O'Dea, with raised diamonds standing out in high relief, possibly reflecting the decoration on a reliquary once present on the site. The Adam and Eve panel on the base recalls the same two figures found frequently on the ninth-century crosses.

12. The box-shapes decorated with an equal-armed saltire cross that are an integral part of the high cross at Inishcealtra, County Clare, may copy twin reliquaries of bronze which once contained the relics of a local saint.

Downpatrick[56] would also seem to hold a reliquary and may represent one of the patron saints of Ireland whose bones John de Courcy claimed to have found in 1183.[57]

These allusions to relics, particularly on the Clare high crosses, must surely be explained in relation to pilgrimage traffic organized by monasteries, reformed or unreformed, but also by the newly created bishopric of Kilfenora, probably because both were equally in need of money, which they hoped the pilgrims would provide. Kilfenora and Dysert may represent two extremi-

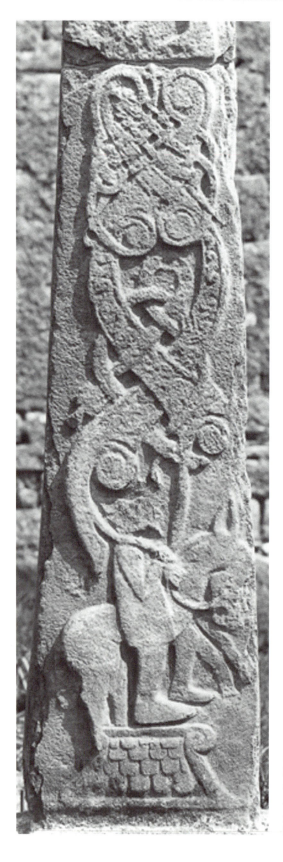

13. The west face of the shaft of the
Doorty Cross at Kilfenora, County
Clare, showing a horseman holding
onto the bottom of an asymmetrical
interlace of Viking inspiration as his
horse struts above a shingled gable

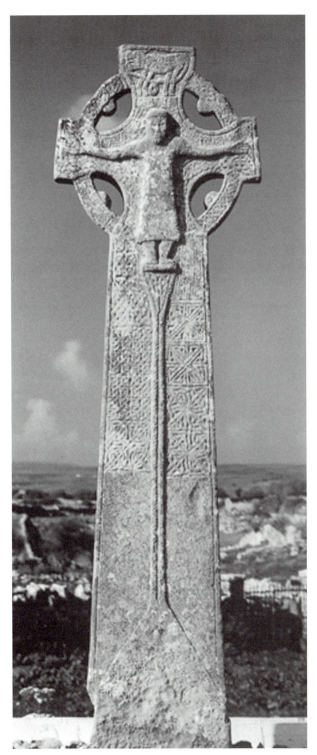

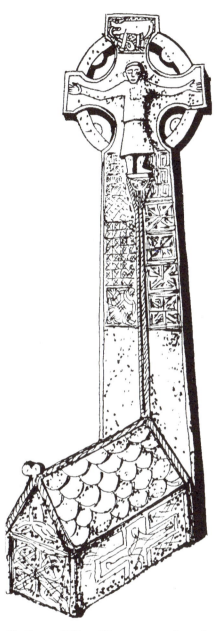

15. Fergus O'Farrell's reconstruction of the "Cross in the Field" at Kilfenora, with the gable end of a sarcophagus placed against the shaft

14. Cross in a field to the west of Kilfenora cathedral, County Clare, which may have had the gable end of a sarcophagus (like that at Clones, Fig. 3) placed up against the bottom of the shaft. The satchel on the breast of the Christ figure on the head may represent another reliquary

ties of a tight network of north Clare pilgrimage sites that would also have included Killinaboy (which may have housed a relic of the true cross in a shrine imitated in the double-armed cross on the external gable[58]) and Ráth Blathmach[59] (both of which, along with Dysert O'Dea, had round towers[60]), as well as Temple Cronan, near Carran, which preserves two slab-shrines near the small twelfth-century oratory.[61] Further evidence of pilgrimage may be hinted at by the fact that there were apparently seven crosses at Kilfenora—a number associated not only with the churches at Glendalough (one of Ireland's oldest pilgrimage places), but also with the churches which pilgrims visited on the seven hills of Rome.[62]

Because of surviving metalwork and the well-preserved details of its limestone crosses, County Clare provides us with an unusual insight into how twelfth-century Ireland used relics as a magnet to lure pilgrims to religious sites. It was the well-preserved traditions and practices of the old Irish monasteries, and the institutional church's view of the need to reform them, together with the urge felt by all parties to service a pilgrimage traffic which would create income (particularly in a poor region like Clare) that provided the climate for creating the unusual reliquaries, the great collection of croziers and crozier-shrines, and the unique high crosses that make Irish arts and crafts of the period so different from their Romanesque counterparts in the rest of Europe. The monasteries, those objects of reformers' zeal, were by then almost unique "fossils" in western Europe and were probably the main reason for the otherness of Irish art in the twelfth century. Their persistent retention of old artistic strengths, occasionally refreshed by new ideas from outside, preserved an ancient cultural identity strong enough to make unnecessary the introduction of many of the traits associated with the Romanesque style in the rest of Europe. This was the Indian Summer of an individualistic Early Christian art which for the most part ceased when the old monasteries which practised it gave up the battle for survival or were incorporated into Augustinian establishments by the time the thirteenth century dawned.

ACKNOWLEDGMENTS

For help with various aspects of this paper I would like to express my gratitude to Raghnall Ó Floinn of the National Museum of Ireland, together with Dr. Colmán Ó Clabaigh and Bro. James MacMahon, Benedictines of Glenstal Abbey.

NOTES

1. L. de Paor, "Cormac's Chapel: The Beginnings of Irish Romanesque," in *North Munster Studies: Essays in Commemoration of Monsignor Michael Moloney*, ed. E. Rynne (Limerick, 1967), 142.

2. H. G. Leask, *Irish Churches and Monastic Buildings*, vol. 1, *The First Phases and the Romanesque* (Dundalk, 1955).

3. H. J. Lawlor, *St. Bernard of Clairvaux's Life of St. Malachy of Armagh* (London and New York, 1920), 109.

4. M. F. Hurley, O. M. B. Scully, and S. W. J. McCutcheon, *Late Viking Age and Medieval Waterford: Excavations 1986–1992* (Waterford, n.d. [1997]), 190–243.

5. Lawlor, *Life of St. Malachy* (as in note 3).

6. R. Stalley, *The Cistercian Monasteries of Ireland* (London and New Haven, 1987).

7. A. Gwynn, *The Irish Church in the Eleventh and Twelfth Centuries*, ed. G. O'Brien (Dublin, 1992), 214.

8. F. Henry, *Irish Art in the Romanesque Period (1020–1170 A.D.)* (London, 1970), pl. 103.

9. De Paor, "Cormac's Chapel" (as in note 1).

10. R. Stalley, "Three Irish Buildings with West Country Origins," in *Medieval Art and Architecture at Wells and Glastonbury*, ed. N. Coldstream and P. Draper (London, 1981), 62–71.

11. F. Henry and G. Zarnecki, "Romanesque Arches Decorated with Human and Animal Heads," *JBAA* 20–21 (1957–58), 1–34.

12. P. Harbison, "Two Romanesque Carvings from

Ráth Blathmaic and Dysert O'Dea, Co. Clare," *NMAJ* 29 (1987), 7–11; P. Harbison, "The Church of Ráth Blathmach: A Photo-Essay," *The Other Clare* 24 (2000), 23–41.

13. Henry, *Irish Art* (as in note 8), 46–73.

14. F. Henry and G. L. Marsh-Micheli, "A Century of Irish Illumination (1070–1179)," *PRIA* 62C (1962), 101–64.

15. A. Grabar and C. Nordenfalk, *Romanesque Painting from the Eleventh to the Thirteenth Century* (Lausanne and New York, 1958).

16. D. M. Wilson and O. Klindt-Jensen, *Viking Art* (London, 1963); S. H. Fuglesang, *Some Aspects of the Ringerike Style: A Phase of Eleventh-Century Scandinavian Art* (Odense, 1980).

17. F. Henry, *The Book of Kells: Reproductions from the Manuscript in Trinity College Dublin* (London and New York, 1974), pl. 29.

18. B. Meehan, *The Book of Durrow* (Dublin, 1996), 39 and 41; Henry, *Book of Kells* (as in note 17), 177–80.

19. Henry, *Irish Art* (as in note 8), 68.

20. P. Harbison, "The Clones Sarcophagus: A Unique Romanesque-style Monument," *Archaeology Ireland* 13, no. 3 (Autumn, 1999), 12–16.

21. H. Swarzenski, *Monuments of Romanesque Art: The Art of Church Treasures in North-western Europe* (London, 1954), pl. 182.

22. T. D. Kendrick and E. Senior, "St. Manchan's Shrine," *Archaeologia* 86 (1937), 105–18.

23. R. Ó Floinn, "Irish Romanesque Crucifix Figures," in *Figures from the Past: Studies on Figurative Art in Christian Ireland in Honour of Helen M. Roe*, ed. E. Rynne (Dun Laoghaire, 1987), 168–88. See also his "Innovation and Conservatism in Irish Metalwork of the Romanesque Period," in *The Insular Tradition* (SUNY Series in Medieval Studies), ed. C. E. Karkov, M. Ryan, and R. T. Farrell (Albany, N.Y., 1997), 259–81. My thanks are due to Raghnall Ó Floinn for valuable discussion on some points raised in this paper.

24. H. O'Neill, *The Fine Arts and Civilisation of Ancient Ireland* (London and Dublin, 1863), 39–45.

25. Henry, *Irish Art* (as in note 8), 78.

26. C. Bourke, "Irish Croziers of the Eighth and Ninth Centuries," in *Ireland and Insular Art, A.D. 500–1200*, ed. M. Ryan (Dublin, 1987), 166–73.

27. For the latest on these twelfth-century crosses, see R. Cronin, "Late High Crosses in Munster: Tradition and Novelty in Twelfth-Century Irish Art," in *Early Medieval Munster: Archaeology, History, and Society*, ed. A. Monk and J. Sheehan (Cork, 1998), 138–46.

28. See most recently S. Ní Ghabhláin, "Church and Community in Medieval Ireland: The Diocese of Kilfenora," *JRSAI* 125 (1995), 61–84.

29. Henry, *Irish Art* (as in note 8), 139.

30. Henry, *Irish Art* (as in note 8), pl. 19.

31. For interpretations, compare those listed in P. Harbison, *The High Crosses of Ireland: An Iconographical and Photographic Survey* (Bonn, 1992).

32. A. Gwynn and R. N. Hadcock, *Medieval Religious Houses: Ireland* (London, 1970), 83.

33. R. Ó Floinn, "Arm Shrine of St. Lachtin," in *Treasures of Ireland: Irish Art, 3000 B.C.–1500 A.D.*, ed. M. Ryan (Dublin, 1983), 169–70.

34. I believe that it was on an original head-section of the cross which was later replaced by the existing one.

35. Gwynn and Hadcock, *Medieval Religious Houses* (as in note 32), 383.

36. Harbison, *High Crosses* (as in note 31), vol. 2, figs. 93–95.

37. L. de Paor, "The Limestone Crosses of Clare and Aran," *JGAHS* 26 (1955–56), 71.

38. Harbison, *High Crosses* (as in note 31), vol. 2, figs. 304–7.

39. Illustrated in Maggie Williams's contribution to this volume, Figures 4 and 5. See also P. Harbison, "Church Reform and Irish Monastic Culture in the Twelfth Century," *JGAHS* 52 (2000), 2–12.

40. Harbison, *High Crosses* (as in note 31), vol. 2, figs. 541–47.

41. Harbison, *High Crosses* (as in note 31), vol. 2, fig. 427b.

42. Harbison, *High Crosses* (as in note 31), vol. 2, figs. 568, 571, 572, 578, and 579.

43. Harbison, *High Crosses* (as in note 31), vol. 2, figs. 422–26.

44. Harbison, *High Crosses* (as in note 31), vol. 2, figs. 466–69.

45. The fact that Brecan was apparently a saint of the O'Brien family, which had introduced church reform into Ireland, could, however, negate the suggestion made here.

46. D. Ó Corráin, "Prehistoric and Early Christian Ireland," in *The Oxford History of Ireland*, ed. R. F. Foster (Oxford and New York, 1989), 40.

47. Harbison, *High Crosses* (as in note 31), vol. 2, figs. 541 and 263, respectively.

48. E. Rynne, "The Tau Cross at Killinaboy: Pagan or Christian?" in *North Munster Studies* (as in note 1), 146–65.

49. P. Harbison, "Early Christian Antiquities at Clonmore, Co. Carlow," *PRIA* 91C (1991), 177–200.

50. Of the kind discussed in M. Blindheim, "A House-Shaped Irish-Scots Reliquary in Bologna and Its Place among the Other Reliquaries," *ActArch* 55 (1984), 1–53.

51. Harbison, *High Crosses* (as in note 31), vol. 2, fig. 422.

52. F. O'Farrell, " 'The Cross in the Field,' Kilfenora: Part of a 'Founder's Tomb?' " *NMAJ* 26 (1984), 8–13.

53. The cross fragments erected in The Diamond at the centre of the town are much earlier: see Harbison, *High Crosses* (as in note 31), vol. 2, figs. 126–29.

54. See Harbison, *High Crosses* (as in note 31), vol. 2, fig. 95.

55. Henry, *Irish Art* (as in note 8), pl. 26.

56. Harbison, *High Crosses* (as in note 31), vol. 2, fig. 205.

57. Gerald of Wales, *The History and Topography of Ireland*, trans. J. J. O'Meara (Harmondsworth, 1982), 105.

58. P. Harbison, "The Double-Armed Cross on the Church Gable at Killinaboy, Co. Clare," *NMAJ* 18 (1976), 3–12.

59. T. J. Westropp, "Excursions of the Royal Society of Antiquaries of Ireland, Summer Meeting, 1900," *JRSAI* 30 (1900), 418–19; Harbison, "Ráth Blathmaic" (as in note 12); and R. Ó Floinn, "Ecclesiastical Objects of the Early Medieval Period from Co. Clare," *The Other Clare* 15 (1991), 14.

60. T. J. Westropp, "Churches with Round Towers in Northern Clare," *JRSAI* 24 (1894), 25–34 and 150–59.

61. P. Harbison, "Some Romanesque Heads from County Clare," *NMAJ* 15 (1972), 3–5.

62. Further thoughts on this subject may be found in P. Harbison, "An Ancient Pilgrimage 'Relic-Road' in North Clare?" *The Other Clare* 24 (2000), 55–59.

Masks and Monsters: Some Recurring Themes in Irish Romanesque Sculpture

•

TESSA GARTON

ROMANESQUE SCULPTURE made a late appearance in Ireland but rapidly developed a distinctive regional style. In this paper I will attempt to trace some of the elements derived from earlier Irish, Insular, and Viking traditions which contributed to the formation of an independent style of Irish Romanesque sculpture.

THE INTRODUCTION OF ROMANESQUE IN IRELAND

Since the publication of Liam de Paor's article on Cormac's Chapel,[1] that building has been widely accepted as marking the introduction of the Romanesque style in Ireland.[2] Begun in 1127 by Cormac Mac Carthaigh, king of Munster, it was designed as a royal chapel and was consecrated in 1134 in the presence of a great assembly of clergy and important laymen.[3] Its role in the development of Irish Romanesque has been seen as similar to that of Abbot Suger's St. Denis for French Gothic, or Canterbury cathedral choir for English Gothic. More recently, the view that Cormac's Chapel was the sole monument responsible for the introduction of Romanesque in Ireland has been modified by evidence of early Romanesque sculpture at other sites. Cormac Mac Carthaigh built other churches at Lismore in 1127, from which some fragmentary remains of Romanesque sculpture survive, indicating the existence of other models for the development of the Romanesque style in Munster.[4] The series of voussoirs with human heads at St. Fin Barre's Cathedral, Cork, probably from Cormac's foundation of Gill Abbey (before 1138), suggests the presence of masons from Cormac's Chapel and also indicates that Cormac's Chapel was not a unique example of imported Romanesque style.[5] The west facades of Ardfert cathedral and Roscrea have also been suggested as independent examples of Romanesque influence in Ireland.[6]

Cormac's Chapel remains, however, the most impressive and best-preserved example of early Romanesque architecture in Ireland, and it reflects a wide range of cultural influences, including Anglo-Norman, German, and western French elements, as well as traditional Irish features.[7] Its simple plan, small scale, and steeply pitched roof are reminiscent of earlier Irish traditions; however, the barrel-vaulted nave and rib-vaulted chancel incorporate some of the most up-to-date building techniques of Anglo-Norman Romanesque.[8] The decoration includes a number of typically Anglo-Norman features, including exterior and interior blind arcading and chevron ornament. The doorways are decorated with chevron and have carved tympana with animals in relief, similar in style and iconography to Anglo-Norman tympana.[9]

A feature that is more unusual in an Anglo-Norman context is the use of human heads around the chancel arch, on the ribs of the chancel vault, and on corbels and capitals (discussed elsewhere in this volume by Susanne McNab). This motif appears to be derived from western French examples, either through direct influence or through lost English intermediaries.[10] Henry compared the human heads on the chancel arch of Cormac's Chapel with those at Belle-garde-du-Loiret, where the placing of the heads in a hollow moulding and parallel to the arch is particularly close to the arrangement at Cashel.[11]

The chancel arch and corbels include a mixture of naturalistic and grotesque heads; most are human, but there are also some monsters and animals. In addition to the corbel heads, there are also heads biting mouldings, a motif which has sources in Romanesque sculpture of the West Country in England.[12] The transverse arches of the nave vault include a number of capitals with human heads at the angles, some bearded or with tongue or foliage protruding from gaping jaws. Small angle heads on capitals are fairly common in English Romanesque, but heads which take up the full height of the capital like those at Cashel are more unusual.[13]

Cormac's Chapel appears to have been built by Anglo-Norman masons and sculptors working together with Irish masons, incorporating some ideas derived from western France. It represents the purest form of Anglo-Norman Romanesque in Ireland. The design and decoration of the chapel introduced new Romanesque elements into the vocabulary of Irish masons and sculptors. These included blind arcading, the articulation of arches and doorways, chevrons, carved tympana, and the decoration of arches, corbels, and capitals with human and animal heads. Significantly, the sculpture did not include any narrative or religious imagery. In this respect it is also similar to what survives of early Gothic sculpture in Ireland, where there is a similar emphasis on secular imagery and on the head in particular. The structural innovations such as rib-vaulting had little impact in Ireland, but the decorative forms were taken up and elaborated elsewhere by Irish masons.

While the concept of architectural sculpture was new in Ireland, the native tradition of monumental stone sculpture, which had developed in the decoration of free-standing crosses erected around the ninth century, was still active. This tradition is evident in the decoration of the high crosses which continued to be erected during the Romanesque period and is reflected in the decoration of the sarcophagus located at the west end of the nave in Cormac's Chapel. This has been identified either as the tomb of Cormac Mac Carthaigh, or more probably of his brother and predecessor King Tadhg Mac Carthaigh (d. 1124).[14] The sarcophagus is decorated with interlaced animals similar to those found in earlier Irish metalwork and manuscript illumination.

A number of objects connected with the patronage of Turlough O'Connor, king of Connacht (1106–56), illustrate the popularity of animal interlace in a variety of media. The Cross of Cong, made by Maelisu between 1122 and 1136 to enshrine a fragment of the true cross, is decorated with gilt-bronze animal interlace.[15] Similar animal interlace decorates the shaft of the Market Cross at Tuam (Co. Galway), made, according to an inscription, for the same patron between 1126 and 1156.[16] Stalley has recently suggested that designs or even templates for the sculptor of the cross may have been provided by the metalworker.[17] The twelfth-century Corpus Missal, containing initials decorated with interlaced monsters and snakes, includes prayers for the king of Ireland and his son, and may also be connected with the patronage of Turlough O'Connor.[18]

Thus the situation in Ireland around 1135, on the completion of Cormac's Chapel, involved two very different artistic traditions. Alongside the new Anglo-Norman architectural sculpture in-

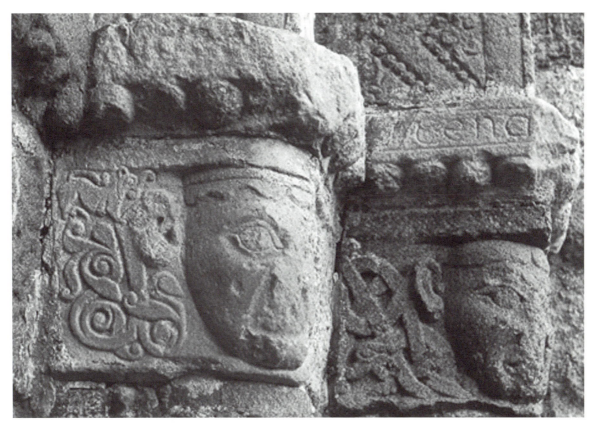

1. Killeshin, County Laois, west doorway, capitals

troduced in Cormac's Chapel and in the lost churches built by Cormac Mac Carthaigh at Lismore and Cork, there existed the Irish Urnes tradition, used in stone carving, metalwork, and manuscript illumination. These two traditions were both incorporated in the development of a distinctive Hiberno-Romanesque style (discussed elsewhere in this volume by Peter Harbison).

CAPITALS WITH ANGLE HEADS

A distinctively Irish form of capital with human angle heads appears to have developed in a group of buildings dating from the 1150s and 1160s. The greatest concentration of these is in Leinster, but there are a significant number of examples in the west of Ireland.[19] The heads take up the full height of the capital, like those at Cormac's Chapel, but are typically flanked by panels of interlace and traditional Irish motifs. The heads vary from more naturalistic faces to highly stylized masks, but are not grotesque or grimacing in the manner of those at Cashel.

Some of the finest and most characteristic examples are those on the west doorway at Killeshin in County Laois (Fig. 1). The fragmentary inscriptions on the portal have been interpreted as referring to Diarmait Mac Murchada, king of Leinster from 1126 to 1166.[20] Diarmait patronized a number of churches, including the Augustinian abbey of St. Mary at Ferns (founded ca. 1158) and the Cistercian abbey at Baltinglass (founded in 1148).[21] There is no documentation of

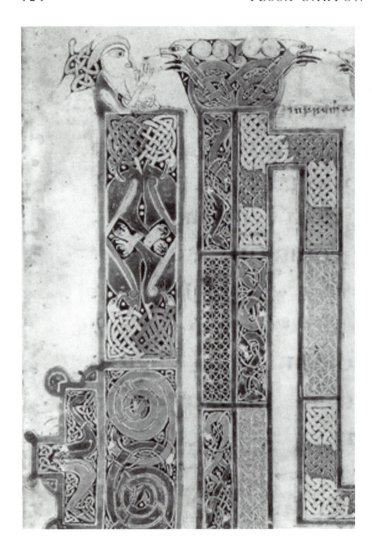

2. Oxford, Bodleian Library, Ms. Auct.
D.2.19, Gospels of MacRegol, f. 127r,
opening page of St. John, detail

the building of the church at Killeshin, but similarities with the decoration of Baltinglass suggest a date around the mid-twelfth century.[22]

The frieze-like capitals have angle heads placed over the pseudo-angle shafts of the jambs. The heads are of two types: some bearded and carved in shallow relief, some beardless and carved in higher relief. These two types correspond to the different types of stone used in the doorway and thus do not necessarily represent the work of different sculptors, but rather an adaptation to the different qualities of the stone. Flanking the heads are a variety of interlaced designs in shallow relief, with the hair extending into lacertine animals or foliage. Similar designs of heads with interlaced hair are found in Insular manuscripts, such as the Gospels of MacRegol, written and illuminated by MacRegol, abbot of Birr in the early ninth century (Fig. 2).[23] A similar manuscript could have served as a model for the sculptor at Killeshin. The interlaced beasts on the Killeshin capitals also show Viking influence: the curling lappets on their jaws are similar to those on an eleventh- or twelfth-century bone trial-piece found in the excavations of High Street in Dublin.[24] The shallow relief carving at Killeshin is also similar to metalwork. The doorway was

probably painted to render the carving more visible, a technique which would have masked the random use of stones of different colour in the doorway. There is a single human head at the apex of the arch.

The doorway of the round tower at Timahoe appears to be by the same workshop or sculptor as the Killeshin doorway.[25] Here the heads on the capitals are all bearded, and are flanked by interlaced strands of hair on the sides and face of the capitals. The sculpture of the Augustinian Priory of St. Saviour at Glendalough (Co. Wicklow) is also closely related to that at Killeshin (and to Baltinglass). The similarities may be explained by the close personal connection between Diarmait Mac Murchada, the patron of Killeshin and Baltinglass, and Laurence O'Toole, abbot of Glendalough from 1154 to 1162, who was probably responsible for the building of the church of St. Saviour.[26] The inner order of the chancel arch has capitals with angle heads (Fig. 3). The heads are in high relief, due to their placement on a semi-column instead of a pilaster. In the centre of the capital, the long hair interlaces with an inverted beast head with Scandinavian style lappets.[27] On the right face of the capital is an animal in profile.

Other examples of capitals with angle heads are varied in style and have been found over a wide geographical area. Among the most finely carved examples are those in the rebuilt chancel arch at Kilteel (Co. Kildare).[28] They show naturalistic modelling of facial structure combined with detailed but highly stylized treatment of hair and beard, which extends to form panels of interlace flanking the heads. The capitals are similar to those at Killeshin, but seem more advanced and are probably somewhat later in date.

In contrast, the capitals with angle heads at Duleek (Co. Meath)[29] and Kilmore (Co. Cavan)[30] have a savage, stylized quality that suggests strong influence from Scandinavian art. As at Kilteel,

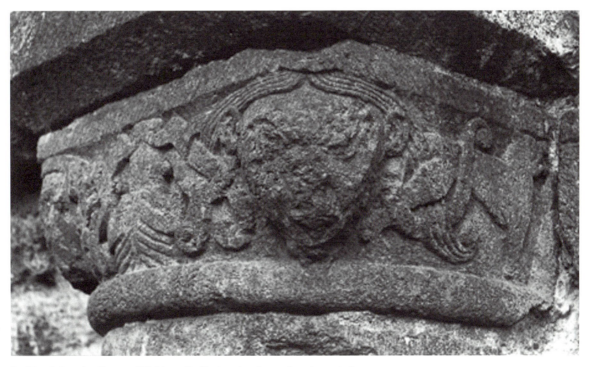

3. Glendalough, County Wicklow, St. Saviour's, chancel arch capital

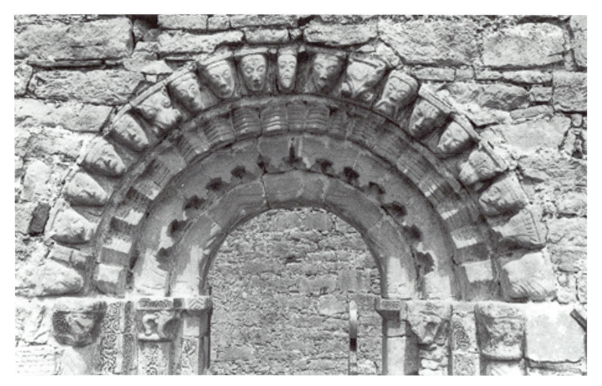

4. Dysert O'Dea, County Clare, arch of south doorway

the hair, beard, and moustache are interlaced, but the face is stylized, the eye enlarged, and the expression more monster-like than human. The chancel arch capitals at Rahan (Co. Offaly)[31] combine stylized human angle heads with shallow incised foliage designs. The heads are powerful and expressive, with a projecting jaw accentuating the angle of the capital and the colonette below. Hair, moustache, and beard terminate in spirals instead of the more usual interlace. The chancel arch at Inisfallen (Co. Kerry)[32] has a block-like capital with an angle head somewhat similar to those at Rahan.

There is also an important group of capitals with angle heads in the west of Ireland, at Dysert O'Dea (Co. Clare), and at Annaghdown and Inchagoill in Galway. The remains at Annaghdown Priory, on the shore of Lough Corrib, are fragmentary, consisting of the dismantled jambs of a chancel arch with frieze-like capitals decorated with angle heads and panels of zoomorphic interlace. The church was confirmed to the Arroaisian canonesses of Clonard in 1195, but was in existence earlier and may have become Arroaisian soon after Clonard, in about 1144.[33] The sculpture of the Saints' Church at Inchagoill, near Annaghdown on an island in Lough Corrib, is probably by the same workshop.[34] The capitals of the west doorway have similar angle heads with interlaced hair or moustaches, and there are also human heads around the arch. Other details at Inchagoill, notably the facing chevron and the monster head capitals of the second order, are similar to the west doorway of the Nuns' Church at Clonmacnois (Co. Offaly), dated 1167.[35] This might indicate a date in the 1160s or 1170s for the sculpture at both Inchagoill and Annaghdown.

The combination of capitals with angle heads and an arch with human heads is also found

in the south doorway at Dysert O'Dea (Co. Clare) (Fig. 4).[36] The use of detached angle colonettes rather than pseudo-angle shafts probably indicates closer connections with the purer forms of Anglo-Norman Romanesque, as found in Cormac's Chapel. The capitals with angle heads are also more three-dimensional and less frieze-like than those at Annaghdown or Inchagoill. The heads on the inner order have small animals biting at (or whispering in?) their ears. This motif is found on a number of earlier pieces of metalwork, such as the eighth- or ninth-century bell shrine crest in the National Museum of Ireland.[37] The capitals of the outer order instead have the more usual interlaced hair.

ARCHES DECORATED WITH HUMAN HEADS

Like the capitals with human heads, arches decorated with human and animal heads also became a distinctive feature of Irish Romanesque.[38] There are remains of arches which appear to have had a row of human heads at Cashel, Cork, Dysert O'Dea, Inchagoill, Ballysadare, Inishcealtra, and possibly Kilmore. There are some significant differences between the arches at Cormac's Chapel and the other Irish examples. The other arches form part of doorways rather than being chancel arches, and all have heads placed radially rather than parallel to the arch, whereas at Cashel only the top voussoirs have radial heads. Unfortunately, all of these arches with human heads, apart from the chancel arch at Cashel, have been dismantled or rebuilt, and none remains intact.

The six voussoirs found in St. Fin Barre's Cathedral, Cork, appear to be the earliest of the group and are closely related to the heads at Cashel. They were re-used as building stones in the tower of Cork cathedral in 1674, and Bradley and King have convincingly suggested that the stones may come from Gill Abbey, Cork, founded by Cormac Mac Carthaigh between 1134 and 1138.[39] The heads are of high quality, with finely detailed carving and a varied treatment of the hair. They are larger in relation to the voussoirs than those at Cashel and were placed radially beneath an edge moulding. The original context of the voussoirs is uncertain, but they appear to have come from the outer order of an arch.

The arch at Inchagoill has evidently been rebuilt with a shallower curve due to the loss of one or two voussoirs.[40] The arch now consists of ten human heads on nine voussoirs, set radially under a moulding. The heads are varied; most are beardless, but one has curly hair and a beard, and one, on the far right, wears a cowl or hood.

The doorway at Dysert O'Dea has been rebuilt into the south wall of the church, probably using the remains of the original west doorway (Fig. 4).[41] The outer order of the arch contains a mixture of human and animal heads. The twelve human heads show a variety of hairstyles, mostly beardless, some bearded, comparable to the heads at Cashel and Cork. They are interspersed with seven animal heads, three of which are biting at a section of roll moulding. The voussoirs do not appear to be in their original sequence, and may have come from more than one arch. The human heads show typically Irish features. Henry compared the biting beast heads to the metalwork example at the base of the Cross of Cong, and suggested a date of circa 1125–35 for the portal, based on the similarities with the Cross of Cong and with western French examples of beast heads.[42] However, there seems no reason to assume that sculptural designs could not be influenced by earlier as well as by contemporary metalwork models, and on the basis of stylistic

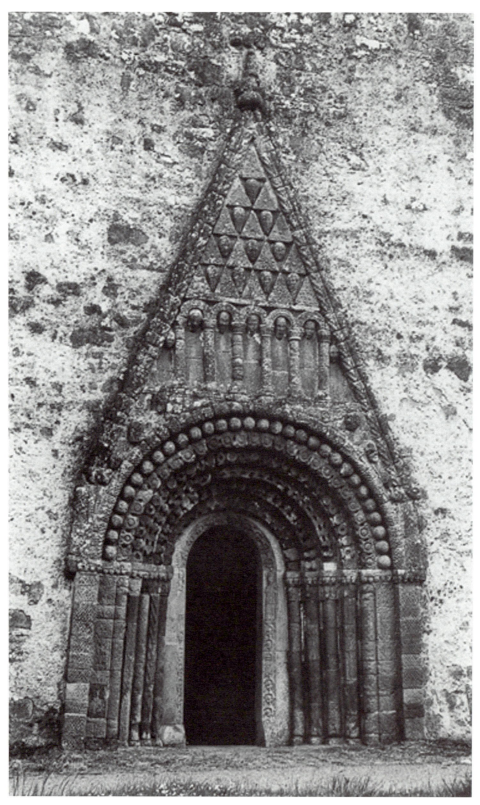

5. Clonfert cathedral, County Galway, west portal

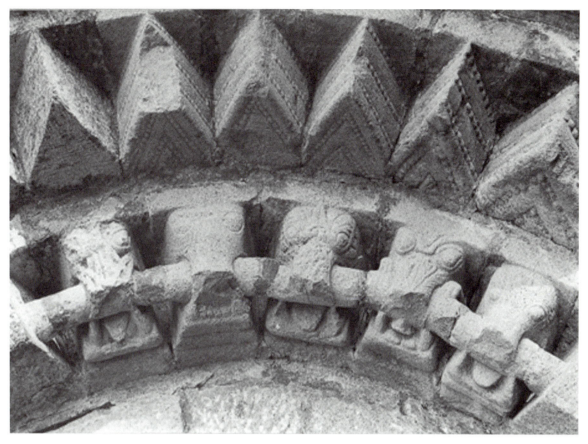

6. Clonmacnois, County Offaly, Nuns' Church, west doorway, detail of arch

analysis and comparison with other dated examples of Irish Romanesque, a mid-twelfth-century date seems more likely for the sculpture at Dysert O'Dea.[43]

Perhaps the most extraordinary and striking use of human heads in Hiberno-Romanesque is in the west doorway at Clonfert (Co. Galway), where they fill the tangent gable, set under blind arcades and in triangular panels (Fig. 5).[44] The heads under the arcades must have had painted bodies, like the enamelled bodies of figures on Limoges enamel shrines.[45] The treatment of the gable is flat and two-dimensional, and the doorway incorporates a rich variety of characteristically Irish decorative elements, including interlace, animal ornament, spirals, and decorative bosses derived from the decoration of metalwork and stone crosses.

ANIMAL HEADS

Animal heads used to decorate arches and jambs are also a common motif in Irish Romanesque. There are well-preserved examples at Clonmacnois, Clonfert, and Dysert O'Dea.[46] The west doorway of the Nuns' Church at Clonmacnois (Co. Offaly), completed in 1167 by Derbforgaill, the wife of Tigernán O'Rourke, has an arch with beast heads biting a roll moulding (Fig. 6). The same motif is used on the west doorway at Clonfert (Fig. 5).[47] Although similar to English beak-

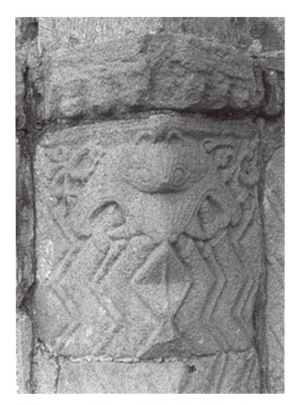

7. Clonmacnois, County Offaly, Nuns' Church, west
doorway, detail of jamb

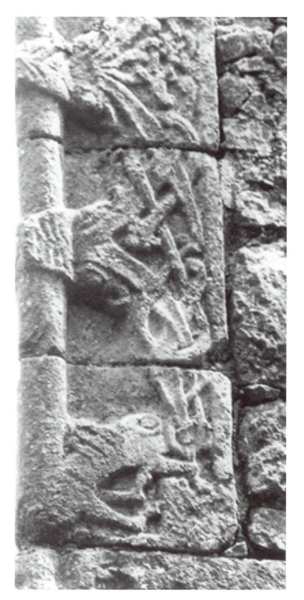

8. Dysert O'Dea, west window, detail of jamb

head, such as that found at Iffley in Oxfordshire,[48] the Irish type of biting beast differs from the
bird-like forms of beak-head in that the jaws clasp the moulding, instead of having a beak laid
over the moulding. Henry compared the design to the biting horse heads on arches at Perignac
and at St. Fort-sur-Gironde in western France.[49] It seems unlikely, however, that a small detail of
this kind would be transmitted from western France to Ireland without a more general influence
also being evident in the design of the doorway. Stalley has recently proposed a more specific and
convincing comparison with an eighth-century bronze door handle from Donore (Co. Meath).[50]
Similar door handles may have adorned the churches at Clonmacnois, and this parallel suggests
that the sculptors looked at locally available models for specific details of design, transposing im-

ages from doors to the carved portal, while deriving general themes such as the arch with radiating heads from more distant sources.

Similar beast heads biting a moulding appear on the jambs of the chancel arch of Temple Finghin, Clonmacnois, where their jaws clasp the angle shafts.[51] The rebuilt west window at Dysert O'Dea also includes a series of jambstones with beast heads biting the angle roll, their heads linked by interlaced lappets (Fig. 8).[52] Beast heads are also commonly found at the top of the jambs. At the Augustinian priory of Monaincha (Co. Tipperary), they occur on the west doorway, swallowing the arris roll. At the Nuns' Church, Clonmacnois, there are beast heads on the west doorway which appear to be swallowing snake-headed chevron (Fig. 7), while on the chancel arch there are capitals with heads at the angles, some of which appear to be swallowing the angle shaft (Fig. 14). There are both English and French sources for this motif of column-swallowers, which had already been introduced into the repertoire of Irish Romanesque at Cashel.[53]

ZOOMORPHIC MOULDINGS

Zoomorphic decoration in Irish Urnes style, as found on the Cashel sarcophagus and the Tuam cross, is a common element in Irish Romanesque sculpture. It appears as a low-relief decoration on some of the capitals of the chancel arch of the Nuns' Church, Clonmacnois (Fig. 14), and on the capitals at Killeshin (Fig. 1). A more creative and architectural variation of the beast and snake motif involves the use of zoomorphic mouldings. Chevron mouldings may be formed of the bodies of snakes, as at the Nuns' Church at Clonmacnois (Fig. 7), Tuamgraney (Co. Clare), and Killaloe.[54] At St. Saviour's, Glendalough, the chevron moulding of the left jamb of the east window terminates with a spiral enclosing a beast head. At Dysert O'Dea the jambs of the south portal are decorated with interlaced beasts of Irish Urnes type, as well as with chevron with zoomorphic mouldings (Fig. 9). Small beast heads emerge from the chevron mouldings and turn back to bite at them. This treatment of mouldings can be compared to earlier examples in manuscript illumination and metalwork, for example, on the Tara brooch, where the borders of the brooch break out into similar beast heads (discussed and illustrated elsewhere in this volume by Naimh Whitfield). In the reconstructed west window at Dysert O'Dea, the window moulding itself is zoomorphic, ending in the forequarters of an animal (Fig. 8).

The late Romanesque doorway at Killaloe (Co. Clare) includes a rich variety of chevron forms combined with masks and monsters.[55] Three human heads on the arch are flanked by small animals, snakes appear in the chevron and on the jambs, and the angle shafts and mouldings are transformed into monsters which bite other mouldings at the top and base of the jambs (Fig. 10). The doorway at Killaloe probably dates from circa 1200 and belongs to a late Romanesque school in the west of Ireland. Similar zoomorphic mouldings can be seen in the remains of Romanesque windows at Tuamgraney and Ráth Blathmach in County Clare. A window in Annaghdown cathedral (Co. Galway), also probably dating from about 1200 or slightly later, has a moulding in the form of a great beast extending around the window and battling with smaller snakes which emerge from the chevron mouldings (Fig. 11).[56] This beast and snake motif has a long history in Viking and Irish art.[57] The motif at Annaghdown can be compared to a detail in the Book of Kells, where similar small snakes battle with a larger beast which forms the initial (Fig. 12).

9. Dysert O'Dea, south doorway, detail of jamb

10. Killaloe cathedral, County Clare, Romanesque doorway, detail of right jamb

The use of zoomorphic elements in architectural sculpture persisted into the early thirteenth century in the west of Ireland. Masks, monsters, and snakes appear on the capitals and mouldings of the east windows of the Augustinian abbey of Ballintober (Co. Mayo), built between 1216 and 1225.[58] The central and flanking mouldings terminate at the top of the jambs in a central mask and flanking beast heads, from the jaws of which emerge interlocking snakes. The Cistercian abbey of Corcomroe in County Clare (dated 1210–25) has another variation on the theme of zoomorphic mouldings; the exterior angle shafts of the chancel become monsters biting at a stringcourse.[59] A striking comparison can again be made with manuscript illumination, where the frame of a text page is frequently transformed into an animal, for example, in the Lindisfarne Gospels (Fig. 13).[60]

The sculptor at Corcomroe would not have needed to look back to earlier manuscripts for such a motif, however, since this kind of decoration continued to be used in the twelfth century,

11. Annaghdown cathedral, County Galway, east window, detail of jamb

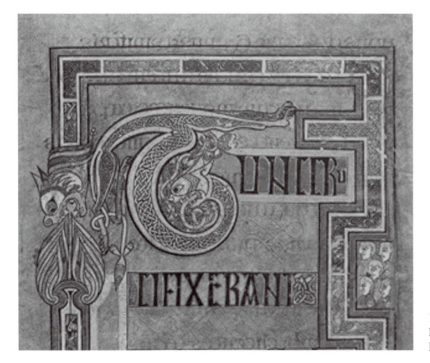

12. Dublin, Trinity College Library, Ms. A.I.6 (58), Book of Kells, f. 124r

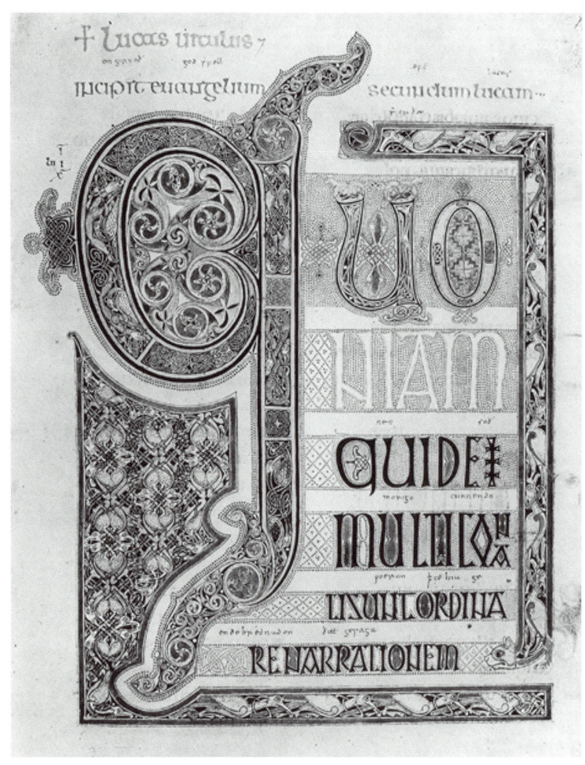

13. London, British Library, Ms. Cotton Nero D.IV, Lindisfarne Gospels, f. 139r

even in a Cistercian context. The Psalter of Cormac, now in the British Library, which was probably copied for an Irish Cistercian monastery in the second half of the twelfth century,[61] has pages with zoomorphic frames, as well as initials with interlaced beasts and snakes, a form of decoration clearly contrary to Cistercian regulations.[62]

CONCLUSIONS

Cormac's Chapel was clearly an important influence in introducing the new Romanesque fashion for architectural sculpture, and its decoration included an unusual emphasis on the human head, which remained a popular theme in later Irish Romanesque. The new style was, however, soon modified according to local taste and native traditions, incorporating animal interlace and zoomorphic decoration from Insular and Viking art.

It is hard to explain the enthusiasm with which the motif of human heads on corbels, arches, and capitals was taken up and developed in Irish Romanesque sculpture. Henry and Zarnecki remarked on the popularity of the human head motif in France and in Ireland, and questioned whether it would be too far-fetched to suggest that it may be due to its analogy with Celtic decoration.[63] Although there is little evidence of continuity in the use of human heads from ancient Celtic art to the Romanesque period, there is some evidence of a continuing interest in the motif in Early Christian and pre-Romanesque art in Ireland.[64] The significance of these human heads remains enigmatic, but in view of the evidence for a continuity of native traditions in the use of other motifs, it was perhaps a similar influence which inspired sculptors to populate the doorways and arches of Romanesque churches with such a profuse array of human heads.

This revival (or survival) of native traditions in Irish Romanesque raises a number of questions regarding the contribution of patrons or sculptors to the development of the Romanesque style. If the masons employed to carve the new forms of architectural sculpture were trained as stone sculptors and also worked carving high crosses, it is not surprising that motifs and designs from these monuments were transferred to the context of architectural sculpture. The similarities with metalwork might also indicate that metalworkers were employed in designing or carving templates for architectural sculpture, as suggested by Stalley for the high cross at Tuam.[65] Objects such as bone motif-pieces could have served to transmit designs from one medium to another.[66] It is questionable to what extent valuable objects of metalwork or illuminated manuscripts would have been available for use as models in the masons' yard, but if such objects served as models for sculptors, they could have included earlier shrines or manuscripts as well as contemporary works.

The emphasis on ornament and decoration rather than religious iconography can be seen as a survival of Insular traditions. The simplified articulation of Irish Romanesque architecture, as seen in the chancel arch of the Nuns' Church, Clonmacnois, with low-relief carvings of animal interlace and geometric ornament on square capitals and circular bases (Fig. 14), is similar to the two-dimensional treatment of the arcades in the canon tables of Insular manuscripts. The canon tables in the Book of Kells have similar square capitals and circular bases, and the architectural forms are transformed into biting beast heads (Fig. 15). Thus the enrichment of doorways and chancel arches with ornament emphasizes their importance as areas of entrance into sacred

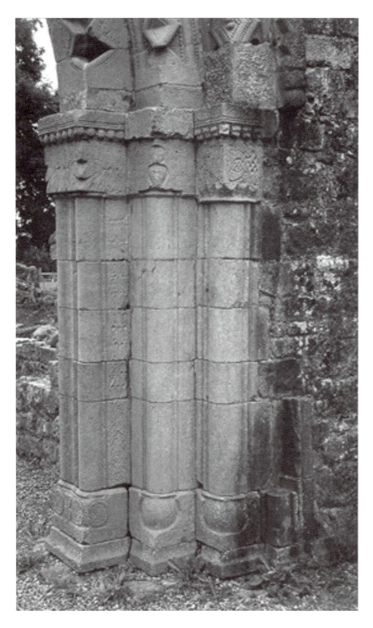

14. Clonmacnois, County Offaly, Nuns'
Church, jamb of chancel arch

space in the church, in much the same way as the illumination of an Insular manuscript empha-
sizes the sacred nature of the text, and the canon tables function as the entrance to the text that
follows.

The traditions of Insular art appear to have been so dominant in twelfth-century Ireland that
other influences—whether from Viking, Anglo-Norman, or French art—were transformed and
reinterpreted according to the aesthetic principles of the Insular style. Only those forms which
conformed to Irish taste were adopted, such as abstract, geometric, and, in particular, animal or-
nament. Elements from the repertoire of earlier Irish art, such as animal interlace and the trans-
formation of borders and mouldings into animals, were incorporated into the new Romanesque
architectural sculpture.

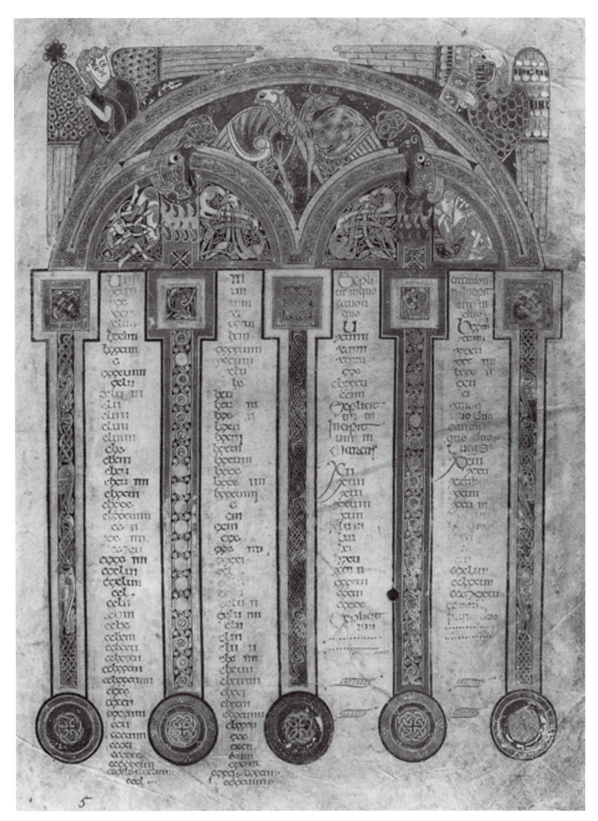

15. Dublin, Trinity College Library, Ms. A.I.6 (58), Book of Kells, f. 5r

NOTES

1. L. de Paor, "Cormac's Chapel: The Beginnings of Irish Romanesque," in *North Munster Studies: Essays in Commemoration of Monsignor Michael Moloney*, ed. E. Rynne (Limerick, 1967), 133–45.

2. This topic is discussed elsewhere in this volume by Peter Harbison. See also R. Stalley, "Three Irish Buildings with West Country Origins," in *Medieval Art and Architecture at Wells and Glastonbury* (British Archaeological Association Conference Transactions for the Year 1978) (London, 1981), 62–65; T. Garton, "A Romanesque Doorway at Killaloe," *JBAA* 134 (1981), 31–57.

3. F. Henry, *Irish Art in the Romanesque Period (1020–1170 A.D.)* (London, 1970), 170.

4. T. O'Keeffe, "Lismore and Cashel: Reflections on the Beginnings of Romanesque Architecture in Munster," *JRSAI* 124 (1994), 118–52.

5. J. Bradley and H. King, "Romanesque Voussoirs at St Fin Barre's Cathedral, Cork," *JRSAI* 115 (1985), 146–51.

6. T. O'Keeffe, "La Façade romane en Irlande," *CahCM* 34 (1991), 362–63; O'Keeffe, "Lismore and Cashel" (as in note 4).

7. For a more detailed analysis of these influences, see Stalley, "Three Irish Buildings" (as in note 2); and O'Keeffe, "Lismore and Cashel" (as in note 4), 138–43.

8. Stalley, "Three Irish Buildings" (as in note 2), 64. Stalley demonstrated specific links with English Romanesque in the West Country and suggested that English-trained masons were involved in the construction of the chapel.

9. The tympanum at Fritwell (Oxon.) has animals similar in style to those at Cashel, and at Kencott (Oxon.) there is a centaur (identified as Sagittarius) shooting an arrow at a monster, similar to the image on the north doorway at Cashel.

10. Stalley, "Three Irish Buildings" (as in note 2), 63. Stalley points out a parallel for the heads at Cashel in the Romanesque doorway at Prestbury (Lancs.), where the hood moulding has small heads in relief placed both parallel and radial to the arch, as at Cashel. He suggests the possibility of other lost English examples of this technique.

11. Henry, *Irish Art* (as in note 3), 175, pl. VI; F. Henry and G. Zarnecki, "Romanesque Arches Decorated with Human and Animal Heads," *JBAA*, 3rd ser., 20 (1957), 18–19. Bellegarde-du-Loiret, although located east of Orleans, is related to western French traditions.

12. The mask on the apex of the hood moulding of the north portal at Cashel (Henry, *Irish Art* [as in note 3], pl. 102) can be compared to a beast head from Old Sarum (ca. 1140) in Salisbury Museum, which also appears to come from the apex of an arch. A series of similar beast heads biting mouldings appears at the apex of the nave arcades of Malmesbury Abbey in Wiltshire (ca.

1160). See G. Zarnecki, *Later English Romanesque Sculpture, 1140–1210* (London, 1953), pls. 45, 46.

13. A number of the capitals of the tower arches and south doorway of St. Kyneburgha, Castor, dated 1124, have large human angle masks with foliage emerging from the nose or mouth, similar to those in Cormac's Chapel. N. Pevsner, *Buildings of England: Bedfordshire and the County of Huntingdon and Peterborough* (Harmondsworth, 1968), 227–29; G. Zarnecki, *English Romanesque Sculpture, 1066–1140* (London, 1951), pl. 42.

14. J. Bradley, "The Sarcophagus at Cormac's Chapel, Cashel, Co. Tipperary," *NMAJ* 26 (1984), 14–35; Henry, *Irish Art* (as in note 3), 146–47, pl. 89.

15. Henry, *Irish Art* (as in note 3), 106–10, pls. 41–43, M; R. Ó Floinn, "Schools of Metalworking in Eleventh- and Twelfth-Century Ireland," in *Ireland and Insular Art, A.D. 500–1200*, ed. M. Ryan (Dublin, 1987), 186; R. Ó Floinn, "Innovation and Conservatism in Irish Metalwork of the Romanesque Period," in *The Insular Tradition*, ed. C. Karkov, R. Farrell, and M. Ryan (New York, 1997), 269.

16. Illustrated in Maggie Williams's contribution to this volume, Figs. 2–5; see also Henry, *Irish Art* (as in note 3), 124, 140–41, pls. 63, 64.

17. R. Stalley, "The Mason and the Metalworker" (paper presented at the symposium on Romanesque sculpture in Ireland, Trinity College, Dublin, 13 May 1995).

18. Oxford, Corpus Christi College, Ms. 282. Henry, *Irish Art* (as in note 3), 61, pls. 4, 5, J.

19. There are examples at Killeshin and Timahoe (Co. Laois), Glendalough (Co. Wicklow), Kilteel (Co. Kildare), Rahan (Co. Offaly), Freshford and Ullard (Co. Kilkenny), Duleek (Co. Meath), Kilmore (Co. Cavan), Cashel and Roscrea (Co. Tipperary), Dysert O'Dea (Co. Clare), Inisfallen and Ardfert (Co. Kerry), Annaghdown and Inchagoill (Co. Galway).

20. R. A. S. Macalister, *Corpus Inscriptionum Insularum Celticarum* (Dublin, 1945–49), vol. 2, 26–28, no. 574. H. G. Leask, *Irish Churches and Monastic Buildings*, vol. 1 (Dublin, 1955), 102–6, suggested that the inscription referred to a King Diarmait who died in 1117, but this is clearly too early. See R. Stalley and J. Brady, "Killeshin," in *The Corpus of Romanesque Sculpture in Britain and Ireland*, forthcoming (to be published electronically under the auspices of the British Academy). For illustrations of the capitals, see Henry, *Irish Art* (as in note 3), pl. 92.

21. A. Gwynn and R. N. Hadcock, *Medieval Religious Houses: Ireland* (Dublin, 1988), 127, 175; R. Stalley, *The Cistercian Monasteries of Ireland* (London and New Haven, 1987), 242.

22. T. O'Keeffe, "Romanesque Sculpture and the Patronage of Diarmaid McMurrough" (paper presented at

the symposium on Romanesque sculpture in Ireland, Trinity College, Dublin, 13 May 1995). O'Keeffe also suggested Diarmait's possible involvement in providing masons and sculptors for the construction of St. Saviour, Glendalough, during the abbacy of Laurence O'Toole.

23. Oxford, Bodl., Ms. Auct. D.2.19, f. 127; J. J. G. Alexander, *Insular Manuscripts, Sixth to the Ninth Century* (A Survey of Manuscripts Illuminated in the British Isles, vol. 1) (London, 1978), 77–78, cat. no. 54, ill. 269.

24. Dublin, National Museum of Ireland. G. F. Mitchell, *Treasures of Early Irish Art, 1500 B.C. to 1500 A.D.* (New York, 1977), 189, fig. 37; U. O'Meadhra, *Early Christian, Viking, and Romanesque Art: Motif-Pieces from Ireland* (Stockholm, 1979), cat. no. 32, pl. 9; U. O'Meadhra, "Irish, Insular, Saxon, and Scandinavian Elements in the Motif-Pieces from Ireland," in *Ireland and Insular Art* (as in note 15), 162–63.

25. Leask, *Irish Churches* (as in note 20), 107–10, fig. 60; R. Stalley, "Timahoe," in *Corpus of Romanesque Sculpture* (as in note 20), forthcoming.

26. O'Keeffe, "Romanesque Sculpture" (as in note 22); R. Stalley, "Glendalough," in *Corpus of Romanesque Sculpture* (as in note 20), forthcoming; Henry, *Irish Art* (as in note 3), 145, 152–53; Leask, *Irish Churches* (as in note 20), 96–100.

27. Leask, *Irish Churches* (as in note 20), 96–97, interpreted this as "the gunwale of a boat or galley, complete with sail and indications of the crew." This would be a unique subject in the context of Irish Romanesque, whereas animal masks are a common motif. There is a similar mask in the chevron of the east window of the chancel. The capital of the north side of the chancel arch is unfinished, with roughly carved lumps in place of angle heads and a triangular motif in between.

28. Henry, *Irish Art* (as in note 3), pl. 93; H. G. Leask, "Carved Stones Discovered at Kilteel, Co. Kildare," *JRSAI* 65 (1935), 1–8; C. Manning, "Excavation at Kilteel Church, Co. Kildare," *JCKAS* 16 (1981–82), 173–229; S. L. McNab, "Irish Figure Sculpture in the Twelfth Century" (Ph.D. thesis, Trinity College, Dublin, 1986), 379–402. The chancel arch was rebuilt in 1935, using fragments found on the site and in nearby buildings. More sculpture was discovered during further excavations of the church in 1977–78. McNab has suggested that the carved stones may have belonged to a doorway rather than to a chancel arch.

29. Leask, *Irish Churches* (as in note 20), 100, fig. 53.

30. Leask, *Irish Churches* (as in note 20), 146. The doorway was removed from Trinity Island, Lough Oughter (Co. Cavan).

31. Leask, *Irish Churches* (as in note 20), 88–92; Henry, *Irish Art* (as in note 3), 178–79, pl. 70.

32. Leask, *Irish Churches* (as in note 20), 100, fig. 54.

33. Gwynn and Hadcock, *Medieval Religious Houses* (as in note 21), 156–57, 312; Leask, *Irish Churches* (as in note 20), 100, pl. v; Henry, *Irish Art* (as in note 3), 178; T. Garton, "Annaghdown," in *Corpus of Romanesque Sculpture* (as in note 20), forthcoming.

34. Leask, *Irish Churches* (as in note 20), 110–11, pl. VII; Henry, *Irish Art* (as in note 3), 165, 176, 178, fig. 22; T. Garton, "Inchagoill," in *Corpus of Romanesque Sculpture* (as in note 20), forthcoming.

35. Gwynn and Hadcock, *Medieval Religious Houses* (as in note 21), 315; Leask, *Irish Churches* (as in note 20), 146–47; Henry, *Irish Art* (as in note 3), 157–58.

36. Leask, *Irish Churches* (as in note 20), 151; Henry, *Irish Art* (as in note 3), 162–65, pls. 72–75; T. Garton, "Dysert O'Dea," in *Corpus of Romanesque Sculpture* (as in note 20), forthcoming.

37. M. Ryan, in *"The Work of Angels": Masterpieces of Celtic Metalwork, Sixth to Ninth Centuries A.D.*, ed. S. Youngs (London, 1989), 143–44, cat. no. 137.

38. For a general discussion and list of examples in Ireland and elsewhere in Europe, see Henry and Zarnecki, "Romanesque Arches" (as in note 11), 1–34. Henry's discussion of the examples in Ireland includes those at Dysert O'Dea, Inchagoill, Ballysodare, Kilmore, Cashel, the Nuns' Church at Clonmacnois, and Clonfert. For examples of human heads combined with other ornament, see Garton, "Killaloe" (as in note 2), 44. See also Susanne McNab's contribution to this volume.

39. Bradley and King, "Romanesque Voussoirs" (as in note 5).

40. See note 34 above.

41. See note 36 above.

42. Henry, *Irish Art* (as in note 3), 164, pl. 74.

43. See Garton, "Killaloe" (as in note 2), 56.

44. T. O'Keeffe, "The Romanesque Portal at Clonfert and Its Iconography," in *From the Isles of the North: Early Medieval Art in Ireland and Britain* (Proceedings of the Third International Conference on Insular Art Held in the Ulster Museum, Belfast, 1994), ed. C. Bourke (Belfast, 1995), 261–69. The date of ca. 1180 proposed by O'Keeffe seems more likely than the mid-twelfth-century date suggested by Henry, in *Irish Art* (as in note 3), 159–62.

45. Henry, *Irish Art* (as in note 3), 161. Stalley, "Mason and Metalworker" (as in note 17), suggested that Clonfert might have owned a Limoges enamel which could have served as a model. O'Keeffe, "Clonfert" (as in note 44), 264, also refers to Anglo-Saxon examples of stone heads with painted bodies.

46. There are also voussoirs at Dromineer (Co. Tipperary) and Ardfert (Co. Kerry), and a jambstone at Donaghmore (Co. Tipperary), indicating the former presence of arches and jambs with animal heads at these sites. See T. Garton, "Dromineer Bay," "Donaghmore," and "Ardfert, Temple na Hoe," in *Corpus of Romanesque Sculpture* (as in note 20), forthcoming.

47. Henry, *Irish Art* (as in note 3), pl. 82.

48. Henry and Zarnecki, "Romanesque Arches" (as in note 11), 27, pl. xii(i). This form of beak-head appears to have originated at Reading Abbey around 1125. See G. Zarnecki, *English Romanesque Art, 1066–1200* (London, 1984), 131, cat. nos. 129–131.

49. Henry, *Irish Art* (as in note 3), 159, 161.

50. "Mason and Metalworker" (as in note 17); M. Ryan, in *The Work of Angels* (as in note 37), 69, cat. no. 64.

51. Henry, *Irish Art* (as in note 3), 159. The loose jamb-stone at Donaghmore must have formed part of a similar design (see note 46 above).

52. The four lower jambstones on the right, with three beast heads and the forequarters of a beast, have been combined with other jambstones of different designs in the rebuilt window. Garton, "Dysert O'Dea" (as in note 36).

53. Stalley, "Three Irish Buildings" (as in note 2), 63–64.

54. Garton, "Killaloe" (as in note 2), 40–43.

55. Garton, "Killaloe" (as in note 2).

56. Garton, "Killaloe" (as in note 2), 53–54. The pointed bowtell moulding suggests a date slightly later than Killaloe and not before ca. 1200.

57. D. Wilson and O. Klindt-Jensen, *Viking Art*, 2nd ed. (London, 1980), 120–21, 147, 157, 159. It is found in the Mammen style, on the Jellinge stone, and on the Norwegian stave church at Urnes, as well as on the Cross of Cong and the Cashel sarcophagus.

58. R. Stalley, "A Romanesque Sculptor in Connaught," *Country Life* (21 June 1973), 1826–30; Stalley, *Cistercian Monasteries* (as in note 21), 184–87.

59. R. Stalley, "Corcomroe Abbey: Some Observations on Its Architectural History," *JRSAI* 105 (1975), 21–46; Stalley, *Cistercian Monasteries* (as in note 21), 187–88, 243–44, pl. 203.

60. London, B.L., Cotton Ms. Nero D.IV, f. 139v. There are numerous examples of this motif in Insular manuscripts of the eighth to ninth century, and the motif appears again in the eleventh-century Ricemarch Psalter (Dublin, T.C.L., Ms. A.4.20[50]). See Alexander, *Insular Manuscripts* (as in note 23), pls. 33, 76, 201, 217, 220, 247, 253, 254, 346.

61. London, B.L., Add. Ms. 36.929. Alexander, *Insular Manuscripts* (as in note 23), 90, cat. 78; F. Henry and G. Marsh-Micheli, "A Century of Irish Illumination (1070–1170)," *PRIA* 62 (1962), 161–64; Henry, *Irish Art* (as in note 3), 72–73, pl. H; Stalley, *Cistercian Monasteries* (as in note 21), 217–18.

62. Similar infringements of the statutes against sculptural decoration occurred in a number of Irish Cistercian houses, particularly in the early thirteenth century. See Stalley, *Cistercian Monasteries* (as in note 21), 184–89.

63. Henry and Zarnecki, "Romanesque Arches" (as in note 11), 31: "Is it also too far-fetched to suggest that if the human-head motif became so popular in France and in Ireland it may be because of its analogy with Celtic decoration, just as the immediate transformation into monster heads in England may be due to the extensive use which the Saxon artists had made of such ornament?"

64. Discussed by the author in "Human Heads in Hiberno-Romanesque" (paper presented at the symposium on Romanesque sculpture in Ireland, Trinity College, Dublin, 13 May 1995). Human heads form one of the elements in the illumination of the Book of Kells. They also occur on a number of the early stone crosses at Monasterboice, Clonmacnois, and Durrow, where the heads are encircled by snakes. Human heads held in the jaws of beast heads decorate a pair of late eighth- or early ninth-century gilt-bronze mounts in the Musée des Antiquités at St.-Germain-en-Laye. A number of eleventh- to twelfth-century Irish croziers have a human head at the crest of the crook, as on the crozier of the Abbots of Clonmacnois (National Museum of Ireland, inv. R.2988). The early twelfth-century Glankeen bell shrine (British Museum) has a human head set on the crest between the eyes of a Scandinavian-style beast.

65. Stalley, "Mason and Metalworker" (as in note 17).

66. O'Meadhra's catalog, *Motif-Pieces from Ireland* (as in note 24), includes some 160 examples dating from the fifth to the twelfth century.

Constructing the Market Cross at Tuam:
The Role of Cultural Patriotism in
the Study of Irish High Crosses

·

MAGGIE MCENCHROE WILLIAMS

PORTRAYING IRELAND

IN 1857, the antiquarian artist and ardent Irish nationalist Henry O'Neill published a book entitled *Illustrations of the Most Interesting of the Sculptured Crosses of Ancient Ireland*.[1] This work was the first to be devoted exclusively to the illustration and description of the early medieval stone crosses that survived in large numbers throughout the Irish countryside. In a lithograph of the Tall Cross at Monasterboice (Co. Louth), O'Neill provides a precise visual rendering of the monument, and he also includes two finely dressed gentlemen—presumably antiquarians—who are enthralled with the cross (Fig. 1). These scholarly personages mirror the viewer's gaze, allowing the observer to consider the object's majesty along with them. They study the cross admiringly, inspiring the viewer to partake in O'Neill's mission to rescue these objects from the ravages of time and to preserve them for posterity. In his introduction, O'Neill proclaims that the value of Irish art lies in its expression of a "national" character: "In all the remains of ancient Irish Art there is a peculiar style, as truly national as that of Greece, of Assyria, of Egypt, or any other country that has been distinguished in Art."[2]

Asserting that Irish art is stylistically unique, O'Neill associates its singularity with a notion of Ireland as a unified nation, a country with an ancient, indigenous, and sophisticated artistic culture. He explicitly states that previous scholars' attempts to argue that the crosses were not executed by Irish artists are "very weakly advocated and opposed to fact."[3] Like many early writers on the topic, O'Neill was determined to prove that the Irish high crosses represented the greatest achievement of native artists, a perspective that often resulted in an infusion of cultural patriotism into scholarly texts.

Although Irish intellectuals of the mid-nineteenth century were by no means unanimous in their positions on political independence from the British Crown, for many, a notion of a distinct *cultural* identity seems to have transcended political disagreements. Catholics and Protestants, the Anglo-Irish and the Irish by birth, the rich and the poor—all cherished their Irishness and saw it reflected in the visual imagery of the Middle Ages. In fact, political nationalism was clearly *not* co-

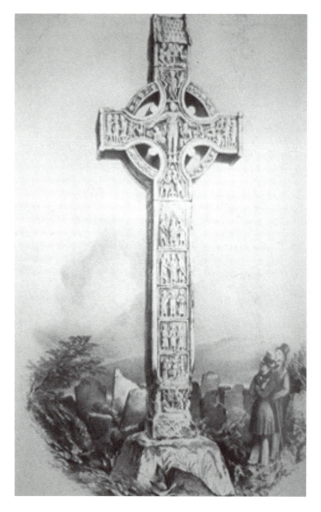

1. Henry O'Neill, *The Tall Cross at Monasterboice*,
from his *Illustrations of the Most Interesting of the
Sculptured Crosses of Ireland* (Dublin, 1857)

terminous with cultural patriotism. In the pages of moderate nationalist publications like *The Nation*, the Young Ireland movement proclaimed:

> To win and sustain her rank as a nation Ireland must possess the elements that constitute a nation in a high degree. . . . She wanted a national literature and art. To obtain them she must honour and reward the scholars and artists who made Ireland their home, whatever might be their political opinions; for great men make a great nation.[4]

As Benedict Anderson has demonstrated in *Imagined Communities*, an insightful study of the origins of nationalism, the phenomenon of nationalistic consciousness was a cultural artifact created towards the end of the eighteenth century.[5] At that time, the village—a concrete, knowable social unit in which individuals encountered one another face-to-face—was supplanted by the nation, an intellectually constructed political community that was defined by a more abstract set of cultural practices. The intangible bonds that delineated such national communities were dependent upon a sense of common experience over time, a collective memory or history that was conveniently manifested in the visual arts.

In Ireland, institutions like the Ordnance Survey in the 1830s and '40s and the Industrial

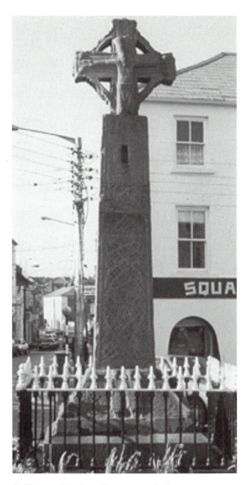

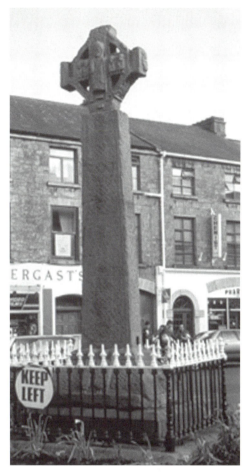

2. Tuam, Market Cross, south face 3. Tuam, Market Cross, north face

Exhibition of 1853 helped the population to visualize a collective national identity. They generated maps and inspired museums that became the repositories of the country's tradition, the vitrines within which the nation was displayed for public consumption. Scholarly investigation into the Irish high crosses was conceived in the midst of this intellectual climate, and many early contributors to the field saw their project as one intimately related to the definition of an Irish cultural identity. Along with the shamrock, the harp, and the wolfhound, the ringed cross was adopted as an emblem of Irishness.[6] As a consequence of their patriotic impulses, many early scholars of high crosses chose to emphasize certain examples or issues in the field.

In this paper, I will investigate the particular case of the Tuam market cross and examine the ways in which the information bequeathed by nineteenth-century antiquarian scholars has colored subsequent perceptions of such an enigmatic object. The Market Cross at Tuam is a large, imposing monument, standing to a height of approximately 3.5 meters and adorned with elaborate geometric designs as well as figural scenes in high relief (Figs. 2–5). It includes two inscriptions that name prominent historical individuals, and it is located in a town that was an important twelfth-century ecclesiastical center. Yet, curiously, it has been largely ignored by modern scholars.[7]

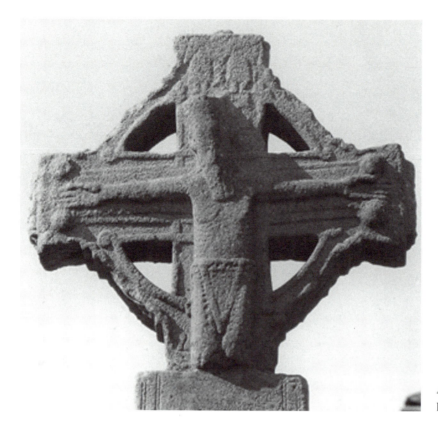

4. Tuam, Market Cross, cross-head, south face

5. Tuam, Market Cross, cross-head, north face

Of the many possible reasons for this neglect, one of the more compelling is the notion that nineteenth- and twentieth-century scholars have viewed Tuam's cross to be an inadequate example of Irish cultural identity. I suggest that such a judgment results from the fact that the Tuam cross is a composite monument, an object constructed from the remnants of several crosses. The cross was first assembled in its present form for the 1853 Dublin exhibition, and its inclusion in such a formative event should have guaranteed its position in the scholarly literature. However, it lacked certain key elements, especially an intimate connection with the native earth. The Tuam cross was an ancient and awe-inspiring monument, but it was composed of bits of stone that had been found scattered throughout the town; consequently, it lacked a definitive location and, unlike many other crosses, it was not physically rooted in the Irish soil.

The Tuam market cross was created in the late nineteenth century from a number of fragments—I am tempted to say found objects—which were assembled to create a sculpture that mimics the form of the early medieval Irish high cross. Despite its characteristic ringed shape, the Tuam cross's authenticity as a true example of ancient Irish art has always been fundamentally questionable. Not only was it reconstituted from a series of component parts, but its physical relocation also called into question its connection to the land. The Tuam market cross was not a naturally occurring specimen of ancient Irish art; rather, its restorers constructed it for the 1853 exhibition in order to situate it within the contemporary patriotic discourse. In 1870, the cross was installed in the town's marketplace, where it was endowed with a secular function that may or may not have been present in its original twelfth-century setting. This intensely Christian symbol became a town landmark, uniting the local community while it simultaneously participated in representing the cultural identity of the entire nation.

Displaying Her Treasures

In the first volume of the *Transactions of the Gaelic Society of Dublin*, published in 1808, a challenge was extended to scholars of Irish antiquity: "An opportunity is now, at length, offered to the Learned of Ireland, to retrieve their Character among the Nations of Europe, and shew that their History and Antiquities are not fitted to be consigned to eternal oblivion."[8] Impassioned exhortations like this one set the tone in antiquarian circles for many years to come. Scholars and artists of all classes and creeds banded together in the interest of defining an Irish cultural identity, an unmistakable personality that distinguished Ireland's aesthetics and poetics from those of any other culture. Not only did historians and antiquarians begin unearthing long-lost examples of Irish artistic production, but contemporary illustrators, printmakers, and painters also mined ancient imagery for culturally resonant material. Antiquarian artists like Henry O'Neill and George Petrie wrote and illustrated works that were perfectly suited to this purpose. These men were simultaneously scholars of ancient Irish material culture and artists who were capable of producing the "national art" that so many zealots were demanding.[9]

George Petrie, a Dublin-born artist and member of the Royal Irish Academy, was the head of the topographical and historical department of the Ordnance Survey in the late 1830s and early 1840s.[10] The Ordnance Survey systematically mapped the entire country on a scale of six inches to the mile, and it recorded a number of previously neglected monuments. Petrie's work with the

Ordnance Survey exposed him to the richness of the ancient Irish architectural and sculptural landscape, and he became one of the country's first archaeologists.

As Benedict Anderson has shown, the map was an important tool that allowed colonial states to visualize their possessions.[11] Although the Irish scenario was somewhat different from a colonial one, the country was nonetheless under English rule at the time that the Ordnance Survey was conducted. According to Sir Thomas Larcom, director of the central office near Dublin, the goal of the survey was threefold: (1) to describe the land in its natural state, (2) to describe manmade additions to the landscape, both ancient and modern, and (3) to describe each particular locality's present function. These three stages of research corresponded to a developmental model in which Larcom presented previous generations' constructions as improvements on the landscape and present occupants' changes as further advances. One of the most important goals of the survey was to demonstrate the potential of the Irish land for future development.[12]

The Ordnance Survey defined and classified Ireland's landscape and material remains on behalf of the British Empire, but the archaeological exploration that accompanied the mapping of the landscape also provided the Irish with substantial proof of their own culture's history. By discovering, depicting, and above all circulating images of Ireland's ancient material culture, antiquarians like George Petrie provided concrete visual evidence of a collective Irish identity. Representations of Ireland's high crosses and round towers were infinitely reproducible through the print and photographic media, and they began to serve as logos of a developing Irish nation. Eventually, even the shape of the map itself became a recognizable symbol of the culture.

As a consequence of his work with the Ordnance Survey, Petrie wrote *The Ecclesiastical Architecture of Ireland, Anterior to the Anglo-Norman Invasion* in 1833 and published it in 1845. He was the first to argue convincingly for the Early Christian Irish origins of both the round towers and the high crosses. Once these ancient monuments were established as native constructions, they began to be co-opted as emblems of the mythologized pre-Norman native culture that was being revived and revised.[13]

In addition to his scholarly writings, Petrie worked as a visual artist. In the 1820s, he painted two watercolors entitled *The Last Circuit of Pilgrims at Clonmacnoise, Co. Offaly*, one for the album of a Mrs. Haldiman (later exhibited at the Royal Hibernian Academy) and a second, larger version now in the National Gallery of Ireland (Fig. 6).[14] Against the backdrop of a dramatic setting sun, a group of devout penitents circulates among the crumbling ruins of an Early Christian monastic site. An enormous round tower dominates the right side of the scene, and the ringed Cross of the Scriptures stands on the left, surrounded by faithful visitors. In the foreground, several reclining grave slabs inscribed with ringed crosses lie among the vines.

The figures climbing through this wasteland are the Irish peasants who persevere in their faith. They have come to do penance or to mourn their dead, and they bow their heads, kneel, or finger rosary beads as they say their final prayers for the day. As Petrie wrote in his journal, "I was inspired by those groups of pilgrims, clothed in draperies of the most picturesque form, and the most splendid and varied colors."[15] In fact, the pilgrims' simple, brightly colored cloaks seem to have no specific temporal reference at all; rather, they evoke a sense of timelessness, a vague notion of the archetypal Irish past. The figure on the right provides a particularly powerful example of the timeless dimension of the work. Standing atop a windswept peak, this figure's hooded cloak and staff are simultaneously reminiscent of the costume of a biblical personage and a medieval monk. In the smaller version of the scene, the figure gestures to an ancient boat that

6. George Petrie, *The Last Circuit of Pilgrims at Clonmacnoise, Co. Offaly*, ca. 1838, pencil and watercolor on paper. National Gallery of Ireland, no. 2230

floats down "the Irish Ganges, the mighty Shannon," imbuing the entire scene with an almost Nilotic aura.[16]

The dramatic lighting provided by the sunset was apparently not sufficient to evoke the kind of intensity that Petrie sought, so he also depicted a sharp drop in the land. The ground at Clonmacnois is actually rather flat. In *The Last Circuit of Pilgrims at Clonmacnoise*, Petrie fuses an archaeological record of the ruins with a saccharine vision of Christian practice, creating an image that romanticizes Ireland's landscape as well as its cultural history. In his ekphrasis of the site, Petrie waxes poetic:

> Let the reader picture to himself a gentle eminence on the margin of a noble river, on which, amongst majestic stone crosses and a multitude of ancient grave-stones, are placed two lofty round towers and the ruins of seven or eight churches, presenting almost every variety of ancient Christian architecture. A few lofty ash trees, that seem of equal antiquity and sanctity, wave their nearly leafless branches among the silent ruins above the dead.[17]

Although his biographer, William Stokes, suggested that Petrie's Scottish heritage permitted him to be "uninfluenced by national prejudices and traditions,"[18] the archaeologist admitted to

7. Frederic Burton, *The Blind Girl at the Holy Well*, engraving, ca. 1840

an interest in presenting the scene in a nostalgic manner with the goal of arousing a sense of duty regarding the preservation of the surviving monuments:

> It was my wish to produce an Irish picture somewhat historical in its object, and poetical in its sentiment—a landscape composed of several of the monuments characteristic of the past history of our country, and which will soon cease to exist, and to connect with them the expression of human feelings equally belonging to our history, and which are destined to similar extinction.[19]

Works like *The Last Circuit of Pilgrims at Clonmacnoise* are fascinating from a historiographic point of view because they are among the earliest representations of the Irish high crosses, and they cannot help but influence our perception of the objects. The crosses were illustrated in 1699 by Edward Lhuyd, but the first photographs of them did not appear until 1875.[20] Consequently, they were reproduced in prints, drawings, and paintings like Petrie's throughout much of the nineteenth century, the period in which the boundaries of the field were being set.

The high crosses also formed part of the repertoire of other artists whose work was not as intimately connected to a scholarly, antiquarian enterprise. For instance, an engraving of Frederic Burton's *The Blind Girl at the Holy Well* (Fig. 7) incorporates a large ringed cross into its composition.[21] This depiction of popular faith employs several of the same themes as Petrie's *The Last Circuit of Pilgrims at Clonmacnoise:* the ancient holy site with its magical healing powers, the ruined cross, the dramatic landscape, and the kneeling peasant figures. However, in Burton's print the women wear recognizable nineteenth-century costumes, and the model for the blind girl was in fact one of Petrie's daughters![22] Despite Burton's friendships with many of the major antiquarians

of his day and the patriotic tone of some of his works, his politics were staunchly unionist. The artistic endeavors of Frederic Burton demonstrate that the cultural patriotism of nineteenth-century Irish artists and antiquarians cannot be equated with political nationalism; establishing an Irish cultural identity did not necessarily require political independence from Britain.

Like Petrie's painting, Burton's *The Blind Girl at the Holy Well* was exhibited at the Royal Hibernian Academy in 1840. The museum, like the map, was a crucial factor in the development of nineteenth-century nationalism. After having recorded and classified the geographical and archaeological features of a country, the governing state generally liked to display its material heritage. Such exhibitions were statements of power, ownership, and authority: by making a country's material products visible, the dominant power rendered them knowable and demonstrated its ability to survey and arrange the objects as well as the culture. But the collective experience of viewing and recognizing the products of ancestral peoples sometimes created a profound sense of community among the local population. In the case of the 1853 Industrial Exhibition in Dublin, ancient Irish material culture was made available and familiar to the public, sparking substantial interest in the replication and study of the high crosses.[23]

For this exhibition, the city of Dublin built an enormous six-and-a-half-acre glass and timber pavilion to house a massive display of arts and industry. The Dublin exhibition was at once trade fair, museum, social gathering, and political statement.[24] From May to October of 1853, approximately one million visitors entered the Dublin galleries to see spectacular European works of art alongside the latest developments in machine technology and Irish craftsmanship.[25] The building, known as the Temple of Industry, inspired a sense of authority and had been designed to maximize the quality of the exhibition. Since glare had been a problem at the London Crystal Palace of 1851, the Irish pavilion, designed by John Benson, incorporated tinted glass and timber walls. According to the catalogue, "a cool, grayish tone prevailed," and there was "an entire absence of direct rays of sunshine." Prince Albert himself praised Benson for having "solved the problem of lighting a Picture Gallery."[26]

Most of the project was funded by William Dargan (1799–1867), a railway tycoon whose financial support later helped to build the National Gallery of Ireland.[27] In fact, the foundation of the National Gallery was inspired by the 1853 exhibition, which included imported Old Master paintings, among them works by Rubens, Rembrandt, Titian, and Tintoretto.[28] The creation of a permanent forum in which to display these foreign works of art was an emphatic statement of Ireland's cultural prowess, for European paintings were not included in the Crystal Palace exhibition in London. Not only did these imported works provide the impetus for the organizers of the Dublin exhibition to found the National Gallery, they also served to demonstrate Ireland's value as a cultural center—an artistic jewel in the British Crown.

In a watercolor painting of Queen Victoria and Prince Albert's visit to the Fine Art Hall of the exhibition (Fig. 8), James Mahony captures the drama and pageantry of this remarkable event. Mahony was an associate of the Royal Hibernian Academy known for his panorama painting, and he executed a series of four watercolor illustrations of Victoria and Albert's pilgrimage to the so-called Temple of Industry.[29] As Nancy Netzer pointed out in an article on this painting and its three companion pieces, this particular visit actually took place before the public was admitted to the galleries, and consequently Mahony must have invented most of the crowd. Among the people present, he includes the members of the Royal Hibernian Academy in the left foreground. The presence of these figures—and indeed the choice of the Fine Art Hall itself as a set

8. James Mahony, *The Visit of Queen Victoria and Prince Albert to the Fine Art Hall of the Irish Industrial Exhibition*, watercolor on paper. National Gallery of Ireland, no. 7009

ting—places Ireland among those refined nations capable of patronizing and producing art, and demonstrates her emergence from a destitute past.[30]

A writer for the London *Art Journal* described the opening ceremony:

> The ceremonial was most impressive. There seemed to prevail over the assembly, numbering at least fifteen thousand of the elite of the Irish metropolis, a solemn feeling of hope, that "peace and goodwill," as well as commercial prosperity, might arise out of this—the first great effort for Ireland, in which all her people of all grades and all creeds were unanimous; and a firm conviction that no event had ever occurred in the country, so pregnant of good to its future.[31]

This the writer contrasted with earlier events:

> It appears as if it were but yesterday that a famine, unexampled in the annals of civilisation, desolated the sister isle. We still remember in all their fearful reality the heart-rending accounts brought by every post of the sufferings of millions of our fellow-subjects: every rank prostrated, and every heart low.[32]

In the upper right-hand corner of Mahony's painting are two small busts of William Dargan, the benefactor, with an inscription that reads: "An uair is dorcha sé an uair roimh breachadh an lae," or "The darkest hour is always before the dawn."[33] This sentiment parallels the desired effect of the exhibition itself: the event was to provide renewed hope, national pride, and optimism for Ireland's future in the wake of the disastrous famine. Among the magnificent treasures on display in the galleries were several medieval stone crosses that had been transported from their locations throughout the country. The "stone cross from the Market-place of Tuam, county Galway" made an appearance, as did an example from County Meath. Plaster casts of several additional crosses were also made for the event.[34] The *Art Journal* reporter was especially impressed by the Hall of Irish Antiquities:

> The collection of Irish Antiquities forms beyond doubt the most original and the most interesting division of the Exhibition; they have been collected with amazing industry; casts have been procured of a very large number of the most famous remains; these have been arranged with admirable skill, and we are bound to express gratitude to . . . the sub-committee, to whom this important task was confided . . . for it is a monument of the glories of ancient Ireland.[35]

The exhibition of 1853 demonstrated the venerability of Irish artistic culture and forged a profound sense of history and community. As J. H. Smith declared in an article published shortly after the exhibition, the desired effect of the high crosses' inclusion in the exhibition was "to make Ireland better known."[36] The 1853 Industrial Exhibition was followed by several others in subsequent years, both in Ireland and abroad, many of which included casts of the crosses. An "Irish Industrial Village" was constructed at the World's Columbian Exposition at Chicago in 1893, and at the 1904 World's Fair in Saint Louis, a plaster cast of Muiredach's Cross at Monasterboice and a reconstruction of Cormac's Chapel in Cashel were both on display.[37] These events generated widespread interest in Irish antiquities, and the image of the ringed cross adorned with elaborate interlace decoration captured the public imagination, becoming an emblem of the height of Irish artistic achievement.

THE MARKET CROSS AT TUAM

Despite its inclusion in the 1853 exhibition, Tuam's market cross (Figs. 2–5) has been curiously neglected in literature on Irish high crosses. As Roger Stalley pointed out in a 1981 article on the cross, early antiquarian authors were quite enthusiastic about it. Petrie called it "the most magnificent specimen of its kind remaining in Ireland,"[38] and Richard Kelly referred to it as "a fine specimen of workmanship of its time and kind."[39] What makes this neglect even more curious, as Stalley mentions, is that Tuam was a powerful royal and monastic center at the time the cross was erected in the twelfth century; in fact, it became the seat of an archbishopric in 1152.[40]

Although it was erected in the town square in the late nineteenth century, the cross now stands inside the Protestant cathedral, where it was moved in 1992. Made of sandstone, the completed cross currently stands approximately 3.5 meters in height. It consists of a pyramidal base; a slender, tapered shaft; and a ringed head. It probably originally had a capstone, and slots in the arms and shaft suggest that additional figures were likely to have been attached to the monu-

ment.[41] Two tiny ecclesiastical figures are carved in high relief on both the north and south sides of the base, while the head includes a figure of the crucified Christ on the south side and several figures in ecclesiastic garb on the north.[42] There has been some debate as to how many fragments comprise the market cross, but the current consensus is that the head belonged to one cross and the shaft and base to another.

Most of the shaft and base are decorated with carved interlace designs, mainly in the Irish Urnes style, which was prominent in twelfth-century Irish metalwork.[43] Interlace decoration has provided fodder for heated debates over the role of native and foreign styles in Irish art. For instance, Françoise Henry and David Wilson presented opposing viewpoints on the sources of animal interlace in sculptures such as the Tuam cross: Henry minimized the Viking impact while Wilson endowed the imported style with a substantial degree of influence.[44] More recently, Roger Stalley has attempted to mediate this dispute by demonstrating that the Tuam carvings reveal distinct differences from the Scandinavian Urnes style, ultimately concluding that they represent a fusion of several styles.[45] The Tuam cross's ability to straddle art-historical concepts and styles, both the native and the foreign, may have contributed to its absence from the literature. Such an integrated style would have been particularly distasteful to the nineteenth-century scholars who were unabashedly driven to prove the indigenous origins of the high crosses.

Some of the iconography of the cross has also proved somewhat elusive. On the south side of the cross's head, Christ is crucified (Fig. 4). He wears a loincloth, a crown, and a beard, and his head is slightly tilted to one side. His body and arms are rigid, and his torso and garments are constructed from a series of angular, geometrical shapes. Stalley suggests that the figure of Christ may be based on a bronze crucifix, possibly one imported from the south of England. There are also two tiny incised figures above Christ's head that have yet to be identified.

On the north face (Fig. 5) the scene is more difficult to identify. A large figure wearing a hooded robe and holding what may be a crozier raises his right hand, probably in a gesture of blessing. He is flanked by four smaller figures with shorter robes, two on each side. An additional figure appears on the end of each of the cross's arms. This scene has been interpreted as a depiction of St. Jarlath, the sixth-century founder of the monastery at Tuam, surrounded by some of his brethren. Or it might be a representation of the archbishop and his suffragans.[46] Such ambiguous or unusual iconography would have destabilized the self-proclaimed scientific approach of the nineteenth-century antiquarians in whose parlance the Tuam cross was a marvelous "specimen" of Irish workmanship. An inability to categorize the iconographic program would render this example virtually useless in a wider typology.

Two inscriptions on the cross's base provide more definitive evidence. Beginning on the south face, they read: (OR) DO THOIRDELBUCH U CH(ON)CHUBUIR DON'T . . . AR-LATH S INDE(RN)AD INSAE . . . ("Prayer for Turlough O'Connor for the . . . of Iarlath by whom this was made . . . "); and on the north: (OR DO) U OSSIN DOND ABBAID (LASA NDE)RN(AD) ("Prayer for O'Oissin, for the abbot, by whom was made").[47] These inscriptions have been used to date the base to approximately 1128 to 1152, the period in which both Turlough O'Connor and Aed O'Oissin were active on the site.[48] Turlough O'Connor was king of Connacht from 1106, laid claim to the high kingship (*ard rí*) from 1119, and died in 1156. He was an ambitious and somewhat brutal ruler who faced opposition as high king, but he was also the patron of fine art objects, such as the Cross of Cong.[49] Aed O'Oissin (abbot from 1128 to 1161) is

not described as an archbishop on the cross, so the monument probably precedes his ordination in 1152.

Françoise Henry suggested that the cross might have been erected as part of a campaign of urban renewal that is mentioned in the Annals of Tigernach for the year 1127.[50] At that time King Turlough and the abbot of Tuam erected an enclosure around the monastic buildings, dividing the town into an ecclesiastical and a secular sector.[51] However, Henry's argument only applies to the lower portions of the cross, as the head belongs to a separate monument and remains undated. It is generally considered to be roughly contemporary with the shaft and base, but there is very little in the way of conclusive chronological evidence.[52]

According to Henry O'Neill, the cross's base was found under some rubbish in the marketplace around 1827.[53] Stalley tells a similar tale, relating that the base was seen in the meat market, now the modern marketplace, in 1837.[54] Other fragments were found on the cathedral grounds, including the head, which was depicted lying in the monastery around 1830.[55] The entire monument was assembled for the Dublin Industrial Exhibition, finally being erected in the town square in 1870. O'Neill expressed some doubts that the component pieces all belonged to one cross, but he and most of his contemporaries ultimately concluded that they did.[56] Petrie lamented the cross's incomplete condition, saying: "to the disgrace of the inhabitants of that ancient city [Tuam], its shaft, head, and base, though all remaining, are allowed to be in different localities, detached from each other."[57]

In an 1875 work entitled *Notes on Irish Architecture*, engravings of the Tuam market cross's base and head (Fig. 9) were published alongside the first photographs of some of the crosses.[58] Originally written by Edwin, the third earl of Dunraven, the book was edited by Margaret Stokes, who also republished the engravings in her 1887 work, *Early Christian Art in Ireland*.[59] These early depictions of the carvings on the cross's head exaggerate the naturalism of the figure style, perhaps with the goal of improving upon the quality or at least the clarity of the sculptures. In this version of the Tuam Christ, the head and torso appear to be much more anatomically precise than in the carving itself: the proportions of the figure's facial features have been altered to correct the pronounced forehead in the sculpture, and Christ's upper body—especially his ribs and pectoral muscles—have been rendered in a softer, more natural manner that practically eliminates the flat geometrical pattern of the carving.

In another early rendition of the Tuam cross, Daniel Grose, a self-trained artist and nephew of the early antiquarian Francis Grose, was less attentive to Christ's body.[60] In Grose's watercolor version (Fig. 10), he applied shading to the loincloth to give the effect of soft drapery folds where the sculpture uses more abstract, triangular shapes. Unlike the engraving, Grose's painting remained unpublished until quite recently. Despite its awkwardness, it is in some ways more faithful to the original.

These early depictions of Tuam's market cross were probably intended as accurate records of the sculpture's appearance, clarifying the centuries of damage that the stone had suffered. But they simultaneously glorified the sculptor's ability to depict the human body—a skill that was highly prized by nineteenth-century audiences. By altering the style of the carvings, however, the engravers actually made the Tuam cross *less* appealing to many Irish scholars and artists. By correcting its unusual depiction of Christ's body, they erased some of its Irishness, transforming it into a second-rate version of the continental Romanesque and removing it from the contempo-

9. Margaret Stokes, *Head of the Market Cross at Tuam*, engraved by Swain after a drawing by George Petrie, ca. 1870

10. Daniel Grose, *Head of the Market Cross at Tuam*, ink with ink wash and watercolor, ca. 1832–38

rary patriotic discourse. Petrie certainly seemed to favor other examples: "The style of these crosses [at Tuam and Cashel] is—as I shall hereafter show . . . of a more complex character than that of the cross at Clonmacnois, which is of that simple form, which may be now considered to be as peculiarly Irish as the Round Towers themselves."[61]

While the Tuam cross may not have fulfilled the nineteenth-century requirements for a perfect manifestation of Irish cultural identity, its history illuminates a great deal about the role of patriotism in scholarship. Even though the cross is composed of several distinct monuments, it continues to be exhibited, depicted, and studied as a unified entity. Not only does the nineteenth-century vision of the cross invade our current perception of the object, but we also continue to perpetuate the notion that the sculpture is somehow whole. What does it mean to encounter a composite cross? Is it not as much a creation of the nineteenth century as it is of the twelfth?

Interestingly, O'Neill illustrated the Tuam cross in parts.[62] He did not depict the reconstructed monument, nor did he include it within its town setting. The Tuam cross's public surroundings were probably detrimental to its status as a cultural icon because they detracted from the stereotypical image of the lone, lichen-encrusted cross in the midst of a windswept landscape. Some scholars, such as Françoise Henry, even went so far as to publish doctored images of the Tuam cross in order to eliminate its crowded, worldly backdrop.[63]

However, the selection of the main square as the location for the cross is noteworthy. Although the component pieces were found scattered throughout the town, including on the cathedral grounds, the restorers chose to erect it in a secular district. This decision may indeed reflect the cross's original purpose, for the rebuilding campaign that Turlough O'Connor initiated in 1127 probably involved the erection of at least one stone cross that served a topographical as

well as a religious function. But it was the restoration of Tuam's cross that definitively established it as a monument with both Christian and secular functions. It was already a venerable devotional object, and it became the centerpiece of the town around which the population could rally and discover their collective identity.

EXPORTING THE CROSS

The nineteenth century's re-creation of the high cross as a monument to Irish cultural identity did not only occur in the scholarly realm. In fact, the form of the ringed cross appeared in sculpture, painting, architectural decoration, and tourist arts—everything from tombstones to paperweights.[64] Throughout modern Ireland and the Irish diaspora, graveyards are dotted with headstones that reproduce the characteristic form of the ringed Latin cross. For instance, in Trinity Cemetery on 155th Street in Manhattan, the artist, ornithologist, and naturalist John James Audubon is buried beneath an enormous ringed cross adorned with beasts, floral motifs, and interlace decoration (Fig. 11).[65] Born in Santo Domingo (now Haiti), Audubon was raised in Brittany and lived on both sides of the Atlantic. He spent much of his life trying to compensate for his illegitimate birth by creating a fictional resumé of study with famous painters, and he seems to have latched onto a Celtic identity in death. In 1842, he and his family moved to a New York estate, then called "Minnie's Land," where he died in 1851 and is now buried. Audubon's tombstone is probably based on Scottish examples, such as the crosses at Iona, because he was well received in Edinburgh, where he lived for several years. Consequently, it exemplifies the broader notion of "Celtic" culture as an imagined community that comprises not only Ireland, but Scotland, Wales, and parts of France and England as well.

The "Celtic cross" developed into an even more powerful symbol of collective identity once it was transported to America. As soon as the form began to be exported, it became associated with a lost sense of community as well as a sorely missed landscape. If an Irish-American emigrant could not be buried in his or her native soil, the next best thing was to be buried beneath a symbol of the homeland. Around 1910, it was even possible to purchase an elaborate "Celtic cross" tombstone from Sears, Roebuck, and Company, Chicago (Fig. 12).[66]

Once it had taken root in the Irish diaspora, the form of the high cross was linked more directly to Catholicism and political nationalism, for many of the emigrants were members of the Catholic lower classes whose nationalistic impulses only increased with time and distance. The form of the cross was eventually reintegrated into twentieth-century nationalist agendas, both in Ireland and abroad. In a 1987 mural on Springhill Avenue in Belfast, the coats of arms of the four Irish provinces surround an Irish cross, an inscription, and the figures of several IRA men killed in Loughall, County Armagh.[67]

Although the life of the Irish high cross has been charged with political nationalism and Catholic spirituality in the twentieth century, older institutions such as the Ordnance Survey and the Industrial Exhibition were designed to prevent just such revolutionary wildfires from raging out of control. By classifying and exhibiting Ireland's ancient material culture alongside its modern technological products, the British Empire hoped to demonstrate her supremacy over the entire span of Irish history. When addressing the crowd at the exhibition galleries in Dublin in 1853, Queen Victoria had no qualms about articulating her sovereignty. She expressed her plea-

11. Gravestone of John James Audubon,
Trinity Cemetery, 155th Street, Manhattan

sure "to see the complete success of an enterprise which has been carried out in a spirit of energy and self-reliance, and with no pecuniary aid but that derived from the patriotic munificence of one of my loyal subjects [i.e., William Dargan]."[68] From an imperial point of view, the Ordnance Survey maps constituted topographical mastery of the Irish landscape, and the confinement and display of the country's past, present, and future in John Benson's Temple of Industry advertised the quality of Britain's possessions.

And yet, both institutions metamorphosed into celebrations of Irish culture. George Petrie's work with the Ordnance Survey resulted in a profoundly romanticized view of early medieval Ireland, and the Dublin exhibition engendered a spirit of cultural unity among much of the local citizenry. Under the aegis of these controlling institutions, the high crosses were transformed into emblems of Irish cultural identity, signifying a human bond that transcended and virtually erased both political and religious differences.[69] The ringed cross became a sign of the modern Irish nation, and ultimately its status as a cultural icon affected the ways in which it was described, studied, and illustrated.

Despite its inclusion in the great exhibition of 1853, the Market Cross at Tuam has been noticeably absent from the literature on the Irish high crosses. Its ringed shape and elaborately carved interlace reflect the nineteenth-century notion of a quintessentially Irish monument, but

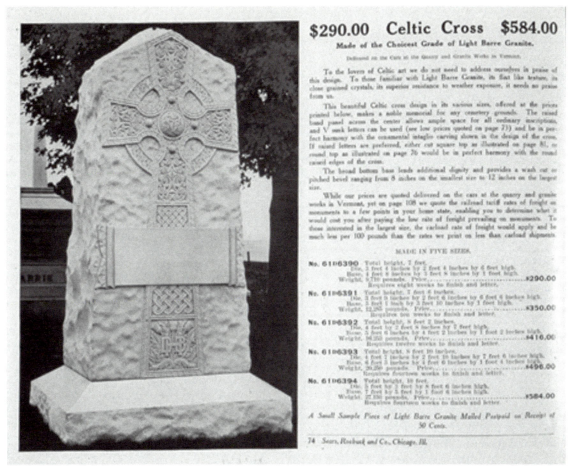

12. Celtic cross tombstone, Sears catalogue, ca. 1910

its ambiguous iconography and assimilation of foreign styles subvert that norm. Moreover, it is a composite monument whose physical and chronological origins are uncertain. I propose that we look to examples like the Tuam market cross to discover more about the ways in which nineteenth- and twentieth-century discourses on national identity have influenced our current approach. Not only have the inconsistencies inherent in the Tuam cross affected its selection as an acceptable example of medieval Irish art, but the act of constructing the cross from disparate components also bears a striking resemblance to our scholarly practice. The particular history of the Tuam cross provides substantial insight into the effects of cultural patriotism in the field, and the monument itself serves as an apt metaphor for our constant need to fit the final piece into the puzzle.

ACKNOWLEDGMENTS

I would like to thank Colum Hourihane for inviting me to give this paper at the conference "From Ireland Coming: Irish Art from the Early Christian to the Late Gothic Periods and Its Context within Europe."

NOTES

1. H. O'Neill, *Illustrations of the Most Interesting of the Sculptured Crosses of Ancient Ireland* (Dublin, 1857). O'Neill also wrote a political pamphlet entitled *Ireland for the Irish: A Practical, Peaceable, and Just Solution of the Irish Land Question* (London, 1868). A few works on the crosses were published around the same time as O'Neill's, including R. R. Brash, "The Sculptured Crosses of Ireland: What We Learn from Them," *JRSAI* 12 (1872–74), 98–112; F. Grose, *The Antiquities of Ireland*, 2 vols. (London, 1791–95); G. Petrie, *The Ecclesiastical Architecture of Ireland, Anterior to the Norman Invasion*, 2nd ed. (Dublin, 1845); and J. H. Smith, "Ancient Stone Crosses in Ireland," *UJA* 1 (1853), 53–57. See P. Harbison, *The High Crosses of Ireland: An Iconographical and Photographic Survey* (Bonn, 1992), vol. 1, 5.

2. O'Neill, *Illustrations* (as in note 1), i.

3. O'Neill, *Illustrations* (as in note 1), iii.

4. C. G. Duffy, *Young Ireland: A Fragment of Irish History, 1840–1850* (New York, 1881), 159.

5. B. R. Anderson, *Imagined Communities: Reflections on the Origin and Spread of Nationalism* (London, 1983). In my discussion of both the map and the museum, I am also relying on the ideas of Michel Foucault, *The Order of Things: An Archaeology of the Human Sciences* (New York, 1970).

6. J. Sheehy, *The Rediscovery of Ireland's Past: The Celtic Revival, 1830–1930* (London, 1980).

7. The main sources on the Market Cross at Tuam are Harbison, *High Crosses* (as in note 1), vol. 1, 177–78; F. Henry, *Irish Art in the Romanesque Period (1020–1170 A.D.)* (Ithaca, 1970), 33–35, 140; R. Stalley, "The Romanesque Sculpture of Tuam," in *The Vanishing Past: Studies of Medieval Art, Liturgy and Metrology Presented to Christopher Hohler* (BAR International Series 111), ed. A. Borg and A. Martindale (Oxford, 1981), 179–95, reprinted in R. Stalley, *Ireland and Europe in the Middle Ages: Selected Essays on Architecture and Sculpture* (London, 1994), 127–63.

8. *Transactions of the Gaelic Society of Dublin* 1 (1808), ix.

9. C. Barrett, "Irish Nationalism and Art, 1800–1921," *Studies: An Irish Quarterly Review of Letters, Philosophy, and Science* 64, no. 256 (winter, 1975), 393–409 at 405.

10. Sheehy, *Rediscovery of Ireland's Past* (as in note 6), 22; M. de Paor, "Irish Antiquarian Artists," in *Visualizing Ireland: National Identity and the Pictorial Tradition*, ed. A. M. Dalsimer (London and Boston, 1993), 119–32 at 128.

11. Anderson, *Imagined Communities* (as in note 5), esp. 163–85, chap. 10, "Census, Map, Museum."

12. W. Stokes, *The Life and Labours in Art and Archaeology, of George Petrie* (London, 1868), 88. For Larcom's assessment, see J. H. Andrews, *A Paper Landscape: The Ord-*

nance Survey in Nineteenth-Century Ireland (Oxford, 1975), 147–48.

13. Petrie, *Ecclesiastical Architecture* (as in note 1). The round towers are colossal stone structures, many of which are nearly one hundred feet high and are capped with conical stone roofs. Nearly a hundred of these objects were still standing in the early nineteenth century. Petrie established that they were constructions of the Christian era, built by native Irishmen, and that they should be identified with the *cloigtheachs*, or bell-houses, mentioned in the written sources. Prior to Petrie's work, scholars had presented a variety of speculative theories that denied the possibility that the round towers could have been constructed by local builders—theories that ranged from the idea that they might have been sorcerers' temples or astrological observatories to the notion that they were built by Phoenicians, African sea-champions, or Danes. For a detailed study of the round towers and the theories they have inspired, see Roger Stalley's contribution to this volume. Like the round towers, the high crosses have frequently been considered improbable oddities: M. F. Hearn, *Romanesque Sculpture: The Revival of Monumental Stone Sculpture in the Eleventh and Twelfth Centuries* (Ithaca, 1981), 22, refers to them as "provincial survival[s]."

14. *The Last Circuit of Pilgrims at Clonmacnoise, Co. Offaly;* private collection, pencil and watercolor on paper, 18.5 × 25.6 cm.

15. Stokes, *Life and Labours* (as in note 12), 29.

16. Stokes, *Life and Labours* (as in note 12), 28.

17. Stokes, *Life and Labours* (as in note 12), 28.

18. Stokes, *Life and Labours* (as in note 12), 1.

19. Stokes, *Life and Labours* (as in note 12), 15.

20. E. Dunraven, *Notes on Irish Architecture*, ed. M. Stokes, 2 vols. (London, 1875 and 1877).

21. Burton's original watercolor was destroyed in 1860, but H. T. Ryall's engraving of the work survives. See Sheehy, *Rediscovery of Ireland's Past* (as in note 6), 42, fig. 24.

22. Sheehy, *Rediscovery of Ireland's Past* (as in note 6), 42.

23. *The Resources and Manufacturing Industry of Ireland as Illustrated by the Exhibition of 1853*, ed. J. Sproule (Dublin, 1853); T. Bennett, "The Exhibitionary Complex," in *Culture/Power/History: A Reader in Contemporary Social Theory*, ed. N. B. Dirks, G. Eley, and S. B. Ortner (Princeton, 1994), 123–54.

24. In some ways it was not unlike the ancient Irish assembly, or *oenach*, which incorporated many of the same characteristics. See F. Henry, *Irish Art during the Viking Invasions (800–1020 A.D.)* (Ithaca, 1967), 1–32.

25. M. Bence-Jones, "Ireland's Great Exhibition,"

Country Life 153, no. 3951 (15 March 1973), 666–68.

26. *Resources and Manufacturing*, ed. Sproule (as in note 23), 32.

27. N. Netzer, "Picturing an Exhibition: James Mahony's Watercolors of the Irish Industrial Exhibition of 1853," in *Visualizing Ireland* (as in note 10), 89–98.

28. R. Keaveney et al., *National Gallery of Ireland* (London, 1990), 6–9; *Resources and Manufacturing*, ed. Sproule (as in note 23), 457–67.

29. James Mahony, *The Visit by Queen Victoria and Prince Albert to the Fine Art Hall of the Irish Industrial Exhibition, Dublin 1853*, National Gallery of Ireland no. 7009, watercolor on paper, 62.8 × 81 cm.

30. Netzer, "Picturing an Exhibition" (as in note 27), 89–98.

31. "The Great Exhibition in Dublin," *The Art Journal* 15 (1853), 117, 161–62, 262–63, 301–3, at 161.

32. "Great Exhibition in Dublin" (as in note 31), 301.

33. B. P. Kennedy, *Irish Painting* (Dublin, 1993), 20.

34. *Resources and Manufacturing*, ed. Sproule (as in note 23), 477. In addition to the Tuam cross, the "stone cross of SS. Patrick and Columba, from the churchyard of Kells, county Meath; casts of St Boyne's stone cross; of the great stone cross at Monasterboice, county Louth; of the stone cross at Kilerispeen, county Tipperary; of the stone cross at Kilkieran, county Kilkenny" and a model of the Moone cross were also on view.

35. "The Exhibition of Art and Industry in Dublin, 1853: Illustrated Catalogue with Introduction," supplement to *The Art Journal* 15 (1853), vii.

36. Smith, "Ancient Stone Crosses" (as in note 1), 53–57.

37. *Irish Industrial Exhibition, World's Fair, St. Louis, 1904: Handbook and Catalogue of Exhibits* (Saint Louis, 1904), 24.

38. Petrie, *Ecclesiastical Architecture* (as in note 1), 127.

39. R. Kelly, "Antiquities of Tuam and District," *JRSAI* 34 (1904), 257–60 at 260.

40. Stalley, "Romanesque Sculpture of Tuam" (as in note 7), 179.

41. Stalley, "Romanesque Sculpture of Tuam" (as in note 7), 182, says that a crucifix was probably originally attached to the tenon on the shaft's south face, and that there might have also been two additional supports with figures of Mary and John.

42. References to the north and south faces of the cross describe the object's current position and do not necessarily bear any relationship to its original orientation.

43. For instance, in the Cross of Cong (1119–36), which is also associated with King Turlough O'Connor; see notes 46, 47, and 48 below.

44. Henry, *Irish Art in the Romanesque Period* (as in note 7), 103–5, 114, 192, 201–2; D. M. Wilson and O.

Klindt-Jensen, *Viking Art* (London, 1966), 147–61.

45. Stalley, "Romanesque Sculpture of Tuam" (as in note 7), 184–88.

46. Stalley, "Romanesque Sculpture of Tuam" (as in note 8), 183, n. 34. See also Peter Harbison's interpretation of this program elsewhere in this volume.

47. Harbison, *High Crosses* (as in note 1), vol. 1, 365.

48. Stalley, "Romanesque Sculpture of Tuam" (as in note 7), 182–83.

49. D. Ó Corráin, "High-kings, Vikings and Other Kings," *Irish Historical Studies* 21 (1979), 283–323.

50. Henry, *Irish Art in the Romanesque Period* (as in note 7), 35, n. 3.

51. *The Annals of Tigernach*, trans. W. Stokes (reprinted from *RCelt* 16–18 [1895–97]) (Felinfach, 1993), vol. 2, 51: "Toirdelbach Hua Conchobair, overking of Ireland, and the successor of S. Iarlaithe surround the common of Tuam from the southern end of Clad in renda to Findmag. Then the king gave an offering of land from himself to the church in perpetuity from Ath mbo (the Ford of the Kine) to Caill Clumain."

52. Stalley, "Romanesque Sculpture of Tuam" (as in note 7), 183.

53. O'Neill, *Sculptured Crosses of Ireland* (as in note 1), 4–6.

54. Stalley, "Romanesque Sculpture of Tuam" (as in note 7), 182, n. 29.

55. Stalley, "Romanesque Sculpture of Tuam" (as in note 7), 183, n. 32.

56. O'Neill, *Sculptured Crosses of Ireland* (as in note 1), 4–6.

57. Petrie, *Ecclesiastical Architecture* (as in note 1), 312. According to Harbison, *High Crosses* (as in note 1), vol.1, 175, a piece of the Tuam cross was found in the dean's kitchen chimney.

58. Dunraven, *Notes on Irish Architecture* (as in note 20), vol. 2, 89–90, figs. 101, 102.

59. Margaret Stokes was the daughter of William Stokes, a physician who was Petrie's biographer and a friend of Frederic Burton. Margaret and her brother Whitley, the philologist, were both active antiquarians.

60. Daniel Grose was the nephew of Francis Grose (1731–91), whose *Antiquities of Ireland*, published posthumously in 1795, was one of the earliest Irish antiquarian studies. Daniel had no professional training as an artist, which may account for some of the awkwardness of his figure drawing. This work, executed in ink with ink wash and watercolor, dates to around 1832–38 but is based on drawings that go back as far as 1792. Daniel compiled a supplement to his uncle's work which remained unpublished until it was discovered by the Irish Architectural Archive in 1991: *Daniel Grose, The Antiquities of Ireland: A Supplement to Francis Grose*, ed. R. Stalley (Dublin, 1991); Grose's watercolor of the Tuam Cross is

p. 61, fig. 24.

61. Petrie, *Ecclesiastical Architecture* (as in note 1), 267.

62. So did Peter Harbison, *High Crosses* (as in note 1), vol. 2, figs. 616, 617.

63. F. Henry, *La Sculpture irlandaise pendant les douze premiers siècles de l'ère chrétienne* (Paris, 1932), vol. 2, pl. 109.

64. For more on nineteenth- and twentieth-century replicas of the Irish high crosses, see Margaret McEnchroe Williams, "The Sign of the Cross: Irish High Crosses as Cultural Emblems" (Ph.D. diss., Columbia University, 2000).

65. E. M. Foshay, *John James Audubon* (New York, 1997), 142. Other "Celtic" cross gravestones exist in New York cemeteries: see E. F. Bergman, *Woodlawn Re-members: Cemeteries of American History* (New York, 1988), 52–53; and J. Culbertson and T. Randall, *Permanent New Yorkers: A Biographical Guide to the Cemeteries of New York* (Chelsea, Vermont, 1987), 27–32.

66. Sears, Roebuck, and Company, *Tombstones and Monuments* (Chicago, ca. 1910).

67. B. Rolston, *Politics and Painting: Murals and Conflict in Northern Ireland* (Cranbury, N.J., 1991), following p. 80.

68. *Resources and Manufacturing*, ed. Sproule (as in note 23), 16.

69. I would like to thank Peter Brown for suggesting that the selection of an early *Christian* object also helped to circumvent the contemporary friction between Catholics and Protestants.

Celtic Antecedents to the Treatment of
the Human Figure in Early Irish Art

·

SUSANNE McNAB

IN EARLY CHRISTIAN IRISH ART the human figure is portrayed in ways which point to a continuity with earlier, Celtic traditions that were established over hundreds of years. These traditions include stylistic traits which may be connected to meaning (and which will be analysed here in relation to types of facial profile), a dogged schematization of the figure away from any concern with naturalism, certain ways of portraying horses and riders, as well as the extreme longevity of specific designs over many centuries. The stylistic aspects can be linked to unusual motifs, such as the human figure twisted into contorted shapes, and a recurring iconography and range of favoured designs which incorporate human elements and strange anthropomorphic imagery. These traits may reflect philosophical ideas linked with Irish mythology and pre-Christian beliefs, and there are also clear stylistic echoes of far distant Iron Age Celtic artifacts.

The mixture of influences that produced such distinctive representations of the human figure in Early Christian Irish art is complex. There is a marked interplay between very disparate classical and Celtic traditions which fuse into an idiosyncratic and recognizable style that transcends the various media of manuscript painting, stone sculpture, and metalwork.[1] The styles have been classified according to their leanings towards classical naturalism (style A1) or Celtic anti-classicism (style A2).[2] In addition, a distinctive type of facial profile has been named the "Kells Profile" because, whilst it is frequently found on the high crosses and in metalwork, it proliferates in its most developed form in the Book of Kells, where it is unmatched in terms of quality and quantity (Fig. 1).[3] The origins of this profile can be traced back to the Iron Age. Study of these Celtic traits has revealed an intriguing mix of stylistic and conceptual resonances and the extraordinary persistence of such ideas in indigenous Irish art throughout the entire Early Christian period before it was overwhelmed by Norman influences at the end of the twelfth century.

It has long been a source of frustration that our understanding of the introduction of the La Tène style into Ireland is clouded with many unanswered questions. These have been enumerated by Barry Raftery, who juxtaposed what he called "the considerable lacunae in our knowledge" with a recognition of the quality achieved in Irish La Tène art.[4] His admission that we do not know how or when the La Tène art style was introduced into Ireland dramatically illustrates how impossible it would be to make such determinations in relation to the Irish absorption of influences from an even wider geographical spread of Celtic art in Europe over an even longer period of time. Consequently, this study will not propose direct sources or suggest the existence of particular workshops or regional style groups. Its aim is to show that a large number of diverse ideas related to the depiction of the human figure are indebted to Celtic art, and that these

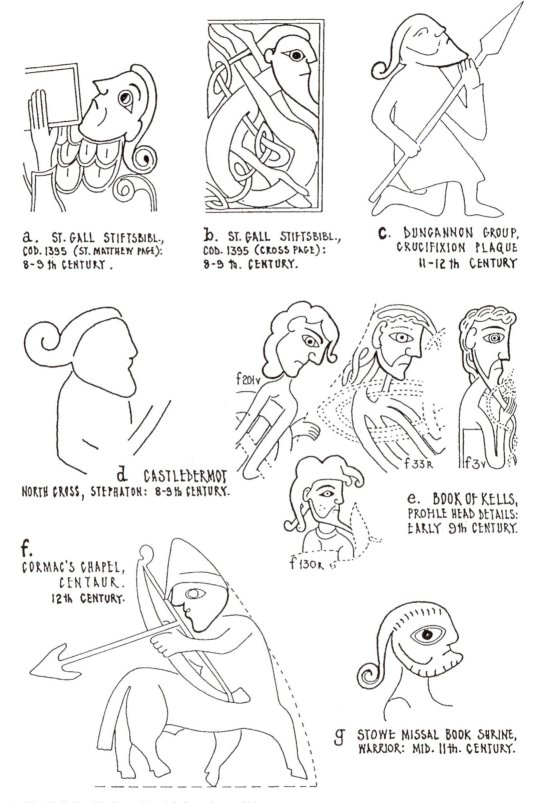

a. ST. GALL STIFTSBIBL.,
COD. 1395 (ST. MATTHEW PAGE):
8-9th CENTURY.

b. ST. GALL STIFTSBIBL.,
COD. 1395 (CROSS PAGE):
8-9th. CENTURY.

c. DUNGANNON GROUP,
CRUCIFIXION PLAQUE
11-12th CENTURY

d CASTLEDERMOT
NORTH CROSS, STEPHATON: 8-9th CENTURY.

f 201v

f 33R

f 3v

f 130R

e. BOOK OF KELLS,
PROFILE HEAD DETAILS:
EARLY 9th CENTURY.

f.
CORMAC'S CHAPEL,
CENTAUR.
12th CENTURY.

g STOWE MISSAL BOOK SHRINE,
WARRIOR: MID. 11th. CENTURY.

1. The Kells Profile from the eighth to the twelfth century A.D.

2. Trinity College, Dublin, Ms. 58, Book of Kells, f. 201v, showing interlaced figures forming the *Q* of *Qui* from the genealogy of Christ

may have been transferred from a pagan context into the formal repertoire of Early Christian Irish art.

THE KELLS PROFILE

The Kells Profile continues in use in Ireland up to and throughout the Romanesque period. This beaky-nosed profile, with its large frontal eye, elongated jawline, and curling tail of hair, is found in a very small number of eighth- and ninth-century Irish manuscripts, where it accompanies designs of interlaced human figures (Fig. 2).[5] Interlaced human figures with Kells Profiles occur in such a restricted number of manuscripts, especially in comparison with the numerous examples of animal interlace, that they appear to be an Irish idea within the broader context of Insular manuscript art. This motif had a permanent presence in Ireland and was translated into elaborate designs in stone on many of the Irish high crosses of the Early Christian period. It is found on at least six crosses in highly developed forms, may occur on more, and is not restricted to any particular geographic area.[6] An example on a bone trial-piece excavated from Garryduff ring fort may date to the seventh or eighth century, pre-dating the Book of Kells and the high crosses, and indicating that its home was in Ireland in the Early Christian period.[7]

3. Celtic coin from Armorica, Bretagne, second or first
century B.C. London, British Museum, 1919-2-13-1021

In his search for the origins of early Irish figure styles, Otto Werckmeister picked out some
fascinating parallels with late seventh-century Visigothic Spanish work, for example, the carved
capitals of San Pedro de la Nave in Zamora. He suggested that these styles might have been dis-
seminated via a lost manuscript such as Isidore of Seville's *De natura rerum*, possibly through
copies such as the eighth-century manuscript now in Paris.[8]

The common factor which could link Visigothic and Irish styles might reside in a shared bar-
baric or at least non-classical background. There are indications, however, that the profile is an
older Celtic mannerism. Celtic coins which belong to the second or first century B.C., for exam-
ple, some Gaulish coins produced in Armorica, Bretagne (a region which runs from the Cher-
bourg peninsula to Finistère), show horsemen with this kind of profile (Fig. 3). A hard, straight
line which separates the nose and runs parallel to the outer line of the nose from the inner
corner of the eye to the nostril is noticeable on these coins. This odd trait also occurs on the
Visigothic carvings at San Pedro de la Nave in Zamora and in the Paris manuscript studied by
Werckmeister. It appears in stone on the carvings of the Flight into Egypt and the Adam and Eve
figures on the high cross at Moone in County Kildare. These comparisons make it clear that the
Kells Profile was in use from at least the second century B.C. to the eighth or ninth century A.D.

But further research shows that its life span was even longer than this, extending further into
the Iron Age. Some of the situla artifacts produced in northern Italy show startlingly similar pro-
files. A fragment of a bronze plaque from Este in northern Italy, which has been dated to the
fourth or third century B.C., shows a procession of warrior horsemen (Fig. 4). Their faces have
typical Kells Profiles complete with prominent noses, enormous eyes, and curling tails of hair.
The fragment was found in a local shrine dedicated to the Etruscan goddess Reitia, together with
a number of votive figures and other objects, and its style follows the traditions of the region's sit-
ula art.[9] Another bronze situla, this one dated to the early fifth century B.C., is more detailed and

4. Bronze plaque from Este, northern Italy, fourth or third century B.C. Este, Museo Nazionale Atestino

executed in stronger repoussé relief.[10] The profiles of these faces clearly show the same linear feature from eye to nose. In this case the feature, which has been described as an odd characteristic, is clearly the result of the repoussé technique. These examples show that the Kells Profile was in use for about sixteen hundred years.

The Kells Profile occurs in many contexts, translated into stone, metal, and paint, but the Irish contortionist or interlaced figures are never seen without this type of profile or a full-face version of it.[11] This must be significant and must be a reflection of both the origin and meaning of these figures: it is most unlikely that they had no meaning or were merely intended as drolleries.[12] It is clear in every complex nuance of line and colour that the illuminators of the Book of Kells or the sculptors of the crosses, far from indulging in chance effects, were working to very precise, even formulaic intentions. It would be hard to believe that such strong stylistic conventions did not have symbolic meaning, especially as recent studies have argued that detailed codes lie even within nuances of textual presentation.[13]

INTERLACED FIGURES

Werckmeister has suggested that the interlaced figures in manuscripts belong to the other-world and have cosmological significance as part of the imagery of all creation.[14] His suggestion is of interest since these contortionist figures all have similar faces, even when executed by different scribes. This may be a sign that they are indeed supernatural, angelic, cosmological, or archetypal. They do, however, appear in a variety of contexts. In stone they are always discrete designs within panels, but in manuscripts they form interlaced patterns within geometric frames which may be elements within a larger design. In the Book of Kells, for example, they are incorporated into the eight-circle cross-carpet page (f. 1v) and the four symbols of the Gospels page (f. 27v); sometimes they are squeezed one on top of one another in the dividing columns of canon tables (ff. 2r and 3v). In other cases, as on folio 68v, a single figure contorts to form an initial letter (Fig. 5).

5. Trinity College, Dublin, Ms. 58, Book of
Kells, f. 68v, detail of initial *h* of *haec*

So while the designs using interlaced figures are found in a variety of contexts, they vary in
both form and function. Perhaps Françoise Henry came very close to the truth when, in discuss-
ing another idea used in the Book of Kells, she identified the figure whose head, arms, and feet
emerge from behind the frame of the portrait of St. John (f. 291v) as "fairly obviously the
Word."[15] Could it be that the interlaced figures or those twisted to form initial letters represent
the Word made flesh, the incarnation of Christ as made manifest in the words of the Gospels?
The extent to which philosophical ideas were being developed in Ireland prior to and during the
Carolingian period has stimulated much debate.[16] The contribution to theological and philo-
sophical thought made by the Irish scholar John Scottus Eriugena (ca. 810–75) at the Court
School of Charlemagne is well attested.[17] In his *De praedestinatione* Eriugena sought to dem-
onstrate how the arts and study of knowledge bring about the immortal happiness of the soul. He
viewed philosophy as a contemplation of the created world which changes the fantasies of this
world into divine theophanies. The liberal arts and dialectic are seen to be one with the *Logos*,
Christ himself.[18] Eriugena translated all the works of pseudo-Dionysius the Areopagite (including
De divinis nominibus, *De mystica theologia*, *De coelesti hierarchia*, *De ecclesiastica hierarchia*, and his

letters), and we learn that an artist who looks at the archetypal form without distraction will pro-
duce an image which can be taken for the original ("the one in the other") while differing from
the original in essence and nature.[19] Eriugena also translated the *Ambigua* of Maximus the Con-
fessor (ca. 580–662) which modified Dionysian doctrine and emphasized that Christ was the *Logos*
or Word through whom the ideas or archetypes of creation were realized.[20] In this light, it is
tempting to read the interlaced figures or the contortionists who form initial letters as literal de-
scriptions of the Word coming into being.

We do not know, and may never know, whether coeval theological and philosophical ideas
find explicit visual parallels in Irish art throughout this period. It is clear, however, that a belief in
mythology was translated into both word and image. The scribes in the early monastic settlements
wrote down both sacred texts in Latin and traditional stories in their Irish vernacular.[21] Earlier in
this century Arthur Kingsley Porter stated, perhaps too vigorously, the case for identifying many
of the enigmatic images on the high crosses as Finn macCumhaill, Cú Chulainn, or Conchobar.
His ideas deserve to be reconsidered, particularly in light of the fact that the Finn stories were
known as early as the seventh century[22] and that pagan mythology, folklore, and Druidism be-
came so entwined with Irish hagiography that, in Daniel Binchy's words, it gained an unenviable
notoriety.[23]

It can also be recalled that, in her early work on Early Christian Irish art, Françoise Henry
drew attention to the parallels between the eighth-century legends of the voyages of Bran and
Maelduin (who encountered the shape-shifting abilities of fantastic animals) and the imagination
of Irish scribes which resulted in zoomorphic designs in manuscript illumination.[24] Writing about
the author of the voyage of Maelduin, she states that "the same unshakable belief in the incred-
ible as was in the mind of the painter of the Book of Kells rings in his tone":

> And when they came near, a great beast leaped up and went racing about the island,
> and it seemed to Maelduin to be going quicker than the wind. And it went then to the
> high part of the island, and it did the straightening-of-the-body feat, that is, its head
> below, its feet above; and it is the way it used to be: it turned in its skin, the flesh and the
> bones going around but the skin outside without moving. And at another time the skin
> outside would turn like a mill, and the flesh and bones not stirring.[25]

Another vivid account of the ability to magically transform comes in Manannan, son of Ler's
song to Bran predicting the birth of Mongan:

> 53. He will be in the shape of every beast,
> Both on the azure sea and on land,
> He will be a dragon before hosts at the onset,
> He will be a wolf of every great forest.
> 54. He will be a stag with horns of silver
> In the land where chariots are driven,
> He will be a speckled salmon in a full pool,
> He will be a seal, he will be a fair-white swan.[26]

Perhaps this is the kind of description Proinsias MacCana had in mind when he saw a tangi-
ble relationship between zoomorphic ornament and mythology.[27] The same kind of analogy,

however, has not been applied to designs of interlaced human figures. Yet the description of Cú Chulainn's battle frenzy allows us to make a clear comparison:

> Then a great distortion came upon CuChulainn so that he became horrible, many-shaped, strange and unrecognisable. All the flesh in his body quivered. . . . He performed a wild feat of contortion with the body inside his skin. His feet and his shins and his knees came to the back; his heels and his calves and his hams came to the front.[28]

The Book of Kells abounds in small human, animal, and abstract decorative details. Opinions on whether symbolic meaning can be attached to them have been tentative at best, and most scholars have been downright sceptical. Françoise Henry has kept an open mind about the potential for symbolic meanings within decorative details.[29] An example of the latter tendency concerns the small figure sitting on and facing away from the opening text of the *Breves Causae* of St. Matthew's Gospel in the Book of Kells (f. 8r, Fig. 6), who has been described as thumbing his nose.[30] It may well be, however, that this image calls up the warrior-huntsman Finn macCumhaill, who possessed supernatural powers, was a leader of the other-world folk, and may have been an equivalent of the god Lugh.[31] Whenever he sought clairvoyance, Finn had merely to suck his thumb, for while cooking the salmon of wisdom he touched it and burned his thumb, which he put into his mouth, thus inadvertently tasting the fish. This small figure could thus be an example of the transfer of pagan traditions into the Christian period in Ireland. Kim McCone has described how the well with five streams represents the five senses through which knowledge is obtained. The symbolic act of cooking the fish transforms knowledge into the cultural and the usable. Finn cooks the salmon, is burnt by it, and tastes it, thereby achieving great and poetic knowledge.[32] He could hence double as an allegorical figure in the context of the new Christian knowledge or wisdom received through the Gospels.

McCone has amply demonstrated how similar mythologies appear in varying guises throughout the northern European world. The parallel between the smith who forges the weaponry in the magic fire to produce arms of invincible power and the seer who cooks food which becomes cultural or poetic wisdom finds expression in the carved wooden doorway from a twelfth-century Romanesque stave church at Hylestad, Setesdal, in south-west Norway (Fig. 7).[33] Here the figure, who is cooking a heart on a spit, shows in the gesture of thumb to mouth that he has just burnt his finger. The other scenes on this door demonstrate that this is a depiction of part of the saga of Sigurd the seer, who, having killed Fafair (who had turned himself into a dragon), roasted his heart, burned his thumb in so doing, and in sucking it gained the gift of prophecy and the ability to understand the speech of birds.[34] The parallels with Finn's story are clear. The detailed rendering of the pagan myth in the context of a Romanesque church speaks for itself. In another part of the same episode of Sigurd's legend, an otter eats a salmon. It should be noted that there is an image of an otter eating a salmon on the Chi-Rho page of the Book of Kells (f. 34r).

The warrior figures in the Book of Kells may also be parallels of the great heroes of Irish legends. Porter saw this as the meaning of many such figures on the high crosses.[35] The examples in manuscripts are heavily bearded, and on the crosses, at Durrow for example, it is clear that the beards are often lavishly plaited. Folio 200r of the Book of Kells, a page showing the beginning of the genealogy of Christ (Luke 3:22–26), begins the text with a youthful, bearded interlaced figure and ends with a dark-bearded warrior (Fig. 8). Christian de Mérindol has recently explored beard-tuggers, who appear with great frequency in the Book of Kells, either in pairs tugging each

6. Trinity College, Dublin, Ms. 58, Book of Kells, f. 8r, detail showing the small figure sitting on the opening text of the *Breves Causae* of St. Matthew's Gospel

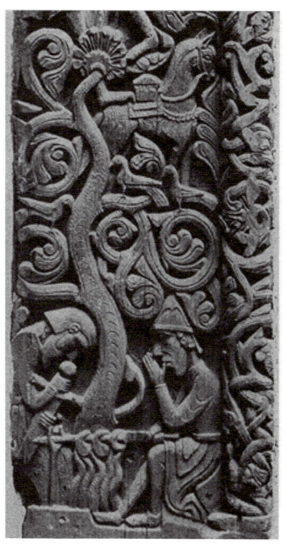

7. Doorway from a church at Hylestad, Setesdal, southwest Norway. Oslo, Universitetets Oldsaksamling

other's beards or singly pulling at their own.[36] This concept appeared in the northern parts of western Europe around A.D. 800, namely, in the Book of Kells and in the Corbie Psalter.[37] Amongst a number of possible meanings, these scenes have been equated with the struggle over evil prior to the redemption of man through Christ's birth. But more interestingly for this discussion, they can once again be related to Irish mythology. The story is told of how warriors refused to fight with the youthful, beardless Cú Chulainn, who then decided to make himself a false beard from grasses. The beard as symbol of virility and as a rite of passage to warrior/magician status permeates various branches of mythology. De Mérindol has also pointed out the barbaric custom of wearing elaborate styles of beards.[38] Many examples of finely plaited beards or lavishly curling moustaches appear throughout early Irish art in all media, and some gorgeous examples can be seen on Muiredach's Cross in Monasterboice (Co. Offaly).

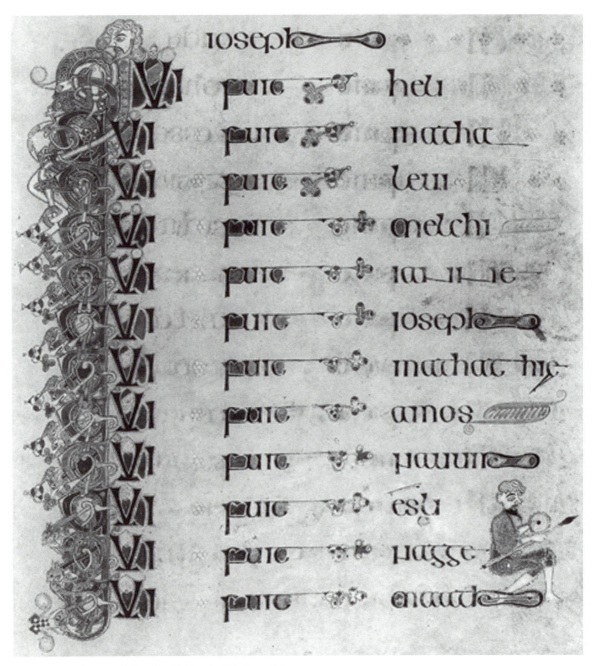

8. Trinity College, Dublin, Ms. 58, Book of Kells, f. 200r

Two enigmatic images of humans with fish's tails, again found in the Book of Kells, on folios 213r and 201r (Fig. 9), have been described as mermen. But we learn from Irish mythology that Tuan MacCairill was changed into a salmon and eaten by the wife of Cairill who then gave birth to him in human form so he could recite the early history of Ireland in the *Lebor Gabala* or Book of Invasions.[39] Thus Tuan MacCairill becomes the cipher of received wisdom or culture and is instrumental in the preservation of Ireland's history. In this role, his image—half man, half fish—

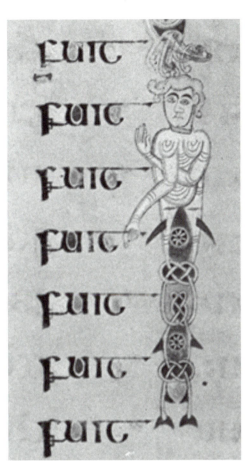

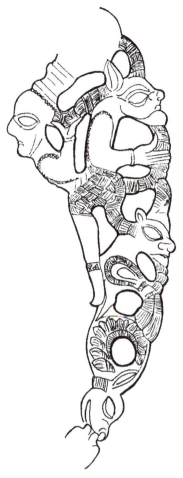

9. Trinity College, Dublin, Ms. 58, Book of Kells, f. 201r, showing "merman"

10. Gold neck ring from Erstfeld, Switzerland, fifth century B.C. Zürich, Schweizerisches Landesmuseum

could once again be allegorical and appropriated into the new knowledge and history of a Christian culture written down and preserved in the Gospels.

The ability of Celtic gods and warrior heroes to change into a variety of animal or fish forms is well known. If the many anthropomorphic entities which inhabit the Book of Kells or the high crosses have to be explained either as meaningless diversions or as signifiers of deeply felt mythological belief, the latter explanation would make the most sense. It should also be understood how vivid, important, and relatively immediate the Irish sagas and myths would have been in the eighth and ninth centuries when the Insular manuscripts and high crosses were produced. The Celtic belief system survived over centuries, through the Iron Age and into the Christian period; in Ireland it was uninterrupted by the Roman occupation. The centrality of religion and mythology to the Celts is reflected in every aspect of their culture.

If we look at Iron Age culture we find parallels for designs and styles which were still in use more than a thousand years later. A distant stylistic echo of the idea of contortionist figures is per-

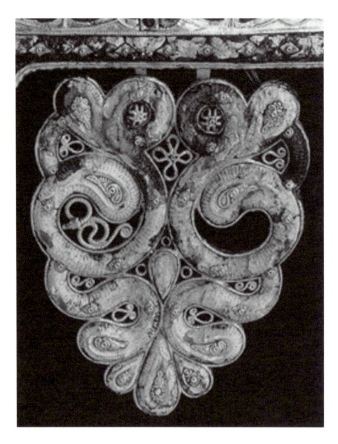

11. Helmet from Agris, Charente, France, fourth century B.C. Angoulême, Musée des Beaux-Arts 81.9.1

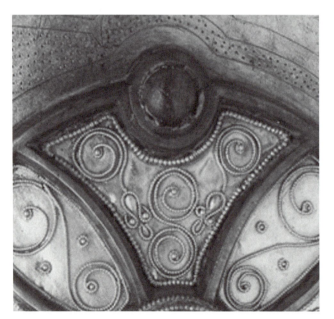

12. Ardagh chalice, filigree miniature in roundel. Dublin, National Museum of Ireland 1874:99

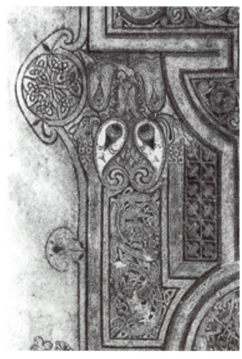

13. Trinity College, Dublin, Ms. 58, Book of Kells, f. 188r, detail of snake

haps visible on the fifth-century B.C. gold neck rings which were found in a cache in Erstfeld, Switzerland (Fig. 10). This consists of a complex design of animal and human elements with a lower animal fused with a griffin-like creature below, while above are "siamese twins" who are separate above the waist, one of them more distinctly human than the other. Megaw has suggested that this object was the product of an itinerant craftsman who may have come from Germany.[40] A bronze belt plaque with coral inlay, of the late fifth century B.C., from barrow I at Weiskirchen, Kr. Merzigg-Wadern, is also decorated with ambiguous imagery of "siamese twin"/griffin-sphinx creatures. Megaw relates the style of this plaque to twin wine flagons from Basse-Yutz and a fourth-century B.C. Hallstatt phase bronze scabbard from Salzkammergut, grave 994 (Fig. 19d), and proposes that the plaque, like the Erstfeld neckrings, was made by a special craftsman whom he calls the "Durkheim goldsmith." All these examples, he believes, may have come from the Rhineland region.[41] This is intriguing, as there are other arguments for the Rhineland being the source of a sleek figure style found in metalwork in Ireland up to and including the twelfth century.[42]

SERPENTS

While this discussion has declared itself to be about treatment of the human figure, a dramatic interloper has slipped into these lines for a brief appearance. Everywhere in the Book of Kells, on almost every page of design, serpents form entangled patterns, and they are just as common on the high crosses.[43] As with the human elements, there has been speculation as to whether these snakes have a particular meaning. In Celtic belief snakes appear everywhere as chthonic symbols, and the ram-headed or ram-horned serpent is often the companion of the god Cernunnos. A famous example occurs on the second-century B.C. Gundestrup cauldron, but this symbol was already established by the Hallstatt phase of Celtic art.[44] Part of the intricately worked cheek-piece of the iron, bronze, gold, and coral helmet from Agris, Charente, France, which dates to the fourth century B.C., comprises a curled serpent whose body is formed of gold pellets (Fig. 11). A small, strange design which looks like the bulbous eyes and snout of a snake is used to fill the small empty parts of the cheek-piece. In Early Christian Irish art this round-eyed serpent takes many related forms. Surprisingly, it appears as part of the filigreed miniature detail on the Ardagh chalice, which dates to the eighth century (Fig. 12). This snake has a body of individually soldered gold pellets and large rounded eyes.[45] The shape of the head and snout is distinctive and becomes such a deep-rooted part of the Irish repertoire of designs that it travels forward for centuries and finds itself amongst Irish Romanesque ornament in the twelfth century. There are many examples, but a spectacular twelfth-century specimen in stone is the sarcophagus inside Cormac's Chapel, Cashel (Co. Tipperary), which is covered by two large beasts untidily entangled in such snakes. This type of snake thus survives for approximately sixteen hundred years. In the Book of Kells it often has elaborate lappets, ears, or horns, and seems to carry the religious/mythological chthonic significance of its pagan existence within a new transcendental spiritual context. Examples of such snakes occur on folio 60r and, most brilliantly, on the *Quoniam* page of St. Luke's Gospel (f. 188r, Fig. 13), where there is a black and red-eyed snake of quite terrifying appearance.

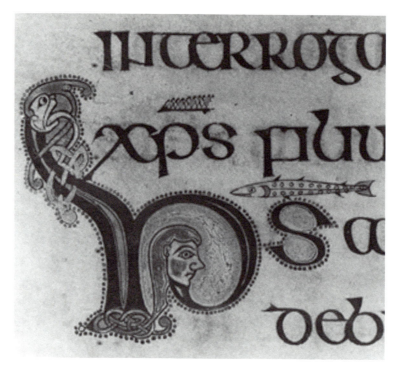

14. Trinity College, Dublin, Ms. 58, Book of Kells, f. 179v, abbreviated form of name of Jesus with fish

THE DISEMBODIED HEAD

The disembodied head is one of the most potent symbols in Celtic art, and the cult associated with it reached into all areas of life.[46] As a result of this significance (as evidence of triumph in war, for its evil-averting powers, and for its ritualistic importance) it appears in numerous contexts through every phase of Celtic art. It was used, for example, on fibulae which consist of an abstract curved shape topped with a human head. There are dozens of examples which belong to early Iron Age Celtic art: on wine flagons, on discs which form part of horse trappings, on finger rings and other items of jewelry, as well as carved in stone in sanctuaries. It is not surprising that it continues to be frequently used into the Christian period in Ireland. In various Insular manuscripts, abstract designs frequently terminate in human heads—in the tiny detail on folio 179v in the Book of Kells, for example (Fig. 14), and in a more elaborate manner on the Chi-Rho page of St. Matthew's Gospel (f. 34r), where the dramatic loop of the letter ends in a human head.

This is another idea which persists into Irish Romanesque art. An example in architectural stone decoration is found on the inner arch of the south doorway at Dysert O'Dea in County Clare, where an order of abstract chevron ornament ends in a small inverted human head. Another occurrence in low relief is on the west doorway at Killeshin in County Laois, where a flow of vegetal ornament terminates in a Kells Profile human head (Fig. 15). In both cases an ancient idea has been applied in a thoroughly Romanesque manner. Disembodied heads in stone occur on the earlier high crosses and continue into the twelfth century in the following architec-

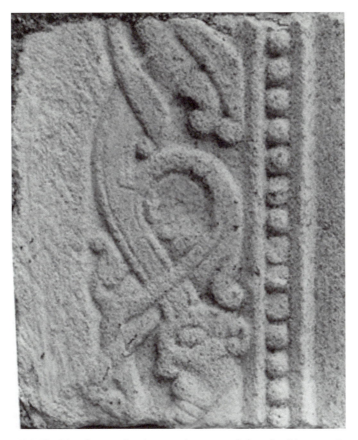

15. Killeshin, County Laois, west doorway of church with vegetal
ornament and a Kells Profile human head

tural contexts: as single heads at the apex of doorways or chancel arches, forming the voussoirs of doorways or chancel arches, in the form of capitals, inset into chevron designs, within the gable over a doorway, on high crosses, as corbels, and decorating abaci. To these may be added the common use of these heads in a variety of secular and ecclesiastical metalwork objects.

ANTI-CLASSICISM

Reference has already been made to the anti-classical (A2) style found in Early Christian Irish art, and this in essence also goes back to the Iron Age. The treatment of the body as an undifferentiated cylindrical form can be seen all over Europe. Representative Early Christian Irish examples include the high cross at Moone (Co. Kildare) and on the Second Coming page of the Turin Gospel book fragment (f. 2a).[47] A rather uncanny similarity can be recognized between the pillar statue accompanied by the totemic boar from Euffigneux, Haute-Marne, France, which has been dated to the first century B.C. (Fig. 16), and the undated stone caryatid figure holding a pair of bird-like creatures which is one of a group found in a Christian architectural context on White Island (Co. Fermanagh) (Fig. 17).

16. Pillar statue from Euffigneux, Haute-Marne, France, first century B.C. Saint-Germain-en-Laye, Musée des Antiquités Nationales 78243

17. Caryatid figure from White Island, County Fermanagh

A favourite Celtic motif consists of addorsed or opposed human heads connected by a linking element. A large range of examples can be found from the Hallstatt period onwards, and the particular version consisting of facing heads can be traced over at least sixteen hundred years (Fig. 18). An early example is a piece of a third-century B.C. bronze mount for a wooden jug from Brno-Maloměřice, Moravia (Fig. 18a). The design also occurs on gold finger and arm rings which belong to the fifth century B.C., such as those from Rodenbach and Schwarzenbach in Germany, and on an early fourth-century B.C. arm ring from Bad Dürkheim.[48] Another item intended for

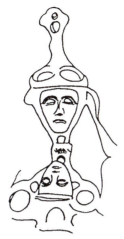

a. BRONZE JUG MOUNT, 3c.BC BRNO-MALOMĚRICE, MORAVIA.

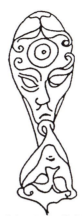

b. BRONZE FIBULA, 5c.BC SLOVENSKÉ, PRAVNO, SLOVAKIA.

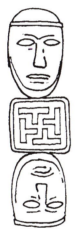

c. HANGING BOWL MOUNT, 8c.AD LØLAND, NORWAY.

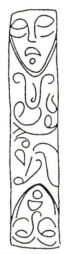

d. FILAGREE PANEL, 9c.AD DERRYNAFLAN CHALICE

f. TAU CROSS 12c.AD KILLINABOY, CO. CLARE

e. LA TÈNE PLAQUE, 1c.BC–early 1c.AD TAL Y LLYN, MERIONETHSHIRE, WALES.

18. Designs of facing heads from the fifth century B.C. to the twelfth century A.D.

personal adornment is the bronze fibula from Slovenské, Právno, Slovakia, of the fifth century B.C. (Fig. 18b).

Nearer to home, the broken plaque from Tal y Llyn, Gwynedd, in Wales consists of two human heads joined by a common neck (Fig. 18e).[49] The appearance of this design on a hanging bowl mount from Løland in Norway (Fig. 18c) prompted Françoise Henry to believe that it "betrays the survival of pre-historic representation."[50] It is also found in filigree decoration on the girdle of the Derrynaflan chalice (18d).[51] It survives up to the twelfth century on the stone tau cross formerly at Killinaboy (Co. Clare) (Fig. 18f), an object which, significantly, has often been mistakenly identified as belonging to the pagan Celtic period.[52]

THE HORSEMAN

We may conclude by mentioning the low-seated horseman, another motif which survived in a particular, mannered form for many hundreds of years (Fig. 19). The horseman which appears as a small detail in the Book of Kells, for example, has been regarded as comical and impossibly exaggerated in its stylisation, yet it reflects this mannerism in an exaggerated way (Fig. 19g). The rider is very low or deep-seated, and his leg stretches straight forward across the horse's shoulders. Once again, Iron Age art can provide parallels. The fourth-century B.C. Hallstatt scabbard from Salzkammergut is incised with a warrior who, although more naturalistic, is seated in a similar way (Fig. 19d). The horsemen on the Este plaque are curiously "deep-seated" (Fig. 4). Horsemen appear with great frequency on the early Irish high crosses: they are represented, often more than once, on twenty-two different crosses.[53] On several geographically widespread examples, at Banagher (Fig. 19c), Bealin (Fig. 19a), Clonmacnois (Fig. 19b), and Muiredach's Cross, Monasterboice (Fig. 19f), they are shown in a mannered pose with the leg forward. The tenth-century Corp Naomh bell shrine provides a comparable example in metalwork (Fig. 19e).[54] All of the horse and rider motifs on the Irish crosses follow a single formula very closely and have remarkably similar details. These include a horse with a downwards slanting eye, a heavy fringe of mane, a long luxuriant tail, and a well-collected stance with head down, hind quarters under, and foreleg stepping forward. The rider is seated low down on the horse's back with his legs swinging forward over the horse's shoulders and his hands low or concealed inside a cloak, and he has a Kells Profile and a curling tail of hair. All of this is consistent and exact in the various examples.

Mention of the Kells Profile brings us back to the beginning of this exploration of aspects of tradition and continuity. There are many other features, not dealt with here, that Iron Age and Irish early medieval art have in common: the recurrence of horned and cross-legged figures reminiscent of the Celtic god Cernunnos on the crosses and in the context of church architecture, the schematization of faces into exotic patterns, and certain types of vegetal or animal head designs. An array of styles and ideas persists and crosses the borderlands between Celtic and Christian cultures. One of the bonds which holds and unites these into a persistent tradition in Ireland is the belief system of pagan Celtic myth and legend which gradually fused with Christianity. It is the strength of this system of beliefs which is the key, because it persists across centuries and is expressed not only in words, but also in images. Hence stylistic types existed for well over a thousand years—as long in fact as the indigenous culture survived in Ireland, for the first twelve hundred years following the birth of Christ.

a. BEALIN CROSS b. CLONMACNOISE "PILLAR"

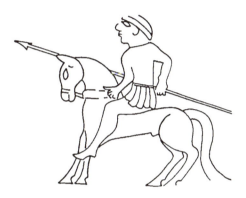

c. BANAGHER SHAFT d. BRONZE SCABBARD 4c. BC HALLSTATT

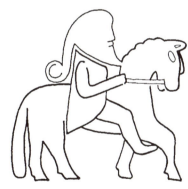

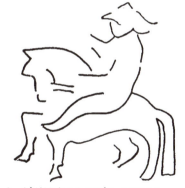

e. CORP NAOMH BELL SHRINE f. MUIREDACH'S CROSS

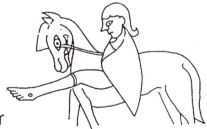

g. BOOK OF KELLS f.89r

19. Horsemen from the fourth century B.C. to the tenth century A.D.

NOTES

1. S. McNab, "The Interplay of Celtic and Classical Influences in Early Irish Art," *Irish Arts Review Yearbook* (1990–91), 164–71.

2. The term "anti-classical" is borrowed from Carl Nordenfalk's assessment of Insular manuscripts: *Celtic and Anglo-Saxon Painting: Book Illumination in the British Isles, 600–800* (London, 1977), 15. For the classification of styles, see S. McNab, "Styles Used in Twelfth-Century Irish Figure Sculpture," *Peritia* 6–7 (1987–88), 265–97, figs. 1, 2, pls. 1–15.

3. McNab, "Styles" (as in note 2), 270–71.

4. B. Raftery, "La Tène Art in Ireland," in *Ireland and Insular Art, A.D. 500–1200: Proceedings of a Conference at University College Cork, 31 October–3 November 1985,* ed. M. Ryan (Dublin, 1987), 12. Even the major exhibition of Celtic art in Venice in 1991 did nothing to dispel the cloudy mystery of the influences which gave rise to objects of such brilliant technical skill and beauty; the catalogue of the exhibition is *The Celts,* ed. S. Moscati, E. Arslan, and D. Vitali (Milan, 1991).

5. Such designs abound in the Book of Kells (Dublin, T.C.L., Ms. A.1.6 [58], siglum Q) and occur in the MacRegol or Rushworth Gospels (Oxford, Bodl., Ms. Auct. D.2.19 and Ms. S.C. 3946, siglum R), the Turin fragment (Biblioteca Nazionale, Cod. O.IV.20), and the St. Gall fragment (Stiftsbibl., Cod. 1395). Q and R have been assigned to a very small family of Insular mixed text manuscripts (DELQR) which are regarded by a number of scholars as Celtic and Irish. Martin McNamara has summarized and extended the discussions of the textual correspondences: "The Echternach and MacDurnan Gospels: Some Common Readings and Their Significance," *Peritia* 6–7 (1987–88), 217–22, and "Irish Gospel Texts, Amb. 1.61 Sup., Bible Text and Date of Kells," in *The Book of Kells: Proceedings of a Conference at Trinity College Dublin, 6–9 September 1992,* ed. F. O'Mahony (Aldershot, 1994), 78–101.

6. It can be found on the Market Cross and the Cross of Sts. Patrick and Columba in Kells (Co. Meath); on Muiredach's Cross at Monasterboice (Co. Louth); on the Cross of the Scriptures at Clonmacnois (Co. Offaly); on the North Cross at Ahenny (Co. Tipperary); on the Banagher cross (Co. Offaly); and probably, though indistinctly now, on the Killamery cross (Co. Kilkenny), on the Old Kilcullen cross (Co. Kildare), and on the Tihilly cross (Co. Offaly).

7. A debased version occurs in Pictish art on a grave marker from Meigle ECM26, now in the Perthshire Museum, Scotland. The classification is derived from J. R. Allen and J. Anderson, *The Early Christian Monuments of Scotland* (Edinburgh, 1903); see I. Henderson, "Pictish Art and the Book of Kells," in *Ireland in Early Mediaeval Europe: Studies in Memory of Kathleen Hughes,* ed. D.

Whitelock, R. McKitterick, and D. Dumville (Cambridge, 1982), pl. xiid.

8. Paris, B.N.F., Ms. cat. 6413, ff. 3v and 25v. O. K. Werckmeister, "Three Problems of Tradition in Pre-Carolingian Figure Style: From Visigothic to Insular Illumination," *PRIA* 63C, no. 5 (1963), 167–89, pls. 21–34, at 170. His argument was augmented by Hillgarth's historical analysis of contacts between Ireland and Spain and his belief that Isidore is omnipresent in the Irish writings of the late seventh, eighth, and ninth centuries: J. N. Hillgarth, "Visigothic Spain and Early Christian Ireland," *PRIA* 62C (1962), 189, n. 113.

9. J. V. S. Megaw, *Art of the European Iron Age: A Study of the Elusive Image* (New York, 1970), cat. nos. 34, 57.

10. Certosa di Bologna, grave 68, now in the Museo Civico Archeologico, Bologna; Megaw, *Art of the European Iron Age* (as in note 9), cat. no. 24.

11. The full-face version has been described by McNab, "Styles" (as in note 2), 272.

12. In spite of E. Rynne's entertaining discussion in "Drolleries in the Book of Kells," in *Book of Kells Conference* (as in note 5), 311–21.

13. C. Farr, "History and Mnemonic in Insular Book Decoration," in *From the Isles of the North: Early Medieval Art in Ireland and Britain,* ed. C. Bourke (Belfast, 1995), 137–45, and C. A. Farr, "Textual Structure, Decoration, and Interpretive Images in the Book of Kells," in *Book of Kells Conference* (as in note 5), 437–49.

14. O. K. Werckmeister, *Irisch-northumbrische Buchmalerei des 8. Jahrhunderts und monastische Spiritualität* (Berlin, 1967), 154–57.

15. F. Henry, *The Book of Kells* (London, 1974), 194.

16. J. J. O'Meara, "Introduction," in *The Mind of Eriugena: Papers of a Colloquium, Dublin, 14–18 July, 1970,* ed. J. J. O'Meara and L. Bieler (Dublin, 1973), x.

17. M. Haren, *Medieval Thought: The Western Intellectual Tradition from Antiquity to the Thirteenth Century* (London, 1985), 75.

18. D. Moran, *The Philosophy of John Scottus Eriugena: A Study of Idealism in the Middle Ages* (Cambridge, 1989), 130.

19. Moran, *Philosophy* (as in note 18), 50, 51. Dionysius's hierarchical cosmology orders all reality in an outflowing from this unknowable godhead down into sensible and material reality. This outflowing from the One proceeds in a triadic manner showing the immanence of the Trinity in all created things.

20. Haren, *Medieval Thought* (as in note 17), 76. See also Moran, *Philosophy* (as note 18), 52ff.

21. M. Heaney, *Over Nine Waves: A Book of Irish Legends* (London, 1994), ix.

22. A. K. Porter, "St. Patrick and the Pagans," in *The Crosses and Culture of Ireland* (New Haven and London,

1931; repr. New York, 1979), 15ff.

23. D. A. Binchy, "A Pre-Christian Survival in Medieval Irish Hagiography," in *Ireland in Early Mediaeval Europe* (as in note 7), 165–77.

24. F. Henry, *Irish Art in the Early Christian Period*, 2nd ed. (London, 1947), 193ff.

25. Henry, *Irish Art in the Early Christian Period* (as in note 24), 195.

26. *Voyage of Bran, Son of Febal, to the Land of the Living: An Old Irish Saga Now First Edited, with Translation, Notes, and Glossary, by Kuno Meyer* (London, 1895–97; reprint of pp. i–xvii and 1–99, Felinfach, 1994), 24–26, stanzas 53–54. It is further on in the saga that it becomes clear that Morgan is Finn.

27. P. MacCana, *Celtic Mythology* (London, 1970), 71.

28. *Táin Bó Cúailnge, Recension 1*, trans. C. O'Rahilly (Dublin, 1976), lines 2245–78, cited by S. James, *Exploring the World of the Celts* (London, 1993), 160. An expanded description can be found in *The Táin*, trans. T. Kinsella (Dublin, 1969), 150ff.

29. Henry, *Book of Kells* (as in note 15), 174ff.

30. Rynne, "Drolleries" (as in note 12), 314, is adamant: ". . . is cock-a-snoot thumbing his nose at us all and defying us to interpret him otherwise or to read a symbolic or liturgical meaning into his gesture." There is another similar example in the Book of Kells, on the f. 1v canon tables.

31. MacCana, *Celtic Mythology* (as in note 27), 110.

32. K. McCone, *Pagan Past and Christian Present in Early Irish Literature* (Maynooth Monographs 3) (Maynooth, 1990), 169ff. He refers to *The Boyhood Deeds of Finn* or the *Macgnimartha Finn*.

33. M. Blindheim, *Norwegian Romanesque Decorative Sculpture, 1090–1210* (London, 1965), 52, 53, figs. 197, 198.

34. H. R. Ellis Davidson, *Scandinavian Mythology*, 4th ed. (London, 1988), 101.

35. Porter identified many of the warriors on the high crosses with the leading players in Irish mythology. One quite convincing example occurs on the west side of the cross at Old Kilcullen (Co. Kildare), where a mounted warrior blowing a horn and accompanied by a hound is identified as Cú Chulainn: Porter, *Crosses and Culture* (as in note 22), 16.

36. C. de Mérindol, "Du Livre de Kells et du Psautier de Corbie à l'art roman: Origine, diffusion et significance du thème des personnages se saisissant à la barbe," in *Book of Kells Conference* (as in note 5), 290–300. Peter Harbison has discussed this iconography and relationships to work produced in Europe and elsewhere in Ireland in "Three Miniatures in the Book of Kells," *PRIA* 85C (1985), 193, and *The High Crosses of Ireland: An Iconographical and Photographic Survey* (Bonn, 1992), vol. 1, 321.

37. The Corbie Psalter (Amiens, Bibliothèque Munici-

pale, Ms. 18), f. 73, shows beard-tuggers in a pelleted circle.

38. De Mérindol, "Du Livre de Kells et du Psautier de Corbie" (as in note 36), 298, 299.

39. J. MacKillop, *Dictionary of Celtic Mythology* (Oxford, 1998), 365.

40. Megaw, *European Iron Age* (as in note 9), 80, cat. no. 84.

41. For the pieces from Weiskirchen, Basse-Yutz, and Salzkammergut, see Megaw, *Art of the European Iron Age* (as in note 9), cat. nos. 62, 60–61, and 30.

42. T. D. Kendrick and E. Senior, "St. Manchan's Shrine," *Archaeologia* 86 (1937), 105–18, and S. McNab, "Irish Figure Sculpture of the Twelfth Century" (Ph.D. thesis, University of Dublin, 1986), vol. 1, 226ff.

43. As well as being frequently incorporated into panels of animal interlace, it occurs on the Cross of the Scriptures at Clonmacnois, Durrow (Co. Offaly), and Muiredach's Cross, Monasterboice (Co. Louth), in a figure-of-eight design in which muscular, pelleted snakes with large "ears" encase small glowering human heads. This has been interpreted as a Celtic variation of the classical *imago clipeata*: McNab, "Interplay" (as in note 1), 166, 167.

44. A. Ross, *Pagan Celtic Britain: Studies in Iconology and Tradition* (London, 1967), 130.

45. For the most comprehensive account of the goldworking techniques of this object, see N. Whitfield, "Motifs and Techniques of Celtic Filigree: Are They Original?" in *Ireland and Insular Art* (as in note 4), 75–85.

46. A. Ross, *The Pagan Celts*, rev. ed. (London, 1986), 51ff.; she also devotes a chapter to this cult in *Pagan Celtic Britain* (London, 1967), 61–126.

47. Turin, Biblioteca Nazionale, Cod. O.IV.20, first half of the ninth century, Irish, according to J. J. Alexander, *Insular Manuscripts: Sixth to the Ninth Century* (A Survey of Manuscripts Illuminated in the British Isles 1) (London, 1978), cat. nos. 61, 80.

48. For provenances, assessments, bibliographies, and illustrations, see Megaw, *Art of the European Iron Age* (as in note 9), cat. nos. 158, 58, 53, and 54, respectively.

49. Now in the National Museum of Wales, Cardiff; see R. and V. Megaw, *Celtic Art from Its Beginnings to the Book of Kells* (London, 1989), 226.

50. Henry, *Irish Art* (as in note 24), 123.

51. M. Ryan, "The Menagerie of the Derrynaflan Chalice," in *The Age of Migrating Ideas: Early Medieval Art in Northern Britain and Ireland*, ed. R. M. Spearman and J. Higgitt (Edinburgh, 1993), 159, points out many examples of this type of design but says that the motif originated "in belt garnitures and the like of late Roman military equipment." He has dated the chalice to the ninth century: M. Ryan, *The Derrynaflan Hoard*, vol. 1, *A Preliminary Account* (Dublin, 1983), 36ff.

52. Ross, *Celtic Britain* (as in note 44), 80, 81. A thor-

ough and most useful examination of this object by Etienne Rynne concludes that it is Romanesque: "The Tau-Cross at Killinaboy: Pagan or Christian?" in *North Munster Studies: Essays in Commemoration of Monsignor Michael Moloney,* ed. E. Rynne (Limerick, 1967), 146–65.

53. They occur on the North and South Crosses at Ahenny (Co. Tipperary); at Bealin (Co. Westmeath, Fig. 19a); at Clones (Co. Monaghan); on the South Cross, the Cross of the Scriptures, and the "pillar" at Clonmacnois (Co. Offaly, Fig. 19b); at Donaghmore (Co. Tyrone); at Dromiskin (Co. Louth); at Durrow (Co. Offaly); on the Market Cross and the Cross of Sts. Patrick and Columba at Kells (Co. Meath); at Kilfenora (Co. Clare); at Kilkieran (Co. Kilenny); at Killamery (Col. Kilkenny); at Killeany (Co. Galway); at Monaincha (Co. Tipperary); on Muiredach's Cross, Monasterboice (Co., Louth, Fig. 19f); at Moone (Co. Kildare); at Old Kilcullen (Co. Kildare); at Seirkieran (Co. Offaly); at Arboe (Co. Tyrone); and at Banagher (Co. Offaly, Fig. 19c).

54. The bell shrine found at Temple Cross (Co. Westmeath) is now in the National Museum of Ireland, Dublin, accession no. 1887:145. See also F. Henry, *Irish Art during the Viking Invasions, 800–1020 A.D.* (Ithaca, 1967), 125.

Deciphering the Art of Interlace

·

MILDRED BUDNY

EDIEVAL PATTERNS of interlace, particularly those created in the British Isles or in-spired by Insular models, have long been admired for their intricacy, mystery, and frequent excellence of design and execution. Superb examples from both domains include initial-pages in the Book of Kells (Fig. 1) and the Second Bible of Charles the Bald, made in Franco-Saxon style.[1] In the hands of Irish, Anglo-Saxon, Pictish, Welsh, and Hiberno-Saxon scribes, artists, and crafts-men, this type of ornament attained great popularity, with the creation of many remarkable pat-terns, especially in the "golden age" of Insular art culminating in the ninth century. Notable ex-amples of that age include Kells and the magnificent "Royal Bible" of St. Augustine's Abbey, Canterbury. Although now reduced to fragments, the latter retains much distinctive interlace in its initials and arcades enclosing both the Gospel opening and the canon arcades (Figs. 2, 9, 10, and 19).[2] This paper surveys the structure and study of interlace across the centuries and the geo-graphical boundaries of western Europe; examines the many ways of reading such patterns; and proposes a new approach to understanding and interpreting the complexities of the designs.

THE STRUCTURE OF INTERLACE

Interlace constitutes a construction in which each element (or strand) of the fabric passes alter-nately *over* and *under* elements crossing its path. It is one of the earliest and most universal of all human inventions, used in weaving, braiding, plaiting, and knotting. The alignment of elements and crossings can be *upright*, or horizontal-vertical, as in many textiles; *diagonal*, as in many plaits and ornamental patterns; or *spiral*, as in many baskets.[3] At a minimum, each pattern comprises a *figure*, formed by the strands themselves, and a *ground*, defined by their interstices. In cases where the strands comprise not single lines but parallel disjoint lines, a third element is generated: the *interior* of a strand, which may establish another form of figure-and-ground.

In theory, such a structure could go on to infinity, except for pre-set limits (such as an enclo-sure) which return the strands into the network or force them to terminate (Fig. 3). In upright alignment, strands regularly make U-turns or *U-bends* connecting parallel diagonals. In diagonal alignment, they make U-bends in the corners and *V-bends*, connecting perpendicular diagonals, at the sides. These names derive from the angle or degree of the bend, not from any curve or point at its tip. The key component is the disposition of the diagonals.

Such is the form of a standard network, which can undergo many variations.[4] It can be set out in different lengths and widths (Figs. 4 and 5), offering many possibilities. Likewise, the strands may vary in width, decoration, or both (Figs. 1, 2, and 6). Features such as ribs or pellets

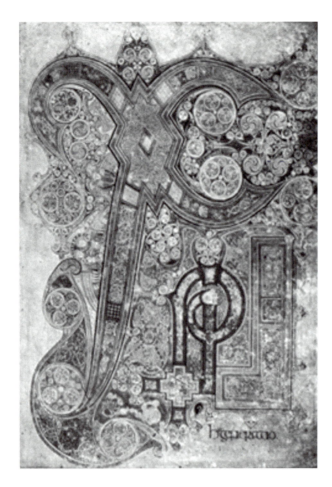

1. Dublin, Trinity College
Library, Book of Kells, Ms. A.I.6
(58), f. 34r. Initial-page of
Matthew 1:18, *Christi autem*

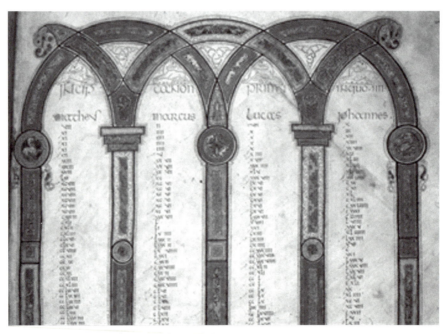

2. London, British Library, Royal Ms. 1 E.vi, Royal Bible, f. 4r, top. Upper part of the
arcade for Canon I

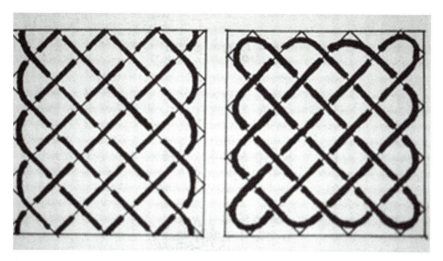

3. Limits for standard networks, with V-bends at the sides and U-bends in the corners

can punctuate the strands and interstices, as in the John initial-page of the eighth-century Cambridge-London Gospels from Northumbria (Fig. 6).[5] Such variants can provide multiple embellishments both within a single pattern and from pattern to pattern within a given work.

THE NETWORKS AND THEIR VARIATIONS

The number of strands along a row of crossings defines the *width* of a network, while the number of rows defines its *length*. Plaitwork of two-strand width forms a succession of twists, as each row contains only one *crossing point* (Fig. 4). In greater widths, the successive rows of crossing points lie in alternate positions. For plaitwork of even-numbered widths, they alternate between seemingly "*even*" rows, in which all the potential crossing points use all the strands, and "*odd*" rows having one uncrossed strand at each side, flanking the crossing point(s). For uneven-numbered widths, each row has a crossing point at one side and an uncrossed strand at the other, so that V-bends and outer crossings stand on alternate sides in consecutive rows, with rows aligned to the left and right respectively, making the plaitwork look lopsided (Fig. 4).

Further permutations are derived through *breaks*, a somewhat misleading term which has gained wide currency.[6] They need not be actual cuts, or terminations, but are usually deviations in the courses of strands around the expected crossing points, so as to link with other parts of the network. The links stand to either side of the crossing point in a *vertical break*, but above and below in a *horizontal break* (Fig. 5).[7]

Each individual pattern derived from plaitwork is thus distinguishable by (1) *the width and length of the network* upon which it is based, defined by the number of crossing strands in the horizontal rows of crossings and the number of rows; (2) *the form of the ends*, defined by whether the pattern is continuous, with strands turning back into the network, or terminates in some way, with loose ends; and (3) *the kinds and distributions of the breaks*, determined by any redirections of the strands from the standard network. Attempts to analyze patterns must take into account all of

2-strand

```
Row 1 →    X
          ( )
Row 2 →    X
          ( )
           X
```

	3-strand	**5-strand**	**7-strand**
Row 1 →	X)	X X)	X X X)
Row 2 →	(X	(X X	(X X X
	X)	X X)	X X X)
	(X	(X X	(X X X
	X)	X X)	X X X)
	(X	(X X	(X X X

	4-strand	**6-strand**	**8-strand**
"Odd" row →	(X)	(X X)	(X X X)
"Even" row →	X X	X X X	X X X X
	(X)	(X X)	(X X X)
	X X	X X X	X X X X
	(X)	(X X)	(X X X)
	X X	X X X	X X X X
	(X)	(X X)	(X X X)
	X X	X X X	X X X X
	(X)	(X X)	(X X X)

	3-strand	**5-strand**	**7-strand**
"Left-hand" row →	X)	X X)	X X X)
"Right-hand" row →	(X	(X X	(X X X
	X)	X X)	X X X)
	(X	(X X	(X X X
	X)	X X)	X X X)
	(X	(X X	(X X X

4. Variable widths of networks (two-strand to eight-strand widths) and the orientations of their rows of crossings

these characteristics. Variations in width and ornamentation of the strands do not constitute structural characteristics, but instead offer decorative variations or embellishments.

Breaks can occur at any crossing point and any combination linking adjacent crossing points in the same row, successive rows, or both. They open up a wide range of configurations in the strands, interstices, and formations along the edges, and they often occur in matching or mirrored pairs. The use of breaks can establish distinctive rhythms, as the repeated or varied pattern-units build a design which can display any, none, or all of horizontal, vertical, or diagonal symmetry. These rhythms can distinguish the style of a particular artist or school.

Such shared rhythms govern two different patterns which stand on opposite sides of the

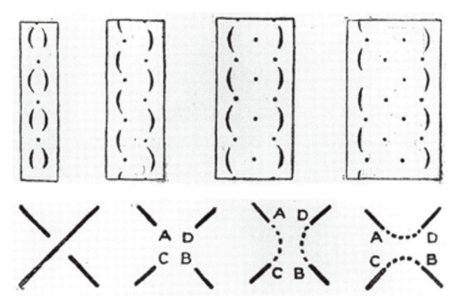

5. Orientation of crossing points and "breaks" in plaitwork: *(a) top:* positions of bends and crossing points in two-strand to five-strand widths; *(b) bottom:* "breaks" in crossing points, vertical and horizontal

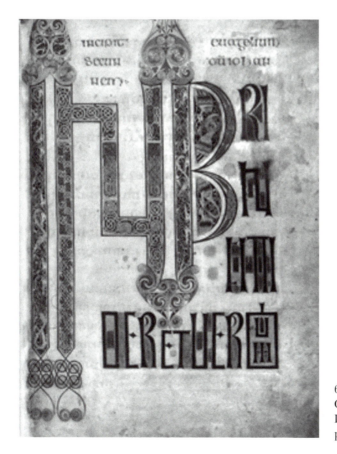

6. Cambridge, Corpus Christi College, Ms. 197B, Cambridge-London Gospels, f. 2r. Initial-page of John Gospel, *In principio*

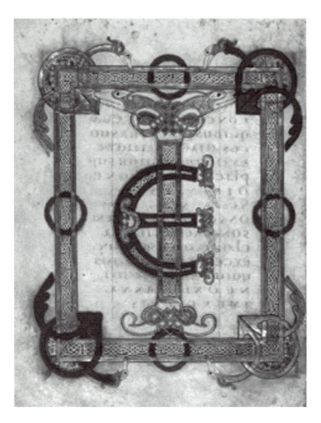

7. New York, Pierpont Morgan Library, Ms. G. 57,
Morgan Sacramentary, f. 4v. *Te Igitur* initial-page

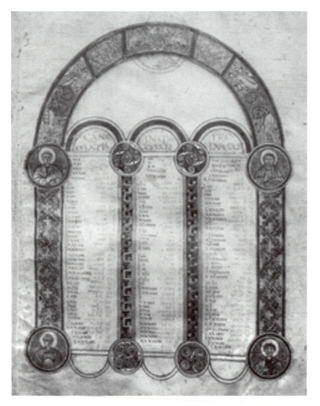

8. Stockholm, Kungliga Biblioteket, Cod. 135,
Codex Aureus, f. 6r. Arcade for Canon II

same arcade in the Royal Bible in panels of about the same size (Fig. 19a, b). Although their networks have different widths and lengths, respectively in six- or eight-strand of forty-one or forty-three rows, each exhibits a similar preference for vertical over horizontal symmetry. In each, the pairs of horizontal inner (Fig. 19a) or outer (Fig. 19b) breaks, made at both sides of a row, are distributed at regular intervals, but leave different expanses of unbroken plaitwork at top and bottom, with more at the bottom. In the former pattern, the pairs occur in every fifth row, from rows 5 to 35. Only the different unbroken expanses at top and bottom (four and eight rows) keep it from displaying horizontal symmetry. These preferences and other clues imply that the artist worked out each pattern as he proceeded vertically down its network.

Combined breaks in adjacent crossing points open up larger shapes. For example, the components of the break can occur in a stepped line which turns back on itself, enclosing a loop within the turn, as in the unusually long zigzag or *chevron break* which descends throughout most of one pattern in the Royal Bible (Fig. 19c). According to their shapes, diverse breaks make the strands curve or bend like *Us*, *Vs*, *Ls*, *Ss*, *Cs* (which form loops), *Os* (or rings), and so on. The bends can occur in *normal* or *extended* versions. The latter can be extended doubly, trebly, or even more, as with the nested V-bends alternating throughout the panels on both sides of the frame for the *Te Igitur* initial-page in the Franco-Saxon Morgan Sacramentary (Fig. 7).[8] A break may be open-ended, as with the sideways T-shaped breaks on both sides of a canon arcade in the eighth-century southern English Codex Aureus now in Stockholm (Fig. 8).[9] There, small inset fields emphasize the shapes of both these *T-breaks* and the *cruciform breaks* down the center.

Particular forms of breaks generate interstices shaped like the letters *L*, *I*, *C*, *S*, and *Z*. By their alignments, they can seem upright, reversed, inverted, or inverted-reversed. All four orientations appear in the *L-breaks* in the four corners of two patterns in the Royal Bible (Fig. 9a, b). Both these patterns also contain L-breaks in mirrored pairs placed either toe-to-toe or back-to-back flanking horizontal or vertical twists respectively, while the second pattern (Fig. 9b) also has series of mirrored pairs of *S-and-Z-breaks* flanking vertical twists.

Formations other than breaks can add to the complexity. Transitional elements change the width of the network, particularly where space dictates, as at the center of the initial *X* (Chi) of the *Christi autem* initial-page in the Book of Kells (Fig. 1), or where patterns deviate from regular plaitwork, as often in the Royal Bible (Fig. 9c). Pairs of strands may extend from a crossing point in three rather than four directions when one strand stops short, in a *butted end*, while the other continues unopposed. One strand can branch with tangents, as seen in spiral or scrolling knotwork, or in cases where interlace merges with a branching stem (Fig. 9c). Sometimes a strand passes "over" two others in consecutive crossings. Modern observers might regard such cases as mistakes, but that judgment is not always appropriate, for example, where branchings or shifts in width require a strand to pass over more than one other in succession.

Some observers criticize what they call "faults" or "beginners' mistakes." For example, John Merne regularly added shading at the crossings to imply perspective, a feature wholly absent from early medieval patterns, and he faulted forms which might untie when pulled tight, even though some rope knots are designed to do just that. His cases include a loop, S-curve, and succession of twists, supposedly "strengthened" by encircled crossings.[10] Such condemnation scarcely suits the twists at the top of the masterful initial *Z* in the Royal Bible (Fig. 10), where qualification as a "beginner" pertains only to its position in the word and on the page.

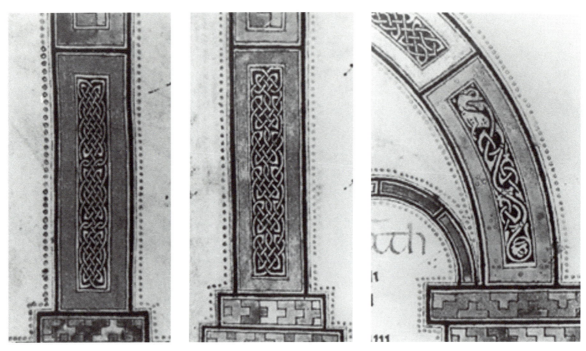

9. London, British Library, Royal Ms. 1 E.vi, Royal Bible. Enclosed interlace patterns in the arcades for Canons II–VII: *(a) left:* 4v: 1E; *(b) middle:* 5v: 1E; *(c) right:* 5r: II*e*

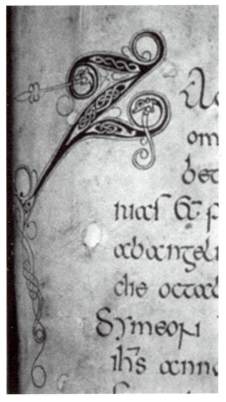

10. London, British Library, Royal Ms. 1 E.vi, Royal Bible, f. 42ra. Initial *Z* of Luke chapter list

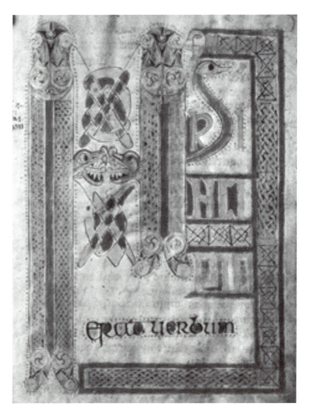

11. St. Gall, Stiftsbibliothek, Cod. 60, Gospel fragment, p. 5. Initial-page of John Gospel

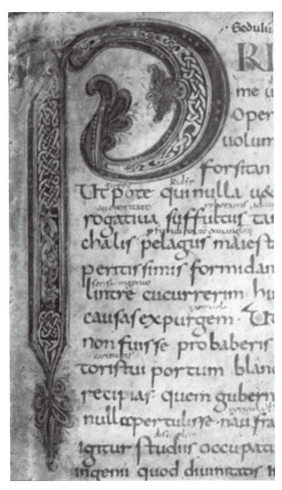

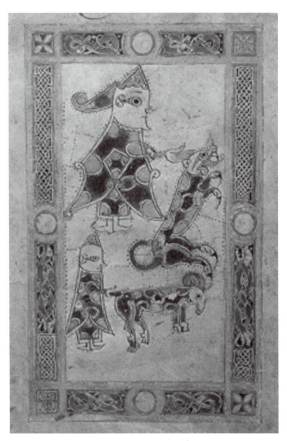

12. Antwerp, Musaeum Plantin-Moretus, Ms. M.17.4 (126), Antwerp Sedulius, f. 2r. Initial *P* of preface to Sedulius's *Paschale carmen*

13. Cambridge, St. John's College, Ms. C.9 (59), Southampton Psalter, f. 4v. David and the Lion

Beginners' misshapen attempts at interlace do exist, however, even during the Insular "golden age," as in an Irish Gospel fragment at St. Gall (Fig. 11).[11] On its facing pages with the frontispiece and initial-page for John (pp. 4–5), the vertical interlace in the monogram letters *INP* is competently rendered, whereas the patterns in the enclosing frames are awkward and inept. The contrast implies the work side-by-side of master and pupil at an early stage in instruction. Similar disparity exists in other cases, as on recto and verso of a single leaf (f. 5r–v) in the Codex Aureus.

Despite the widespread impact of Insular interlace, its examples were not always understood. The botched version of interlaced animals in an initial *P* in the ninth-century Antwerp Sedulius, noted for its many illustrations derived from an Insular model, attests to a lack of understanding of the genre by its otherwise skilled Continental scribe (Fig. 12).[12] In contrast, much better versions are executed in the eleventh-century Southampton Psalter, which, made in Ireland, belongs more fully within a continuing tradition of Insular interlace (Fig. 13).[13]

14. Rome, Biblioteca Vaticana, Palat. Ms. lat. 207, f. 107v. Initial *h* in Augustine's *Tractatus in Iohannem*

15. St. Petersburg, Russian State Public Library, Cod. Q. v. 1.18, St. Petersburg Bede, f. 36v. Initial *H* of Bede's *Historia ecclesiastica gentis Anglorum*, book 2

The Types and Construction of Interlace

The classes of interlace in Insular art mainly comprise plaitwork and its derivatives, plus forms of knotwork, ringwork, or chainwork. More than one class may occur in a given pattern, as its parts apply one strategy after another to the courses and crossings of strands. Interlace may also be combined with any or all of animal, vegetal, and geometric ornament as well as script, as with the highly skilled initial-pages in the Book of Kells, the Royal Bible,[14] and a collection of church canons made in Northumbria in the early eighth century and brought soon after to Cologne.[15]

Although many patterns are fitted within enclosures, some hover upon the surface as "free-floating" suspensions or extensions. They include dotted lines and pen-flourishes, as on the John initial-pages of both the Lindisfarne Gospels[16] and the Cambridge-London Gospels (Fig. 6), as well as the canon arcades of the Royal Bible (Fig. 2). Some were drawn free-hand, so their forms are limited mainly by the scribe's pen or penmanship.

Enclosed patterns were usually constructed over a preliminary grid of lines or dots laid out in drypoint, ink, or pigment. Before pencil and eraser, such marks were there to stay and the grids often remain visible, fortunately for us. They are especially apparent where the pattern was

not completed (Fig. 14); where the grid was only partly covered (Fig. 15); where damage has lifted their covering; or where incised lines and pricked points remain in place (Fig. 11).[17] Techniques such as infrared lighting or backlighting can bring a grid into view through the covering medium.[18] Sometimes the pigment of the dots darkened over time so as to show through the superimposed medium. Occasionally the grid itself forms a dominant part of the pattern, as in some canon arcades of the eighth-century Maaseik Gospel fragment.[19]

Some early methods employed arcs and lines drawn with compass and ruler, outlining the strands themselves, as with an ornamental page of uncertain early date, inserted in an eighth-century manuscript from Corbie in northern France and sometimes regarded as a sampler, pattern sheet, or model-page.[20] This approach to construction has been called "the Roman compass style."[21]

Other methods employed a network of squares, rectangles, or other shapes, now termed a *Quadratschema* in German.[22] The shapes served to outline the interstices, as in the Stowe Missal, made in Ireland,[23] or, more often, to set out pattern-units, mark crossing points or turning points, or both, as in the Durham Cassiodorus, made in Northumbria.[24]

Especially common are dots arranged in alternating rows (*Punkteschema*) to establish and orient the network.[25] The strands could connect or bypass the points. Then, by filling in the background, this "scaffolding" could disappear from view. Such a grid remains clearly visible in the eighth-century St. Petersburg Bede made at Monkwearmouth-Jarrow, where the skilled initial *h* of book 2 encloses a bust-portrait of Gregory the Great (Fig. 15).[26] Thin-strand interlace fills the stem and bow of the letter, while the partly filled interstices between the strands expose some dots of the grid.

Sometimes the construction employed more than one method. Examples include a *Punkteschema* overlaid with roughly sketched circles and ovals, as in the Cuthbert Gospels, made under strong Insular influence at Salzburg,[27] and many *Quadratschemas* combined with *Punkteschemas*, as in the Lindisfarne Gospels.

The grids were intended to produce a regular and accurate design, which they cannot do when they are drawn askew, as in the pupil's part of the St. Gall Gospel fragment (Fig. 11). Experiments in developing or practicing interlace patterns abound in manuscripts as exercises, sketches, or drafts, especially in margins and on endleaves. Examples include the eighth-century Corpus Sedulius and a tenth-century copy of saints' Lives from Canterbury.[28] Some imitate interlace already in the book, and sometimes the trial is superior to the original.

Many trials, often with construction marks, also survive on other media. Many appear on pieces of bone, slate, and wood from various sites, as from Dublin, Dungarvan (Co. Waterford), and Lagore Crannog (Co. Meath).[29] Some carry trials of the same pattern, repeated over and over, manifesting attempts to improve or master the design. Throughout the different materials, the interlace demonstrates a fundamentally similar approach to the layout of design. Indeed, grids of dots were used in Insular interlace construction to a much greater extent than has generally been recognized.[30] However, once one learns to read the networks and their underlying structure, such devices become recognizable nearly everywhere.[31]

THE CORPUS OF INSULAR INTERLACE

Interlace patterns exist in a variety of media. They range from architectural and freestanding stone sculptures, as with the North and South Crosses at Ahenny (Co. Tipperary),[32] the unusually

16. Durham, Cathedral Library, Ms. A.II.10, Bible fragment, f. 3v. Framed script at the end of Matthew Gospel

tall cross at Gosforth in Cumbria,[33] and the multiple carvings preserved at a single site as at Clonmacnois (Co. Offaly),[34] to carvings in ivory, bone, wood, slate, and other materials, as with the Brunswick Casket,[35] and leather, metalwork, and textiles, as with the Derrynaflan paten[36] and the Maaseik embroideries.[37] Interlace is found on all manner of objects. They range from grave covers, as at Durham,[38] and shrines, as with the Shrine of St. Patrick's Bell at Dublin,[39] through weapons, harness, jewelry, and vessels, as with the so-called Tara brooch and the Ardagh chalice,[40] to bookbindings, wax tablets, and styli for writing and drawing, as from Blythburgh in Suffolk and Whitby in North Yorkshire.[41]

Manuscripts contain by far the most patterns. Some can be dated within close, or fairly close, limits, so their multiple aspects can serve as a major guide to the range of patterns in use by a given center or artist at a given time. A proper analysis of their interlace requires a detailed study of the artifact as a whole object, as with my research on the Royal Bible.[42] Its five pages of canon arcades alone have more than 115 interlace patterns (Figs. 2, 9, and 19), displaying a range rarely equalled, and rivalling the other most complex ensembles such as the Book of Kells (Fig. 1) and the St. Petersburg Gospels.[43]

Existing methods of analyzing interlace could not fairly represent such complexity, variety, and style. From principles set out by pioneers including John Romilly Allen and Erich Joseph Thiel, I developed the system of terminology, notation, and analysis introduced here.

Unbroken versus "Broken" Plaitwork

Simple knots and plaitwork had long been used for ornament in the Mediterranean world and beyond, including former parts of the Roman Empire.[44] In the British Isles, from at least the seventh century, increasingly complex patterns developed. In manuscripts, enclosed patterns already appear in the seventh century, as in the Northumbrian Bible fragment at Durham[45] and the Book of Durrow.[46] In the triple frame with a stack of three D-shaped panels enclosing script at the end of the Matthew Gospel in the Durham fragment (Fig. 16), simple plaitwork appears in the lowermost panel, while plaitwork with "breaks" occupies the upper two.

Plaitwork with breaks constitutes a fundamental contribution to the history of design. Some scholars believe that it was invented by Insular artists, who in any case made it their own (as in Figs. 1, 2, 6, and 8–10).[47] Its widespread transmission resulted largely from several factors: Insular missions to the Continent; the establishment of Insular foundations there; the importation or influence of Insular models, as at St. Gall (Fig. 11); the persistent conservatism in Irish and Welsh art and book production (Fig. 13);[48] and the breathtaking beauty of many patterns.

That such patterns were much admired is attested by Gerald of Wales. His praise of the Gospel book which he saw at Kildare between 1185 and 1187 refers specifically to interlace. "That wonderful book," he declared, has

almost as many different designs (*figurae* in Latin) as pages. . . . If you look at them superficially and, as one customarily does, imprecisely, it will seem a jumble (*litura*) rather than an interlacing (*ligatura*), and you will not notice any subtlety, where there is however nothing but subtlety. If, however, you activate the keenness of the eyes to observing more perspicaciously, and at length penetrate to the secrets of the art, then you will be

able to notice plaitings (*intricaturas*) so delicate and subtle, so exact and skillfully wrought . . . that indeed you would assert that all this was created more through angelic than human diligence. For my part, the more often I see the book, and the more carefully I study it, the more I am lost in ever-fresh amazement, and I see more and more wonders in the book.

The translation is mine, though Thiel discerned the reference to interlace. Previous translations render *figurae* as either "drawings" or "Ornamente"; the word *intricaturas* as "intricacies" or "Flechtornamente"; and the difficult phrase *litura potius videbitur quam ligatura* as "mere daubs rather than careful compositions" or "ein Gekritzel . . . als ein Flechtornament."[49]

James Joyce also took inspiration from such patterns in the Book of Kells for his masterpiece *Finnegans Wake.* He often referred to Kells and compared it with his own work, in both that text and his correspondence and conversations.[50] In admiring its intricate designs and encouraging others to do so, Joyce did not simply reproduce the stylistic effects of his model, but translated them into his chosen medium, his own terms, and his own times, as his densely compacted text interlaces languages and puns, even within single words, in virtuoso fashion. The results can seem impenetrable or inextricable, depending upon whether one seeks the way in or out, in the venerable tradition of daunting mazes or interlace. Such a comprehensive re-creation is uncommon among modern approaches to Insular interlace.

MODERN APPROACHES TO INSULAR INTERLACE

Interest in Insular interlace continues to this day. Efforts to recreate so-called Celtic patterns have emerged largely from nationalistic aims or the desire to return to preindustrial modes in the arts and crafts, as in the contemporary sales catalogues for the English company Past Times. Designed by Margaret Stokes, the title page issued in 1861 for the poem *Cromlech on Howth* by Samuel Ferguson[51] conflates two pages of the Book of Kells by combining the initial of one with the layout and lettering of the other.[52] The results seem as stiffly self-conscious as any Neo-Gothic cathedral. However sympathetic, they might recapture aspects of style and details, but cannot resuscitate the full ambiance of life and thought which gave rise to them.

Such aims have produced many instructions for reconstructing or recreating Insular designs, including interlace. Proponents of this effort include the Englishman John Merne, the Scotsmen George Bain and his son Ian, the Irishman Aidan Meehan, and the American Mark Van Stone.[53] Although differing from technical manuals for knots, braids, hair-weaves, and so on,[54] their work mostly reinforces the view of Insular interlace in terms of ropelike structures, to its detriment.

In contrast are those studies of the original works as a whole which strive to understand their art and their times. Especially fine examples are Robert Stevick's detailed studies, which demonstrate that many Insular designs embody mathematical principles of harmonious proportion.[55] Perhaps foremost among those principles is the golden ratio, as found in the eagle evangelist-symbol page of the Echternach Gospels.[56] Stevick reasonably does not insist that his techniques of constructing the designs must have been the ones employed, but only that they could have been, by yielding comparable results.

"Structural Interlace" in Texts

The widespread attention to decorative interlace has spurred the study of its counterparts in the interlacing of words and motifs in Insular texts. "Interlaced structure," or "word-weaving," has become increasingly, though not universally, reported as an aspect of verbal composition.[57] Important cases include the epic poem *Beowulf* and the Latin and Old English riddles popular among Insular audiences.[58] The phenomenon corresponds to the principles of "entrelacement" or "stranding" described for later medieval romances and sagas.[59] In noting the "prolific" use and "pervasive importance of interlace designs" in art, John Leyerle asserted that "structural interlace" or "the technique of word-weaving" served as "the literary counterpart for interlace designs in art."[60] Some applications of this insight, however, appear to take the metaphor literally. The ability to read or write interlace in(to) a text involves different skills and methods of recognition than those required for reading interlace patterns in works of art, and yet the two forms share certain approaches or preoccupations in both shape and style, so as to form a fundamental feature of Hiberno-Saxon casts of mind and modes of expression.

Some scholars, notably Robert Stevick and David Howlett, have gone beyond individual passages, to discern much larger structured patterns interlinking the text as a whole, in prose or verse.[61] Stevick offered a diagrammatic analysis of Old English poems such as *Andreas, Elene, The Phoenix*, and *Guthlac A*,[62] with guidelines for reconstructing lost portions in accordance with their harmonious mathematical proportions, by drawing upon observations of similar proportions in visual patterns in diverse media.[63] Such examination yields valuable clues for deciphering interlace patterns, which formed so prevalent a part of early medieval artifacts, aesthetics, and perception.

Meanings and Functions of Interlace and Knots (Practical and Other)

The original iconographic meanings of Insular interlace patterns remain enigmatic. The loss over the centuries of crucial clues formerly carried by the living language at the time of their production has rendered such meanings mostly indecipherable. Yet many attempts have been made to assign meanings to patterns of interlace. Insular cases have been variously interpreted as "a stylized representation of running water" and even the river Jordan;[64] as an emblem of the Trinity, in the case of triquetra knots;[65] as "a symbol of continuity";[66] and as an apotropaic or amuletic device, whether at the entrance to the church of St. Peter, Monkwearmouth, or on the noseguard of the Coppergate Helmet from York.[67]

The protective, mnemonic, magical, and practical functions of knots and interlace in diverse contexts and cultures is well established, in cases widely ranging from samurai armor from Japan to quipus and mummy bundles from the Pre-Columbian Andes.[68] But it remains unclear how far such meanings pertain to the vast majority of Insular interlace ornament.

It must be wrong to assume that so much interlace, in such works as the Lichfield Gospels (Fig. 17), was mainly intended to befuddle and confuse, supposedly like mazes and labyrinths,[69] although those structures themselves possess complex layers of resonance.[70] Equally untenable is a belief that "the reason for the popularity" of "the more complicated knots . . . and perhaps for

17. Lichfield, Cathedral Library, sine numero, Gospel book, p. 220. Cruciform frontispiece for the Luke Gospel

devising" their system in the first place was their many "repeated Crosses," both implicit and explicit, found in cruciform ornamental pages (Fig. 17) and cruciform breaks (Fig. 8) alike.[71] Otto-Karl Werckmeister was closer to the mark in regarding intricate patterns, at least in religious contexts, as powerful tools to focus reflection upon the multiple layers of meaning in the text, as a guide for conduct, life, and salvation.[72]

"DECIPHERING" INTERLACE

Insular initial-pages (Figs. 1 and 6) powerfully evoke the Old English word *rædan*, "to read," whence comes the modern word. It also meant "to advise, deliberate, peruse, guess [a riddle], conjecture, suppose, explain"—that is, to decipher in some way(s).[73] The development of large decorated initials filling the page, notably in Gospel books, apparently constitutes an Insular contribution to book design.[74] Such full-page initials reinforce the interpretation of *rædan* as deci-

pherment. The opening for Matthew, *Liber generationis,* in the Book of Kells seems to pose a riddle, prompted by the figure at the lower left proffering a book (*liber* in Latin) as a clue.[75]

That such patterns encouraged concentration, even to distraction, is shown by the many spelling mistakes on initial-pages, as for John in the Cambridge-London Gospels (Fig. 6): *In principio eret* [not *erat*] *uerbum.* The mistakes seem as characteristic a feature of this genre as the renowned Hiberno-Saxon ornament and display capitals.[76]

Some patterns starkly challenge decipherment through loss and damage of various kinds. Poignant examples, which forms of image enhancement can help to reconstruct, include the eroded cross-shafts at Clonmacnois and Old Kilcullan (Co. Kildare),[77] and the burnt Mark initial-page in the Cambridge-London Gospels, damaged by fire at Ashburnham House, London, in 1731.[78]

Many patterns pose challenges because they were removed from their original settings, cut down, or reused, as with objects plundered by Vikings or rearranged by later centuries. The broken gilt copper-alloy mount fragment from Romsdal, Norway, apparently belonged to Viking grave-goods,[79] and the Domnach Airgid book shrine, in its present fifteenth-century form, incorporates, and partly obscures, three seventh-century plates engraved with interlace.[80] Even the patterns remaining in their medieval locations have been robbed of their full original settings, which encompassed aspects from architecture and landscapes to costumes and customs.

ARCHAEOLOGICAL APPROACHES TO INTERLACE PATTERNS

For decades, Insular and other interlace has been subject to archaeological examination. Most methods treat interlace patterns either as *ribbon- or ropelike arrangements* or as *arbitrarily detached segments.* Both focus upon the course of individual strands, rather than viewing the pattern as a whole, interacting between figure and ground.

Romilly Allen's ground-breaking study of carvings, especially in Scotland, provided a base for Gwenda Adcock's study for Northumbrian sculpture,[81] which governs the approach to interlace in the British Academy's *Corpus of Anglo-Saxon Stone Sculpture.*[82] Its system identifies six types of strand formations, called "patterns A to F," with "B" oddly listed as number 6, not 2. They group patterns by categories,[83] starting with "complete interlace patterns." That term designates "complete" courses of these types, not strands or patterns complete in themselves. The categories include "half patterns," "simple patterns," "turned patterns," and "spiralled and surrounded patterns." Some terms are arcane, as with "complete and turned patterns with added outside strands or diagonals added through the element." The system can attempt universal application within its own chosen medium only by resorting to such ragbag categories as "other interlace complexities" and "interlaced and related patterns not included in Pattern Lists [I and II]."

This British segmental approach focuses upon particular sequences, by taking horizontal "cuts." Such methods correspond well with the present broken shapes of some fragments,[84] with uncompleted patterns, and with patterns having regular sequences. Romilly Allen even dismissed some examples altogether, on the grounds that asymmetrical configurations do not constitute "patterns" at all.[85] That criterion rules out most Insular art of the ninth century, when a hallmark of the style is a carefully balanced *a*symmetry. The Royal Bible master carried this approach to a high art, in script and ornament alike (as in Figs. 2 and 10), and there are signs that he helped to

18. "Analysis" of interlaced creature
in the Lindisfarne Gospels

set the style of his day. His richly decorated arcades produce a complex balance established by elaborate and intricate means. The variation ranges from the configurations within individual patterns to the alternation of colors and patterns within the arcades as a whole. Even supposedly discordant elements might hope to attain harmonious balance, as attested by the peaceable cats and rats on the *Christi autem* page in Kells (Fig. 1).

The ribbon-or-rope approach to interlace, developed by German and Scandinavian scholars, follows the course of individual strands from one end of the pattern to the other and back again, in successive "passes" (*Durchgänge* in German). Uta Roth approached patterns in the Book of Durrow and the Durham Bible fragment (Fig. 16) in this way.[86] For example, for interlace in the frame of the ornamental page at the beginning of Matthew in Durrow (f. 3v), she produced a series of four drawings (her pls. 8–9) which, without saying so, present the pattern upside-down with respect to the manuscript page.

The ribbon method is most useful for disentangling parts of interlaced creatures from each other and from separate strands within "animate interlace," which uses creatures (or part-creatures) and foliate elements. A doglike animal at the top left of the John initial-page in the Lindis-

farne Gospels is thus "analyzed" in a series of drawings by Günther Haseloff (Fig. 18), although their orientation, too, does not honor that of the original on its page.[87]

Tracing the course of interlacing strands within a pattern might prove entertaining, diverting, or tedious in the multiple redrawings of a single pattern, which add or subtract the different strands one-by-one.[88] But this approach fails when the pattern consists of a single strand interlacing with itself alone; or when a pattern constructed in sections was not completed, as in the manuscript of a Gospel commentary at St. Gall.[89]

The ribbon method reveals little about the form and style of a pattern. As Romilly Allen observed, "the eye becomes hopelessly confused in trying to trace the *endless convolutions* of one or more of the cords . . . but *once the underlying principle of the plait is grasped*, the task becomes comparatively easy."[90] Gerald of Wales reported the same path for deciphering interlace. Instead of treating the patterns as the reduction of three-dimensional knotted constructions to a flat imitation, we should view them as surface patterns in their own right.

Some Insular interlace apparently does include rope. The front cover of the leather binding on the small-format Stonyhurst Gospel of St. John has interlace not only incised and filled with pigment, but also molded in relief over cords on its wooden board.[91] Yet even this pattern only *emulates* the three-dimensional characteristics of knotted rope.

The Representational Characteristics of Interlace Patterns

Many studies of Insular interlace seem to ignore its essential two-dimensionality. Early medieval art in general has an apparent dichotomy, much discussed by modern observers, between starkly stylized representations of humans and some creatures on the one hand, and meticulous detail, on the other hand, of forms of ornament, including some creatures.[92] For example, the Durrow evangelist-symbol of a man for Matthew[93] seems more like a walking version (or illustration) of the polychrome cloisonné inlay of the shoulder clasps from the Sutton Hoo hoard[94] than a full-bodied human being. In contrast, the eagle evangelist-symbol in the Cambridge-London Gospels possesses extraordinary detail, with imbrication and webbing or vaning for feathers, in a powerfully naturalistic depiction.[95] Even so, as here, scribes often labelled the Insular evangelist-symbols as the "imago" ("image, representation, likeness") of the designated creature, and not as the original itself. In many ways, both explicit and implicit, these depictions proclaim themselves as pertaining to the realm of abstraction, as does the ornament.

Similar meticulous detail graces the interlace, interlaced birds, and spiral ornament of the initial-page accompanying the eagle in the Cambridge-London Gospels (Fig. 6). They all contribute to a highly abstract representation of the text, "In the beginning was the Word." In a writing system far removed from pictograms, *the letters are themselves abstractions*, onto which Insular artists piled further layers of abstraction. This drive extends to important contributions by Insular scribes to "the grammar of legibility" (as Malcolm Parkes has called it), by introducing habits of word division and punctuation into the *scriptura continua*, or unbroken strings of letters, passed down by the Late Antique world[96] through manuscripts brought to the British Isles with early missionaries.[97]

Although modern observers sometimes disdain or pity the stylized, and supposedly unso-

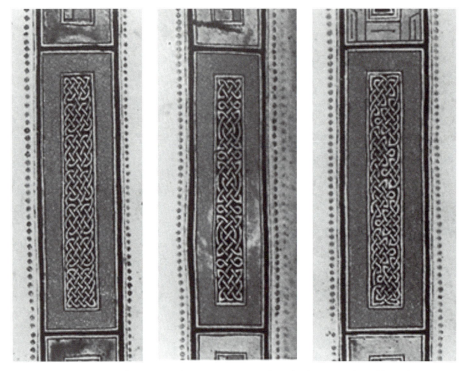

19. London, British Library, Royal Ms. 1 E.vi, Royal Bible, f. 4v. Enclosed interlace patterns in the arcade for Canon II: *(a) left:* 4v: 1C; *(b) middle:* 4v: 7C; *(c) right:* 4v: 4B

phisticated, early medieval depictions of both humans and perspective, accepted mixtures of realism and abstraction are equally interlaced in our own age, as exhibited in multiple media. The perennial predilection or predicament is encapsulated in René Magritte's 1929 painting *La trahison des images,* which proclaims, in word and image, both that "it is, [and is] not, a pipe."[98] In any age, a sensitive audience might understand and appreciate the difference.

A NOTATION FOR INTERLACE PATTERNS

Rather than merely retracing or duplicating the patterns (for which photography is adequate), I introduce a system of notation and analysis for interlace which attends to the patterns *as wholes,* no matter if composed of irregular or varied sections, as most other systems cannot or will not do. I offer a means of reading and of notating the patterns which follows the ways in which they were constructed. O'Meadhra proposed a similar approach for trial-pieces, "with the difference that I do not idealize or abstract the figure from the motif but read it exactly as represented from its beginning to its end."[99]

This notation provides a compact representation for interlace, and serves to extract, or abstract, the particular characteristics which distinguish the individual patterns. It emphasizes the ways in which the patterns conform to, and deviate from, a given standard. It allows us to focus upon the specific characteristics, rather than being diverted by the mesh of interlace itself.

Figure 20a–c shows the notation for three patterns in the Royal Bible (Fig. 19a–c), includ-

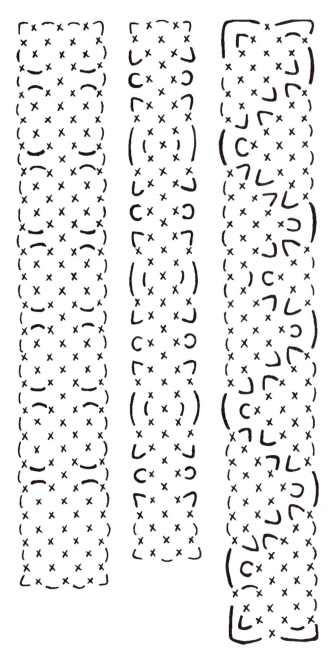

20. Notation for interlace patterns in the Royal Bible: *(a) left:* 4v: 1C; *(b) middle:* 4v: 7C, *(c) right:* 4v: 4B

ing the running chevron pattern. The notation distills the structures by indicating strands as single lines, marking each crossing with an ✕, and noting the shapes of the strands only as they diverge from the standard network. This approach serves to emphasize the shape of specific features, to locate their positions, and to discern their rhythms of recurrence within a pattern. By numbering the rows and recording the location of features in different patterns, their individual designs can be charted precisely. The notation exposes the mechanism and momentum of specific patterns. It allows them to be scanned and read in some ways which their makers and original audience appear to have done.[100]

The "Writing" of Interlace

These observations about "reading" and "writing" interlace are central to the understanding of its complex structure. In manuscripts, the art of interlace was a skill cultivated as part of the craft of lettering, and handed down from master to pupil. From at least the Carolingian period, it was known as the *ars lineandi* ("the art of lineation"), an art highly prized, especially when well executed.[101] The calligraphic aspect is manifest in several ways. The very positioning of the hand in shaping the pattern is that of the scribe or calligrapher, forming strokes with the hand resting upon the surface, as opposed to the artist, making large strokes with the hand sweeping above it. As Carl Nordenfalk observed, though for a different form of scribal ornament, it is as if the forms were "not drawn, but 'written,' just like letters," with short movements of the fingers and not the whole arm.[102]

The formation of different patterns from only a few kinds of strokes, including dots, closely corresponds to the writing of script, which uses a small repertoire of strokes of a few different shapes and lengths to build up an alphabet (Figs. 6 and 10). In minuscule script, short and straight verticals form all or part of the minims (the letters *i*, *m*, *n*, *u*); longer verticals form the stems of ascenders and descenders (as in *b*, *d*, *h*, *p*, *q*); curved strokes form parts of some letters (as in *a*, *c*, *o*, *p*, *q*); and so on.[103] In turn, the few letters of the alphabet, in infinitely varied combinations, construct words, sentences, and entire texts of widely differing character. They represent linguistic structures intended to convey meanings.

Likewise in interlace, a few strokes build a repertoire of diagonals, curves, and bends. When combined in various configurations and distributed according to various rhythms, they can create endlessly varied designs. As in many artistic endeavors, the main limits are imposed by the skill and vision of the maker. Just as in the work of a scribe or author, the range of variations produced by one maker or school fit within a given, or chosen, style.

It can be no coincidence that, in very many unfinished patterns, the worked portions, like the abandoned grids, break off more or less horizontally, as in the panels of an initial *h* in a Continental Gospel commentary (Fig. 14).[104] This condition alone suffices to disqualify modern attempts to analyze interlace in terms of the passages of individual strands through the pattern as a whole.

Scribes approached patterns of interlace in much the same way that they approached a block of text. Whether laying out the grid or filling it in, they began at the top, proceeded downward in sections, and stopped at the bottom of a section or the whole. So too, employing a grid of ruled lines to guide the letters, scribes would begin at the top of a page or column, proceed downward line by line, and stop with or within a line. Each approach is governed by our Western writing system—and the attendant habits of perception—going from top left to bottom right. As the patterns were written, so should they most appropriately be read.

NOTES

1. Dublin, T.C.L., Ms. A.I.6 (58); and Paris, B.N.F., Ms. lat. 2. The latter is considered, for example, in F. Mütherich and J. E. Gaehde, *Carolingian Painting* (New York, 1996), pl. 49. The former is J. J. G. Alexander, *Insular Manuscripts, Sixth to the Ninth Century* [sic] (A Survey of Manuscripts Illuminated in the British Isles, ed. J. J. G. Alexander, vol. 1) (London, 1978), no. 52. It is reproduced in facsimile, with commentary, in *The Book of Kells: Ms. 58, Trinity College Library Dublin*, ed. P. Fox, 2 vols. (Lucerne, 1990).

2. London, B.L., Royal Ms. 1 E.vi + Canterbury, Cathedral Library and Archives, Additional Ms. 16 + Oxford, Bodl., Ms. Lat. Bibl. b.2 (P). A detailed study appears in M. Budny, "British Library Manuscript Royal 1 E.vi: The Anatomy of a Bible Fragment" (Ph.D. thesis, University of London, 1985). The London portion is Alexander, *Insular Manuscripts* (as in note 1), no. 32; and *The Making of England: Anglo-Saxon Art and Culture, A.D. 600–900*, ed. L. Webster and J. Backhouse (London, 1991), no. 171.

3. For a survey, see J. L. Larson with B. Freudenheim, *Interlacing: The Elemental Fabric* (Tokyo, New York, and San Francisco, 1986), in which the different alignments are shown in fig. 21.

4. Many principles of construction in Insular patterns, especially in stone, are assessed by J. Romilly Allen, in idem and J. Anderson, *The Early Christian Monuments of Scotland: A Classified, Illustrated, Descriptive List of the Monuments, with an Analysis of their Symbolism and Ornamentation* (Edinburgh, 1904), pt. 2, "General Results Arrived at from the Archaeological Survey of the Monuments," 140–307, and pt. 3, "Classified, Illustrated, Descriptive List of the Monuments, Arranged by Counties." Principles of construction, especially in manuscripts, are analyzed by E. J. Thiel, "Studien und Thesen zur Initial-Ornamentik des frühen Mittelalters," and "Neue Studien zur ornamentalen Buchmalerei des frühen Mittelalters," *Archiv für Geschichte des Buchwesens* 5 (1963), cols. 1249–330, and 11 (1970), cols. 1058–128, respectively.

5. Cambridge, Corpus Christi College, Ms. 197B + London, B.L., Cotton Ms. Otho C.v + apparently also Royal Ms. 7 C.xii, ff. 2–3; Alexander, *Insular Manuscripts* (as in note 1), no. 12; and *Making of England* (as in note 2), no. 83a–c. The Cambridge portion is M. Budny, *Insular, Anglo-Saxon, and Early Anglo-Norman Manuscript Art at Corpus Christi College, Cambridge: An Illustrated Catalogue* (Kalamazoo, Mich., 1997), no. 3, reporting results of a detailed study of the whole, with the John initial-page reproduced in color in pl. III.

6. J. Romilly Allen, *Celtic Art in Pagan and Christian Times* (London, 1903), for example, 164–65.

7. Romilly Allen, "General Results" (as in note 4), 145.

8. New York, Morgan Lib., Ms. G. 57, f. 4v. The manuscript is considered in A. Boutemy, "Le Style franco-saxon, style de Saint-Amand," *Scriptorium* 3 (1949), 260–64; and J. Deshusses, "Chronologie des grands sacramentaires de Saint-Amand," *Revue Bénédictine* 37 (1977), 230–37.

9. Stockholm, Kungliga Biblioteket, Cod. A.135, f. 6r; Alexander, *Insular Manuscripts* (as in note 1), no. 30; and *Making of England* (as in note 2), no. 154.

10. J. G. Merne, *A Handbook of Celtic Ornament* (Cork and Dublin, 1974), fig. 17 and its caption.

11. St. Gall, Stiftsbibl., Cod. 60; Alexander, *Insular Manuscripts* (as in note 1), no. 60, pls. 283, 284; and J. Duft and P. Meyer, *The Irish Miniatures in the Abbey Library of St. Gall* (Olten, Berne, and Lausanne, 1954), 42–46, 71–72, and 105–6.

12. Antwerp, Musaeum Plantin-Moretus, Ms. M.17.4 (126); Alexander, *Insular Manuscripts* (as in note 1), no. 65, pls. 285–301. The impact of the model is described in M. Budny, "The Anglo-Saxon Embroideries at Maaseik: Their Historical and Art-Historical Context," *Academia Analecta: Mededelingen van de Koninklijke Akademie voor Wetenschappen, Letteren, en Schone Kunsten van België, Klasse der Schone Kunsten* 35:2 (Brussels, 1984), 55–113, at 110–12, with the initial *P* reproduced in pl. Ixb.

13. Cambridge, St. John's College, Ms. C.9 (59), ff. 4v and 72r; Alexander, *Insular Manuscripts* (as in note 1), no. 74; and F. Henry, "Remarks on the Decoration of Three Irish Psalters," *PRIA* 61C:2 (1960), 23–40, at 33–36. Both pages are reproduced in color in F. Henry, *Irish Art during the Viking Invasions (800–1020 A.D.)* (London, 1967), pls. M and O.

14. F. 42r; reproduced in color in *Making of England* (as in note 2), pl. on p. 218.

15. Cologne, Dombibliothek, Cod. 213; Alexander, *Insular Manuscripts* (as in note 1), no. 13; and *Making of England* (as in note 2), no. 126 and pl. in color on p. 162.

16. London, B.L., Cotton Ms. Nero D.iv, f. 211r; reproduced in color in J. Backhouse, *The Lindisfarne Gospels* (Oxford, 1981), pl. 81.

17. The cases in the Lindisfarne Gospels are reported in R. L. S. Bruce-Mitford, "Decoration and Miniatures" in T. D. Kendrick et al., *Evangeliorum Quattuor Codex Lindisfarnensis* (Olten and Lausanne, 1960–65), vol. 2, 107–260, at 221–31, pls. 46–47a–f, and widely reproduced, for example, in D. M. Wilson, *Anglo-Saxon Art from the Seventh Century to the Norman Conquest* (London, 1984), pl. 29.

18. For example, Budny, "Anatomy of a Bible Fragment" (as in note 2), pl. 19.

19. Maaseik, church of St. Catherine, treasury, sine numero, ff. 3v and 5v; Alexander, *Insular Manuscripts* (as in note 1), no. 21, pls. 89 and 91. A detailed account of the manuscript appears in N. Netzer, *Cultural Interplay in the Eighth Century: The Trier Gospels and the Making of a Scriptorium at Echternach* (Cambridge Studies in Palaeography and Codicology 3) (Cambridge, 1994).

20. Paris, B.N.F., Ms. lat. 12190, f. Av; C. Nordenfalk, "Corbie and Cassiodorus: A Pattern Page Bearing on the Early History of Bookbinding," *Pantheon: Internationale Zeitschrift für Kunst* 32 (1974), 225–31 and color pl. on p. 227.

21. R. Gabrielsson, *Kompositionsformer i Senkeltisk Orneringsstil: Sedda mot bakgrunden av den allmäneuropeiska konstutvecklingen* (Kungl. Vitterhets Historie och Antikvi-

tets Akademiens Handlingar 58:2) (Stockholm, 1945), 18 ("den romersk passar stil"); and Nordenfalk, "Pattern Page" (as in note 20), 225.

22. Thiel, "Neue Studien" (as in note 4), 1068–69, figs. 15a and 15b.

23. Dublin, Royal Irish Academy, Ms. D.II.3, ff. 12–67; Alexander, *Insular Manuscripts* (as in note 1), no. 51, and pl. 217.

24. Durham, Cathedral Library, Ms. B.II.30, ff. 81v and 172v; Alexander, *Insular Manuscripts* (as in note 1), no. 17, pls. 74, 75; and *Making of England* (as in note 2), no. 89. The decoration is assessed in R. N. Bailey, *The Durham Cassiodorus* (Jarrow Lecture) (Jarrow, 1978).

25. Thiel, "Studien" (as in note 4), 1258–59; and "Neue Studien" (as in note 4), 1057–64.

26. St. Petersburg, Russian State Public Library, Cod. Q.v.I.18, f. 26v; Alexander, *Insular Manuscripts* (as in note 1), no. 19. A facsimile appears in *The Leningrad Bede: An Eighth Century Manuscript of the Venerable Bede's Historia Ecclesiastica Gentis Anglorum in the Public Library, Leningrad* (Early English Manuscripts in Facsimile 2) ed. O. Arngart (Copenhagen, 1952).

27. Vienna, Nationalbibliothek, Cod. 1224, f. 110v; Alexander, *Insular Manuscripts* (as in note 1), no. 37, fig. 180; and Thiel, "Neue Studien" (as in note 4), fig. 116. The manuscript is assessed in S. E. von Daum Tholl, "The Cutbercht Gospels and the Earliest Writing Center at Salzburg," in *Making the Medieval Book: Techniques of Production*, ed. L. L. Brownrigg (Los Altos Hills, Calif., and London, 1995), 17–37.

28. Cambridge, Corpus Christi College, Ms. 173, Part II, and Ms. 389; Budny, *Manuscript Art* (as in note 5), nos. 4 and 24, pls. 13 and 217.

29. Many cases with Irish provenance are reported in U. O'Meadhra, *Early Christian, Viking and Romanesque Art Motif-Pieces from Ireland: An Illustrated and Descriptive Catalogue of the So-Called Artists' "Trial-Pieces" from c. Fifth–Twelfth Cents. A.D., Found in Ireland, c. 1830–1973* (Theses and Papers in North-European Archaeology 7 and 17) (Stockholm and Atlantic Highlands, N.J., 1979–87). Reproductions in color appear in *Treasures of Early Irish Art, 1500 B.C. to 1500 A.D., from the Collections of the National Museum of Ireland, Royal Irish Academy, Trinity College, Dublin*, ed. P. Cone (New York, 1972), pls. on pp. 137 and 166 (nos. 39 and 54), corresponding to O'Meadhra nos. 64 and 119, pls. 25, 26, 41, and 42.

30. Compare the dismissive remarks by Bruce-Mitford, "Decoration and Miniatures" (as in note 17); and G. Adcock, "A Study of the Types of Interlace in Northumbrian Sculpture" (M.Phil. thesis, University of Durham, 1974), 8–11, 14–15, and 29.

31. For example, R. Cramp et al., *Corpus of Anglo-Saxon Stone Sculpture in England* (Oxford, 1984–), vol. 1, *County Durham and Northumberland* (Oxford, 1984), pls. 190–99; and vol. 2, *Cumberland, Westmorland, and Lancashire North-of-the-Sands* (Oxford, 1988), pls. 5, 8, and 339.

32. F. Henry, *Croix sculptées irlandaises* (Dublin, 1964), pls. 2–5. See also the discussions by Dorothy Verkerk, Peter Harbison, and Maggie Williams in this volume.

33. Cramp et al., *Corpus of Anglo-Saxon Sculpture* (as in note 31), vol. 2, 100–4, pls. 288–308.

34. Henry, *Croix sculptées* (as in note 32), 19, 24–27, 34–35, 69, pls. 6, 8, 10, 11, 45–50.

35. Brunswick, Herzog Anton-Ulrich Museum; J. Beckwith, *Ivory Carvings in Early Medieval England* (London, 1972), no. 2.

36. *The Derrynaflan Hoard*, vol. 1, *A Preliminary Account*, ed. M. Ryan (Dublin, 1983); and *"The Work of Angels": Masterpieces of Celtic Metalwork, Sixth–Ninth Centuries A.D.*, ed. S. Youngs (London, 1989), no. 125.

37. Budny, "Embroideries at Maaseik" (as in note 12), pls. I–IIIa, IV, and VI; and M. Budny and D. Tweddle, "The Maaseik Embroideries," *Anglo-Saxon England* 13 (1984), 81–89.

38. Cramp et al., *Corpus of Anglo-Saxon Sculpture* (as in note 31), vol. 1, 73–74 (Durham 11–12), pls. 234–36.

39. *Treasures of Early Irish Art* (as in note 29), no. 61 and pls. in color on pp. 197–99.

40. *Treasures of Early Irish Art* (as in note 29), nos. 32–33 and pls. in color on pp. 106–17; *Work of Angels* (as in note 36), pls. in color on p. 86; and the discussion by Niamh Whitfield in this volume.

41. *Making of England* (as in note 2), nos. 65 and 107c.

42. Budny, "Anatomy of a Bible Fragment" (as in note 2), especially 611–15.

43. St. Petersburg, Russian State Public Library, Cod. F.v.I.8; Alexander, *Insular Manuscripts* (as in note 1), no. 39, pls. 188–95. A study of its ornament apears in H. Shröder, "Das Leningrader Evangeliar F.v.8: Eine insulare Handschrift des 8. Jahrhunderts" (Ph.D. diss., University of Munich, 1974).

44. Various examples are reproduced in J. M. C. Toynbee, *Art in Britain under the Romans* (London, 1964); H. P. L'Orange and P. J. Nordhagen, *Mosaics from Antiquity to the Early Middle Ages* (London, 1966); and D. S. Neal, *Roman Mosaics in Britain: An Introduction to Their Schemes and a Catalogue of Paintings* (Gloucester, 1981).

45. Durham Cathedral Library, Ms. A.II.10, ff. 2–5 + C.ii.13, ff. 192–95 + C.iii.20, ff. 1–2; the end of Matthew occupies f. 3v in the first portion. Alexander, *Insular Manuscripts* (as in note 1), no. 5, pls. 9 and 10; *Making of England* (as in note 2), no. 79; and C. Nordenfalk, *Celtic and Anglo-Saxon Painting: Book Illumination in the British Isles, 600–800* (New York, 1977), pl. 1 (in color). See also idem, "Before the Book of Durrow," *ActArch* 93 (1947), 141–74.

46. Dublin, T.C.L., Ms. A.4.7 (57); Alexander, *Insular Manuscripts* (as in note 1), no. 6. A facsimile with commentary is A. A. Luce et al., *Evangeliorum Quattuor Codex Durmachensis* (Olten and Lausanne, 1960).

47. Studies concerned with the genre and its origins include E. Lexow, "Hovedlinierne i entrelacornamentik-

kens historie," *Bergens Museums Aarbok: Historisk-antik-varisk raekke* 1 (1921–22), 1–92; H. S. Crawford, *Handbook of Carved Ornament from the Irish Monuments of the Christian Period* (Dublin, 1926), especially 25–33; W. Holmqvist, *Kunstprobleme der Merowingerzeit* (Kungl. Vitterhets Historie och Antikvitets Akademiens Handlingar 47) (Stockholm, 1939), 15–97 and 227–82; N. Åberg, *The Occident and the Orient in the Art of the Seventh Century* (Kungl. Vitterhets Historie och Antikvitets Akademiens Handlingar 56:1–3) (Stockholm, 1943–47), vol. 1, 31–38, 57–60, 96–110; vol. 2, 88–109; and vol. 3, 72–123, 139–73; G. Haseloff, "Fragments of an Hangingbowl from Bekesbourne, Kent, and Some Ornamental Problems," *Medieval Archaeology* 2 (1958), 72–103, at 80–89; and J. Trilling, *The Roman Heritage: Textiles from Egypt and the Eastern Mediterranean, 300 to 600 A.D.* (Textile Museum Journal 21) (Washington, D.C., 1982), at 104–8 (appendix 1: "The Development of Interlace and Related Patterns").

48. As discussed by Peter Harbison in this volume.

49. *Giraldi Cambrensis Opera,* ed. J. F. Dimock, vol. 5, *Topographia Hibernica, et Expugnatio Hibernica* (Rolls Series) (London, 1867), 123–24. The previous translations quoted here are Giraldus Cambrensis, *The History and Topography of Ireland,* trans. J. J. O'Meara (Harmondsworth, 1982), 84–85; and Thiel, "Neue Studien" (as in note 4), 1306–11. On the likely meanings of the words in this passage, see *Facciolati et Forcellini Lexicon Totius Latinitatis,* rev. ed., ed. F. Corradini (Padua, 1859–78), s.v. *litura* and *nodosa;* and R. E. Latham, *Dictionary of Medieval Latin from British Sources* (London, 1975–), s.v. *arcta, artita,* and *intricaturas.*

50. J. Joyce, *Finnegans Wake* (London, 1939). Notable in reporting the connections are J. S. Atherton, *The Books at the Wake: A Study of Literary Allusions in James Joyce's Finnegans Wake* (London and Amsterdam, 1959), 61–67, 250; and O.-K. Werckmeister, "Das Book of Kells in Finnegans Wake," *Neue Rundschau* 70 (1966), 44–63. Joyce owned a copy of E. Sullivan, *The Book of Kells,* 2nd ed. (London, 1920). He frequently pored over its pages; he gave copies of it to his patron and friends; he parodied many parts of its introduction in the *Wake;* and he made a point of showing its plates to his publisher, with a magnifying glass, as he described to her his own intentions.

51. P. Larmour, *Celtic Ornament* (The Irish Heritage Series 33) (Dublin, 1981), pl. in color on p. [4].

52. Ff. 114v and 124r; reproduced in color in F. Henry, *The Book of Kells: Reproductions from the Manuscript in Trinity College, Dublin* (London, 1974), pls. 46, 47.

53. Merne, *Celtic Ornament* (as in note 10); G. Bain, *The Methods of Construction of Celtic Art* (Glasgow, 1951); I. Bain, *Celtic Knotwork* (London, 1986; repr. London, 1990); A. Meehan, *Celtic Design: A Beginner's Manual* (London, 1991); idem, *Celtic Design: Knotwork, The Secret Method of the Scribes* (London, 1991); idem, *Celtic Design:*

Illuminated Letters (London, 1992); idem, *Celtic Design: Animal Patterns* (London, 1992); M. Van Stone, "Ornamental Techniques in Kells and Its Kin," in *The Book of Kells: Proceedings of a Conference at Trinity College, Dublin, 6–9 September 1992,* ed. F. O'Mahony (Aldershot, 1994), 234–42, especially 240; and S. Sturrock, *Celtic Knotwork Designs* (Lewes, East Sussex, 1997).

54. Two among many are: R. Graumont and J. Hensel, *Encyclopedia of Knots and Fancy Rope Work,* 4th ed. (Cambridge, Md., 1952); C. L. Day, *The Art of Knotting and Splicing,* 2nd ed. (London, 1964).

55. The progression of works by R. D. Stevick on Insular designs are: "The Design of Lindisfarne Gospels Folio 138v," *Gesta* 22 (1983), 3–12; "The Echternach Gospels' Evangelist-Symbol Pages: Forms from the 'Two True Measures of Geometry,'" *Peritia* 5 (1986), 284–308; "The Shapes of the Book of Durrow Evangelist-Symbol Pages," *ArtB* 68 (1986), 95–121; "The Frames of the David Pages in the Durham Cassiodorus," *Durham Archaeological Journal* 5 (1989), 43–54; "A Geometer's Art: The Full-Page Illuminations in St. Gallen Stiftsbibliothek Codex Sang. 51: An Insular Gospel Book of the Eighth Century," *Scriptorium* 44 (1990), 161–92; "Representing the Form of Beowulf," in *Old English and New: Essays in Language and Linguistics in Honor of Frederic G. Cassidy,* ed. J. N. Hall et al. (New York and London, 1992), 3–14; *The Earliest Irish and English Bookarts: Visual and Poetic Forms before A.D. 1000* (Philadelphia, 1994); "Page Design of Some Illuminations in the Book of Kells," in *Book of Kells Conference* (as in note 53), 243–56; and "Shapes of Early Sculptured Crosses of Ireland," *Gesta* 38 (1999), 3–21.

56. F. 176v; Stevick, *Irish and English Bookarts* (as in note 55), figs. 4-7, 4-8. The manuscript is Paris, B.N.F., Ms. lat. 9389; Alexander, *Insular Manuscripts* (as in note 1), no. 11, pls. 51–56.

57. For Old English examples, see, for example: J. Leyerle, "The Interlace Structure of *Beowulf,*" *University of Toronto Quarterly* 37 (1967), 1–17; A. P. Campbell, "The Time Element of Interlace Structure in Beowulf," *Neuphilologische Mitteilungen* 70 (1969), 425–35; P. A. Meador, "Interlace Structure in the 'Blickling Homilies,'" *The Quarterly Journal of Speech* 57 (1971), 181–92; R. A. Lewis, "Alliteration and Structural Interlace," *Language and Style* 6 (1973), 196–205; R. B. Burlin, "Inner Weather and Interlace: A Note on the Semantic Value of Structure in Beowulf," in *Old English Studies in Honor of John C. Pope,* ed. R. B. Burlin and E. B. Irving (Toronto, 1974), 81–89; P. R. Schroeder, "Stylistic Analogies between Old English Art and Poetry," *Viator* 5 (1974), 184–98; and J. D. Niles, *"Beowulf": The Poem and Its Tradition* (Cambridge, Mass., and London, 1983).

For Latin styles, see, for example, F. Kerlouegan, "Une mode stylistique dans la prose latine des pays celtiques," *Études celtiques* 13 (1972), 275–97; M. Lapidge, "The Hermeneutic Style in Tenth-Century Anglo-Latin Literature," *Anglo-Saxon England* 4 (1975), 67–111, reprinted

in idem, *Anglo-Latin Literature, 900–1066* (London and Rio Grande, Ohio, 1993), 105–49, with additional notes on 474–79; M. Winterbottom, "Aldhelm's Prose Style and Its Origins," *Anglo-Saxon England* 6 (1977), 39–76, especially 41; and D. Howlett, *British Books in Biblical Style* (Blackrock, Ireland, 1995); and idem, *The Celtic Latin Tradition of Biblical Style* (Blackrock, Ireland, and Portland, Ore., 1995).

58. The many editions and studies of riddles include F. Tupper, *The Riddles of the Exeter Book* (New York, 1910); C. Williamson, *The Old English Riddles of the Exeter Book* (Chapel Hill, 1977); Aldhelm, *The Poetic Works*, trans. M. Lapidge and J. L. Rosier (Woodbridge, Suffolk, 1985); and *Collectanea Pseudo-Bedae*, ed. M. Bayless and M. Lapidge (Scriptores Latini Hiberniae 14) (Dublin, 1998), especially 13–24.

59. E. Vinaver, "Introduction," in *The Works of Sir Thomas Malory*, ed. E. Vinaver (London, 1954), especially vii–x; and C. J. Clover, *The Medieval Saga* (Ithaca and London, 1982), especially 61–108.

60. Leyerle, "Interlace Structure of *Beowulf*" (as in note 57), 3–5; compare Stevick, "Representing the Form of *Beowulf*" (as in note 55).

61. Howlett, *British Books in Biblical Style* and *Celtic Latin Tradition* (as in note 56); and Stevick, *Irish and English Bookarts* (as in note 57), 37–49, 81–91, and 123–31.

62. Stevick, *Irish and English Bookarts* (as in note 55), especially figs. 3-1–3-4 on pp. 36–47, fig. 8-1 on p. 122, fig. 10-1 on p. 155, and fig. 11-3 on p. 173.

63. Stevick, *Irish and English Bookarts* (as in note 55), especially figs. 4-1 and 4-2 on pp. 51–52; figs. 4-6–4-15 on pp. 58–73; figs. 6-3 and 6-4 on pp. 96–97; figs. 7-1–7-6 on pp. 103–15; figs. 9-5–9-11 on pp. 136–50; and figs. 14-1–14-18 on pp. 211–33.

64. F. Henry, *Irish Art in the Early Christian Period (to 800 A.D.)* (London, 1965), 205; Henry, *Irish Art during the Viking Invasions* (as in note 13), 179–80; and Henry, *Book of Kells* (as in note 52), 205. Similar interpretations are advanced by O.-K. Werckmeister, *Irisch-northumbrische Buchmalerei des 8. Jahrhunderts und monastische Spiritualität* (Berlin, 1967), 79–82 and 148–62.

65. V. H. Elbern, "Die Dreifaltigkeitsminiatur im Book of Durrow: Eine Studie zur unfigürlichen Ikonographie im frühen Mittelalter," *Wallraf-Richartz Jahrbuch: Westdeutsches Jahrbuch für Kunstgeschichte* 17 (1955), 7–42; idem, "Zierseiten in Handschriften des frühen Mittelalters als Zeichen sakraler Abgrenzung: Eine Studie zur unfigürlichen Ikonographie im frühen Mittelalter," in *Der Begriff der Representatio im Mittelalter: Stellvertretung, Symbol, Zeichen, Bild*, ed. A. Zimmermann (Miscellanea Mediaevalia 8) (Berlin and New York, 1971), 340–56; and R. B. K. Stevenson, "Aspects of Ambiguity in Crosses and Interlace," *UJA* 44–45 (1981–82), 1–27.

66. Bain, *Construction of Celtic Art* (as in note 53), 15–22.

67. E. Kitzinger, "The Threshold of the Holy Shrine:

Observations on Floor Mosaics at Antioch and Bethlehem," in *Kyriakon: Festschrift J. Quasten*, ed. P. Granfield and H. Jungmann (Münster, 1970), vol. 2, 639–47; and idem, "Interlace and Icons: Form and Function in Early Insular Art," in *The Age of Migrating Ideas: Early Medieval Art in Northern Britain and Ireland*, ed. R. M. Spearman and J. Higgitt (Edinburgh, 1993), 3–13, at 3–6, figs. I:1, 3, 4. The helmet is *Making of England* (as in note 2), no. 47; a detailed study of its decoration appears in D. Tweddle, *The Coppergate Helmet* (York, 1984). The Monkwearmouth doorjambs are Cramp et al., *Corpus of Anglo-Saxon Stone Sculpture* (as in note 31), vol. 1, 125–26, pls. 112–13.

68. The mnemonic, magical, and practical uses of knots in various cultures are surveyed in C. L. Day, *Quipus and Witches' Knots: The Role of the Knot in Primitive and Ancient Cultures, with a Translation and Analysis of Oribasius, "De Laqueis"* (Lawrence, Kan., 1967). The apotropaic function is examined, for example, in Kitzinger, "Threshold of the Holy Shrine" (as in note 67), 642–47; P. Wolters, "Faden und Knoten als Amulett," *Archiv für Religionswissenschaft* 8 (1905), *Beiheft gewidmet Hermann Usener zum siebzigstem Geburtstag*, 1–22; J. Heckenbach, *De Nuditate Sacra Sacrisque Vinculis* (Religionsgeschichtliche Versuche und Vorarbeiten 9:3) (Giessen, 1911), at 69–112; K.-L. Clasen, "Die Überwindung des Bösen: Ein Beitrag zur Ikonographie des frühen Mittelalters," in *Neue Beiträge deutscher Forschung: Wilhelm Worringer zum 60. Geburtstag*, ed. E. Fidder (Königsberg, 1943), 13–36; W. I. Hildburgh, "Indeterminability and Confusion as Apotropaic Elements in Italy and Spain," *Folk-Lore* 55 (1944), 133–49; and G. A. Küppers-Sonnenberg, "Flechtwerk, Knotenband und Knotendrachen," in idem, W. Haiden, and A. Schulte, *Flecht- und Knotenornamentik: Mosaiken (Tuernia und Otranto). Beiträge zur Symboldeutung* (Aus Forschung und Kunst 16) (Klagenfurt, 1972), 9–135.

69. E. H. Gombrich, *The Sense of Order* (Oxford, 1979), especially 262–64 on "knots, mazes and tangles." The manuscript is Lichfield, Cathedral Library, sine numero; Alexander, *Insular Manuscripts* (as in note 1), no. 21, pls. 76–82. A detailed study is provided by W. A. Stein, "The Lichfield Gospels" (Ph.D. diss., University of California, Berkeley, 1980). Gombrich's views regarding the interlace were succinctly expressed in a seminar at the Warburg Institute, London, in 1978.

70. W. H. Matthews, *Mazes and Labyrinths: A General Account of Their History and Developments* (London, 1922); W. L. Hildburgh, "The Place of Indeterminability in Mazes and Maze Dances," *Folk-Lore* 56 (1945), 188–92; P. R. Doob, *The Idea of the Labyrinth from Classical Antiquity through the Middle Ages* (Ithaca and London, 1990); and N. Pennick, *Mazes and Labyrinths* (London, 1990).

71. Stevenson, "Aspects of Ambiguity" (as in note 65), 15 and 20.

72. Werckmeister, *Irisch-northumbrische Buchmalerei* (as

in note 64).

73. J. Bosworth, *An Anglo-Saxon Dictionary*, ed. T. N. Toller (Oxford, 1898), s.v.; and T. N. Toller with A. Campbell, *Supplement with Revised and Enlarged Addenda* (Oxford, 1955), s.v.

74. This development is depicted diagrammatically in Bruce-Mitford, "Decoration and Miniatures" (as in note 17), fig. 11 on p. 114 and fig. 65 on p. 256. Its background is examined in C. Nordenfalk, *Die spätantike Zierbuchstaben* (Die Büchornamentik der Spätantike 2) (Stockholm, 1970).

75. F. 29r; reproduced in color in Henry, *Book of Kells* (as in note 52), pl. 23.

76. Those other characteristic features are examined in Bruce-Mitford, "Decoration and Miniatures" (as in note 17); and G. Henderson, *From Durrow to Kells: The Insular Gospel-Books, 650–800* (London, 1987).

77. Henry, *Croix sculptées* (as in note 32), 27–29 and pl. 18.

78. London, B.L., Cotton Ms. Otho C.v, f. 28r; Henderson, *From Durrow to Kells* (as in note 76), pl. 94. On that fire and its aftermath, see S. Keynes, "The Reconstruction of a Burnt Cottonian Manuscript: The Case of Cotton Ms. Otho A.I," *British Library Journal* 22 (1996), 113–60.

79. *Work of Angels* (as in note 36), no. 139.

80. *Treasures of Early Irish Art* (as in note 29), 216–17 (no. 66), reproduced in color on pp. 208–9. See also the discussion by Raghnall Ó Floinn in this volume.

81. Adcock, "Types of Interlace" (as in note 30); and G. Adcock, "The Theory of Interlace and Interlace Types in Anglian Sculpture" [abstracted by R. Cramp and E. Coatsworth], in *Anglo-Saxon and Viking Age Sculpture and Its Context: Papers from the Collingwood Symposium on Insular Sculpture from 800 to 1066*, ed. J. Lang (BAR, British Series 49) (Oxford, 1978), 33–46.

82. R. Cramp, *Grammar of Anglo-Saxon Ornament: A General Introduction to the Corpus of Anglo-Saxon Sculpture* (Oxford, 1984), xxviii–xlv, with application to Cramp et al., *Corpus of Anglo-Saxon Stone Sculpture* (as in note 31). A comparable approach is applied in studies of Irish sculpture, as reported in N. Edwards, "Abstract Ornament on Early Medieval Irish Crosses: A Preliminary Catalogue," in *Ireland and Insular Art, A.D. 500–1200*, ed. M. Ryan (Dublin, 1987), 111–17.

83. Cramp, *Grammar of Anglo-Saxon Ornament* (as in note 82), xxxii, col. a, figs. 14–26.

84. Many examples appear in Cramp et al., *Corpus of Anglo-Saxon Stone Sculpture* (as in note 31).

85. Romilly Allen, "General Results" (as in note 4), 160; see also p. 270. A comparable sense of disturbance regarding irregular patterns affects the very orientation of the plate from the West Cross at Kilkieran (Co. Kilkenny) in Crawford, *Handbook of Carved Ornament* (as in note 47), pl. XXI, no. 35, with accompanying note on p. 26.

86. U. Roth, "Studien zur Ornamentik frühchristlicher Handschriften des insularen Bereiches: Von den Anfängen bis zum Book of Durrow," *Bericht der Römisch-Germanischen Kommission* 60 (1979), figs. 27, 43, 44, 46–48, 52, 64, 66, pls. 1–16.

87. G. Haseloff, "Insular Animal Styles with Special Reference to Irish Art in the Early Medieval Period," in *Ireland and Insular Art* (as in note 82), 44–55, fig. 9, from London, B.L., Cotton Ms. Nero D.iv, f. 211r; the creature itself is reproduced in enlarged detail in color in Backhouse, *Lindisfarne Gospels* (as in note 16), pl. 56. The ribbon method is applied helpfully to a wide range of animate interlace patterns, for example, in Roth, "Ornamentik frühchristlicher Handschriften" (as in note 86), fig. 80.

88. Among many studies, it might suffice to cite Schröder, "Leningrader Evangeliar" (as in note 43), for its dedication to a little-studied Insular Gospel book containing very many interlace patterns.

89. St. Gall, Stiftsbibl., Cod. 124, f. 7r, reproduced in Thiel, "Studien" (as in note 4), figs. 1–4.

90. Romilly Allen, "General Results" (as in note 4), 271 (italics added), and similarly pp. 148 and 160–61. A similar observation was made by T. Cooke Trench, "Notes of Irish Ribbon Work in Ornamentation," *JCKAS* 1 (1893), 240–44, at 242.

91. London, B.L., Loan Ms. 74; *Making of England* (as in note 2), no. 86 and pl. in color on p. 121. A facsimile and detailed study of the volume, including its binding, appears in *The Stonyhurst Gospel of Saint John, with a Technical Description of the Binding by Roger Powell and Peter Waters*, ed. T. J. Brown (Roxburgh Club 233) (Oxford, 1969).

92. The tension or apparent conflict between "naturalism" and "the tendency to abstraction" in medieval art was ambitiously considered, for example, in W. Worringer, *Formprobleme der Gotik* (Munich, 1912).

93. F. 21v; reproduced in color in Nordenfalk, *Celtic and Anglo-Saxon Painting* (as in note 45), pl. 4.

94. *Making of England* (as in note 2), no. 14; reproduced in color in Wilson, *Anglo-Saxon Art* (as in note 17), pl. 7. The jewelry is assessed in R. L. S. Bruce-Mitford, *The Sutton Hoo Ship-Burial*, vol. 2, *Arms, Armour and Regalia* (London, 1978).

95. F. 1r; reproduced in color in Budny, *Manuscript Art* (as in note 5), pl. II.

96. M. B. Parkes, *Pause and Effect: An Introduction to the History of Punctuation in the West* (Aldershot, 1992), especially 20–29.

97. An example is Cambridge, Corpus Christi College, Ms. 286, the Gospels of St. Augustine of Canterbury; Budny, *Manuscript Art* (as in note 5), no. 1.

98. Los Angeles County Museum of Art; reproduced, for example, in R. Calvocoressi, *Magritte*, rev. ed. (Oxford, 1984), pl. 30.

99. O'Meadhra, *Art Motif-Pieces from Ireland* (as in note

29), vol. 1, 10.

100. A fuller account of this system will appear in my detailed study of the Royal Bible.

101. Thiel, "Neue Studien" (as in note 4), 1249–66.

102. Nordenfalk, *Spätantike Zierbuchstaben* (as in note 74), 110–11: "die strukturelle Nähe . . . zu der Schrift selbst hat in erster Hand damit zu tun, daß sie nicht von dafür herangezogenen Künstlern, sondern von den Schreibern selbst herrühern. Ihre Formen sind nicht gezeichnet, sondern wie die Buchstaben 'geschreiben'. . . . Die Gestaltungsmöglichkeiten . . . hauptsächlich an graphische Kleinformen gebunden sind — Striche von der gleichen Kürze wie die der Schriftzeichen oder gar Punkte, die ein Minimum von Formgebund ausmachen."

103. E. Johnston, *Writing and Illuminating, and Lettering*, rev. ed. (London, 1939), for example, p. 11; and idem, *Formal Penmanship and Other Papers*, ed. H. Child (London, 1971). Many Irish cases are surveyed in T. O'Neill, *The Irish Hand: Scribes and Their Manuscripts from the Earliest Times to the Seventeenth Century, with an Exemplar of Irish Scripts* (Portlaoise, Ireland, 1984).

104. Rome, Bibl. Vat., Palat. Ms. lat. 207, f. 107v; Thiel, "Neue Studien" (as in note 4), 1058–59, fig. 2.

The "Tara" Brooch: An Irish Emblem of
Status in Its European Context

·

NIAMH WHITFIELD

INTRODUCTION

THE "TARA" BROOCH is the most ornate and intricate piece of medieval jewellery ever found in Ireland (Figs. 1 and 2). Despite its present somewhat "gap-toothed" appearance, resulting from the loss of panels since its discovery,[1] it is still matched in splendour only by its closest analogue, the Hunterston brooch (Fig. 3). This was found on the opposite side of the Irish Sea in Ayrshire in south-western Scotland, and though a little larger it is nevertheless simpler in the variety of techniques used and in the range of patterns displayed. It has long been recognized that while both brooches show elements from the native Celtic La Tène repertoire, their design also reflects outside influences and incorporates many foreign elements. In this paper I shall concentrate on this second aspect and shall argue that such brooches are even more European in concept than is generally recognized.

The name "Tara" brooch is misleading. The Hill of Tara is a necropolis and ritual site that was in continuous use from the Neolithic (ca. 3500 B.C.) to the later Iron Age (ca. A.D. 400), and whose kingship acquired a (hotly contested) symbolic status in the early Middle Ages.[2] However, that eponymous site is not the find-place of the brooch. It was actually found some miles away to the south of the mouth of the river Boyne at Bettystown (Co. Meath) (Fig. 4), where it was discovered by chance in 1850 by a child playing near the seashore.[3] The manner of its discovery resulted in a complete absence of any archaeological context. However, local tradition identifies a bank of a stream at the back of the strand as the find-place. Recent excavations have revealed an extensive burial ground nearby, in use from prehistoric to early medieval times.[4] This suggests that the "Tara" brooch may have been buried for safe-keeping by a well-known landmark, possibly as part of a hoard, as at Derrynaflan (Co. Tipperary) and Ardagh (Co. Limerick).[5] While both these hoards contained church plate, there were also brooches in the latter (though in a style slightly different from the "Tara" brooch). On the other hand, the "Tara" brooch may have been buried alone. A story entitled "The Siege of Howth" (*Talland Étair*), recorded in a twelfth-century codex, the Book of Leinster, but which is probably older than the manuscript in which it is transcribed, tells of a precious brooch which was hidden in the earth after a defeat in battle.[6] A similar catastrophe may have prompted the concealment of the "Tara" brooch, but we can only speculate about this.

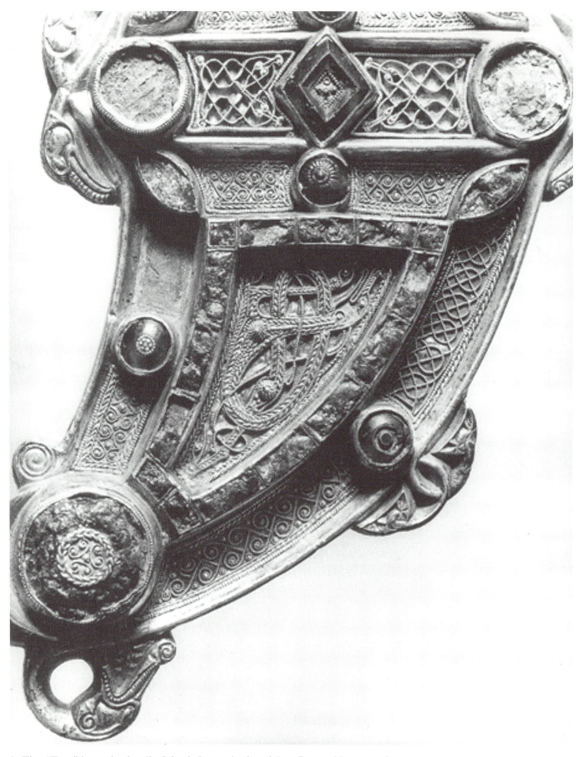

1. The "Tara" brooch, detail of the left terminal and "gap" area. Not to scale

2. (facing) The "Tara" brooch (late seventh or early eighth century), front view. Scale 1:1

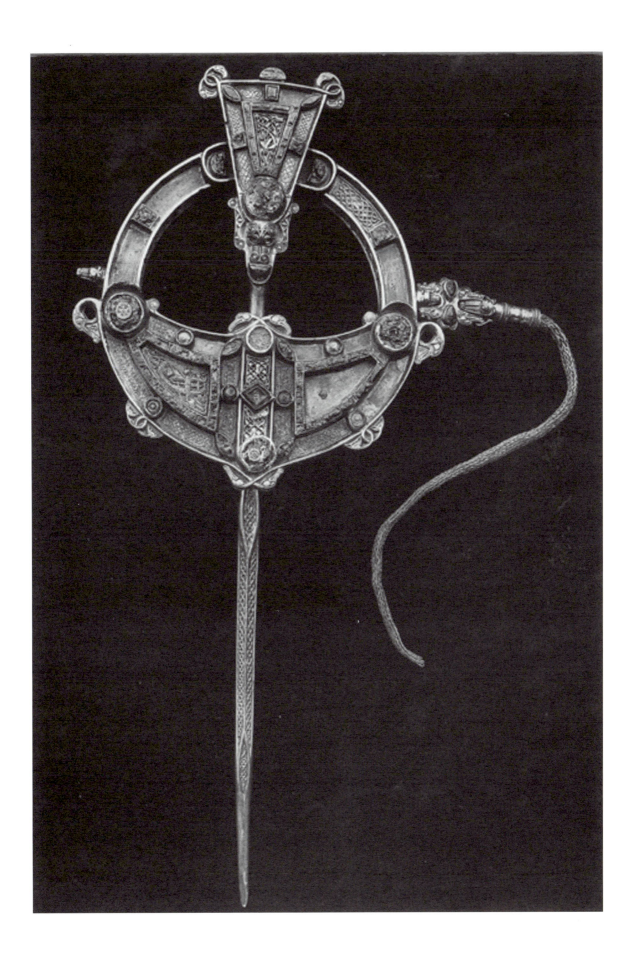

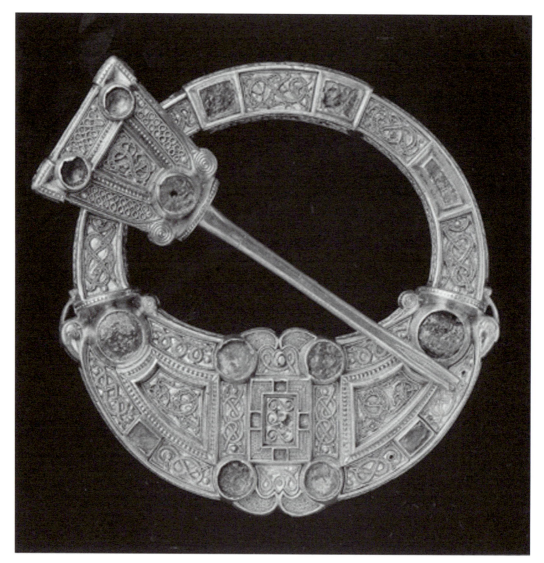

3. The Hunterston brooch (second half of seventh or early eighth century), front view. In this photograph the pin lies over the brooch, but it can be turned over so as to lie behind. Scale 1:1

The Hunterston brooch was also a stray find from near the seashore.[7] The find-place, which lies opposite the Cumbrae Islands, is very close to the ancient Irish kingdom of Dál Riata, founded in Argyll as an extension of their kingdom into Scotland by rulers of Dál Riata in Antrim, perhaps towards the end of the fifth century A.D.[8] However, the brooch did not necessarily originate in this area, as it was an heirloom and in the hands of a Norse speaker by the time it was deposited. This is clear because there is on the back an inscription in Swedo-Norwegian runes which probably dates to the tenth century, stating in Old Norse: "Melbrigda á stilk" (Melbrigda owns [this] brooch).[9] Despite the use of Norse for the inscription, the name Máel Brigte (devotee of Brigid) is Gaelic. It appears frequently in both Irish and Scottish sources,[10] but no obvious candidate for the individual named on the Hunterston brooch appears there.[11]

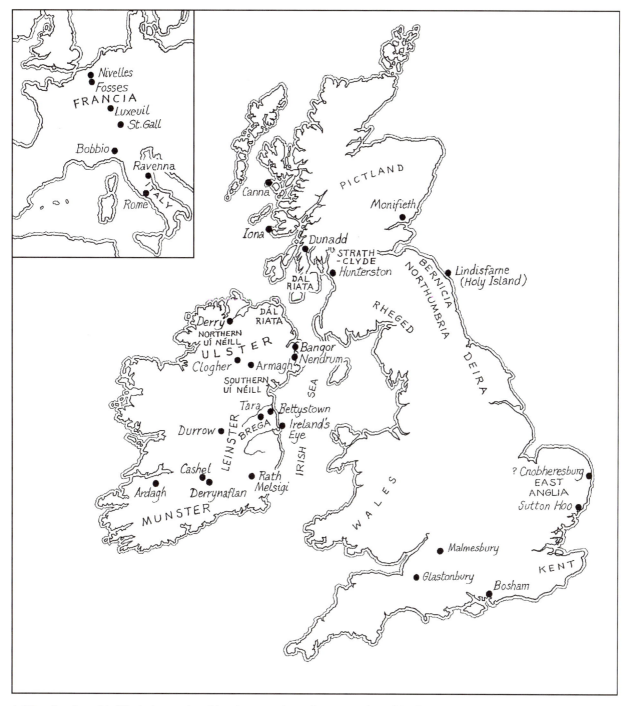

4. Map showing chief find-places, sites, kingdoms, and provinces mentioned in the text

Neither the "Tara" nor the Hunterston brooch can be dated precisely. However, it is generally agreed that they were manufactured in either the late seventh or the early eighth century, and that the "Tara" brooch is probably the later of the two.[12] Such a range of dates is supported by technical analysis and by the many stylistic features which the "Tara" brooch, in particular, has in common with the Lindisfarne Gospels. On the basis of a mid-tenth-century-, but apparently reliable colophon, this manuscript is widely accepted as having been illuminated in an Irish milieu in Northumbria about A.D. 698.[13] In this period Ireland had a relatively cosmopolitan outlook, and it is not surprising that it should have produced jewels which reflected European fashions. Such a situation is explained by the history of the period.

HISTORICAL BACKGROUND

Ireland is situated at the edge of western Europe, "on the extreme boundaries of the world," as Pope Honorius I put it in a letter to the Irish in about A.D. 629.[14] This geographical isolation protected it from some of the more cataclysmic events of early historic times. Ireland was never conquered by the Romans; nor was it invaded by Germanic tribes in the aftermath of the fall of Rome. Nevertheless, the fact that Ireland was not invaded did not mean that it was culturally isolated. On the contrary, archaeological[15] and linguistic[16] evidence increasingly suggests that there was contact with its neighbours even during the Roman period.

Trade, for which there is abundant archaeological evidence, accounts for some communication.[17] However, an even more important factor in establishing links between Ireland and the outside world was the introduction of Christianity in the fifth century or perhaps earlier.[18] Ireland now joined an international community focused on the Mediterranean, and while Old Irish and many archaic institutions and attitudes survived, henceforth Ireland's spiritual centre was Rome (discussed elsewhere in this volume by Dorothy Verkerk and Kees Veelenturf). The Latin language made its appearance, spoken first by Christian missionaries and later by native churchmen, and there soon developed what McCone has described as "a forceful and flourishing monastic culture capable of importing and adapting the latest trends in scholarship from abroad and of exporting its own personnel and products to Britain and Europe."[19]

Church business sometimes took the Irish clerics through Germanic territories to Rome itself. In A.D. 631, for example, a group from the south of Ireland visited the city for a ruling on the correct method of calculating the date of Easter. A Life of St. Brigid composed about A.D. 750 tells how emissaries again went to Rome to learn how the Mass was celebrated there. Ó Carragáin has pointed out that this demonstrates that the Irish knew that the Roman Mass was changing fast, and that repeated visits were needed to keep up-to-date with it.[20] Sporadic expeditions of this type would have broadened the cultural horizons of the Irish, but probably more influential in the history of art was their vigorous missionary expansion into Britain and Europe. This began in the second half of the sixth century. At the head of the movement in north Britain was the monastery Iona in Dál Riata, founded in A.D. 563 by Colum Cille, an aristocrat of the Cenél Conaill branch of the Uí Neill dynasty from the north of Ireland. The Northumbrian historian Bede, who wrote in the early eighth century and was thus probably alive when the "Tara" brooch was made, described how in his day Iona lay at the head of an extensive monastic federation with many houses in Ireland, Scotland, and Northumbria. These included the monastery of Lindisfarne, just

off the coast of north-eastern England, where the Gospel book referred to above was illuminated, and the monasteries of Derry in the north of Ireland and Durrow in the Irish midlands, the latter associated with the equally well-known Book of Durrow.[21] The Columban order provided a network through which ideas about design, among other matters, could circulate.[22] However, there were additional Irish foundations in other parts of England, for example, at Cnobheresburg in East Anglia,[23] Malmesbury in Wiltshire, and perhaps also at Bosham in Sussex. A monastery at Glastonbury in Somerset also had strong Irish connections.[24] Irish monasteries were also established in continental Europe. These missions began in A.D. 590 when Columbanus, a monk of Bangor, set forth with twelve companions. He went on to found Luxeuil, St. Gall, and Bobbio, among other monasteries.[25] An Irish presence was soon established in Gaul, the Rhineland, Switzerland, and Lombardic Italy.

The relevance of this to the study of jewellery is that these missionary endeavours could not have succeeded without aristocratic patronage, so the Irish would have seen on the cloaks of their noble benefactors—the Anglo-Saxons, Franks, and Lombards—extravagant gold brooches of a type unknown in Ireland.

A few examples may be given of the close relationship between Irish monks and their royal patrons. Lindisfarne was founded by monks from Iona at the invitation of the Northumbrian king Oswald (A.D. 634–42), who had been sheltered at Iona when in exile during a dynastic feud.[26] He was succeeded by his brother, Oswiu (A.D. 642–70), whose queen, Eanflaed, was a Kentish princess,[27] so Kentish jewellery was probably also to be seen in the Northumbrian royal court. Bede also tells how in about A.D. 630 the itinerant monk Fursey and his two brothers were given the site Cnobheresburg in East Anglia by King Sigbert,[28] son or step-son of the famous Redwald who was probably buried in splendour at Sutton Hoo in about A.D. 625. Just how dependent the *peregrini* were on royal or aristocratic backing is demonstrated by what happened when they displeased their patrons: the result was banishment. This famously happened to Columbanus when he crossed the Merovingian King Theudoric and Queen Brunhild.[29] Foilan, brother of Fursey, who went on to Francia after his stay in East Anglia, also fell foul of his patron, the *maior* Erchinoald, who had him driven out. However, he went to see Idoberg and Gertrude, the widow and daughter of Pippin I, at Nivelles and was set in charge of the monastery at Fosses.[30]

Not only must the Irish have seen gold and gem-encrusted jewellery, they probably also occasionally encountered goldsmiths. The art of the goldsmith is too technical a craft to learn at second hand, so it is particularly interesting in this context to learn that the great Frankish goldsmith Eligius was deeply involved in the monastic movement founded by Columbanus.[31] This is not to suggest that Eligius himself passed on his technical knowledge to the Irish, but it does show how they must have met foreign goldsmiths who may have passed on their skills. The more important Irish foundations would certainly have had treasures, as is evident from the survival of a shrine and other items at Bobbio.[32]

Indeed, in the sixth and seventh centuries the Irish did not have to travel abroad to meet foreigners. The presence of Irish, English, and Continental scholars is documented, for example, at Rath Melsigi[33] in the Irish midlands and at Iona in Dál Riata. Travellers' tales which brought the outside world much closer were related by some of these visitors, such as the Frankish Arculf, whose pilgrimage to the eastern Mediterranean—to places such as Jerusalem, Alexandria, Constantinople, and Sicily—was recorded in *De locis sanctis* by Adomnán (A.D. 624–704),[34] ninth abbot of Iona in Dál Riata. In addition, Bede tells us that there were "both nobles and commons

in Ireland who had left their own country and retired to Ireland either for the sake of religious studies or to live a more ascetic life."[35] Even a future Merovingian king, Dagobert II, spent twenty years in exile there. As Ó Cróinín has suggested, Dagobert probably had his own personal escort of Franks and Anglo-Saxons.[36] Such visitors would have dressed in exotic clothes, and some probably had jewellery which could have provided inspiration for native smiths.

The links discussed above are all ecclesiastical in nature. However, political connections, particularly with Ireland's nearest neighbour, Britain, probably also played a role in introducing Irish smiths to foreign ideas about art and design. These ties could be very close, and there is considerable evidence that in the seventh century in particular there was Anglo-Saxon involvement in Irish affairs and vice versa.[37]

One channel of communication was the kingdom of Dál Riata, which was in the unusual position of being partly in Ireland and partly in Britain (discussed elsewhere in this volume by Jane Hawkes). In the late sixth century links were forged between the Anglo-Saxon, Bernician royal dynasty of Northumbria, the Columban monastic community of Iona, and the Irish kin of the Iona abbots, the Uí Néill dynasty in Ireland.[38] Very close personal relationships resulted. For instance, one king of Northumbria, Aldfrith (ruled A.D. 685/6–705), who spent much of his youth in Iona, was the illegitimate son of a Northumbrian king, Oswiu (who had also spent time in Dál Riata), and Fín, daughter of the northern Uí Néill high king Colmán Rímid (died A.D. 604), to whom Adomnán addressed *De locis sanctis.*[39]

However, in addition to the general commercial, religious, and political links between Ireland and Europe, there was a special connection between the area where the "Tara" brooch was discovered and neighbouring kingdoms in Britain. Bettystown, where the brooch was found, lay in Brega, a kingdom also ruled by the Uí Néills—a southern sept, the Síl nÁedo Sláine.[40] In the seventh and eighth centuries this was one of the pre-eminent kingdoms of Ireland and a well-known entry point into the east of the country, connected by routeways from the coast to the hinterland.[41] It occupied the fertile region between the Boyne valley and the Liffey, and incorporated some of the major sites of Ireland's prehistory,[42] including the Hill of Tara, whose kingship was such a source of contention between rival dynasties of the Uí Néill in the fifth, sixth, and seventh centuries.[43]

The Síl nÁedo Sláine was a vigorous group, several members of which had claimed the high kingship of Tara. They successfully expanded their territory at the expense of their neighbours, but they were also much given to internal feuding.[44] Not only did they feud at home, they also joined feuds in the wider field of Scottish and British politics. Just how deeply they were involved is demonstrated by the fact that in A.D. 684 raiders from Anglo-Saxon Northumbria crossed the Irish Sea to ravage Brega. This may have been a pre-emptive strike by the reigning king of Northumbria, Ecgfrith, on the Irish supporters of his challenger, Aldfrith, who, as just explained, was related to the Uí Néills. Alternatively, Ecgfrith, who had territorial ambitions, may have wished to extend Northumbrian hegemony over the lands of the Uí Néill and attacked Brega because it was the Uí Néill kingdom which currently enjoyed a primacy of power within Ireland.[45] Whatever the reason, sixty captives were taken from Brega to Northumbria and were only released a year later when Aldfrith gained the throne. They were rescued by their kinsman Adomnán, abbot of Iona, who negotiated with the new king on their behalf.

The Northumbrians also indirectly contributed to further fighting in Brega, because after their destruction of the north British kingdom of Rheged, bands of expelled princes roamed the

Irish Sea; in A.D. 702 one slew the son of the king of Brega (on the island of Ireland's Eye to the south of Brega). More friendly relations with the British are evidenced by the retirement to "Brittania" of a king of South Brega, Fogartach ua Cernaig, in A.D. 714, whence he returned to reclaim his kingdom in A.D. 716.[46]

Brega, then, had complex connections with the other side of the Irish Sea, and its location on the east coast of Ireland made it particularly open to outside forces. That the rulers there were receptive to these forces, and in particular to Anglo-Saxon influence, is attested by the tendency to alliteration of the letter "c" in the pedigree of the North Brega dynasty, as well as by the appearance there of the name Conaing, which is a borrowing of the Anglo-Saxon *cyning*, "king." The first to bear this title was a king of Brega who died in A.D. 662.[47]

As to the history of jewellery, the outcome of all the historical contacts described above was that in the late sixth, or more probably in the seventh century, the Irish modified their own metalwork style in order to rival that of their neighbours.[48] Gold,[49] amber, and glass began to be used, as did new patterns, in particular interlace and interlaced animal ornament derived from Germanic Animal Style II. The Hunterston and "Tara" brooches are two of the earliest examples of this newly developed style and so are especially interesting in the history of early medieval Celtic art.

The impact of foreign models will now be considered, under various headings. Firstly, the manner in which such brooches were worn will be reviewed in the context of the Late Antique and Byzantine world. Secondly, the design of the "Tara" brooch, and in particular the method used to fasten it, will be analysed, along with the geometrical pattern which underlies its shape. Thirdly, foreign prototypes which may have influenced this design will be considered.

Brooches in Ireland and in Late Antiquity and Byzantium

The Mediterranean may seem too remote to have affected attitudes to the wearing of brooches in early medieval Ireland. However, the historical links discussed above show that concepts about dress and jewellery could have reached Ireland from the Late Antique and Byzantine world through various channels. Even during the Roman period, when Ireland was on the fringes of the empire, there was influence from the Roman world, particularly from Roman Britain. In this period, as Jane Stevenson has pointed out,

> some of [Ireland's] boldest and most adventurous people, its military heroes and its entrepreneurs, were in contact in various ways with provincial Roman civilization. Irishmen were settled in Wales and, in addition, St Patrick assures us that substantial numbers of Roman Britains lived in Ireland as slaves.[50]

As a result, changes took place in Irish society. The most significant, of course, was the introduction of Christianity, but other important innovations also stemmed from Roman Britain. These included the addition of Latin loan-words to the Old Irish language[51] and the concept of literacy which led to creation of the ogam alphabet.[52] A significant development in the present context was the introduction in the fifth century of ancestors of brooches of the "Tara" type, the so-called zoomorphic penannular brooches (Fig. 5a).[53] It is interesting that a very early Latin loan-word into Old Irish is one for brooch, *síbal*, a borrowing from the Latin fibula. The substitution of "s"

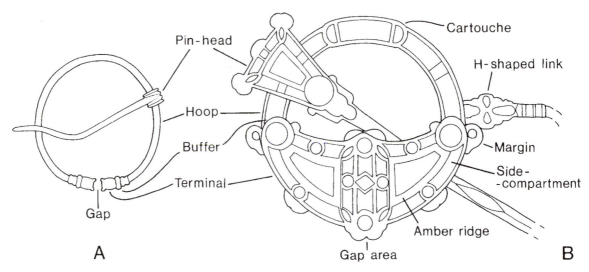

5. Main components of brooches: *(A)* zoomorphic penannular brooch from Calne, Wiltshire (probably A.D. 450–550); *(B)* the "Tara" brooch

for "f" indicates that this term predates the seventh century and may be as early as the fifth century.[54] While this does not prove that the term was introduced at the same time as the zoomorphic penannular brooch, it is tempting to speculate that this may have been the case.[55]

Secondly, the Germanic peoples of Europe whom the Irish encountered in the sixth and seventh centuries saw themselves as the successors of Rome in the West and often invoked Roman antecedents to define and consolidate their authority. As Walter Pohl has pointed out, the extraordinary success of the Roman Empire was due to its ability to integrate various groups, even beyond its frontiers, into its social and cultural world. It was a complex system of a "classical" centre and a "barbarian" periphery which was drawn into the dynamic of the Roman way of life.[56] As a result, in the fifth and sixth centuries barbarian rulers seem to have regarded their kingdoms as actually belonging to the Roman Empire. This is indicated by the fact that their earlier coins, especially in gold, were struck in the name of the ruling emperor.[57] In the sixth century the Byzantine Empire extended into Italy, and was not so remote from western Europe. Its power and prestige was such that it was a source of inspiration in thought, culture, and art not only throughout the whole Mediterranean sphere, but further afield in West and East alike: "the supreme model of excellence that the rest of the world attempted to emulate."[58]

The tendency of Germanic leaders to identify themselves with the legacies and traditions of Rome and Byzantium extended to their clothing.[59] For example, when the Merovingian king Clovis was made consul by the emperor Anastasius in the early sixth century, and scattered gold and silver coins on the people of Tours in the Roman manner, he dressed in the consular regalia of purple cloak, mantle, and diadem.[60] Just how powerful the imperial model remained in the seventh century even on the fringes of Europe is demonstrated by the manner in which the splendid parade armour, regalia, and treasure belonging to the dead king in Mound I at Sutton Hoo in East Anglia consciously evoke imperial Rome.[61] The intention was to show the man as a Roman ruler, so he was "dressed up" as a Roman emperor, or more accurately, as William Filmer-Sankey has commented, in the way an Anglo-Saxon imagined a Roman emperor dressed.[62] It is to be concluded that ideas about dress and jewellery could have reached Ireland from Late Antiquity and

Byzantium via Germanic intermediaries encountered through the ecclesiastical, political, and trading links referred to above.

Against this background, attention can now be drawn to some parallels of the way brooches were worn in early medieval Ireland and the Late Antique world. Some of these have already been pointed out, notably by Margaret Nieke.[63] She suggested that, like Germanic potentates, Celtic rulers also drew on Roman traditions of social organization and power in order to assert their own legitimacy. This proposition will now be explored further.

It should first be explained that there is no cemetery evidence to show how an elaborate brooch such as the "Tara" brooch was worn. However, Ireland possesses the most extensive vernacular literature in Europe, going back to at least the seventh century, and we know how ornate brooches were used through descriptions in narrative texts and references in law tracts. There is additional evidence from stone carvings. All these sources indicate that such a brooch would have been worn singly, and not as one of a pair. It is also clear that, in contrast to Anglo-Saxon England, secular men as well as women wore brooches, as apparently did clerics.[64]

The sources indicate that the brooch held a cloak (*bratt*) which was worn over a tunic (*léine*) (Fig. 6).[65] As the late Liam de Paor pointed out some twenty years ago, this costume clearly derives from the Mediterranean.[66] In the Roman Empire, officials likewise wore a tunic under a distinctive heavy cloak (*paludamentum*) that was fastened at the right shoulder with a brooch (*fibula*). A cloak (Greek, *chlamys*) secured at the shoulder by a brooch was also part of the official costume of the Byzantine emperor and his high-ranking officials.[67]

A second feature worthy of comment is a difference in the way men and women wore brooches in early medieval Ireland. In a well-known passage from an Old Irish law about liability for injury caused by a projecting brooch pin, it was stated that the correct place for a man to wear a brooch was on his shoulder, while a woman should wear a brooch on her breast.[68] The same distinction is seen in stone carvings showing figures wearing brooches. Men wearing brooches fastened on their right shoulders appear, for example, in a panel on the east face of Muiredach's Cross at Monasterboice, dated to the early tenth century (Fig. 6),[69] and on the approximately contemporary Cross of the Scriptures at Clonmacnois (Co. Offaly).[70] Women wearing brooches in a central position on the breast, suggesting a cloak which meets in the middle, are seen on a cross (Fig. 10a), probably of eighth- or ninth-century date, in Dál Riata at A'Chill, Canna, in the Western Isles of Scotland, and also in the Flight into Egypt scene on the early tenth-century high cross at Durrow (Co. Offaly).[71] Women with brooches on their breasts also appear in Pictish sculpture, e.g., on a stone at Monifieth, Angus, dated approximately to the eighth century.[72]

In adopting the practice of wearing a brooch on their right shoulder, early medieval Irish men were conforming to a widespread custom. It was standard practice for men to wear brooches on the right shoulder in the Roman military world, for the practical reason that it kept the sword arm free. This fashion came to be adopted, along with military uniform, by the civilian administration of the Late Empire and continued in court and governmental dress in Byzantium (Figs. 7, 8, and 9).[73] Moreover, Germanic men within the Roman Empire, in the Rhineland and Danube area, also emulated this fashion.[74]

Contemporary Irish women were also following an established practice by placing a brooch on their breast. Evidence from graves in northern Europe shows that aristocratic Germanic women also wore brooches in a central position in the breast region. For example, there was a gilt silver brooch on the breast of the so-called princess of Zweeloo, buried in about A.D. 450 in the

6. The Arrest of Christ on Muiredach's Cross at Monasterboice, County Louth (early
tenth century). Christ wears a *bratt* fastened with a large "Tara"-type brooch on the
right shoulder; the pin faces upwards and outwards. Beneath this garment is a long
léine with a decorative hem. In contrast, the soldiers wear trews, perhaps a Viking
fashion. The lozenge-shaped object worn by the right soldier may be a kite-brooch.

Netherlands.[75] Another case in point is the woman buried in grave 49 at the Cathedral of St.
Denis, Paris, who (on the basis of an inscribed ring) is probably the Frankish queen Arnegunde,
consort of Chlotar I, who died around A.D. 565–70. Her grave contained two disc-brooches, both
worn centrally (Fig. 10b).[76] Late fifth- to seventh-century graves of Anglo-Saxon women also pro-
vide evidence for the wearing of brooches in a central position.[77] Such Germanic models were
probably the source of inspiration for the Irish practice.

 One Byzantine piece indicates that the convention was known in the Mediterranean. This is
a silver-gilt plate from the Second Cyprus Treasure, probably manufactured in Constantinople
between A.D. 613 and 629/30, which shows the marriage of David to Michal presided over by
King Saul (Fig. 7).[78] David, Saul, and even the male musicians wear cloaks secured by brooches on
their shoulders, while the bride's cloak is held in place by one on her breast. Nevertheless, this is
exceptional. In the classical Mediterranean world brooches appear to have been very seldom
worn by women, if at all. A Late Antique origin for the Irish custom is thus problematic.[79]

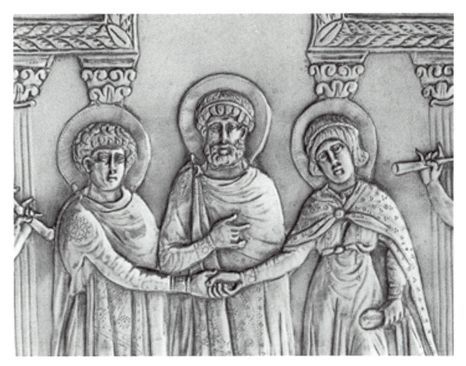

7. Byzantine silver plate from the Second Cyprus Treasure (early seventh century) showing the Marriage of David and Michal presided over by King Saul. David and Saul wear cross-bow fibulae on their right shoulders; the bride, Michal, wears a disc-brooch on her breast. Nicosia, Cyprus Museum

Thirdly, there is the question of the colour of the cloak. Early Irish society was extremely hierarchical, and at the top of the scale were kings, each of whom ruled over a *túath*, or tribal kingdom, and beneath whom was a complex succession of ranks.[80] In the seventh and eighth centuries Irish legal commentaries laid down strict regulations about the colours to be worn by the various grades. Purple (and also blue) were the colours to be worn by sons of kings.[81] Purple is also the colour of the cloak worn by numerous high-ranking individuals portrayed in early Irish sagas. *Brat corcra*, "a purple cloak," is a commonplace descriptive phrase in early Irish narrative,[82] and the wearing of purple was clearly understood to be an attribute of an individual of note. So well accepted was it that in the *Táin Bó Cúailnge* references to a purple cloak on an approaching warrior, even though he is not named, plainly signal his importance.[83] Moreover, when the hero of the tale, Cú Chulainn, puts on his most magnificent finery to display his "gentle, beautiful appearance," he wears a splendid purple cloak over a silk tunic.[84]

As is well known, the association of the colour purple with kingship was also widely disseminated in Mediterranean civilizations. The Roman emperor wore "Tyrian purple" obtained from shellfish of the genus *Murex,* and the right of the powerful to wear purple continued to be guarded by sumptuary laws in Byzantium.[85] There purple pervaded the symbols of imperial power. Certain purple textiles were reserved for the imperial family. During ceremonies the emperor wore a purple cloak[86] and stood on a porphyry disc. He was buried in a porphyry sarcophagus. He signed his name in purple ink. In the fourth century, the phrase *adorare purpuram* des-

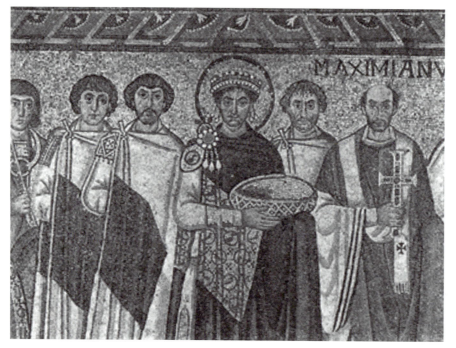

8. Mosaic of Justinian and his retinue in San Vitale, Ravenna (mid-sixth century) showing Justinian wearing an imperial brooch on his right shoulder and his court officials wearing cross-bow brooches on their right shoulders

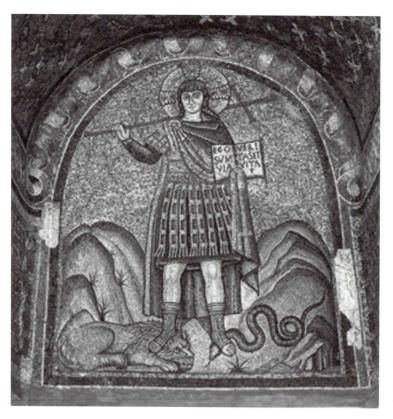

9. Mosaic of Christ the Soldier, Archiepiscopal Chapel, Ravenna (ca. A.D. 500), showing Christ wearing an imperial brooch on his right shoulder

A

B

10. Women wearing brooches on their breasts: *(a)* Virgin in a truncated Adoration scene on a cross at A'Chill, Canna (probably eighth to ninth century); *(b)* reconstruction of the dress of the Frankish queen Arnegunde, consort of Chlotar I, who died around A.D. 565–70, buried in grave 49 in the Cathedral of St. Denis, Paris

ignated an audience in which the beneficiary enjoyed the privilege of kissing the emperor's purple garment. In later centuries children born to emperors were called *porphyrogennetoi*, "born to the purple." Purple parchment is attested for letters to foreign princes, and purple silk cords held the seals that hung from imperial documents.[87]

The assigning of the same significance to the colour purple in early medieval Ireland can hardly be an independent development. In fact, philology confirms that it is was derived from the classical world, since the Old Irish term for purple dye, *corcur,* is a borrowing from the Latin *purpura.* Like *síbal* (brooch), it is actually a very early borrowing. This is indicated by the spelling, a "c" being substituted for "p." Philologists suggest that this particular features pre-dates the seventh century and is probably older, perhaps as early as the fifth.[88] Purple, of course, was recognized as a royal colour all over early medieval Europe, so the Irish were again conforming to contemporary practices. They did not have to use the Mediterranean *Murex* shell to obtain the colour, but extracted it locally from *Coclea* (sting or common dog whelk), or alternatively used Dyer's madder imported from France in E-ware vessels.[89]

Fourthly and lastly, just as the use of purple was controlled by sumptuary legislation in Ireland, so too was the wearing of the brooches of varying degrees of grandeur. The law tract *Críth Gablach* suggests that while kings held the highest rank in society, kings themselves were graded in a hierarchy which depended on the number of superior kings to whom an individual owed allegiance. To quote Thomas Charles-Edwards:

There were three grades of king: the king of a single *túath*, "people", who has no king subject to him but is himself the vassal of another king, the king of a few *túatha*, who is both lord of other kings and himself subject to a higher king, and the supreme king, who is king of kings and not himself subject to any other king.[90]

The position of each king in the hierarchy was, in theory at least, indicated by the type of brooch he wore. This is clear from a well-known legal passage which states that gold brooches with gems were to be worn by the sons of kings of Ireland and kings of provinces, while silver brooches were to be worn by the sons of the kings of territories.[91] More lowly individuals wore smaller, plainer brooches made of cheaper materials. This is consistent with the great variations in size and quality of surviving brooches. Confirmation is found in legal texts. For example, a passage in *Críth Gablach* stipulates that among the possessions of one of the lowest grades of nobility, the *aire déso*, was a silver brooch of an ounce. Kelly has translated this as a "precious brooch worth an ounce of silver" rather than a "precious brooch weighing an ounce."[92] However, as Nieke remarked, whatever the exact translation, such a brooch is likely to have been quite small.[93]

Evidence to suggest that a showy brooch denoted royal office is found in other sources. For example, a large "Tara"-type brooch is used to identify Christ's kingly status on the tenth-century high cross at Monasterboice (Co. Louth) (Fig. 6). On a high cross of similar date at Durrow and also on an eighth- to ninth-century cross on the western Scottish island of Canna, the Virgin is also identified by such an emblem (worn on the breast, rather than the shoulder, as was appropriate for a woman) (Fig. 10a).[94] Another case in point is a passage in a tale recorded in the twelfth-century codex, the Book of Leinster, entitled "Mór of Munster and the Tragic Fate of Cuanu, son of Cailchin" (*Mór Muman ocus Aided Cuanach Meic Ailchine*), which probably dates to the mid-eighth to ninth century A.D.[95] The narrative is set in the capital of the province of Munster, Cashel, and it describes how the queen persuades the king to sleep with a ragged shepherd girl, Mór. This is not to be taken at face value, because Mór actually represents the sovereignty of the province of Munster, and it was an essential for the king to have intercourse with her if he was to become a legitimate ruler.[96] The crucial incident concerns the queen's brooch, which the queen insists the king give to Mór. After the king has consummated his relationship with Mór, he makes her his queen. When he does so he orders his former wife: "Put yet that purple cloak on her [Mór] and the queen's brooch in her cloak."[97] The brooch here, then, is not just a functional dress-fastener. Like the purple cloak, it is an emblem of regal status.

An episode in another tale in the the Book of Leinster, "The Siege of Howth" (*Talland Étair*), about the retrieval of a brooch buried for safe-keeping,[98] suggests, in addition, that in Ireland brooches were dynastic possessions, passed from one generation to another. In this case the protagonist is a poet of high status rather than a king, but the law-texts indicate that a top-ranking poet, or *ollam*, was equal in status to a king of a *túath*,[99] while aspects of the narrative point to the underlying theme of kingship.[100] This is consistent with later sources, which explicitly state that brooches were heirlooms in royal dynasties.[101]

The way brooches were used to mark social standing in early medieval Ireland mirrors the way brooches were used as insignia of office in the late Roman tradition. Here, then, is another way in which the Irish seem to have borrowed and adapted traditions ultimately derived from the world of antiquity.

The history of Late Antique and Byzantine cloak fasteners has been recently discussed in an

article by Dominic Janes which is relevant to the present concerns. Janes has drawn attention to a change in the symbolic meaning of the brooch in male dress which occurred in Late Antiquity and went on to have a fundamental effect on attitudes to jewellery in the early Middle Ages.[102] He points out that men's brooches in Roman art are shown as round and unelaborate: they are practical dress-fasteners rather than emblems of status.[103] In the third century, however, depictions of nobles show that their cloaks were always fastened by a very different clasp type, the cross-bow fibula. This was a badge of high status and service to the empire, and it is visible in numerous Late Antique and Byzantine depictions down to at least the sixth to seventh centuries (Figs. 7 and 8).[104] Sumptuary laws stipulated that the cross-bow brooches were to be "precious only for their gold and for their craftsmanship."[105] The type was distinguished by its lack of gem-stones from a further type of brooch which evolved in the fourth century. This is the imperial clasp, or *Kaiserfibel*. No examples survive in Constantinople itself, but imitations of such brooches occur in the Pietroasa treasure from Romania, while three other jewelled brooches discovered in eastern Europe (at Szilágy-Somlyó II, Romania; Ostropatka, Slovakia; and Rebrin, Slovakia) may be small versions of the type, commissioned by the emperor for presentation to favoured barbarian rulers.[106] The appearance of the *Kaiserfibel* can also be reconstructed, since such brooches are repeatedly shown in representations of the Byzantine emperors. Theodosius I, for example, sports such a clasp on the late fourth-century silver missorium, issued to celebrate his *decennalia* in A.D. 388,[107] and the sixth-century emperor Justinian is shown wearing an imperial brooch in mosaics at San Vitale, Ravenna (Fig. 8). So important was it as a mark of identity that it appears on imperial portraits on small-scale objects such as coins.[108] Indeed, anticipating Monasterboice, even Christ was identified as such by an imperial-style brooch in the Archiepiscopal Chapel at Ravenna, dated to ca. A.D. 500 (Fig. 9).[109] Such representations make it clear that the imperial brooch was, as Janes commented, "a huge and startling object," distinguished by its two, three, or more pendants and numerous gem-stones such as pearls, emeralds, and hyacinths, and which sumptuary legislation laid down was to be at the free disposal of the emperor.[110] Such a brooch became a standard item of the Byzantine emperor's official dress from the second quarter of the fourth century onwards, and was sometimes also worn by the empress.

To sum up, in the Mediterranean, as Janes has said, jewellery played a prominent role in public life:

> The late empire saw the separation by the specific use of material culture of the emperor from the people, including the soldiery with their plain brooches, and from the generals and high officials with their gold honorific examples. Distinction was displayed through symbolic display of specific insignia, so as to display a clear hierarchy through uniform. The desire to make visible distinctions of rank was further satisfied by even more varied use in imperial clothing of high quality purple dye, of silk and of gold-knit decoration. The emperor had once seemed keen to appear as first among equals. But with the passing of time this lapsed as there grew the strong compulsion to express the superiority of the Ruler.[111]

A similar attitude prevailed on the fringes of Europe in early medieval Ireland, where brooches and purple cloaks were also insignia of rank. Among the Iron Age Celts, in contrast, high status was displayed by the wearing of a gold neck torc.[112] So by using a brooch instead to display status, the early medieval Irish were in tune with their times and conforming to contem-

porary rather than prehistoric practices. The "Tara" brooch with its variegated patterns and rich ornament is just the sort of brooch one would expect a powerful individual to wear in the Ireland of the later seventh or early eighth century. This was probably a king, but it may also have belonged to a queen, a powerful cleric, or an even an *ollam* (a poet of the highest grade). We can now examine its design in more detail to see if this displays features which may be explained as a response to contemporary European fashions. It has so much in common with the slightly earlier Hunterston brooch that the latter will also be discussed below.

PENANNULAR AND PSEUDO-PENANNULAR BROOCHES COMPARED

The immediate native antecedents of the brooches like the "Tara" and Hunterston examples are the zoomorphic penannular brooches (Fig. 5a) introduced into Ireland from Roman Britain in the fifth century. They are called "penannular" because they are almost circular, the hoop being broken to create a gap between two so-called terminals; and "zoomorphic" because the terminals, which derive from a prototype of a beast biting a rod, retain vestigial ears and snouts. This type of brooch is generally made of copper-alloy. It has a simple pin with a decorated pin-head which swivels round the circular hoop. There is a buffer at the junctions of the hoop and terminals to stop the pin slipping onto the (slightly) expanded terminals, which are emphasized by ornament.

By the sixth and seventh centuries in Ireland zoomorphic penannular brooches seem already to have been status symbols, and an Irish form was developed which was more elaborate than its Romano-British predecessors (Fig. 11). In this new type of penannular brooch, the terminals became the dominant features while the pin-head also became more eye-catching. Surfaces were textured, and key points were decorated with inlays composed chiefly of opaque red enamel, sometimes with millefiori and plain glass insets. They were also occasionally tinned.[113] They were "the most ornate form of clothes-fastener fashionable in Ireland in the sixth and seventh centuries,"[114] and they provided the basic pattern which was to be elaborated on in the following centuries.

The Hunterston/"Tara" type which replaced them was even more flamboyant, due to a radical change in taste brought about by the discovery of Germanic polychrome jewellery. Instead of being made of copper-alloy and ornamented with enamel and millefiori, the most de luxe examples were made of silver and decorated with splendid inlays inspired by Germanic models, composed of materials such as gold, silver, amber, and multi-coloured glass. The decorated area on such brooches is greatly expanded and the terminals and pin-heads are particularly enlarged (cf. Figs. 5a and 5b). Other novelties are the presence of large round studs at key points, the matching of the ornament on the pin-heads and terminals, and the subdivision of the surface of the brooch into panels separated by studs. The centre of each decorative zone is also clearly demarcated from peripheral ornament, so that on the front of the hoop a central "cartouche" is flanked by filigree panels separated by studs, while each terminal has a central panel edged by a ridge surrounded by a band of side compartments, in turn edged by a fine gilt margin. Yet the ancestry of the Hunterston/"Tara" brooches is clear. Like their zoomorphic penannular predecessors, they each have a movable pin with a decorative pin-head which rotates around a curved hoop with buffers at each end, which prevents the pin from slipping onto the expanded terminals.

A fundamental difference between the two types, however, is that in the earlier class the pin

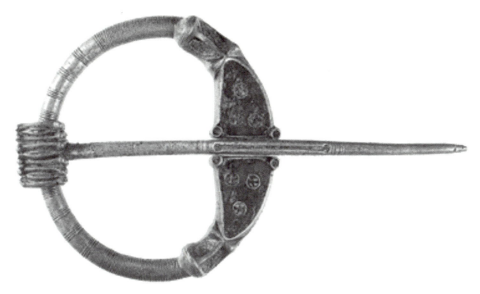

11. Front view of zoomorphic penannular brooch of distinctive Irish type from County Cavan (probably late sixth to early seventh century). British Museum, MLA 1866,3-20,1

slides through a gap between the terminals, whereas in the Hunterston/"Tara" type the "terminals" are joined and the gap closed, hence its description as "pseudo-penannular." Nevertheless, the presence of a gap between the terminals is acknowledged in the design. This is a feature of both the Hunterston and "Tara" brooch, where elaborate panelling decorated by filigree and studs fills this area (Figs. 1–3). Closing the gap led to a different, and less efficient, method of fixing the brooch in position. This was such an important change that the fastening method of both the penannular and pseudo-penannular brooch should be considered more closely.

A true penannular brooch is a very effective clothes-fastener because when the pin has been threaded through the fabric, it can be passed through the gap between the terminals and swivelled into position over the hoop (Fig. 12a–c). In this way it becomes firmly locked in place and cannot be dislodged without again rotating either the pin or the brooch-head. Indeed, it anchors the brooch so firmly that in Morocco, where penannular brooches are still worn, heavy components such as chains or medallions are often suspended from very small specimens.[115]

On a pseudo-penannular brooch, however, it is not possible to lock the brooch in place by this simple action. Three methods of securing brooches of this type have been postulated. In the first the pin lies over the hoop. David Wilson has described the rather tricky manoeuvres necessary to fasten the brooch as follows: "the cloth must first be pulled through the hoop, the pin must then be forced through precisely the right amount of cloth, and the cloth then pulled back so that the pin lies flat on the hoop."[116] This method is exceptionally awkward, and would only work if the pin was relatively short. Another drawback is the risk of damage to the brooch-head by friction from the superimposed pin, and it seems an unsuitable method to use with a highly decorated brooch, even if much of the decoration is recessed, as on the Hunterston and "Tara" brooches.

In the second method the pin is simply thrust into the cloth and the heavy brooch-head left to dangle in front of the pin. This has the disadvantage that there is a risk of the brooch slipping out of place. Nevertheless, this may be the technique used to affix the Hunterston brooch, as

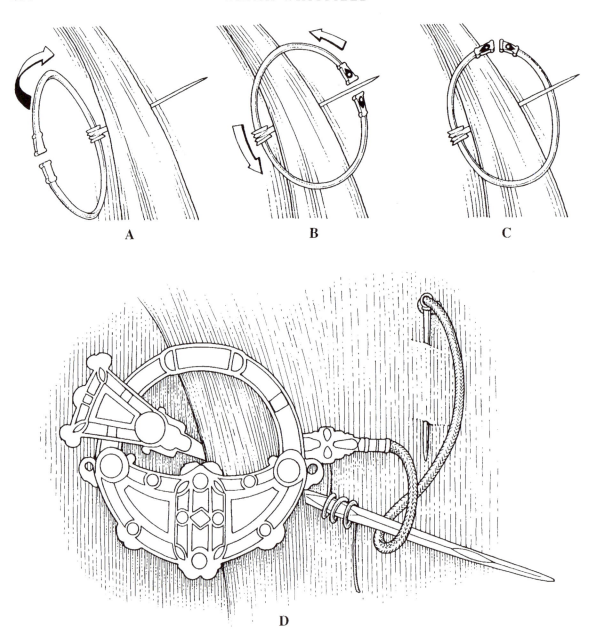

12. Fastening of penannular and pseudo-penannular brooches: (a–c,) three steps in the fastening of a penannular brooch; (d) fastening the "Tara" brooch. There is an attachment for the cord on the reverse of the H-shaped link. The pin at the end of the chain is speculative.

there are no attachments on the brooch-head to secure it.[117] The Hunterston brooch, of course, belongs to the early phase of the history of the pseudo-penannular series, and its fastening method may have been experimental.

The third method is an improvement on this last one. In this case the brooch is again pinned through the fabric of the cloak, but the brooch-head is firmly held in place by a cord or chain attached to the brooch-head. This is wound around the pin, which may be worn in an upright, horizontal, or downwards position. This fastening technique has a long history in Ireland.[118] Many

surviving brooches have on their reverse attachments for a loop to hold a chain or cord,[119] and this third technique seems to have been by far the most widely used. It is clear that this is how the "Tara" brooch was held in place, although in this case both a chain and a cord seem to have been used for extra security (Fig. 12d). The silver chain survives, affixed to the brooch-head by an H-shaped hinged link. It is flexible enough to have been loosely wound around the shaft of the pin. Alternatively, it may have hung loose and been attached by a pin at its tip in the manner of an Anglo-Saxon pin-suite.[120] The more secure fastening, however, was probably provided by a cord (perhaps made of silk and dyed purple, like a cord which survives on a humbler ringed pin[121]) wound around the pin (Fig. 12d). It is now lost, but it is clear that it once existed, since on the reverse of the H-shaped link a lug for a ring for such a cord remains intact. In this way the "Tara" brooch would have been firmly held in place when worn. Nevertheless, this was hardly anything like as secure a method as that used to affix penannular brooches. So why was the gap between the two terminals filled in on the Hunterston/"Tara"-type brooches when this made it so much more awkward to fasten them?

Why Close the Gap on Pseudo-penannular Brooches?

An interesting answer to this question was suggested by the late Robert Stevenson in studies of the Hunterston brooch.[122] He pointed out firstly that there is a short-armed cross radiating from a central rectangular panel in the centre of the "gap" area on the Hunterston brooch (Fig. 3), which he took to be a clear Christian symbol. Secondly, he pointed out that panelling in the "gap" area of the Hunterston brooch forms a design which is very reminiscent of some seventh-century Frankish brooches which appear to have contained relics. He concluded from this that the earliest examples of the Hunterston/"Tara" type of brooch incorporated actual relics set in cross-covered reliquary boxes placed between the two terminals. On this analysis, then, the gap was closed and the fastening method sacrificed in order to incorporate Christian symbolism into the brooch design. As further support for this proposal, he suggested that the minute cruciform pattern formed by five granules inside the blue and gold lozenge in the centre of the "gap" of the "Tara" brooch was also a version of the Christian cross (Fig. 1).[123]

Obvious crosses[124] and Christian inscriptions[125] appear on some sixth- to seventh-century Irish penannular brooches (as they do on sixth- to seventh-century Byzantine jewellery),[126] and this theory has gained widespread acceptance. The view taken here, however, is that it does not answer the question fully. Was the gap closed to incorporate a Christian symbol, or was a cross placed in the "gap" area because the terminals had already been joined and the space was available for this new element?

Here arguments will be advanced to support the second alternative. The most fashionable type of dress-fastener worn by women in the Germanic countries visited by the Irish missionaries in the late sixth and seventh centuries was the disc-brooch. It will be suggested that the influence of the disc-brooch, particularly the composite type worn in Anglo-Saxon England (Fig. 13), is a factor which must be taken into account when seeking an explanation for the puzzling closure of the gap on pseudo-penannular brooches. Women alone wore brooches in Anglo-Saxon England,[127] but this does not preclude such brooches from having some influence on changes in the design of brooches in Ireland, since there, as already noted, brooches were worn by women as

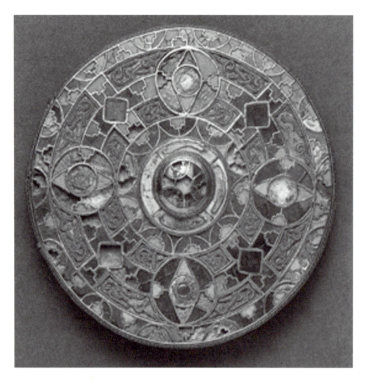

13. Anglo-Saxon disc-brooch from Kingston Down, Kent, grave 205, early seventh century, front view. Scale 1:1

well as men. The suggestion that disc-brooches may be a factor in the development of the pseudo-penannular brooch has already been advanced, but not developed, by Stevenson in 1974, when he wrote that the designer of the Hunterston brooch was "accustomed to disc-brooches . . . [which] demonstrated that the gap was not essential and spoilt the sweep of his design."[128] The arguments given below, however, are based not on these general considerations but on analysis of the geometry governing the design of the "Tara" and Hunterston brooches. The overall geometry of the "Tara" brooch is too complex and subtle to be investigated here: it will be discussed in greater detail in a future publication. That of the Hunterston brooch is considered more closely elsewhere.[129] Only those aspects of the underlying geometry of both brooches which are relevant to the present argument will be discussed here.

It is likely that the outline of both the "Tara" and Hunterston brooches was first worked out in sketches, either on wax tablets or trial-pieces, in advance of manufacture. This is a reasonable assumption not only because the scheme suggested below seems to work, but also because sketches of brooches, albeit simpler ones drawn with compasses and straight-edges, have survived on trial-pieces from Dunadd, in Scottish Dál Riata, and Nendrum in north-eastern Ireland (Fig. 14).[130] This supposition is also supported by previous work on the use of geometry in Hiberno-Saxon artefacts, in particular, Rupert Bruce-Mitford's study of compass work and rulings on the reverse of folios of the Lindisfarne Gospels, which proved beyond doubt that their ornament was planned geometrically with the aid of arcs and grids.[131] The general similarities between this manuscript and the "Tara" brooch makes this discovery especially relevant to the present discussion. A debt must also be acknowledged to Robert Stevick's work on geometrical proportions (what he refers to as "commodular construction") in Hiberno-Saxon manuscripts and Irish high crosses.[132]

14. Trial-piece from Nendrum, County Antrim, showing sketched designs for brooches using a compass and straight edge. The diameter of each brooch is 21 mm.

Following such examples, experiments were carried out with a compass and ruler on tracing paper superimposed on photographs of the "Tara" and Hunterston brooches. This made it possible to pick up some, at least, of the geometrical guidelines which determined their shape. Subsequently, the hypotheses were verified by measurements of the brooches themselves. This was an essential step, because photographs are rarely taken from plumb above either object and can be misleading.

The Geometry of the "Tara" and Hunterston Brooches and Anglo-Saxon Disc-Brooches

A relatively simple geometry determines the basic outline of both the "Tara" and Hunterston brooches, although it is not immediately obvious.[133] It is illustrated here in two diagrams by Nick Griffiths (Figs. 15a and 15b) which show that the design of each brooch is based on a figure whose importance in Hiberno-Saxon design has already been noted by Stevick, namely a cross within a circle, bounded by a square—that is to say, one where each arm of the cross equals the radius of the circle, which in turn equals half the width of each side of the square. In each diagram the centre of the figure is at X, the bounding square is ABCD, and the tips of the arms of the inscribed cross are at E, F, G, and H. These diagrams will now be described in turn.

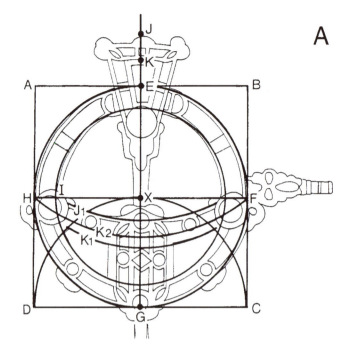

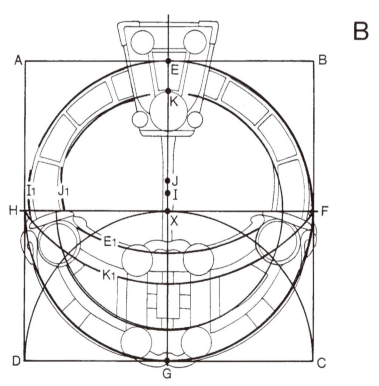

15. Diagrams showing some of the underlying geometry of: *(a)* the
"Tara" brooch; *(b)* the Hunterston brooch. Note that points E and K
on both figures and point J on Figure 15a form part of the underlying
geometry and are *not* derived from the pin-head, which can be ro-
tated. Scale 2:3

First, Figure 15a, which shows the "Tara" brooch. The following points are to be noted:

- The vertical arms of the notional cross, EG, accurately bisect the brooch along a line which runs through the centre of the "cartouche" on the hoop and the centre of the "gap" area between the terminals, so that the areas to the left and right of it are in mirror-symmetry.
- The horizontal arms of the notional cross, HF, likewise accurately bisect the brooch. In this case a notional line runs just above the large studs at the junction of the hoop and terminals, "resting" on the scrolled tails of the two marginal beasts whose necks overlap on the vertical arm of the cross just below point X. The upper part of the brooch, occupying the area ABFH, consists only of the hoop around which slides the pin; the lower part, occupying the area HFCD, consists only of the terminals.
- The outer circumference of the brooch is delineated by the main circle within the square ABCD, which has a radius of 43.5 mm. This is also the length of the arms of the notional cross within the square (XE, XF, XG, and XH).
- A second concentric circle follows the inner curve of the hoop at the top of the brooch (though it veers inwards a little towards the junction with each terminal) and continues down to trace the inner edge of the lower curves of the central compartments on each terminal. The radius of this inner circle, XI, is 34.5 mm, which is 9 mm less than that of the outer circle.[134]
- The upper edge of the terminal area is formed by an arc, J1, which is struck from point J, which lies at a point on an extension of the central vertical line which appears to lie 18 mm above point E on the perimeter of the brooch.
- The inner edge of the central compartments on each terminal are formed by the arc K1, struck from point K on the central vertical line, which appears to lie 9 mm below point J and the same distance above the perimeter of the notional square. The arcs J1 and K1 have the same radius.
- Also struck from point K, but with a radius K2, which is approximately 3 mm shorter than the radius K1, is the curve which falls on the outer side of the amber ridge surrounding the central panels on each terminal.[135] This arc passes by the tips of a pair of ovoid amber studs flanking the inner edge of the "gap" area between the terminals, and ends up at points H and F, where the horizontal arms of the notional cross meet the outer circumference of the "Tara" brooch, bisecting the studs at the junctions of the hoop and terminals.
- The short edge of the central panel on each terminal by the junction with the hoop is delineated by a further arc: its centre lies at G, and it has a radius of DG (or GC), which equals the radius of the greater circle.
- The odd shape of the central panel on each terminal is thus determined by arcs of various circles, namely, the inner circumference, that shown as K1, and that with its centre at G. Just one edge of this central panel, that facing the "gap" area between each terminal, has a straight edge.

Turning now to Figure 15b, which shows the Hunterston brooch, we see there the same system, with minor differences. As before, the cross in a circle in a square is fundamental to the design:

- The vertical arms of the notional cross, EG, likewise accurately bisect the brooch. Once more, the line runs through the centre of the "cartouche" on the hoop and the centre of the "gap" area between the terminals, so that the areas to the left and right of it are in mirror-symmetry.

- Again, the horizontal arms of the notional cross, HF, bisect the brooch. In this case a line exactly cuts the left and right junction of the hoop and terminals on the inner edge, and runs on to terminate at the tips of the ear-lappets of the marginal birds' heads at H and F. As on the "Tara" brooch, the upper part of the brooch, occupying the area ABFH, consists only of the hoop around which slides the pin; the lower part, occupying the area HFCD, consists only of the terminals.

- Another shared feature is that the outer circumference of the brooch is delineated by the main circle with its centre at X within the square ABCD. Here its radius is 60 mm. On the hoop, however, the edge veers inwards above the junction with the terminals. This deviation from the main circumference is delineated by an arc, I1, struck from point I, 7.5 mm above point X in the centre of the circle.

- As on the "Tara" brooch, a second concentric circle follows the inner curve of the hoop at the top of the brooch and continues down to trace the inner edge of the lower curve of the central compartments on each terminal. The radius of this inner circle is 48 mm, 12 mm less than that of the greater circle. On the hoop the edge again veers inwards just above the junction with the terminals. In this case the deviation from the main circumference, J1, is struck from point J, 15 mm above point X.

- The upper edge of the terminal area is formed by an arc, E1, struck from point E at the top of the notional cross underpinning the design.

- The inner edges of the central compartments on each terminal are formed by the arc K1, struck from point K. This point lies below point E on the central vertical line, at the centre of the inner edge of the "cartouche." When this arc is continued it strikes points H and F, where the horizontal arms of the notional cross meet the circumference.

- The outer corners of the stepped ridges which surround the panel in the centre of each terminal meet the large studs at the junction with the hoop at points which lie on arc DXC, whose centre is G.

- The short inner edges of the stepped ridges are formed by arcs whose centres are at the midpoints of those large studs, and whose radii are double the radii of the studs themselves (not shown in the diagram).

- As on the "Tara" brooch, the odd shape of the central panel on each terminal is thus determined by arcs of various circles, although the shortest edge of each panel is formed differently in each case. Again, just one edge, that facing the "gap" area between each terminal, has a straight edge.

What can be derived from these diagrams to support the argument that the designers were sufficiently influenced by Anglo-Saxon composite disc-brooches to be willing to close the gap between the terminals and replace it with panelling? To answer this question it is necessary to compare the analysis of the design of the "Tara" and Hunterston brooches (Figs. 15a and 15b) with that of an early seventh-century composite disc-brooch from Kingston Down (Fig. 13), which, like the pair of Celtic brooches in question, is a particularly splendid example of its type. The following features of the "Tara" and Hunterston brooches point to a connection with this class of Anglo-Saxon jewel:

Firstly, disc-brooches are fully circular. An underlying circle likewise controls the lay-out of both the "Tara" and Hunterston brooches. The outline of each was determined by a circle.[136] Fur-

thermore, the hoop and terminal area each occupy exactly one half of that circle. Other aspects of their design are also controlled by arcs of various circles.

Secondly, the ornament on Anglo-Saxon disc-brooches, including the Kingston brooch, is divided by cruciform ornament into four quadrants. An underlying cross also determines the layout of the "Tara" and Hunterston brooches.

Thirdly, composite disc-brooches are decorated with concentric bands of ornament, which consist of gold filigree panels separated from each other by elaborate studs. A ring of ornament, bounded by the outer and inner circles whose centres lie at X, also runs around the entire perimeter of both the "Tara" and Hunterston brooches, which is likewise decorated with gold filigree panels and studs.

Fourthly, while the shape of the terminals on the "Tara" and Hunterston brooches do not permit the creation of an internal series of concentric bands of ornament like those on disc-brooches, the terminals on each are also entirely decorated with juxtaposed gold filigree panels and studs. Two arcs delimit a band of ornament on the inner edges of the terminals, which is similar to and the same width as the band on the perimeter. Between the inner and the outer band lies the central filigree panel on each terminal.

Fifthly, the Kingston brooch and the "Tara" and Hunterston brooches have many decorative motifs and techniques in common (cf. Figs. 1, 2, 3, and 12). This topic has been discussed more fully in previous publications.[137] Here it will just be noted that the parallels may be very close. For example, the Kingston brooch is decorated with gold filigree panels displaying interlace "drawn" in a three-strand band of beaded wire. Similar panels occur on the "Tara" and Hunterston brooches. On the Kingston brooch, two superimposed gold foils sometimes support the filigree interlace: an upper impressed one pierced to reveal a second, flat gold foil below.[138] The same technique is used on the Hunterston brooch. The garnet which abounds on the Kingston brooch was not available to the Irish, who used amber and coloured glass instead. Yet the circular and lozenge-shaped garnet and blue glass cloisonné studs and bosses on the Kingston brooch are comparable, if technically dissimilar, to the multi-coloured studs on the "Tara" brooch. A particularly close parallel are the large red and blue studs on the reverse of the "Tara" brooch, which clearly mimic in coloured glass cloisonné studs like those in the centre of the Kingston brooch.[139]

Finally, it is worth pointing out that the Hunterston brooch is one of the few surviving pseudo-penannular brooches to make such a feature of the "gap" area. On the "Tara" brooch the panels which replace the gap mimic an authentic space between the terminals far more closely. On most later pseudo-penannular brooches the illusion of a genuine break between the terminals is strengthened by creation of actual apertures in this zone.[140] The trend in the development of the pseudo-penannular brooch was therefore to revert to the illusion of penannularity while retaining the circularity of the overall shape. This provides a further argument in favour of the influence of the disc-brooch on their design.[141]

This is not to suggest that pseudo-penannular brooches, such as "Tara" and Hunterston, are entirely derived from Anglo-Saxon composite disc-brooches. Their design is eclectic. For example, an important decorative element on both brooches is an elaborate margin. Anglo-Saxon disc-brooches lack such margins (cf. Figs. 2, 3, and 13), and inspiration for this feature was found elsewhere in seventh-century Anglo-Saxon metalwork.[142] Furthermore, the penannular shape was by no means abandoned, it was simply modified. The influence of the disc-brooch was subtle, and much of the geometry illustrated in Figures 15a and 15b is disguised, which is probably why it has

not been discussed previously. For instance, on both the "Tara" and Hunterston brooches the horizontal arm of the underlying cross rests on very inconspicuous features. Moreover, the continuity of the ring of ornament from the hoop to the terminals is camouflaged by two features: the splaying of the hoop at the junction with the terminals, and the insertion of a ridge (amber on "Tara," stepped on Hunterston) between the central panel on each terminal and the surrounding side-compartments.

In assimilating foreign traditions, then, the designers of the "Tara" and Hunterston brooches did not copy slavishly, but were quick to develop themes learnt abroad and modify them to suit their own taste. The high standard of craftsmanship exhibited on both brooches cannot be explored here, but it is worth noting that it sometimes far surpasses that on Anglo-Saxon pieces.[143] Moreover, the designers were confident enough to maintain the (by then) traditional penannular form of their brooches. What they attempted was to blend this native status symbol with a foreign one. In the process they sacrificed the gap between the terminals, and therefore a very convenient way of attaching the brooch. However, ostentatious jewels like the "Tara" and Hunterston brooches were hardly worn every day, so the adoption of a less practical fastening method may have seemed a small price to pay for the prestige of wearing such a brooch, which implied power matching that of the most eminent foreign rulers. Moreover, if Stevenson was right about the Christian significance of the cross in the "gap" area of the Hunterston and "Tara" brooches, then the newly created solid area between the terminals provided a conspicuous, central location for the display of a powerful, possibly talismanic, symbol.[144]

It is to be concluded that the flamboyant gold jewellery the Irish saw in Germanic courts, especially those in neighbouring Anglo-Saxon England, made such an impression that they felt they had to modify their own jewellery in order to keep up-to-date. A contemporary source expresses the same attitude. This is the seventh-century Irish law tract, the *Audacht Morainn*, which lists among the requirements of a good king the ability to "estimate gold by its foreign wonderful ornament."[145]

To put this in context, goldsmiths and their patrons were not the only classes in Ireland to adapt to external forces at this time. Similar adjustments were made in other spheres. Recent historical and literary studies have emphasized how receptive the Irish learned classes were to outside ideas. A classic case is the familiarity displayed by Irish writers of Latin with the work of Isidore of Seville in the seventh century, whereas outside Spain the use of Isidore is scarcely attested before the early eighth century.[146] A second example is the well-documented willingness of the jurists to bring traditional learning up to date by incorporating biblical themes into ancient law tracts.[147] In commenting on how this came about, Donnchadh Ó Corráin remarked:

> It is difficult . . . to see how the home-grown traditional lawyers could have stood out successfully against the social prestige and intellectual weight of Christianity and its legal systems and preserved essentially unchanged their inheritance from pre-history.[148]

The same could be said of the manufacturers of brooches. They likewise could scarcely have stood out successfully against the prestige of the dazzling gold and garnet jewellery worn by foreign dignitaries or continued to work in an ancient tradition which used less glowing materials.

In conclusion, it can be said that the use of Hunterston/"Tara"-type brooches as emblems of high status was in keeping with aristocratic practice across Europe in the early Middle Ages. The ultimate models are to be found in the Late Antique and Byzantine world, but Ireland had more

immediate contact with the Germanic peoples, particularly those in Britain, and this explains how Anglo-Saxon jewels, rather than more far-flung examples, had more influence on the appearance of the "Tara" and Hunterston brooches. Both these objects display many features derived from the native tradition, but they cannot be understood without reference to their European background.

ACKNOWLEDGMENTS

In addition to all those whose help has been acknowledged in the notes, I am very grateful to Eamonn Kelly and Mary Cahill of the National Museum of Ireland for facilitating examination of the "Tara" brooch, and Alison Sheridan, Mike Spearman, Fraser Hunter, Jim Wilson, and particularly Ian Scott, of the Royal Museum of Scotland for making repeated examination of the Hunterston brooch possible. I am also indebted to Siobhán O'Rafferty of the Library of the Royal Irish Academy, Bernard Nurse and Adrian James of the Library of the Society of Antiquaries of London, and Edel Bhreathnach and Alex Woolf for help with published sources. Figure 10a by Ursula Mattenberger is reproduced by kind permission of Dorothy Kelly and Ursula Mattenberger, Figure 10b by permission of Gérard Klopp, S.A. Éditeur, Luxembourg. Finally, I offer my warmest thanks to Nick Griffiths, who drew all the diagrams for this paper with his usual patience and skill.

NOTES

1. N. Whitfield, "The Original Appearance of the Tara Brooch," *JRSAI* 106 (1976), 5–30.

2. E. Bhreathnach and C. Newman, *Tara* (Dublin, 1995), 21–25, 32.

3. N. Whitfield, "The Finding of the Tara Brooch," *JRSAI* 104 (1974), 120–41.

4. Excavations were first conducted at a development site just south of the village of Bettystown (sometimes called Betaghstown) in the 1970s by E. P. Kelly, who discovered a sixth-century inhumation site. A second campaign was recently started by J. Eogan, who has found three phases of activity: (1) a late Neolithic timber circle, (2) an Early Bronze Age flat cemetery, and (3) a linear inhumation cemetery dated to the first millennium A.D. See J. Eogan, "Exciting New Discoveries at Meath Development Site," *Archaeology Ireland* 12:3, no. 45 (autumn 1998), 7; J. Eogan, "Recent Excavations at Bettystown, Co. Meath," *Irish Association of Professional Archaeologists News*, no. 30 (March 1999), 9. I am grateful to both excavators for discussing their findings with me. See also E. O'Brien, "Contacts between Ireland and Anglo-Saxon England in the Seventh Century," *Anglo-Saxon Studies in Archaeology and History* 6 (1993), 96–97, fig. 3a, b.

5. For recent discussion of the Derrynaflan hoard, see M. Ryan, "The Derrynaflan Hoard and Early Irish Art," *Speculum* 72 (1997), 995–1017. For a brief description of objects in the Ardagh hoard, see *Treasures of Ireland: Irish Art, 3000 B.C.–1500 A.D.*, ed. M. Ryan (Dublin, 1983), cat. 51a–f.

6. *The Book of Leinster*, ed. R. I. Best and M. A. O'Brien, vol. 2 (Dublin, 1956), 427. A translation of the passage appears in E. O'Curry, *On the Manners and Customs of the Ancient Irish*, ed. W. K. Sullivan (London, Edinburgh, Dublin, and New York, 1873), vol. 3, 161–62. I am grateful to Edel Bhreathnach for discussing this passage with me.

7. R. B. K. Stevenson, "The Hunterston Brooch and Its Significance," *Medieval Archaeology* 18 (1974), 16–17.

8. Throughout this paper I have used the Old Irish spelling Dál Riata, the form generally used by historians. It may also be spelt Dál Riada and is sometimes anglicized to Dalriada. For a recent discussion of the political history of Dál Riata, see M. R. Nieke and H. B. Duncan, "Dalriada: The Establishment and Maintenance of an Early Historic Kingdom in Northern Britain," in *Power and Politics in Early Medieval Britain and Ireland*, ed. S. T. Driscoll and M. R. Nieke (Edinburgh, 1988), 6–21. For a different view to that given here of the origins of Dál Riata, see E. Campbell, *Saints and Sea-kings: The First Kingdom of the Scots* (Edinburgh, 1999), 11–15.

9. M. Olsen, "Runic Inscriptions in Great Britain, Ireland and the Isle of Man," in *Viking Antiquities in Great Britain and Ireland*, pt. 6, ed. H. Shetelig (Oslo, 1954), 169–71.

10. This is not the only one of that name to be commemorated in runes in the tenth century, because a variant of the name appears in the runic inscription on Gaut's cross-slab at Michael, Isle of Man, which states "Melbrigdi, son of Athakan the smith, erected this cross. . . .": see B. E. Crawford, *Scotland in the Early Middle Ages*, vol. 2, *Scandinavian Scotland* (Leicester, 1987), 175, fig 63. Many secular and ecclesiastical leaders of that name appear in historical sources. I am indebted to Breandán Ó Cíobháin for what follows. He kindly in-

forms me that in the Annals of Ulster the first occur-
rence of the name Máel Brigte dates to the mid-ninth
century, where it is the name of a secular leader, and that
between then and the early tenth century, seven other
secular leaders of that name occur in this text, all except
two from the Irish midlands, belonging to the south Ul-
ster area. The name barely occurs in sources relating to
Munster: just one secular and one ecclesiastical leader
are known there, both dating to the early tenth century.
The remaining thirteen bearers of the name found in
Irish sources date from the late ninth to the early twelfth
century and are ecclesiastics from the northern part of
the country. To these can be added one apparently lay
member of an ecclesiastical family and one secular
leader from south-west Ulster, and in addition, Máel
Brigte ua Máeluanaig, who made a commentary on the
Bible in Armagh in the twelfth century (J. Rittmueller,
"The Gospel Commentary of Máel Brigte Ua Máeluanaig
and Its Hiberno-Latin Background," *Peritia* 2 [1983],
185–214). Yet another Irish name to be taken into ac-
count is that of the poet Cormacán mac Maoil Brigte,
whose death is recorded in the Annals of the Four Mas-
ters under the year A.D. 946; see D. Ó Corráin,
"Muirchertach Mac Lochlainn and the *Circuit of Ireland*,"
in *Seanchas: Studies in Early and Medieval Irish Archae-
ology, History and Literature in Honour of Francis J. Byrne,*
ed. A. P. Smyth (Dublin, 2000), 238–250. As for Scotland,
the name is known there also. Two bearers were abbots
of the monastery of Iona in Dál Riata. However, the first,
Máel Brigte mac Tornáin (who was also abbot of Armagh
and died in A.D. 927) appears not to have been resident
at Iona, but to have taken that title by virtue of assuming
the leadership of the *familia* of Columba; see M. Her-
bert, *Iona, Kells and Derry: The History and Hagiography
of the Monastic Familia of Columba* (Dublin, 1996), 74 and
111. A second abbot of Iona, Máel Brigte H[ua] Rimeda,
died in A.D. 1005. Another individual from Scotland
whose name contains a reference to the name is Máel
Colaim m[ac] Máel Brigte m[ac] Ruaidhri, who died in
A.D. 1029 and is stated in the Annals of Tigernach to be
king of Scotland. Under the year A.D. 1032 in the Annals
of Ulster, the death of "Gilla Comgan m[ac] Mael
Brigde, mormaer Murebe [great steward of Moray]" is
recorded. He was the brother of Malcolm, king of Scot-
land (died A.D. 1029), and first cousin of Macbeth, king
of Scotland (died A.D. 1057). Breandán Ó Cíobháin has
also noted that A. O. Anderson, *Early Sources of Scottish
History, A.D. 500–1286,* vol. 1 (Edinburgh, 1922), 475, in-
cludes the following items under the years A.D. 966–71:
"Bishop Maelbrigte rest" and "Maelbrigte, son of Dubi-
can, died." Furthermore, the same source contains pas-
sages from three Norse sagas, Heimskringla, Orkneyinga
Saga, and Olaf Tryggvi Son's Saga, which refer to a cer-
tain Maelbrigte Tooth, a Scottish earl who was treacher-
ously killed in battle by the late ninth-century Viking

earl, Sigurd of Orkney (Anderson, *Early Sources*, 370,
371, and 420).

11. There is evidence for alliance by marriage between
the Vikings and the Irish and Scots: R. Ó Floinn, "The
Archaeology of the Early Viking Age in Ireland," in *Ire-
land and Scandinavia in the Early Viking Age,* ed. H. B.
Clarke, M. Ní Mhaonaigh, and R. Ó Floinn (Dublin,
1998), 163; Crawford, *Scandinavian Scotland* (as in note
10), 47, 212. So the individual in question may have had
parents of different ethnic origin, a Norse father and a
Celtic mother or vice-versa. I owe this suggestion to
Raghnall Ó Floinn and Edel Bhreathnach, and am grate-
ful to them both, and also to Michael Barnes and Bar-
bara Crawford, for discussion of the Norse context of the
name Máel Brigte.

12. Stevenson, "Hunterston Brooch" (as in note 7), 31;
N. Whitfield, "The Filigree of the Hunterston and 'Tara'
Brooches," in *The Age of Migrating Ideas: Early Medieval Art
in Northern Britain and Ireland,* ed. R. M. Spearman and J.
Higgitt (Edinburgh, 1993), 118–27.

13. *The Making of England: Anglo-Saxon Art and Cul-
ture, A.D. 600–900,* ed. L. Webster and J. Backhouse
(London, 1991), cat. 80.

14. *Bede: Ecclesiastical History of the English People,* ed.
B. Colgrave and R. A. B. Mynors, rev. ed. (Oxford, 1991),
II, 19.

15. For a review of the archaeological evidence, see N.
Edwards, *The Archaeology of Early Medieval Ireland* (Lon-
don, 1990), 1–5; see also R. Ó Floinn, "Freestone Hill,
Co. Kilkenny: A Reassessment," in *Studies in Honour of
Francis J. Byrne* (as in note 10), 12–29.

16. For an excellent survey of the linguistic evidence,
see J. Stevenson, "The Beginnings of Literacy in Ire-
land," *PRIA* 89C:6 (1989), 6–165.

17. For recent discussion of the evidence for Ireland as
well as south-western Scotland, see A. Lane, "Trade, Gifts
and Cultural Exchange in Dark-Age Western Scotland,"
in *Scotland in Dark Age Europe,* ed. B. E. Crawford (St. An-
drews, 1994), 103–18; E. Campbell, "Trade in the Dark-
Age West: A Peripheral Activity?" in *Scotland in Dark Age
Britain,* ed. B. E. Crawford (St. Andrews, 1996), 79–91;
and E. Campbell, "The Archaeological Evidence for Ex-
ternal Contacts: Imports, Trade and Economy in Celtic
Britain, A.D. 400–800," in *External Contacts and the Econ-
omy of Late Roman and Post-Roman Britain,* ed. K. Dark
(Woodbridge, 1996), 83–96.

18. The celebrated entry for the year A.D. 431 in the
Chronicle of Prosper of Aquitaine records that Pope Ce-
lestine sent their first bishop, Palladius, "to the Irish be-
lieving in Christ," which suggests that there were Chris-
tians in Ireland already by that date; see D. Ó Cróinín,
Early Medieval Ireland, 400–1200 (London and New
York, 1995), 14.

19. K. McCone, *Pagan Past and Christian Present in
Early Irish Literature* (Maynooth, 1990), 13.

20. É. Ó Carragáin, *The City of Rome and the World of Bede* (Jarrow Lecture, 1994) (Jarrow, 1994), 1–2.

21. *Ecclesiastical History* (as in note 14), III, 4–5.

22. For an excellent account of the history of the Columban *familia*, see Herbert, *Iona, Kells and Derry* (as in note 10).

23. This is sometimes identified as Burgh Castle, but the identification has been challenged by J. Campbell in "Bede's Words for Places," in *Places, Names, and Graves: Early Medieval Settlement*, ed. P. H. Sawyer (Leeds, 1979), 36 n. 6.

24. This list of Irish monasteries in Britain is derived from J. Campbell, "The Debt of the Early English Church to Ireland," in *Ireland and Christendom: The Bible and the Missions*, ed. P. Ní Chatháin and M. Richter (Stuttgart, 1987), 332–46.

25. I. Wood, *The Merovingian Kingdom, 450–751* (London and New York, 1994), 184–92.

26. *Ecclesiastical History* (as in note 14), III, 3.

27. *Ecclesiastical History* (as in note 14), III, 15, 25.

28. *Ecclesiastical History* (as in note 14), III, 19.

29. Wood, *Merovingian Kingdom* (as in note 25), 132–33.

30. Wood, *Merovingian Kingdom* (as in note 25), 190.

31. Wood, *Merovingian Kingdom* (as in note 25), 151.

32. M. Ryan, "Decorated Metalwork in the Museo dell'Abbazio, Bobbio, Italy," *JRSAI* 120 (1990), 102–11. For discussion of the value set on treasure in early medieval monasteries, see Campbell, "Debt of the Early English Church to Ireland" (as in note 24), 344–45.

33. *Ecclesiastical History* (as in note 14), III, 27; D. Ó Cróinín, "Rath Melsigi, Willibrord and the Earliest Echternach Manuscripts," *Peritia* 3 (1984), 17–42, esp. 23.

34. *Adamnan's De Locis Sanctis*, ed. D. Meehan (Dublin, 1983).

35. *Ecclesiastical History* (as in note 14), III, 27.

36. D. Ó Cróinín, "Merovingian Politics and Insular Calligraphy: The Historical Background to the Book of Durrow and Related Manuscripts," in *Ireland and Insular Art, A.D. 500–1200*, ed. M. Ryan (Dublin, 1987), 41.

37. H. Moisl, "The Bernician Royal Dynasty and the Irish in the Seventh Century," *Peritia* 2 (1983), 103–26.

38. These connections are discussed by Moisl in "Bernician Royal Dynasty" (as in note 37); see p. 117 for evidence suggesting that the Bernicians exercised some form of overlordship over Dál Riata, beginning in the reign of Oswald (A.D. 634–42) and ending in the death of Ecgfrith (A.D. 685).

39. F. J. Byrne, *Irish Kings and High-Kings* (London, 1973), 104 and 111. For a genealogical chart of the kings of Northumbria, see D. Mac Lean, "The Date of the Ruthwell Cross," in *The Ruthwell Cross* (Index of Christian Art Occasional Papers 1), ed. B. Cassidy (Princeton, 1992), fig. 4.

40. For discussion of the history of Brega, see F. J. Byrne, "Historical Note on Cnogba (Knowth)," in G. Eogan, "Excavations at Knowth, Co. Meath, 1962–1965," *PRIA* 66C:4 (1968), 383–400. See also the following articles in *Studies in Honour of Francis J. Byrne* (as in note 10): C. Swift, "Óenach Tailten, the Blackwater Valley and the Uí Néill Kings of Tara," 112–13; P. Byrne, "Ciannachta Breg Before Síl nÁeda Sláine," 121–26; M. Byrnes, "The Árd Ciannachta in Adomnán's *Vita Columbae:* A Reflection of Iona's Attitude to the Síl nÁeda Sláine in the Late Seventh Century," 127–36.

41. E. Bhreathnach, "Gods, Kings and Priests: Tara 400–800 A.D.," in *Tara: New Perspectives. Proceedings of a Conference Held in Dublin Castle, 25 April 1998*, ed. The Discovery Programme (Dublin, forthcoming). I am extremely grateful to Edel Bhreathnach for allowing me to refer to this paper in advance of publication and for much other generous help in connection with the historical sources.

42. That this was appreciated is evident from a passage in the twelfth-century rescension of the *Táin Bó Cúailnge* in the Book of Leinster, which tells how the boy hero, Cú Chulainn, on his first expedition with his charioteer, visits *déntai ocus dindgnai*, "the buildings and renowned places" of Brega. These included the two Neolithic passage graves at Newgrange and Knowth; see *Táin Bó Cúalnge from the Book of Leinster*, ed. C. O'Rahilly (Dublin, 1967), lines 1055–60, pp. 29 and 167.

43. Byrne, "Historical Note on Cnogba" (as in note 40), 395; Bhreathnach and Newman, *Tara* (as in note 2), 21–22.

44. This trait earned them a reprimand from their Uí Néill kinsman, Adomnán, abbot of Iona, and brought about their downfall within a generation of Adomnán's death; see Byrne, "Historical Notes on Cnogba" (as in note 40), 395.

45. The first explanation was proposed by Moisl, "Bernician Royal Dynasty" (as in note 37), 144; the second was recently proposed by T. M. Charles-Edwards, "'The Continuation of Bede,' *s.a.* 750: High-Kings, Kings of Tara and 'Bretwaldas,'" in *Studies in Honour of Francis J. Byrne* (as in note 10), 144. The incident is also discussed by Herbert, *Iona, Kells and Derry* (as in note 10), 48.

46. Byrne, "Historical Note on Cnogba" (as in note 40), 398.

47. Byrne, "Historical Note on Cnogba" (as in note 40), 397; Byrne, *Irish Kings and High-Kings* (as in note 39), 111–12.

48. I have discussed the development of the new metalwork style elsewhere: N. Whitfield, "Motifs and Techniques of Celtic Filigree: Are They Original?" in *Ireland and Insular Art* (as in note 36), 75–84; N. Whitfield, "Formal Conventions in the Depiction of Animals on Celtic Metalwork," in *From the Isles of the North: Early Medieval Art in Ireland and Britain*, ed. C. Bourke (Belfast, 1995),

89–104; N. Whitfield, "Filigree Animal Ornament from Ireland and Scotland of the Late-Seventh to Ninth Centuries," in *The Insular Tradition*, ed. C. Karkov, M. Ryan, and R. T. Farrell (New York, 1997), 211–26. See also Whitfield, "Filigree on the Hunterston and 'Tara' Brooches" (as in note 12).

49. The word for gold in Old Irish, *ór*, is not of archaic origin, but a borrowing from the Latin *aurum*; see D. Mc Manus, "A Chronology of Latin Loan-Words in Early Irish," *Ériu* 34 (1983), 42. This is not as surprising as it may seem, because gold seems to have fallen out of use in Ireland in the early centuries of our era and was reintroduced there only in the later sixth or seventh century A.D.; see N. Whitfield, "The Earliest Filigree in Ireland," in *Proceedings of the Fourth International Conference on Insular Art,* ed. N. Edwards, M. Redknap, and S. Youngs (Oxford, forthcoming).

50. Stevenson, "Beginnings of Literacy in Ireland" (as in note 16), 132.

51. Mc Manus, "Chronology of Latin Loan-Words" (as in note 49), 21–71.

52. For the probable pre-Christian origins of ogam, see A. Harvey, "Early Literacy in Ireland," *Cambridge Medieval Celtic Studies* 14 (1987), 1–15; and Stevenson, "Beginnings of Literacy in Ireland" (as in note 16), 139–48. For a philological study, see D. Mc Manus, *A Guide to Ogam* (Maynooth, 1991).

53. This type of brooch will be discussed further below. The most thorough and best illustrated account of the type is by H. Kilbride-Jones, *Zoomorphic Penannular Brooches* (Reports of the Research Committee of the Society of Antiquities of London 39) (London, 1980), but his discussion is now outdated. See also J. Graham-Campbell, "Dinas Powys Metalwork and the Dating of Enamelled Zoomorphic Penannular Brooches," *Bulletin of the Board of Celtic Studies* 38 (1991), 220–32; S. Youngs, "A Penannular Brooch from near Calne, Wiltshire," *Wiltshire Archaeological Magazine* 88 (1995), 127–31 (new drawings of which are reproduced here in Figures 5a and 12a–c by kind permission of Susan Youngs and Nick Griffiths); C. Newman, "The Iron Age to Early Christian Transition: The Evidence from Dress Fasteners," in *From the Isles of the North* (as in note 48), 17–25; R. Ó Floinn, "Politics and Patrons: Archaeology, Artefacts and Methodology," in *Proceedings of the Fourth International Conference on Insular Art* (as in note 49).

54. Mc Manus, "Chronology of Latin Loan-Words" (as in note 49), 29, 30, and 54. I would like to thank Susan Youngs for drawing this borrowing into Old Irish from Latin to my attention. It is one of the many words used to indicate brooch in the Ulster cycle of tales, where such brooches are described as being of either gold or silver but not of the cheaper *findruine*, bronze or iron; see J. P. Mallory, "Silver in the Ulster Cycle of Tales," in *Proceedings of the Seventh International Congress of Celtic Studies Held at Oxford, 10th to 15th July 1983*, ed. D. Ellis

Evans, J. G. Griffiths, and E. M. Jope (Oxford, 1986), 51. The term *síbal* may also mean a clasp, buckle, or pin, with examples occurring in *Táin Bó Fraic, Imthecht na Tromdáime,* and *Buile Shuibhne Tebe;* see *Contributions to a Dictionary of the Irish Language,* ed. E. G. Quin (Dublin, 1953), 211–12.

55. Cf. Mallory's observation that another word for "brooch" in Old Irish, *bretnas,* may be derived from *Bretain,* and hence may allude to a Romano-British item; see "The World of Cú Chulainn: The Archaeology of Táin Bó Cúailnge," in *Aspects of the Táin,* ed. J. P. Mallory (Belfast, 1992), 145.

56. This passage is summarized from W. Pohl, "The Barbarian Successor States," in *The Transformation of the Roman World, A.D. 400–900,* ed. L. Webster and M. Brown (London, 1997), 34.

57. M. Archibald, M. Brown, and L. Webster, "Heirs of Rome: The Shaping of Britain, A.D. 400–900," in *Transformation of the Roman World* (as in note 56), 209–10, cat. 17 and 20.

58. D. Talbot Rice, "Preface," in P. Lasko, *The Kingdom of the Franks: North-West Europe before Charlemagne* (London, 1971), 8. The previous passage is also derived from this source.

59. For recent discussion of this theme, see I. Wood, "The Transmission of Ideas," in *Transformation of the Roman World* (as in note 56), 111–27, and other essays in the same volume.

60. L. Thorpe, *Gregory of Tours: The History of the Franks* (Harmondsworth, 1974), vol. 2, 28. Quoted by W. Filmer-Sankey, "The 'Roman Emperor' in the Sutton Hoo Ship Burial," *JBAA* 149 (1996), 8.

61. For fuller discussion of this aspect of the Sutton Hoo ship burial, see M. Archibald, M. Brown, and L. Webster, "Heirs to Rome: The Shaping of Britain, A.D. 400–900," in *Transformation of the Roman World* (as in note 56), 222–23, cat. 53; and Filmer-Sankey, "The 'Roman Emperor' in the Sutton Hoo Ship Burial" (as in note 60), 1–9.

62. Filmer-Sankey, "The 'Roman Emperor' in the Sutton Hoo Ship Burial" (as in note 60), 8.

63. M. Nieke, "Penannular and Related Brooches: Secular Ornament or Symbols in Action?" in *Age of Migrating Ideas* (as in note 12), 128–34.

64. For discussion of the wearing of brooches by clerics, see D. M. Wilson, "The Treasure," in *St. Ninian's Isle and Its Treasure,* ed. A. Small, C. Thomas, and D. M. Wilson (Oxford, 1973), 103–5; Nieke, "Penannular and Related Brooches" (as in note 63), 132; and C. Bourke, "A Note on the Delg Aidechta," in *Studies in the Cult of Saint Columba,* ed. C. Bourke (Dublin, 1997), 184–92.

65. M. Dunlevy, *Dress in Ireland* (London, 1989), 17; B. L. Hillers, "Topos in Early Irish Literature" (M.Phil. thesis, University College, Dublin, 1989), 21–30. I am very grateful to Barbara Hillers for allowing me to draw on her thesis in advance of publication.

66. L. de Paor, "The Christian Triumph: The Golden Age," in *Treasures of Early Irish Art, 1500 B.C. to 1500 A.D.*, ed. P. Cone (New York, 1977), 94. The point is also made by Dunlevy, *Dress in Ireland* (as in note 65), 17.

67. D. Janes, "The Golden Clasp of the Late Roman State," *Early Medieval Europe* 5, no. 2 (1996), 128 and 137.

68. *Ancient Laws of Ireland* (Dublin, 1865–1901), vol. 3, 290–91. There the law-text is translated under the incorrect title of *Leabar Aicle*, "the book of Aicill." Its correct title is *Bretha Étgid*, "judgments of inadvertence"; see F. Kelly, *A Guide to Early Irish Law* (Early Irish Law Series 3) (Dublin, 1988), appendix I.33.

69. Exceptionally, a brooch is worn on the left (rather than the right) shoulder of the warrior or king on an eighth- to tenth-century stone pillar at White Island (Co. Fermanagh); see *"The Work of Angels": Masterpieces of Celtic Metalwork, Sixth–Ninth Centuries A.D.*, ed. S. Youngs (London 1989), fig. 2, p. 89. For further discussion of the wearing of brooches in early medieval Ireland, see T. Fanning, *Viking Age Ringed Pins from Dublin* (National Museum of Ireland, Medieval Dublin Excavations 1962–81, ser. B, vol. 4) (Dublin, 1994), 124–28.

70. See F. Henry, *Irish Art during the Viking Invasions (800–1020 A.D.)* (London, 1967), pl. 92, or Edwards, *Archaeology of Early Medieval Ireland* (as in note 15), fig. 36.

71. This illustration by Ursula Mattenberger was originally published in D. Kelly, "The Virgin and Child in Irish Sculpture," in *From the Isles of the North* (as in note 48), fig. 4. For a photograph of the Durrow high cross, which clearly shows the brooch on the breast of the Virgin (who is on foot), see Henry, *Irish Art* (as in note 70), pl. 99.

72. See Nieke, "Penannular and Related Brooches" (as in note 63), fig. 15.1.

73. Janes, "Golden Clasp of the Late Roman State" (as in note 67), 128.

74. John Peter Wilde, personal communication; see also *Les Francs, précurseurs de l'Europe* (Paris, 1997), 45–46.

75. S. Y. Comis, "De Kledeng van de 'Prinses van Zweeloo,'" *Kostuum* (1996), 46, fig. 4. I am grateful to Hero Granger-Taylor for this reference.

76. This figure is taken from M. Fleury and A. France-Lanord, *Les trésors mérovingiens de la basilique de Saint-Denis* (Luxembourg, 1998), fig. II-133.

77. V. I. Evison, *Dover: The Buckland Anglo-Saxon Cemetery* (London, 1987), fig. 13, a diagram of the positions of brooches in female graves in the Anglo-Saxon cemetery at Buckland, Dover, Kent, shows brooches in central (as well as other positions) in the neck and breast region. For example, a brooch at the neck is connected to one in the middle of the chest by a swag of beads in graves 48 and 92, which belong respectively to the first phase of the cemetery, which dates to A.D. 475–525, and the second phase, which dates to A.D. 525–75. In eight graves of phase 3, which dates to A.D. 575–62 (namely, graves F, 1, 29, 30, 32, 35, 38, and 59), a disc-brooch is at or very near the neck. A number of disc-brooches are also described as having been found at the neck of female skeletons by R. Avent in *Anglo-Saxon Garnet Inlaid Disc and Composite Brooches* (BAR 11) (Oxford, 1975). Examples include brooches from the following sites: grave 74 at Bifrons, Kent (Avent, corpus no. 2); grave 213 at Broadstairs, Kent (Avent, corpus no. 3); and grave 41 at Gilton, Kent (Avent, corpus no. 15). I am grateful to Cathy Haith and Bruce Eagles for help with these references.

78. Nicosia, Cyprus Museum, inv. J.452; *Wealth of the Roman World, A.D. 300–700*, ed. J. P. C. Kent and K. S. Painter (London, 1977), cat. 180.

79. Women's brooches from the Mediterranean world are markedly absent from catalogues of exhibitions which included Late Roman and Byzantine jewellery, e.g., *Goldschmuck der römanische Frau: Eine Ausstellung des Römanischen Museums, Köln, vom 16. Juni–3. Oktober 1993*, ed. B. Schneider (Cologne, 1993), and *Rom und Byzanz: Schatzkammerstücke aus bayerischen Sammlungen*, ed. R. Baumstark (Munich, 1998). Nor do they appear in Byzantine hoards of aristocratic female jewellery of the sixth and seventh centuries: see A.-M. Manière-Lévêque, "L'Évolution des bijoux 'aristocratiques' féminins à travers les trésors proto-byzantins d'orfèvrerie," *RevArch* 97 (1997), 79–106. It is striking also that none of Theodora's attendants in the mosaic at San Vitale, Ravenna, dated to A.D. 546–47, wear brooches; see A. Grabar, *Byzantium from the Death of Theodosius to the Rise of Islam* (London, 1966), pl. 172. There is evidence from the provinces of the Roman Empire from the first to third centuries A.D. for the wearing of fibulae of distinctive regional styles, often in pairs linked by chains; see A. Böhme, *Schmuck der römischen Frau* (Stuttgart, 1974), 19–21, and *Goldschmuck der römischen Frau* (as in this note), 36. However, later they become rarer and rarer. I am very grateful to Hero Granger-Taylor, Catherine Johns, Daffyd Kidd, Dominic Janes, and Chris Entwistle for much help with these sources.

80. On evidence of genealogies and other sources, F. J. Byrne has estimated that there were probably no fewer than 150 kings in Ireland at any given date between the fifth and twelfth century, which was remarkable in a population which was probably well under half a million; see Byrne, *Irish Kings and High-Kings* (as in note 39), 7. For a recent comparison of Celtic and Anglo-Saxon kingship, see T. M. Charles-Edwards, "Early Medieval Kingships in the British Isles," in *The Origins of Anglo-Saxon Kingdoms* (Studies in the Early History of Britain), ed. S. Bassett (Leicester, 1989), 28–39.

81. F. Kelly, *Early Irish Farming: A Study Based Mainly on the Law-Texts of the Seventh and Eighth Centuries A.D.* (Dublin, 1997), 263. The sons of commoners were to wear dun colour, yellow, and black; the sons of lords, red, grey, and brown.

82. This and other literary clichés related to dress are discussed by Hillers, "Topos in Early Irish Literature" (as in note 65), 24–29.

83. This device is used in a number of passages in re-scension II of the *Táin* in the Book of Leinster; see O'Ra-hilly, *Táin Bó Cúalnge* (as in note 42), line 166 (pp. 5 and 142), line 4305 (pp. 119 and 254), line 4539 (pp. 125 and 261).

84. "Baí dá étgud immi.i fúan caín cóir corcra cortha-rach cóicdíabuil" (Of that raiment was a fair mantle, well-fitting, purple, fringed, five-folded); see O'Rahilly, *Táin Bó Cúalnge* (as in note 42), lines 2357–58 (pp. 64 and 204).

85. D. Janes, *Gold and God in Late Antiquity* (Cambridge, 1998), 21, 28, 37, 129, 149, 151; Janes, "Golden Clasp of the Late Roman State" (as in note 67), 143. See also M. Reinhold, *History of Purple as a Status Symbol in Antiquity* (Collection Latomus 116) (Brussels, 1970). I am very grateful to Mark Bradley for drawing this reference to my attention and for allowing me to read the chapter "The Colour Purple," in his unpublished B.A. dissertation "Politics of Colour in Ancient Rome" (University of Cambridge, 1998), 22–28. I also thank Éamonn Ó Carragáin and Máire Herbert for their comments and advice.

86. A case in point is the cloak worn by Justinian at San Vitale, Ravenna. For excellent colour illustrations, see Grabar, *Byzantium from the Death of Theodosius* (as in note 79), pls. 170, 171.

87. This paragraph is summarized from "Purple," in *The Oxford Dictionary of Byzantium* (Oxford, 1991), vol. 3, 1759–60.

88. Mc Manus, "Chronology of Latin Loan-Words" (as in note 49), 42 and 48. I am very grateful to Damian Mc Manus for discussing with me this term, and also the dating of Latin loan-words in Old Irish.

89. Indications of dye extraction from dog whelk have come to light on a number of sites along the west coast of Ireland, while on the island of Inishkea North (Co. Mayo) a dye workshop has been excavated, probably primarily for the dyeing of yarn (rather than for the painting of manuscripts, as Françoise Henry suggested); see Edwards, *Archaeology of Early Medieval Ireland* (as in note 15), 82–83. Bede was also aware of the extraction of dye from dog whelk; see *Ecclesiastical History* (as in note 14), I, 1. See also G. Henderson, *Bede and the Visual Arts* (Jarrow Lecture, 1980), 4; and G. Henderson, *Vision and Image in Early Christian England* (Cambridge, 1999), 122–35. On madder imported in E-ware vessels, see Campbell, "Archaeological Evidence" (as in note 17), 92; and Campbell, *Saints and Sea-kings* (as in note 8), 45.

90. T. M. Charles-Edwards, "A Contract between King and People in Early Medieval Ireland: *Críth Gablach* on Kingship," *Peritia* 8 (1994), 107–8.

91. *Ancient Laws* (as in note 68), vol. 2, 146–47.

92. Kelly, *Guide to Early Irish Law* (as in note 68), 114.

93. Nieke in "Penannular and Related Brooches" (as in note 63), 129.

94. Kelly, "Virgin and Child in Irish Sculpture" (as in note 71), figs. 3 and 4.

95. T. P. O'Nolan, "Mór of Munster and the Tragic Fate of Cuanu, Son of Cailchin," *PRIA* 30C (1912), 261–82. I am very grateful to Edel Bhreathnach for drawing this text to my attention.

96. Byrne, *Irish Kings and High-Kings* (as in note 39), 16–22.

97. "Gaibid, or Fingen, in mbrat corcra ucut impe ocus delg inna rigna im a bratt": O'Nolan, "Mór of Munster and the Tragic Fate of Cuanu" (as in note 95), 263 and 269.

98. *Book of Leinster* (as in note 6), 427. The episode concerns a poet of high status, Aithirne, an Ulsterman, who visited the province of Leinster in an attempt to raise contributions from the kings who feared his art. At the hill of Ard Brestine he demanded to be paid for his services with the most valuable jewel on the hill. No one knew where this jewel was, and while the king and his people were puzzling about what to do, a young man galloped by and kicked up a clod of earth containing a golden brooch (*derg ór*) into the king's bosom. At this point Aithirne claimed the brooch as his own, saying that his father's brother had buried it in the earth after the Ulstermen had lost the battle of Ard Brestine.

99. The highest grade of poet (*fili*) is the *ollam*; he had the same honour-price as the king of a *túath*: Kelly, *Guide to Early Irish Law* (as in note 68), 46. I am grateful to Edel Bhreathnach for drawing my attention to this passage.

100. Edel Bhreathnach, personal communication.

101. The first source is Manus O'Donnell's *Life of Columcille*, of 1532, compiled from earlier sources; see A. O'Kelleher and G. Schoepperle, *Betha Colaim Chille: Life of Columcille Compiled by Maghnas O'Domhnaill in 1532* (Urbana, 1918), 340–43, and *Manus O'Donnell's Life of Colum Cille*, ed. B. Lacey (Dublin, 1998), 173. This describes how Colum Cille visited the convention of Druim Cet in Ireland partly in order to prevent its poets being exiled "because of their multitude, their sourness, their complaining, and for their wicked words. And moreover because they had satirised Áed mac Ainmerech, king of Ireland [an Uí Néill king], about the dynastic jewel of the royal family: that is the golden brooch he had, with a stone of precious lustre set in it which had the same light by day or night" (delg oir bui aicce con a geim do líce loghmair a cumdach and dia mbó comsolus la 7 ad-haigh). The narrative concludes with a short poem stating that the poets spent a year at the fort of Clogher in County Tyrone, where "they made fun of Aed's golden brooch, that, to him, was important and dear." A second source relating the same incident is Geoffrey Keating's *History of Ireland (Foras Feasa ar Éirinn)*, compiled in the seventeenth century: see O. Bergin, *Sgéalaigheacht Chéi-*

tinn: Stories from Keating's History of Ireland, 3rd ed. (Dublin, 1996), 36. In this version the poets' crime was to demand the brooch as a gift: "For a brooch it was, indeed, that every king would leave as an heirloom to every king who would come after him." I am very grateful to Edel Bhreathnach and Cormac Bourke for kindly drawing my attention to the first and second source respectively, and to them both, and also Nollaig O'Muráile, for their comments.

102. Janes, "Golden Clasp of the Late Roman State" (as in note 67), 127–53.

103. A case in point is the brooch worn by the late second-century A.D. emperor Marcus Aurelius on a panel from a triumphal arch which shows the submission of the barbarians: there the brooch worn by the emperor is not markedly different from the brooches worn by his fellow soldiers. This panel is illustrated in N. H. Ramage and A. Ramage, *Roman Art: Romulus to Constantine* (New York, 1991), fig. 8.20.

104. Janes, "Golden Clasp of the Late Roman State" (as in note 67), 146.

105. *Codex Justinianus,* cited by Janes in "Golden Clasp of the Late Roman State" (as in note 67), 146, note 77: "de curcumis vero omnem prorsus qualiumcumque gemmarum habitum praecipimus sobmoveri. Fibulis quoque in chlamydibus his utantur, quae solo et arte pretiosae sunt."

106. M. Schnauzer, "Imperial Representation or Barbaric Imitation? The Imperial Brooches (*Kaiserfibeln*)," in *Strategies of Distinction: The Construction of Ethnic Communities, 300–800,* ed. W. Pohl and H. Reimitz (Leiden, 1998), 281–96, figs. 1–18. For a colour illustration of the Pietroasa treasure, see V. Bierbrauer, O. von Hessen, and E. Arslan, *I Goti* (Milan, 1994), fig. III:13. For a colour photograph of the clasp from Szilágy-Somlyó, see *Transformation of the Roman World* (as in note 56), pl. 7.

107. See Janes, *Gold and God in Late Antiquity* (as in note 85), fig. 1; Janes, "Golden Clasp of the Late Roman State" (as in note 67), fig. 5. For exceptionally fine colour photographs of Theodosius's missorium, see Grabar, *Byzantium from the Death of Theodosius* (as in note 79), pls. 348, 349, and 351.

108. Janes, "Golden Clasp of the Late Roman State" (as in note 67), fig. 3.

109. Janes, *Gold and God in Late Antiquity* (as in note 85), 119, fig. 12, p. 131. In the same passage Janes points out that an imperial brooch (and a diadem and chlamys) were also used to identify King David in the sixth-century Sinope Gospels, while the less "imperial" but nevertheless illustrious archangels at San Apollinare in Classe, Ravenna, likewise wear imperial brooches. In later centuries the use of Mediterranean models led to such brooches appearing in northern European contexts. Charles-Edwards has convincingly argued that one is represented on the eighth-century St. Andrew's sarcophagus, in Scotland, where it is shown on the figure of King

David killing the lion: see Charles-Edwards, "Continuation of Bede" (as in note 45), 142–43. Moreover, in the ninth century it was used to denote the imperial status of the Emperor Lothair in folio 1v of the Lothair Gospels (Paris, B.N.F., Ms. lat. 266), although in this case it was misunderstood, as it is ornamented with ribbons rather than pendants. For a colour illustration, see C. Nordenfalk, *Early Medieval Book Illumination* (Geneva and New York, 1988), 68.

110. Janes, "Golden Clasp of the Late Roman State" (as in note 67), 138 and 146.

111. Janes, "Golden Clasp of the Late Roman State" (as in note 67), 136.

112. For a discussion of the torc in Iron Age Ireland, see B. Raftery, *Pagan Celtic Ireland: The Enigma of the Irish Iron Age* (London, 1994), 127–28.

113. For a brief survey of the development this type of brooch together with examples ranging from the fourth to fifth century through the seventh century, see S. Youngs, "Fine Metalwork to c. A.D. 650," in *The Work of Angels* (as in note 69), 20–23, and in addition, cat. 15, 16, 17, 18, and 19 in the same work. Other references are given above in note 53.

114. J. Graham-Campbell, "A Lost Zoomorphic Penannular Brooch from Kells, County Meath," *JRSAI* 116 (1986), 123.

115. Personal observation by the author, who in 1995 met an itinerant merchant in Morocco, who travelled through the Atlas Mountains on foot, buying up brooches and other silver items from local women, which he planned to sell subsequently to antique shops in tourist centres.

116. Wilson, "Treasure" (as in note 64), 103.

117. It is to be added that, as the Hunterston brooch pin is broken, it is impossible to estimate its original length. If it was as long as that on the "Tara" brooch, the method described by Wilson would simply not have been feasible. An additional point is that on the Hunterston (as on the "Tara") brooch there is openwork on the terminal margins at the points where they meet the hoop. A cord could, in theory, have been tied to one of the perforations, but this seems a very crude method of securing such a delicate object as the Hunterston brooch.

118. Fanning, *Viking Age Ringed Pins* (as in note 69), 124–28; N. Whitfield, "The Waterford Kite-Brooch and Its Place in Irish Metalwork," in *Late Viking Age and Medieval Waterford, Excavations 1986–1992,* ed. M. F. Hurley, O. M. B. Scully, with S. W. J. McCutcheon (Waterford, 1997), 496.

119. Examples of such attachments are found on brooches featured in *The Work of Angels* (as in note 69). On some this consists of a lug on the reverse which contained a ring through which was threaded a chain, as, for example, on the Loughmoe, Roscrea, and Killamery brooches (cat. 78, 79, and 80). On others an animal mask on the outer edge of the gap area holds a ring for a

chain in its mouth, e.g., the Westness brooch (cat. 70). Brooches which lack such attachments often have narrow bars linking the terminals to which a cord could be tied, e.g., the County Cavan brooch (cat. 73). The first two types of attachments also occur on Irish kite-brooches; see Whitfield, "Waterford Kite-Brooch" (as in note 118), 493.

120. E.g., the Roundway Down, Wiltshire, pin-suite; see *The Work of Angels* (as in note 69), cat. 40. It is sometimes asserted that the chain on the "Tara" brooch was cut, but this is not the case, as intact loops survive at the tip. The chain is thus its original length, but the attachment at the tip is lost.

121. The cord on a ringed pin from Fishamble Street, Dublin, was examined scientifically and was found to retain traces of a pinkish-purple substance, suggesting that the silk was almost certainly dyed; see Fanning, *Viking Age Ringed Pins from Dublin* (as in note 69), 125.

122. Stevenson, "Hunterston Brooch" (as in note 7), 40; R. B. K. Stevenson, "Further Notes on the Hunterston and 'Tara' Brooches, Monymusk Reliquary and Blackness Bracelet," *PSAS* 113 (1983), 469–72.

123. Stevenson, "Further Notes" (as in note 122), 470.

124. For an excellent drawing of crosses on penannular brooches, see G. Haseloff, *Email im frühen Mittelalter: Frühchristliche Kunst von der Spätantike bis zu den Karolingern* (Marburger Studien zur Vor- und Frühgeschichte, Sonderband 1) (Marburg, 1990), upper figure, p. 158.

125. M. Brown, "Appendix: The Inscriptions," in C. Newman, "Fowler's Type F3 Early Medieval Penannular Brooches," *Medieval Archaeology* 33 (1989), 16–18.

126. An example of Byzantine jewellery decorated with a cross is a pair of sixth- to seventh-century gold earrings in the Musée des Beaux-Arts, Lyons; see *Byzance: L'Art byzantin dans les collections publiques françaises,* ed. J. Durand, I. Aghion, D. Gaborit-Chopin, M.-O. Germain, M. Martiniani-Reber, and C. Morrisson (Paris, 1992), cat. 81. An example of a Byzantine jewel with a Christian inscription is a seventh-century gold and pearl finger-ring from Constantinople at Dumbarton Oaks; see M. Ross, *Catalogue of the Byzantine and Early Medieval Antiquities in the Dumbarton Oaks Collection,* vol. 2, *Jewelry, Enamels, and Art of the Migration Period* (Washington, D.C., 1962 and 1965), cat. 71.

127. *Making of England* (as in note 13), 47. I am grateful to John Hines and Barry Ager for discussion of the wearing of brooches by women in Anglo-Saxon England.

128. Stevenson, "Hunterston Brooch" (as in note 7), 33–34.

129. N. Whitfield, "Design and Units of Measure on the Hunterston Brooch," in *Northumbria's Golden Age,* ed. J. Hawkes and S. Mills (Stroud, 1999), 296–314.

130. For a discussion of these trial-pieces, see Whitfield, "Design and Units of Measure" (as in note 129), 306–7, fig. 24.7A and B. Note that, due to an error, an inaccurate scale of 1 mm was used to illustrate the Du-

nadd trial-piece, which is not reproduced at a scale of 1:1, as stated in the caption. The radius of the brooch is 18 mm, as stated in the text.

131. R. L. S. Bruce-Mitford, "Decoration and Miniatures," in *Evangeliorum Quattuor Codex Lindisfarnensis,* ed. T. D Kendrick, T. J. Brown, R. L. S. Bruce-Mitford, H. Roosenrunge, A. S. C. Ross, E. G. Stanley, and A. E. Werner, vol. 2 (Olten and Lausanne, 1960), 109–258.

132. R. D. Stevick, *The Earliest Irish and English Bookarts* (Philadelphia, 1994); R. D. Stevick, "Shapes of Early Sculptured Crosses of Ireland," *Gesta* 38 (1999), 3–21; R. D. Stevick, "High Cross Design," in *Proceedings of the Fourth International Conference on Insular Art* (as in note 49). For further debate of the use of geometry in Irish art, see two papers in *From the Isles of the North* (as in note 48): M. Ryan, "The Decoration of the Donore Discs," 27–35, and M. A. Gelly, "The Irish High Cross: Methods of Design," 157–66. See also D. Kelly, "A Sense of Proportion: The Metrical and Design Characteristics of Some Columban High Crosses," *JRSAI* 126 (1996), 108–46.

133. For helpful discussion of the geometry of the "Tara" and Hunterston brooches I am very grateful to the following: Adrian Whitfield, Robert Stevick, Luke Drury, and Nick Griffiths.

134. Dimensions of 9 mm recur on the "Tara" brooch. This length was an important element in the planning of its design, as it was on the Hunterston brooch and other pieces of Irish-style metalwork. For further discussion of such units of measure, see Whitfield, "Design and Units of Measure" (as in note 129), 307–11. The units of measure used to plan the "Tara" brooch will be discussed more fully in a forthcoming paper on its design.

135. This amber ridge is tapered and so is broader at its base than on its top. The base is approximately 3 mm from edge to edge; the upper edge is narrower than this.

136. The fully circular design of these two objects suggests that they may belong to the category of brooch which early Irish sources refer to as *roth* (wheel). For a brief discussion of terms used to describe brooches, see J. P. Mallory, "Silver in the Ulster Cycle of Tales," in *Proceedings of the Seventh International Congress of Celtic Studies Held at Oxford from 10th to 15th July, 1983,* ed. D. Ellis Evans, J. G. Griffiths, and E. M. Jope (Oxford, 1986), 50–52.

137. See the references in note 48.

138. Personal observation by the author.

139. Colour photographs of the Kingston brooch appear in *The Making of England* (as in note 13), cat. 32a. Excellent colour photographs of the reverse (and also the front) of the "Tara" brooch are found in *Treasures of Early Irish Art* (as in note 66), cat. 32, and in *Treasures of Ireland* (as in note 5), cat. 48, cover illustration.

140. For example, all the brooches cited in note 119, with the exception of the Westness brooch, which has a solid "gap" area like that on the "Tara" brooch.

141. Perhaps also relevant to the argument is the larg-

est brooch from the Ardagh hoard, which, like the Hunterston brooch, has a raised feature in the centre of a solid "gap" area. The latter is flanked by birds (probably derived from the Early Christian motif of paired birds obtaining spiritual sustenance from the act of eating or drinking). Birds occupy the centre of each terminal. They are ringed on their outer edge by three concentric panelled bands of ornament very reminiscent of the concentric bands of ornament found on Anglo-Saxon disc-brooches. For a good colour illustration of the Ardagh brooch, see *Treasures of Early Irish Art* (as in note 66), cat. 40, or *The Work of Angels* (as in note 69), cat. 76.

142. Margins appear on various pieces of seventh-century Anglo-Saxon metalwork. An example is an early seventh-century mount from Barham, Suffolk, whose marginal birds' heads represent a Germanic version of the more Celtic marginal birds' heads found on the "Tara" and Hunterston brooches; see *Making of England* (as in note 13), cat. 39. Brooches with bird friezes have a long history in Germanic art; see B. Magnus, "Monsters and Birds of Prey: Some Reflections on Form and Style of the Migration Period," in *The Making of Kingdoms: Papers from the Forty-seventh Sachsensymposium, York, September 1996* (Anglo-Saxon Studies in Archaeology and History 10), ed. T. Dickenson and D. Griffiths (Oxford, 1999), 157–60.

143. Their filigree, especially, is more intricate than that found on Anglo-Saxon prototypes; see Whitfield, "Filigree of the Hunterston and 'Tara' Brooches" (as in note 12), 121–22. Further examples of extreme technical sophistication are the black Ultimate La Tène patterns on the reverse of the "Tara" brooch, sometimes seen against a gold, sometimes a silver background; see N. Whitfield, "'Corinthian Bronze' and the 'Tara' Brooch," *Archaeology Ireland* 11:1, no. 39 (Spring 1997), 24–28.

144. For a discussion of the probable prophylactic role of the cross on brooches, see Nieke, "Penannular and Related Brooches" (as in note 63), 132.

145. "Ad-mestar ór asa fhorníamaib allmaraib adamraib." See F. Kelly, *The Audacht Morainn* (Dublin, 1976), 12–13.

146. J. N. Hillgarth, "Ireland and Spain in the Seventh Century," *Peritia* 3 (1984), 9.

147. For example, D. Ó Corráin, L. Breathnach, and A. Breen, "The Laws of the Irish," *Peritia* 3 (1984), 382–438; D. Ó Corráin, "Irish Vernacular Law and the Old Testament," in *Ireland and Christendom* (as in note 24), 284–307; L. Breathnach, *Uraicecht na Ríar: The Poetic Grades in Early Irish Law* (Early Irish Law Series 2) (Dublin, 1987).

148. Ó Corráin, "Irish Vernacular Law" (as in note 147), 284.

"From Ireland Coming": Fine Irish Metalwork from the Medway, Kent, England

•

SUSAN YOUNGS

ABROKEN GILT-BRONZE MOUNT was recovered in 1994 with the aid of a metal detector on farm land at Upper Bush near Cuxton, on the west bank of the river Medway in Kent, close to the modern city of Rochester and not far from where the river flows north into the Thames estuary (Fig. 10).[1] The corroded green metal, broken arm, and hole did not prevent the finder from seeing the remains of fine ornament in the protected areas of the front, and he showed his discovery to a specialist, through whom it eventually reached the British Museum. The finder and his companion were keenly interested to learn more about it and also determined to find the missing arm, which they were certain would still be in the ground. After months of fruitless searching, the companion found the missing element which had been moved down a slope by plough action, and this was also acquired by the British Museum for the national collection.[2] During the last ten years a number of other Irish pieces of this type have been found in England, and the publication of the Cuxton find is an opportunity to list these and to briefly discuss their function and their presence in England "from Ireland coming."[3]

The Cuxton mount is of cast bronze and is roughly cruciform in outline (Fig. 1). Some of the details described below have been recovered from corroded areas by the sharp eye and persistent efforts of James Farrant, Senior Graphics Officer, British Museum, when preparing drawings for this publication (Figs. 2, 3). The short upper arm contains a human face, almost obliterated by corrosion, but a frontal mask is seen on a number of other mounts discussed below.[4] The face is bordered by a curved frame, part of which is missing. The side arms are not true rectangles but expand slightly at the outer ends, while the lower arm has the shape of a pelta, which is emphasized by two spirals flanking a central panel. All the arms and panels have raised borders with the remains of fine diagonal hatching which represent the bodies of four creatures. The centre is filled by the looped frames of the broad side arms which form a loose knot in chip-carved style. At the outer end of the left arm these raised frames cross and terminate in a profile head and a trefoil tail, respectively, which cross and hang pendant within the arm (Fig. 2). Following these borders through the knot at the centre, they can be seen to end in a complementary head and tail at the end of the right arm, so that the head of one animal is on one arm and its tail on the other, with a hatched ribbon-like body in between. Towards the centre of the piece, the two vertical borders of the lower arm run under and over the horizontal frames and end on the left above the mask in a degraded bird's head in profile; this was originally one of a pair meeting beak to beak, a reconstruction based on comparative evidence discussed below.

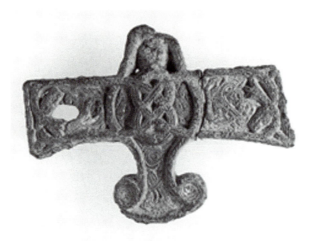

1. Gilt-bronze Irish mount found at Cuxton, Kent. Scale 1:1

Inside the panels created by the raised borders, stylized animals were skilfully fitted into the irregular fields on the casting model (Figs. 2, 3). Flanking the central knot are two small animals in mirror image with slight variation between them, head turned back over the tail which lies along the back, front limb raised. These are finely detailed despite the diminutive scale and show spirals at the limb joints. The left arm of the mount has traces of an interlaced beast; although it is damaged by a large hole, it can be reconstructed in mirror image from detail which survives on the right arm. These animals are much more complex versions of the inner ones. The neck tapers elegantly to form a complete loop before the first hip joint, all four legs are depicted, and a long strand or lappet from the head weaves across the design. Another animal in the same style but with its head in the centre of the design fills the central area of the suspended pelta. These animals are all highly stylized, with broad ribbon-like bodies with hatched decoration inside borders, spirals marking hip joints, large oval eyes, and blunt snouts, but some fine detail has been lost through corrosion. The spirals of the pelta are gently recessed at their centres. The whole of the front surface was originally gilded, but gold survives largely on the recessed surfaces. On the back (Fig. 2) are the remains of three of the four integral lugs that would have been pierced for attachment by means of a cross-pin on the other side of the backing material. The missing fourth lug is indicated by a large hole which suggests that the piece was torn from its backing.

All this decoration is typical of fine Irish metalwork of the eighth or early ninth century, and the larger animals are matched in design and quality, for example, by those on the shrine boss from Steeple Bumpstead in Essex.[5] The crannóg workshop at Moynagh Lough (Co. Meath) has yielded moulds of mid-eighth-century or earlier date for smaller pieces in this style that are very similar to the small mounts from a Viking burial at Gausel, Norway. It is also possible that production was not limited to workshops within Ireland, but that such items were also made by Irish communities elsewhere, principally in Scottish Dál Riata where there is evidence for workshops in the seventh and eighth centuries.[6] The animal style of the panels derives from the chip-carved tradition, but here it is almost two-dimensional. The animal styles, conventions, zoomorphic borders, and face on the Cuxton mount are all drawn from a well-understood repertoire which can be compared to the attributes of other recent English finds (see Table 1). Faces framed by bird

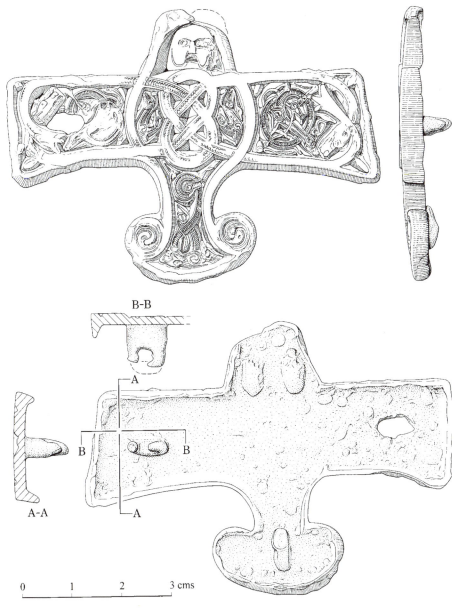

2. The Cuxton mount

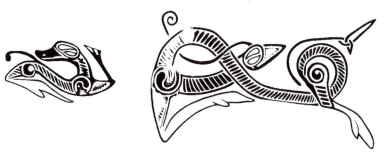
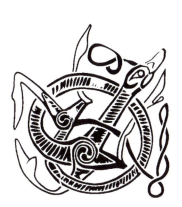

3. Partial reconstruction of animal ornament on the Cuxton mount. Scale 3:1

Table 1. Simple analyses of the characteristics of the Irish "harness" mounts from English find-places listed in the gazetteer below

FIND-PLACE	FORM			FRAMES		PANEL SHAPE				ORNAMENT IN PANELS						SETTINGS	ATTACHMENT			RE-USE
	Asym.	Sym.	Lock.	Plain	Zoom.	Circ.	Semic.	Rect.	Pelta	Face	Interl.	Spir.	Triq.	Trisk.	Zoom.		Lugs	Pin	Rivets	
1. Felmersham	x			?	?	x	x	x			x	?		x				x		x
2. Shilvinghampton		x			x	x		x	x?		?				?		?		x	
3. Markyate		x	x	x				x		x	x				x		x			
4. Cuxton		x			x		x	x	x	x	x	x			x		x			
5. Newtown Linford		x		?		x	x	x	x		x	x		x			x			
6. Ketsby		x		?				x		x	x				x					?
7. North Ormsby		x	x	dec				x		x	x	x					x		x	x
8. Tallington		x		x				x		x	x						?		x	
9. Welton-le-Wold		x		?				x	x	x	x						?			
10. West Rudham		?		x		x	x				x		x	x		x	x			
11. Northampton		x		x		x					x					x	x			
12. Chiswick		x		x		x	x					x		x			x			
13. Wiltshire?		x	x	x		x			x		x					x	x		x	x

asym. = asymmetrical, circ. = circular, dec. = decorated, lock.= interlocking, interl. = interlace, sym. = symmetrical, rect. = rectangular, semic. = semicircular or lunate, spir. = spiral, triq. = triquetra, trisk. = triskeles, zoom. = zoomorphic

heads may originally have had a Christian significance, as on a mount bearing a Crucifixion scene from Hofstad, Norway, but the common usage of the mask motif suggests a more general pro-phylactic function.[7] The centrally looped and knotted frames are found on two bar-shaped mounts from a Navan (Co. Meath) burial group, one of which has a pendant pelta panel and pan-els of crouched animals, while the same device was used twice on a piece excavated at the Jarl-shof, Shetland settlement.[8] Pendant beasts' heads also occur in a slightly more elaborate style on the Hofstad piece and on a mount from Orre, Rogaland, Norway.[9] There are several other exam-ples, and this detail seems to be associated with high-quality design.

The Cuxton fitting can therefore be identified, like the others cited above, as a strap-mount from horse harness and more specifically as a bridle mount. Groups of mounts of this style have been found with iron horse-bits and horse bones in Viking burials in both Ireland and Norway. The most notable of these finds were made at Navan (Co. Meath) and at Gausel, Soma, and Bella in Hordaland, with another set from the ship burial at Oseberg.[10] Individual pieces were depos-ited in other graves in Norway and have been found in Viking contexts on contemporary sites in Scotland and the Scottish islands.

These robust, gilt-bronze castings share several features (see Table 1): some have irregular asymmetrical shapes, for example, cruciform mounts with the arms deliberately set at acute an-gles, chip-carved interlace, panels in raised frames, frames which end in beast heads, and original attachment by deep lugs cast with the panel and pierced at the ends for fixing by a cross-pin. They also show the same range of animal and abstract ornament, which includes interlace, spi-rals, triskeles, and human masks. The dates of the burial contexts and the style of the decoration place the production of these pieces in the eighth or early ninth century. The angles of the projecting arms appear to confirm that the primary function of these mounts was as strap-union covers.

This identification is complicated, however, by another characteristic feature of some of the mounts found both in the groups associated with horse gear and in other sets. They were clearly designed to originally fit against other mounts of circular shape, to judge from the curved rims and a matching pair from the Gausel deposit. Bar-shaped pieces with complementary knobs and recesses were made to interlock like jig-saw puzzle pieces. The most famous examples of the latter bar type are four links deposited in 834 in the richly furnished ship burial at Oseberg.[11] In his study of the remarkable mounts from Crieff, Perthshire, Spearman made the important observa-tion that when the interlocking pieces, in particular the bars which peg together, are so engaged they form rigid assemblies not suitable for use on harness straps or other flexible surfaces.[12] This presents a problem regarding the original purposes for which some of these sets were made and whether some, or all, were made for use on solid surfaces such as boxes or shrines with compos-ite fittings. The applied decorative studs on house-shaped shrines are all attached through the wooden core by pierced lugs of the type found on these mounts. The Lough Kinale book shrine is an interesting variation because, even though it has a complex fixed assembly of the type sug-gested, the separate components were attached by interlocking nailed bindings without lugs be-hind every piece. The interlocking mounts are in effect miniature versions of the complex book shrine with its detached frames and panels.[13]

Should all these mounts be called harness mounts, on the evidence of deposition, or could it be suggested that, parallel with the manufacture of box mounts Irish smiths adapted the

mounts to an expanded market for horse gear, developing the oddly angled pieces as strap-union covers? There is also no doubt about the secondary use of some of these Irish mounts from Scandinavian and British contexts when they have been turned into brooches by the addition of pins and catches. Large holes, secondary rivets, and the removal of the lugs from the back also indicate re-use and adaptation. There is no evidence for such modification on the piece from Cuxton, although it was damaged.

The loss of much of the upper surfaces and of the frame round the head through corrosion does not hide the original subtle quality of the design of the Cuxton mount, particularly when compared to many other mounts of this type. A piece from the Soma group, for example, has the same cruciform shape with pendant pelta, but lacks the fine ornamental detail and is mainly decorated with panels of chip-carved interlace.[14] The detailed treatment of the raised zoomorphic frames contrasts with that on a mount from County Longford, which at first sight looks very similar because of its framed face, but it has plain raised borders and relatively crude detail.[15] The looped beasts of the Cuxton frames are best paralleled by the fishy beasts on the inner panel decoration of one of the Oseberg set of mounts, where the bodies are knotted together in the same way.[16] The detail of the Cuxton panels is finely executed, and they can be reconstructed on the models of other bronze castings with animals in this formulaic style.

The presence in England of this Medway mount, and of the other Irish pieces listed below, is not to be read as an indicator of furnished Viking burials, which are notoriously scarce in England even within the Danelaw. It is better explained as the result of trading and recycling of decorative metalwork in the ninth and tenth centuries. The mount excavated in 1936 from a midden at Jarlshof in Shetland is a good parallel for the find from Welton-le-Wold, Lincolnshire (Fig. 7a, gazetteer no. 9), and also resembles the Cuxton piece, a distribution which vividly illustrates the trading networks and broad horizons of the Danish and Norse communities. It also demonstrates how many highly decorative, semi-precious items, in addition to bullion and silver jewellery, were coming from Ireland in the ninth and tenth centuries. The re-use of offcuts of decorative metalwork of this kind on lead weights which are widely found at sites in Britain, including the Viking period settlement at Llanbedrwrgoch on Anglesey, supports the case for trade as the mechanism of their dispersal after the initial devastation of raids in the ninth century. An Irish mount of the same general type as the Cuxton piece was recovered from the bank of the Thames, above Chiswick Bridge near London (Fig. 9, gazetteer no. 12). It may perhaps have been deposited here under circumstances similar to those of the Cuxton find, and a great hoard of decorative oddments was recovered from the river Blackwater in Armagh and Tyrone with its offcuts and remnants originally en route to markets elsewhere.[17] Other items recovered from the Cuxton site included two Anglo-Scandinavian-style bridle mounts of eleventh-century date, which suggest that it may have been a trading place, if not a horse fair. Without a known archaeological context this must remain speculation.

GAZETTEER BY COUNTY OF IRISH MOUNTS FROM ENGLAND (FIG. 10)

All of the mounts are of cast bronze, and most are gilded, but some are heavily corroded and incomplete. NGR is the National Grid Reference.

4. Bronze Irish
mount found at
Shilvinghampton,
Dorset. Scale 1:1

5. Gilt-bronze Irish mount found near
Newton Linford, Leicestershire.
Scale 1:1

Bedfordshire

1. Felmersham, NGR SP 92 57. Small asymmetrical mount, incomplete, converted to a brooch with a bronze sprung pin. Max. d. 33.5 mm. Bedford Museum, acc. no. 1990/50. Published with drawing: C. Wingfield, *Bedfordshire Archaeology* 19 (1991), fig. 3.2.

Dorset

2. Shilvinghampton area, near Weymouth (Fig. 4), NGR SY 62 84. Symmetrical, may be complete, very poor condition. Max. d. 38.3 × 28.2 mm. Recorded: British Museum. Private collection. Unpublished.

Hertfordshire

3. Markyate, NGR TL 06 16. Bar type, symmetrical form, complete. L. 61.0 mm. Private collection. Published: *Work of Angels* (as in note 10), 118–19, no. 116, with bibliography.

Kent

4. Cuxton (Figs. 1–3), NGR TQ 69 66. Largely complete, description above. British Museum MLA 1995,2-2,1 and 1997,3-4,1.

Leicestershire

5. Newtown Linford (Fig. 5), NGR SK 51 10. Openwork, incomplete. Max. d. 54.5 mm. Private collection. Recorded by Peter Liddle and Richard Knox, Leicester County Museums, M10488.1991.

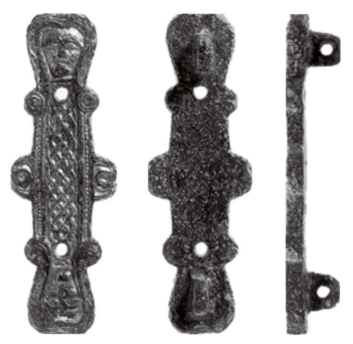

6. Gilt-bronze Irish mount from North
Ormsby, Lincolnshire. Scale 3:2

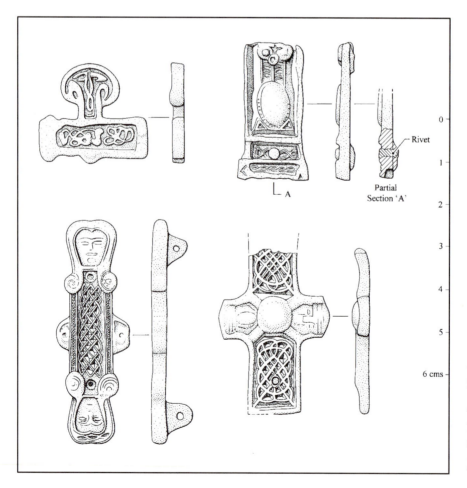

7. Irish mounts found
in Lincolnshire: *(a) top
left:* from Welton-le-
Wold; *(b) top right:* from
Ketsby; *(c) bottom left:*
from North Ormsby;
(d) bottom right: from
Tallington

Lincolnshire

6. Ketsby (Fig. 7b), NGR TF 36 76. Sub-rectangular plaque, incomplete, surface worn. Large animal mask. Two rivet holes with associated iron. 32.0 × 12.1 mm. Recorded by Kevin Leahy, North Lincolnshire Museums.

7. North Ormsby (Figs. 6, 7c), NGR TF 06 94. Bar type, symmetrical form, complete but with surface damage. Elaborate frames, beaded and with interlace. Max. d. 52.3 mm. Lincoln City and County Museum. Recorded by Kevin Leahy, North Lincolnshire Museum. Published: Christie's Antiquities Sale catalogue, 21 April 1999, lot 143.

8. Tallington (Fig. 7d), grid reference not supplied. Cruciform, incomplete. Max. d. 38.9 mm. Private collection. Recorded by Kevin Leahy, North Lincolnshire Museum.

9. Welton-le-Wold (Fig. 7a), NGR TF 27 97. Rectangle with pendant pelta. Possibly complete, very corroded, S-shaped hole. Max. d. 30.0 mm. Less elaborate version of the Jarlshof mount (Hamilton, *Jarlshof, Shetland* [as in note 8], 116, fig. 60), and similar in form but not ornament to a Navan piece (Mahr, *Christian Art* [as in note 4], pl. 33, no. 4). Private collection. Recorded by Kevin Leahy, North Lincolnshire Museum.

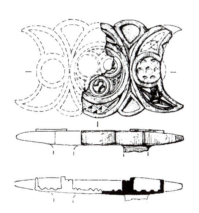

8. Bronze Irish mount from West Rudham, Norfolk. Scale 1:1

Norfolk

10. West Rudham (Fig. 8), NGR TF 81 27. Part (half?) of a shaped bar made from lunate panels and infilling. Remains of a lug. No gilding visible. Max. d. 28.0 mm. Private collection. Recorded: Norwich Castle Museum, Norfolk.

Northamptonshire

11. Northampton, St. Peter's Street (NGR SP 75 61). Circular stud with band of looped interlace, part of integral lug. Diameter 28.0 mm. Excavated find from the palace complex. Published: J. H. Williams, *St. Peter's Street, Northampton: Excavations 1973–1976* (London, 1979), 252, no. 44.

[Overstone, NGR SP 80 66. Heavy bronze casting of a truncated dome, side gilded with six semicircular panels of varied interlace, flat top not gilt, pierced centrally, with four circular collars of residues evenly spaced around the edge. Diameter 18.7 mm. Private collection. Recorded:

MLA British Museum. A decorative stud which is not part of the flat mount tradition but is another example of eighth-century Irish metalwork from this part of the former Danelaw.]

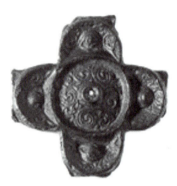

9. Bronze Irish mount from
the river Thames at Chiswick.
Scale 1:1

Chiswick

12. North bank of the river Thames between Chiswick Eyot and Chiswick Bridge (Fig. 9). Cruciform mount with central circular panel and four lobes, all with curvilinear ornament. This has been described as unfinished, but x-ray fluorescence evidence of gilding makes this improbable. Max. d. 50.0 mm. British Museum MLA 1984,11-2,1.

Wiltshire: Find-place Uncertain

13. Broad Hinton School collection. This mount may not have been a local find because there is at least one antiquity from Northern Ireland in the group. Four arms project regularly from a large disc, two arms are recessed for interlocking. Complete. Integral lugs for attachment behind the arms but filed down, and two rivet holes. Diameter of disc 36.0 mm. Displayed in The Museum, Devizes. Published: A. Burchard, "A Dark Age Mount from Broad Hinton School," *Wiltshire Archaeological Magazine* 63 (1968), 105–6, pl. VIIIc.

NOTES

1. National Grid Reference TQ 69 66.

2. Registration numbers MLA 1995,2-2,1 and 1997,3-4,1. It is a pleasure for the British Museum to exhibit this Irish antiquity found in England, particularly since the fine piece from Markyate in Hertfordshire (see gazetteer, no. 3) was sold to a private collection after many years on loan to the museum.

3. My thanks to Colum Hourihane for inviting me to contribute to the conference proceedings, and for his editorial patience. Others have been most helpful and generous with information and illustrations, principally Kevin Leahy of the North Lincolnshire Museum, and Peter Liddle and Richard Knox of Leicester County Museums Service.

4. Mounts with a face are illustrated by A. Mahr, *Christian Art in Ancient Ireland*, vol. 1 (Dublin, 1932), pl. 29, no. 4, pl. 35, nos. 6, 8. The principal discussion of the framed face mask and its symbolism is by C. Bourke, T. Fanning, and N. Whitfield, "An Insular Brooch-Fragment from Norway," *Antiquaries Journal* 68 (1988), 90–98.

5. The details and variations of this animal style and its dating are discussed in N. Whitfield and J. Graham-Campbell, "A Mount with Hiberno-Saxon Chip-carved Animal Ornament from Rerrick, near Dundrennan, Kirkcudbright, Scotland," *Transactions of the Dumfries and Galloway Natural History and Antiquarian Society*, 3rd ser., 68 (1992), 9–27, with a historical overview in N.

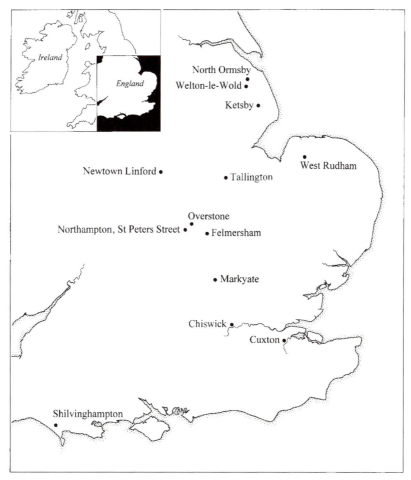

10. Find-places of Irish mounts found in England

Whitfield, "Formal Convention in the Depiction of Animals on Celtic Metalwork," in *From the Isles of the North: Early Medieval Art in Ireland and Britain*, ed. C. Bourke (Belfast, 1995), 89–104. The Steeple Bumpstead boss is illustrated by Whitfield and Graham-Campbell "Mount from Rerrick," fig. 2d; see also S. Youngs "The Steeple Bumpstead Boss," in *The Age of Migrating Ideas: Early Medieval Art in Northern Britain and Ireland*, ed. R. M. Spearman and J. Higgitt (Edinburgh, 1993), 143–50.

6. For Moynagh Lough, see J. Bradley, "Moynagh Lough: An Insular Workshop of the Second Quarter of the Eighth Century," in *Age of Migrating Ideas* (as in note 5), 74–81; for Scottish workshops, E. Campbell and A. Lane, "Celtic and Germanic Interaction in Dalriada: The Seventh-Century Metalworking Site at Dunadd," in *Age of Migrating Ideas* (as in note 5), 52–63, and Whitfield and Graham-Campbell "Mount from Rerrick" (as in note 5).

7. Bourke, Fanning, and Whitfield, "Insular Brooch-Fragment"(as in note 4). The Hofstad plaque is discussed

by E. Wamers, *Insularer Metallschmuck in wikingerzeitlicher Gräbern Nordeuropas* (Neumünster, 1985), cat. 90, pl. 20.

8. The best illustrations of these examples are in Mahr *Christian Art* (as note 4), pl. 33, nos. 4, 7, and pl. 35, no. 12. The Jarlshof mount is published in J. R. C. Hamilton, *Excavations at Jarlshof, Shetland* (Ministry of Works Archaeological Reports 1) (Edinburgh, 1956), 116, fig. 60.

9. Mahr, *Christian Art* (as in note 4), pl. 35, no. 12.

10. *"The Work of Angels": Masterpieces of Celtic Metalwork, Sixth–Ninth Centuries A.D.*, ed. S. Youngs (London, 1989), 116–18, 157–58; Wamers, *Insularer Metallschmuck* (as in note 7), 24, 26, 97, pl. 26.

11. G. Haseloff, "Insular Animal Styles," in *Ireland and Insular Art, A.D. 500–1200*, ed. M. Ryan (Dublin, 1987), 44–55; *Work of Angels* (as in note 10), 157, bottom left. The date of the burial chamber at Oseberg is one of the few fixed points providing a terminus ante quem for artefacts of this period: N. Bonde and A. E. Christensen,

"Dendrochronological Dating of the Viking Age Ship Burials at Oseberg, Gokstad and Tune, Norway," *Antiquity* 67 (1993), 575–83.

12. R. M. Spearman, "The Mounts from Crieff, Perthshire, and Their Wider Context," in *Age of Migrating Ideas* (as in note 5), 135–42, especially 139.

13. E. P. Kelly "The Lough Kinale Book-Shrine," in *Age of Migrating Ideas* (as in note 5), 168–74.

14. *Work of Angels* (as in note 10), 157, lower left.

15. British Museum MLA 1933,11-10,2; Mahr *Christian Art* (as in note 4), pl. 35, no. 8.

16. Haseloff, "Insular Animal Styles" (as in note 11), 52, fig. 11.

17. British Museum MLA 1984,11-2,1; C. Bourke, *Patrick: The Archaeology of a Saint* (Belfast, 1993), 24–38.

An Iconography of Identity?
The Cross-Head from Mayo Abbey

·

JANE HAWKES

INTRODUCTION

U NTIL VERY RECENTLY an Early Christian cross-head stood in the cemetery of the fifteenth-century Mayo Abbey, County Mayo, where it functioned as a somewhat "anony-mous" grave marker (Fig. 1). When exactly it came to serve this purpose is unknown, as no in-scription identifies the grave in question. In the early 1990s, however, its original identity as the head of an Early Christian high cross was recognized, and in 1997 it was removed for safe-keeping.[1]

The site on which the cemetery and the ruins of the abbey stand is well documented and, like other Early Christian monasteries in Ireland, such as Ti Saxon (Co. Galway) and Rath Melsigi (Co. Carlow), is noted for its Anglo-Saxon associations. Having been founded exclusively as an Anglo-Saxon monastery, it is known to posterity as "Muigheo na Sacsan" (Mayo of the Saxons).[2] According to Bede's account of the events surrounding the establishment of this centre, its orig-ins lay in the aftermath of the Synod of Whitby (664) when Colmán of Lindisfarne, along with others who were unwilling to conform to the practices and dogma of the "universal" Church of Rome, "returned to their own people," taking with them "some of the bones" of Aidan, the Iona monk who had founded the Lindisfarne community.[3] Initially "their own people" were to be found at the ecclesiastical centre (mother house) on Iona, but eventually the Lindisfarne "exiles" moved to Inis Bofin (Co. Galway), where they established another monastic house. A dispute soon arose, however, between the "men of English race" (*gente Anglorum viros*) and the "Scotti" be-cause:

> the Irish, in the summer times when the harvest had to be gathered in, left the monas-tery and wandered about, scattering into various places with which they were familiar; then when the winter came, they returned and expected to have a share in the things which the English had provided.[4]

As a result of this dispute, Colmán, along with the thirty "men of English race," left Inis Bofin for the mainland, where he searched "far and near" for a site suitable for a monastery. This he found (ca. 670) at "Mag éo," where he purchased a small tract of land from a member of the local aris-tocracy, and on it constructed a monastery with the assistance of this secular patron. Here he es-tablished the English monks, "leaving the Irishmen in the island."[5]

Concluding his account of this foundation story in circa 731, Bede remarked that, having grown from "small beginnings," the community at Mayo Abbey was "still occupied by English-

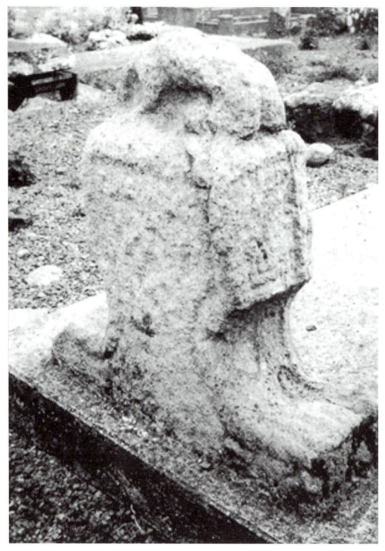

1. Mayo Abbey cross-head as grave marker

men," who had adopted "a better Rule" and lived "in great devotion and austerity . . . supporting themselves by the labour of their own hands." In so doing they continued to attract others from England to join their community.[6] In fact, by the time Bede was recording his account of Mayo Abbey, the monastery had not simply grown in size from its "small beginnings," it had become the seat of an episcopal see. Garaalt, the first abbot named in the annals (with his death recorded in 732), is referred to as "Bishop of Mayo of the Saxons" (*Pontifex Maighe Heu Saxonum*). The same title is accorded Hadwine (Hibernicized in the annals as Aedán), who ruled circa 768–73, and to his successor, Leudfrith (d. 786), who received correspondence from Alcuin, schoolmaster of York and abbot of Tours (from 781), after the abbey was burned in 782. Moreover, by the eighth century (and despite the original inspiration for its foundation) the monastery seems to have been organized in "the Roman manner." Bede's approval of the centre implies that he regarded it in this light, as does his elucidation of the "better Rule" as involving the canonical election of

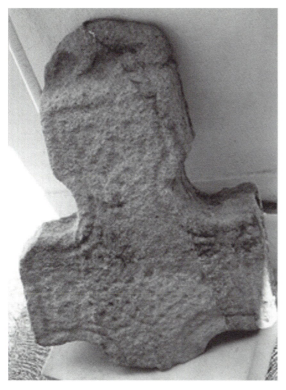

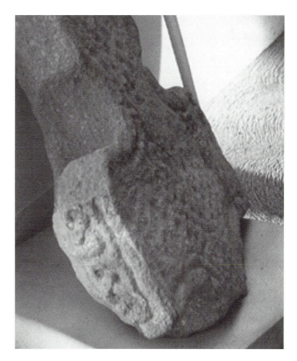

2. Mayo Abbey cross-head, main face decorated with interlace

3. Mayo Abbey cross-head, end of cross-arm decorated with interlace

the abbot; this assumption is confirmed by Alcuin's correspondence, both to Leudfrith and, subsequently, to the "beloved fathers in Christ of the church of Mayo." Certainly, by the end of the eighth century Mayo was under the jurisdiction of the metropolitan of York: in 786 Eanbald, the archbishop of York, with the assistance of Tiberht (bishop of Hexham) and Hygebald (bishop of Lindisfarne), consecrated Ealdwulf bishop of Mayo at Corbridge (Northumberland).[7]

THE CROSS-HEAD

The Early Christian cross-head preserved at this site is cut from a single piece of red-yellow sandstone in the form of a free-armed Anglian type (A10),[8] consisting of block-ended arms with circular armpits, and is surmounted by a leonine creature carved in the round (Figs. 1, 2). This beast crouches with its hind legs tucked under its body, and its head lying between its extended front legs. The main faces and the ends of the cross-arms are decorated, and the carving is contained within plain, narrow, rounded moldings. The stone is badly weathered, and many of the details of the carved decoration cannot be discerned. Nevertheless, it is still apparent that the ends of the cross-arms were filled with panels of wide-stranded, loosely knotted interlace, while one of the main faces was filled with a single panel of tightly knotted, thin-stranded interlace. The damage is such that the type of interlace cannot be easily determined (Figs. 2, 3).[9]

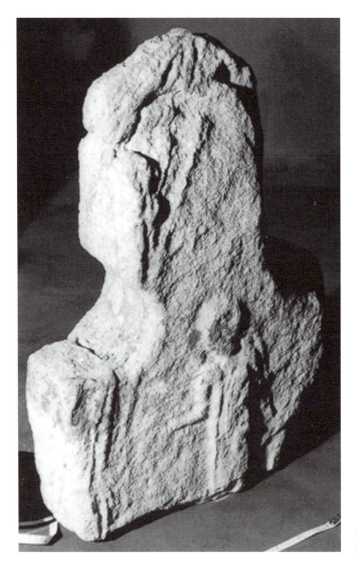

4. Mayo Abbey cross-head, main face decorated with standing figure

The other main face of the cross-head was finely dressed but undecorated except for a small figure set at the centre. This figure, somewhat naïvely presented, looks forwards. The head, a well-defined circular shape with a pointed chin and indentations for the eyes still discernible, is set on slightly raised (hunched), rounded shoulders. The body is clothed in a plain, full-length robe with a "windswept" length of drapery that emerges from the line of the rounded left shoulder and falls as two folds down the full length of the body (following the line of the upper arm) to terminate in a point that turns upwards.[10] The exact positions of both the figure's arms are not clear: the upper arms are held at the sides, and the lower right arm is visible, bent at the elbow and held out at right angles to the body at waist height. The lower left arm, however, is obscured by the weathering of the stone; visible only in certain lights, it appears to extend from the body at waist height, but is longer than the right arm. The feet probably turn outwards, but again this detail is not certain due to the break in the stone at this point (Fig. 4).

QUESTIONS OF FORM, STYLE, AND ICONOGRAPHY

The combination of this particular type of cross-head and the decorative motifs on it make it unique among the surviving corpus of Early Christian carved monuments in Ireland and indeed elsewhere in the Insular world, although its various elements are in evidence separately throughout the region.[11] The A10 type of free-armed cross-head is common in Anglo-Saxon England, particularly in the north in the eighth and first half of the ninth centuries, but in Ireland it seems to be extremely rare, surviving elsewhere only at Inishcealtra (Co. Clare). In Scotland it is also an unusual phenomenon, with the Anglian cross at Ruthwell (Dumfriesshire) providing one of the few extant examples.[12]

The use of fine, tightly knotted interlace to fill the main face of a stone cross-head is not unknown in Insular contexts, although it generally occurs in discrete panels decorating the shaft of the cross. However, among the cross-heads which have interlace contained within thin, plain moldings decorating the main face, there are apparently no other examples with the field of interlace arranged as a single panel uninterrupted by a central motif, such as a large boss. The fine knots of interlace filling the head of the ninth-century cross at Irton (Cumbria), for instance, are interrupted by a circular frame filled with five bosses, while the knotwork decorating both sides of the fragmentary cross-head at Downpatrick (Co. Down) surrounds large circular features at the centre of the transom. The very worn cross-head of the East Cross at Inishcealtra, which was once filled with interlace, does not feature a central motif, but here the interlace itself is organized in a series of five circles rather than filling the field as a single panel.[13]

Furthermore, although a figure set at the centre of a cross-head is a feature seen on both Irish and Anglo-Saxon monuments, it is unusual to find it standing isolated in the cross-head with no accompanying figures, ornament, or frame. When figures are set against a large area of undecorated stone at the centre of a transom, they usually (although not exclusively) depict Christ crucified. Thus the tenth-century fragments from Great Ayton (Cleveland) show the remains of a crucified figure with its arms outstretched, isolated against the plain field of the cross-head, while the broken cross-heads from Durrow (Co. Offaly) and Monasterboice (Co. Louth, now in the National Museum, Dublin) show a figure with extended arms against an undecorated background, similarly unaccompanied by other figures, but with interlace and curvilinear patterns filling the terminals of the cross arms. The cross-head from Balsitric (Co. Meath) surrounds the figure with a rounded molding forming an elaborately shaped crucifix. Those from Teaglach Éinne (Co. Galway), Colp (Co. Meath), and Monasterboice depict similar figures against plain backgrounds at the centre of the cross-head, but they are accompanied by Stephaton and Longinus.[14] In all these instances of a centrally placed figure set against a plain background, that figure (whether accompanied or unaccompanied) stands with its arms outstretched at shoulder height, as is normal in the iconography of the Crucifixion in both Insular and early medieval art in general, so that they extend into the horizontal arms of the cross-head. They are thus clearly intended to depict Christ crucified.

Exceptions to this general portrayal of the crucified Christ do exist at Castledermot and Moone (Co. Kildare), Kells (Co. Meath), and Ullard (Co. Kilkenny), where the arms of the crucified figure appear to extend at right angles from waist height. Yet even in these instances the arms occupy the horizontal arms of the cross-head, and the figure of Christ crucified is accompa-

nied by Stephaton and Longinus bearing the sponge and spear as well as by a series of figural scenes that fill the terminals of the cross-arms.[15] In contrast, the Mayo Abbey figure is so small in relation to the dimensions of the cross-head that its outstretched limb(s) do not fill the arms of the cross-head nor is it accompanied by other figures or carved decorative features. Thus, while the placement of the figure on the cross-head in relation to the arms of the cross may have dictated the positioning of the crucified's limbs at Castledermot, Moone, Kells, and Ullard, such considerations were clearly not relevant to the depiction of the figure at Mayo Abbey. So, viewed as a whole, the form of the Mayo Abbey cross-head, along with the interlace and figure decorating it, distinguish it quite dramatically within the context of Insular sculpture.

The apparently plain background of the figured side of the cross-head is a feature of Insular high crosses that, although associated with figural decoration, is more usually coupled with symbolic geometric motifs set at the centre of the transom. An early eighth-century piece from Hexham (Northumberland), for example, features a floriated cross motif at the centre of an otherwise plain cross-head, while the two composite monuments at Clogher (Co. Tyrone) show a large interlaced boss and a lozenge formed from the bodies of pairs of interlacing birds at the centre of the heads.[16]

When considering the use of such plain backgrounds in an Insular sculptural context, however, it should be remembered that many of the Anglo-Saxon and Early Christian Scottish monuments were originally covered with gesso and brightly coloured paint, and were sometimes inset with pieces of paste-glass and metal.[17] Although little work has been undertaken on this aspect of the Irish high crosses, the possibility that the Mayo Abbey cross-head was originally painted should not be discounted; certainly the practice of setting stone crosses with insets of another medium was not unknown in Irish examples (and is discussed elsewhere in this volume by Peter Harbison). The broken cross-head from Downpatrick was probably originally set with a large circular feature at its centre, as was the South Cross at Eglish (Co. Armagh).[18] Through the medium of paint, details which are not currently present at Mayo Abbey could originally have been easily visible, and the figure, now apparently isolated, may once have been accompanied by any number of identifying features, such as (subsidiary) figures, a cross, or a mandorla.

In terms of its iconographic detail, the Mayo Abbey piece also has much to distinguish it. The manner in which the figure's arms are apparently extended at waist height is particularly distinctive. In the absence of other identifying features, this pose has a number of possible explanations within the corpus of extant early medieval Christian art: that of the orant, of Christ in the attitude of being crucified, or of Christ with his arms extended in blessing.

If the iconography of the Crucifixion in early medieval art is considered, the manner in which the Mayo Abbey figure's arms are extended might suggest that a Late Antique (possibly eastern Mediterranean) prototype ultimately lies behind the image. As already noted, Christ crucified with his arms extended at waist height is a rare posture in the context of Crucifixion iconography, but beyond the complex narrative scenes of the Irish high crosses, where the pose may in any case have been determined by the shape of the field, it is featured in a series of more "iconic" early Eastern images. The fifth-century wooden doors of the church of Santa Sabina in Rome, carved by Syrian craftsmen, depict Christ and the two thieves standing (the crosses reduced to small blocks extending from their finger-tips) with their arms extended from their bodies at waist height. A sixth-century ampulla from Monza also depicts Christ crucified standing with his arms held at right angles to his waist; the thieves flanking him stand with their hands tied

behind their backs. On another Monza ampulla, the Crucifixion is represented symbolically by the haloed bust of Christ surmounting the cross, but the two thieves accompanying him stand with their arms apparently extended from their waists. In these instances the crosses are again almost invisible.[19]

If, alternatively, the Mayo Abbey figure is considered in the light of the iconography of Christ blessing, the potential sources of influence are less easy to identify, since the attitude is common from the earliest Christian art onwards. It appears in depictions of the eucharistic miracle of Christ Blessing the Loaves and Fishes on Early Christian sarcophagi, as well as in images of Christ extending his hands in blessing to Peter and Paul, and continues to be used in more general donor portraits in tenth-century Ottonian art.[20] The iconography of the orant in Christian art is, of course, even more universal.

Closely related to such general iconographies of prayer and benediction, however, is that of Christ resurrected, particularly in the ninth and tenth centuries. In depictions of Christ appearing after the Resurrection, he is often shown standing with his arms at right angles, extended at waist height, in the attitude of benediction and/or prayer, as, for instance, in the ninth-century Khludov Psalter, now in Moscow, or on a similarly dated Carolingian ivory book cover in Aachen, where he also wears a full-length garment with a length of drapery hanging from his left shoulder.[21]

Although some of the Early Christian (Eastern) images of the Crucifixion, such as that on the seventh-century ampulla from Monza, depict Christ in a full-length robe, it is hard to explain the "windswept" nature of the Mayo Abbey drapery as deriving from such contexts. In Early Christian art generally, Christ crucified is usually depicted wearing a loin cloth; it was only between the fifth and ninth centuries that it was common to portray him in a long robe. This, however, was the tube-like, sleeveless *colobium*, not a voluminous garment with folds of flowing drapery, such as seems to be worn by the Mayo Abbey figure.[22] Some images of the Crucifixion in the Early Christian art of Ireland (such as the cast bronze Crucifixion plaques) do depict Christ wearing a full-length sleeved robe, but in these instances the garments are not characterized by folds of flowing drapery.[23] This detail suggests that the carving has affinities with Christian art produced under Carolingian influence, both in Anglo-Saxon England and on the European mainland. It is a distinctive and characteristic feature of such art, and reveals the Late Antique or Early Christian nature of the models lying ultimately behind many of these works.[24]

Thus, if the details of the Mayo Abbey figure were all dependent on pre-existing iconographic images, the combined use of the standing figure, the distinctive attitude of the arms apparently outstretched at waist height, and the full-length robe with windswept drapery hanging from one shoulder might well suggest an image depicting the resurrected Christ that, although derived from Late Antique types, was probably of a later date.

Apart from the standing figure, the most distinctive feature of the Mayo Abbey cross-head is the leonine creature, carved in the round as a piece with the rest of the cross-head, that crouches on the top of the upper cross-arm with its head between its outstretched front paws. In its attitude this beast is comparable to lions appearing in Insular and Continental metalwork of eighth-century date, for example, the four highly stylized creatures in very high relief that crouch over the spherical surface of the Steeple Bumpstead boss, or the lion crouching at each end of the upper "ridge-pole" of the Enger Reliquary (dated to ca. 780–85).[25] Hence the Mayo Abbey creature can, in all likelihood, be identified as a lion.

In the extant corpus of Insular high crosses in both Britain and Ireland, however, lions crouched in the round over the monument are extremely unusual. The capstones surmounting many of the Irish high crosses, although varied in shape, are not zoomorphic. Furthermore, unlike most of these capstones, the Mayo Abbey creature is not a separately carved piece attached to the cross-head by means of a tenon and mortise. The best sculptural parallels, in fact, are found in the group of mid-eighth-century crosses associated with Iona (Argyll). On the upper arm of the so-called Cross of St. John on Iona itself, two leonine creatures carved in the round stand confronting each other (Fig. 5). These too are carved from the same piece of stone as the upper part of the cross-arm on which they stand. On the closely related cross at Kildalton, on Islay, no creature stands over the cross, but four lions, so deeply undercut that they are almost "free-standing," are set round the central boss of the main face of the cross-head (Fig. 6). Those above and below the boss are crouching and portrayed as though seen from above; their pose is exactly comparable to that of the lion on the top of the Mayo Abbey cross-head, if viewed from above.[26] So similar is this beast to those on the Kildalton cross that it is possible to hypothesize that its inspiration came from the Iona centre responsible for the production of the Islay cross. At Mayo Abbey the creature was transposed, carved in the round, and placed on the upper arm in the manner found in contemporary metalworking traditions and at the top of the Cross of St. John.

QUESTIONS OF ICONOGRAPHIC SIGNIFICANCE

Although the decoration of the Mayo Abbey cross-head is apparently simple—consisting of interlace, a single standing figure, and a single lion—both the figural and interlace ornament present a potentially rich set of iconographic references. Characteristic of interlace, for instance, is the manner in which the individual strands change direction, forming a series of discrete sections. In many of the spaces between these sections it is possible to discern cross shapes. Indeed, it has been argued that the plain interlace (as opposed to the zoomorphic interlace of early Germanic metalwork) which is so characteristic of Early Christian Insular art may have evolved because of the potential for patterns such as crosses inherent in the lay-out of interlacing patterns.[27] Certainly the phenomenon of cross shapes within interlace designs is discernible in the decoration of works of art in most media extant from the Insular world. It is visible in manuscript decoration of the seventh century in the Book of Durrow, in metalwork of the eighth century in the paten from the Derrynaflan hoard (Co. Tipperary), and in sculpture as widely dispersed as the early eighth-century cross at Bewcastle in Cumbria and those dated to the tenth century at Ahenny and Kilkieran (Co. Tipperary), or Drumcliffe (Co. Sligo).[28]

Thus, the panel of interlace filling one of the main faces of the cross-head, although it is extremely weathered, would probably originally have presented the viewer with one or more intricate crosses "hidden" in the spaces between the strands, a feature that could have been highlighted by the addition of colour. On the cross-head, as in any context, the interlace itself can be regarded as having functioned as a positive pattern, while the negative patterns of its background, which are not easy to see, would have demanded that the viewer make a conscious "jump" from one pattern to the other. Both the interlace and the background cross cannot be seen simultaneously. Yet while the "hidden" crosses have to be discovered on a stone cross, the

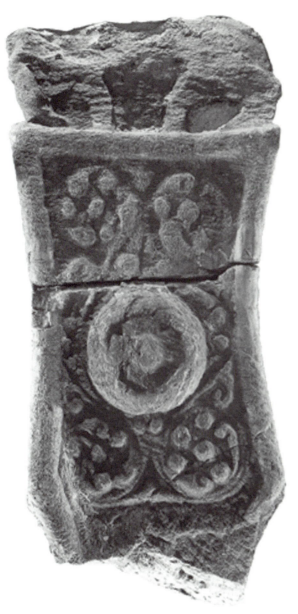

5. Iona, Cross of St. John, detail of lions over upper cross-arm

6. Islay, Kildalton cross, detail of cross-head with lions

overall setting of the monument allows the small-scale crosses within the interlace to function not only as a metaphor of Christ—his death, salvation, and the way of life to be followed by anyone who "bears within him the best of signs"[29]—but also as a commentary on the larger-scale cross on which they are presented. In other words, the symbolic (life-giving) message expressed by the monument-as-cross is also expressed "disguised" in the interlace that fills its head, in a manner that requires meditation to identify and understand it. Through this method of active observation, those viewing the monument participate in an act that both demonstrates, and in the process achieves, the insight necessary for perceiving and understanding the multiple and intricate "signs" of the cross.

More evident perhaps (at least to the modern eye) is another potential iconographic refer-
ence to the Crucifixion, and all that it signifies, on the other side of the cross-head (Fig. 4). The
figure standing at the centre of the field can in all likelihood be identified as Christ, who, as al-
ready noted, is most commonly featured (in a wide variety of iconographic contexts) at the centre
of cross-heads on the high crosses of Britain and Ireland. Admittedly, the iconography of the Cru-
cifixion as it survives in Early Christian art does not seem to have inspired the actual depiction of
the Mayo Abbey figure. Nevertheless, a viewer presented with the figure of Christ standing with
his arms outstretched at the centre of a cross-head cannot (and presumably could not) help but
recall the Crucifixion. The general presentation of Christ with his arms extended is almost uni-
versal in depictions of this central event in Christian art, and in the absence of a (carved) cross
"behind" the figure, the monument itself functions as a rood. Thus, whatever the intended pri-
mary significance of the image, and regardless of the identity of the model underlying it, some
iconographic reference to the Crucifixion can be inferred in the Mayo Abbey figure. Neverthe-
less, because the figure does not obviously hang on a cross and is depicted wearing a full-length
robe with flowing drapery, a reference to the Crucifixion cannot be taken as the sole, or even pri-
mary, iconographic significance of the figure. In fact, as noted above, the clothing and attitude
adopted by the Mayo Abbey figure suggest that, in addition to any implicit references to the Cru-
cifixion, a reference to Christ resurrected may also have been intended.

The expression of such double references (to Crucifixion and Resurrection) through the
portrayal of one figure are, of course, common in the iconography of the Crucifixion. It has long
been established that one of the impulses lying behind the "iconic" depictions of Christ crucified
as standing upright, often with his eyes open, and without an obvious cross (as, for example, at
Santa Sabina or on the Monza ampullae mentioned above) was the desire to express that event as
a theophany: the revelation of the double reality of Christ who dies on the cross as a man, and in
dying, as God, overcomes death. "The significance of the 'living Christ' on the cross . . . is that of
the *Christus victor*," the eternal and exalted Lord.[30] In other words, the iconography of the Cru-
cifixion commonly contains within it reference to the eternally living Christ, who in the act of
dying overcomes death and so proves the possibility of the Resurrection. In such images the
drawn-out series of narrative events that unfold from the moment of the crucifixion itself
(through the death, burial, descent into hell), to culminate eventually in the Resurrection, are vis-
ually compressed into a single moment; the "end" and the "beginning" are made one.

Thus, an image that appears to depict Christ resurrected at the centre of a cross-head in an
attitude that recalls the Crucifixion (as seems to be the case at Mayo Abbey) can probably be un-
derstood to function iconographically in an analogous manner. It can be regarded as portraying
the victorious Christ whose "death" was the means to life everlasting, an eventuality that was proved
possible by his resurrection, and so is the promise of salvation held out to all true believers.

Any references to the Resurrection suggested by the iconography of the Mayo Abbey figure
were probably also extended to include the lion crouched over the cross-head. Literary discus-
sions of lions were common in many texts known to have been circulating in medieval Britain
and Ireland. One of the most popular of these was the *Physiologus*, a collection of animal lore in
which the animal's behaviour was described and explained in terms of its Christian significance.
In these texts the lion was commonly interpreted as symbolic of the resurrection of Christ.[31]

There has been much discussion about the dates at which such texts (in the form in which
they existed by the eleventh century) may have begun to circulate in Anglo-Saxon England and

Early Christian Ireland, but regardless of such considerations, it does seem that the ideas and definitions articulated in the *Physiologus* were in existence in the Insular world in a number of disparate texts from a very early date.[32] Having their origins in the literature of Late Antiquity, these ideas inform the exegetical texts of the holy fathers from the second century onwards, and through this medium influenced the work of Anglo-Saxon and Hiberno-Latin writers.[33] In this vast literary corpus the notion of the lion as symbolic of the resurrection of Christ is well established and, moreover, encompasses a matrix of ideas involving the duality of Christ's nature, divine power, resurrection, and rebirth (often through baptism, which in itself was construed as a re-enactment of the descent into death and rebirth into life).[34] Thus, as Gregory the Great outlined in his Homily on Ezekiel:

> The only-born Son of God was himself truly made man, and himself considered it worthy to die . . . for our redemption, and himself rose up as a lion by virtue of his strength. The lion is also said to sleep with its eyes open; thus, in the same death in which through his humanity our Redeemer was able to sleep, he was awake through being infused with his immortal divinity.[35]

Regarded in this manner, the Mayo Abbey lion functions iconographically as a fitting apogee to the ideas surrounding the death and resurrection of Christ expressed below on the main faces of the cross-head, in the interlace patterns, and in the figure of Christ himself.

Thus the iconography of this monument, fragmentary though it is, presents a potentially rich set of references to the central tenets of Christianity. Through the shape of the cross itself, as well as the figure of Christ displayed on it, the salvation made available to all Christians through the Crucifixion is conveyed. Through the image of Christ and the lion surmounting the cross, that theme is extended to include the fulfillment of that salvation in the promised resurrection from the dead, with the concomitant life everlasting promised to the faithful of the Christian community. It is an orthodox and canonical iconography, but one that is complex in the multivalence of its presentation and furthermore indicates the presence of a learned and esoteric cultural milieu that was responsible for its production.

QUESTIONS OF IDENTITY

Consideration of the cultural context of the carving raises questions concerning the identity of that milieu and the not unrelated question of the date of the monument. As outlined above, the cross-head has certain affinities to the Iona crosses, particularly in the placing of a lion over the upper cross-arm, and those monuments are dated to the middle of the eighth century. In its Anglian form (type A10) it is also related to the Northumbrian world of the eighth and first half of the ninth centuries, while the iconographic details of the figure of Christ suggest access to Christian art produced in the later eighth and ninth centuries. Taken together, these factors suggest that the monument to which this cross-head belonged was probably produced in the late eighth or first part of the ninth century. A date later in that century would remove it too far from the Iona crosses to which it seems to be so closely linked.

Despite the similarities the cross-head displays with the carved stone monuments of Anglo-Saxon England and Iona, it does have its differences with the sculpture of those regions, such as

the overall design of the main panels containing the interlace and the standing figure. These imply that the cross was produced at a centre that had close links with continental Europe as well as the Insular world, in other words, with early Carolingian Gaul as well as Iona and Northumbria. Such contacts would certainly not be at odds with what is known of the cultural milieu of Mayo Abbey itself at the end of the eighth century. By that time, with its foundation as part of the Iona community over a century old, it was an episcopal centre in its own right, with its members and bishop receiving correspondence from Alcuin (at Tours) and at least one of its bishops being consecrated by the archbishop of York.

In fact, against this background it is possible to hypothesize that an elaborate monumental stone cross erected at Mayo Abbey in the later eighth or early ninth century was part of the re-establishment of the centre after it was burned in 782. It was as a result of this event that Alciun saw fit to address the spiritual needs of the community (as he did more famously at Lindisfarne a few years later), and, significantly, it is only after this date that the annals record the consecration of a Mayo bishop (Ealdwulf) by the archbishop of York. Certainly the so-called Cross of the Scriptures at Clonmacnois (Co. Offaly) indicates that high crosses could serve this purpose at a somewhat later date in Ireland, while in Anglo-Saxon Northumbria these large-scale public stone monuments were often used as markers of high status and self-conscious association with "Rome" in the late eighth and early ninth centuries.[36]

Regardless of such speculation, it does seem that the cross-head "discovered" in the cemetery at Mayo Abbey was part of a high cross made for the episcopal monastic centre at that site in the later eighth or the first part of the ninth century. Given its use of features that, combined as they are on the cross-head, are unusual anywhere in an Insular context, it is also possible that the cross was intended to express factors over and above the "iconographic." It seems that in designing this particular monument certain key motifs were consciously selected as "signs" of the cultural identity of the Mayo community. Its original links with Iona, the centre of the Columban network of which it was historically a part, are expressed through the lion set over the cross-head. Relations with Anglo-Saxon Northumbria that were both historic (in the Lindisfarne origins of the founding monks) and "renewed" (in the association of the centre with the metropolitan of York, which by the end of the eighth century also included Lindisfarne) are expressed in the distinctive form of the cross-head.[37] The wider Insular context of the Mayo Abbey community is signified by the single panel of interlace set so prominently at the head of the monument, while its links with the larger fellowship of the Christian (European) world are denoted in the single standing figure set at the centre of the cross-head. The form and decoration of this piece do not simply promulgate the tenets of the Christian faith observed by the Mayo Abbey community. They also establish permanently (in stone) the cultural context of that faith in its particular situation at Mag nÉo in a very public and highly visible manner.

ACKNOWLEDGMENTS

Thanks are due to Carmel Joyce and the Mayo Abbey FÁS Heritage Project; to Princeton University's Index of Christian Art for open access to their wealth of comparative material; and to Ian Fisher, Aidan MacDonald, Jennifer O'Reilly, Michael Ryan, John Sheehan, and Sue Youngs for advice, help, and critical comments made during the preparation of this paper.

NOTES

1. The nature of the cross-head was initially recognized by Ian Fisher of the Royal Commission of Ancient and Historical Monuments of Scotland, and the piece will be discussed in his forthcoming book on the early medieval sculpture of the Western Highlands. Its removal, for safe-keeping, was organized by the Mayo Abbey FÁS Heritage Project. For previous discussion, see J. Hawkes with C. Joyce and S. Goldrick, "Mayo of the Saxons: An Introduction to Its History and Archaeology," in *South Central Mayo* (Irish Association for Quaternary Studies Field Guide 22), ed. K. Barton and K. Molloy (Dublin, 1998), 32–39. Local tradition, preserved in the Mayo Abbey folklore interviews, records that the site for a family plot in the graveyard was selected (approximately two hundred years ago) on the basis of its relationship to the cross-head. At some point in the last twenty to thirty years the cross-head was lifted and erected over that same family grave (C. Joyce, pers. comm.).

2. *The Annals of Clonmacnoise, Being Annals of Ireland from the Earliest Period to A.D. 1408, Translated into English A.D. 1627 by Conell Mageoghagan*, ed. D. Murphy (Dublin, 1896; repr. Felinfach, 1993), 9.

3. Bede, *Historia ecclesiastica* 5.24, 3.28, in *Bede's Ecclesiastical History of the English People*, ed. B. Colgrave and R. A. B. Mynors (Oxford, 1969), 564–65, 308–9.

4. Bede, *Hist. eccles.* 4.4, ed. Colgrave and Mynors (as in note 3), 346–47.

5. Bede, *Hist. eccles.* 4.4, ed. Colgrave and Mynors (as in note 3), 348–49.

6. Bede, *Hist. eccles.* 4.4, ed. Colgrave and Mynors (as in note 3), 348–49. These events are almost ignored in the Irish annals, although the voyage of Colmán to Inis Bofin with the relics of Aidan in ca. 667 is cited: *The Annals of Ulster: To A.D. 1131*, pt. 1, *Text and Translation*, ed. S. Mac Airt and G. Mac Niocaill (Dublin, 1983), 138–39; cf. *Annals of Clonmacnoise* (as in note 2), 108. For an account of the early history of the site through extant documentary sources, see K. Hughes, "Evidence for Contacts Between the Churches of the Irish and English from the Synod of Whitby to the Viking Age," in *England Before the Conquest: Studies in Primary Sources Presented to Dorothy Whitelock*, ed. P. Clemoes and K. Hughes (Cambridge, 1971), 49–68, esp. 51–53.

7. *Annals of Ulster* (as in note 6), 184–85, 226–27, 238–39; *Annals of Clonmacnoise* (as in note 2) 114, 122, 126; Alcuin, *Epistle* 2, 287, in MGH Epistolae, 4, 19, 446, and Letters 32 and 33 in S. Allott, *Alcuin of York, c. A.D. 732 to 804: His Life and Letters* (York, 1974), 43–45; Bede, *Hist. eccles.* 4.4, ed. Colgrave and Mynors (as in note 3), 348–49; Hughes, "Evidence for Contacts" (as in note 6), 51.

8. The typology used here is that established for An-

glian cross-heads in R. Cramp, *Grammar of Anglo-Saxon Ornament: A General Introduction to the Corpus of Anglo-Saxon Stone Sculpture* (Oxford, 1984), xiv–xvii. The cross-head measures approximately 64 cm from top to bottom (excluding the lion, 70 cm including it), 50 cm across the horizontal arms, and 28 cm across the upper and lower cross-arms (21 cm across the narrowest points of the arms); it is approximately 15 cm thick.

9. According to the classification outlined in Cramp, *Grammar of Anglo-Saxon Ornament* (as in note 8), xxvii–xlv. The difficulties encountered in discerning and identifying the details of this piece are further exacerbated by the conditions in which it is currently stored (see above, note 1).

10. This feature should probably not be identified as a wing. It occurs on only one side of the figure, and rather than rising from the shoulder, as might be expected of a wing, it follows the line of the raised, rounded left shoulder (that is symmetrical with the other shoulder), before "falling" from it.

11. For a survey of the Irish material, see P. Harbison, *The High Crosses of Ireland: An Iconographical and Photographic Survey*, 3 vols. (Bonn, 1992). For the Anglo-Saxon material, see surveys in the first five volumes of the British Academy's *Corpus of Anglo-Saxon Stone Sculpture*: vol. 1, R. Cramp, *County Durham and Northumberland* (London, 1984); vol. 2, R. N. Bailey and R. Cramp, *Cumberland, Westmoreland, and Lancashire-North-of-the-Sands* (London, 1988); vol. 3, J. Lang, *York and Eastern Yorkshire* (London, 1991); vol. 4, D. Tweddle, M. Biddle, and B. Kjølbye-Biddle, *South-East England* (London, 1995); vol. 5, P. Everson and D. Stocker, *Lincolnshire* (London, 1999). For Scotland, see J. R. Allen and J. Anderson, *The Early Christian Monuments of Scotland*, reprint ed., with introduction by I. Henderson (Balgavies, 1993); for Wales, see V. E. Nash-Williams, *The Early Christian Monuments of Wales* (Cardiff, 1950).

12. See Harbison, *High Crosses* (as in note 11), vol. 2, fig. 317, for the West and East Crosses at Inishcealtra. For the Anglo-Saxon examples, see, e.g., the Rothbury cross-head: J. Hawkes, "The Rothbury Cross: An Iconographic Bricolage," *Gesta* 35 (1996), 73–90, fig. 1; for further examples, see surveys in the five volumes of the *Corpus of Anglo-Saxon Sculpture* (as in note 11), and W. G. Collingwood, *Northumbrian Crosses of the Pre-Norman Age* (London, 1927). For a survey of the Scottish monuments, see Allen and Anderson, *Early Christian Monuments* (as in note 11); for Ruthwell, see *The Ruthwell Cross*, ed. B. Cassidy (Princeton, 1992).

13. For Irton, see Bailey and Cramp, *Cumberland* (as in note 11), vol. 2, 115–17, ills. 355, 360; cf. Dewsbury (Yorkshire), where the cross-head was filled with a large boss surrounded by interlace (Collingwood, *Northum-*

brian Crosses [as in note 12], fig. 106; cf. fig. 78, part of a ninth-century cross-head from Thornhill [Yorkshire]). For Downpatrick and Inishcealtra, see Harbison, *High Crosses* (as in note 11), vol. 2, figs. 206–7, 317; see also note 18 below. The County Tipperary (ring-headed) crosses of Ahenny and Kilkieran also have large bosses set in the cross-arms and at the centre of the cross-heads against a background of interlace, but in these cases the whole is surrounded by wide frames of cable molding; cf. the ring-headed cross from Drumgooland (Co. Down), now at Castlewellan, where the frames are wide, albeit plain and flat. Elsewhere, at Bealin (Co. Westmeath) and Teaglach Éinne (Co. Galway) interlace fills one side of the (ringed) cross-heads, but these patterns are not strictly comparable, being composed of extremely loose knots (Harbison, *High Crosses* [as in note 11], vol. 2, figs. 9, 19, 72, 233, 235, 391, 392, 427a. See also this survey for panels of thin bands of close interlace set in the shafts of the Irish high crosses).

14. For the Great Ayton fragments, see Collingwood, *Northumbrian Crosses* (as in note 12), 100, fig. 122; for Irish examples, see Harbison, *High Crosses* (as in note 11), vol. 2, figs. 64, 177, 260, 427b, 501, 505; see also fig. 431, a cross-head from Killesher (Co. Fermanagh) now in the County Museum, Enniskillen, where the crucified figure is surmounted by a large boss and has triangular-shaped frames set under his outstretched arms.

15. See Harbison, *High Crosses* (as in note 11), vol. 2, figs. 101, 107, 354, 508, 642.

16. For the Hexham cross, see Cramp, *County Durham* (as in note 11), pl. 172:910–913; J. Hawkes, "Statements in Stone: Anglo-Saxon Sculpture, Whitby and the Christianisation of the North," in *Basic Readings in Anglo-Saxon Archaeology*, ed. C. Karkov (New York, 1999), 403–21, esp. 413–15; cf. cross-heads from Carlisle, in Bailey and Cramp, *Cumberland* (as in note 11), ills. 196, 214. For the Clogher crosses, see Harbison, *High Crosses* (as in note 11), vol. 2, fig. 115; cf. figs. 172, 173, 629, 630, for crosses at Clonmore (Co. Carlow) and Tynan (Co. Armagh). A notable exception to this general "rule" is the fragmentary ninth-century cross-head from Hart (Co. Durham) where the Agnus Dei is centrally placed against a plain, finely dressed field, with the evangelist symbols set in the arms (Cramp, *County Durham* [as in note 11], pl. 82:417). For the symbolic value of the lozenge in Insular art, see J. O'Reilly, "Patristic and Insular Traditions of the Evangelists: Exegesis and Iconography," in *Le isole britanniche e Roma in età romanobarbarica*, ed. A. M. Luiselli Fadda and É. Ó Carragáin (Rome, 1998), 49–94, esp. 77–94.

17. For discussion of this aspect of the early Anglo-Saxon crosses, see, e.g., R. N. Bailey, *England's Earliest Sculptors* (Toronto, 1996), 119–24; J. Hawkes, "Northumbrian Sculpture: Questions of Context," in *Northumbria's Golden Age*, ed. J. Hawkes and S. Mills (Stroud, 1999), 204–15, esp. 213–14; Hawkes, "Statements in

Stone" (as in note 16); eadem, "Reading Stone," in *Theorising Anglo-Saxon Stone Sculpture*, ed. F. Orton and C. Karkov (Kalamazoo, Mich., forthcoming). For the Scottish material, see, e.g., I. Henderson, "The Insular and Continental Context of the St. Andrews Sarcophagus," in *Scotland in Dark Age Europe*, ed. B. Crawford (St. Andrews, 1994), 71–102.

18. For Downpatrick and Eglish, see Harbison, *High Crosses* (as in note 11), vol. 2, figs. 207, 268; cf. fig. 63, a small cross-head from Balsitric (Co. Meath), now in the National Museum, and figs. 77, 79, 215–217, 602, 606, the shafts of the crosses at Boho (Co. Fermanagh), Drumcliffe (Co. Sligo), and the base of the much later (twelfth-century) cross at Tuam (Co. Galway). It should be noted that the Interpretative Centre at Clonmacnois (Co. Offaly) presents the Cross of the Scriptures in its original form, as a brightly painted monument.

19. G. Schiller, *Iconography of Christian Art*, vol. 2 (Gütersloh, 1972), figs. 324–26; cf. fig. 334, a seventh-century metal pectoral cross, now in Augsburg.

20. See Schiller, *Iconography*, vol. 2 (as in note 19), fig. 3, for an example of a sarcophagus image of Christ with Peter and Paul (from Arles, ca. 400), and vol. 1 (1971), figs. 476, 479, 480, for fourth- and fifth-century images of Christ with his hands extended at waist height in miracle scenes. For Ottonian imagery, see, e.g., Christ crowning Otto II and Theophano on an ivory plaque of 972–83 (*Lexikon der Christlichen Ikonographie*, vol. 1 [Freiburg, 1968], pl. III:17). For the iconography of Christ with Peter and Paul, see, e.g., C. Kinder-Carr, "Aspects of the Iconography of St. Peter in Medieval Art of Western Europe to the Early Thirteenth Century" (Ph.D. diss., Case Western Reserve University, 1978); and J. Hawkes, "A Question of Judgement: The Iconic Programme at Sandbach, Cheshire," in *From the Isles of the North: Early Medieval Art in Ireland and Britain*, ed. C. Bourke (Belfast, 1995), 213–20.

21. M. Shchepkina, *Miniatiury Khludovskoi Psaltyri: Grecheskii Illustrirovannyi Kodeks IX Veka* (Moscow, 1977), 82; G. Schiller, *Ikonographie der Christlichen Kunst*, vol. 3 (Gütersloh, 1971), fig. 333; cf. figs 324, 331 (tenth-century Evangelistary of Otto III, from Reichenau; Egbert Evangelistary, from Trier).

22. For surveys, see Schiller, *Iconography*, vol. 2 (as in note 19), 88–117; E. Coatsworth, "The Iconography of the Crucifixion in Pre-Conquest Sculpture in England" (Ph.D. Thesis, University of Durham, 1979).

23. C. Bourke, "The Chronology of Irish Crucifixion Plaques," in *The Age of Migrating Ideas: Early Medieval Art in Northern Britain and Ireland*, ed. M. Spearman and J. Higgitt (Edinburgh, 1993), 175–81, fig. 21:1a–d.

24. See, for instance, the ninth-century panel at Hovingham in Yorkshire (J. Hawkes, "Mary and the Cycle of Resurrection: The Iconography of the Hovingham Panel," in *Age of Migrating Ideas* [as in note 23], 254–60, fig. 31:1; Lang, *York* [as in note 11], 148), and in a Con-

tinental context, the ninth-century ivory "Harrach Diptych" (Schiller, *Iconography*, vol. 1 [as in note 20], fig. 76).

25. For discussion of the Steeple Bumpstead boss, see S. Youngs, "The Steeple Bumpstead Boss," in *Age of Migrating Ideas* (as in note 23), 143–50; for the Enger Reliquary, see J. Hubert, J. Porcher, and W. F. Volbach, *The Carolingian Renaissance* (New York, 1970), 209–13, fig. 193; see also fig. 194, the ninth-century reliquary at Monza, although here the lions do not crouch as they do over the Enger Reliquary. I am grateful to Sue Youngs for reminding me of these artifacts.

26. For the Cross of St. John, see *Argyll: An Inventory of the Monuments*, vol. 4, *Iona* (Edinburgh, 1982), 197–204; for the Kildalton cross, see *Argyll: An Inventory of the Monuments*, vol. 5, *Islay, Jura, Colonsay, and Oronsay* (Edinburgh, 1984), 206–12.

27. G. Adcock, "A Study of the Types of Interlace on Northumbrian Sculpture" (M.Phil. thesis, University of Durham, 1974); eadem, "The Theory of Interlace and Interlace Patterns in Anglian Sculpture," in *Anglo-Saxon and Viking Age Sculpture and Its Context: Papers from the Collingwood Symposium on Insular Sculpture from 800 to 1066* (BAR British Series 49), ed. J. Lang (Oxford, 1978), 333–46; R. B. K. Stevenson, "Aspects of Ambiguity in Crosses and Interlace," *UJA* 44–45 (1981–82), 1–27; J. Hawkes, "Symbolic Lives: The Visual Evidence," in *The Anglo-Saxons from the Migration Period to the Eighth Century: An Ethnographic Perspective*, ed. J. Hines (Woodbridge, 1997), 311–44, esp. 328–34.

28. Discussed elsewhere in this volume by Susanne McNab. See also B. Meehan, *The Book of Durrow: A Medieval Masterpiece at Trinity College, Dublin* (Dublin, 1996), illustrations on 47, 48, 56, 58; M. Ryan, *The Derrynaflan Hoard*, vol. 1, *A Preliminary Account* (Dublin, 1983), pl. 48; Bailey and Cramp, *Cumberland* (as in note 11), ill. 101; Harbison, *High Crosses* (as in note 11), vol. 2, figs. 9, 213, 393.

29. *Dream of the Rood*, line 118 (*þe him . . . in breostum bereð beacna selest*), in *The Dream of the Rood*, ed. M. Swanton, rev. ed. (Exeter, 1987), 99.

30. Schiller, *Iconography*, vol. 2 (as in note 19), 93. See also, in an Insular literary context, the extensive literature on *The Dream of the Rood* (summarized by Swanton in *Dream of the Rood* [as in note 29]), and in an Insular sculptural context, Coatsworth, "Iconography of the Crucifixion" (as in note 22).

31. M. J. Curley, *Physiologus* (Austin, 1979); C. Hicks,

Animals in Early Medieval Art (Edinburgh, 1983), 106–11; J. Hawkes, "Old Testament Heroes: Iconographies of Insular Sculpture," in *The Worm, the Germ, and the Thorn: Pictish and Related Studies Presented to Isabel Henderson*, ed. D. Henry (Balgavies, 1997), 149–58, esp. 155.

32. The *Physiologus* is preserved in Old English in the "Exeter Book"; see *The Old English Physiologus*, ed. A. Squires (Durham, 1988). For a summary of the current discussion surrounding the availability of the *Physiologus*, see C. Neumann de Vegvar, "The Echternach Lion: A Leap of Faith," in *The Insular Tradition*, ed. C. Karkov, M. Ryan, and R. Farrell (New York, 1997), 167–88, esp. 172–73 and note 32.

33. Research on this topic is currently being undertaken by Dr. Jennifer O'Reilly, and I am grateful to her for information on the subject. For the iconographic significances summarized here, see also the more sustained discussion in Neumann de Vegvar, "Echternach Lion" (as in note 32).

34. See, e.g., the articulations of the symbolic nature of the lion in discussions of the evangelist symbols (Irenaeus, *Adversos Haereticos*, 3.xi.8, in PL 7, col. 885; Jerome, *Commentariorum in Ezechielem Prophetam*, i.1, in PL 25, col. 21); and in the nature and liturgy of baptism (Leo, *Sermo 51*, ii, in PL 54, 310; the Bobbio Missal, in *The Bobbio Missal: A Gallican Mass-Book*, ed. E. A. Lowe [London, 1920], 54–59); cf. P. A. Underwood, "The Fountain of Life in Manuscripts of the Gospels," *DOP* 5 (1950), 41–138. For further discussion, see Neumann de Vegvar, "Echternach Lion" (as in note 32).

35. Gregory, *In Hiezechihelem I: Homilia IV*, 1–3, in CCSL 142, 47–49; cf. Neumann de Vegvar, "Echternach Lion" (as in note 32), 175–76.

36. See note 7 above. For Alcuin's letter to the monks at Lindisfarne in 793, see *Epist.* 20 (as in note 7); Letter 26 in Allott, *Alcuin* (as in note 7), 36–38. For summary and bibliography of the Clonmacnois cross, see Harbison, *High Crosses* (as in note 11), vol. 2, 48–53; for the Anglo-Saxon material, see Hawkes, "Statements in Stone" (as in note 16), Hawkes, "Northumbrian Sculpture" (as in note 17), Hawkes, "Reading Stone" (as in note 17), and J. Hawkes, "*Iuxta Morem Romanorum*: Stone and Sculpture in the Style of Rome," in *Anglo-Saxon Style*, ed. C. Karkov and G. Hardin Brown (Kalamazoo, Mich., forthcoming).

37. These historic links are discussed in detail elsewhere in this volume by Niamh Whitfield.

Ornament and Script in Early Medieval
Insular and Continental Manuscripts:
Reasons, Functions, Efficiency

·

EMMANUELLE PIROTTE

IN ILLUMINATED INSULAR Gospel books ornament is everywhere, submitting Christian symbols, the human body, zoomorphic representations, and script to the oddest and most original configurations. In these manuscripts ornament seems omnipotent: it is the king of metamorphoses, the Great Architect of the sacred book. Ornament was obviously one of the most distinctive means by which barbarian peoples could appropriate the book.[1] By infusing their native repertoire of forms into a foreign and alien cultural object—the Gospel book—they made it their own; in other words, they created an aesthetic and conceptual fusion of their own cultural background with the new Christian tradition.

In the British Isles, sooner than in the Frankish kingdoms, the text of the Gospels became the particular focus of paleographical, aesthetic, and structural experiments. The Book of Durrow,[2] the earliest surviving fully illuminated Gospel book produced in the British Isles, already displays an elaborate articulation of texts, iconic images, and ornament, opening the way to generations of deluxe Insular books. The dialectical triad of carpet-page, evangelist page, and incipit page that appears in the Book of Durrow and the Lindisfarne Gospels,[3] or the pairing of evangelist page and incipit page more common in other deluxe Gospel books, functions as a glorious and solemn entry to the divine words. Each type of representation—purely ornamental, iconic, or scriptural—reveals its own mode of visual and symbolic efficiency. I have dealt with the questions of the meaning and function of carpet-pages and figural images elsewhere;[4] my focus in this paper will be on the reasons, functions, and efficiency revealed by the interplay between ornament and script in incipit pages. This will be followed by some observations on the related subject of the principles of letter decoration in Merovingian and Carolingian manuscripts.

The Cathach of Saint Columba, dated to the end of the sixth or the early seventh century, is the oldest preserved Insular example of this interaction between script and ornament.[5] The initials in this manuscript already combine the basic principles of extension and distortion of the letter by ornament. They are charged with a typically "kinetic" energy and are no longer separated from the body of the text, as was always the case in Late Antique manuscripts, but harmoniously merge with it, thanks to the principle of diminuendo. The classical taboo concerning the interpenetration of picture, ornament, and script is of no significance here.[6] On the contrary, it seems that in Insular manuscripts this interaction was needed from the start, and it rapidly became the object of obsessional creative endeavor that gave birth to the most striking images in

later Gospel books such as the Book of Kells[7] and the Gospels of MacRegol.[8] Initial extension, diminuendo, space between words, punctuation marks, small dots surrounding initials or first letters, abbreviations—all of these form a set of devices that Malcolm Parkes has called "the grammar of legibility."[9] This grammar was elaborated by Irish and later Anglo-Saxon scribes confronted with a written foreign language which they did not speak, or which at least was completely alien to their mother tongue. Latin was for them a visual language, a purely graphic mode of expression.[10] It is of particular interest to note that this grammar of legibility was in fact the starting point of aesthetic developments leading to what can be called a "grammar of illegibility" that is dramatically obvious in the monumental incipit pages of the Book of Kells and the Gospels of MacRegol.

The reasons for this paradoxical situation must lie in the contradictory requirements of Latin in Insular societies: Latin was a language that had to be read and understood, but it was also the instrument of faith that inspired, in content and appearance, an infinite quest for truth and meaning. Early Christian culture is haunted by the search for the spiritual meaning that lies in the sacred text of the Bible. Beyond the "killing letter" stands the spirit, the divine truth that is partly accessible to man. Exegetes open the text, creating paths through a constellation of meanings concealed in every word, every name, and even every letter. But exegesis is not confined to verbal discourse: several scholars have demonstrated that iconic images in Insular illuminated Gospel books were also the powerful matrix of exegesis. The "Arrest" scene in the Book of Kells (f. 114), to cite one of the numerous complex images of Insular production, has been the subject of brilliant analyses by Carol Farr,[11] Jennifer O'Reilly,[12] and Éamonn Ó Carrágain.[13] Textual images, particularly ornamented monograms of Christ, function in a parallel way, as was shown by O'Reilly: "the decorative veiling of the sacred text offers a metaphor of the art of spiritual reading to discern the meaning hidden within the literal letter of the fourfold Gospels."[14]

Christian writers of the early Middle Ages considered the act of writing to be a metaphor for Incarnation and Redemption. In his *De orthographia*, Cassiodorus, praising the activity of the scribe, eloquently writes: "a man increases the celestial words, and in a metaphoric sense, what is uttered by the power of the Holy Trinity, is written by three fingers."[15] Isidore of Seville, writing about the pen, compares the ink that flows through it to the blood of Christ, flowing from his side for Redemption.[16] With these strong associations in mind, one cannot doubt that the artistic creativity and the labor required for most of these wonderfully decorated medieval manuscripts had a tremendous theological and mystical dimension. In the British Isles particularly, veneration of the scribe and calligrapher was extremely strong in the early Middle Ages;[17] the poem by Aethelwulf, written during the first quarter of the ninth century, glorifies Ultan the scribe, whose hands, guided by God to ornament the divine words, became relics after Ultan's death.[18] Aethelwulf describes the joy and ecstatic pleasure of artistic creativity with this beautiful phrase: "it is no wonder if a worshipper of the Lord could do such things, when already the Creator Spirit had taken control of his fingers, and had fired his dedicated mind to journey to the stars."[19]

Writing was not considered to be essentially different from painting, as attested, for example, by Aldred of Chester-le-Street's use of the same Anglo-Saxon verb, *awritan*, to describe the activities of copying and illuminating the Gospel displayed by Eadfrith of Lindisfarne.[20] Scribe and illuminator were often one and the same person. Both activities required an absolute and total participation of body and spirit that was considered to be an important act of devotion.[21]

The act of ornamenting letters by extending them visually was probably seen as equivalent to

extending them verbally—to digging through the sacred text, following its windings, and finding unexpected connections, oppositions, or associations. Copying and illuminating the sacred text, an activity that must have frequently been accompanied by reading aloud,[22] was also an incorporation of the word, a *rumination* and digestion relevant to the *lectio divina*, a practice at the heart of monastic life. The archetype or ultimate model for these activities was no doubt the eating of the book by John the Evangelist in Revelation 10:1–11. So we can assume that writing and illuminating, which were closely associated in the British Isles, were both charged with a highly mystical and exegetical value.

Continental artists also endowed the written sign with a high aesthetic quality, but the characteristics of initial or text decoration in Continental manuscripts are not obviously comparable to those displayed in Insular books. Jonathon Alexander has drawn attention to the rigidity of the Merovingian ornamented initial, contrasting with the elasticity and dynamism of the Insular initial.[23] The tremendous power to grow, to distort, and to progressively occupy the entire surface of the page is typical of Insular creations. In the incipit pages of the Book of Kells and the Mac-Regol Gospels (and already in the Durham,[24] Lindisfarne, Lichfield,[25] and St. Gall[26] Gospel books) ornament has become the absolute master of the page; it is given full control over the body of the letter, which has to conform to the whole structure or gestalt that the artist had in mind. These pages have almost completely lost their written aspect—they are figural images, pictures close to carpet-pages. They are no longer meant to be read but to be contemplated, and our eyes have to stare at their intricate surface. Ornament proclaims the sacred nature of the letter by revealing another, unexpected aspect of it and by concealing and even denying its legibility.

The Western world has long forgotten the aesthetic, visual dimension of script,[27] despite numerous attempts to reincarnate the letter since Stéphane Mallarmé and his famous *Coup de dés.*[28] In our logocentric and above all phonocentric mode of thought, script is the transparent, empty means of transferring oral speech.[29] This attitude is firmly rooted in classical antiquity, and the Late Antique books in uncial transmitted to the Irish were most probably eloquent witnesses of it. Insular scribe/artists were the first in the West to give back to script in such a radical way its essential visuality, its autonomy of form, and an existence that does not entirely depend on phonation.

The incipit pages of the most deluxe books and the ornamented text pages of the Book of Kells escape from the tyranny of phonology. There is no regard for the reading process, for example, in the incipits of Luke in the Barberini Gospels (f. 80)[30] and of John in the Book of Kells (f. 292), where the written space is treated as a purely ornamental composition that requires an effort to decipher letters in what looks at first sight to be a tangle of knots and interlaces. The text has become a mysterious weave that celebrates, beyond all words, the central mystery of the Word. These images have an undeniable speculative value: according to Jean-Claude Bonne, they confront the viewer with the question of script and language as proper modes of knowing the Unknowable.[31]

Language and script in Christian thought have both an obscure, negative connotation, and a luminous and sacred aura. Saint Paul was the first to bring discredit to script in favor of the spoken word, the supreme medium of the divine Spirit and Truth.[32] Augustine went further in discriminating the oral language and the written word, and many pages of his *Confessions* are extensive meditations on language as a sign of differentiation.[33] For Augustine, language is the result of the Fall par excellence. It became necessary in order for man to comprehend God after

losing unmediated knowledge of him. Language is bound to temporality;[34] but on the other hand, the Word of God, the creative Logos, is spoken eternally and in silence. Language is for Augustine a painful reminder of his differentiation from God, but also the inevitable means of searching and approaching God. The written language, which was not dissociated from oral speech, suffered the same kind of prejudices.

The breathtaking Insular incipit pages appear as the solutions to, or at least in purely aesthetic terms, the pendant of the crucial problems posed by language in relation to the transcendent Logos. The strongest desire of Christianity was the reunification of sign and meaning which was to happen at the end of time; but that was in the far distant future. Experiments were undertaken by artists to summon the Invisible by means of the visible, or at least to evoke the Invisible in visible forms.[35] The monumental, cryptic Insular incipit pages escape from linearity and therefore from temporality. They seem to open to another dimension where time is suspended and reading is no longer necessary. Their vibrating, shimmering surfaces have a strange taste of eschatological fusion and even offer a glimpse of eternity.

To this point we have examined the theological conceptions that can explain the aesthetic character of script in Insular Gospel books. Their astonishing written images, however, also have an anthropological dimension that extends beyond the purely religious. They show the symptoms of a unique historical phenomenon: the collision between literacy, embodied by Christian culture, and the oral modes of transmission specific to Irish and Anglo-Saxon pre-Christian societies. As Walter Ong, Jack Goody,[36] and others have demonstrated, the passage from an oral or semi-oral tradition to literacy involves "a difficult, and often traumatic reorientation of the human psyche."[37] The suggestion made by Jane Stevenson[38] and Anthony Harvey[39] that the Irish were quite familiar with literacy long before the arrival of Christianity in the fifth century is not fully convincing. Except for the laconic ogam inscriptions on stone, there is no real evidence from the period prior to the seventh century to support these hypotheses.

In his work on the psychoanalysis of art, Jean-Pierre Martinon analyzes the symptoms of schizophrenic art and offers some interesting reflections on the incipit pages of the Book of Kells. He interprets their illegibility and cryptographic character as a symptom of violence, of a murder of the written sign and its indigence of meaning.[40] But to Martinon this paranoid attitude toward the written text is sublimated by the absolute mastery of the image's complex construction. This mistrust or paranoia is rooted in the collective unconscious of many traditional nonliterate societies,[41] even if their primary attitude (on a conscious level) toward literacy is a positive one and even close to fascination.[42]

Oral transmission involves a continual and dynamic evolution and transformation of the original text.[43] The mythological, legal, or epic material conveyed orally is submitted to constant adaptations depending on various factors—type of audience, performer, evolution of mentalities. Knowledge is not fixed once and for all; it transmigrates and is always subjected to reappropriations and reassertions. Even when literacy was firmly established in Insular societies, oral transmission continued to be a vivid and crucial mode of communicating the native and probably the Christian tradition.[44] The dynamic conception of the text therefore probably influenced writing practices.[45] As Edgar Slotkin demonstrated,[46] when Irish medieval scribes transcribed a text which was for the most part known orally, or which was originally created orally, they felt free to change it, to remove parts of it—in other words, to do what a performer would have done orally.

When the text to be copied was rooted in the manuscript tradition, the scribes carefully respected the original.[47]

Of course the sacred text, the words spoken by God himself or inspired by him, were not subjected to change in any way. They were the foundations of knowledge and truth.[48] But what could be transformed was the appearance of the text, what was transmitted graphically. The Irish and, to a lesser extent, the Anglo-Saxon scribes[49] always asserted their freedom in the visual aspect of language, a sovereign freedom of gesture in tracing the curves and extensions of letters. Calligraphy seems never to have been a real constraint for them; it was instead a means of integrating and appropriating the written word, and allowed the most joyful visual fantasies. Therefore, each *in principio* or each sacred Greek monogram of Christ, every minor decorated initial must be considered a unique visual performance, a "happening" celebrating and reasserting the vital and creative virtue of the words of Life and Salvation. Between about 650 and 850, insular scribe/artists created the equivalents, in graphical terms, of the oral performance of texts. In other words, they succeeded in sublimating the archaic paranoia toward the written medium.

This may help us to understand the tremendous aura and sacred value of the book in Insular societies, particularly in Ireland, where the book had the status of an important relic, performing miracles, staying incorruptible in water, or guaranteeing victory in battle. If there is no question of a so-called cult of orality in early medieval Ireland, as Donnchadh Ó Corráin has stated,[50] there existed nevertheless a dialectical relationship between the oral and the written. The aesthetic splendor and the magical dimension of the Gospel book in the British Isles are among the most important witnesses of this fluid interaction. From the seventh century onward the book was no longer alien to the Irish and Anglo-Saxons, but it was still considered to be an object apart, ethnically appropriated and marked, but nevertheless isolated in a transcendent dimension.

Reverence for the book is not restricted to the Insular world, but the situation on the Continent in the early Middle Ages is different from what can be observed in Britain and Ireland.[51] The visual development of the written text appeared much later in the Frankish kingdoms, not before the eighth century.[52] The aesthetics of these texts are more faithful to the classical tradition of decorated initials, and this is not surprising: on the Continent there was no collision between the barbarian preliterate or semiliterate tradition and the classical one. Celtic civilization was eradicated by the fall of the Roman Empire, and the process of Christianization took place in a deeply Romanized territory. The Frankish kings saw themselves as the heirs of the Roman Empire, and Latin never ceased to be a spoken language in the regions west of the Rhine.[53] These factors clearly explain the major characteristics of text ornamentation in Continental manuscripts, which involved a specific attitude toward the written sign.

The Merovingian decorated initial is rigid and stiff; the letter is replaced by zoomorphic figures (mostly birds and fish) and is sometimes filled with abstract ornament. The canonical elementary structure—or body—of the letter dictates its law to the ornamental motifs. Ornament is not the master of script and cannot transform or extend it with complete freedom. The real master of the page is the letter; its form must be readable, its legibility preserved. The text often lies on a neutral, undecorated background.[54] We are not plunged here into an inextricable surface that catches us in its toils and stimulates the quest for something beyond the words that are presented. The overall aspect of the decorated text page lacks the reflective, metallic character of

many Insular incipit pages. We know that Anglo-Saxons were fascinated by the fluctuant, vibrating effects of light on precious objects[55] and that this aesthetic taste resulted in symbolic associations. Aldhelm writes that "nature is more beautiful than golden bosses on a precious brooch";[56] in the riddles of the Exeter Book, the word of God is said to be of "jewelled gold," and his blood is compared to a red gem.[57] In the production of Insular manuscripts, every attempt was made to give the appearance of precious metal to mat surfaces, to parchment. The Merovingians, on the other hand, did not feel the need to transfer onto parchment the luminous and animated aspect of adorned metallic surfaces.

The influence of the Late Antique and Mediterranean repertoire of motifs on the decoration of letters, and the respect for the legibility of the page are so strong that they represented a constraint on Merovingian scribes. Insular influences are often strongly felt in Merovingian book illumination, but what Continental artists retain is essentially the vocabulary of motifs, and less often the principles of extension, contortion, and interlacing of figures. When these principles are applied they look like unskillful reproductions, appropriations of something not clearly understood and certainly not necessary, as, for example, on folio 1r of the *Quaestiones in Heptateuchum* by Augustine, copied in northern France before 750 (Fig. 1).[58] Interlace fills the two verticals of the initial *N* without any possibility of breaking through the outlines. An animal fills the diagonal of the *N*, but the artist did not make use of the natural dynamic impetus of the beast to animate the letter. The decoration that surrounds the initial is not actually linked to it. There is no real interrelationship between script and ornament; instead both exist in a state of co-presence or cohabitation. The initial *Q* is doubled by a rather lifeless quadruped entangled with a lacertine band of interlace. In Insular manuscripts, the first decorated initial of an incipit is almost never doubled, even when it is not clearly intelligible, following the requirement that the incipit page have a cryptic character. But in this case the artist chose to reproduce the *Q* more clearly at the beginning of the text to preserve its legibility and its unity. We can observe here a certain mistrust of the radical fusion of the different fields of expression that is typical of Late Antique manuscripts. Of course the historiated initial which appears in the Corbie Psalter in a very elaborate form is based on a close interaction of letter and picture, but the letter preserves its independence and legibility, forming a sort of frame for the scene or the figures. But historiated letters present complex problems which deserve study on their own.

The interplay between script and ornament is one of the most important phenomena resulting from the merging of barbarian and classical traditions. Nevertheless, the degree of freedom displayed in the ornamentation and distortion of the written signs is dependant on the strength and vitality of the pre-Christian and prehistoric background of the individual barbarian cultures.

The Carolingian Renaissance did not bring a radical change or break in the development of previous Continental aesthetics in the field of text ornamentation. The general fascination with antiquity, and the related cultural policy imposed by the Court School of Charles the Great, did not happen by chance. The special taste for antique scripts, the respect for the legibility and clarity of the written page, and the discrete intermingling of ornamental script in incipit pages displayed in manuscripts from the first half of the ninth century are not alien to previous generations of manuscripts.

The principle of the monumental incipit, where the first initials occupy the entire height of the page, was borrowed by Carolingian artists from the Insular tradition. In an elegant page of the Gospel book of Saint-Martin-des-Champs (Fig. 2)[59] the written space is no longer an ambig-

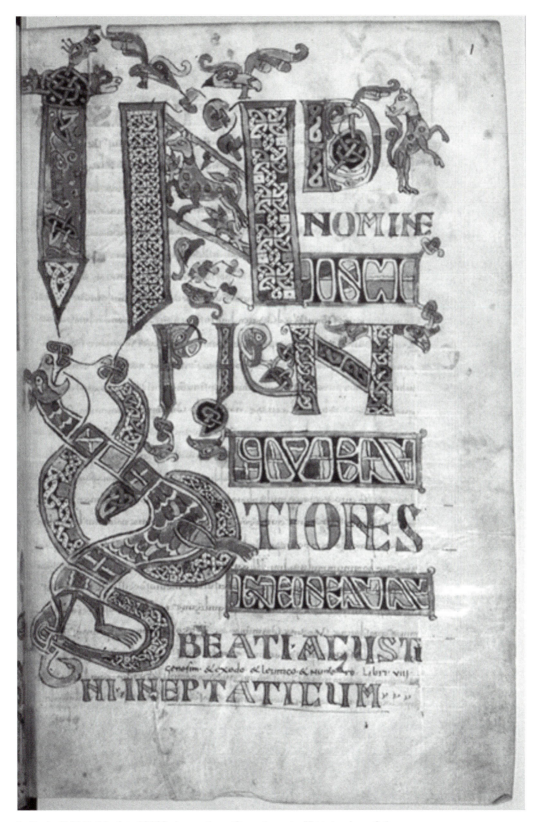

1. Paris, B.N.F., Ms. lat. 12168, Augustine, *Quaestiones in Heptateuchum*, f. 1r

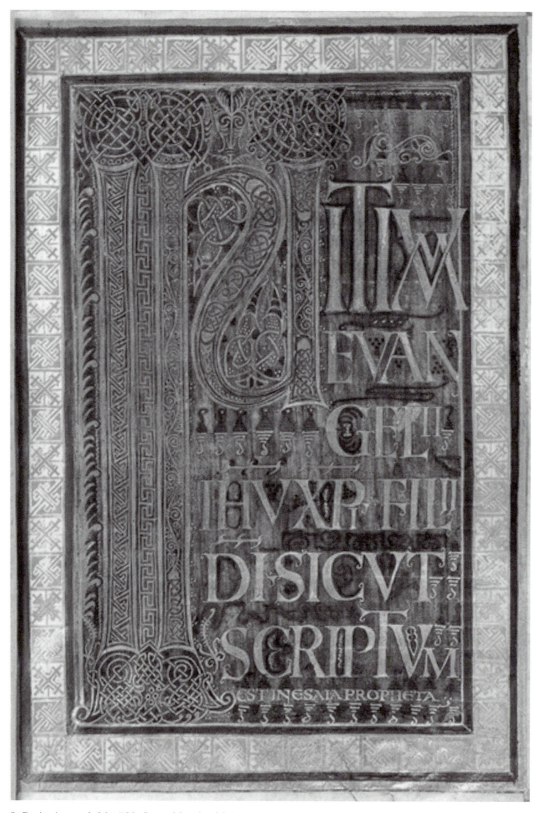

2. Paris, Arsenal, Ms. 599, Gospel book of Saint-Martin-des-Champs, f. 61r

uous and inextricable weave: capital letters stand against a background that does not conceal them nor fuse with them, and the frame is a strict boundary from which the initial is not allowed to escape, as is almost always the case in Insular Gospel books. This folio and others from the first generation of deluxe Carolingian books are magnificent visual celebrations of the divine words; but they are also celebrations of script and writing as the ideal media of expression—knowledge and truth—that give direct and unequivocal access to the message.[60] The Carolingians played an important role in the iconoclastic debate and expressed a real mistrust of pictures, a suspicion that they seem not to have shared with the Irish and Anglo-Saxons.[61] It is no wonder, therefore, if the written page in Carolingian books did not transform itself into an ambiguous cloudiness and mysterious picture as it did in Insular manuscripts: the letter is and must remain a clear sign meant to be understood in only one way.

Around 800, shortly after the redaction of the *Libri Carolini*, in a period when strong arguments were developed on the Continent to restrict the power and status of images, the Book of Kells was created, the ideal and absolute book, one that displays the most radical metamorphoses of script into picture ever attempted in the Christian Middle Ages, and possibly in the entire history of writing.

I have attempted to bring to light some of the religious, linguistic, and broadly socio-cultural aspirations, conceptions, and conscious or unconscious desires that played a role in the visual emphasis of the script in Insular Gospel books. I have also sought to compare the suggestions inspired by Insular products with Continental manuscripts, where a different aesthetic of the written text reveals different concepts of the functions and efficiency of the letter. To do so, it was necessary only to consider the phenomenon of the ornamented letter not as a purely decorative and superfluous device, but as a crucial witness to, or incarnation of, an entire culture's labyrinths of thought.

NOTES

1. On the concept of "appropriation" in art history, see R. S. Nelson, "Appropriation," in *Critical Terms for Art History*, ed. R. S. Nelson and R. Shiff (Chicago and London, 1996), 116–28.

2. Dublin, T.C.L., Ms. 57, dated ca. 660–710.

3. London, B.L., Cotton Ms. Nero D. IV.

4. The subject of this paper is part of my Ph.D. thesis, presented in March 1999 at the Université Libre de Bruxelles and written under the direction of Prof. A. Dierkens, titled "La Chair du Verbe: L'Image, le texte et l'écriture dans les évangéliaires insulaires enluminés (VII–IXème siècles)." On carpet-pages, see E. Pirotte, "Hidden Order, Order Revealed: New Light on Carpet-Pages," in the *Proceedings of the Fourth International Conference on Insular Art*, ed. N. Edwards, S. Young, and M. Redknap (forthcoming).

5. Dublin, Royal Irish Academy, Ms. 12 R.33. C. Nordenfalk, "Before the Book of Durrow," *ActArch* 18 (1947), 141–74; F. Henry, "Les Débuts de la miniature irlandaise," *Gazette des beaux-arts* 92 (1950), 5–34. On the development of Insular calligraphy and the debate concerning the provenance and date of Insular manuscripts, see W. O'Sullivan, "Insular Calligraphy: Current State and Problems," *Peritia* 4 (1984), 346–59. See also D. N. Dumville, *A Paleographer's Review: The Insular System of Scripts in the Early Middle Ages* (Osaka, 1999).

6. O. Pächt, *Book Illumination in the Middle Ages*, trans. K. Davenport (Oxford, 1994), 63.

7. Dublin, T.C.L., Ms. A.I.6 (58).

8. Oxford, Bodl., Ms. Auct. D.2.19.

9. M. B. Parkes, *Pause and Effect: An Introduction to the History of Punctuation in the West* (Aldershot, 1992), 20ff.

10. Parkes, *Pause and Effect* (as in note 9), 24.

11. C. A. Farr, "Textual Structure, Decoration and Interpretive Images in the Book of Kells," in *The Book of Kells: Proceedings of a Conference at Trinity College, Dublin, 6–9 September 1992*, ed. F. O'Mahony (Aldershot, 1994), 437–49. See also C. A. Farr, *The Book of Kells: Its Function and Audience* (London and Toronto, 1997).

12. J. O'Reilly, "The Book of Kells, Folio 114r: A Mystery Revealed Yet Concealed," in *The Age of Migrating Ideas: Early Medieval Art in Northern Britain and Ireland,*

ed. R. M. Spearmann and J. Higgitt (Edinburgh, 1993), 106–14.

13. É. Ó Carrágain, *Traditio Evangeliorum* and *Sustentatio:* The Relevance of Liturgical Ceremonies to the Book of Kells," in *Book of Kells Conference* (as in note 11), 388–437.

14. J. O'Reilly, "Gospel Harmony and the Names of Christ: Insular Images of a Patristic Theme," in *The Bible as a Book: The Manuscript Tradition*, ed. K. Molinari and J. I. Sharpe (London, 1998), 73–88, at 85. See also S. Lewis, "Sacred Calligraphy: The Chi-Rho Page in the Book of Kells," *Traditio* 36 (1980), 139–59.

15. *Grammatici Latini*, vol. 7, *Scriptores de Orthographia*, ed. H. Hagen (Leipzig, 1880), 145: "Verba caelestia multiplicat homo, et quadam significatione contropabile, si fas est dicere, tribus digitis scribitur quod virtus Sanctae Trinitatis effatur."

16. *Etymologies*, ed. Migne, PL 82, col. 241. On the theological value of the act of writing in the early Middle Ages, see P. Zumthor, "Le Livre et l'univers: A propos de manuscrits carolingiens," in *Amor Librorum: Bibliographic and Other Essays. A Tribute to Abraham Horodisch on His Sixtieth Birthday* (Amsterdam, 1958), 29–35.

17. As early as the *Vita Columbae* by Adomnán at the end of the seventh century, a canonical attribute of Irish sanctity is the copying of the sacred Scriptures. On this subject and on the veneration of the book in Ireland, see J. F. Kelly, "Books, Learning, and Sanctity in Early Medieval Ireland," *Thought* 54 (1979), 253–61.

18. *De abbatibus*, ed. and trans. A. Campbell (Oxford, 1967), 21–23.

19. *De abbatibus*, trans. Campbell (as in note 18), 19.

20. *Evangeliorum Quattuor Codex Lindisfarnensis*, ed. T. D. Kendrick, T. J. Brown, R. L. S. Bruce-Mitford, H. Roosenrunge, A. S. C. Ross, E. G. Stanley, and A. E. Werner (Olten and Lausanne, 1960), vol. 2, 4ff.

21. To my knowledge no work has yet been done on the aspect of physical involvement in calligraphy and its mystical dimension in the early Middle Ages. This would considerably improve our understanding of the sociocultural and religious status of the great illuminated Insular Gospel books. On what Roland Barthes called "the corporeal truth of script," see his "Sémiographie d'André Masson," in *L'Obvie et l'obtus* (Paris, 1982), 143. See also "La peinture et l'écriture des signes" (discussion led by R. Barthes with the participation of H. Damisch, J.-C. Bonne, and others) in *La sociologie de l'art et sa vocation interdisciplinaire: L'Oeuvre et l'influence de Pierre Francastel* (Paris, 1976), 171ff. On the technical aspects of medieval calligraphy, see M. Drogin, *Medieval Calligraphy: Its History and Technique* (Montclair, N.J., 1980; repr. New York, 1989). See also T. O'Neill, "Columba the Scribe," in *Studies in the Cult of Saint Columba*, ed. C. Bourke (Dublin, 1997), 69–79.

22. On the links between letter decoration and vocal performance in medieval manuscripts, see M. Camille,

"Seeing and Reading: Some Visual Implications of Literacy and Illiteracy," *Art History* 8 (1985), 26–49.

23. J. J. G. Alexander, *The Decorated Letter* (New York and London, 1978), 8.

24. Durham, Cathedral Library, Ms. A.II.17.

25. Lichfield, Cathedral Library, Ms. I.

26. St. Gall, Stiftsbibl., Cod. 51.

27. A.-M. Christin, *L'Image écrite, ou, la déraison graphique* (Paris, 1995), analyzes the status of script in the Western world and the history of this status from antiquity to the twentieth century, when various attempts were made by writers and poets to break with phonocentrism.

28. S. Mallarmé, *Un Coup de dés jamais n'abolira le hasard, poème* (Paris, 1914). This pioneering text and other writings and experiments by Mallarmé inspired most of the creations in the field of spatialist and concrete poetry. On this subject, see E. Formentelli, "Rêver l'idéogramme: Mallarmé, Segalen, Michaux, Macé," in *Ecritures: Systèmes idéographiques et pratiques expressives. Actes du colloque international de l'Universitè Paris VII, 22, 23 e 24 avril 1980*, ed. A.-M. Christin (Paris, 1982), 209–33. On the affinities between the Mallarméan concept of the book, ideographic systems of writing, and Insular Gospel books, see E. Pirotte, "La Parole est aux images: La Lettre, l'espace et la voix dans les évangéliaires insulaires (VII–IXème siècle)," in *Les Images dans les sociétés médiévales: Pour une histoire comparée. Actes du colloque international*, ed. J.-C. Shmitt and J.-M. Sansterre (*Bulletin de l'Institut Historique Belge de Rome* 69 [1999]), 61–75.

29. Christin, *L'Image écrite* (as in note 27), 11–58; J. Derrida, *De la grammatologie* (Paris, 1967).

30. Rome, Bibl. Vat., Ms. Barb. lat. 570.

31. J.-C. Bonne, "Noeuds d'écriture: Le Fragment de l'évangéliaire de Durham," in *Bild/Text*, ed. S. Dümchen and M. Nerlich (Berlin, 1990), 85–105, at 102.

32. W. H. Kelber, *Tradition orale et écriture* (Lectio Divina 145) (Paris, 1991), chap. 4, "Oralité et textualité chez Paul," 201–57; B. Schneider, "The Meaning of St. Paul's Antithesis: The Letter and the Spirit," *Catholic Biblical Quarterly* 15 (1993), 163–207.

33. Particularly in book 6 of the *Confessions*. On Augustine and language, see J. M. Gellrich, *The Idea of the Book in the Middle Ages: Language Theory, Mythology, and Fiction* (Ithaca and London, 1985), 116ff. See also M. Irvine, *The Making of Textual Culture: "Grammatica" and Literary Theory, 350–1100* (Cambridge, 1994), 184ff.

34. E. Vance, "St. Augustine: Language as Temporality," in *Mimesis: From Mirror to Method, Augustine to Descartes*, ed. J. D. Lyons and S. G. Nichols Jr. (Hanover, N.H., 1982), 20–35.

35. On this concept of Western Christian art as *symptom* of the divine, and for the theoretical approach of medieval visual exegesis, see the brilliant contributions of Georges Didi-Huberman: *Devant l'image: Question posée aux fins d'une histoire de l'art* (Paris, 1990), and "Puissances de la figure: Exégèse et visualité dans l'art

chrétien," in *Encyclopaedia Universalis: Symposium*, vol. 1, *Les Enjeux* (Paris, 1993), 608–21.

36. W. Ong, *The Presence of the Word: Some Prologomena for Cultural and Religious History* (New Haven and London, 1967); idem, *Orality and Literacy: The Technologizing of the Word* (London, 1982; repr. London 1988); J. Goody and I. Watt, "The Consequences of Literacy," in *Literacy in Traditional Societies*, ed. J. Goody (Cambridge, 1969), 27–68.

37. Ong, *Presence of the Word* (as in note 36), 176.

38. J. Stevenson, "The Beginnings of Literacy in Ireland," *PRIA* 89C (1989), 127–65; idem, "Literacy and Orality in Early Ireland," in *Cultural Identity and Cultural Integration: Ireland and Europe in the Early Middle Ages*, ed. D. Edel (Dublin, 1995), 11–22.

39. A. Harvey, "Latin Literacy and Celtic Vernaculars around the Year 500," in *Celtic Languages and Celtic Peoples: Proceedings of the Second American Congress of Celtic Studies Held in Halifax, August 16–19, 1989*, ed. C. J. Byrne, M. Harry, and P. Ó Siadhail (Halifax, 1992), 11–26; idem, "Early Literacy in Ireland: The Evidence from Ogam," *CMCS* 14 (1987), 1–14.

40. J.-P. Martinon, *Les Métamorphoses du désir et l'oeuvre. Le Texte d'Eros; ou, Le corps perdu* (Paris, 1970), 61.

41. On the attitude toward writing in Celtic societies, see G. Dumézil, "Le Vivant et le mort: La tradition druidique et l'écriture," *Revue de l'histoire des religions* 72 (1940), 125–33. See also the more recent paper by T. Duddy, "Derrida and the Druids: Writing, Lore, and Power in Early Celtic Society," *Religion and Literature* 28, nos. 2–3 (1996), 9–20, demonstrating that the resistance to writing in Celtic societies is associated with the maintenance of power and social status. My thanks to Dorothy Verkerk for drawing my attention to this paper.

42. Goody and Watt, "Consequences of Literacy" (as in note 36). On the process of acculturation, see the study of Y. M. Lotman, *Universe of the Mind: A Semiotic Theory of Culture* (London and New York, 1990), 146–47.

43. E. A. Havelock, *The Muse Learns to Write: Reflections on Orality and Literacy from Antiquity to the Present* (New York and London, 1986), 70.

44. M. Richter, *The Formation of the Medieval West: Studies in the Oral Culture of the Barbarians* (Dublin, 1994), chap. 9, "The Celtic Countries," 181ff.

45. On the interpenetration of orality and literacy in the Western medieval manuscript tradition, see P. Dagenais, "That Bothersome Residue: Towards a Theory of the Physical Text," in *Vox Intexta: Orality and Textuality in the Middle Ages*, ed. A. N. Doane and C. B. Pasternack (Madison, Wisc., 1991), 246–59.

46. E. M. Slotkin, "Medieval Irish Scribes and Fixed Texts," *Eigse: A Journal of Irish Studies* 17 (1977–79), 437–50, at 441–450.

47. K. O'Brien O'Keefe has brought to light similar kinds of scribal practices in Anglo-Saxon manuscripts: "Orality in the Developing Text of Caedmon's Hymn," in *Visible Song: Transitional Literacy in Old English Verse* (Cambridge Studies in Anglo-Saxon England 4) (Cambridge, 1990), 23–46.

48. This was particularly true for the Irish school of exegesis, which was still influenced by the Antiochene or literal school of biblical commentary: M. McNamara, "The Irish Tradition in Biblical Exegesis," in *Iohannes Scottus Eriugena: The Bible and Hermeneutics*, ed. G. van Riel, C. Steel, and J. McEvoy (Leuven, 1996), 25–55.

49. The Anglo-Saxons were much more fascinated by Roman and classical types of script than were the Irish, as is attested by the activity of the Wearmouth-Jarrow scriptorium at the end of the seventh and the first quarter of the eighth century: M.B. Parkes, *Scribes, Scripts and Readers: Studies in the Communication, Presentation, and Dissemination of Medieval Texts* (London, 1991), 93–120, chap. 5, "The Scriptorium of Wearmouth-Jarrow."

50. D. Ó Corráin, "The Historical and Cultural Background of the Book of Kells," in *Book of Kells Conference* (as in note 11), 1–32 at 21.

51. The last part of this paper consists of some preliminary reflections and pointed observations on Continental illuminated books and the underlying conceptions regarding the written sign. This is the beginning of a post-doctoral research project consisting of an anthropological comparative study of Insular and Continental deluxe manuscripts.

52. On the activity of scriptoria in Merovingian Gaul, see B. Bischoff, "Die Kölner Nonnenhandschriften und das Skriptorium von Chelles," in *Mittelalterliche Studien: Ausgewählte Aufsätze zur Shriftkunde und Literaturgeschichte*, vol. 1 (Stuttgart, 1966), 16–34; R. McKitterick, "The Scriptoria of Merovingian Gaul," in *Columbanus and Merovingian Monasticism* (BAR International Series 113), ed. H. B. Clarke and M. Brennan (Oxford, 1981), 173–207; D. Ganz, "The Merovingian Library of Corbie," in *Columbanus* (as in this note), 153–72.

53. R. McKitterick, *The Carolingians and the Written Word* (Cambridge, 1989); M. Banniard, *Viva Voce: Communication écrite et communication orale du IVème au IXème siècle en occident latin* (Paris, 1992).

54. These are general characteristics applicable to most Frankish decorated initials created during the eighth century. For illustrations, see F. Zimmermann, *Vorkarolingische Miniaturen* (Berlin, 1916), vol. 2; J. Porcher, J. Hubert, and W. F. Volbach, *L'Europe des invasions* (L'Univers des formes) (Paris, 1967), 165–92.

55. C. R. Dodwell, *Anglo-Saxon Art: A New Perspective* (Manchester, 1982), 27. Precious materials were appreciated for their own sake in the Middle Ages; the shimmering and changing effects of brilliant surfaces—gems, glass, enamel, metal—charged the object adorned (reliquary, liturgical vessel) with a tremendous visual presence and contributed actively to its sacredness and aura. On this subject, see the brilliant paper by J.-C. Bonne,

"L'Image et la matière: La choséité du sacré en Occident," in *Les Images dans les sociétés médiévales* (as in note 28), 77–111.

56. *Adhelmi Opera* (MGH, Auctorum Antiquissimi Morum 15), ed. R. Ehwald (Berlin, 1919), 146.

57. Dodwell, *Anglo-Saxon Art* (as in note 55), 27, 29.

58. Paris, B.N.F., Ms. lat. 12168.

59. Paris, Arsenal, Ms. 599, f. 61r.

60. The literature concerning the attitude of Carolingian theologians to text and image is extensive. Among the many articles and collected volumes devoted to this subject, see *Testo e immagine nell'alto medioevo* (Settimane di studio di Centro italiano di studi sull'alto medioevo 41), 2 vols. (Spoleto, 1994); *Nicée II, 787–1987: Douze siècles d'images religieuses*, ed. F. Boespflug and N. Lossky (Paris, 1987); C. M. Chazelles, "The Cross, the Image, and the Passion in Carolingian Art and Thought" (Ph.D. diss., Yale University, 1985); R. McKitterick, "Text and Image in the Carolingian World," in *The Uses of Literacy in Early Medieval Europe*, ed. R. McKitterick (Cambridge, 1990), 297–318; A. Freeman, "Carolingian Orthodoxy and the Fate of the *Libri Carolini*," *Viator* 16 (1985), 65–108.

61. B. Raw, *Trinity and Incarnation in Anglo-Saxon Art and Thought* (Cambridge, 1997), 62. See also G. Henderson, *Bede and the Visual Arts* (Jarrow Lecture, 1980). Bede defended the didactic and emotive function of religious images in his *De templo*, II (CCSL 119A) (Turnhout, 1969), 212–13. On the other hand, it seems rather difficult, due to the lack of texts, to know anything about the impact of the iconoclastic debate on the Irish Church or, more generally, to have a clear idea of the Irish beliefs concerning the power and status of religious art. A recent paper by N. Delierneux deals with the report by Adomnán in his *De locis sanctis* of three miracles performed by Constantinopolitan icons: "Arculfe, sanctus Episcopus gente Gallus: Une existence historique discutable," *RBPhil* 75 (1997), 911–41. Adomnán's choice of inserting these specific miracles in a work of exegetical nature reveals, according to Delierneux (who supports her conclusion with convincing arguments), a rather positive view of foreign cultural practices.

Goldsmiths' Work in Ireland, 1200–1400

·

RAGHNALL Ó FLOINN

INTRODUCTION

IN 1970, Françoise Henry chose as the terminal date of the third and final volume of her survey of early Irish art the Anglo-Norman "invasion" of Ireland of 1169–70, which she described thus:

> In many ways, the Norman invasion marks in Ireland the end of a world, and certainly the death of original artistic endeavour. For centuries after that, art in Ireland was almost completely dominated by foreign models, and the old fire of invention was nearly always lacking, though the great sense of proportion and the decorative feeling of the old style survived for a long time.[1]

This vision of the cataclysmic effect of the Anglo-Norman incursion on Irish art, although now written almost thirty years ago, is one that has received widespread acceptance, and it is easy to see why. The arrival of colonists from England was seen as a convenient point to fix the end of the political, social, and artistic structures of "Early Christian" Ireland. Advances in historical, archaeological, and art-historical research since the early 1970s have shown that this paints too simplistic a picture. In the case of architecture, for example, the events of 1169–70 did not have an immediate effect: Roger Stalley has shown how Irish Romanesque architecture survived the Anglo-Norman incursions by more than half a century and that Gothic was not introduced into Ireland until around the year 1200.[2]

Many of the developments credited to the Anglo-Normans were in fact already underway for a century or more, including the reform of the Irish Church, the increasing influence of the English Church in Ireland, and the introduction of the reformed orders. All of these were to have an impact on artistic taste and style, craftsmen and their products, and patterns of patronage. A series of urban excavations over the last twenty-five years has revealed substantial evidence of trade between Ireland, western Britain, and north-western Europe well before the close of the twelfth century.

In the case of metalwork, what makes the events of 1169–70 so attractive as an artistic watershed is the apparent absence of Irish metalwork dateable to the period 1150–1350. There is no surviving piece of signed Irish goldsmiths' work which can be dated to the period between the Cross of Cong (made between 1123 and 1136) and the book shrine known as the Domnach Airgid, of ca. 1350. There are some accounts of reliquaries being commissioned by Irish patrons to contain relics of Irish saints in 1162, 1166, and 1170, but none of these survive.[3]

This situation is best paralleled by the case of illuminated manuscripts. Between the Corpus

Missal of ca. 1180 and the great compilations of the late fourteenth century, such as the Book of Ballymote and the Leabhar Breac, no illuminated manuscript in an Irish hand survives. In the late twelfth and thirteenth centuries in particular, such illuminated liturgical works with Irish provenances that do survive are either of English manufacture or are copied from English exemplars.[4] This is in part a direct result of church reforms which required new liturgical texts and vessels that were not part of the traditions or practices of the Irish Church up until then.[5]

This paper is concerned with the evidence in Ireland for the products of the goldsmith in what could be called the early Gothic style between ca. 1200 and ca. 1400. As mentioned above, Gothic as an architectural style was introduced ca. 1200, and it would seem appropriate to fix this as the upper limit of investigation here. Although the term "Gothic" does not sit naturally with the study of Irish medieval metalwork, it is nevertheless applicable in an Irish context because of the seemingly clear break in the later twelfth century between what might variously be called late Insular or Irish Romanesque metalwork, characterized by the group of late eleventh- to early twelfth-century reliquaries (discussed elsewhere in this volume by Peter Harbison) and the mid-fourteenth century when objects, prinicipally reliquaries, dated by inscriptions reappear. Despite their seeming conservatism, many of the latter show in their form or ornamental techniques an awareness of current European trends.[6] The Shrine of St. Lachtin's Arm, for example, dated between 1118 and 1121, is one of the earliest surviving arm reliquaries in the Western Church and was based on Byzantine prototypes, while the reliquary known as the Breac Maedhóg, of the mid-eleventh century, takes its inspiration from contemporary gabled chasses.[7] The Breac Maedhóg is the earliest Irish reliquary to employ rows of standing figures (apostles or saints) set within niches, a feature which was to become common on later medieval Irish reliquaries. The experimental nature of this design is indicated by the fact that on the Breac the niches are formed of interlace and are not truly architectural features. The lower limit of ca. 1400 is set by the surviving objects datable by their inscriptions. These range in date from ca. 1350 (the book shrine known as the Domnach Airgid)[8] to 1418 (the Limerick Mitre and Crozier).[9] There is a noticeable gap thereafter in objects dated by inscriptions until the final decade of the fifteenth century, but these objects, along with the more detailed fifteenth-century records for goldsmiths and their products, lie outside the scope of the present paper.[10]

I define goldsmiths' work in the terms of contemporary statutes governing the craft, as including not only all objects of gold or silver, but in addition ecclesiastical metalwork in base metals which has been gilt.[11] This definition would therefore exclude secular metalwork in copper and lead alloy. Goldsmiths were, however, called upon to mark pieces in other metals, to judge from the payment to a Dublin practitioner of the craft, Walter, who was paid 9d. for marking pewter vessels worth 7s. for the prior of Holy Trinity, Dublin, in 1344.[12]

Not all of the material presented here can be confidently attributed to Irish craftsmen. Some of it, in particular the jewellery, is almost certainly the work of foreign goldsmiths that was imported during the Middle Ages, while in other cases it may be the product of English or other non-Irish craftsmen based in Ireland and commissioned by an Irish client. There is the further complication with medieval jewellery that some of the pieces without provenance in nineteenth-century collections may have been acquired abroad and may therefore have no connection with Ireland.

The study of the fine metalwork of any period is dependent on the material which survives. Unlike architectural sculpture, metalwork is subject to processes of selective survival—silver plate

and other objects in precious metals are more likely to be melted down and recycled. In Ireland the range of surviving metalwork produced by goldsmiths in the early Gothic period is limited and consists principally of objects made for the church. These consist for the most part of repairs and additions to earlier reliquaries associated exclusively with Irish saints and commissioned primarily by Irish patrons. There is also a modest amount of jewellery, principally ring brooches and finger rings. To this may be added the products of the seal-maker. Although specialist craftsmen known as *selers* made seal matrices in a variety of materials (including copper and lead alloys),[13] goldsmiths exclusively produced matrices of silver and gold. No medieval Irish gold seal matrix survives, but a significant number of examples in silver are known. Irish seals of copper alloy, although not certainly goldsmiths' work, will also be mentioned in this discussion. The study of Irish medieval sigillography has been shamefully neglected since the pioneering work of Armstrong in the early years of this century.[14] This is regrettable, as seals offer the best potential means of tracing some of the developments in Irish metalwork from the close of the twelfth century through the end of the Middle Ages, and of comparing these developments with English and Continental tastes. Moreover, seal matrices constitute the only certain products of Irish goldsmiths which can be dated to the thirteenth century.

The known corpus of material has hardly increased from the beginning of the century. Despite the increase in excavations and the use of metal detectors, few pieces of decorated metalwork of the thirteenth and fourteenth centuries have been discovered. This is perhaps itself a testimony to the relatively modest size of the Irish economy compared to that of England or France. A more apt comparison would be to Scotland, where political and social conditions most closely resembled those of Ireland in the later Middle Ages, and it therefore comes as no surprise that there are close similarities in the development of seal design, jewellery, and the decoration of reliquaries in these two countries.[15]

No native secular plate survives from the period, the earliest Irish piece being the Dunvegan cup made in 1493, only a year before the earliest piece of altar plate, the De Burgo-O'Malley chalice.[16] Because the surviving ecclesiastical objects consist primarily of repairs and additions, it is difficult to determine what models were used in the creation of new objects. It would, for example, be interesting to establish the physical appearance of the new shrine made in 1185 to house the bones of Patrick, Brigid, and Columba, whose translation at Downpatrick was organized by John de Courcy, the Anglo-Norman earl of Ulster.[17] These same relics appear to have been again translated and placed in a shrine by the abbot of Armagh in 1293.[18] However, such references to metalwork in the contemporary written sources are few, and indeed reliquaries are rarely mentioned after about 1180. This is perhaps more a reflection of the changing preoccupations of medieval chroniclers than of a real absence of goldsmiths' work during the period. It may also reflect the reforms in the Irish Church, which would not have emphasized relics to the same extent as the church had previously.

IMPORTS

For much of the earlier part of the period under discussion, the surviving metalwork is dominated by imports. I have noted elsewhere that the few pieces of metalwork imported into Ireland in the twelfth century are of English or north German origin.[19] Among the most important of

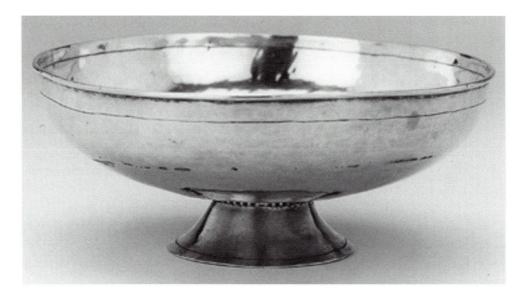

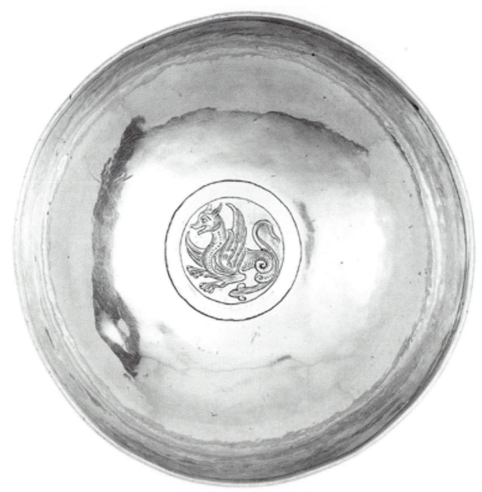

1. Silver bowl, English or German, thirteenth century, found with two others at Taghmon,
County Westmeath. London, British Museum

these is a hoard of two silver drinking bowls dating to the later twelfth century, probably of German or English workmanship, found in a churchyard at Taghmon (Co. Westmeath).[20] A third bowl, now in the British Museum, which is probably of thirteenth-century date, may also be part of the same hoard (Fig. 1).[21] This hoard can now be seen to represent an accumulation of secular drinking vessels of different dates, reminiscent of the much larger hoard from Dune churchyard in southern Sweden which contained silver drinking vessels ranging in date from the twelfth to the mid-fourteenth century.[22] The vessels in the Irish hoard came from a number of sources (England and Germany) and range in date from the later twelfth to the thirteenth century, illustrating the fact that such high-quality tableware was used in Ireland and was preserved for several generations before being buried for safe-keeping. The only other pieces of later twelfth- or thirteenth-century silver plate from Ireland are a chalice and paten from a grave at the Cistercian monastery of Mellifont (Co. Louth).[23] The paten and chalice are of a type commonly found throughout northern Europe and which was likely to have been produced in a number of countries. German influence is certainly evident in the earliest surviving seal matrix of an Irish ecclesiastic, that of an unknown archbishop of Armagh.[24] This shows the figure of an enthroned ecclesiastic and appears to be influenced by contemporary seals from imperial Germany rather than those of England or France, which depict a standing figure.[25]

French imports are dominant in the thirteenth century. The need for new forms of liturgical vessels was served in part by importing products from the Limoges workshops of south-western France. Perhaps the best known is the early thirteenth-century crozier head found in a grave at Cashel (Co. Tipperary) (Fig. 2).[26] Other finds of Limoges enamels with secure Irish provenances (mostly fragments of objects found in churchyards) indicate that a wide variety of liturgical objects was imported, including croziers, crosses, pyxides, censers, and a rare example of an enamelled cruet from Grangewalls (Co. Down).[27] French imports in the fourteenth century include a gilt copper alloy crucifix figure of unknown (but probably Irish) provenance and an ivory leaf of a diptych depicting the Crucifixion, probably from a Parisian workshop, found in Thomas Street, Dublin, both dateable to the middle of the century.[28] The Dublin civic sword, which dates from the end of the fourteenth century, a gift from King Henry IV to the citizens of Dublin, bears silver-gilt mounts with the king's motto, *souereyne*, which were probably made by the king's goldsmith, Herman van Cleve.[29] The traffic was not all in one direction, however. A treatise by Matthew Paris on the rings and gems of St. Albans Abbey contains a sketch of a gold ring set with a sapphire held by four claws given by John, bishop of Ardfert (deposed in 1221);[30] and in 1245 Geoffrey, bishop of Ossory, was given the weight equivalent of fifteen or sixteen shillings "in place of the chalice which the Bishop caused the King to have for the chapel of the castle of Gannock, Evesham."[31]

ORGANIZATION OF THE INDUSTRY

Insofar as we can tell from the limited documentary evidence available, it would appear that by the thirteenth century at the latest, goldsmiths in Ireland, as elsewhere in Europe, worked largely in the towns. This process of concentration in large centres of population is a trend which was already apparent in Ireland in the course of the eleventh and twelfth centuries.[32] By the end of the fourteenth century we have records of goldsmiths being present in Dublin,[33] Limerick,[34] Tipper-

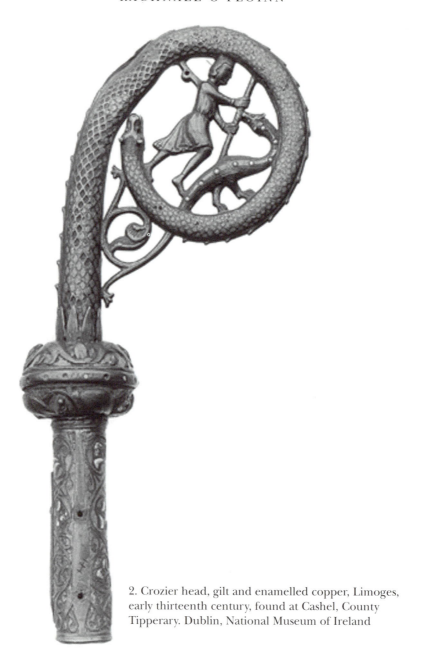

2. Crozier head, gilt and enamelled copper, Limoges,
early thirteenth century, found at Cashel, County
Tipperary. Dublin, National Museum of Ireland

ary(?),[35] Kildare,[36] Kilkenny,[37] Waterford,[38] and Cork.[39] We know most about the situation in the
capital, Dublin. The Dublin goldsmiths received their first charter at an unknown date prior to
its replacement in 1557.[40] Of the goldsmiths' names recorded for Dublin in the thirteenth and
fourteenth centuries, none are certainly Irish, and most appear to be English. Foreign goldsmiths
were present in Dublin from at least the late twelfth century: the Dublin Roll of Names contains
the names of the goldsmiths William of Shrewsbury and Godard of London.[41] In 1299 another
English goldsmith, John de Ely, is mentioned in Dublin, charged in connection with the false as-
saying of foreign money.[42]

The goldsmiths' quarter in Dublin was located in Castle Street, close to the castle and its associated mint. It is in this area, in Christchurch Place, that extensive evidence for fine metalworking of the eleventh and twelfth centuries was uncovered in the 1970s in the course of archaeological investigations of the Hiberno-Norse town.[43] Archaeological evidence for metalworking in Dublin in the succeeding centuries has to date proved disappointing. Excavations at the Cornmarket in Dublin in 1992 uncovered evidence for a thirteenth-century metalworker's workshop, including metalworking debris, a buckle mould, and unfinished pins, rings, buckles, and brooches, all in base metal. This discovery is doubly significant, as bucklers are recorded as being present in the vicinity in later thirteenth-century documents.[44] The archaeological and historical evidence thus suggests that metalsmiths specializing in different products lived in different parts of the medieval town.

There is even less archaeological evidence for metalworking outside the towns. Excavations on the site of the east range of the Augustinian Priory of St. Mary, Devenish (Co. Fermanagh), uncovered a pit used as a furnace for bronze smelting which contained a number of clay moulds, including one for what appears to be a pointed oval mount, perhaps a blank for a seal. A stone mould from the same site bore an incised pointed oval device of a standing figure flanked by foliate sprays and triquetra devices in the manner of a seal matrix and was perhaps used for casting copper- or lead-alloy badges.[45]

We know little of how commissions were made or whether goldsmiths were fixed or itinerant. In some cases it would appear that the objects were brought some distance to the goldsmith. In 1451, for example, the cross of Archbishop Tregury of Dublin had to be brought to Drogheda for repair.[46] Irish sources for goldsmiths and their work are even scarcer, and obits of metalworkers do not occur in the Irish annals before the fifteenth century.[47] It is unclear whether the goldsmith Maurice of Connaught, admitted to the Dublin Gild Merchant in 1257, was Irish or English.[48] In areas under Irish control, there is some evidence for continuity from the pre-1200 period in the way metalworking as a trade was organized. It is likely, for example, that the craft of the metalsmith, as with other professions, continued to be an hereditary one. A common feature of both pre- and post-1200 metalwork inscriptions is that the family names of the craftsmen are unusual. It would appear that the craft was practised by families whose names do not otherwise figure prominently in the written sources. What little is known of them suggests that they appear to have been drawn from a "mandarin class" affiliated to churches who specialized in metalworking from an early date.

Inscriptions on surviving metalwork record the names of craftsmen, all of whom bear Irish names. In about 1350 the abbot of the monastery of Clones (Co. Monaghan), John O'Carbry, commissioned the refurbishment of the Domnach Airgid, a book shrine of the eighth century, and this is signed JOHANES O BARRDAN FABRICAVIT (Fig. 3).[49] The surname O'Bardan is not common. A goldsmith of the same name is recorded a century later as being resident in Drogheda (Co. Louth), and it is possible that the O'Bardans were a family of goldsmiths based in the town for several generations.[50] The reliquary may therefore have been sent from Clones to Drogheda for refurbishment. The Limerick Mitre, made in 1418 for Cornelius O'Dea, bishop of Limerick, is signed THOMAS O CARRYD ARTIFEX.[51] The latter may well have been based in Limerick. The surname O'Carryd is again unusual and is borne by a canon of Limerick cathedral, Malachias Macharrayd, in 1480, perhaps a relative of the craftsman.[52] Irish is more commonly the language of surviving metalwork inscriptions. The Shrine of the Book of Dimma, com-

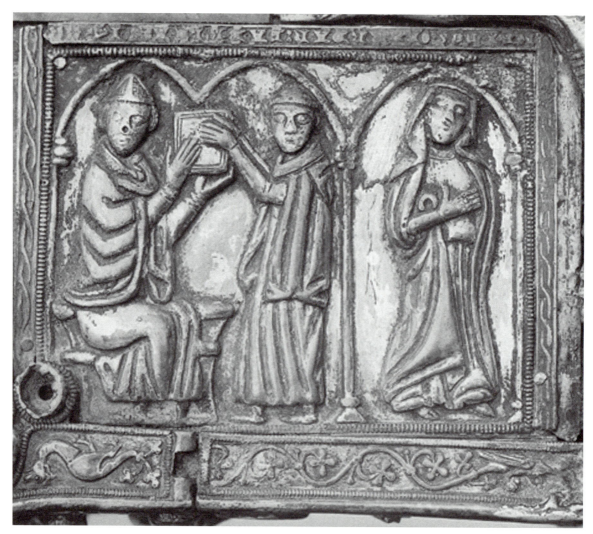

3. Domnach Airgid book shrine, silver gilt with niello, ca. 1350, detail of front showing repoussé figures. Note the inscription with maker's name above, placed upside down. Dublin, National Museum of Ireland

missioned by Tadhg Ó Cearbhaill (O'Carroll), king of Éile (1380–1407) is signed TOMAS CEARD DACHORIG IN MINDSA, that is, "Thomas the goldsmith arranged [repaired?] this reliquary" (Fig. 4).[53] Other signed works include the Shrine of the Stowe Missal (1371–81) with its maker's inscription in Irish, DOMNALL O TOLARI DOCORIG MISI, "Domnall Ó Tolairi arranged [repaired?] me" (Fig. 5).[54] Later Irish medieval sources suggest that metalworkers were employed exclusively for particular patrons and that grades of craftsman were recognized.[55]

JEWELLERY

An examination of medieval jewellery found in Ireland shows that it reflects the evidence of ecclesiastical metalwork, at least insofar as that it too was largely imported from England and

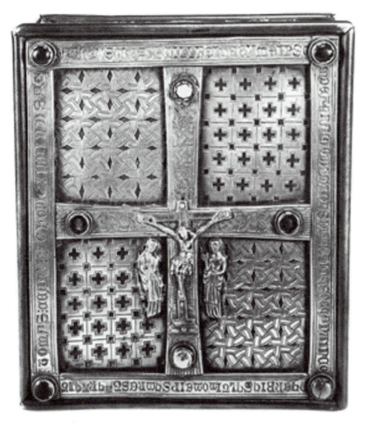

4. Shrine of the Book of Dimma, silver gilt with inset glass and paste, 1380–1407, view of front. Dublin, National Museum of Ireland

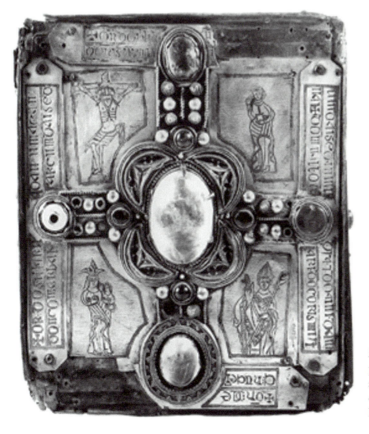

5. Shrine of the Stowe Missal, silver, parcel-gilt with inset rock crystal, glass, semi-precious stones, and translucent enamel, 1371–81, view of front. Dublin, National Museum of Ireland

France in the thirteenth century.[56] It is notoriously difficult to determine where jewellery of the thirteenth and fourteenth centuries was made due to the similarity of types across much of northern Europe. The gold and silver ring brooches and finger rings from Ireland are very much the same as those found elsewhere in northern Europe and are almost certainly all imported, but whether from England, France, or elsewhere it is impossible to tell. There are no pieces of jewellery which bear either an individual's name or an inscription in the Irish language which would suggest Irish manufacture. The exceptional pieces include an early thirteenth-century ring brooch recently excavated in Waterford,[57] decorated with gold filigree and set with gems, and a filigreed gold finger ring from Castletown (Co. Louth) set with an antique intaglio (unpublished, National Museum of Ireland). However, a survey of Irish medieval jewellery shows that its range of products is restricted to ring brooches and finger rings of types that are found in Britain and the Continent and which exhibit little local flavour, that the quantities which survive are small, and that no hoards of medieval jewellery are known.

SEALS

It would be tempting to attribute to the Anglo-Normans the introduction of sealed charters and therefore the concept of seals as authenticators of written documents. A recent survey by Marie Therese Flanagan of the surviving Latin charters in the European tradition from the twelfth century has clearly demonstrated that their use in Ireland occurred independently of, and before, the Anglo-Norman intervention.[58] Surviving charters sealed by Irish kings include one of Muirchertach mac Lochlainn, king of Cenél Eógain and high king of Ireland, dated 1156–57, and another of 1162–65 by Diarmait Mac Murchada, king of Leinster, although the seals attached to these documents are now lost. All the surviving twelfth-century Latin charters were made by or on behalf of churchmen, and Flanagan argues persuasively of these charters that the "context for their introduction was undoubtedly the reform movement . . . which began to have a discernible impact on the Irish Church from no later than 1100."[59] The Ó Brien kings of Thomond were to the forefront of the reform of the Irish Church in the twelfth century, founding monasteries of the reformed Continental orders and building cathedrals. It is not surprising, therefore, that a sealed charter of Domnall Ua Briain, king of Thomond, dated 1168–75, is known, and that the earliest extant seal of an Irish king is that of his son, Donnchadh Cairprech Ó Briain, king of Thomond (1210–41), which shows a variant of the common equestrian seals of secular lords.[60] We have already noted how the Armagh archiepiscopal seal was modelled on German imperial seals, and in this context it is worth noting Flanagan's remark that the writing of an Ó Brien charter dated 1168–85 "bears analogy with contemporary scripts of the papal chancery and of the German imperial chancery."[61] By contrast, the earliest archiepiscopal seal from Dublin is that of Lorcán Ua Tuathail, archbishop of Dublin, attached to a deed dated 1177 and depicting the more standard figure of a standing ecclesiastic.[62] The earliest Anglo-Norman settlers would have brought their seals with them, and these in turn would have influenced the designs of the developing Irish seals.

Most of the extant matrices are alloys of copper or lead. In general they would appear to follow contemporary trends in England, although Irish seals are less elaborate and smaller than their English counterparts. Seals of Irish bishops rarely exceed 6 cm in length, whereas many of

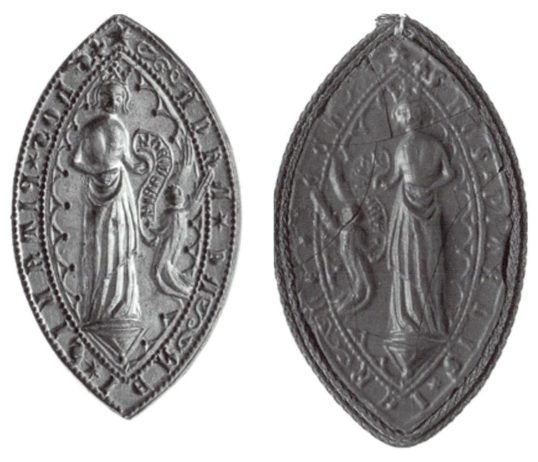

6. Seal matrix of the Hospital of St. John of Jerusalem, Nenagh, County Tipperary, silver, thirteenth century. Dublin, National Museum of Ireland. Scale 2:1

the larger English bishops' seals measure 8 cm or more. It is often difficult to establish whether some seal matrices are of Irish manufacture or were made in England or elsewhere for an Irish client, especially when nothing is known of their history. Two of the earliest silver seals in the collections of the National Museum of Ireland illustrate these problems. The first is unique as being the only extant ecclesiastical matrix of silver.[63] It was purchased in Kingston-on-Thames at the turn of the century. The device shows the Annunciation, with the crowned Virgin in a pose typical of the early thirteenth century, and the angel holding a scroll inscribed AVE MARIA (Fig. 6). The cutting of both figures and letters is exquisite, yet the inscription raises doubts as to whether it is Irish at all. Inscribed + S HOS*PITALIS* IER*NE*NACH, it has been claimed as belonging to the Hospital of St. John of Jerusalem near Nenagh (Co. Tipperary), founded ca. 1200 by Theobald Walter, ancestor of the Butler earls of Ormond.[64] Contemporary records indicate that the hospital was, in fact, dedicated to John the Baptist. Against this, it is worth pointing out that, in Ireland, houses of the Crutched Friars and those of the Knights Hospitallers are sometimes confused in medieval documents, and houses of both were dedicated to John the Baptist.[65] The Nenagh hospital appears to have been founded from Dublin, and the exceptional quality of the seal might be explained if it were cut by an English goldsmith based in Dublin. The second silver

7. Seal matrix of Vivian de Aula,
silver, late twelfth century,
perhaps found at Piercetown,
County Meath. Dublin, National
Museum of Ireland. Scale 2:1

seal is that of Vivian de Aula, acquired by the Royal Irish Academy in 1847 and said to have been found in Ireland in "a castle of the Black Bull," perhaps to be identified as Piercetown Castle, near Black Bull (Co. Meath) (Fig. 7). The device consists of a building or hall with tiled roof, being a pun on the name, de Aula. The owner of the seal was almost certainly one of the first of the Anglo-Norman settlers in Ireland. The name de Aula is recorded in contemporary medieval Irish documents. The earliest, a charter dated 1172–76 in respect of lands in County Meath in favour of one Vivian (who may well be the owner of this seal), was witnessed by one Roger de Aula.[66] If this is indeed the case, this is most likely to be a seal brought by him from his homelands in England. The style of the seal is close to the silver seal matrix of Exeter, ca. 1200, suggesting that it was made by a goldsmith based in south-west England.[67]

The prior's seal of the Cluniac monastery of Sts. Peter and Paul, Athlone, which was in existence by 1208–10, was found near the river Shannon and is one of the finest copper alloy monastic seals. It depicts the prior holding a chalice in front of an altar on which an equal-armed cross stands. Above him and separated by a triple arch is the half-length figure of the Virgin and Child.[68] In the seal matrix of the Chapter of Leighlin, the cutting is less expert but is of interest for its depiction, in simple round-arched niches, of St. John the Baptist with a disk bearing the Agnus Dei and the figure of a mitred bishop holding a crozier of Irish type.[69] Thirteenth- and fourteenth-century seals of abbots and bishops are, in contrast, more formal and follow contemporary English designs, as in the case of the seals of John Kennedy, abbot of Bangor (Co. Down), and Thomas Barrett, bishop of Elphin (Fig. 8), both belonging to the end of the fourteenth century.[70]

Apart from the Nenagh and de Aula seal matrices and a few gem-set counter-seals, all the other surviving Irish silver matrices are those of Irish chieftains and are of considerable historical, if not artistic, interest. I have noted earlier how Irish kings adopted the use of seals by the later twelfth century. The earliest surviving heraldic matrices of Irish chieftains date to the mid-fourteenth century, about the same time as the earliest surviving post-1200 metalwork inscriptions. Modest in size, some of these are of exquisite workmanship. The finest is that of Hugh O'Neill, who is described on his seal as *Regis Hyberniorum Ultonie*, "king of the Irish of Ulster."[71] It is more likely to belong to Aodh Reamhar Ó Néill, king of Tír Eoghain (1345–64), than to his

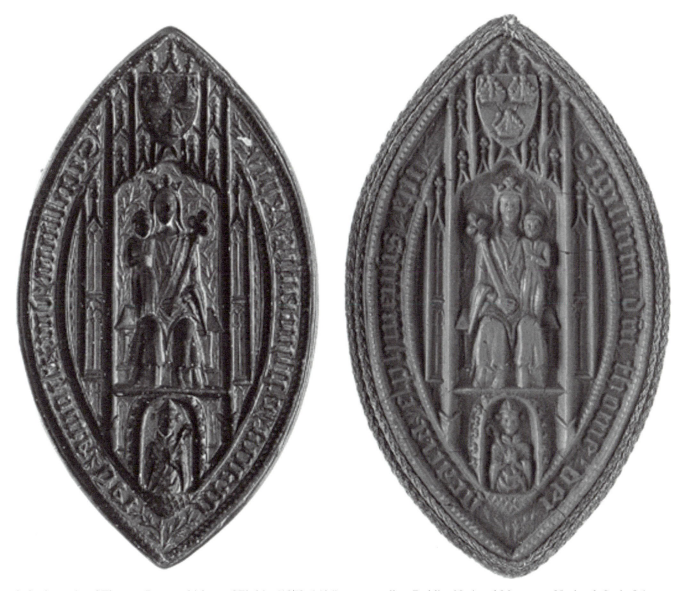

8. Seal matrix of Thomas Barrett, bishop of Elphin (1372–1404), copper alloy. Dublin, National Museum of Ireland. Scale 2:1

mid-thirteenth-century namesake, as the O'Neills did not style themselves kings of Ulster until the 1280s, when the ancient kingship of Ulster was revived. It is important for being the earliest surviving Irish heraldic matrix. The device consists of a shield bearing a raised hand supported by a pair of wyverns. It was almost certainly made by an Irish goldsmith, and stylistically it is very close to the seals of the towns of Dundalk and Carrickfergus, indicating a craftsman based in the north-east of Ireland.[72] A contemporary heraldic seal of Roderic O'Kennedy, king of Éile, survives on a document dated 1356.[73]

Two silver matrices of the fourteenth century, belonging perhaps to a provincial Irish king (or a member of his family) and one of his vassals, illustrate the relationships between lord and

9. Seal matrix of Mac Con Mac Namara (1312–28), silver. Dublin, National Museum of Ireland. Scale 2:1

10. Seal matrix of Brian O'Brien, silver, fourteenth century. Dublin, National Museum of Ireland. Scale 2:1

vassal in late medieval Ireland. The first is an equestrian seal of Mac Con, described on the matrix as *Ducis de Ui Caissin*, "lord of Uí Caissén," a territory in east County Clare whose principal family were the Mic Conmara (modern MacNamara).[74] This enables the matrix to be dated to the years 1312–28.[75] It is the seal of the head of a family of once important minor kings who by the early fourteenth century were vassals of the O'Brien kings of Thomond. The seal is of modest size, measuring 4.5 cm in diameter, and depicts Mac Con mounted on horseback and wearing helmet, sword, and rowel spurs, within a cusped border (Fig. 9). The lettering of the inscription is somewhat ragged, but the use of sprigs of foliage between the letters suggests it is the work of an accomplished craftsman. It would be virtually indistinguishable in design from contemporary English and Anglo-Irish seals but for the fact that it lacks a heraldic shield, as, for instance, in the case of the O'Neill and O'Kennedy seals discussed above. Evidently the use of heraldry and heraldic shields had not percolated down to the level of petty kings. This example may be contrasted with the seal of a member of the Mac Conmara's O'Brien overlords. This seal, inscribed simply SIGILLVM BRIAN IBRIAN, measures 3 cm in diameter and bears as a device a well-cut figure of a griffin (Fig. 10).[76] The style of the carving and of the lettering suggests a mid- to late fourteenth-century date. Two kings of Thomond bore the name at this time: Brian Bán (1343–50) and Brian Sreamhach (1369–1400). Brian was a very common name among all branches of the O'Briens, and the small size of the seal suggests that it may well have belonged to a member of a junior branch of the O'Briens. The device, if intended to be heraldic, was not hereditary. What is of interest in relation to these two seals is that the Mac Conmara vassals (who traditionally presided at the inauguration of their O'Brien overlords at precisely this time) were exploiting the weakness of their masters and were forging independent alliances with the Anglo-Irish de Clares, whose attempted colonisation of Thomond was finally frustrated at the battle of Dysert O'Dea in 1318. In the often complex, shifting political alliances of the time, Mac Con succeeded in obtaining a charter to his own lands from de Clare. His seal was not modelled on those of his overlords but finds its closest parallel on an almost contemporary seal of one of the Mac Carthaigh kings of Desmond, and is thus testimony to Mac Con's political ambitions.[77]

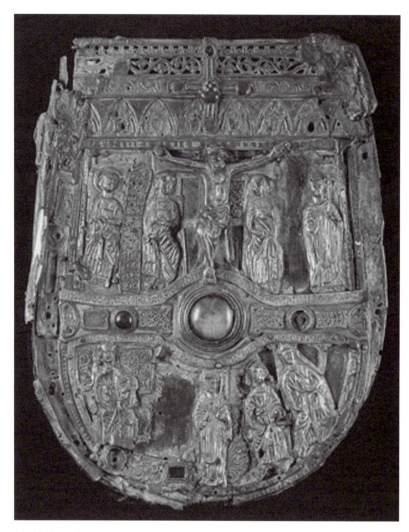

11. Shrine of St. Patrick's Tooth, gilt silver with gold filigree, rock crystal, and glass, third quarter of the fourteenth century, view of front. Dublin, National Museum of Ireland

RAW MATERIALS AND TECHNIQUES

During the later Middle Ages Ireland would appear to have had deposits of gold, and silver mines were also known. The earliest Anglo-Norman accounts of Ireland, by Gerald of Wales, speak of "gold with which that island abounds" as well as gifts of Irish gold to Henry II and advice to King John to tax the Irish in gold.[78] Silver mines at Knockaunderrrig, north Tipperary, were exploited between 1276 and 1303 by a group of Florentine and Genoese merchants who brought with them miners to work the deposits, a fact which suggests a lack of native expertise. References to miners going to Waterford and Munster suggest that the Tipperary mines were not the only ones exploited at this time.[79]

Gold objects survive only in the form of rings and brooches, none of which, as we have seen,

may be Irish. Gold was more frequently used in gilding, and parcel-gilding was used to highlight engraved patterns on sheet silver, such as on the Shrine of the Stowe Missal or the Shrine of St. Patrick's Tooth, dated by its inscription to between ca. 1350 and 1375.[80]

Casting was used sparingly, probably because the technique required greater amounts of metal. Cast crucifix figures occur as central elements on a number of fourteenth-century reliquaries. Moulds or models were re-used to cast similar features on more complex objects. Some of the figures on the Limerick Crozier, made in 1418 for Bishop O'Dea, were cast from the same model, the details being added subsequently.[81] Casting was also used for architectural details on the crozier and was particularly useful for crests, such as on the Shrine of St. Patrick's Tooth, which incorporates open-work foliate scrolls, friezes of animals, and Gothic window tracery (Fig. 11).

Engraving, Repoussé, and Die-stamping

By far the most common decorative techniques used by the Irish goldsmith were those of engraving and raising the surface, whether by repoussé or by the use of stamps. The figured scenes on the front of the Shrine of St. Patrick's Tooth (Fig. 11), the Shrine of the Cathach, and the Domnach Airgid (Fig. 3) are all executed in repoussé, and in the case of the latter two this is supplemented by engraving.

The use of dies is a feature of much Irish metalwork of the fourteenth century and later. Dies enabled goldsmiths to make small quantities of precious metals go a long way, and they were especially suited for making borders. They are of particular interest in that a number of dies are known. These include a hoard of three dies found at Lough Fea (Co. Monaghan) in 1874–77.[82] The finest, a circular die of copper alloy representing a lion and dragon in combat (Fig. 12, top), was most likely designed to produce medallions or prints for a mazer and finds a close parallel on a copper alloy die-stamped mount of unknown provenance in the National Museum of Ireland (Fig. 13). The other two stamps were designed to produce long strips or friezes and are decorated with pairs of confronted lions and griffins, and birds, respectively, set within beaded borders (Fig. 12, bottom).

These dies, particularly that with the confronted lion and griffin motif, are closely paralleled on metalwork of the fourteenth and fifteenth centuries. The same motif occurs, for example, on the Shrine of the Cathach and on the Domnach Airgid, both probably products of northern craftsmen, the latter for a client, the abbot of Clones, not thirty kilometres distant from where the hoard of dies was found.[83] Another die, found near Durrow (Co. Offaly), bears a frieze of animals: confronted griffin and lion flanked by a hare and a stag (Fig. 14).[84] Such dies could have remained in use over several generations, passed from one goldsmith to the next. This is the most likely explanation for the fact that the same impression found on the Shrine of the Cathach, of ca. 1350, appears on the reliquary known as the Corp Naomh, which also bears die-stamped panels identical to those on the Dunvegan Cup, an Irish product of the end of the fifteenth century, some 150 years later.[85] Dies were used in a more informal arrangement on the back of the Shrine of St. Patrick's Tooth, which bears four different die-stamp designs used to fill voids between figures (Fig. 15).

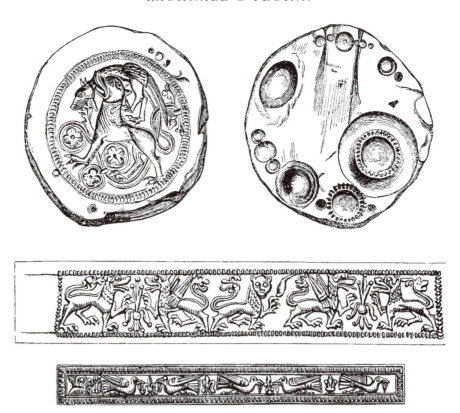

12. Hoard of three dies, copper alloy, thirteenth–fourteenth century(?), found at Lough Fea, County Monaghan. Current location unknown

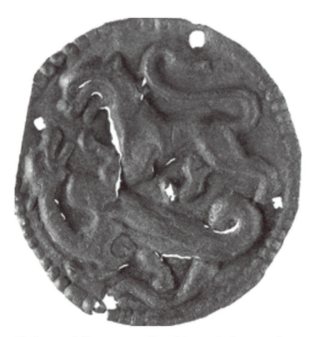

13. Stamped disc, copper alloy, thirteenth–fourteenth century(?), find-place unknown. Dublin, National Museum of Ireland. Scale 2:1

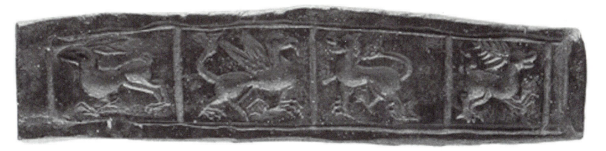

14. Die, copper alloy, fourteenth century, found near Durrow, County Offaly. Dublin, National Museum of Ireland

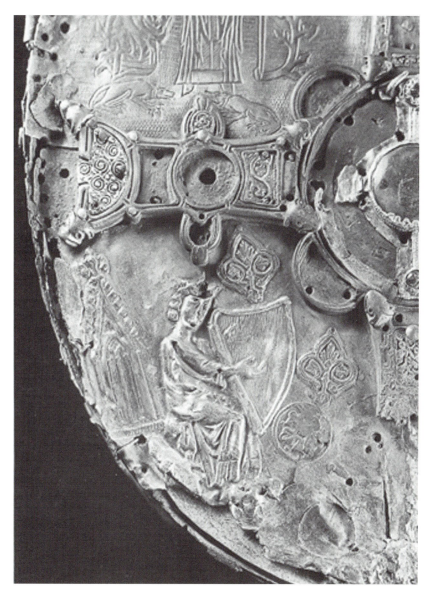

15. Shrine of St. Patrick's Tooth, gilt silver, third quarter of the fourteenth century. View of back showing repoussé figure and dies. Dublin, National Museum of Ireland. Scale 1.5:1

INSETS AND INLAYS

Although the use of gems is known in Irish metalworking from the eighth century, it is only from the eleventh century that their use became widespread. In the period under review, the earliest examples of gem-setting are found on seals, finger rings, and brooches. Gem-setting was invariably confined to goldsmiths, as the temperature required to solder gems in position had to be low, which precluded the use of copper alloy. There are no Irish medieval examples of cameos, but intaglios are known on jewellery and were particularly suited for use in seal matrices. Some of the gem-set silver seals in Irish collections may not be of Irish manufacture or even of Irish provenance, but there are at least two which were made for Irish clients. The first is a seal of Archdeacon John of Cashel (Co. Tipperary), found at Cashel in the late eighteenth century. It is set with an intaglio of black stone—perhaps jet—bearing a sea-horse as a device and which is possibly dateable to the second quarter of the thirteenth century.[86] The second is a seal of an Irish chieftain, Brian O'Harny, perhaps of early fourteenth-century date, which is set with an antique gem bearing the figure of a helmeted warrior.[87] These are, however, exceptional pieces. Brooches and finger rings of gold and silver were set with semi-precious stones—rubies, emeralds, and amethysts seem to have been the most popular. None of these, however, are demonstrably Irish and were most likely imported from north-western Europe.

The preferred method of setting semi-precious stones on objects of certain Irish manufacture was to fix them in collar or claw settings which were then soldered or pinned to the object. Since no study of the settings used on medieval Irish metalwork has been undertaken, the terminology used to describe them is imprecise. It would appear, however, that precious or semi-precious stones were rare, to judge from the mixture of settings used on the front of the Shrine of the Stowe Missal, dating to the 1370s (Fig. 5). The variety and unmatched sizes of the settings suggest that the jeweller used whatever came to hand. Rock crystal seems to have been the most easily available stone and was set in a variety of gold or silver collets with beaded mouldings. The Limerick Mitre, on the other hand, contains no fewer than 160 jewel settings, and although most are of rock crystal, amethysts, sapphires, tourmalines, and jacynths were also used.[88]

The surface of an object could be further embellished with inlays of niello and enamel. Niello was used particularly in combination with engraving on sheet silver, to highlight figures, as on the Shrine of St. Patrick's Tooth of ca. 1350–75 (Fig. 11) or that of St. Senan's Bell,[89] or the lettering of inscriptions, as on the Domnach Airgid of ca. 1350 (Fig. 3). There is no example of gold inlaid with niello.

Enamel is found on Irish metalwork of the period, although its use is sparing. Champlevé enamel occurs on the front of the Domnach Airgid and on the Limerick Mitre and Crozier. Translucent or *basse-taille* enamel, a technique invented in the late thirteenth century, occurs on a number of objects. The lunate lobes with Gothic tracery around the central rock crystal on the Shrine of the Stowe Missal contain red and blue translucent enamel (Fig. 5). The most accomplished examples of the technique occur on the Limerick Mitre and Crozier. The mitre may be compared to that given by William of Wyckham, bishop of Winchester, to New College, Oxford, and dated ca. 1361.[90] It bears plaques of translucent enamel with designs of animals with foliate tails very similar to those on the girdle preserved at New College, Oxford, and thought to be part of William of Wyckham's pontificalia.[91] The best parallels for the crozier are a number of Euro-

pean croziers dating to the middle of the fourteenth century, including the crozier of Egmont, of 1351, from Haarlem in the Netherlands, or that of William of Wyckham, of ca. 1367, now in New College, Oxford.[92] In their design, these are much more elaborate objects, as befitting their owners, who were bishops of some of the richest dioceses in England and the Low Countries. Their tabernacle-work knops, enamelled crooks, and open-work figured scenes within the volutes indicate that they were the inspiration for the Limerick Crozier. The Irish craftsman, however, made use of designs which had gone out of fashion elsewhere in Europe—a feature which has been noted in much of Irish late Gothic architecture.[93]

CONCLUSIONS

Irish metalwork of the later Middle Ages has not received anything like the attention lavished on the study of metalwork of the pre-Anglo-Norman period. It has also suffered from the artificial divisions imposed on the surviving body of material by modern scholars, which has resulted in brooches, finger rings, seals, plate, and other ecclesiastical metalwork being studied in isolation. Roger Stalley, however, has pointed out the similarities between the Crucifixion scene on the front of the Shrine of the Book of Dimma from Roscrea (Co. Tipperary) and that on the seal of the Cistercian Abbey of Holycross in the same county, and has suggested that they were made by the same goldsmith.[94] Comparisons between Irish metalwork and contemporary sculpture are confounded by the lack of any significant body of material for the second half of the fourteenth and beginning of the fifteenth centuries.[95] The largest single body of material, the reliquaries of the medieval church, were almost all made by Irish craftsmen for Irish patrons. What I have attempted to do here is to draw together all the evidence for Ireland, irrespective of the ethnic origin of patron and craftsman. Little, apart from jewellery and seals, survives from those areas of Ireland under Anglo-Norman or English control. Thus, we have as yet no way of establishing if indeed there were differences in taste between the church *inter Anglicos* and the church *inter Hibernicos* or between the great Anglo-Norman barons of Ireland and their Irish counterparts.

Much of the surviving ecclesiastical metalwork has often been seen as an expression of a "Gaelic revival" in the later Middle Ages. Certainly many of the Irish patrons responsible for the redecoration of reliquaries associated with early Irish saints were to the forefront of the fourteenth-century revival of earlier kingship titles: the O'Kennedys of Ormond, the O'Carrolls of Éile, and the Mac Murrough-Kavanaghs of Leinster. The close similarity in design, decoration, and techniques of two roughly contemporary objects—the Shrine of St. Patrick's Tooth, commissioned by an Anglo-Norman baron in Connacht, and the Shrine of the Stowe Missal, made on behalf of Philip O'Kennedy, king of Ormond, for the monastery of Lorrha (Co. Tipperary)—suggests that both may have patronized the same craftsman. The surviving corpus of goldsmiths' work, jewellery and seal matrices apart, is heavily biased in favour of the church *inter Hibernos*, made by Irish craftsmen for Irish patrons, while almost all the work for Anglo-Norman and English patrons has been destroyed. We are still a long way, therefore, from being in a position to address the fascinating question of whether (if at all) goldsmiths' work reflected different polities and cultural identities during the thirteenth and fourteenth centuries.

NOTES

1. F. Henry, *Irish Art in the Romanesque Period (1020–1170 A.D.)* (London, 1970), 25.

2. R. Stalley, "Irish Gothic and English Fashion," in *The English in Medieval Ireland*, ed. J. Lydon (Dublin, 1984), 65–86, at 69.

3. R. Ó Floinn, "Schools of Metalworking in Eleventh- and Twelfth-Century Ireland," in *Ireland and Insular Art, A.D. 500–1200*, ed. M. Ryan (Dublin, 1987), 179–87, at 180.

4. F. Henry and G. Marsh-Micheli, "Manuscripts and Il-luminations, 1169–1603," in *A New History of Ireland*, vol. 2, *Medieval Ireland, 1169–1534*, ed. A. Cosgrove (Oxford, 1987), 781–813, at 783–89.

5. The Corpus Missal of ca. 1180, although written in an Irish hand, "reflects contemporary liturgical usages of the Latin church, rather than the Celtic rite"; M. T. Fla-nagan, "The Context and Uses of the Latin Charter in Twelfth-Century Ireland," in *Literacy in Medieval Celtic Societies*, ed. H. Pryce (Cambridge, 1998), 115.

6. R. Ó Floinn, "Innovation and Conservatism in Irish Metalwork of the Romanesque Period," in *The Insular Tradition*, ed. C. E. Karkov, R. T. Farrell, and M. Ryan (New York, 1997), 259–81.

7. For the Shrine of St. Lachtin's Arm and its Byzan-tine prototypes, see Ó Floinn, "Innovation and Conser-vatism" (as in note 6), 267–68. For the Breac Maedhóg, see Henry, *Irish Art* (as in note 1), 117–99, pls. 34–37.

8. R. Ó Floinn, "Domnach Airgid Shrine," in *Treasures of Ireland: Irish Art, 3000 B.C.–1500 A.D.*, ed. M. Ryan (Dublin, 1983), 176–77.

9. J. Hunt, *The Limerick Mitre and Crozier* (Dublin, n.d.).

10. The evidence for Irish goldsmiths' work in the post-1400 period is discussed in R. Ó Floinn, "Irish Gold-smiths' Work of the Later Middle Ages," *Irish Arts Review Yearbook* 12 (1996), 35–44.

11. See E. Taburet-Delahaye, *L'Orfèvrerie goth-ique, XIII^e–début XV^e siècle, au Musée de Cluny* (Paris, 1989), 8–9.

12. *Account Roll of the Priory of the Holy Trinity, Dublin, 1337–1346*, ed. J. Mills (Dublin, 1891), 90.

13. John le Seler is listed as a witness to an inquisition taken in Tipperary in 1302: *CJR, 1295–1303*, 449.

14. E. C. R. Armstrong, *Irish Seal Matrices and Seals* (Dublin, 1912); idem, "Some Matrices of Irish Seals," *PRIA* 30C (1913), 451–76; idem, "Descriptions of Some Irish Seals," *JRSAI* 45 (1915), 143–48.

15. The best survey of Scottish medieval decorative art, especially metalwork, is *Angels, Nobles, and Unicorns: Art and Patronage in Medieval Scotland*, ed. D. Caldwell (Ed-inburgh, 1982).

16. J. J. Buckley, *Some Irish Altar Plate* (Dublin, 1943), 12–18.

17. See R. Ó Floinn, "Insignia Columbae I," in *Studies in the Cult of St. Columba*, ed. C. Bourke (Dublin, 1997), 136–61, at 141–42.

18. Ó Floinn, "Insignia Columbae" (as in note 17), 142–43.

19. Ó Floinn, "Innovation and Conservatism" (as in note 6), 266.

20. Ó Floinn, "Innovation and Conservatism" (as in note 6), pl. 13:1.

21. Sir H. Read and A. B. Tonnochy, *Catalogue of the Silver Plate, Medieval and Later, Bequeathed to the British Museum by Sir Augustus Wollaston Franks* (London, 1928), 5, no. 12, pl. 8. The evidence for this will be presented elsewhere.

22. A. Andersson, *Medieval Drinking-Bowls of Silver Found in Sweden* (Stockholm, 1983).

23. L. de Paor, "Excavations at Mellifont Abbey, Co. Louth," *PRIA* 68C (1969), 109–64, at 138–39 and pls. XXXIX–XLII.

24. Armstrong, *Irish Seal Matrices* (as in note 14), 41, fig. 31.

25. A similar experimentation occurred in England in the early twelfth century: see T. A. Heslop, "Seals," in *En-glish Romanesque Art, 1066–1200*, ed. G. Zarnecki, J. Holt, and T. Holland (London, 1984), 298–300, at 299.

26. Most recently discussed by J. Bradley, "The Sar-cophagus at Cormac's Chapel, Cashel, Co. Tipperary," *NMAJ* 26 (1984), 14–35, at 16 and illus. 2.

27. No survey of Limoges enamels from Ireland exists. For some published examples, see G. Coffey, *Guide to the Celtic Antiquities of the Christian Period Preserved in the National Museum, Dublin* (Dublin, 1910), fig. 106; J. Raft-ery, *Christian Art in Ancient Ireland*, vol. 2 (Dublin, 1941), pls. 100 and 127:2; P. L. Macardle, "Blessed Oliver Plun-kett Church at Ballybarrack," *JCLAHS* 4, no. 4 (1916–20), 387 and pl. opposite 357; C. Bourke, "An Enamelled Cruet from Grangewalls, Co. Down," *Lecale Miscellany* 6 (1988), 38–43.

28. For the crucifix figure, see C. Hourihane, "'Hollye Crosses': A Catalogue of Processional, Altar, Pendant, and Crucifix Figures for Late Medieval Ireland," *PRIA* 100C (2000), 23–24, no. 30, pl. 34. For the ivory, see Raft-ery, *Christian Art* (as in note 27), pl. 121:2.

29. *Age of Chivalry: Art in Plantagenet England, 1200–1400*, ed. J. Alexander and P. Binski (London, 1987), no. 730.

30. *Age of Chivalry* (as in note 29), no. 318.

31. *CDI*, vol. 1, 416–17.

32. Ó Floinn, "Schools of Metalworking" (as in note 3), 179.

33. H. F. Berry, "The Goldsmiths' Company of Dublin (Gild of All Saints)," *JRSAI* 31 (1901), 119–33.

34. *CJR, 1305–7*, 448.

35. *CDI*, vol. 4, 137.

36. *CJR, 1295–1303*, 7.

37. *CDI*, vol. 5, 7.

38. *CDI*, vol. 3, 65, 131, 136, 401.

39. *CJR, 1295–1303*, 268.

40. *Directory of Historic Dublin Guilds*, ed. M. Clark and R. Refaussé (Dublin, 1993), 21.

41. Berry, "Goldsmiths' Company" (as in note 33), 119.

42. *CJR, 1295–1303*, 268.

43. A. B. Ó Ríordáin, "Christchurch Place," in *Excavations: Summary Accounts of Archaeological Excavations in Ireland* 1974, ed. T. Delaney, 14–15, and *Excavations: Summary Accounts of Archaeological Excavations in Ireland* 1975–76, ed. T. Delaney, 11.

44. A. Hayden, "Cornmarket/Francis St. Lamb Alley," in *Excavations: Summary Accounts of Archaeological Excavations in Ireland* 1992, ed. I. Bennett (Dublin, 1993), 20–21.

45. D. M. Waterman, "St. Mary's Priory, Devenish: Excavation of the East Range, 1972–4," *UJA* 42 (1979), 34–50, at 44–45 and fig. 10.

46. *Registrum Iohannis Mey*, ed. W. G. H. Quigley and E. F. D. Roberts (Belfast, 1972), 432–33.

47. Ó Floinn, "Irish Goldsmiths' Work" (as in note 10), 36.

48. Berry, "Goldsmiths' Company" (as in note 33), 120.

49. The maker's inscription is illustrated in *Christian Inscriptions in the Irish Language*, vol. 2, ed. M. Stokes (Dublin, 1878), 98, fig. 93a.

50. *Registrum Iohannis Mey* (as in note 46), 52, refers to one "Iohannis Bardan aurifaber" at Drogheda in a document dated 1440.

51. Hunt, *Limerick Mitre and Crozier* (as in note 9), pl. VI.

52. M. Moloney (ed.), "Obligationes pro Annatis Diocesis Limiricensis, 1421–1519," *Archivium Hibernicum* 10 (1943), 104–62.

53. *Christian Inscriptions* (as in note 49), pl. XLV, fig. 94. The term *cerd/ceard* in the inscription is specifically used of a goldsmith, while the term *saer*, or "wright," is used to denote sculptors in wood or stone.

54. *Christian Inscriptions* (as in note 49), pl. XLIV, fig. 92b.

55. Ó Floinn, "Irish Goldsmiths' Work" (as in note 10), 36.

56. For Irish medieval jewellery, see E. C. R. Armstrong, *Catalogue of Finger Rings in the National Museum Dublin* (Dublin, 1914); J. Cherry, "Medieval Jewellery from Ireland: A Preliminary Survey," in *Keimelia: Studies in Medieval Archaeology and History in Memory of Tom Delaney*, ed. G. MacNiocaill and P. F. Wallace (Galway, 1988), 143–61; M. B. Deevy, *Medieval Ring Brooches in Ireland: A Study of Jewellery, Dress, and Society* (Bray, 1998).

57. R. W. Lightbown, "The Jewellery," in *Late Viking Age and Medieval Waterford, Excavations 1986–1992*, ed. M. F. Hurley, O. M. B. Scully, and S. W. J. McCutcheon (Waterford, 1997), 518–23, at 519–20 and pl. 44B.

58. Flanagan, "Latin Charter" (as in note 5), 113–33.

59. Flanagan, "Latin Charter" (as in note 5), 114.

60. Armstrong, *Irish Seal Matrices* (as in note 14), 16, 126.

61. Flanagan, "Latin Charter" (as in note 5), 116.

62. Armstrong, "Descriptions" (as in note 14), 143–44, pl. XI, fig. 1.

63. Armstrong, *Irish Seal Matrices* (as in note 14), 95–96.

64. *Medieval Religious Houses: Ireland*, ed. A. Gwynn and N. Hadcock (London, 1970), 214–15.

65. *Medieval Religious Houses* (as in note 64), 209.

66. *Chartularies of St. Mary's Abbey, Dublin*, ed. J. T. Gilbert, vol. 1 (London, 1884), 288.

67. *Age of Chivalry* (as in note 29), no. 378.

68. Armstrong, *Irish Seal Matrices* (as in note 14), 88, fig. 67.

69. Armstrong, *Irish Seal Matrices* (as in note 14), 70–71, fig. 52.

70. Armstrong, *Irish Seal Matrices* (as in note 14), 83–84, fig. 63, and 45, fig. 34.

71. Illustrated in W. Reeves, "The Seal of Hugh O'Neill," *UJA* 1 (1853), 255–58, at 255.

72. For the Dundalk seal, see R. Ó Floinn, "Two Medieval Seals from County Louth," *JCLAHS* 22, no. 4 (1992), 387–94.

73. Illustrated in M. Ó Comáin, *The Poolbeg Book of Irish Heraldry* (Dublin, 1991), 36.

74. Armstrong, *Irish Seal Matrices* (as in note 14), 11–12, fig. 3.

75. The dates are to be found in A. Ní Ghiollamhaith, "Kings and Vassals in Later Medieval Ireland: The Uí Bhriain and the MicConmara in the Fourteenth Century," in *Colony and Frontier in Medieval Ireland: Essays Presented to J. F. Lydon*, ed. T. B. Barry, R. Frame, and K. Simms (London, 1995), 201–28.

76. Armstrong, *Irish Seal Matrices* (as in note 14), 22, fig. 14.

77. Armstrong, *Irish Seal Matrices* (as in note 14), 11, fig. 2.

78. N. Whitfield, "The Sources of Gold in Early Christian Ireland," *Archaeology Ireland* 7, no. 4 (1993), 21–23.

79. D. F. Gleeson, "The Silver Mines of Ormond," *JRSAI* 67 (1937), 101–16.

80. Illustrated in Ó Floinn, "Irish Goldsmiths' Work" (as in note 10), figs. 1 and 5.

81. Hunt, *Limerick Mitre and Crozier* (as in note 9), 20–21, pls. XII, XIV, and XV.

82. E. P. Shirley, *The History of the County Monaghan* (London, 1879), 170 and 518. Although the caption on the former states that it was found in 1874 and the latter in 1877, it is unlikely that the dies represent two separate finds.

83. Illustrated in Raftery, *Christian Art* (as in note 27), pl. 113 (Cathach) and pl. 118:2 (Domnach Airgid).

84. National Museum of Ireland, reg. no. W.85; W. Wilde, "List of Antiquities Purchased from the 16th of March, 1858, to the 16th of March, 1859," *PRIA* 7 (1857–61), at 130.

85. Illustrated in *Christian Art in Ancient Ireland*, ed. A. Mahr, vol. 1 (Dublin, 1932), pl. 68.

86. Armstrong, *Irish Seal Matrices* (as in note 14), 68, fig. 50, inscribed S IOHIS CASELL ARCHID. Archdeacons bearing the name are recorded in documents of 1220 and 1230: see H. Cotton, *Fasti Ecclesiae Hibernicae*, vol. 1 (Dublin, 1851), 52. There is a possibility that the seal belonged to John O'Grady, archdeacon of Cashel, who was elevated to the archbishopric of Tuam in 1365 (Cotton, *Fasti*, vol. 1, 53), but the style of the lettering suggests an earlier date. Compare the seal with an inset intaglio said to have been found in Ireland: see *Age of Chivalry* (as in note 29), no. 456.

87. Armstrong, *Irish Seal Matrices* (as in note 14), 23, fig. 16.

88. Hunt, *Limerick Mitre and Crozier* (as in note 9), 19–20.

89. Illustrated in *Treasures of Ireland* (as in note 8), 186.

90. *Age of Chivalry* (as in note 29), no. 606.

91. *Age of Chivalry* (as in note 29), no. 609.

92. *Age of Chivalry* (as in note 29), no. 608.

93. Stalley, "Irish Gothic" (as in note 2), 80–85.

94. R. Stalley, *The Cistercian Monasteries of Ireland* (London and New Haven, 1987), 225, pls. 272, 273.

95. Stalley, "Irish Gothic" (as in note 2), 79; J. Hunt, *Irish Medieval Figure Sculpture*, 2 vols. (Dublin and London, 1974), vol. 1, 53.

Sheela-na-gigs and Other Unruly Women: Images of Land and Gender in Medieval Ireland

·

CATHERINE E. KARKOV

THIS ESSAY has two goals: first, to explore the possible meanings and functions of sheela-na-gigs within their original medieval setting, and, second, to consider the ways in which they have been interpreted and reinterpreted in modern times. The process of creating meaning is important, as sheela-na-gigs developed out of a Continental context but have been changed over the centuries into representations of a distinctly Irish past, often set against a postcolonial present. Like the historical and fictional women with whom they are so often connected, and with whom I will continue to connect them, they refuse to be pinned down to one meaning, role, or interpretation. As Eamonn Kelly has stressed, "the process of redefinition" is ongoing.[1]

MEANING AND FUNCTION

According to the Annals of the Four Masters, in 1167 Derbforgaill, wife of Tigernán O'Rourke, king of Bréifne, "finished" the Nuns' Church at Clonmacnois. What exactly is meant by "finished" is debatable. It may be that she built the church whose ruins survive today; it may be that she simply added the elaborate portal and chancel arches to a previously existing structure;[2] it may mean that she did nothing more than give the building a new roof. But no matter how we wish to interpret "finished," we can be certain that Derbforgaill was both familiar with and associated with the Nuns' Church, which was decorated in the latest French-influenced twelfth-century Romanesque style (discussed and illustrated elsewhere in this volume by Tessa Garton and Peter Harbison).

Why Derbforgaill finished the Nuns' Church is another matter. She was both the daughter and sister of successive Ua Máel Sechlainn kings of Mide, and her family was associated with control of that kingdom. Her patronage of Clonmacnois, the cathedral church of West Mide, is therefore to be expected. (According to Gwynn and Hadcock, Derbforgaill's sister Agnes was abbess of Clonard, the cathedral church of East Mide.[3]) Her prime motivation, however, is often cited as penitence. Her husband, Tigernán, was a rival of Toirrdelbach Ua Conchobhair, king of Connacht, and Diarmait Mac Murchada, king of Leinster, and part of what was at stake was control of Mide. Shortly after a conference at Beleek (Co. Sligo) in 1152, Ua Conchobhair burned

O'Rourke's fortress and established a rival king of Bréifne, while Mac Murchada abducted Derbforgaill—who some say may not have been altogether unwilling—along with her dowry. Derbforgaill returned to her husband within the year. Fourteen years later, in 1166, the year before the Nuns' Church was "finished," O'Rourke was paid one hundred ounces of gold for the insult to his honor, and Mac Murchada was banished.[4] Francis John Byrne notes that the abduction and the punishment must have been politically motivated, as in 1152 Derbforgaill was no lusty young maid. As he puts it, "she may have been fair but she was certainly forty."[5] (John Ryan puts her age at forty-one and Mac Murchada's at sixty-two.[6]) In any case, in 1169 Mac Murchada returned with his Anglo-Norman allies, and thus began the conquest of Ireland. While Derbforgaill was by no means the only cause of Mac Murchada's banishment or the Anglo-Norman invasion, the story has become legend. The woman herself slipped not altogether quietly into history; having "brought shame on her husband, and disaster to her country . . . she spent decades repenting for her misdeeds and after many unhappy years died at Mellifont in 1193."[7] If the dates are correct, she was eighty-five at her death. Lady Gregory memorialized this picture of the guilty but penitent Derbforgaill in her play of the same name (*Dervorgilla*) first produced at the Abbey Theatre in 1907. In the play the fallen queen laments:

> Was it not I brought the curse upon O'Rourke, King of Breffney, the husband I left and betrayed? The head I made bow with shame was struck off and sent to the English king. The body I forsook was hung on the walls shamefully, by the feet, like a calf after slaughter. It is certain there is a curse on all that have to do with me. What I have done can never be undone. How can I be certain of the forgiveness of God?[8]

A slightly different portrait of Derbforgaill survives in the *Benshenchas*, or *The Lore of Women*, written in 1147 by Gilla Mo-Dutu Ó Caiside. Surviving in both poetic and prose versions, the *Benshenchas* is a catalogue of famous women, mostly the wives and daughters of the high kings of Ireland, from the creation of Eve to the twelfth century. Derbforgaill is of course among these great wives and daughters, and the poetic version ends with a tribute to her, her husband, and her parents, suggesting that it was written in her honor.[9]

Derbforgaill's story is in many ways commonplace. She was a political pawn lost in the doings of male heroes. The way she is portrayed by historians, both medieval and modern, is in keeping with the contradictory ways in which women were perceived and portrayed in Ireland, from prehistoric nature goddesses to Yeats' Cathleen ni Houlihan to Jude in the film *The Crying Game*. She was both tempting and deadly, beautiful and ugly (not only because she was forty but because of the aggressive sexuality attributed to her), and she was a human woman whose body was made to stand for land and kingdom.

If Derbforgaill is problematically associated with the entrance of the Anglo-Normans into Ireland, her church is equally problematic in its association with the entrance of a new image, the sheela-na-gig, into Irish architecture.[10] The association is problematic because it can be argued that the Nuns' Church carving (Fig. 1) is *not*, as is sometimes claimed, the earliest of the sheela-na-gigs, or even that it is a sheela-na-gig at all. Sheela-na-gigs are by accepted definition "carvings of naked females posed in a manner which displays and emphasizes the genitalia."[11] Few can be precisely dated, but the corpus as a whole is generally dated from the late twelfth to the sixteenth century, with most dated toward the end of that period. They are often, but not always, located on or near openings such as doors, windows, and arches, and seem to have appeared first on

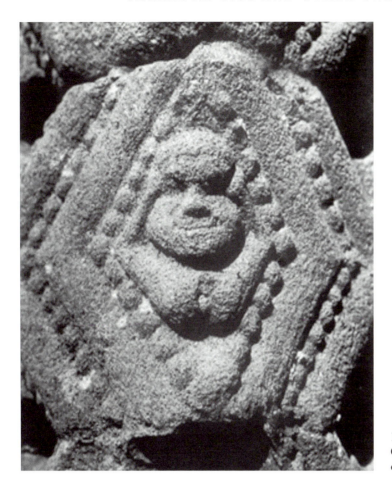

1. The Nuns' Church, Clonmacnois, County Offaly, acrobat figure on the chancel arch

churches, only later spreading to secular structures such as castles and town walls (Fig. 2).[12] Ultimately sheela-na-gigs are likely to be derived from classical images of Terra, the personification of mother earth, but they are more immediately influenced by the grotesque acrobats and images of lust that became popular in churches across France and England in the eleventh and twelfth centuries.[13] The little Clonmacnois figure, with its legs behind its ears and displaying its rear end, is much closer to its French acrobatic models than are the rest of the Irish sculptures, which is one of the reasons it is believed to be so early in the series.[14] It is indeed possible to question whether the figure is either part of the corpus or female at all.[15] However, as the main message of the sheela-na-gigs lies in the open threatening body, and as the figures frequently combine clear gender signifiers (the vulva) with signs of genderless ambiguity (monstrous faces, bald heads, skeletal torsos), the Clonmacnois acrobat is clearly in the same tradition.

As with Derbforgaill, so with the sheela-na-gigs: amateur antiquaries and professional scholars alike give differing and often contradictory accounts of their meaning and function within Irish culture. Clearly the sheela-na-gigs began life in Ireland as an Anglo-Norman import, and Eamonn Kelly's study of their distribution has shown that the heaviest concentration of them is in areas of Anglo-Norman settlement.[16] They most likely represented the sin of lust, the traditional interpretation given to similar figures outside of Ireland. At least in the minds of the invaders, the

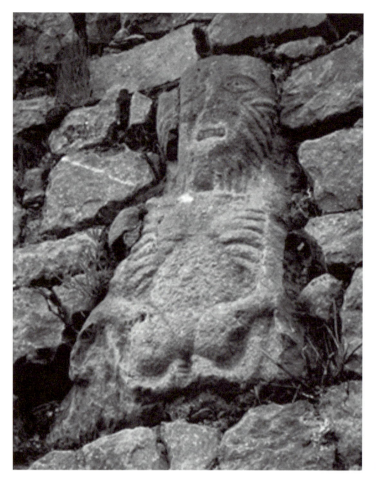

2. Sheela-na-gig in the town wall at Fethard, County Tipperary

sheela-na-gig may also have served to reinforce their image of the Irish as a filthy, bestial, and vice-ridden people. Sexual impropriety on a massive scale was part of both papal and English justification for invasion.[17] Hadrian IV, the only English pope, wrote to King Henry II at the request of John of Salisbury in support of his desire to "enter this island of Ireland, to make that people obedient to the laws, and to root out from there the weeds of vices . . . checking the descent into wickedness, correcting morals and implanting virtues."[18] Bernard of Clairvaux described his encounter with the Irish in similar terms:

> When he began to administer his office, the man of God understood that he had been sent not to men but to beasts. Never before had he known the like, in whatever depth of barbarism; never had he found men so shameless in regard of morals, so dead in regard of rites, so stubborn in regard of discipline, so unclean in regard of life. They were Christians in name, in fact pagans.[19]

And most famously of all, Gerald of Wales, whose family played an important role in the conquest, characterized Ireland as being, like the East, a country on the edge of civilization inhabited by barbaric freaks who exhibited all manner of physical deformity; indulged in bestiality, incest, and adultery; had no idea how to contract legal marriages or inaugurate kings; and even had

the world's most violent and vindictive saints.[20] For Gerald, the hideous outward appearance of the Irish was a sign of their inner moral depravity.[21] He worried further that the English colonizers would be infected by the barbarous Irish and their uncivilized ways.[22] This is the familiar rhetoric of war and conquest, one still popular in political cartoons, and one into which the sheela-na-gig as an image of unruly lust *seemed* to fit perfectly. However, over the course of the thirteenth century the meaning began to shift, and the sheela-na-gig came to serve as an apotropaic icon. The twin catalysts for the change seem to have been the beginning of a Gaelic resurgence and the almost total absorption of Irish ways by Anglo-Normans living outside the Pale.[23] With each wave of newcomers, the "Old English" came to be perceived as less and less English and more and more Irish, until many, like the seventeenth-century earl of Ormond, who lamented that he was the "first Englishman to be treated like an Irishman," chose to identify themselves as Irish.[24] The sheela-na-gigs, too, parted company with their Continental prototypes, resisting the tendency of the latter to take on increasingly naturalistic and erotic forms.

Both Eamonn Kelly and Lisa Bitel have recently connected sheela-na-gigs to the Irish legal, intellectual, and literary traditions which preserved a different set of images—representations of strong, often sexually aggressive women (sometimes good, sometimes evil), all in one way or another having to do with the protection or control of land and kingship. The best-known of these women are found in the sagas: Medb, queen of Connacht, the poet/prophetess Fedelm,[25] and the Morrigan, all capable of shifting from hideous to beautiful, from barren to fertile, as circumstances dictated. The *Benshenchas* reveal that under Ireland's early divorce laws, women as well as men engaged in multiple marriages that reflected the shifting fortunes and political alliances of their families. Derbforgaill, daughter of Tadg of Ossory (d. 1098), married six times, as did Toirrdelbach Ua Conchobhair.[26] Despite the general disapproval voiced by the papacy, the Annals of Connaught record that in 1233 the pope offered Ruaidri Ua Conchobhair, Toirrdelbach's son, the kingship of Ireland and six wives if he would give up adultery. (He seems to have deliberately chosen adultery as morally and politically preferable to multiple marriages.[27]) In addition to, or perhaps in aid of, political expediency, Irish law provided women with fourteen grounds for divorce, including a husband's failure to satisfy his wife sexually due to impotence, sterility, bi- or homosexuality, obesity, or the taking of holy orders.[28]

As Lisa Bitel notes, unsatisfied sexual longing could make a woman turn ugly—sometimes more like a beast than a human.[29] The goddess who personified the sovereignty of Ireland was an old crone, lonely and barren until sex with the future king transformed her into a fertile beauty (and him into a legitimate sovereign).[30] The legend is early medieval, but well into the late Middle Ages and beyond poets cast their aristocratic patrons as the husbands of their territories.[31] The English, too, portrayed themselves as the legitimate husbands of the virgin land,[32] the pacifiers of Ire-land, "Land of Ire."[33] It is not surprising, then, that a number of the sheela-na-gigs on both churches and castles can be associated with the patronage of some of the most powerful aristocratic families of both Anglo-Norman and native Irish descent: the Fitzmaurices in Kerry, the Melaghlins (descendants of Derbforgaill's family) at Carne Castle in Westmeath, the Talbots at Malahide Abbey, and the earls of Ormond. The latter were patrons of a major late Gothic school of sculpture characterized, at least as far as funerary sculpture is concerned, by its backward-looking, deliberately Irish, neo-Romanesque style.[34] Very soon after its introduction, the sheela-na-gig seems to have come to embody something politically and culturally Irish.

Equally important for both its medieval and modern audiences, however, is the power of the

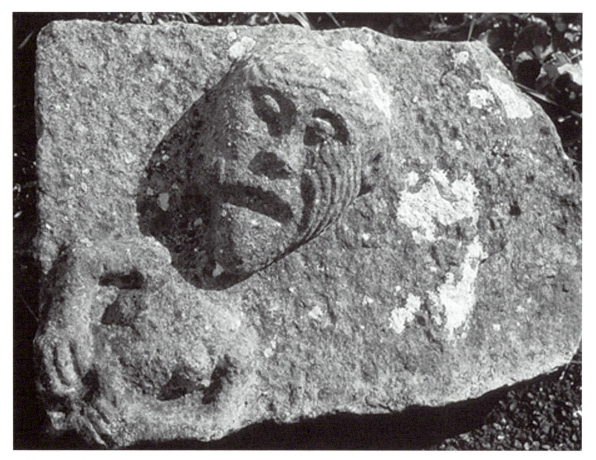

3. Sheela-na-gig found in the Figile River, County Offaly

image to startle and disrupt. Rather than attracting the viewer with alluring feminine bodies or titillating conversation, as do so many late medieval representations of the "female" sins of lust and gossip,[35] the sheela-na-gigs stalk and shriek with both mouth and womb along the liminal areas of the structures they inhabit. Here, too, they seem to resonate with the images of naked or seminaked women from the sagas. Cú Chulainn, for example, is prevented from killing Medb at the end of the *Táin Bó Cúailnge* by the grotesque sight of her squatting to relieve herself in the dust.[36] Perhaps more directly relevant is the multinamed and yet nameless crone in the story of the destruction of Da Derga's hostel. As the legendary king of Temair, Conaire Mór, begins to break his *gessa* (taboos) and hence approach his fated end, he encounters an old hag at his door (letting a single woman into his house after sunset was one of his taboos). She had pubic hair that reached down to her knees, and her mouth was on one side of her head. When asked her name she rattled off a litany of names, among them Destruction (*Coill*), Oblivion (*Díchuimne*), and the name of the war goddess (*Badbh*).[37] Her entry into the building was the end of both king and hostel. Shrieking wombs, as the story of Deirdriu reveals, could be equally disastrous.[38] The sheela-na-gig transfers the threat of these voices of doom to the walls of church, town, or castle. But, like the women in the sagas, these are also disruptive voices ultimately intended to preserve and protect the social order, just as Medb's exposed genitals protected her life or Conaire's hag pre-

served the preordained order of the story, ensuring that his life ended when and how it had been destined to from the beginning.

We should, however, be wary of reducing a corpus of really very different images to a single monolithic meaning, and of understanding a visual image *only* through a set of texts. Certainly the sheela-na-gigs can be associated with land and power; distribution alone indicates that. Moreover, the structures on which the figures appear—castles, churches, town walls—are themselves the architecture of the institutions of church and state, the architecture of authority. The style in which so many of the figures are carved might also carry meaning. Sheela-na-gigs are only partially human, and their monstrous heads and decaying bodies set many of them apart as distinctly "other." They are certainly the products of many different sculptors of varying abilities working at different times, for different patrons, and for different purposes; yet the figures all appear roughly carved and archaic in comparison to some other contemporary types of medieval Irish figural sculpture.[39] It is possible that style is being used here as a sign of death and decay, as an index of the other than human, or as a means of suggesting the archaic, giving the images the look of age and tradition. Differences within the corpus of figures might also be an index of a variety of meanings within the larger idea of an apotropaic sign of power.

Sheela-na-gigs come in an impressive variety of forms. Some are depicted with beasts (Rath Conrath, Co. Clare); some, like the figure found in the Figile River near Clonbulloge (Co. Offaly) (Fig. 3), reach behind or in front of their legs to pull open the vagina; some masturbate (Ballylarkin, Co. Kilkenny, Fig. 4); some hold objects (Lavey, Co. Cavan, Fig. 5), and while most are bald, at least one, the sheela-na-gig from Rahara (Co. Roscommon), has an elaborate hairdo (Fig. 6). These differences in pose, gesture, action, and degree of "femininity" or "feminine" attributes have been noted before, but have not yet been studied for the range of meanings and/or functions they might reveal. Admittedly, only a minority of the sheela-na-gigs survive in situ; nevertheless, we can make some general distinctions. Certainly the location of the open body of the sheela-na-gig on the church invites a comparison between it and the body of Ecclesia, which by the twelfth century was identified with Mary. Whereas Mary, or Ecclesia, is a closed, silent, fertile yet virginal and accepting body, the sheela-na-gigs are open, shrieking, seemingly barren in their cadaverous appearance yet powerfully sexual and repulsive bodies. On the fabric of the church they may have been understood as embodiments of and warnings against the mouth of hell.[40] The representation of the mouth of hell as an ambiguously gendered body goes back to at least the tenth century in Irish art.[41] A warning against the mouth of hell could be extended to the very doorway of the church, typically decorated with projecting chevron ornament, toothy serpents, and fanged beast heads. On the Nuns' Church at Clonmacnois the threat of the latter is held in check by the roll molding that they grasp with tooth and claw (Fig. 7, discussed elsewhere in this volume by Tessa Garton). Perhaps the location of several of the sheela-na-gigs on horizontal quoins, so that they are reclining rather than standing upright, is a way of suggesting a similar controlled danger. The Kiltinane (Co. Tipperary) sheela-na-gig, for example, was located on a quoin at the angle of the east gable of the church (Fig. 8). Turning a figure on its side or upsidedown is a standard medieval way of suggesting defeat or powerlessness. Sheela-na-gigs placed upright in close proximity to doors or windows, on the other hand, could clearly be more narrowly apotropaic in function, serving as guardians over the vulnerable entrances of churches or castles, as at Blackhall castle (Co. Kildare) or Killinaboy church (Co. Clare). The location of a sheela-na-gig by the door through which the grain entered an old mill at Rosnaree (Co. Meath)[42] further

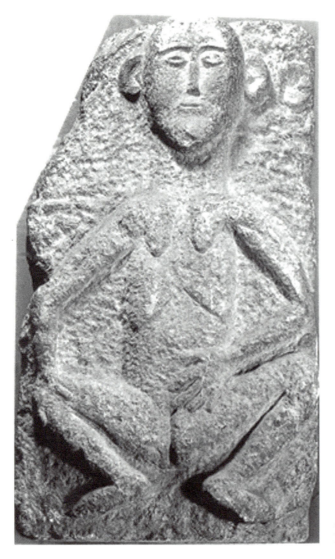

4. Sheela-na-gig from Ballylarkin, County Kilkenny

suggests a connection between the fertility of the earth and that of the body. Admittedly, this figure is likely to be in a secondary context, but it may well reflect the sculpture's original function. At the very least it can be seen as providing an important guide to interpretation, or reinterpretation, through re-use.

The Ballylarkin sheela-na-gig (Fig. 4), slender, smiling, and obviously not engaged in any sort of violent activity, hardly fills us with the same sense of terror produced by the scowling and aggressive County Cavan figure (Fig. 9), though both are said to come from old churches. Since so little is known about the specific context in which either was created or displayed, we can only speculate about the differences in their meaning. As different as they are, however, they do illustrate a characteristic of Irish sheela-na-gigs not seen on related images elsewhere in Europe: the correspondence between the shape of the genitals and that of the mouth. If the vagina is depicted as a gaping cavern, so is the mouth; if the vagina is simply a narrow slit, so is the mouth. The sheela-na-gig from Kiltinane church (Fig. 8), one hand to its mouth, the other to its genitals,

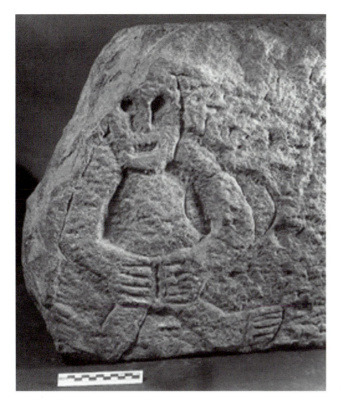

5. Sheela-na-gig, Lavey, County Cavan

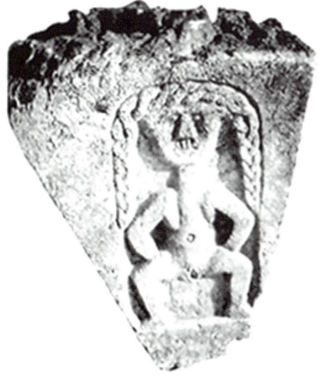

6. Sheela-na-gig from Rahara, County Roscommon

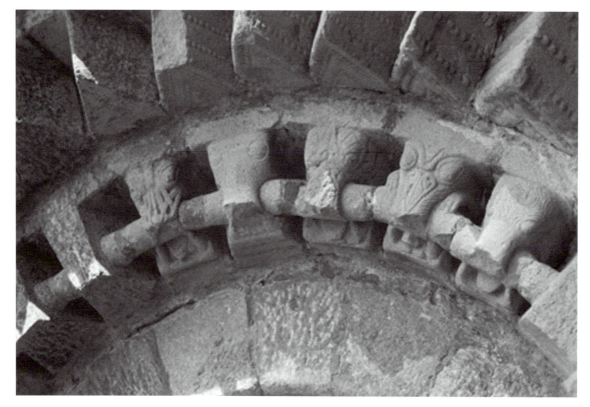

7. Portal arch of the Nuns' Church, Clonmacnois

makes the connection quite clear. The tension between aggressive threat and frozen action, be-
tween the suggestion of voice and the silence of the stone, is a powerful one. These are mouths
that cannot speak and wombs that cannot reproduce. It is easy to see how in their original con-
texts images such as the Cavan figure could be interpreted as references to the *vagina dentata*, the
wandering womb, death, and the mouth of hell (all interrelated phenomena). One could also
speculate that, as man-made creations, sheela-na-gigs with their empty wombs are attempts at
usurping the power of the female body or, at the very least, that as monstrous creations they
might have been perceived as contrasting with the perfection of divine creation.

 Some of the most monstrous wombs also appear on figures that are otherwise ambiguously
gendered. Only one of the sheela-na-gigs has long, feminine (but tightly braided) hair, that other
great sign of feminine lust. Several have breasts, but they are small, withered, and sometimes
streaked as if with tattoos or scars. The vast majority are either bloated or emaciated torsos with
bulbous heads, their bodies or faces often marked by deep striations suggesting protruding
bones, sagging flesh, or possibly, again, tattoos. In several instances, as with the "sheela-na-gig"
from Fethard Abbey (Co. Tipperary) (Fig. 10), there is nothing about the figure to suggest that it
is female rather than male. Thomas Wright may have picked up on this aspect of the sheela-na-
gigs in his 1866 drawing of a very masculine looking "sheela" from Ballynahend (Co. Tipperary)
(Fig. 11), identified by Jørgen Andersen as the Ballynahinch figure.[43] While the exact origins and
meaning of the name "sheela-na-gig" are unclear, Andersen also points out that "síle" is not just a

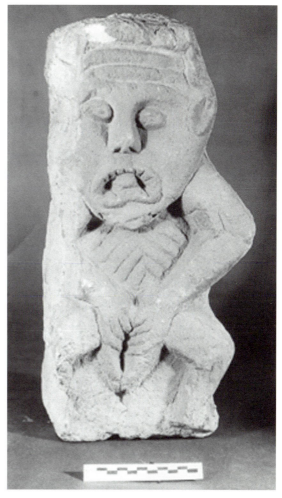

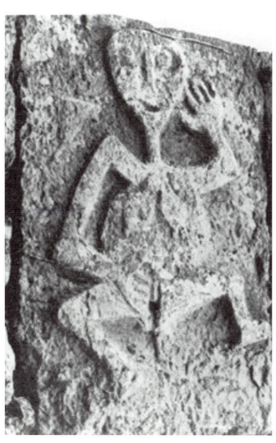

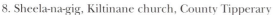

8. Sheela-na-gig, Kiltinane church, County Tipperary 9. County Cavan sheela-na-gig

term for a woman or hag, but can also be used to describe "an effeminate man, a girl too fond of boys' company, or a boy too fond of being with girls, in fact examples of a person showing a heavy leaning towards the other sex, in his or her behavior or psychological make-up."[44] In the Middle Ages such ambiguity of gender was a sign of the monstrous. The most terrifying and awe-inspiring figures were those that transgressed the boundaries of male and female, the living and the dead, the human and the animal or supernatural. Hildegard von Bingen's vision of the end of time included a monstrous woman with a mobile and excrement-covered head in place of her genitals: "It had fiery eyes, and ears like an ass', and nostrils and mouth like a lion's; it opened wide its jowls and terribly clashed its horrible iron-colored teeth."[45] Milton described his figure of Death as most terrifying in its shapelessness, while Satan:

> In shape and gesture proudly eminent
> Stood like a tower; his form had not yet lost
> All her original brightness. . . .[46]

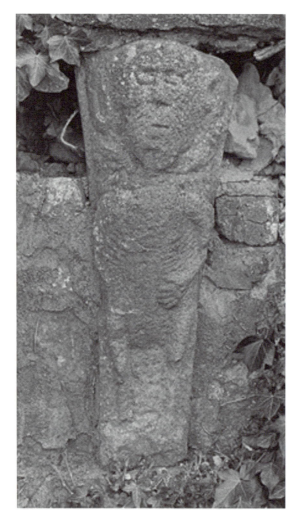

10. Fethard Abbey, County Tipperary, "sheela-na-gig"

11. Drawing of sheela-na-gig from Ballynahend, County Tipperary, from Thomas Wright, *The Worship of the Generative Powers during the Middle Ages of Western Europe*

DESIRE AND INTERPRETATION

If such images could be threatening in a religious context, so too could they serve to embody political threat. The same literary tradition of powerful women that was the basis of the Irish reinterpretation of the sheela-na-gig as a protective symbol also provided a historical tradition for real-life subversive women such as Fionuala MacDonnell, lauded as having "the heart of a hero and the mind of a soldier,"[47] or Gráine Ní Mháille (Grace O'Malley), who led uprisings against the English in the late sixteenth century. The latter, commemorated in the figure of Granuaile, became a personification of colonial Ireland. According to one commentator, "Tradition and reality kept alive in the consciousness of the native Irish the pagan Celtic association between the land in which they lived, and protective, multiple, female figures who often mysteriously com-

bined strength, age and ferocity with beauty, youth and fertility."[48] Similar associations no doubt led Lisa Bitel to use the Cavan sheela-na-gig as the cover illustration of her *Land of Women*, a revisionist history of women's social and cultural roles in early medieval Ireland. In both instances the authors are connecting the images with a series of textual sources with which they have no direct or concrete link and, like their medieval predecessors, reinterpreting the figures to accord with a contemporary scholarly agenda. The Cavan image could equally well illustrate Spenser's famous description of the starving and defeated Irish of the Elizabethan reconquest:

> Out of everie Corner of the woodes & glennes they came creeping forth upon their hands, fr theire legges could not beare them, they looked Anatomies of death, they spake like ghostes cryinge out of their graves, they did eate of the dead Carrions.[49]

But lacking firm dating and clear architectural and iconographic contexts for the sculptures, texts are almost all we have to go on.

Interpretation and reinterpretation, acknowledged and unacknowledged, have dominated scholarship on sheela-na-gigs. While they may not have much to tell us about the origins of sheela-na-gigs, such reinterpretations have much to tell us about the history of scholarship and how it has positioned sheela-na-gigs as mirrors of changing cultural values. The summary presented here is not all-inclusive but is intended only to provide examples of the ways in which objects from the past can intersect with presentest agendas, becoming, in the case of the sheela-na-gigs, veritable icons of a romanticized past.

Neglected by historians for several centuries, sheela-na-gigs were first brought to the attention of the scholarly community in the 1840s by antiquaries whose recording of the material was frequently an overt act of interpretation. Two nineteenth-century sketches of the now lost Moycarky (Co. Tipperary) and Rochestown (Co. Tipperary) sheela-na-gigs are preserved in the Royal Irish Academy. The Rochestown drawing (Fig. 12) was produced for John Windele's *Miscellaneous Antiquarian Gleanings* in the early 1840s. Both drawings show large-breasted, slender, long-haired women with their eyes closed and one hand to their genitals, presumably in the act of masturbation. There are no surviving sheela-na-gigs anywhere that look the least bit like them. While it is always possible that the sketches preserve a hitherto unknown variant of the sculptures, it is far more likely that the feminization and sexualization of both show the influence of the high-art tradition, with its voyeuristic pleasure in the naked and passive feminine idol (Fig. 13). Notions of what constituted the Irish "picturesque" might also be relevant, though, as Andersen points out, sheela-na-gigs are oddly missing from early antiquarian architectural sketches.[50] It is perhaps the Moycarky and Rochestown drawings that have led some scholars to label the sheela-na-gigs "erotic" images,[51] as the adjective is hardly applicable to the sculptures themselves.

Ghostliness and deathliness are qualities frequently attributed to the sheela-na-gigs for obvious reasons, and in the nineteenth century some scholars believed that they had originally marked graves.[52] A report in the *Proceedings of the Royal Irish Academy* for 1840–44 states that "There is . . . in the best sculpted figures a certain expression of countenance which resembles that of death."[53] This is fair enough, but others provide the "sculpted figures" with an uncanny animation akin to (and perhaps influenced by) the specters and ghostly heroines of Gothic novels. In the same volume of the *Proceedings*, Charles Halpin recounted his "discovery" of the Lavey figure (Fig. 5):

12. Drawing of Rochestown sheela-na-gig for John Windele's *Miscellaneous Antiquarian Gleanings* (Royal Irish Academy, Ms. 12 C1, f. 246)

13. Daniel Maclise, *The Origin of the Harp*, 1842. Manchester City Art Gallery

About two years ago as I drove past the *old graveyard* of Lavey Church, I discovered this curious figure, laid loosely, in a half reclining position on the top of a gate pier that had been built recently to hang a gate upon, at the ancient entrance of the old church-yard. I believe the stones used in building these piers were taken from the ruins of the old church of Lavey (there is scarcely a trace of the old church on the site it occupied) and I think probable that this figure was found amongst them, and laid in the position in which I found it, by the masons employed at the work.[54]

The Lavey figure here materializes like a phantom odalisque out of the ruins of the lost church. Halpin does credit masons working on the piers with placing the image in the location in which he found it; nevertheless, there is something eerie about the vanished church, the emphasis on the words "old graveyard," and the discovery of the "curious figure" rescued from the ruins. John O'Donovan animates the object even further when, in a letter from Nenagh dated 18 October 1840, he writes that he "met" a sheela-na-gig on a cornerstone in the castle of Ballyfinboy. The images do seem to appear among the ruins from out of nowhere like the heroines of Sophia Lea's *The Recess*, published 1783–85, or the ghostly living woman mistaken for a portrait in Regina Maria Roche's *The Children of the Abbey*, published in the last years of the eighteenth century.[55] They can be equally threatening, too. At about the same time that Halpin and O'Donovan were writing, the Rev. Mr. Tyrrell buried a sheela-na-gig near Lusk.[56] Certainly he did not mistake the object for a ghost, but whatever his reasons for the burial, the act demonstrates a belief that the object could have some sort of power over the living that could only be negated by the permanency of burial, by treating the image like the real dead. (Interestingly, in the earliest "Gothic" novel, Walpole's *The Castle of Otronto*, published in 1765, the ghosts are not actual bodies but fragments of an effigy and an image from a portrait.[57])

These are not just nineteenth-century phantoms. The tradition of animating the sheela-na-gigs continued well into the twentieth century, perhaps spurred on by the fact that their origins are obscure, and that they are so often considered to be older than the contexts in which they are discovered. Jørgen Andersen describes several of the authors and authorities he cites as being "confronted" by sheela-na-gigs,[58] while the Errigal Keerogue figure in the Ulster Museum is a "rewarding acquaintance."[59]

In the nineteenth century, as in the thirteenth and sixteenth centuries, Ireland was a postcolonial country. At the same time that antiquaries were discovering and recording sheela-na-gigs and other monuments of the Irish past, the English were characterizing the Irish as animalistic, aggressive, uncivilized, and grotesque, as had Gerald of Wales in the twelfth century and Edmund Spenser in the sixteenth. Cartoons satirizing the barbarous Irish appeared regularly in *Pat* and *Punch* (Fig. 14). The "Irish Frankenstein" might have been intended as a satirical character, but in Mary Shelley's novel the "real" Frankenstein seeks refuge in Ireland (pictured as even more remote than the Orkneys),[60] while that most famous of Gothic heroes, Heathcliff, is likely to have been an Irish famine victim found starving in the streets of Liverpool.[61] He is filthy and illiterate, untamed and untamable, speaks an incomprehensible gibberish, and corrupts everyone with whom he comes in contact. No one is safe until, like the Rev. Mr. Tyrrell's sheela-na-gig, he is dead and buried.

But even when safely buried sheela-na-gigs can remain a threat. In July and August of 1987 a series of letters and articles appeared in the Irish press in which the meaning and interpretation

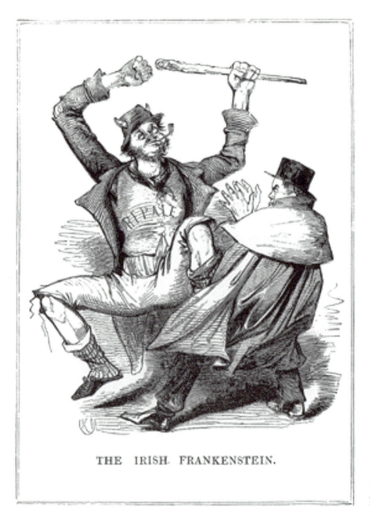

THE IRISH FRANKENSTEIN.

14. "The Irish Frankenstein," *Punch*, 4
November 1843

of the images, nationalistic interests, the role of the museum, and the politics of display were
heatedly debated. Debate began when a Canadian, Dale Colleen Hamilton, feeling she had been
wrongly denied access to the National Museum of Ireland's collection of sheela-na-gigs, voiced
her frustrations in a letter to *The Irish Times*. Scholars, journalists, and interested members of the
public all took sides. Issues ranged from the spelling of the name sheela-na-gig[62] to questions of
national security,[63] since the store in which the collection was housed adjoined the Dáil Éireann,
the seat of Irish government. In the course of the debate the National Museum was unwittingly
cast as a grotesque, tyrannical, and cannibalistic parent, keeping its dangerous progeny hidden
deep within its bowels. The accusation that the museum was deliberately hiding the sculptures
from the public kept alive the specter of nineteenth-century morals and moral censorship. Like
Derbforgaill, the sheela-na-gigs had become not quite defenseless victims in a battle for access
and control—this time access to and control of the past rather than the land. And like Derbfor-
gaill, they had become symbols of a lost Ireland. But they had also undergone yet another trans-
formation, having been taken up as icons of women's power by contemporary artists and femi-
nists alike.[64]

It was also as combined symbols of a powerful female body and a lost Irish past that the sheela-na-gigs appeared in *From Beyond the Pale: Art and Artists at the Edge of Consensus*, an exhibition organized by the Irish Museum of Modern Art in 1994–95. The exhibition included ten of the thirteen sheela-na-gigs in the National Museum of Ireland displayed alongside the work of modern and postmodern artists including Picasso, Duchamp, Kiki Smith, Beverly Semmes, and Jeff Koons. Yet in spite of the emphasis on difference, and the competing or coexisting identities, the sheela-na-gigs were once again reduced to a single monolithic identity/meaning/interpretation, albeit one that the catalogue noted changed through time. Differences among the sculptures and the possibility of a variety of simultaneous meanings within the group were not explored. Moreover, the sheela-na-gigs were the *only* premodern works on display (and only temporarily), leading many to question whether only certain moments of the premodern were relevant to, or capable of functioning simultaneously with, the modern.[65]

The modern construction of a lost Irish past has, however, fueled our interest in understanding the way in which history, including the history of images, is interpreted and recorded. For the sheela-na-gigs the new focus on accurate distribution maps and patterns of patronage mapped out by Eamonn P. Kelly promises to reveal much about the original contexts of these works, while an emphasis on differences among images that have so often been treated as the same, and an awareness that a variety of meanings may have existed simultaneously offer new ways of thinking about their meaning. Like Derbforgaill, with whom we began, the sheela-na-gigs can be associated with land, sovereignty, and power, as well as lack of the same; they are disruptive, yet are also part of a pre-established (and, one could also add, male-dominated) order, powerful and powerless at different times and depending on their audience. In this respect they are typical of the portrait of women created by Irish historians, jurists, and literati, who used the same Old Irish term *caillech* to refer to wives, hags, crones, nuns, and witches, and the same laws to protect or limit the rights of nuns, abbesses, lunatics, and female werewolves.[66] But they are also typical of our interest in (or fear of) the *unheimlich*, the "entrance to the former *Heim* of all human beings, to the place where everyone dwelt once upon a time and in the beginning."[67] Freud's words uncannily echo those of the nineteenth-century antiquaries who associated sheela-na-gigs with graves and crypts "in which were deposited the bodies, or material principles of the deceased, originally derived from mother earth . . . to whom the body of the dead returned by interment."[68] The history of the sheela-na-gigs is every bit as important as their origins. Only it can reveal how past and present unite in images that are reproduced, redefined, and translated in an effort to identify and preserve a tradition and a past that remain less a "faithful sign of historical memory" than "a strategy of representing authority in terms of the artifice of the archaic."[69]

NOTES

1. E. P. Kelly, *Sheela-na-gigs* (Dublin, 1996), 46; E. P. Kelly, "Sheela-na-gigs: A Brief Description of Their Origin and Function," in *From Beyond the Pale: Art and Artists at the Edge of Consensus* (Dublin, 1994), 45–51, at 51.

2. Annals reveal that there was a church on the site by 1026. A. Gwynn and R. N. Hadcock, *Medieval Religious Houses: Ireland* (Dublin, 1988), 315.

3. Gwynn and Hadcock, *Religious Houses* (as in note 2).

4. S. Duffy, *Ireland in the Middle Ages* (New York, 1997), 62.

5. F. J. Byrne, *Irish Kings and High-Kings* (London, 1987), 273. See also F. X. Martin, "Diarmait Mac Murchada and the Coming of the Anglo-Normans," in *A New History of Ireland*, ed. A. Cosgrove, vol. 2, *Medieval Ire-*

land, 1169–1534 (Oxford, 1987), 43–66, at 49–50.

6. J. Ryan, *Clonmacnois: A Historical Summary* (Dublin, 1973), 63.

7. K. MacGowan, *Clonmacnoise* (Dublin, 1985), 32. The Annals of Ulster record her death in 1193. On the monastery in general, see *Clonmacnoise Studies*, vol. 1, *Seminar Papers, 1994*, ed. H. King (Dublin, 1998).

8. Quoted in C. L. Innes, *Women and Nation in Irish Literature and Society, 1880–1935* (Athens, Ga., 1993), 153.

9. M. Ní Bhrolcháin, "The *Benshenchas* Revisited," in *Chattel, Servant or Citizen: Women's Status in Church, State and Society*, ed. M. O'Dowd and S. Wichert (Belfast, 1995), 70–81, at 71. For editions of the *Benshenchas*, see M. Dobbs, "The Ben-shenchus," *RCelt* 47 (1930), 283–339; M. Ní Bhrolcháin, "An Benshenchas Filíochta" (M.A. thesis, University College, Galway, 1977); M. Ní Bhrolcháin, "The Prose *Benshenchas*" (Ph.D. diss., University College, Galway, 1980).

10. Kelly, *Sheela-na-gigs* (as in note 1), 11; L. M. Bitel, *Land of Women: Tales of Sex and Gender from Early Ireland* (Ithaca, 1996), 229; J. Andersen, *The Witch on the Wall: Medieval Erotic Sculpture in the British Isles* (Copenhagen, 1977), 37–38. See also F. Henry, *Irish Art in the Romanesque Period (1020–1170 A.D.)* (Ithaca, 1970), 24.

11. Kelly, *Sheela-na-gigs* (as in note 1), 5.

12. Kelly, *Sheela-na-gigs* (as in note 1), 5.

13. For comparanda, see the collected images in A. Weir and J. Jerman, *Images of Lust: Sexual Carvings on Medieval Churches* (London, 1986); N. Kenaan-Kedar, *Marginal Sculpture in Medieval France* (Aldershot and Brookfield, 1995).

14. E. Rynne, "A Pagan Celtic Background for Sheela-na-gigs?" in *Figures from the Past: Studies on Figurative Art in Christian Ireland in Honour of Helen M. Roe*, ed. E. Rynne (Dun Laoghaire, 1987), 189–202. Rynne has commented on the relationship between the Clonmacnois figure and its Continental prototypes (p. 198).

15. A point noted by both Stella Cherry and Etienne Rynne: S. Cherry, *A Guide to Sheela-na-gigs* (Dublin, 1992), 2; Rynne, "Pagan Celtic Background" (as in note 14), 202, n. 9.

16. Kelly, *Sheela-na-gigs* (as in note 1), fig. 1.

17. Duffy, *Ireland* (as in note 4), 25–26.

18. Quoted in P. Berger, "The Historical, the Sacred, the Romantic: Medieval Texts into Irish Watercolors," in *Visualizing Ireland: National Identity and the Pictorial Tradition*, ed. A. M. Dalsimer (Boston and London, 1993), 71–87, at 74–75.

19. Quoted in Martin, "Diarmait Mac Murchada" (as in note 5), 60.

20. Gerald of Wales, *The History and Topography of Ireland*, trans. J. J. O'Meara (Harmondsworth, 1982), 31, 74–75, 91, 106, 110, 117–18.

21. Gerald of Wales, *Topography of Ireland* (as in note 20), 117–18.

22. Gerald of Wales, *Topography of Ireland* (as in note 20), 109.

23. Kelly, *Sheela-na-gigs* (as in note 1), 45. See also E. C. Rae, "Architecture and Sculpture, 1169–1603," in *Medieval Ireland* (as in note 5), 737–80, at 762.

24. A. Hadfield and W. Maley, "Irish Representations and English Alternatives," in *Representing Ireland: Literature and the Origins of Conflict, 1534–1660*, ed. B. Bradshaw, A. Hadfield, and W. Maley (Cambridge, 1993), 1–23, at 12.

25. Fedelm is identified as a poet in the Old Irish version of the *Táin Bó Cúailnge*, and as a prophetess in the Middle Irish recension. See K. Simms, "Women in Gaelic Society in the Age of Transition," in *Women in Early Modern Ireland*, ed. M. MacCurtain and M. O'Dowd (Dublin, 1991), 32–42.

26. Ní Bhrolcháin, "*Benshenchas* Revisited" (as in note 9), 75–77.

27. Ní Bhrolcháin, "*Benshenchas* Revisited" (as in note 9), 76.

28. D. Ó Cróinín, *Early Medieval Ireland, 400–1200* (Harlow and New York, 1995), 129; F. Kelly, *A Guide to Early Irish Law* (Dublin, 1988), 74.

29. Bitel, *Land of Women* (as in note 10), 19, 24, 69.

30. Bitel, *Land of Women* (as in note 10), 69–70.

31. Kelly, *Sheela-na-gigs* (as in note 1), 46.

32. See, for example, John Derricke's *The Image of Ireland*, ed. J. Small (Edinburgh, 1883), 49, and texts quoted in Hadfield and Maley, "Irish Representations" (as in note 24), 4–5.

33. Hadfield and Maley, "Irish Representations" (as in note 24), 3.

34. Kelly, *Sheela-na-gigs* (as in note 1), 12, and pers. comm.

35. See, for example, the famous image of Lust in the church of St. Radegunde, Poitiers, reproduced in Weir and Jerman, *Images of Lust* (as in note 13), pl. 59.

36. See L. Motz, *The Beauty and the Hag: Female Figures of Germanic Faith and Myth* (Vienna, 1993), 21; Bitel, *Land of Women* (as in note 10), 70–71.

37. Bitel, *Land of Women* (as in note 10), 209–10.

38. Deirdriu's mother's womb shrieked while she was serving the Ulstermen at a feast. This was obviously, and correctly, interpreted as a sign of future catastrophe. The story can be found in *Loinges Mac nUislenn*, in *The Book of Leinster*, ed. R. I. Best, M. A. O'Brien, and A. O'Sullivan, 6 vols. (Dublin, 1954–83), vol. 5, 1162–70.

39. I would like to thank Roger Stalley for drawing my attention to issues of style and technique.

40. For an interesting parallel from outside Ireland, see the fresco of hell by Bartolo di Fredi or Biagio di Goro Gezzi in the parish church of S. Michele Arcangelo in Paganico (Siena) of 1368. In this painting death is depicted as a withered hag with sagging breasts and a gaping, toothy mouth who flies out of the mouth of hell toward a seductive young woman. The fresco is illustrated

in *A History of Women*, vol. 2, *Silences of the Middle Ages*, ed. C. Klapisch-Zuber (Cambridge, Mass., and London, 1992), 364–65.

41. A little human figure with intertwined legs stands at the entrance to hell on the east face of the tenth-century Muiredach's Cross at Monasterboice. See C. Karkov, "Adam and Eve on Muiredach's Cross: Presence, Absence and Audience," in *From the Isles of the North: Early Medieval Art in Ireland and Britain*, ed. C. Bourke (Belfast, 1995), 205–11, fig. 4.

42. Described in Andersen, *Witch on the Wall* (as in note 10), 24.

43. Andersen, *Witch on the Wall* (as in note 10), fig. 3, p. 12.

44. Andersen, *Witch on the Wall* (as in note 10), 15.

45. Hildegard of Bingen, *Scivias*, trans. Mother Columba Hart and J. Bishop (New York, 1990), 493.

46. *Paradise Lost*, I, 589–99. For his description of Death, see II, 666–73.

47. Simms, "Women in Gaelic Society" (as in note 25), 38.

48. B. Loftus, *Mirrors: William III and Mother Ireland* (Dundrum, 1990), 50.

49. E. Spenser, *A View of the Present State of Ireland*, ed. W. L. Renwick (London, 1934), 135.

50. Andersen, *Witch on the Wall* (as in note 10), 13.

51. Andersen, *Witch on the Wall* (as in note 10), 21. Andersen claims that it is Peter Harbison who stresses the eroticism of the figures in the glossary to his 1970 *Guide to the National Monuments of the Republic of Ireland*, but Harbison (p. 264) uses the word "lewd," not "erotic." Etienne Rynne labels the sculptures "pseudo-erotic": "Pagan Celtic Background" (as in note 14), 189.

52. *PRIA* 2 (1840–44), 566–67.

53. *PRIA* 2 (1840–44), 572.

54. *PRIA* 2 (1840–44), 565–66. Quoted in Andersen, *Witch on the Wall* (as in note 10), 11.

55. In the former, the heroines, secret daughters of Mary Queen of Scots, are raised in a recess beneath a ruined convent and grow to threaten the security of Elizabeth I: S. Lea, *The Recess, or a Tale of Other Times*, 3 vols. (London, 1783–85). In the latter, the heroine Amanda, while searching the ruins of her mother's castle, mistakes a deathlike woman for the lost portrait of her dead mother.

56. Andersen, *Witch on the Wall* (as in note 10), 11.

Judging by the number of sheela-na-gigs recovered from rivers, he was not alone in his fears.

57. H. Walpole, *The Castle of Otranto*, ed. W. S. Lewis and J. W. Reed (Oxford, 1982), 23–24. See also J. E. Hogle, "The Gothic Ghost as Counterfeit and Its Haunting of Romanticism: The Case of 'Frost at Midnight,'" *European Romantic Review* 9 (Spring 1998), 283–92, at 284.

58. Andersen, *Witch on the Wall* (as in note 10), 11, 12, 98.

59. Andersen, *Witch on the Wall* (as in note 10), 82.

60. Chapters 20 and 21. See also J. E. Hogle, "Frankenstein as Neo-Gothic: From the Ghost of the Counterfeit to the Monster of Abjection," in *Romanticism, History and the Possibilities of Genre: Re-forming Literature, 1789–1837*, ed. T. Rajan and J. M. Wright (Cambridge, 1998), 176–207.

61. See S. Kilfeather, "Origins of the Irish Female Gothic," *Bullán: An Irish Studies Journal* 1.2 (1994), 35–45; T. Eagleton, *Heathcliff and the Great Hunger: Studies in Irish Culture* (London and New York, 1995), 3.

62. Sile na gig, sheela-na-gig, sheila-na-gig. See particularly E. Rynne's letter in *The Irish Times*, Saturday, 15 August 1987.

63. Ibid.; Dale Colleen Hamilton's letter in *The Irish Times*, Wednesday, 12 August 1987; "Sile na Gig and That (Sad) British Connection," *The Irish Press*, 13 August 1987.

64. M. Mullin, "Representations of History, Irish Feminism and the Politics of Difference," *Feminist Studies* 17 (1991), 42–43. See also the series of paintings and installations by Nancy Spero, including *Propitiatory* and *Sheela-na-gig at Home*.

65. C. E. Karkov and E. P. Kelly, "Sheela-na-gigs: Beyond the Pale," paper delivered at the College Art Association conference, Boston, 1996; H. Robinson, "Reframing Women," *Circa* 72 (Summer 1995), 18–23.

66. Bitel, *Land of Women* (as in note 10), 221; Kelly, *Guide to Early Irish Law* (as in note 28), 351.

67. S. Freud, "The Uncanny," in *The Standard Edition of the Complete Psychological Works of Sigmund Freud*, ed. J. Strachey, vol. 17, *An Infantile Neurosis and Other Works* (London, 1955), 219–52, at 245.

68. *PRIA* 2 (1840–44), 567.

69. H. K. Bhabha, *The Location of Culture* (London and New York, 1994), 35.

Late Medieval Irish Crosses and
Their European Background

·

HEATHER KING

JENNET DOWDALL, born in the second half of the sixteenth century of a wealthy landed family long established in County Louth, would have gone virtually unrecorded in the history of the Dowdalls[1] were it not for the number of building works with which she was associated. In the closing years of the sixteenth century Jennet and her husband William Bathe, who was a justice of the Court of Common Pleas, were engaged in updating their home at Athcarne castle in County Meath and in building bridges on their lands. These works were recorded on stone plaques inscribed with their initials, coats of arms, and the dates when the work was carried out. Jennet and William had no children, and when he died in 1599 Jennet commissioned two crosses to be erected in his memory. The Annesbrook cross was located close to Athcarne castle, and the Duleek cross (Fig. 1) was erected adjacent to the church where William Bathe was buried. She subsequently married Oliver Plunket, fourth baron of Louth, and when he died in 1607 she had a further two crosses erected for him.

These pillar crosses consist of a tall shaft with a dividing collar. They are decorated with inscriptions, heraldry, panels of foliage and fauna, and religious iconography including the Crucifixion, the Virgin and Child, a number of apostles, and some saints. While the immediate sources for the Dowdall crosses lie in County Meath over a century earlier, the original influences are more difficult to identify.

Ireland is virtually unique in western Europe in having a tradition of free-standing stone crosses from the eighth century to the present day. The early medieval high crosses, which span the period from ca. A.D. 700 to the mid-twelfth century, have been the subject of much scholarly research, and are discussed further in this volume by Peter Harbison, Jane Hawkes, Dorothy Verkerk, and Maggie Williams. Harbison's invaluable corpus of these crosses[2] leads one from the early Fahan slab, where the free-standing cross has not quite broken free from the stone, to the slab-like but Latin-form Carndonagh cross, through the solid- or open-ringed crosses, some with scriptural panels (e.g., Clonmacnoise), to the twelfth-century crosses, such as that at Dysert O'Dea, where the large relief figures of Christ and a bishop stand at the end of a tradition intimately associated with the Early Christian monasteries.[3]

The early medieval crosses are distributed in clusters in the east, north, midlands, and in an area extending along the west coast. Their location and function have been discussed by several authors, and while it has been suggested that they may have delimited an area of sanctuary, demarcated the territory owned by a monastery, marked a burial or the place where a saint had died,[4] or functioned as market crosses,[5] it is clear that they were mainly erected in monastic en-

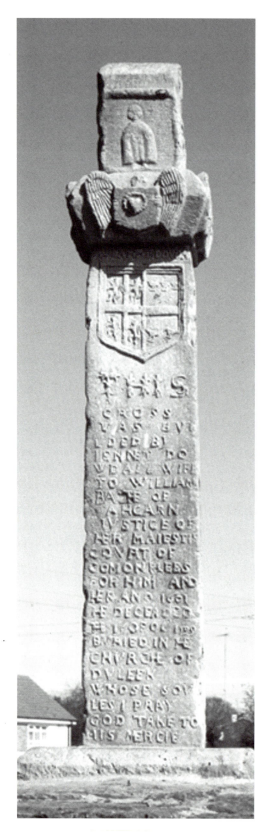

1. Duleek, County Meath, William
Bathe cross

closures or on lands owned by the monasteries, that some were placed in wayside locations, and that others came to be considered market crosses.

In contrast, the late medieval and post-medieval Irish crosses are rarely associated with monastic sites, although they are found in parish churchyards. They are most frequently located by the wayside or in a market-place. The function of the later crosses is generally commemorative, but some had a secondary role, especially in market squares, which were the focal point of life in the medieval town. The patronage of these later crosses is often easier to identify due to inscriptions, heraldry, or historical references. Three basic forms of the late medieval cross have been identified, and while the Latin cross retains its popularity, disc-headed and pillar crosses also occur.[6]

Very little research has been done on these crosses, which date from approximately 1200 to 1700. With a few exceptions, they have been published only in parish histories, where they receive only a brief mention and there is no appreciation of the wider context to which they belong. It is clear even at a superficial glance, however, that the medieval and later crosses do not belong to the early tradition of cross building: their forms and the materials used are different, and the range of motifs is considerably narrower and is now drawn from the *Vitae Sanctorum* and from the decorative traditions which originated on the Continent during the late twelfth and early thirteenth centuries. These new ideas were introduced into Ireland by the Anglo-Normans in the twelfth century, and the form and iconography of the late medieval crosses reflect the Insular styles which developed from them in the succeeding centuries.

In Europe, free-standing late medieval and post-medieval crosses abound, but, as with Ireland, no complete survey of any country has been attempted. As a result of this incomplete state of research, knowledge of their distribution, form, and iconography is greatly hindered. This neglect means that it is impossible to arrive at an accurate assessment of the numbers or precise distribution of the European monuments.

The crosses of central Europe, the former West Germany in particular, have been well researched, and the publications of the Deutsche Steinkreuzforschung include such monuments from all periods. However, the nomenclature is bewildering, and one has to try to distinguish among *Kerzenturm* (candle tower), *Totenleuchte* (death-light), *Andachtsmale* (memorial marker), *Flurdenkmale* (field memorial), *Wegkreuzen* and *Feldkreuzen* (wayside and field crosses), *Bildstocke* (picture post), and *Nischenbildstocke* (picture post with niche), among others. With such a multiplicity of descriptions it is not surprising to find that the reasons for erecting crosses in central Europe are also very diverse. Some were set up in towns and the countryside to mark the burials of plague victims, while other wayside crosses were erected for protection against demons, witches, and devils. This custom was promoted by the church to "weaken the strength of the devil and the evil spirits."[7]

The pillar cross, often referred to as a lantern, is the most popular form of monument in central Europe, Italy, and the Iberian peninsula. This consists of an undecorated shaft with an expanded or Latin cross-head. Some early examples decorated in Romanesque style survive, but the majority date from the fifteenth century onwards, and there are late Gothic, Renaissance, and Baroque style monuments to be seen. The crosses are usually carved from local stone, and religious motifs such as the Crucifixion, the Pietà, and the Virgin and Child are common to all areas, but there are regional preferences for local saints, iconography, and motifs. In some areas distinctive groups of crosses have emerged, such as those in the middle Rhine region carved from

basalt.[8] The large number of crosses in this area has enabled researchers, through analysis of the nature and plasticity of the carving, to identify distinct workshops, the length of time they were in operation, and in some cases individual sculptors.

A study of crosses in Galicia[9] indicates that octagonal or cylindrical columns with a capital, sometimes Ionic in style, and a Latin upper shaft were being erected at the same period as the late crosses in Ireland. The Galician crosses often have a skull at the base, and the martyrdom of Christ and the grief of his mother are the most widely used motifs. A third well-known group of crosses is found in lower Brittany in the north-west of France.[10] Many of these are simple Latin or lantern-style cross and are situated by the wayside. They demarcate the boundaries of parishes, dioceses, properties, and land holdings; mark the route of pilgrimages and pardons; and indicate the presence of chapels of ease, holy wells, and old burial grounds. These crosses are also found in market squares and churchyards, but the type known as a "calvary" is exclusively associated with parish closes or churchyards. These calvaries, unique to Brittany, represent the Hill of Golgotha and are often multi-storied monuments with life-sized figures creating a tableau of the life of Christ.

The erection of crosses during the later medieval period was not confined to Europe but was taken much further afield in the fifteenth century by Portuguese explorers. The stone crosses brought by their ships were set up in prominent positions to prove Portuguese sovereignty and to be symbols of Christianity in the newly discovered lands of South Africa and India. The crosses in South Africa were called *padraos*, and the first of these was erected by Dioga Cao in 1483 on the southern headland of the Congo River.[11] It was a pillar cross set on a chamfered rectangular base and had a rectangular collar decorated with a coat of arms and a Latin cross above. Similar crosses were erected by the explorers Bartolomeu Dias and Vasco da Gama in the Cape area. Even farther away, when Christianity was introduced by the Portuguese Jesuits to Japan in the mid-sixteenth century, stone lanterns, or *ishi doro*, which had a long history of association with Buddhism, became symbols of the new religion. When Christianity was proscribed in 1614, rather plump depictions of the Virgin and Child, not dissimilar to a Buddha figure, were added by "hidden" Christians.[12]

In Britain it is necessary to rely on nineteenth-century antiquarians to provide information on late crosses. One has the impression that several hundred monuments survive, that the greatest density of crosses occurs in the south and west of the country, and that the majority are now damaged or incomplete. The literature, similar to that on mainland Europe, is somewhat confusing in that no consistent terminology is used to describe the monuments. Description by shape (monolith, lantern, wheel-head, spire-shaped), by function (commemorative, weeping, preaching), and by location (churchyard, boundary, wayside) is used interchangeably by most writers.

In any event, it is difficult to study the late medieval crosses of Britain without taking into account the influence and impact of the Eleanor crosses. These monuments were set up following the death of Queen Eleanor of Castile, who died at Harby in Nottinghamshire in 1290. Her husband, Edward I, gave orders that in every place where her bier rested "a cross of the finest workmanship should be erected in her memory so that passers-by might pray for her soul."[13] The idea of setting up a wayside memorial cross for a relative was not without precedent. William II had a cross set up in the Strand in London in memory of his mother, Queen Matilda, who died in 1083, and Henry III erected a cross in 1240 at Merton in Surrey to commemorate his cousin William, earl of Warenne.[14] Indeed, the custom of erecting wayside memorial crosses in Britain goes back

at least as early as 709, when the body of St. Aldhelm, who died in Doulting in Somerset, was taken for burial to Malmesbury Abbey and seven crosses were erected along the route.[15] However, the immediate source of inspiration for the Eleanor crosses were the *montjoies* which were erected at the resting places of Louis IX's funeral procession when his body was brought from Tunis to Paris following his death in 1270.[16] From the descriptions of these *montjoies*[17] and their appearance in the Très Riches Heures of the Duc de Berry[18] it is clear that they provided Edward I and his sculptors with the models for the twelve crosses which he caused to be carved.

The three surviving Eleanor crosses at Geddington and Hardingstone in Northamptonshire and Waltham in Essex consist of tiers of pinnacled and traceried ogee-headed niches with statues of Queen Eleanor (Fig. 2). These are extraordinary monuments from several points of view: they are so well documented that one knows when and by whom they were made, the type of stone used, the length of time they took to set up, and, most importantly, the costs involved.[19] As many writers have pointed out, they were also key monuments in the development of English sculpture, representing "one of those evolutionary shifts after which nothing is quite the same again."[20] Furthermore, they appear to be the prototypes for many crosses which were erected in the following centuries, particularly in market-places. The influence of the Eleanor crosses continued into the nineteenth century, when new market crosses at Glastonbury and Taunton[21] and war memorials, such as the Martyr's Memorial at Oxford, were modelled on the Waltham cross.

It is difficult to establish links between the late medieval Irish crosses and either the early high crosses or the later medieval series in Europe. Ireland does not have any surviving late medieval cross which can be dated prior to the second half of the fifteenth century. There is a record of a wayside cross erected in Dublin in 1180 by the Anglo-Norman Hugh de Lacy, warden of Dublin and justiciar of Ireland, in memory of his wife, Rohesia de Verdun.[22] However, there is no description of this cross, which predates the Eleanor crosses by a century, nor is it known for how long it remained standing, so its influence, if any, on later crosses cannot be ascertained. Documentary sources indicate that a number of market crosses were erected in the new towns established by the Anglo-Normans in the thirteenth and fourteenth centuries, but with the exception of the Kilkenny cross, which was set up in 1335 and was clearly influenced by some of the English market crosses, nothing is known of their form or decoration. The other market crosses, such as those in Dublin and Athenry (Fig. 3), are all much smaller in scale and are, in any event, contemporary with the surviving crosses in County Meath.

The sudden interest in cross building in the later fifteenth century in Meath may reflect what was happening in Europe, but more immediately the crosses form part of the revival of stone sculpture which began in Ireland in the fifteenth century. John Hunt noted that there is comparatively little figurative material dating from the late fourteenth and early fifteenth centuries, but from the mid-fifteenth century there is evidence that churches were being built or repaired, and that church additions such as chantry chapels, fonts, effigial slabs, and large table tombs were being commissioned, particularly in the Meath area.[23] This fifteenth-century revival of stone carving includes a number of decorated wayside crosses which were mainly sponsored by the Plunket family, who were one of the major landowners in that area.

The Meath crosses consist of short pillars set in chamfered bases, sometimes erected on a plinth, and set up beside the road close to the castle in which the patrons lived. The highly ornamented rectangular shafts, decorated in Gothic style with figures in ogee-headed niches embellished with pinnacles, crockets, cusped perpendicular tracery, and stylized foliage, have all been

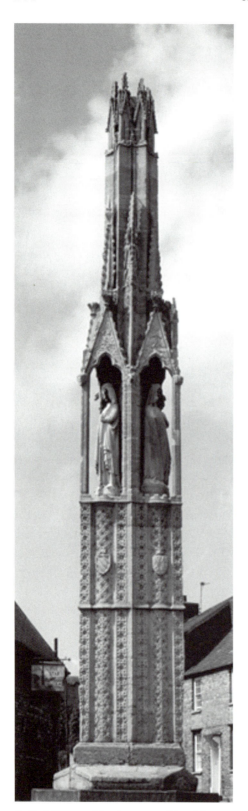

2. Geddington, Northamptonshire, Eleanor cross

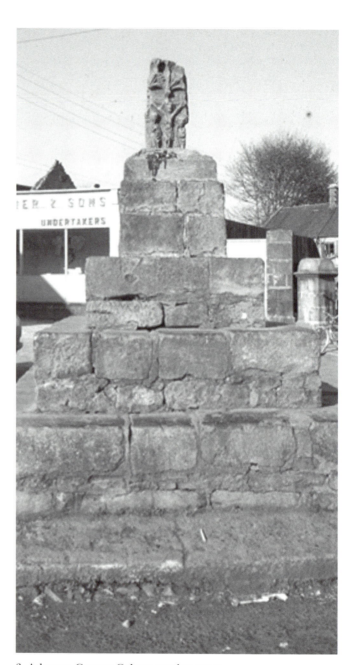

3. Athenry, County Galway, market cross

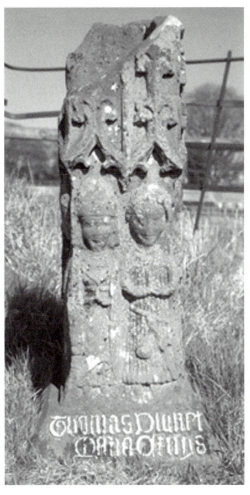

4. Killeen, County Meath, Thomas Plunket
and Maria Cruys cross

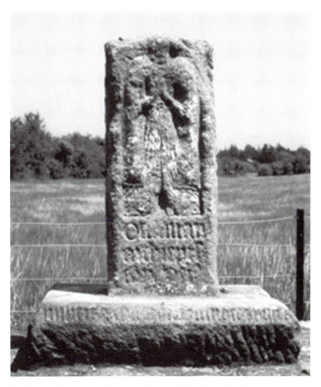

5. Sarsfieldstown, County Meath, Plunket family cross

damaged, and only two appear to be complete. Some have inscriptions asking for prayers for the donors and occasionally offering indulgences to those who pray for the deceased. They can be dated to the period between 1470 and 1520.

The earliest cross in the series is the Killeen I cross (Fig. 4) set up by or for Thomas Plunket and Maria Cruys in about 1470. Their daughter Elizabeth was also involved in erecting a cross (Fig. 5) on her husband's lands at Sarsfieldstown some twenty years later, while their grandson Christopher set up a cross circa 1519 in the centre of the manor village at Rathmore. The remaining six crosses in this group are uninscribed and therefore their patronage is uncertain. However, the fact that the crosses are on Plunket lands or on lands into which the Plunkets married suggests a connection with that family.

During the second half of the sixteenth century this almost exclusively Plunket custom was adopted by other landed families in the area. The Plunket family continued to erect crosses, as the tall pillar cross near the gateway of the family estate at Dunsany testifies. A second phase of cross building began about 1554, when the Summerhill cross was erected for Peter Lynch. In his

will he directed his wife, Elizabeth Thunder, to have prayers said for him.[24] The inscription on the shaft, "Orate pro anima Petri Lince," may be a fulfillment of this request. Other landed Meath families who imitated this public display of religious belief and social standing included the Cusacks, the O'Broins, the Nangles, and the Moures.[25] Many of these crosses are damaged or incomplete, but the crosses erected by Jennet Dowdall in the opening years of the seventeenth century are especially fine examples of the late medieval tradition. These pillar crosses vary in scale and decoration from the earlier series: they are taller, show a smaller range of motifs, introduce different styles of cross, and the earlier Gothic decoration gives way to designs influenced by the Renaissance. In contrast to the earlier series, which had joint dedications, these crosses were almost exclusively erected as memorials and were particularly patronized by women. The one exception in this group is the plain Latin Berford cross set up by Bartholomew Moure in memory of his wife.[26] He was clearly following an old County Meath tradition, but, despite being a substantial landowner,[27] he did not believe in paying for overly elaborate memorial monuments.

A third group of crosses was set up in the late seventeenth century, in some cases by the descendants of those who had erected the earlier two groups, thereby carrying on the tradition of setting up memorial crosses. However, they have very little in common with one another, and their form and decoration varies from a folk-art attempt by the Cruice family at copying an Early Christian high cross (Fig. 6) to the very elaborate Athcarne cross set up by a descendant of Jennet Dowdall (Fig. 7).

The most common motif on these monuments is the Crucifixion or elements associated with the martyrdom of Christ. The crucified figure on the cross at Athenry (Co. Galway), with John and Mary on either side (Fig. 3), can be paralleled on several crosses in Meath and is also an extremely popular motif on tomb surrounds of the fifteenth and sixteenth centuries. A variation of this image occurs on the Platin (Co. Meath) cross, where Christ is depicted as the redeemer of mankind in a panel formed by intertwined bunches of grapes.[28] The Passion of Christ is most fully represented on the Lismullin cross, where the crucified figure is flanked by two Latin crosses, probably representing the two thieves Dismas and Gestas (Fig. 8). Above the Crucifixion is the INRI and a depiction of the sun and moon, a motif seldom seen after the fifteenth century in Europe but which was to become very popular on Irish grave slabs of the eighteenth century. These symbols may represent the three hours of darkness at the time of the Saviour's death or perhaps the prefiguration of the Old Testament (the moon) which could be understood by the light (the sun) shed on it by the New Testament. On the opposite face is the carrying of the cross and an IHS encircled by flames, the monogram of Christ which was fostered by St. Bernardino of Siena in the fifteenth century. Symbols of Christ's Passion and the five wounds can be seen at Kilmore (Co. Cavan), while the collar at Duleek (Fig. 1) has similar images, including the face of Christ on the veil of Veronica, which are arranged in heraldic fashion on shields with angels' heads and wings as mantling.[29]

The Pietà occurs on a number of crosses, but the attitude of the figures is different in each case. The Virgin on the Keenoge cross[30] supports her son in an upright position and holds his hands, whereas the Balrath example (Fig. 9) shows Christ's figure horizontally across her knees with his right arm hanging down. The Virgin has one hand to her veil in a gesture of grief. These sculptures indicate an awareness of differing European styles and suggest that the patrons or the sculptors must have had access to portable or painted images. While there are parallels to the attitude of the figures at Balrath, particularly in the area of central Europe, the Irish sculptor

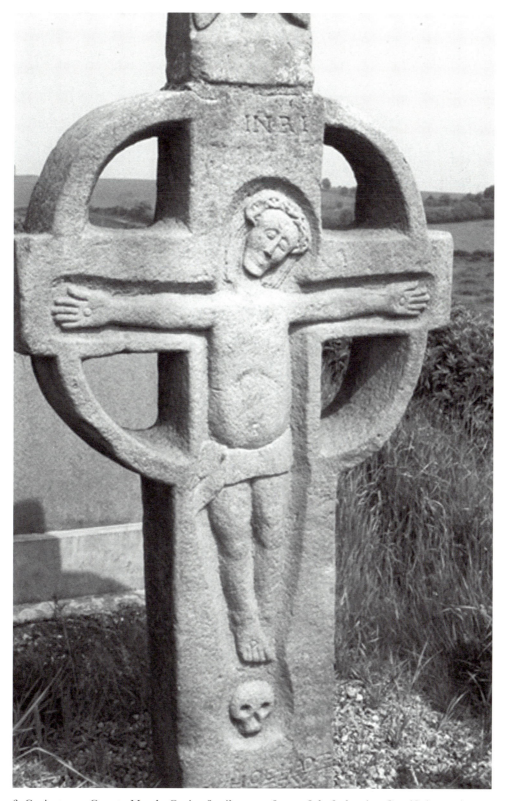

6. Cruicetown, County Meath, Cruice family cross, front of shaft showing Crucifixion

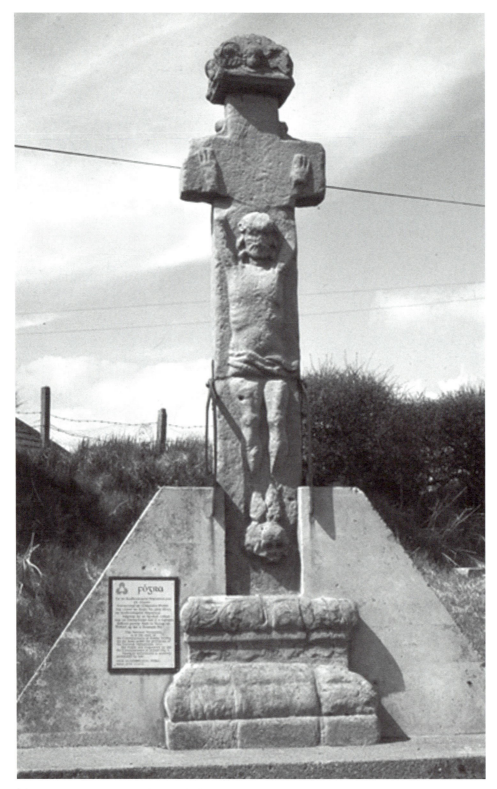

7. Athcarne, County Meath, Dowdall cross, front of shaft showing Crucifixion

8. Lismullin, County Meath, cross with Crucifixion

carved the Virgin's head-dress in cruder form, and there is also a problem with the scale of the figures. This carving illustrates, in part, the beginning of the breakdown of the traditional mode of depicting religious imagery in Ireland. Iconographical details that were rigidly adhered to in the thirteenth, fourteenth, and early fifteenth centuries are omitted; late examples of the Crucifixion, such as that at Cruicetown (Fig. 6), may omit the cross, show the head of Christ bent onto the wrong shoulder, leave out the nails in the feet and hands, and often depict a figure that is no longer emaciated but very childlike in form.

A similar progression can be traced in depictions of the Virgin and Child. The Mater Amabilis at Platin and the Queen of Heaven on the Arodstown (Co. Meath) cross[31] are clearly late medieval in date, whereas the rustic simplicity of the late seventeenth-century Cruicetown carving (Fig. 10) has very little in common with the early medieval depictions, showing, as it does, a rather

9. Balrath, County Meath, cross with Pietà

10. Cruicetown, County Meath, Cruice family cross, Virgin and Child

mature young boy sitting on his mother's knee. An exception to this general trend is the Ath-carne Virgin and Child (Fig. 11), carved very competently in the second half of the seventeenth century. This must have been inspired by a Continental Baroque-style exemplar.

In addition to images from the life of Christ, the apostles and a small number of other saints are a popular part of the iconographic repertoire used by Irish sculptors during the fifteenth and sixteenth centuries. The apostles were carved on tombs and fonts commissioned by the Plunket family in the late fifteenth and early sixteenth centuries, and they also appear on the Plunket crosses, where they are shown with their identifying attributes (Fig. 12). The later Dowdall cross at Duleek identifies and labels a number of apostles, as well as St. Catherine and St. Cianan, who

11. Athcarne, County Meath, Dowdall cross, back of shaft, Virgin and Child

founded an early monastery there. St. James of Compostela is depicted on a number of crosses with the cockle-shell on his purse and hat,[32] and there is a particularly interesting depiction of St. Laurence on the Keenoge cross (Fig. 13). His appearance on this shaft fragment underscores the connection of the Plunket family with St. Laurence, who was the patron saint of the family and who appears in Irish medieval sculpture only on monuments commissioned by the Plunkets.

Although the patrons of the crosses were primarily celebrating their religious beliefs, some of them also displayed their position in life by portraying themselves richly attired in fashionable dress. On tomb chests men are generally depicted in knight's armour, so the occurrence of three male figures in contemporary fashion adds significantly to our knowledge of the repertoire of

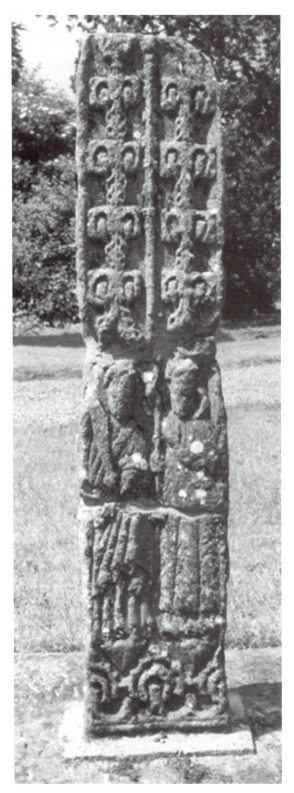

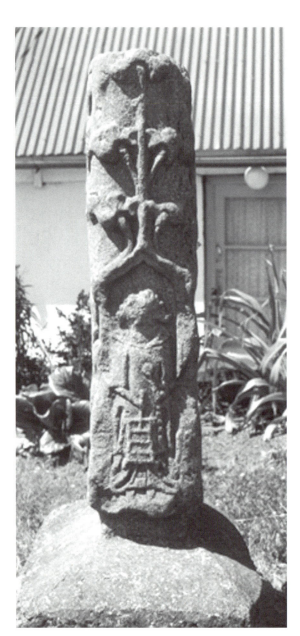

13. Keenoge, County Meath, Plunket cross with St. Laurence

12. Killeen, County Meath, Plunket cross with apostles

male costume in Ireland. Christopher Barnewall, second lord Trimbleston at Sarsfieldstown circa 1500, is richly clothed in a furred gown with jewelled buckle, furred mantle, and chain of office (Fig. 5), while Sir Thomas Plunket, lawyer at Killeen circa 1470, wears a plain legal gown with the implements of his profession around his waist (Fig. 4). The small unidentified man on the late seventeenth-century cross at Moybolgue, just over the border in County Cavan, wears a long-skirted Persian coat with many buttons and horizontally slashed pockets, along with high-heeled shoes tied with ribbons (Fig. 14).

Maria Cruys and the other ladies at Killeen are wearing the high-waisted V-necked gown and horned head-dress which were fashionable in the latter half of the fifteenth century (Fig. 4), while Elizabeth Plunket, Sir Christopher's wife, wears a gown with tight-fitting bodice and very elaborate head-dress in fashion around the turn of the century.[33] The late sixteenth-century cross fragment from Navan (Co. Meath) shows a lady wearing a stomacher and farthingale with puffed sleeves and ruff which rises behind the bejewelled hairstyle; this certainly suggests that the ladies of the Nangle family who erected the cross in about 1585 were well aware of the fashions being worn at the court of Queen Elizabeth in London.[34]

Inscriptions and armorial shields not only identify the patrons but also assist in creating a chronology for patronage and iconography. The inscriptions also indicate the changes in writing and language between the fifteenth and seventeenth century. Fifteenth- and early sixteenth-century crosses are incised in Gothic Latin, whereas the inscriptions on the later crosses are in relief and in Roman English. Throughout the period the inscriptions request prayers for the patrons, but two crosses of the early sixteenth century offer indulgences to the passer-by in return for a Paternoster and Ave for the deceased. At Annesbrook a medieval version of the Hail Mary is carved in its entirety on the cross.[35]

The custom of erecting crosses in Meath in the fifteenth and sixteenth centuries spreads from there into County Kildare in the second half of the sixteenth century. The earliest cross in this county is dated circa 1575 and was built for Sir Maurice FitzGerald, whose mother was from County Meath. The pillar cross was set up on the roadside near Castle Morris by his wife, Margaret Butler, who was a daughter of the great house of Ormond. His effigial slab in Kildare cathedral, which she also commissioned, has several armorial shields providing a veritable genealogy of all their family connections in Meath and Kildare.[36] The cross has suffered very badly, and while the base is still in position by the wayside, part of the shaft with the Crucifixion was used as a spud-stone for a gate.

The FitzGeralds were one of the major landowning families in Kildare, and they, like the Plunkets in Meath, continued the fashion of commissioning crosses. Sir Maurice's grand-daughter Ellenor is mentioned on the early seventeenth-century pillar cross at Glassealy,[37] and a cousin, John FitzGerald of Narraghbeg, had a cross erected for him by his wife, Ellen Tallon, at Castledermot.[38] Other crosses in Kildare, such as those at Ballysax[39] (where the collar is now on top of the west gable of the church) and at Coughlinstown, also have FitzGerald connections.[40] Indeed, the extended FitzGerald family are responsible for bringing the tradition south into County Kilkenny, and it is in Kilkenny city in the early part of the seventeenth century that wealthy merchant families were erecting crosses. Very few cross shafts survive in this county, the broken Latin cross from Newtown Jerpoint, with a Crucifixion, being an exception. The inscriptions and armorial plaques tend to be placed on large fossiliferous limestone bases. The spread of crosses to

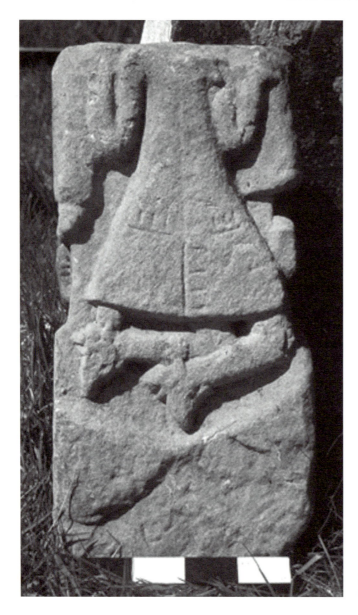

14. Moybolgue, County Cavan, cross with
unidentified figure

the north and west of Meath at this period was largely due to the landed classes and was the re-
sult of marriage alliances between families in Meath, Westmeath, and Cavan.

There is evidence for almost 150 crosses in Ireland that can be dated to the late medieval
and post-medieval period, but many are represented only by fragmentary shafts or by bases whose
wooden or stone shafts have been destroyed. The majority are wayside crosses, a small number
are market crosses, and about one-third are located in graveyards, although they do not appear
to have functioned as grave markers. Their main concentration is, similar to the Early Christian
high crosses, in the Leinster area, with a small scatter to the west and north-east of Ireland. South-
ern counties such as Kerry, Cork, and Waterford have no crosses, nor has Donegal. Those in the
north of Ireland are mainly market crosses erected in the new plantation towns established dur-
ing the seventeenth century, but, again, many of these have disappeared.

Regional preferences can be seen in the choice of stone and form. The rectangular pillar cross with collar and upper shaft can be seen in most areas, although monuments as elaborate as the Dowdall crosses in Meath and Louth appear only in small numbers in Kildare, and these are now very damaged. The John FitzGerald cross of circa 1620 from Castledermot, now at Kilkea castle, uses the Duleek format of saints in panels on each face of the shaft but is much less elaborate and is carved in a much flatter technique. Elsewhere they are undecorated except for an inscription on the shaft or collar. At Kilconnell (Co. Galway)[41] the collar is in the shape of an orb, and the dedicatory inscription is carried around its circumference. Disc-headed crosses are found in most counties from Meath to Galway, but the amount of imagery decreases as one goes westward, and some have no ornamentation apart from an inscription.

The crosses were set up in three phases: the first series clusters around 1500, while the second group spans the period from about 1554 to 1635. There is an absence of crosses dating to the mid-sixteenth century and again during the period after 1635, but these gaps may be explained by the reforming religious policies of Henry VIII and Elizabeth I, while the Cromwellian incursions in the middle of the seventeenth century would have militated against the erection of symbols of Catholicism in the countryside. However, the return of a Catholic monarch to the throne in England in 1685 generated a revival of interest in cross building at the end of the century. The king is specifically mentioned on the Robertstown cross in Meath, where the inscription states that it was erected in the reign of the "Soveraign Lord King James the Second by the Grace of God."[42] Indeed, it was also at this time that there was a revival of interest in the Early Christian high crosses, and a number of them which may have fallen, including the Market Cross at Kells and the crosses at Ballymore-Eustace and Dysert O'Dea, were repaired and re-erected.[43]

The late crosses of Ireland are contemporary with the market, wayside, and churchyard crosses in Europe, and it is clear that influences and ideas were percolating to the western edges of the Continent, as is seen so clearly in the Balrath Pietà or the Athcarne Virgin and Child. The study of these monuments, both in Ireland and in Europe, however, is still in its infancy, and more work needs to be done before we will fully understand the ebb and flow of influences on the medieval and post-medieval Irish crosses.

NOTES

1. *Dowdall Deeds*, ed. C. McNeill and A. J. Otway-Ruthven (Dublin, 1960).

2. P. Harbison, *The High Crosses of Ireland: An Iconographical and Photographic Survey* (Bonn, 1992).

3. Harbison, *High Crosses* (as in note 2), vol. 2, figs. 276, 87, 132, 261.

4. A. Hamlin, "Crosses in Early Ireland: The Evidence from Written Sources," in *Ireland and Insular Art, A.D. 500–1200: Proceedings of a Conference at University College Cork, 31 October–3 November 1985,* ed. M. Ryan (Dublin, 1987), 138.

5. C. Doherty, "Exchange and Trade in Early Medieval Ireland," *JRSAI* 110 (1980), 67–89.

6. H. A. King, "Late Medieval Crosses in County Meath, c. 1470–1635," *PRIA* 84C (1984), 79–115; eadem, "Irish Wayside and Churchyard Crosses, 1600–1700,"

Post-Medieval Archaeology 19 (1985) 13–33; eadem, "A Possible Market Cross Fragment from Drogheda," *JCLAHS* 20 (1984), 334–39; eadem, "A Late Medieval Cross from Kilpatrick, Co. Westmeath," in *Keimelia: Studies in Medieval Archaeology and History in Memory of Tom Delany*, ed. G. Mac Niocaill and P. F. Wallace (Galway, 1988), 67–71; eadem, "The Ardee Cross," *JCLAHS* 20 (1983), 210–14.

7. K. Müller-Veltin, *Mittelrheinische Steinkreuze aus Basaltlava* (Neuss, 1980), 77.

8. Müller-Veltin, *Steinkreuze aus Basaltlava* (as in note 7).

9. A. R. Castelao, *As cruces de pedra na Galiza* (Buenos Aires, 1950; repr. Vigo, 1984).

10. E. Royer, *Nouveau guide des calvaires bretons* (Rennes, 1985).

11. E. Axelson, "Beacons of Portuguese Discovery," *His-*

toria 1 (1957), 231–38.

12. P. Yamada, "Guardians of Serenity: The Stone Lanterns of Kyoto," *Winds* (October, 1986), 84–88.

13. *Willelmi Rishanger, quondam Monachi S. Albani, et Quorundam Anonymorum, Chronica et Annales (A.D. 1259–1307)*, ed. H. T. Riley (Rolls Series 28, vol. 2) (London, 1865), 210–11.

14. E. M. Hallam, "Introduction: The Eleanor Crosses and Royal Burial Customs," in *Eleanor of Castile, 1290–1990: Essays to Commemorate the 700th Anniversary of Her Death, 28th November 1290*, ed. D. Parsons (Stamford, 1991), 18.

15. C. Pooley, *An Historical and Descriptive Account of the Old Stone Crosses of Somerset* (London, 1877), 140–41.

16. N. Coldstream, "The Commissioning and Design of the Eleanor Crosses," in *Eleanor of Castile* (as in note 14), 60.

17. R. Branner, "The Montjoies of St. Louis," in *Essays in the History of Architecture Presented to Rudolf Wittkower on His Sixtieth Birthday*, ed. D. Frazer, D. Hibbard, and M. Lewine (London, 1967), 13–16.

18. *Les Très Riches Heures du Duc de Berry*, ed. J. Longnon, R. Cazelles, and M. Meiss (London, 1989), pls. 4, 48.

19. R. A. Brown, H. M. Colvin, and A. J. Taylor, *The History of the King's Works*, vol. 1, *The Middle Ages*, ed. H. M. Colvin (London, 1963), 479–85.

20. Coldstream, "Eleanor Crosses" (as in note 16), 55.

21. Pooley, *Stone Crosses of Somerset* (as in note 15), 18–19, 35.

22. *Register of the Abbey of St. Thomas, Dublin*, ed. J. T. Gilbert (London, 1889), 75.

23. J. Hunt, *Irish Medieval Figure Sculpture, 1200–1600: A Study of Irish Tombs with Notes on Costume and Armour* (Dublin and London, 1974), vol. 1, 5, 114. See also H. G. Leask, *Irish Churches and Monastic Buildings*, vol. 3, *Mediaeval Gothic, the Last Phase* (Dundalk, 1960); H. M. Roe, *Medieval Fonts of Meath* (Longford, 1968).

24. M. Devitt, "Summerhill and Its Neighbourhood," *JCKAS* 6 (1910), 277.

25. King, "Late Medieval Crosses" (as in note 6), 94–96.

26. King, "Late Medieval Crosses" (as in note 6), 106–7.

27. R. C. Simington, *The Civil Survey, A.D. 1654–1656*, vol. 5, *County of Meath, with Returns of Tithes for the Meath Baronies* (Dublin, 1940), 47.

28. J. Hall, *Dictionary of Subjects and Symbols in Art* (London, 1974), 142; King, "Late Medieval Crosses" (as in note 6), pl. v.

29. King, "Late Medieval Crosses" (as in note 6), pls. xviii, xvi.

30. King, "Late Medieval Crosses" (as in note 6), pl. ii.

31. King, "Late Medieval Crosses" (as in note 6), pls. v, xii.

32. King, "Late Medieval Crosses" (as in note 6), pls. ii, v.

33. King, "Late Medieval Crosses" (as in note 6), pl. vii.

34. King, "Late Medieval Crosses" (as in note 6), pl. xix.

35. King, "Late Medieval Crosses" (as in note 6), 104.

36. H. A. King, "The Medieval and Seventeenth-Century Carved Stone Collection in Kildare," *JCKAS* 17 (1987–91), 75–77, 91–93.

37. Lord W. FitzGerald, "Glassealy Churchyard," *Journal of the Association for the Preservation of the Memorials of the Dead* 8 (1910–11), 355–56.

38. Lord W. FitzGerald, "The FitzGeralds of Lackagh," *JCKAS* 1 (1894), 250–51.

39. Omurethi, "Ballysax and the Nangle Family," *JCKAS* 6 (1909), 99–100.

40. E. Sommerville-Large, "Notes," *JCKAS* 2 (1899), 453.

41. Lord Killanin and M. V. Duignan, *Shell Guide to Ireland* (London, 1962), 316.

42. H. A. King, "Seventeenth-Century Effigial Sculpture in the North Meath Area," in *Figures from the Past: Studies on Figurative Art in Christian Ireland in Honour of Helen M. Roe*, ed. E. Rynne (Dun Laoghaire, 1987), 305.

43. Harbison, *High Crosses* (as in note 2), figs. 55, 261, 343.

Index

•